Praise for *Against Val*

'*Against Value* is a remarkably astute
temporary moment—both cultural and political—desperately needs. The language
of "value" has itself become a means through which the essential threat that art
poses to our social norms can be contained and constrained. This book menaces
that political conservatism, restoring the very possibility of a criticism that might
actually go towards changing our society. That, though not the value of the book, is
the point.' —**Thomas Docherty**, Professor of English and of Comparative Litera-
ture, University of Warwick

'This fascinating and multifaceted collection questions the audit culture currently
destroying the arts and education. The assembled authors expose a pervasive and
allegiance-demanding regime of "value" that parades itself as rational but is deeply
and madly self-referential and empty. These arguments are frightening in a sense,
as they ask us to take the first halting steps into an unknown territory where we re-
learn how properly to defend what we really love—without regard to everything's
serviceability to some externally imposed "value." This first-rate volume helps to
provide an initial vocabulary for describing what so many of us feel in our bones
but cannot quite articulate.' —**David J Blacker**, author, *The Falling Rate of
Learning and the Neoliberal Endgame* and Professor of Philosophy of Education
and Director of Legal Studies, University of Delaware

'This book is a tonic for those tired of the pieties of value-talk in the fields of
education and the arts. It suggests that the very notion of value is totally compro-
mised, unthinkingly reflecting, rather than challenging, the ills of neoliberalised
society. Bravo to the editors for bringing together such a simulating collection of
essays.' —**Lars Iyer**, author of the *Spurious* trilogy (2011–2013) and *Wittgen-
stein Jr* (2014); Reader at Newcastle University

'An ultra-narrow notion of value dominates contemporary art and education. The
old adage that our time knows the price of everything and the value of nothing is
more germane now than ever. *Against Value in the Arts and Education* assembles a
brilliant array of commentators to sketch out a coming future, one in which the
spent figure of *homo economicus* is finally abandoned, but also free of the false
criticality and faux nostalgia that has functioned as neoliberalism's twin for too
long. This remarkable and prescient book will fundamentally reshape the debate to
come." —**Peter Fleming**, author of *The Mythology of Work: How Capitalism
Persists Despite Itself*

'How could anyone be against value? What could this mean? The counter-intuitive thesis heralded in the title of Sam Ladkin, Robert McKay and Emile Bojesen's provocative and insightful book constitutes a bold and cogent attack on the culture of accountability. The insistence on "values" that today pervades the arts, education, and so much else is exposed here in all its hollowness. The essays collected in the volume, complemented by a powerful introduction, work with and through the arts to reveal what is at stake and what matters, in original, sometimes disturbing, and always thought-provoking ways.' —**Paul Standish**, UCL Institute of Education

'For some time now, the field of Design has been preoccupied with demonstrating its value to and its role in society, articulated in endless projects that evaluate the "impact" of Design and designers on business and social problems. And yet somehow we never quite get to the answer, so the cycle starts again, while other aspects of the field would benefit from sustained inquiry. This book provides useful challenges to even thinking about this question. It opens up the context in which questions of value and valuing have come to dominate, and hobble, the arts and education. The arguments in the book shift attention away from the methods and practices for determining value—which people in my field often reach for—towards a critical exploration of the worldviews and assumptions that shape and drive evaluation. By proposing that the arts and education resist value, this book opens up new ways of thinking about the nature of art and design practice and the worlds they help bring into being. This links helpfully to recent research about the value of ignorance in doing research and inventing new social arrangements and provides new directions for research, practice and policy.' —**Dr Lucy Kimbell**, Director, Innovation Insights Hub, University of the Arts London and author of *Audit* (2002)

Against Value
in the Arts and Education

Disruptions

Disruptions is a series that interrogates and analyses disruptions within and across such fields and disciplines as culture and society, media and technology, literature and philosophy, aesthetics and politics.

Against Value
in the Arts and Education

Edited by
Sam Ladkin, Robert McKay
and Emile Bojesen

ROWMAN &
LITTLEFIELD
——————————INTERNATIONAL
London • New York

Published by Rowman & Littlefield International, Ltd.
Unit A, Whitacre Mews, 26-34 Stannary Street, London SE11 4AB
www.rowmaninternational.com

Rowman & Littlefield International, Ltd. is an affiliate of Rowman & Littlefield
4501 Forbes Boulevard, Suite 200, Lanham, Maryland 20706, USA
With additional offices in Boulder, New York, Toronto (Canada), and London
(UK)
www.rowman.com

British Library Cataloguing in Publication Information Available
A catalogue record for this book is available from the British Library

ISBN: HB 978-1-7834-8489-8
ISBN: PB 978-1-7834-8490-4

Library of Congress Cataloging-in-Publication Data

Names: Ladkin, Sam, editor. | McKay, Robert, editor. | Bojesen, Emile, editor.
Title: Against value in the arts and education / edited by Sam Ladkin, Robert McKay, and
 Emile Bojesen.
Description: London ; New York : Rowman & Littlefield International, 2016. | Series: Dis-
 ruptions
Identifiers: LCCN 2015044200 (print) | LCCN 2016004222 (ebook) | ISBN 9781783484898
 (cloth : alk. paper) | ISBN 9781783484904 (pbk. : alk. paper) | ISBN 9781783484911
 (Electronic)
Subjects: LCSH: Arts--Moral and ethical aspects. | Humanities--Moral and ethical aspects. |
 Education--Moral and ethical aspects. | Value.
Classification: LCC NX180.E8 A43 2016 (print) | LCC NX180.E8 (ebook) | DDC 700.71--
 dc23
LC record available at http://lccn.loc.gov/2015044200

♾TM The paper used in this publication meets the minimum requirements of
American National Standard for Information Sciences Permanence of Paper for
Printed Library Materials, ANSI/NISO Z39.48-1992.

Printed in the United States of America

In memory, Stephen Rodefer

You know, interstellar gravity notwithstanding,
Someday I'm going to teach someone
How to do this, and take a rest.

Contents

Acknowledgements

Research for *Against Value* was supported by the Arts and Humanities Research Council (AHRC), UK, as part of its Cultural Value Project. This support made possible the 'Against Value Symposium', held at the Humanities Research Institute of the University of Sheffield in March 2014; our thanks to all of the participants, including Rebecca Gordon-Nesbitt (Manchester Metropolitan University), Sara Jane Bailes (University of Sussex), Dominic Lash (musician and independent scholar), Mike Neary (University of Lincoln), Fabienne Collignon (University of Sheffield), Rachel Beckles Willson (Royal Holloway), Maria Aristodemou (Birkbeck), Marie Morgan (University of Winchester), and Ansgar Allen (University of Sheffield). We remain grateful to the University of Sheffield for its generous support of the first incarnation of this project (despite the project's antagonistic stance) and for the 'Against Value in the Arts and Humanities' public lecture held at the university in 2012, as well as to the participants and especially the speakers on that occasion: Marilyn Strathern, Tim Etchells, Peter Thompson, and Emile Bojesen. We want to thank the students and colleagues who worked with us at Sheffield, following the public event, for the enthusiasm, intelligence and time they devoted to teaching and learning against value. This pedagogic work was also supported by the Higher Education Academy by way of the National Staff-Student Partnership Award (2013). Our specific thanks go to Susan Fitzmaurice, Adam Piette, Marcus Nevitt, Frances Babbage, George Nicholson, Julia Dobson, Adam Stansbie, Cathy Shrank, Anna Barton, Fabienne Collignon, David McCallam, John Miller, and especially John Barrett. Last, we gratefully acknowledge the students who matriculated in and after 2012; their fees paid for much of the work that went into this book.

Sam offers his thanks to Robin Purves and Sara Crangle; Bob offers his to Tom Tyler and Gayle McKay; Emile offers his to Chris Mounsey and John Llewelyn. Our gratitude also goes to the publishers and editorial staff at Rowman & Littlefield and to series

editor Paul Bowman. The editors would also like to thank each other, which is nice.

Chapter 3 was originally published as Hal Foster, 'Post-critical', *October*, 139 (2012), 3–8; we are grateful to the original publisher, October Magazine Ltd. and the Massachusetts Institute of Technology. Chapter 15 is a revised version of Griselda Pollock, 'Saying No! Profligacy versus Austerity, or Metaphor Against Model in Justifying the Arts and Humanities in the Contemporary University', *Journal of European Popular Culture*, 3.1 (2012), 89–106; we are grateful to the original publisher, Intellect.

ONE

Introduction

Against Value

Sam Ladkin, Robert McKay and Emile Bojesen

> When we refuse, we refuse with a movement free from contempt
> and exaltation, one that is as far as possible anonymous, for the
> power of refusal is accomplished neither by us nor in our name,
> but from a very poor beginning that belongs first of all to those
> who cannot speak. Today, one might say that it is easy to refuse,
> that the exercise of this power carries little risk. This is no doubt
> true for most of us. I think, however, that refusal is never easy,
> that we must learn how to refuse and to maintain intact the pow-
> er of refusal, by the rigor of thinking and modesty of expression
> that each one of our affirmations must evidence from now on.
> —Maurice Blanchot, 'Refusal'

This collection traces just some of the implications of 'value', in its
variety of mutable guises, as it tears across the terrain of the arts and
education, through our work lives and private lives, and outwards
onto the grounds of continued existence on a finite planet. Whether
utilised by those with elitist or at least non-egalitarian ideological
programmes in mind or by those wishing, broadly, to pursue an
amiable impulse to defend the humanising effect of the arts and
education, value, helped by the audit culture, which is its regulato-
ry ecosystem, damages that which it seeks to measure. *Against Value
in the Arts and Education* describes how the arts and education can

1

be motivated by or incorporate a critique of value or values and how previous defences of the arts and education too often depend upon uncritical notions of value. *Against Value* probably sounds like a counter-intuitive way to go about describing and defending the value of anything. And it is.

The hypothesis presented to the contributors of this volume was as follows: It is often the staunchest defenders of art and of education who do them the most harm, by suppressing or mollifying their dissenting voice, by neutralising the painful truths they reveal, and by instrumentalising the ambivalence they produce.[1] The result is that rather than expanding the autonomy of thought and feeling of the artist and the audience, of student and teacher, their defenders make art and education self-satisfied or otherwise an echo chamber for the limited and limiting self-description of people's lives lived in an 'audit culture', a culture pervaded by the direct and indirect excrescence of practices of accountability.

Against Value therefore seeks to work as a theoretical rejoinder to the evidently held but often strategically veiled values of the neoliberal economy, 'post-ideological' state management, and audit culture. *Against Value* also resists a defence of the arts or education that is predicated on establishing the value of their contestation of those dominating values, which all too readily provides another market for their expansion.

There are two major threads here: a critique of the use of a discourse of value, particularly in its economic guise but more broadly wherever relative or contingent values are offered as necessary or unconditional, and a responding insistence that the arts and education are, or perhaps should be, critical of iterations of value, whatever that value might be, and (crucially) *however ostensibly virtuous* (the good, the beautiful, the happy). That is to say, the arts and education are fundamentally against value. It does not invalidate this claim that it is inherently paradoxical or that these arenas are constituted by all kinds of values as well as being critical of them; indeed, the truth that the arts may even also be expressions of the values they critique is primary evidence of the need for an understanding of them that goes against value.

The chapters collected here describe some of the ways in which the arts and education work against value(s): normative, repressive, alienating, and so forth. Our claim is that they are not best understood as offering the beneficent value of the balm or therapy to be set against such maladies. They messily inhabit or haunt the normative, disturbing its order, rather then seeking new norms. They

voice both the whispered appeal of repression in a culture of surveillance (including audit), with its pretence that complete knowledge is complete safety, and the more audible barked command of forcible state repression—voice them so as better to deafen them. The arts and education work by producing alienation as well as by demystifying it.

This book therefore works to diagnose the counterproductive effects of the irredeemable advancement of value. The auditing of values pervades the fabric of people's work lives, their educations, and increasingly their everyday experiences: they (we) are asked with ever-increasing frequency to justify our value in every sense, including the value of our labour, both in the past and as a prediction of its future, and to translate our own ambiguous lives into the metrics of the dominating system of values of our times. Beneath it all works the conditioning effect of such iterations, that to be asked to justify one's value, even when one's value *can* be justified in the terms on offer, is to be conditioned into abjection, a devaluation from which we can only ever be temporarily saved (given our health, productivity, and so forth). Those of us who work in education see how substantially our students and pupils have incorporated the psychological subservience, submissiveness, and blank acquiescence necessary to navigate towards the future in which they imagine they will live their lives.

We are asked to read, to listen, to teach, to think, and to feel in ways that do not threaten with dissonance or dissent the explicit and implicit regulatory powers of the social. We are asked only to make that art, or educate, in ways which affirm and do not agitate against the ostensible values of our times, even as those values shield the realities of capital, of employment, of debt—those values which do not care for the lives on which they remain parasitical. The rhetoric of value is used to disguise and justify the continued privatisation of wealth of immeasurable kinds that is held in common, the scale of the present indebtedness to the future, the burden of the risks of those debts on the state and its citizens, and the ever-increasing diremption (contradiction) between the socially necessary value produced by abstract labour and the profits won by predicting (and manipulating) the future of that potential in the financial markets.

In turn, this collection uncovers figures of resentment, disenchantment, and alienation fostered by the dogma of value. These reveal how value judgements can behave insidiously and incorporate aesthetic, ethical, or ideological values fundamentally opposed

to the 'value' they purportedly name and describe. Chapters neces-
sarily cross disciplinary boundaries because 'value' proves its most
insidious characteristic—the fact that assuring it predicates its fun-
gibility—when transgressing domains (ethical to economic, aesthet-
ic to cultural, tragedy, comedy, history, pastoral, pastoral-comical,
historical-pastoral, tragical-historical, tragical-historical-pastoral
. . .).

Studying value brings into clearer sight one of the challenges for
critical thinking and resistance, which is the question of its timeli-
ness. On the one hand, political expediency demands fidelity to
present conditions, to answer the question asked here and now (and
so to ignore the determining events of our conditions). On the other,
critical thinking suffers in the condition of belatedness, not because
its analysis becomes immediately outmoded (although it can) but
because by seeking to comprehend prior determinants of present
conditions, it insists that the questions asked of the present depend
on past conditions. In the state of exception of contemporary poli-
tics, the question follows the decision; it is the spectre of a possibil-
ity which receded even before the question was uttered.

It is worth emphasising from the beginning that putting forth an
argument *against value* does not obviate the need to provide ratio-
nales for instrumentalised justifications of the arts, even on, or espe-
cially on, economic terms and even if only offered in bad faith.
Ruthless economic arguments might be the only ones capable in
today's climate of speaking—or, more accurately, selling—truth to
power, and the arts *can*, for example, be of practical benefit and
cost-effective in areas of the health service and with mental health
provision.[2] The crucial question remains, however, what deeper ar-
guments do we cede when we choose to snatch back victories from
our opponents? If the only answer to the question of the value of the
arts is an instrumentalised one, then have we not already aban-
doned the possibility that the arts can resist the predations of instru-
mentalised thinking?

We who work broadly in the arts and education as makers or
critics are expected to defend 'the value of the arts and humanities'
but must understand that the demand to do so follows their devalu-
ation by the philistine keepers of our political economy. And fur-
thermore, we should understand that the terms of the question itself
are couched in the instrumentalised thinking and language against
which the arts and education may offer some respite. It is not only
that the question is being asked by those who have implicitly taken
against them in the defensive posture of their asking but that those

who ask do so to gather apparently legitimate cultural authority by asking. The very question of value rebounds to inflate the value (authority) of those doing the asking. We also have to understand that the reason for the question circumscribes elements of the past as outside the ostensible pragmatism of its remit (the causes of our current crisis are no longer relevant—we are here now).

Of course, it remains tempting to offer a defence, and indeed many arguments have been so exercised; there's plenty to say from this trying era and plenty that has already been compiled from past civilisations.[3] According to Benjamin, the 'tradition of the oppressed teaches us that the "state of emergency" in which we live is not the exception but the rule' and is in fact one of the ways in which the oppressed are ruled.[4] So should we defend the arts and education now, under the augury of a permanent present of the state of exception?

At the very least, when choosing whether or how to defend them, rather than rushing to proclaim their value, we should first think through a series of related questions. Do the arts and education constitute a critique of value rather than act as expressions of value, or can they? Rather than intrinsically constituting or generating exchange value, should the arts and education struggle against the unthinkingness of value, value as that unthought region we take for granted? We have to ask ourselves what harm we carry out on those who make art, or who educate, by insisting on a metric of value. Does the insistence on value stifle the darker, more violent, less affirming ghosts of the unconscious imagination or demand of us that we repress our discontent? Ultimately, should we defend the value of arts and education at all? 'Civilisation' is the name of one such iteration of value, a phenomenon of a historical period under the shadow of which unimaginable horrors have been and continue to be perpetuated. As Benjamin famously puts it, 'There is no document of civilization which is not at the same time a document of barbarism', an assessment which might give pause for thought when returning to the former UK secretary of state for culture, media, and sport's otherwise banal claim that the 'arts are a civilising influence'.[5] Who, exactly, is in need of being civilised? What does the redemption offered by the arts matter when set against civilisation's unceasing barbarism, if art's value 'redeems the catastrophe of history'?[6]

THE HARM OF VALUE

Value tends to take critical thinking as its first hostage: complexity, nuance, counter-intuitive logic, long-term planning, doubt all follow.

The call to justify value tends only to be answerable by shifting from one domain of knowledge to another, predominantly, of course, into the economic (knowledge into capital, say) but also more generally. Its measurement requires a putatively unambiguous foundation in an alternative discursive model; each model, in turn, seeks its security elsewhere.

Value tends to require an artificial break in the fabric of influence, for example by cutting at the point of a copyright document or scientific breakthrough: when, and for whom, and to what profit do we halt the flow of knowledge?

Value tends to found itself upon problematic, untheorised terms such as 'culture' or 'the public', but if the arts and education speak at all to the most intimately held emotional, psychological and aesthetic experiences, then might not 'the public' legislate against the freedom and perversity of the 'private', and might not 'culture' homogenize the infelicities of experience?

Value tends to stand in for that which has been sublimated; that is, the notion of value sits more easily with some palatable effect of culture rather than with those truths which culture seeks to repress. Value tends to be ruled by piety, by the conservatism of consensus.

The discourse of value tends to be fundamentally patronising and authoritarian. Those with power demand its elaboration, thereby producing a craven attitude in those without power.

Value is a good method of social control (particularly by prioritising social stability over disturbance), as it provides permission for surveillance (often under the auspice of transparency), which can be used to undermine the integrity of a profession or other group.

The domain of value is such a frustrating territory because it is so easily instrumentalised by those with malicious intent and because it wraps up in the counter-intuitive damages of audit culture those who are wishing to act conscientiously.

The territory of value is a battlefield of ad hominem attacks; conflict between people, solely in terms of the different 'values' they

are taken to espouse, displaces analysis of the principles that give rise to those values.

Value tends to honour the integrity of the subject rather than permitting the kinds of necessary crises of the self described by, for example, Gillian Rose or Leo Bersani. The arts, in Bersani's reading, demonstrate 'our continuously renewed efforts to disguise and to exercise the tyranny of the self in the prestigious form of legitimate cultural authority'.[7] Rose, when analysing problems of representation of the Holocaust, distinguishes between the wet 'sentimental tears, which leave us emotionally and politically intact' and the 'dry eyes of a deep grief, which belongs to the recognition of our ineluctable grounding in the norms of the emotional and political culture'; such is the difficult recognition that liberal assurances of the 'value' of the arts implicitly disavow.

Value tends to be used to address if not dress the wounds caused elsewhere in the social, economic, and political system. The inevitable failure of the artwork or education on the terms of the damage caused by other means becomes part of the audit against its value.

The discourse of value tends to deaden the artist's hand. Choreographer Jonathan Burrows writes about funding proposals, 'Before you write this description [of what you are going to do] you most likely don't know what you're going to do, only that you need to do it. Once you've written this description, however, you're in a different position. Now you still don't know what you're going to do, but you have a piece of paper saying that you do. The question is: how do you stop yourself from being tempted into believing what you wrote?'[8]

Value tends to encourage the arts and education to mirror the values that dominate (in) a society. For example, the rise of participatory art goes hand in hand with the intensification of damage to the social contract between the individual and the state and the continuation of the transfer of the public good (both in terms of capital and the 'values' of the care of the state) into private capital (and its core value, profit). Its formal, aesthetic properties (networks, mobility, project work, affective labour) match, unnervingly, those of neoliberalism.[9]

Value is often undefined, or worse, its instrumental use depends upon its fundamental vacuity. One of the tasks of value as a token is to stand in for something impossible to describe, something which is incommensurable, or something which is ambivalent; when this happens, it does not speak, finally, to anything

'intrinsic' but instead works to maximise fungibility, the ability of meaning to be manipulated toward the real and implicit purpose of those with the power to demand explications and justifications of value.

Value is a function not an essence. It appears to warrant a final definition, some closing down of its opportunistic obedience, and yet value remains elusive because it claims attachment and dependence, to be the *value of something* or value *for someone*, even when (or especially when) it is pointing toward something held to be 'intrinsic'.

Value is a malleable term, indiscriminate in its allegiances; it is a term that mediates, whilst establishing itself as the source of action or its desired end, veiling the truth of each of those positions. It is therefore useful to those seeking to obfuscate and so able to be turned to the purposes of power.

This series of accusations against value suggests the concept's affinity with Paul Bové's description of the function of 'discourse' when he explains why its essentialist properties cannot simply be defined. We are intrigued by the consonance between 'value' and discourse, as *supposedly* neutral terms, the purpose of which is to direct attention towards some ineffable space that itself harbours meaning. For Bové, discourse means

control by the power of positive production: that is, a kind of power that generates certain kinds of questions, placed within systems that legitimate, support, and answer those questions; a kind of power that, in the process, includes within its systems all those it produces as agents capable of acting within them. [10]

We might exchange 'value' for 'discourse' in repeating his questions too: 'How does discourse [value] function? Where is it to be found? How does it get produced and regulated? What are its social effects?' [11] Bové writes here to caution against the 'mastery' of discourse, where mastery is 'the device that slides critics back within the servility that discourse has planned for them'. [12] Even the most ostensibly critical of critics is all too easily recuperated by the ideology implicit in his or her discourse. The temptation when writing on value, too, is to imagine its critique confers a mastery over its contents. Bové warns,

The weakness of discourse lies just in its seriousness, in its demand for and efforts to impose universal recognition. This means that the world of critics always stands within it, that discourse

always masters critics as they become what they are. Yet as mastery discourse cannot be complete in itself; its partiality, its weak strength, its frustrated insistence that nothing can happen that it does not contain—all this must be made the object of derision, but from within the diminished, subaltern position alone left to those who might try to deride it.[13]

This warning against the arrogance of critical academics imagining themselves sufficiently above or outside that field on which they cast judgement is necessary counsel for those who feel well placed to pronounce on value.

WHAT CRISIS?

The genesis of *Against Value* can be attributed to an accumulation of what filmmaker Ken Jacobs describes as the 'social disgust and anger that I have cultivated, refined, monumentalised, and I am gagging on', amidst the myriad major and minor humiliations, barbarisms, and miseries evident in the contemporary moment.[14]

The term for the present that is utilised and manipulated to dismiss critical thought and to tenderise the flesh of the public is 'crisis'. The latest incarnation of crisis, following the global economic recession that commenced in 2008, has been seized and monetised with prodigious speed. This has turned a crisis of capitalism into its own expansion, a state-funded hastening of privatisation, the financialisation of everyday life, and the fungible-commoditisation of the self.[15] Crisis is the rhetorical name for rendering the neoliberal social-economic causes of our condition invalid for the reckoning of it; and so the defence of the value of the arts and education, to the extent that it derives from that crisis, is its expression rather than a response to it.

Of course crisis has been theorised before.[16] In 'The Crisis of Education', Hannah Arendt understands the double threat of 'crisis', both its immanent danger and the crisis as an opportunity for exploitation. She writes,

A crisis forces us back to the questions themselves and requires from us either new or old answers, but in any case direct judgements. A crisis becomes a disaster only when we respond to it with preformed judgements, that is, with prejudices. Such an attitude not only sharpens the crisis but makes us forfeit the experience of reality and the opportunity for reflection it provides.[17]

Arendt also writes of the figure of the 'philistine' and the 'cultured philistine'. The philistine was one who in the eighteenth century 'judged everything in terms of immediate usefulness and "material values" and hence had no regard for such useless objects and occupations as are implied in culture and art'.[18] The inversion of values occurred when exactly this uselessness of culture began to be monopolised to gain 'social position and status'.[19] Culture was used to 'educate oneself' out 'of the lower regions, where supposedly reality was located, up into the higher, non-real regions, where beauty and the spirit supposedly were at home'.[20] For Arendt artworks are misused whenever they 'serve purposes of self-education or self-perfection'.[21] The flourishing of modernism occurred when 'genteel society had lost its monopolizing grip on culture', though along with modernism came the proliferation, too, of 'neo-Classic, neo-Gothic, neo-Renaissance structures'.[22] It was in this 'disintegration' that culture was used as a 'social commodity which could be circulated and cashed in in exchange for all kinds of other values, social and individual'.[23] This social commodity she provides in scare quotes: 'value'.[24] She summarises,

> Cultural values were treated like any other values, they were what values always have been, exchange values; and in passing from hand to hand they were worn down like old coins. They lost the faculty which is originally peculiar to all cultural things, the faculty of arresting our attention and moving us. When this had come about, people began to talk of the 'devaluation of values' and the end of the whole process came with the 'bargain sale of values' (*Ausverkauf der Werte*) during the twenties and thirties in Germany, the forties and fifties in France, when cultural and moral 'values' were sold out together.[25]

It is also clear, sixty years on from this, that recent economic crises have been met more forcefully, been more assertively defended against, with neoliberal propositions than with a renewed effort to reflect on reality. For instance, we need only look to the transfer of public assets into corporate hands following the Greek debt crisis[26] or, in the United Kingdom, to the privatisation of services within a framework of public ownership; the latter was designed as a temporary way station to inhibit the ability of collective social institutions to ward off further privatisation at a later stage, an example of such divide and rule being the denigration of the role of Local Education Authorities and promotion of Free Schools.[27] Or consider the more slippery example of activities under the aegis of the concept of the

'Big Society', the use of the charitable 'third sector' to replace, but more importantly undermine, state provision in the United Kingdom; that is, to make the social contract one of charitable compassion rather than a structural adjustment of neoconservative iniquities by redistributing taxes.[28] It is a helpful example because the charitable status of 'providers' promotes ostensibly virtuous values whilst, *by doing so*, dismantling the state's infrastructure.

Returning to the question of crisis, we can see that crisis itself has a value, a value typically in lowering the possibilities of resistance to the debt economy or to the predations of those marketing spiritual or non-spiritual solutions.[29] Arendt's joke is that the philistine has not been discontinued as a model but rather has taken up his place as a cultured figure; not the loss of the philistine but his acculturation. This contradiction between an instrumentalised vision of the arts (the philistine) and the necessity of the non-instrumentality of the arts so that the arts develop an alternative economy of 'cultural capital' (the cultured philistine) is the false dialectic we see in too many current descriptions of cultural value.[30]

We are now, perhaps, in a new era of unbridled philistinism, no longer one of acculturated philistines preserving a space for art as a social hieroglyphic to enable their own revaluation. The philistine of neoliberalism instead instrumentalises the arts as the proliferation of circuses against the yield of bread and sees no reason to retain an autonomy of art as the hallowed ground by which art retains its aura and is thereby able to elevate its philistine supporter because it offers an alternative economy to that of capital, or instrumentality. The neoliberal philistine sees no instrumental reason in protecting a space for aesthetics that is (by necessity, because it revalues as invaluable) de-instrumentalised.

WHY NOW?

Philosophically and critically, then, our move against value is hardly novel. Postmodernity came with its own promotional material about the crisis of value.[31] The Frankfurt School diagnosed the contradiction at the heart of the Enlightenment and its values. The uncanny reflections of post-structuralism and the equally slippery late-capitalist financial markets (actually, not late-capitalist, presuming the 'late' suggests an endgame that actually seems ever more distant, post-apocalyptic) confuse the right wing about cause and effect, as it laments the loss of core humanistic values to philo-

sophical ephemera even as the liquidation of values by capital continues apace. So why conceive of this collection at this particular time? We can say it is a confluence of four things.

First is the mobilising of neoconservative politics in concert with the hastening of neoliberal economics *as a result of* the 'crisis' determined by the contradictions at the core of that ideological model (in which the market is treated as a 'natural' system, yet requires periodic saving from its crises by the state).

Second, and most directly, is the sustained attack on the arts and education in the United States and the United Kingdom, effected in economic terms and supported by an emphasis on transparency and the practices of audit. Neither transparency nor audit, however, is a simple virtue, and both support the impulses of those determining the terms of value being accounted (e.g., short- versus long-term goals, wealth creation for private interests or the state, debt held by the private or public sector).

Third is the increasing role of affective labour and the relentless demand for an affirmational attitude as the measure of that employability. The moral humility diagnosed by Friedrich Nietzsche has been replaced by gratefulness; dissent, subversion, and transgression have long been co-opted into the mainstream (iconoclasm is brand-savvy). As workers who will now sell our affect as a property of social labour (whereas this had remained, though never off limits, at least primarily reserved for processing alienation), we increasingly need to describe ourselves in commodified terms. To sell ourselves successfully as commodities, we emphasise the affirmational affects we contribute to employers (our smiles and the happiness behind our smiles). There are only so many times we can sell ourselves in bad faith before we believe our own self-commodification in order to avoid the pain of cognitive dissonance. And hence, despite the traumas of anxiety, depression, and failure that are narratavised everywhere, a stupefied upbeat positivity reigns. Peter Fleming puts it like this: 'Along with so many other crucial raw materials, life, cooperation, and association are but resources to be prospected, objectified, and put to work.'[32] We can see the turning of social values into the mineral mines of the financial economy: 'Realized in the thousand moments of common association, this pre-profit stratum of social interaction persists despite the antisocial code of the corporation.' Value is thus one of the means by which that which has been held outside the circuits of capital is brought into its broad church.

The fourth pressure towards this collection stems from the strange inverted value(s) of capital and finance against labour value. Arguing towards his labour theory of value and away from a conventional notion of monetary exchange as its measure, Karl Marx explains the logic of the commodity with the telling example of a manufactured table. Materially, as wood and as use value, it 'stands with its feet on the ground'; yet in relation to all other commodities, it 'stands on its head'.[33] This topsy-turviness speaks crucially to the 'mystical character' of the commodity,[34] its existence as a fetish in which the material social relations between productive workers are abstracted and misrecognised as relations between things. 'Value', Marx writes, 'does not stalk about with a label describing what it is'.[35] And by 'what value is' he means not only the 'homogenous human labour' without which there would be no use values. Rather, the obscure truth of value is that the exchange of commodities in fact establishes the very field of equality on which the twofold social character of labour exists, *in the very act of mystifying it*: 'Whenever, by an exchange, we equate as values our different human products, by that act, we also equate, as human labour, the different kinds of labour expended upon them'.[36]

Notwithstanding this dialectical critique of value, it is clear that the fetishism of commodities produces, for Marx in the 1860s, an obscure notion of value that abstracts and inverts the source of value in human labour. How much more occluded must such value be, then, in the postmodern world of finance capital, in which the exchange value of commodities (which at least seems tangible in production capital) is wholesale abstracted once again via the market in derivatives (which Marx terms 'fictitious capital')?[37] Here, the notional exchange values of commodities are hedged against or leveraged through the purchase of futures. This, of course, is a market to which universities (and, though in quite different ways, art) are certainly susceptible. One obvious example of this is the defunding of higher education in the United Kingdom in 2012, which was ostensibly offered as an 'austerity' measure designed to help balance the UK budget that was in huge deficit following state bailouts of the financial sector.[38]

Of course, in classical Marxist terms the educational labour of teachers and students is regarded as unproductive, part of the reproducing of productive labour, and so notionally outside the Marxian logic of value just described.[39] And yet, we regularly see the labour of the university and of the creative arts sector described as producing value in terms of local, regional, and national econom-

ic benefits—that is, by delivering to market commodities that are sold nationally and internationally.[40] Indeed, a usual way that this transaction is presented in a post-state-funded education environment is as students' (or their parents') personal investment in future earning power (and thus, it is assumed, happiness). Universities have done much to collude with this classic neoliberal sleight of hand by incorporating the notion that enhancing employability is a suitable (or key) rationale for higher education. In the United Kingdom, David Willetts used his first speech as higher education minister in 2010 to call for universities to publish 'employability statements' that 'summarise what universities and colleges offer students to help them become job-ready in the widest sense and support their transition into the world of work'.[41] This links employability with the rule of audit and places it at the heart of a government's broader belief that transparent information will lead to an effective market in higher education. Prospective students, required to pay the upfront cost of their education, supposedly make rational decisions about which university to attend. In this case, their supposedly straightforward cost-benefit analysis takes account of 'the cost of different university courses, as well as related graduate earnings and student satisfaction'.[42] We might wonder, however, what the grounds are for presuming that current and future students might have the idea that the principle goal of higher education is future employment, let alone whether they share Willetts's conception of employment as nothing more than 'graduate earnings'.

Moreover, when education is presented as an investment, it is conventionally understood as debt based, paid for by a loan taken up and repaid. But given the subsidised, sub-market, and earnings-dependent terms of student loans, this is a very strange kind of capitalist transaction. The supposed 'investments' made by student-purchasers (in the educational institution and in themselves) and by the state (in the form of loan subsidy and by taking on of the risk of non-repayment) are made subject to the largely unpredictable future of the job market and the personal life choices of the borrower.[43] And yet, it is perhaps not so strange if we look to the world of finance capital. In the current arrangement, universities are in essence funded by fee-paying students who have leveraged themselves by purchasing their student loan value's worth of future exposure to the vagaries of life and work; simultaneously, the government has proportionately decreased its investment. Yet the government retains a pretty decent hedged position: at any point in the future, by spending the requisite amount of electoral capital, it can

always choose to change the terms of repayment in favour of the Exchequer (thus minimising its risk).

Whether in response to this, the neoliberal's dream accounting of value, to the way that, within capital, artists' work is deemed to have value as an agent in the reproduction of civil society or to the way that university teachers necessarily 'co-produce new labour power [which] will in turn be employed to produce value and surplus value', a reminder seems pertinent of the Marxian-humanist notion of 'what value is'.[44] Art is the fulfilment of unconstrained human creativity; education, as David Harvie puts it, is a 'natural propensity to impart knowledge and nurture thinking in others'.[45] Such a reminder is offered by some of the contributors to this volume, just as it is (in somewhat different terms) by Thomas Docherty when he argues for a commitment to an idea of education in which state funding offers 'money for values' as opposed to seeking 'value for money': 'a model driven by the demands of an essential humanity—grace—which might simply mean something like a generous opening to future possibility'.[46] Of course, the challenge for the antagonistic critical spirit of a volume such as this is to work out the precise extent of its sympathy with such critiques of dominant logics of value, while remaining suspicious of the new (or, in the case of Docherty's secularised Christian ethic of the human, old) foundations on which they are based. A certain dissonance is therefore to be expected, with some contributions offering more or less explicit correctives to the humanism of the very notion of privileging art's or education's 'human' values.

THE VALUE OF AUDIT AND THE AUDIT OF VALUE

We live in an 'audit culture'.[47] 'Value' as not simply a description but as a challenge or even implicit threat can be seen across a number of features that affect workplaces in both the private and state sectors. Most notable is the rise of audit cultures, with audit often providing methodological cover for the manipulation of crisis. That is, audit provides the rhetoric of reason and strategic delay necessary to offset the charge of political vandalism. From its basis as an ideal of economic transparency, the practice of audit has burgeoned through management models and exploded into a cult of transparency, operative across all sectors being asked to justify their existence.[48]

One major theorist of audit is social anthropologist Marilyn Strathern. Though largely responding to the incursion of auditing from economics, through management ideology, and into higher education, Strathern's analysis grew out of reflections on the methods and difficulties of ethnographic engagement.[49] Briefly, we can find four key claims in this material: auditing is bad ethnography; the auditing of values that might be thought of as virtuous can work against those very values (for example, when audit damages trust); an obsession with transparency echoes a Euro-American cultural preference for self-reflexive knowledge; there can be 'tyranny' in transparency.[50]

Strathern describes audit as 'a set of institutional practices deeply committed to a certain form of description—namely, to eliciting from auditees their descriptions of themselves'.[51] The overlapping of moral and financial forms of valuation in 'rituals' of accountability is a 'distinct cultural artefact'.[52] As she writes, although audit is 'almost impossible to criticize in principle' because it advances ostensibly positive virtues of 'responsibility, openness about outcomes and widening of access', its effects often run counter to these virtues when instrumentalised teleologically. To explain, whilst 'policy and audit sound on the face of it like opposite ends of a process', the 'distance between the poles is illusory' since 'the one is also inside the other: policymakers may build auditing practices into their schema, and auditing will replay to policy the grounds of its own effectiveness'.[53] This 'feedback loop' is a political mechanism: Strathern refers to research on the rise of neoliberalism with its promoted values of market competition, enterprise, and family as ideological choices made to diminish the role of the welfare state. Audit culture is therefore a wing of enterprise culture in which 'auditors and auditees create their own reality, not as some by-product of but as stemming from/contributing to a political doctrine of reinforcement'.[54]

According to Strathern audit replicates the tendency of Euro-Americans to 'present knowledge to themselves as though a condition were its reflexivity: one knows things because one can reflect on why and how one knows'.[55] The art of description therefore takes precedence over latent forms of knowledge without due comprehension of the distortions enacted by description. In audit the 'investigation—the research if you will—is in that sense retrospective; that is, it works backwards from the bottom line up, from the categories by which accountability (say) can be ascertained to the evidence for it. . . . In looking at outcome as output, audit looks at

the *effect* of productive processes'.[56] This analysis is so crucial to the *Against Value* thesis because the interpellation of values in the structure of the audit effectively reifies the values it supposedly records neutrally.

Against the bureaucratic procedure with its internalised system of aims and objectives, Strathern contrasts the ideals of ethnography; these can keep 'open a place for the unpredictable or contingent', remaining ambiguous where 'ambiguity signals the way in which claims elicit counterclaims, open themselves up to explanation by third parties and so forth'.[57] The 'ethics in advance, of anticipated negotiations' of an auditing model, which ultimately 'belittles the creative power of social relations', is replaced by respect for the 'exploratory, indeterminate and unpredictable nature of social relations' as sanctified in ethnographic approaches.[58] Ethnography, on the other hand, is 'the very opposite of self-description and means nothing—has no efficacy—unless one knows the conditions of its compilation or its theoretical underpinnings; it cannot be made abstract in this sense'.[59] As Robert Kaufman describes in an essay on the continuing influence of Walter Benjamin, lyric poetry 'experimentally commits its precision, emotion, musicality, and intellections to its social materials, attempting formally to realize its special versions of art's determinate indeterminacy, art's exact but capacious—and sociopolitically enabling—ambiguity'.[60] What holds for Strathern's ideal of ethnography might be thought to hold too for the at once exploratory, indeterminate, and unpredictable domains of art and education and the precision, detail, and exactitude with which they express fealty to the ambiguity of social relations: so goes the thesis of *Against Value*.

AGAINST VALUE AND THE ART OF INDIRECTION

Maurice Merleau-Ponty describes two kinds of language: the first kind is pragmatic and empirical and involves the 'opportune recollection of a preestablished sign'; the other is 'true'. The first is, 'as Mallarmé said, the worn coin placed silently in my hand' (that is, an exchange operating within a given, well-rehearsed structure akin to capital), whereas true language is 'oblique and autonomous, and if it sometimes signifies a thought or a thing directly, it is only a secondary power derived from its inner life'.[61] Such language is 'not meaning's servant. . . . There is no subordination between them. Here no one commands and no one obeys'.[62] What we mean

is instead 'only the excess of what we live over what has already been said'.

Although these quotations from Merleau-Ponty are from an essay on the relations of painting and language, they map onto his claims for political thought; this is 'always the elucidation of a historical perception in which all our understanding, all our experience, and all our values simultaneously come into play—and of which our theses are only the schematic formulation'.[63] Warning against direction by 'a calculus and wholly technical process' (the self-serving logic of instrumentality), Merleau-Ponty advises indirection: 'Personal life, expression, understanding, and history advance obliquely and not straight toward ends or concepts.' If we are to heed Bové's warning above, we had best listen to Merleau-Ponty's conclusion: 'What we strive for too reflectively eludes us, while values and ideas come forth abundantly to him who, in his meditative life, has learned to free their spontaneity.'

This collection is divided intro three sections, namely, "Critique," "Arts," and "Education," though most chapters included here speak across the borders between all three. The chapters that conclude one section and begin the next section have been so placed since they demonstrate particular affinities for one another. A suspicion underlying the thesis of this collection is that there is a great deal to be gained without resolving the tension evident here between detail and indirection. Close attention to particularities may yield insights into areas of knowledge worlds away from their origins. Moreover, the more apparently self-explanatory the value(s) to which we refer, the more assiduously we attempt to uncover their counter-intuitive logic and effects.[64] Detail presumes a level of incommensurability, whilst the indirect workings of language, knowledge, emotion, and sociability ensure that no detail can be attended to which fails to spark some alternative train of thinking. As E. M. Cioran puts it, 'All means and methods of knowing are valid: reasoning, intuition, disgust, enthusiasm, lamentation. A vision of the world propped up on concepts is no more legitimate than another which proceeds from tears, arguments, or sighs—modalities equally probing and equally vain.'[65] We hope that this collection will be read in such a spirit of attention to detail and openness to the indirect, each in their way obviating the dull wits of the rhetoric of value.

SIGNIFICANCE AND INSIGNIFICANCE

There is an analogy to be drawn between art and education through what Maurice Blanchot calls 'the purpose of criticism'.[66] Art and education are both subject to a constant and banal form of socio-economic criticism. This criticism is not necessarily the criticism of academic critics; it is usually the criticism implicit in a society that judges 'itself' in terms of value. Because society judges itself in terms of value, it must also defend itself in terms of value. This is where arguments for the value of the arts and humanities as educational subjects come from. If it is not obvious what the socio-economic value of a state-funded activity is, *why are we paying for it? Why are we learning about it? Why are we occupying our time with it?* These questions inform the rationale of an audit culture. Art and education must be *of* value and *reveal* value: the value of criticism and teaching especially is found in its revelation of value.

Blanchot's essay 'What Is the Purpose of Criticism?' is primarily engaged in opposing Martin Heidegger's argument that the purpose of criticism is to illuminate the value of its subject.[67] For Heidegger, the value of criticism is to reveal value: what is of value to *everyone*. In opposition, Blanchot argues,

> Criticism is no longer an external judgement placing the literary work in a position of value and bestowing its opinion, after the fact, on this value. It has come to be inseparable from the internal working of the text, belonging to the moment when it becomes what it is. Criticism is the search for and the experience of this possibility.[68]

For Blanchot, there is no inherent value in the text to be revealed by the critic; rather there is the experience of the reading itself. The reading itself is what 'makes' the text mean. In the same way, teachers 'make' meaning in the classroom, in a mode that is specific to them, the subject, and their students (as well as many other elements of context). Meaning cannot be made in a context where the very language of criticism or teaching implies its pre-existence: it can only be found and affirmed, rather than being constructed by teachers and learners in the context of the classroom itself. How then to differentiate these two forms of criticism or teaching: on the one hand, the socio-economic and Heideggerian forms of criticism which reveal value, and, on the other, a criticism which rejects value and instead focuses on (the search for) experiential significance?

The latter asks, what are the many things this might mean for me, you, us, here, now, and for a future we can or cannot imagine?

This differentiation is made possible by differentiating between the meanings of the words 'value' and 'significance'. The word 'value' is often incorrectly and unhelpfully co-opted to stand in the place of the word 'significance'. We say things like, 'value is subjective'; 'just because it has no value for you doesn't mean it has no value for me'; 'my own experience has value for me'. Although there might be circumstances where these sentences could be correct in their use of the word 'value', it is more likely that 'significance' would be the appropriate word to make their meaning. Significance can be described, but it cannot be transferred without changing (for better or worse) its context of signification and therefore also its significance. Value, on the contrary, implies transferability: the ability to hold the same meaning in different (although not all) contexts. An assertion of value implies a double bind of meaning which is ultimately a form of rhetoric: *this* thing has a quality or a meaning for *me/us* which can be maintained, which has an equivalent and static value for *me/us*. This logic of value holds arts and humanities education to ransom through its processes of evaluation (exams, league tables, Ofsted reports in the United Kingdom, as well as the reduction of the 'content' of texts and subjects to lessons which are adapted to and determined by these processes). On the contrary, significance does not require an equivalent. Something can be significant but *invaluable* or *valueless*. At an existential level, anything that occurs has significance, even insignificance. As Ramon tells D'Ardelo in Milan Kundera's *Festival of Insignificance*,

> Insignificance, my friend, is the essence of existence. It is all around us, and everywhere and always. It is present even when no one wants to see it: in horror, in bloody battles, in the worst disasters. It often takes courage to acknowledge it in dramatic situations, and to call it by name. But it is not only a matter of acknowledging it, we must love insignificance, we must learn to love it. . . . [I]t is the key to wisdom, it is the key to a good mood.[69]

Against Value is an example of turning lovingly towards insignificance and affirming that which exists outside systems of value, taking on Blanchot's 'task of preserving and of liberating thought from the notion of value':

> We complain about criticism no longer knowing how to judge. But why? It is not criticism that lazily refuses to evaluate, it is the

novel or poem that shirks evaluation because it seeks affirmation outside every value system. And, insofar as criticism belongs more immediately to the life of the literary work, it turns what is not able to be evaluated into the experience of the work, it grasps it as the depth, and also the absence of depth, which eludes every system of value, being on the side of what is of value and challenging in advance every affirmation that would like to get its hands on it to validate it. In this sense, criticism—literature—seems to me to be associated with one of the most difficult, but important, tasks of our time, played out in a necessarily vague movement: the task of preserving and of liberating thought from the notion of value, consequently also of opening history up to what all these forms of value have already released into it and to what is taking shape as an entirely different—still unforesee-able—kind of affirmation.[70]

Value may very well play a useful role: the transferable values of rights, money, property, meanings of words, and so on, provide useful and sometimes vital functions in society. However, when existence is implicitly forced to be read in terms of value, there is much which *cannot be read* and much which cannot but be *misread* most reductively. For significance to avoid being reduced to merely another value, let alone as that which is of absolute value, the context of this concept must carry with it the mark and risk of insignificance. This is because the teaching of a subject which is not reducible to value cannot be confident in the possibility of its meaning holding.

The significance of education—the meaning it actually evokes—is not limited by provisionality in the same way as a value-based education. Something that is taught to be of value implies not only its significance but also its continued significance: this mode of teaching is uncritical because it is forced to always assert its truth rather than its provisionality. In the first section of *The Infinite Conversation*, Blanchot engages with the unknowable in communicative relations, specifically those of teaching and research:

> The unknown that is at stake in research is neither an object nor a subject. The speech relation in which the unknown articulates itself is a relation of infinity. Hence it follows that the form in which this relation is realised must in one way or another have an index of 'curvature' such that the relations of A to B will never be direct, symmetrical, or reversible, will not form a whole, and will not take place in a same time; they will be, then, neither contemporaneous nor commensurable. One can see which solutions will prove inappropriate to such a problem: a language of

assertion and answer, for example, or a linear language of simple development, that is to say, *a language where language itself would not be at stake.*[71]

The language we use to communicate in the context of the arts and education is precisely what is at stake in *Against Value in the Arts and Education*. The against-value thesis is not to be against *all* value but rather to be against the necessity of reducing and translating all (in)significance to value, or else rejecting or even ejecting it from the social, our own experience, or worse, explicitly or implicitly teaching others to do so in their lives. Why do, or even *experience*, something which only has significance but not value? Something which runs the risk of insignificance? Or even only signifies its insignificance? Why learn or teach something which has no objective value or even a determinable subjective value? To teach *against value* is not simply to offer a new set of values against a socially dominant set of values; it is to teach against value altogether. One way to teach *against value* is to teach *significance first*, or even to presuppose insignificance, a neutrality or suspension of knowing out of which significance grows. Because value also has significance, it would not be excluded from this teaching, merely deprioritised. The chapters collected in this book show variously how and where we can locate the insidiousness of value in the arts and education, as well as how it is possible to think and engage in the arts and education against or outside value. In the words of Blaise Pascal, *Against Value in the Arts and Education* seeks to attend to the fallacies of towers and the significance (or insignificance) of the cracks and abysses.[72]

THE CHAPTERS

Marilyn Strathern's contribution to this collection describes how 'evaluation and auditing is turned from the quality of work being done to the quality of those doing it'. By force of iteration, by the logic of 'adding value', and by insisting on acts of 'conversion' (for example, between knowledge and information), the subject of audit becomes abject.

In 'Post-critical' Hal Foster critiques the 'post-critical condition', which is supposed to release us from our straightjackets (historical, theoretical, and political), yet for the most part has abetted a relativism that has little to do with pluralism. First, there was a rejection of *judgement*, of the moral right presumed in critical evaluation. Then, there was a refusal of *authority*, of the political privilege that

allows the critic to speak abstractly on behalf of others. Finally, there was scepticism about *distance*, about the cultural separation from the very conditions that the critic purports to examine. One understands the fatigue that many feel with critique today, especially when, taken as an automatic value, it hardens into a self-regarding posture. 'Post-critical' argues, however, that given the echo of the 1920s in our current crisis, in which a state of emergency becomes more normal than exceptional, this surely is a bad time to go post-critical.

Robert McKay's chapter responds directly to Foster's defence of critique. Beginning with a reflection on how Marx's theory of labour implies but also complicates essentialist notions of the human, McKay explores the extent to which a post-humanist (or better, post-anthropocentric) critique of such ideas might remain possible. This theoretical inquiry is then teased out through a reading of Romain Gary's novel *The Roots of Heaven*, written and set in a post-war world in which the camps, the bomb, mass technology, totalitarianism, and the neo-imperial reality of decolonisation, as the disastrous result of modernity, have turned the rictus of 'human values' into the hollow laughter of cynical despair. For Gary, any hypothesised value of the human can and must only be expressed in an absolutely necessary but actually impossible defence of animals against humans. The paradoxes of this position are evidence of the notion that 'value' is only ever *valuation* and of what McKay calls 'the against-value of critique'.

Tom Jones introduces the possibility of an 'enlightenment against value'. He suggests, after Jakob von Uexküll, that cultural values 'are different from prices (the most readily determined economic value) in that valuing something anew is a change in the environment of the person who values'. He presents the eighteenth-century theory and practice of 'taste' as 'a problematic modality of attachment to the world' (quoting Antoine Hennion), rather than as a means of legitimising social difference and distinction. To do so, he disputes a model of taste as 'the faculty for discriminating amongst perceptions' with a reading of David Hume's 'Of the Standard of Taste' as a phenomenology of taste and by invoking a term from Edmund Burke's account of aesthesis, 'indifference'. Such indifference, a setting at 'nought' or 'disregard', subtends the very possibility of 'openness to the other, an ability to find the other admissible' since 'the person who is going to be open to the other must in some sense see life in its qualitative aspect as indifferent'. Put simply, there is another way of doing things.

Though the 'liquidization of durable goods, values, populations, and institutions has become a permanent and virtually totalizing condition', Jonathan Eburne finds some hope in the discovery of key works of deconstruction in bargain-basement bookstores. By reflecting on their diminution in financial value, we might discover a 'margin of inutility—if not necessarily of instrumental resistance—that could spare us from either clinging to our plastic belongings or resigning ourselves to the flood'. This is the 'archive of error, obsolescence, and obscurity' of the remainder bin, a 'bargain-basement circulation' against the temporality of use value and exchange value. This circulation, however imperfect, and its 'lingering entanglements' offer something of a rejoinder to the intellectual value taken to be an 'inherent property of an idea'.

Fabienne Collignon's particular target is the 'sacred humanism' that remains safeguarded within the techno-criticism of Paul Virilio, but its reckoning branches out to incorporate the sanctity and insidiousness of the 'human' subject more generally. By a 'theoretical and theorized . . . process of dehumanization', by concentrating on a contradictory term of worth and worthlessness—'flesh', that which is 'dead, commodified, appraised, sold'—the chapter proposes a 'flesh/machine and multiplicity' by which to disturb the integrity of the 'human' subject.

From flesh to the disposable body. Rob Halpern's chapter contemplates the incommensurable body of the poet writing against the 'occulted corpse' of the detainee, in the first instance that described in an autopsy report from 2009 of a Yemini man who had been held in US custody since December 2001 and detained at Guantánamo Bay. The chapter is in two sections, the first of which considers the commonality shared by the artwork and the commodity in the theory of Walter Benjamin, that is, the commonality of their uselessness. Benjamin understood how the 'commodity's immanent critique of value reveals itself most transparently in the phenomenon of amassing storehouses of armaments, whose only function is war and whose "use" coincides with the destruction of human lives'. For Benjamin, then, 'the experience of humanity's destruction as an aesthetic pleasure is inextricably entangled with the value-form and inseparable from the domination and exploitation of human bodies'. In the second section, Halpern turns toward the body of the detainee and offers a critique of the idealist assumption (the body as 'concept') residing within Giorgio Agamben's notion of 'bare life' (or 'mere flesh'), since 'geopolitical and social vulnerabilities are unevenly distributed, and this uneven development

has to do with economies of value'. Aiming to 'draw lyric poetry itself into the field of inquiry', Halpern expresses the desire for the poem to 'arouse a living intimacy' where a social relation has been withdrawn, paradigmatically in the isolation of the detainee. The chapter asks, 'Can a poem model "a different economy of bodies and pleasures" and materialise, by way of language and fantasy, a somatic limit—at once embodied and felt—of our current economy at one of its most vulnerable points, while making the obstacle to the transformed conditions it desires perceptible, as if for the first time?'

Karen Kurczynski argues that Asger Jorn 'sought to devalue all that was held sacred in the art world at that time: the esteemed high-modernist values of originality, individualism, expressivity, authenticity, purity, virtuosity, calligraphic skill, and profundity— as well as the nationalism, pre-war School of Paris traditionalism, and Cold War proclamations of freedom that increasingly framed abstract art in political discourse'. Jorn theorised the artist as an agent of 'devalorisation' in society during his involvement with the Situationist International (co-founded with Guy Debord and others in 1957) and wrote two books revising Marx's theories of value in relation to artistic practice. Jorn's theory suggests a dynamic conception of value as something continually changing as society evolves, with the artist acting as a catalyst. The artist's role is thus to create 'counter-values' to aid resistance to the emphasis on productivity and commodification in modern society. Kurczynski's chapter situates Jorn's theory in relation to post-war aesthetics and examines how theory meets practice in Jorn's turbulent 'anti-abstract' painting, as well as in his series of *Modifications* of found paintings, exemplary monuments of his approach to art as devalorisation.

Christian Lotz analyses *Das Kapital Raum 1970–1977* by Joseph Beuys in relation to ideas on social plasticity, human sensuality, and creativity within a non-capitalist social horizon. He argues that Beuys's ideas can be traced back to Ludwig Feuerbach's and Karl Marx's humanism, which includes central Marxist concepts such as alienation, value, and human productivity, arguing that Beuys's work is based on a conception of images as *plastic* images [*Gebilde*], that is, the idea that an image organically *contains its genesis* and brings out its own formation as an *inner* result. Lotz argues that *Das Kapital Raum 1970–1977*, as a multidimensional, multimedia, and multisensual installation, should be understood as a *Denkraum*, that is, as 'spatialized thought' and a 'room' that opens up and contains a vision of a non-capitalist form of social existence and social activ-

ity. As such, it should be understood as a vision that is against the abstractions of (capitalist) value.

Rachel Beckles Willson diagnoses a contradiction within the music criticism of Edward Said that runs counter to the politics to which he was otherwise dedicated. Said's very different responses to, on the one hand, the classical piano recital and, on the other, Arab music, the experience of which he found to be 'horrible', reveal significant effects of taste felt viscerally in the body. Said's pride at having 'perfect pitch' reflects not a natural state but rather 'exposure to industrial production', in this case of Western musical instruments in the nineteenth century, which proves 'suggestive of how a measurement made standard for the purposes of economics can be normalized and inscribed on the body as memory, value, and potential power or vulnerability'. The argument of the chapter uncovers within this 'revulsion on experiencing sonic alterity', against the pluralism and tolerance of Said's politics, a salutary lesson: 'His frankness brings us into confrontation with aspects of humanity (ourselves) that we wish not only to overcome *but also to evade*'. We need, instead, to encounter and explore our 'abject visceral' responses to artworks as a way to engage with the 'fraught realities of the world we inhabit'. If not we place our value judgements ahead of an openness to the visceral feelings of abjection that expose us to our own intolerance and which might begin to explain the tenacity of such intolerance.

Dominic Lash argues for an attention to detail when listening to music *without* referring that detail to overall or global form. Instead we judge 'in the thick of things, from the midst of which we can if we choose orient ourselves towards the possible'. Such is the implicit aesthetic of improviser Derek Bailey. The practical action, of which a study of detail makes one aware, is 'directed towards freedom', 'an example of a hopeful attitude' which does not ignore reality but rather endeavours 'to become fully part of it'.

Sam Ladkin argues that it is necessary to conserve the concept of art and of its value against descriptions of it, and even *despite* those descriptions, if we are to resist living in a censorious culture in which the tacit promotion of positive values blunts the ability of artworks to discover uncomfortable truths and machinations of power. To do so he works through a number of works by social anthropologist Marilyn Strathern, in particular her work on the distinction between audit cultures and ethnography and her reading of intermittency and partial connections when conceptualising knowledge. By way of conclusion, the chapter considers a poetics of inter-

mittency in the work of Tom Raworth, whose poem *Ace* is exemplary of an acuity, a sharpness, that resists — or, perhaps more honestly, fails to care about — the kind of self-reflexive knowledge that feeds into an accumulative capitalist ethos.

Geoff Gilbert begins with the riots (*émeute*) that flourished in France in 2005 and, in particular, the damage rioters caused to public education buildings. Such attacks reflect, for Gilbert, the contradictory status of schools as walled spaces of relative autonomy, 'relative to which the social being of the student is an externality', and at the same time as microcosms 'for social totality' that impose social form on their charges. Gilbert goes on to propose a corollary in the agitation of the communards and hones in on the figure of riotous poet Arthur Rimbaud, taught in French schools. The question for Gilbert becomes one of translation: 'Can we find in a socially possible, concrete, contemporary language-stock' (for example, the newspaper), the forms through which to translate Rimbaud's poetry? Gilbert's self-described failure is evidence of a kind. Such a language would need to allow us to see how bodies, autonomy, and joy cannot be turned into commodities 'because there is no use value in the world that would compensate for them', and yet also recognise how 'we know of course that these kinds of deals are desperately made every day, because money demands it'. Poetry needs such language, but so do schools, which cannot do so 'as long as their walls are charged with bounding and defining and confirming values which condemn much of the social life of our students to the status of waste and externality'.

Griselda Pollock argues that, under the twin rationalisations of audit culture — with the accounting of excellence and the new model that defines the arts and humanities as 'profligate' expenses in an age of financial rationing based on economic necessity and required technological orientation — there is a temptation to fall back on nostalgia for an imagined period of academic freedom; this is identified, problematically but not untruthfully, with struggles for democracy through and in education. Taking up Hannah Arendt's defence of thinking via a reading of it by Judith Butler, and developing Gayatri Spivak's notions of teaching to read as a necessary route to the creation of a 'planetary' community, this chapter seeks to move beyond the historically compromised defences of self-determining academic freedom, themselves shown to be founded in nationalist and imperialist agendas of the past.

Peter Thompson argues for an alternative history of the non-utilitarian uses of education. Against the prevalent dogma that ex-

penditure on higher education is resented, we instead read a personal account of a life in education. The chapter concludes with a critique of the teleology of capitalism as the universal commodification of society and a restatement of a faith in a teleology as autopoiesis by making teleology retrospective, concluding, 'It is precisely the value of art and the value of the humanities, that it has no value other than as an attempt to unravel the metaphysics of contingency and to unpick the stitches of teleology and outcome'.

Value is the core concept for Marxist social science, and Mike Neary discusses its significance, asking, 'How can we oppose the dominant and dominating ascriptions of value in ways that are rigorous and constitutive?' Such opposition, the chapter argues, can be based on the recognition of value as 'a common measure', where value is understood as an organising function that mediates all aspects of social life, including the arts and the humanities, and this form of common measure can be subverted to create a new measure and meaning of the common(s).

Marie Morgan argues for a philosophical notion of education that calls into question the integrity of imposed values that, as external means to ends, remain separated from the learning 'subject' whilst validating the worth or otherwise of his or her education. The chapter pushes against instrumental models of education and associated external values and seeks instead a comprehension of learning which recognises the educational value of life and thinking as emerging through, and from within the work of, the contingent learning 'subject'.

Finally, Emile Bojesen argues for the 'negative' in negative aesthetic education as that which exceeds or exists before or without value. Aesthetic education has been explicitly and consistently concerned with the development of social harmony through shared values; hence the majority of educational policy and practice today is framed by a market-value-oriented form of aesthetic education. It is aesthetic because it has to do not simply with the development of knowledge and skills but also with the development of the disposition of the individual towards the social. That disposition is one which emphasises qualities such as resilience, independence, employability, competitiveness, wealth, and success. A negative aesthetic education, therefore, is an attempt to formulate an aesthetic education which rejects value and reflects upon that part of life which has no explicit or easily assignable value. Thus to ignore this fact in education would be to act as if knowledge of value were sufficient to the task of making one's way through life. But what do

we do when life feels valueless and that valuelessness has been taught to us as being an evil or ill? And what if we are drawn to doing or experiencing something that makes no sense or seems to have no value?

NOTES

1. This is the premise of Jonathan Dollimore's *Sex, Literature, and Censorship* (Cambridge: Polity, 2001): 'It's customary for these enlightened voices to ridicule state laws against obscenity, and to regard others who support such laws as not merely authoritarian, but stupid as well. But these opponents of obscenity know, albeit perhaps stupidly, something about the power of art which the enlightened often do not. To take art seriously—to recognize its potential— must be to recognize that there might be reasonable grounds for wanting to control it' (p. 97). It is a guiding hypothesis of this book that the same logic holds true for the power of education.

2. See, for example, the account of the long-term relationship between arts participation and health, which has been funded by the Arts and Humanities Research Council's Cultural Value Project, being developed by primary investigator Dr Rebecca Gordon-Nesbitt and hosted at http://longitudinalhealthbenefits.wordpress.com [accessed 27 June 2014].

3. Powerful and complementary defences in this liberal-democratic line are offered by Stefan Collini, *What Are Universities For?* (London: Penguin, 2012); Martha Nussbaum, *Not for Profit: Why Democracy Needs the Humanities* (Princeton, NJ: Princeton University Press, 2012); and Thomas Docherty, *For the University* (London: Bloomsbury, 2015); a synoptic account of such defences is offered by Helen Small, *The Value of the Humanities* (Oxford: Oxford University Press, 2014); a defence in a different vein, focused on the deprofessionalisation of academic labour, is Michael Berubé and Jennifer Ruth, *The Humanities, Higher Education and Academic Freedom: Three Necessary Arguments* (Houndmills: Palgrave Macmillan, 2015). Other relevant titles include Steven Connor, *Theory and Cultural Value* (Oxford: Blackwell, 1992); Barbara Herrnstein Smith, *Contingencies of Value: Alternative Perspectives for Critical Theory* (Cambridge, MA: Harvard University Press, 1988); *Humanities in the Twenty-First Century: Beyond Utility and Markets*, ed. by Eleonora Belfiore and Anna Upchurch (Basingstoke: Palgrave Macmillan, 2013); Rita Felski, *Uses of Literature* (Oxford: Blackwell, 2008); Isobel Armstrong, *The Radical Aesthetic* (Oxford: Blackwell, 2000); Peter Boxall, *The Value of the Novel* (Cambridge: Cambridge University Press, 2015). On various forms of valuation see *Beyond Price: Value in Culture, Economics, and the Arts*, ed. by Michael Hutter and David Throsby (Cambridge: Cambridge University Press, 2008).

4. Walter Benjamin, 'Theses on the Philosophy of History', in *Illuminations*, trans. by Harry Zohn (New York: Schocken, 1969), p. 256.

5. Chris Smith in Mark Wallinger and Mary Warnock, eds., *Art for All? Their Policies and Our Culture* (London: Peer, 2000), pp. 14–15. See also Zygmunt Bauman, *Modernity and the Holocaust* (Ithaca, NY: Cornell University Press, 1989).

6. Leo Bersani, *The Culture of Redemption* (Cambridge, MA: Harvard University Press, 1990), p. 22.

7. See these notions of 'grief' in Gillian Rose, *Mourning Becomes the Law: Philosophy and Representation* (Cambridge: Cambridge University Press, 1996),

pp. 41–54; see Bersani, *Culture of Redemption*, for the 'practical convenience' of the 'value of selfhood' as it is 'promoted to the status of an ethical ideal' (p. 4).

8. Jonathan Burrows, *A Choreographer's Handbook* (Abingdon: Routledge, 2010), p. 52.

9. See Claire Bishop, *Artificial Hells: Participatory Art and the Politics of Spectatorship* (London: Verso, 2012); Paolo Merli, 'Evaluating the Social Impact of Participation in Arts Activities', *International Journal of Cultural Policy*, 8.1 (2002), 107–18; and both Foster and Neary in this volume.

10. Paul Bové, *Mastering Discourse: The Politics of Intellectual Culture* (Durham, NC: Duke University Press, 1992), p. 6.

11. Bové, *Mastering Discourse*, p. 6.

12. Bové, *Mastering Discourse*, p. xii.

13. Bové, *Mastering Discourse*, pp. xii–xiii.

14. Quoted in a press release for Light Cone distributors: 'Ken Jacobs', Light Cone, http://lightcone.org/fr/cineaste-163-ken-jacobs [accessed 7 September 2015].

15. See, for example, Philip Mirowski, *Never Let a Serious Crisis Go to Waste: How Neoliberalism Survived the Financial Meltdown* (London: Verso, 2013).

16. 'In his masterful analysis of the dialectics of early bourgeois Enlightenment in the period of the absolutist state, Reinhart Koselleck reminds us of an etymological detail concerning the terms "critique" and "crisis". Both have their origin in the Greek κρίσις, which means dividing, choosing, judging, and deciding. *Krisis* refers to dissent and controversy but also to a decision that is reached and to a judgement that is passed. "Critique" is the subjective evaluation or decision concerning a conflictual and controversial process—a crisis. The connection between a process of social and natural disturbance and subjective judgment upon this process is even more striking in medical terminology, to which the terms were restricted in the Middle Ages. In this context "crisis" designates a stage in the development of a disease that is a turning point and during which the decisive diagnosis concerning the healing or worsening of the patient is reached. Expressions like "a critical illness" and "the patient is in critical condition" are evidence that this original philological context has been preserved in the English language as well' (p. 19). On crisis and disaster, see also Maurice Blanchot, *The Writing of the Disaster*, trans. by Ann Smock (Lincoln: University of Nebraska Press, 1995); Rob Halpern, *Disaster Suites* (Long Beach, CA: Palm Press, 2009); Christopher Nealon, 'Value | Theory | Crisis', *PMLA* 127.1 (2012), 101–6; Joshua Clover, '*Value | Theory* | Crisis', *PMLA* 127.1 (2012), 107–14.

17. Hannah Arendt, 'The Crisis in Education', in *Between Past and Future: Eight Exercises in Political Thought* (Harmondsworth: Penguin, 1977), pp. 174–75.

18. Hannah Arendt, 'The Crisis in Culture', in *Between Past and Future: Eight Exercises in Political Thought* (Harmondsworth: Penguin, 1977), pp. 194–222 (p. 201).

19. Arendt, 'The Crisis in Culture', p. 202.

20. Arendt, 'The Crisis in Culture', p. 202.

21. Arendt, 'The Crisis in Culture', p. 203.

22. Arendt, 'The Crisis in Culture', p. 203.

23. Arendt, 'The Crisis in Culture', p. 204.

24. Arendt, 'The Crisis in Culture', p. 204.

25. Arendt, 'The Crisis in Culture', p. 204.

26. See the 'Asset Development Plan' of 30 July 2015, part of the 'Hellenic Republic Asset Development Fund', which lays out in stark terms the 'Privatisation Method' for the Greek state assets and provides the name of the corporations to whom those assets are being transferred: http://ec.europa.eu/economy_

finance/assistance_eu_ms/greek_loan_facility/pdf/01_mou_annex1_20150730_
en.pdf [accessed 14 September 2015].
27. See Dawn Foster, 'Free Schools', *LRB*, 37.9 (2015), 8–9.
28. See the UK government publication 'Building the Big Society', Gov.uk,
18 May 2010, https://www.gov.uk/government/publications/building-the-big-
society [accessed 1 September 2015].
29. See the work of Annie J. McClanahan, notably, 'Coming Due: Accounting
for Debt, Counting on Crisis', *South Atlantic Quarterly* 10.2 (2011), 539–45; 'The
Living Indebted: Student Militancy and the Financialization of Debt', *qui parle*,
20.1 (2011), 55–77; 'Dead Pledges: Debt, Horror, and Credit Crisis', *Post-45*,
http://post45.research.yale.edu/2012/05/dead-pledges-debt-horror-and-the-
credit-crisis [accessed 20 September 2015].
30. See Pierre Bourdieu, *Distinction: A Social Critique of the Judgement of Taste*,
trans. by Richard Nice (Cambridge, MA: Harvard University Press, 1984).
31. See Thomas Docherty, *Alterities: Criticism, History, Representation* (Oxford:
Clarendon Press, 1996), p. 197.
32. Peter Fleming, *Authenticity and the Cultural Politics of Work: New Forms of
Informal Control* (Oxford: Oxford University Press, 2009), p. vii.
33. Karl Marx, *Capital*, 3 vols. (London: Allen and Unwin, 1971), I, trans. by
Samuel Moore and Edward Aveling, p. 42.
34. Marx, *Capital*, p. 42.
35. Marx, *Capital*, p. 43.
36. Marx, *Capital*, p. 45.
37. See Richard Godden, 'Labor, Language, and Finance Capital', *PMLA*, 126
(2011), 412–21 (p. 415).
38. The precise account of this defunding is extremely complex, owing to the
structuring of student debt amongst other things, but for figures, see Andrew
McGettigan, *The Great University Gamble: Money, Markets and the Future of Higher
Education* (London: Pluto, 2013). Most universities, not only those with endow-
ments, are of course also more directly dependent on such markets to the extent
that budget surpluses are invested in them. On the role of hedge funds in the art
market, see Kelly Crow, Sara Germano and David Benoit, 'New Masters of the
Art Universe,' *Wall Street Journal*, 23 January 2014, http://www.wsj.com/articles/
SB10001424052702303448204579337154245172202 [accessed 14 September 2015].
39. The case is of course not quite so simple; see David Harvie, 'Value-Pro-
duction and Struggle in the Classroom', *Capital and Class* 88 (2006), 1–32.
40. See, for example, *Enriching Britain: Culture, Creativity and Growth: The 2015
Report by the Warwick Commission on the Future of Cultural Value*, available at
http://www2.warwick.ac.uk/research/warwickcommission/futureculture/
finalreport/warwick_commission_report_2015.pdf [accessed 1 September 2015].
41. David Willetts, 'University Challenge', Gov.uk, https://www.gov.uk/
government/speeches/david-willetts-university-challenge [accessed 1 Septem-
ber 2015].
42. Willetts, 'University Challenge'.
43. On the dubious fiscal economics of student loans, see McGettigan, *The
Great University Gamble*.
44. Harvie, 'Value-Production and Struggle in the Classroom', p. 12.
45. Harvie, 'Value-Production and Struggle in the Classroom', p. 13.
46. Docherty, *For the University*, p. 161. Godden's reflections on finance capi-
tal also finally insist that 'labour', together with its affective personal history,
'retains its place at value's core' (p. 421).
47. See Marilyn Strathern, ed., *Audit Cultures: Anthropological Studies in Ac-
countability, Ethics and the Academy* (London: Routledge, 2000); Michael Power,

The Audit Society: Rituals of Verification (Oxford: Oxford University Press, 1997). For something of a counter-argument, see Paul du Gay, ed., *The Values of Bureaucracy* (Oxford: Oxford University Press, 2005).

48. See, for example, the description of management in education in Rosemary Deem, Sam Hillyard, and Mike Reed, *Knowledge, Higher Education, and the New Managerialism* (Oxford: Oxford University Press, 2008), p. 4.

49. Marilyn Strathern, 'Introduction: New Accountabilities', in Strathern, *Audit Cultures*, 1–18.

50. See Marilyn Strathern, 'The Tyranny of Transparency', *British Educational Research Journal* 26.3 (2000), 309–21; Thomas Docherty, *Confessions: The Philosophy of Transparency* (London: Bloomsbury, 2012).

51. Marilyn Strathern, 'Abstraction and Decontextualization: An Anthropological Comment', in *Virtual Society? Technology, Cyberbole, Reality*, ed. by Steve Woolgar (Oxford: Oxford University Press, 2002), pp. 302–13 (p. 305). An analysis of how some of these issues play out in universities is offered by Chris Lorenz, 'If You're So Smart, Why Are You under Surveillance? Universities, Neoliberalism, and New Public Management', *Critical Inquiry*, 38 (2012), 599–629.

52. Strathern, 'Introduction', p. 2.

53. Marilyn Strathern, 'Afterword: Accountability . . . and Ethnography', in Strathern, *Audit Cultures*, 279–304 (p. 282).

54. Strathern, 'Afterword', in *Audit Cultures*, p. 289.

55. Marilyn Strathern, 'The Nice Thing about Culture Is That Everyone Has It', in *Shifting Contexts: Transformations in Anthropological Knowledge*, ed. by Marilyn Strathern (London: Routledge, 1995), pp. 153–76 (p. 160).

56. Strathern, 'Abstraction and Decontextualization', p. 307.

57. Strathern, 'Afterword', p. 287.

58. Strathern, 'Afterword', p. 295.

59. Strathern, 'Afterword', p. 306.

60. Robert Kaufman, 'Aura, Still', *October*, 99 (2002), 45–80 (p. 61).

61. Maurice Merleau-Ponty, 'Indirect Language and the Voices of Silence', in *The Merleau-Ponty Aesthetics Reader*, ed. and intro. by Galen A. Johnson (Evanston, IL: Northwestern University Press, 1993), pp. 76–120 (p. 82).

62. Merleau-Ponty, 'Indirect Language and the Voices of Silence', p. 120.

63. Merleau-Ponty, 'Indirect Language and the Voices of Silence', p. 120.

64. See, for example, Sara Ahmed, *The Promise of Happiness* (Durham, NC: Duke University Press, 2010). The injunction towards happiness can be seen from ancient Greek notions of flourishing, through utilitarianism, and into recent metrics of happiness. On the latter, see John Heliwell, Richard Layard, and Jeffrey Sachs, eds., *World Happiness Report* (New York: Earth Institute, Columbia University, 2012). For a defence of utilitarianism, see Connor, *Theory and Cultural Value*.

65. E. M. Cioran, *A Short History of Decay*, trans. by Richard Howard (London: Penguin, 2010), pp. 150–51.

66. Maurice Blanchot, 'What Is the Purpose of Criticism?', in *Lautréamont and Sade*, trans. Stuart Kendall and Michelle Kendall (Stanford, CA: Stanford University Press, 2004).

67. Blanchot, 'What Is the Purpose of Criticism?', p. 2.

68. Blanchot, 'What Is the Purpose of Criticism?', p. 5.

69. Milan Kundera, *The Festival of Insignificance*, trans. by Linda Asher (London: Faber & Faber, 2015), p. 113.

70. Blanchot, 'What Is the Purpose of Criticism?', p. 6.

71. Maurice Blanchot, *The Infinite Conversation*, trans. by Susan Hanson (Minneapolis: University of Minnesota Press, 1993), p. 6.

72. Blaise Pascal, *The Pensées*, trans. by J. M. Cohen (Harmondsworth: Penguin, 1961), p. 54.

Part I

Critique

TWO

The Authority of Value and Abjection from Value

Marilyn Strathern

My interest in audit cultures stemmed from a mixture of profound disquiet at the implications of the Research Assessment Exercise (RAE) for scholarly practice and education in the broadest sense and the necessity of having, as head of the social anthropology department at the University of Manchester at the time, to be one of its administrators.[1] This frames the approach described here. I conclude with a recollection which, with hindsight, appears as an 'anti-value' moment, though in the urgency of its own time it was articulated as an 'anti-RAE' moment. An alternative set of recollections, however, to begin.

I shall never forget the shock of seeing a form filled in with all its ticks, meant to keep track of the times a carer came in to check on a very ill patient; it covered a period when I had sat with the patient and no one had attended (this was in an English clinic). I was reminded of this by a news item about employees of a firm hired by the UK government to help unemployed young people being accused of a kind of embezzlement, not by fiddling the accounts in a direct way but by fiddling the forms on which they had to report the numbers who had been placed in work (the activity for which they were being paid): there were more ticks than people they had actually helped.[2] Then again, I recollect hearing about field assist-

ants on a clinical trial in a rural setting (not in the United Kingdom) who, after visiting a village, would sit round to compile the reports in what they thought was a suitable manner. In other words, their attention was not on the research record but on those for whom the record was being compiled. In a quite different medical setting, however, I saw another facet of record-keeping altogether, this time in Papua New Guinea: a health worker who spent hours and hours seeing villagers, infants and their mothers, patiently and for every one in turn filling in the day's report in a booklet. The mothers held on to those booklets as crucial evidence of the child's progress and medical history. So not all externally imposed systems corrupt those who use them—the perseverance and doggedness of the health worker to attend to each child and its form in turn has remained a vivid memory.

The issue is less whether or not corruption is inevitable than what it is that particular systems (such as record-keeping) enable. The history of fiddling the auditing account is seemingly contiguous with the invention of the report form. This is no less so when the system in question is established in order to capture behaviour, measure it, and set targets against which it is measured, thereby redescribing behaviour as performance. In other words, the record itself becomes the object of attention, as anyone who complains of all the 'paperwork' that accompanies any kind of reporting well knows. Ticking the box relegates the job the tick was supposed to reflect.

When we look at the way performance is monitored, then, as where the record itself becomes the end in sight, the system can encourage corruption. The old RAE was an example of this; it had a perverting and corrupting effect. Such systems are tempting substitutes for other standards. At the same time we live in a world where aspirations and concerns are embodied in external standards we would like to see applied to everyone and anyone. In fact it can be inspiring to feel that there are practices that are not dependent on the particular circumstances of individuals. This was the classic argument about the virtue of money as a ubiquitous means of transaction, free from bondages of feudalism. Crucially, when we critique accountability, we are not, so to speak, critiquing practice that is inherently bad: the challenge is how to effect a critique of good practice, or rather how a good practice—such as keeping records—becomes bad.

This chapter seeks to register a recent shift from the task of accountability (for example, the demonstration of how public money

has been spent) to the 'impact' agenda (a demonstration that specific publics have been served by the activity being recorded). In higher education in the United Kingdom, this is encapsulated in the move from the RAE to the Research Excellence Framework (REF).[3] The shift marks the distinction between pervasive distrust in what we do (accountability to prove a lack of corruption) and a distrust that we do it at all—and, for some parts of higher education, something nearer abjection (being already discarded, what one has to offer can never compete in 'real world' terms). Value may prove a tool by which to witness this transgression.

For too often the 'value' already attributed to the arts and humanities, and we might add the social sciences as well, incorporates the judgement of a state of no-worth from which they must be rescued for their own good. Where defences seem defeatist, it is as though the value of these fields entailed a prior admission of this state (hence my reference to abjection, a state of being of no-worth). It is not insignificant that value so conceived touches on the sense of self-worth.

I briefly lay out three coordinates that sustain the appeal to value.

1. *Iteration.* We should be suspicious of the rhetorical use of this term (value)—the constant reiteration of the value of value, so to speak, that, like accountability, comes to be taken for granted. When any term becomes a mantra, and not only when taken up by policymakers with their own agendas, there is cause for alarm. There was a time during the high days of the much trumpeted 'enterprise culture' of the 1980 and 1990s when 'enhancement' held this position, until I felt compelled to declare myself as 'against enhancement'. Perhaps one should conclude that no ostensible virtue can be located as a normative target without becoming a site of damage.

 The case of 'value' has the great benefit of being parasitical (it can attach seemingly anywhere), transgressive (often implicitly exchanging values in one register for those in another, from economic to cultural and back being amongst the most pervasive), and finally tautologous (what is of value should be valued, implying there are things not of value that simply don't measure up). When it comes to the impact agenda, however, that tautology conceals the hand of 'the system': public value—or at least the public recognition of value—is

to be added to or drawn out of an item in the same way as exchange value adds to the utility value of a commodity. It is not just that what you do has worth but that it is a given a *mark* of worth (a 'price', an accreditation) that can be communicated to others, transacted with them, and so on. So shouldn't we also be looking at the very act of conferring value on something?

2. *Adding value.* Adding value is like second-order recognition. Think of the ancient distinction between the *apodictic* (showing: to *monstrate*) and the *deictic* (demonstrating: showing that you are showing). The question that lies behind evaluation is how people can demonstrate what they have done. Spanish anthropologist Corsín Jiménez pointed to the distinction in the course of commenting on the perplexities facing members of a Centre for Humanities and Social Sciences when it was reorganised within an Institute of Knowledge Management: How, for a start, do they 'demonstrate to themselves that what they "do" is knowledge'?[4] When value is incumbent on the demonstration of value, other contexts disappear.

Second-order recognition can circulate like a currency, can be a means of communication, just as something of value is given value all over again in being given a price, which makes it fungible, that is, subject to transactions. The longstanding impact factor of science journals is an example of such a metric. Impact factors do not become directly tradable, but there can be trade-offs in how a person's scholarly worth is registered in different journals and their fields.

It is important, however, to recognise that one cannot just scrape off the added value as though it were always an excrescence on the surface of a pristine entity that had its own value. Take away the impact factor of the journal, and you will find that the original work already had added value in getting into publishable form in the first place; take away that, and you will find that the prepublication communications among peers had already given the work added value . . . in other words, *added value all the way down.* We know this logically: the very description of saying something has worth, including intrinsic worth, has already 'added' a description. I return to the point that we are describing here ordinary, decent (if not actually 'good') practice: it is when particular elements are seized for very specific agendas that one should start worrying.

3. *Conversions.* And how they are seized. On the verge of the introduction of impact assessment in 2009, a self-declaratively reassuring letter came round British universities from the former chair of the UK Research Councils consortium. Picked out in bold, there was a reassuring sentence: 'I cannot emphasise sufficiently that excellent research without obvious or immediate impact will continue to be funded by the Research Councils and will not be disadvantaged within the assessment process'. The rest of the letter was all about impact. So how was information about the impact of completed projects to be captured? 'The demonstrable contribution that excellent research makes to society and the economy [is to be] embodied in the questions that *applicants* for research grants have to answer when they are completing the Impact Summary' (my italics). There is a value conversion here, and it contains a lie. Let me say what I mean.

The letter claims that defining benefits and use does not take away from other aspects of the application, just 'adds value' to it. The questions are there simply to encourage the applicant to envisage making an impact that will 'stimulate interest from wider stakeholders'. Indeed the need to show usefulness has been stated in some form or other ever since the British university system was brought under economic scrutiny in the early 1980s. But what is being imagined in the managerialist notion of adding value? To claim that showing the impact of research 'adds value' to research—here is enhancement again—is also to claim that the research *is not fundamentally altered thereby*. This is the lie. The pretence is that knowledge created in the course of research loses nothing by becoming information that can be put to use. That masks a huge displacement.

We all have our own usage of these terms, but I am following Sheila Jasanoff's *States of Knowledge* in taking information as knowledge 'stripped of its theoretical, formal, logical . . . layers . . . [amenable to] to fit quick, often "do it yourself" tasks'.[5] Information is, it is suggested, more 'socially transportable' than knowledge. In the process of communication, information is forever being converted into information, that is, made informative in fresh ways.

One rubric under which added value is itself made evident (given value) is 'knowledge transfer'. Transfer makes explicit what is already implicit in the idea of turning academic out-

put to use. Government agencies and similar institutions generally mean by 'use' the deployment outside the immediate academic context, or at least outside the home discipline. Identifying 'external' collaborators, like identifying 'external' users, is a way of differentiating the interests at stake. Collaboration with colleagues across ostensible disciplinary lines can thus appear as one step towards demonstrating external and thus 'wider' interests. Indeed collaboration with non-academic organisations was the first of the suggestions in the Research Councils' letter (above) for how humanities and social science researchers can show that their work has 'impact'.

The inference is that 'internal' circulation, however defined, does not count: to qualify, knowledge transfer must demonstrate that what was generated in one context can be used in another, 'external' one. That there is generic, or even generalisable, difference between internal and external is of course a chimera, but there are palpable enough effects of this way of thinking: 'adding value' in such a manner effects a value conversion from knowledge to information. What is 'known' is validated by how it 'informs'.

The preceding, however, could have been written at any time this last ten or fifteen years. How might abjection make apparent the tyranny of value?

With abjection, we return to no-worth and self-worth. I suspect that persons (whether being treated as amenable subjects or, more pertinently, as agents co-opted into the impact agenda) are being called to account in fresh ways. Evaluation and auditing are turned from the quality of work being done to the quality of those doing it. If the talk is of 'creativity' and 'productivity', one question simply slides into another: How, then, do academics use their knowledge to creative effect? How do they show not just their productions but their creativity in the creativity of their productions? Knowledge produced for evaluation requires of persons that they perform the energy that goes into knowing.

The REF has subsequently watered down early proposals that the UK Research Councils should keep track of everything academics produce, the idea that 'impact data' would be gathered for five years following a research award, under an Outputs and Outcomes Collection scheme.[6] The drivers, however, are still there: 'We are all aware of the increasing imperative to demonstrate clearly the way

our [national] investments in research benefit society and the economy. . . . We want to work with the research community to tell the story of its success.'[7] Not the story of its travail, of its work, note, but of its success.

Lack of success comes perilously close to lack of personhood, for one implication is that the academic as a person may turn out to be a defective agent, to have failed to seize the potential of knowledge. The defective agent has not just failed to realise its usefulness and relevance to society or whatever the target should be, thereby failing as a communicator, but has failed to be creative or productive in his or her own terms. Failure is ultimately attributed to *his or her* not giving sufficient value to what he or she does.

Obviously it is not giving 'value'—or even adding it—that is the problem. Everything turns on how the concept is deployed and to what ends. Yet there may well be a time, as the editors of this volume envisage, when value has to be recovered on altogether different terms. That is, we deliberately *make* value the problem.

And my own anti-value moment? This was in the far-off days of the 1980s when the RAE was briefly concerned with quantity of output (a concern subsequently abandoned). I am sitting on some steps before a Faculty of Social Sciences meeting at the University of Manchester, and the dean comes along and asks me what I am doing. He is looking at the manuscript on my lap and pencil in my hand. A mischievous imp jumps onto my tongue, and I say, jokingly but without hesitation, 'This is anti-RAE activity!' What I was doing was editing the manuscript—very largely a matter of pruning and cutting words out—that is, reducing it (which it badly needed). My joke was about the absurdity of the RAE word-counting requirement, when discarding words was to me the knowledge-enhancing act. Yet I could no more avoid the demands of the RAE than I could summon the idea of 'enhancement' without also registering its appropriation for quite different kinds of value making.

To think of this as an anti-value moment as well moves the argument. Abjection is about *being* (already) discarded. Perhaps something with which to struggle in a state of abjection is how to turn discarding into an intentional act. This refers not just to editing but to many situations where one needs to get rid of material or to abandon a project: to admit a dead end in order to find a live one, to throw away and start again. Yet, can you imagine abandoning a research project these days, especially if it is funded, even if it turns out not really to be getting anywhere? Everything has to be positive and upbeat; everything has to have value just in order to live and

breathe. The culture is affirmative. Perhaps in these circumstances one of the states of mind produced by abjection is evident in the counter-tendency to hold on to everything. And maybe this is where knowledge/education/art 'for its own sake' needs critiquing, as Sam Ladkin has said. For what one also needs is to be free to do one's own discarding.

ACKNOWLEDGEMENTS

Apart from the stimulus of the occasion for which this was written, special gratitude indeed to Sam Ladkin for his generous editing and pertinent comments, as well as those of the co-editors and reviewers. I am no longer actively part of the academic milieu that compelled me to work out what I thought about auditing and deliberately retain that distance here. Thus, aside from a couple of retrospective references, I have not contextualised this account by detailing the work of many scholars who inspired me at the time. They will know who they are, and my thanks are still due.

NOTES

1. Editor's note: The Research Assessment Exercise (RAE) was instigated by higher education funding councils to assess the quality of research in British universities, the first under that term in 1992, which was replaced or rebranded as the Research Excellence Framework (REF) in 2014. See Marilyn Strathern's account in *Audit Cultures: Anthropological Studies in Accountability, Ethics and the Academy*, ed. by Marilyn Strathern (London: Routledge, 2000); also Marilyn Strathern, 'Abstraction and Decontextualization: An Anthropological Comment', in *Virtual Society? Technology, Cyberbole, Reality*, ed. by Steve Woolgar (Oxford: Oxford University Press, 2002), pp. 302–13. See also Michael Power, *The Audit Society: Rituals of Verification* (Oxford: Oxford University Press, 1999). This paper was first presented at the 'Against Value in the Arts and Humanities' symposium at the University of Sheffield, 23 February 2012.

2. *Today*, BBC Radio 4, 22 February 2014.

3. See note 1.

4. Alberto Corsín Jiménez, 'Relations and Disproportions: The Labor of Scholarship in the Knowledge Economy', *American Ethnologist*, 35.2 (2008), 229–42.

5. Yaron Ezrahi, 'Science and the Political Imagination in Contemporary Democracies', in *States of Knowledge: The Co-production of Science and the Social Order*, ed. by Sheila Jasanoff (London: Routledge, 2004), pp. 254–73 (p. 257).

6. See *Times Higher Education*, 16 April 2009.

7. Sue Smart, head of performance and evaluation for the Engineering and Physical Sciences Research Council (EPSRC), quoted in Zoe Corbyn, 'Research Intelligence: Is It Worth It in the Long Run?', *Times Higher Education*, 4 February 2010.

THREE

Post-critical

Hal Foster

Critical theory took a serious beating during the culture wars of the 1980s and the 1990s, and the 2000s were only worse. Under George W. Bush, the demand for affirmation was all but total, and today there is little space for critique even in the universities and the museums. Bullied by conservative commentators, most academics no longer stress the importance of critical thinking for an engaged citizenry, and, dependent on corporate sponsors, most curators no longer promote the critical debate once deemed essential to the public reception of advanced art. Indeed, the sheer out-of-date-ness of criticism in an art world that couldn't care less seems evident enough. Yet what are the options on offer? Celebrating beauty? Affirming affect? Hoping for a 'redistribution of the sensible'? Trusting in 'the general intellect'? The post-critical condition is supposed to release us from our straightjackets (historical, theoretical, and political), yet for the most part has abetted a relativism that has little to do with pluralism.[1]

How did we arrive at the point where critique is so broadly dismissed? Over the years most of the charges have concerned the positioning of the critic. First, there was a rejection of *judgement*, of the moral right presumed in critical evaluation. Then, there was a refusal of *authority*, of the political privilege that allows the critic to speak abstractly on behalf of others. Finally, there was scepticism about *distance*, about the cultural separation from the very condi-

tions that the critic purports to examine. 'Criticism is a matter of correct distancing', Walter Benjamin wrote over eighty years ago. 'It was at home in a world where perspectives and prospects counted and where it was still possible to adopt a standpoint. Now things press too urgently on human society.'[2] How much more urgent is this pressing today?

Yet not all critique depends on correct distancing. Estrangement à la Bertolt Brecht is not correct in this sense, and there are interventionist models in art (from Dada to the present) in which critique is produced immanently through techniques of mimetic exacerbation and symbolic *détournement*.[3] As for the other old charges (which come mostly from the Left), they boil down to two in the end: critique is driven by a will to power, and it is not reflexive about its own claims to truth. Often enough two fears drive these two accusations: on the one hand, a concern about the critic as 'ideological patron' who displaces the very group or class that he represents (the famous caution given by Benjamin in 'Author as Producer' [1934]), and, on the other, a concern about the scientific truth ascribed to critical theory in opposition to 'spontaneous ideology' (the dubious position assumed by Louis Althusser in his rereading of Karl Marx). Such fears are not misbegotten, but are they reason enough to throw the baby out with the bathwater?

More recent attacks, especially on the critique of representation and the critique of the subject, have operated through guilt by association. Rather than being too confident of its truth, the critique of representation was said to sap truth value as such and so to promote moral indifference and political nihilism.[4] The critique of the subject was also charged with unintended consequences, as its demonstration of the constructed nature of identity was said to abet a consumerism of subject-positions (e.g., multiculturalism repackaged as the 'United Colors of Benetton'). For many these two outcomes count as postmodernism tout court, which is to be condemned outright as a result. Yet this is a caricature that reduces postmodernism to the rote expression of neoliberal capitalism (i.e., as neoliberalism deregulated the economy, so postmodernism derealised the culture).[5]

More pointed questions about critique have come from Bruno Latour, who focuses on his field of science studies, and Jacques Rancière, who focuses on his hobby horse of contemporary art. For Latour the critic pretends to an enlightened knowledge that allows him to demystify the fetishistic belief of naive others—to demonstrate how this belief is 'a projection of their wishes onto a material

entity that does nothing at all by itself'.[6] Here the fatal mistake of the critic is not to turn this antifetishistic gaze on his own belief, that is, his own fetish of demystification, a mistake that renders him the most naive of all. Latour concludes,

> This is why you can be at once and without even sensing any contradiction (1) an antifetishist for everything you don't believe in—for the most part religion, popular culture, art, politics, and so on; (2) an unrepentant positivist for all the sciences you believe in—sociology, economics, conspiracy theory, genetics, evolutionary psychology, semiotics, just pick your preferred field of study; and (3) a perfectly healthy sturdy realist for what you really cherish—and of course it might be criticism itself, but also painting, bird-watching, Shakespeare, baboons, proteins, and so on.[7]

For Rancière, too, critique is compromised by its dependence on demystification. 'In its most general expression,' he writes, 'critical art is a type of art that sets out to build awareness of the mechanisms of domination to turn the spectator into a conscious agent of world transformation.'[8] Yet not only is awareness not transformative per se, Rancière continues, but 'the exploited rarely require an explanation of the laws of exploitation'. Moreover, critical art 'asks viewers to discover the signs of capital behind everyday objects and behaviors', but in so doing only confirms the 'transformation of things into signs' that capital performs. Like the critic for Latour, the critical artist for Rancière is trapped in a vicious circle.

Yet much the same can be said of these two meta-critics. Latour replays the ur-critical move of Marx and Sigmund Freud, who argued as follows: 'You moderns think you are enlightened, but in fact you are as fetishistic as any primitives—fetishists not only of the commodity but of any object you desire inappropriately.' To this reversal Latour now adds his own: 'You antifetishistic critics are also fetishists—fetishists of your own cherished method or discipline.' To this extent, then, he remains within the rhetorical coils of the very critique he wants to cut.

Rancière joins in this challenge to the hermeneutics of suspicion at work in critique à la the Frankfurt School. Yet not only is this challenge a familiar one within critical theory, but it was also fundamental to its own shift from a search for hidden meanings to a consideration of 'the conditions of possibility' of discourse (as in Michel Foucault), of the significance of textual surface (as in Roland Barthes), and so on.[9] Moreover, Rancière condemns critique for its

projection of a passive spectator in need of activation (this is his version of the naive believer in need of demystification); yet he, too, assumes this passivity when he calls for such activation beyond mere awareness.[10] Finally, his 'redistribution of the sensible' is a panacea, and when pitted against the capitalist 'transformation of things into signs', it is little more than wishful thinking, the new opiate of the art-world Left.[11]

All this said, one understands the fatigue that many feel with critique today, especially when, taken as an automatic value, it hardens into a self-regarding posture. Certainly its moral righteousness can be oppressive, and its iconoclastic negativity destructive.[12] Against this image of the critic Latour offers his own:

> The critic is not the one who debunks, but the one who assembles. The critic is not the one who lifts the rugs from under the feet of the naïve believers, but the one who offers the participants arenas in which to gather. The critic is not the one who alternates haphazardly between antifetishism and positivism like the drunk iconoclast drawn by Goya, but the one for whom, if something is constructed, then it means it is fragile and thus in need of great care and caution.[13]

Who could not warm to this figure of the empathetic critic? Yet such an ethics of generosity introduces a problem of its own, which is in fact the old problem of fetishism, for here again the object is treated as a quasi-subject.[14]

Recent art history shows a marked tendency to do much the same thing: images are said to have 'power' or agency, pictures to have 'wants' or desires, and so on. This corresponds to a similar tendency in recent art and architecture to present work in terms of subjecthood.[15] Although many practitioners aim, in good minimalist fashion, to promote phenomenological experience, they often offer the near-reverse: 'experience' returned as 'atmosphere' and/or 'affect' in spaces that confuse the actual with the virtual and/or with sensations that are produced as effects yet seem intimate, indeed internal, nonetheless (examples range from James Turrell to Olafur Eliasson in art and from Jacques Herzog and Pierre de Meuron to Philippe Rahm in architecture). In this way the phenomenological reflexivity of 'seeing oneself see' approaches its opposite: an installation or a building that seems to do the perceiving for us. This, too, is a version of fetishisation, for it takes thoughts and feelings, processes them as images and effects, and delivers them back to us for

our appreciative amazement. As such it calls for antifetishistic critique.[16]

The same is true, more generally, of 'cynical reason', the dismissive knowingness that drains so much energy from our cultural lives and our political lives alike.[17] The problem is not that truths are always hidden (Latour and Rancière are right here) but that many are all too apparent—yet with a transparency that somehow blocks response: 'I know the mantra of "no taxes" is a boon to the rich, and a bust for me, but nevertheless . . .' or 'I know the big museums have more to do with finance capital than with public culture, but nevertheless . . .'. As a fetishistic operation of recognition and disavowal (precisely 'I know but nevertheless'), cynical reason is also subject to antifetishistic critique. Of course, such critique is never enough: one must intervene in what is given, somehow turn it, and take it elsewhere.[18] Yet that turning begins with critique.

Maybe I am dead wrong: What about the blossoming of 'critical art' today? The rub here lies in how these two words do (or do not) come together. It is common to speak of 'social practice art', but this rubric underscores how removed art is from everyday life even as it attempts to close that divide (it is with a similar magic that Rancière declares the political and the aesthetic always-already bound up with one another). In fact, rather than hold the two terms together, such rubrics tend to release a given practice from the criteria of either social effectivity or artistic invention; the one tends to become the alibi for the other, with any pressure from the one side dismissed as sociological and any from the other as aestheticist—and so the announced resolution breaks down again.

Let me end with an opposition that, though schematic, seems pertinent to this predicament. On the one side, there is the quasi-Gramscian position of activist art that, with aesthetic autonomy dispatched by an unholy alliance of critique and capital, sees a field wide open for social practice. On the other side, there is the quasi-Adornian position that insists on the category of art, but with the forlorn sense that its minimal autonomy now holds minimal negativity and with little left to do but go through the formalist motions. In a way this complementarity recalls that of Dada and surrealism as seen by Guy Debord, who (in his version of dialectics as mutually assured destruction) once wrote, 'Dadaism sought to abolish art without realizing it, and Surrealism sought to realize art without abolishing it.'[19] However, our situation might evoke the 1920s in more alarming ways still: economically as an age of boom and bust;

politically as a period in which a state of emergency becomes more normal than exceptional; and artistically as a time when, as some practitioners act out economic crisis and political emergency (e.g., Dada again) or build from this chaos (e.g., constructivism), others flee it in a *retour à l'ordre* (the parallel to the return to degraded versions of the neoclassical tradition in the 1920s might be the return to old idioms of modernist painting and sculpture now).[20] If there is anything to this echo, then surely it is a bad time to go post-critical.

NOTES

1. Not much of this is new; see the roundtable published some years ago, 'The Present Conditions of Art Criticism,' *October*, 100 (2002). The fundamental problem remains one touched on there. Confident as a class, the bourgeoisie once sought out the test of criticism; it was seen as central to the give-and-take of its own ideal of a public sphere—but that was long ago. My account here begins with the big picture, hence the slippage between 'critique', 'criticism', 'critical theory', and 'critical art'; in what follows I focus on the latter two. Finally, 'post-critical' has a different valence in architectural debate, where it is used to draw a line after the theoretical reflexivity of such architects as Peter Eisenman and to announce a renewed pragmatism of 'design intelligence'. But its effects do not appear to be much different.

2. Walter Benjamin, 'One-Way Street' (1928), trans. by Edmund Jephcott, in *Selected Writings*, vol. 1: *1913–1926*, ed. by Marcus Bullock and Michael W. Jennings (Cambridge, MA: Harvard University Press, 1996), pp. 448–88 (p. 476). The other negative association, too complicated to take up here, is that between critique and *ressentiment*.

3. Not to mention the different variants of deconstruction. On mimetic exacerbation, see Hal Foster, 'Dada Mime,' *October*, 105 (2003).

4. In fact such nihilism is an attribute of the Right more than of the Left. Recall the 2004 acknowledgement of a George W. Bush official (said to be Karl Rove): 'We're an empire now, and when we act, we create our own reality. And while you're studying that reality—judiciously, as you will—we'll act again, creating other new realities, which you can study too, and that's how things will sort out.' See Ron Suskind, 'Faith, Certainty, and the Presidency of George W. Bush,' *New York Times Magazine* (27 October 2004). Or consider how the notion of 'the social construction' of science is used to dispute the fact of global warming. See Bruno Latour, 'Why Has Critique Run Out of Steam? From Matters of Fact to Matters of Concern', *Critical Inquiry*, 30.2 (2004), 225–48.

5. Sometimes the connection is said to be very direct. For example, Luc Boltanski and Eve Chiapello charge that 'artistic critique' of the disciplinary workplace was key to 'the new spirit of capitalism'—though what they mean by 'artistic critique' has little to do with art. See Luc Boltanski and Eve Chiapello, *The New Spirit of Capitalism*, trans. by Gregory Elliott (London: Verso, 2004).

6. Latour, 'Why Has Critique Run Out of Steam?', p. 237. Also see Bruno Latour, 'What Is Iconoclash? Or Is There a World Beyond the Image Wars?', in *Iconoclash: Beyond the Image Wars in Science, Religion, and Art*, ed. by Bruno Latour and Peter Weibel (Karlsruhe and Cambridge, MA: ZKM and MIT Press,

2002); Bruno Latour, *We Have Never Been Modern*, trans. by Catherine Porter (Cambridge, MA: Harvard University Press, 1993).
 7. Latour, 'Why Has Critique Run Out of Steam?', p. 241.
 8. Jacques Rancière, *Aesthetics and Its Discontents*, trans. by Steven Cochran (Cambridge: Polity Press, 2009), pp. 46–47.
 9. In the hands of others both positions have degenerated, the Foucault into discursive generalities without much purchase on actual practices (e.g., the 're-gimes' that Rancière goes on about), the Barthes into a celebration of effect and affect (more on which below).
 10. See Jacques Rancière, *The Emancipated Spectator*, trans. by Gregory Elliott (London: Verso, 2009).
 11. Defined as what can and cannot be sensed and said, 'the distribution of the sensible' differs little from what Marx, in his best moments, understood as ideology—that is, less the specific content of thought than its structural delimitation (i.e., how some thought is rendered unthinkable).
 12. In this light a suspension of the critical reflex can be beneficial, as Jeff Dolven suggests in a response to this text: 'Here my basically pragmatist impulses are in play, for I want to know how far it is possible to understand and inhabit versions of aesthetic experience that are uncritical, without surrendering my party ID: epideictic? ludic? freely interpretive? imitative? . . . Can we give play to the kinds of conceptual suspension and ideological indeterminacy that Kant seems to find in aesthetic experience? Can we trust the capacity of properly aesthetic experience of a work of art to resist ideology? Are we prepared to credit works of art with soliciting such experience? And trust that, when we need to (which will be often), we can put our guard up again, have the resources of critique at our disposal, and train them on the very same objects? And allow, perhaps, critique to bound and restrain that aesthetic freedom, and allow, perhaps, aesthetic possibility to redeem objects that critique might urge us to banish? This is a *practical* question—of which, when.'
 13. Latour, 'Why Has Critique Run Out of Steam?', p. 246.
 14. My critique of fetishization is not a suspicion of desire, pleasure, and so on; it is simply a resistance, more Blakean than Marxist, to any operation whereby human creation (e.g., God, the Internet) is projected above us with an agency of its own, from which position it is as likely to subjugate us as it is to serve us.
 15. See Isabelle Graw, ed., *Art and Subjecthood: The Return of the Human Figure in Semiocapitalism* (Berlin: Sternberg Press, 2011).
 16. What was condemned in minimalism as a concern with objecthood was really a concern with objectivity—the objectivity of structure, space, bodies in space, and so on. This concern drove the primary line of work out of minimalism, but now a secondary line has become dominant. On this reversal, see 'Painting Unbound' in Hal Foster, *The Art-Architecture Complex* (London: Verso, 2011).
 17. Peter Sloterdijk, *Critique of Cynical Reason*, trans. by Michael Eldred (Minneapolis: University of Minnesota Press, 1987).
 18. As indeed Paolo Virno has urged us to do with cynical reason; see Paolo Virno, *A Grammar of the Multitude*, trans. by Isabella Bertoletti et al. (Los Angeles: Semiotext[e], 2004). For a better example of this troping of a given condition, in this case our own as defined by neoliberalism, see Michel Feher, 'Self-Appreciation, or the Aspirations of Human Capital', *Public Culture*, 21.1 (2008), 21–41. There are many more instances in recent art.
 19. Guy Debord, *The Society of the Spectacle*, trans. by Donald Nicholson-Smith (1967; New York: Zone Books, 1994), p. 136.

Hal Foster

20. See David Geers, 'Neo-Modern', *October*, 139 (2012), 9–14; Hal Foster, 'Preservation Society', *Artforum*, 49.5 (2011), 178–85.

FOUR

Invaluable Elephants, or the Against-Value of Critique (for Animals)

Robert McKay

THE AGAINST-VALUE OF CRITIQUE

In *The German Ideology*, Karl Marx writes: 'Men can be distinguished from animals by consciousness, by religion, or anything else you like'.[1] I have always been struck by something strange in these words of Karl Marx, and this is the way that the ground of value on which the human species is said to be distinguishable from animals seems to slide away—perhaps it would be better to say it is given away—just as Marx imagines it to be most self-evidently won. He is offering us a statement of the obvious—*of course* 'men' are different from animals, and you can take your pick which field of inquiry you draw on to demonstrate it. His slightly dismissive 'or anything else you like' is intended simply to clear the ground of the rationales offered by idealist or metaphysical modes of inquiry such as philosophy-psychology and religion. This prefaces the presentation of what is for Marx the proper origin of species distinction: the 'definite mode of life' of humanity begins when 'men . . . produce their means of subsistence' (p. 42). As David Harvey puts it, 'at the basis of Marx's conception of the world lies the notion of an appropriation of nature by human beings in order to satisfy their wants

and needs'.[2] The necessary relation of appropriating 'man' to an appropriated nature is the humanist value-frame that delineates the entire project of Marx's political economy. Harvey explains just how contentious debate about the Marxian theory of value is; nevertheless, to the extent that the critique of value is expressed most memorably in the key notion that the accumulation of capital is finally dependent on the specific capacity of labour to produce surplus value, Marx points firmly to the idea that the properly historical foundation of value is the conversion of nature into socially necessary use values by the work of human labour. And yet, let us return to Marx's 'or anything else you like'. A suspicion lingers around it that the very project of separating man from and raising him above the animal might be, to use an apposite word, cavalier. The throwaway ease with which we are supposed able to prove human uniqueness hints that it may not be quite so definitive a proposition. After all, if anyone can say what distinguishes the human from the animal, *and do so any old way*, then perhaps the proper grounds of human exceptionalism are not quite so certain after all. This is a good example of a simple but profound way that the concept of value proves itself to be something of a feral beast: when a notion is just so certain as to be unquestionable, it can easily be taken so much for granted that the force of its value, the very value of that value, escapes.

I begin here principally because this reading of Marx allows me to raise the question of the humanism of value. More specifically, I am interested in the consistency (with respect to our understandings of the relations between humans and other animals, that is) of the humanist role played by value and its mechanisms—distinguishing, separating, discriminating, and the corollaries suggested by this latter: ranking, hierarchy, dominance. This role spans from the sphere of ideas to which Marx is antipathetic (philosophy, religion) and into his own historical materialism. This fact attests to two important perspectives on critique (and, implicitly, value) offered by Hal Foster in his essay 'Post-critical'. The spatial metaphor in the Benjaminian truism of which Foster importantly reminds us—that 'criticism is a matter of correct distancing'—is ironically telling here.[3] For it is by establishing the ontological separation of human beings from their literal ground in nature and animal existence that Marx insinuates the distance that allows for the human relation to it (productive labour) that is the very matter of materialist critique. The principal challenge for the critic of humanist value, then—for the post-humanist (or, better, anti-anthropocentric) critic—is how to

refute Marx's substantiating of value in a human 'species-being' based on human-animal or human-nature difference without replicating the same move—that is, without either accepting the separation of human from animal that justifies the materialist critique or establishing by default some new and supposedly solid ground of value. Put another way: Is it possible to resist anthropocentric humanism without retreating to a safe critical distance that formalises a new standard of value?[4] This is where Foster's corrective to Walter Benjamin—'not all critique depends on correct distancing'—is helpful. Foster's key exemplars of immanent critique are 'mimetic exacerbation and symbolic *détournement*'—that is satirical, parodic, pastiching forms that rely on an intimacy with their object—and 'the different variants of deconstruction'.[5] This latter method returns me to the way that, as I read it, the expression of Marx's humanism in his 'or anything else you like' itself seems to mean more than it intends (or, rather, to say less because it says too much); that is to say, the surety of human uniqueness is undermined by the strength of its expression, an undermining that awaits a critical reader. As Foster quite rightly says, though, 'critique is never enough: one must intervene in what is given, somehow turn it and take it elsewhere', a turning that 'begins with critique'.[6]

The 'elsewhere' towards which I want to take Foster's defence of critique (with which I am fully in sympathy) is the question of the value of the human and, beyond this, to the politics of human-animal relations. This allows me to say something in passing about the way the English-speaking academy has taken on the value of animals in the last fifteen years or so in the form of interdisciplinary 'human-animal studies', 'animal studies', and 'post-humanist' inquiry. For here we find something of a tension between more and less ethico-politically committed forms of analysis in terms of justice for animals. This tension has given rise to a project of critical animal studies; the assertion of criticality attests, more or less, to the role of the academic as committed intellectual for this cause.[7] Here, the fact that Foster offers a rejoinder to the work of Bruno Latour is particularly significant—for Latour's book *Reassembling the Social* is a compelling example of the case against the stance, principally taken by what he calls 'sociologists of the social', that opposes power relations critically first and foremost through a resistant revelation of them (he has in mind analyses inspired by Marx, Pierre Bourdieu, or Erving Goffman). For Latour, this attitude simply hypostasises a general agency of 'power' which critique then counteracts; it thereby siphons off some of the power necessarily inherent in the un-

equal distribution of power for the project of critique itself: 'It's
much too tempting to *use* power instead of *explaining* it' is his blunt-
est accusation of this problem.[8]

We see here, in what Foster calls the 'antifetishist critique' of the
'fetish of demystification',[9] Latour's statement of precisely the theo-
retical problem I isolated for the anti-anthropocentric critic of hu-
manist value: the danger of reinstating absolute value too easily (in
the search for a critical ground on which to speak 'for' animals).
And yet, one wonders if this just leaves us in a position not unlike
the one diagnosed by Herbert Marcuse at the end of *One Dimension-
al Man*, of 'succumb[ing] to the fallacies of a misplaced concreteness,
thus performing an ideological service while proclaiming the elimi-
nation of value judgements'.[10] It is beyond the scope of discussion
here to detail the differing gains and pitfalls of explanatory (as op-
posed to critical) approaches in terms of understanding hu-
man–non-human relations.[11] But it is true that the differences
present a continuing dilemma, and this dispute reveals that the
stakes are high for non-human animals in any discussion of the
value of critique.

For example, let us take the work of Jane Bennett, perhaps the
most astute developer of Latour's position into a more-than-human
political theory. She avers that 'demystification is an indispensable
tool in a democratic, pluralist politics that seeks to . . . check at-
tempts to impose a system of (racial, civilisational, religious, sexual,
class) domination'; but she also resists the way that demystification
'tends to screen from view the vitality of matter and to reduce *politi-
cal* agency to *human* agency'.[12] However, as the telling absence of
the word 'species' from her list of possible forms of domination
suggests, her work insists that the indispensable issue of resis-
tance—something I am titling here 'against-value'—is the point at
which critique and the human coincide. She writes, 'I cannot envi-
sion any polity so egalitarian that important human needs . . .
would not take priority' because 'I identify with members of my
species, insofar as they are bodies most similar to mine'.[13] Thus
Bennett's avoidance of the Scylla of fetishising critique itself—her
demystification-as-humanism position is a version of Latour's cri-
tique-as-powermongering one—steers into the gaping maw of the
Charybdis of political quietism about the violence of human–non-
human relations.[14] The impossibility of a more radical egalitarian
vision is here asserted on the basis of a notion of species-being that
supposes that substantive politico-moral value resides in the biolog-
ical reality of 'similar' bodies. Of course, comforting though such a

community of similarity might be, as the history of racism and disability discrimination makes perfectly clear, proposed biological or morphological similarity could not be more of a political project, a fantasy of human identity-as-sameness. Quite to the contrary, to be known as such at all, 'human' bodies must always be recognised (or misrecognised) in multifarious relations of difference to construed forms of the inhuman. The implications of Bennett's position can therefore be rephrased in biopolitical terms: the human deems itself exceptional with respect to the broader field of life by arrogating the sovereign power to distinguish similarity from dissimilarity, human bodies from not-human bodies, absolute biological value from relative biological value. However, there is no reason for the recognition to stop at the water's edge of species difference. Given, for one, the evolutionary continuity of animal life—and this is to say nothing of identifications with something, or someone, even more radically other—Bennett is simply left needing to justify why certain kinds of bodily similarity have absolute rather than relative value. From the 'correct distance' provided by evolutionary biology, that is to say, the political privileging of 'human' bodies can be critiqued as an ethnocentrism within the expanded field of animal life of which humans are a part. And this, in large part, is the broad ground on which the critique of human speciesism on the basis of sentience is set out.

Of course, the problem remains that 'the expanded field of animal life' is thereby presented as the absolute value-ground for political recognisability, on the basis of moral patiency or capacity to feel and suffer. (In the framework of biopolitical critique, the implied value is strictly speaking simply 'life itself' in the face of power.) The conventional humanist argument against this (which is not one that Bennett would accept) is that valuing, at least ethical valuing, is necessarily human to the extent that the capacity to respond morally is dependent on a conceptual relation to the object *as such*; for this reason moral value itself resides only in the human. Cary Wolfe has recently suggested a way around this antinomy, developing the critique of the 'identity-as-sameness' of the human:

> Questions of value indeed necessarily depend on a 'to whom it matters', but that 'to whom' need not be—indeed . . . *cannot* only be—human, either in the sense of excluding by definition nonhuman animals, or in the sense of a 'human' who is not always already radically other to itself.[15]

Hereafter, Wolfe makes a particularly significant intervention; he argues that in organic life itself—or at least in those 'creatures of sufficient neurophysiological plasticity'[16] to develop phenomeno- logically in response to their environment—'the capacity to "re- spond", to be a "to whom", is not given but emerges'. A living being's capacity to be a valuer 'is brought forth, out of a complex and enfolded relation to the "what", to its outside (whether in the form of its environment, the other, the archive, the tool, or the "in- stinctive" programme of behaviour)'.[17] The crucial point here, in terms of my argument, is that Wolfe's understanding of value in a more-than-human realm insists precisely on the importance—the critical importance, one might say—of an 'against-value' which po- sitions the political subject as much as the organism in an ongoing relation of resistance/adaption to its environment.[18]

Shifting this more or less ontological analysis into a more strictly ethico-political register, this argument offers something of a route past the dilemma of fetishising critique and political quietism that I addressed earlier; it allows Wolfe to turn to his advantage the anti- fetishist position that 'all norms are "exclusionary" simply because they are contingent'—which is to say, every critical distance estab- lishes its own 'correctness'. For it is precisely *and only* because politi- cal norms are exclusionary or closed to some others that they are occasions of against-value, are open to the perspective of critique. Wolfe suggests, I think rightly, that the political focus on 'things' one finds in Latour and Bennett risks 'flattening' the description of the world, whereas a 'thickening and deepening' of qualitative dis- tinctions is needed;[19] thus when he ultimately offers his own asser- tion of moral value, it is important that it is an act of differential valuing. There is, he thinks 'a qualitative difference between the chimpanzee used in biomedical research, the flea on her skin, and the cage she lives in' which matters more 'to the chimpanzee than to the flea or the cage'.[20] Moreover, Wolfe is perfectly aware that he is drawing a moral distinction here that remains open to critique.[21] Endemic within any assertion of value, one might say, is its against- value: it will always-already have been wrong.

So, having taken Foster's defence of critique elsewhere, I would like to end this section by returning it to his own work. In a piece that is roughly contemporaneous with 'Post-critical', Foster offers his own take on biopolitical critique and the challenges it poses to all grounds of value, challenges which have led us to this point. He worries that the 'groundlessness' such analysis suggests might be taken instead 'as a grounds for anarchism, to romanticise its refusal

of any political institutionality'.[22] As does Wolfe, Foster rejects this too easily won notion. But he also asserts, I think mistakenly, that the work of Jacques Derrida and Giorgio Agamben in this vein 'has little to do with animal rights'; this is perhaps because he is rightly nervous of the aesthetic and political primitivism that can often be found in collocations of human and non-human and so assumes that animal rights similarly obscure the distance between humans and non-humans. Instead, Foster looks to the animal figures in the 1950s artworks of Asger Jorn and the CoBrA group and finds something human: 'a political opening to the creaturely as a potent sign of the post-war crisis in symbolic order and political authority alike';[23] he hopes that a return to such work might offer scope for 'an intense imagining, via the creaturely, of new social links'.[24] In this expansive hope, Foster is not at all misguided, I think. It is just that, as his refusal of the 'post-critical' condition allows us to see, the political indistinction of human and animal is one (perhaps the paradigmatic) such crisis in the post-war, and the 'new social links' it demands we imagine must necessarily extend across species boundaries as well as within them.

To see this claim borne out, I turn now to another (in this case literary) post-war example of the creaturely aesthetic, Romain Gary's novel *The Roots of Heaven*. Its representation of an ambivalent example of 'animal rights'—the ethics and politics of species conservation—expresses and tests the limits of humanist value in an arena which only came fully to significance as a political cause in the post-war international order.

INVALUABLE ELEPHANTS: ROMAIN GARY'S *THE ROOTS OF HEAVEN*

Let me first return to the notion that all value is *valuation*: value is necessarily always contingent and distributed rather than inherent, and so all valuations necessarily both produce and ward off alternative redistributions of value. Such points warrant statement in the context of discussions of human-animal relations because the discourse of species (as Cary Wolfe terms it)—the rhetorical, political, and institutional mobilisation of the imputed fact of human-animal difference—consistently plays a crucial role in the presentation of contingent and tactical (anthropocentric) *valuations* as necessary, absolute *values*.[25] This, of course, happens in the consideration of humans' lethal encounters with non-humans, of the kind that is omni-

present in conservation as 'biodiversity management': for example, in the killing of individuals of an 'invasive' species to protect 'indigenous' ones or of individuals for a proposed ecosystemic benefit. The coding of a speciesist or, at the very least violent, biopolitical choice as *necessity* is a good instance of the crucial mechanism that Wolfe, following Derrida, names a 'sacrificial logic'.[26] It is not just that affective possibilities that exceed anthropocentric or humanist accounting—such as a specific animal's interest in its own or another specific animal's ontogeny or cross-species 'social links' such as possible animal friendship—are *devalued*. Rather, ironically imagined as unimaginable, they are ruled out of court, sacrificed in a presentation of the field of value as necessarily human and therefore justifiably, 'naturally', anthropocentric.

Contemporary ecological and pro-animal critique should therefore address head-on the contingency of anthropocentric valuations by exploring specific historical instances of this sacrificial logic at work. Such a project can offer a genealogical account of both (1) the reproduction of the discourse of species and its material effects on living beings, and (2) such potential redistributions of value as are both produced and foreclosed by anthropocentric processes of valuation. It is my guess that cultural texts offer particular leverage for this critical operation, because they both embody the social processes of value making and distribution of their time and resist that process in subtle ways. The historical intimacy of conservation with the practices and legacies of hunting hints at the complex intertwining of difficult and competing values in relation to animal life that underpins environmentalist thought as it develops in the twentieth century. The issues become even more complex when the animal at stake is under a number of different hunting threats and rationales for conservation, each of them very differently politicised, as was the case with elephants in the decolonisation period after World War II. This moment, therefore, presents an important case study in the political and moral distribution of value I have been discussing. In the rest of this chapter, then, I want to show how this plays out in *The Roots of Heaven* and to explore the competing political, moral, and aesthetic valuations of elephants at play.[27]

Gary's novel is a story of the intellectual genesis and troubled execution, failure, and fallout of an earnest but quixotic, not to say chaotic, campaign to put an end to the killing of elephants, waged in the French colonies of sub-Saharan Africa, principally Chad, in the early 1950s. This focus on pachyderms is certainly in tune with post-war conservation interests. And yet, I say that it is about put-

ting an end to the killing of elephants quite pointedly (rather than just 'conserving' the species), because one of the most compelling aspects of the novel is the way that it seeks to radicalise the values underpinning the politics of conservation in the period, which were developing fast under the auspices of the United Nations, in the form of the International Union for the Conservation of Nature (IUCN), founded in 1948: the self-proclaimed 'world's oldest and largest global environmental organization'.[28] One of the ways the novel is radical is by refusing to limit its concerns to those most charismatic of megafauna, even if they do remain the key constituents of the novel's animal politics: the protection of another kind of leaf eater, the May beetle, for example, plays a determining role in its moral argument. This notwithstanding, the elephant campaign is conducted by a ragtag group of post-war characters, only partly ironically named a *Maquis* after the French Resistance cells, and is led by one Morel, a refugee resistance fighter and concentration camp survivor himself. Generically combining several oft-disparaged fictional modes—political satire and the novel of ideas; the grand historical romance and the (late-)colonial adventure—*The Roots of Heaven* was written in bursts in the first half of the 1950s, while Gary was the secretary to and spokesman for the head of the French delegation to the United Nations in New York.[29] On publication in 1956, the novel won France's most prestigious literary honour, the Prix Goncourt, and went on to sell over 300,000 copies; the translation, produced under Gary's supervision, appeared to yet more success in the United Kingdom and the United States in 1958 to coincide with a Hollywood adaptation directed by John Huston.

The novel is no longer widely read outside France.[30] And if some of its drawbacks as literary fiction can be sensed in this background sketch, they are not entirely separable from what made it fascinating for contemporary readers. It is as chaotically organised as Morel's campaign itself, and yet (intentional or not) this confirms one of the book's key themes, which is precisely the directionlessness, inchoateness, and inherent corruptibility of human values and political endeavour. I should admit, too, that in keeping with much satirical fiction, and in order to marshal its ideas towards its rhetorical purpose, there is a great reliance on, if not quite stereotype—the novel draws heavily on real historical figures for some of its players—then at least a rather inflexible and determinedly motivated kind of characterisation. This is in part because the polemical energy of satire tends towards characterisation as exemplification and on people as instantiations of ideas or values. The aim is starkly

to apprise readers of something missing in their world by showing the horrible ironies of its absence, that is, rather than by exploring in detail the possibility of its existence. In this case—to give the game away—what is shown to be missing in the post-war world, as Gary envisions it, is a richly imagined care for, and a personal and moral attention to, animal life that brings with it a scrupulous commitment to animals' protection.

In keeping with the twentieth-century turn in the moral economy of nature tourism from the gun to the camera, Morel's campaign is focused on trophy hunting, but in principle it is addressed towards all forms of violence against elephants (and indeed against the abuses of humans that accompany them): trafficking in ivory and other animal products, inextricably linked to slave trading; deforestation and the aggressive cultivation of land; and more radically, zoo stocking and the sanctioned protection of arable land and property through trapping and hunting elephants by fire. At its most speculative, the campaign hopes that standard-of-living increases might stop the eating of elephant proteins by indigenous peoples. With a vigilance that puts much contemporary environmental critique to shame, Morel insistently indicts not just the abuse of hunting permits and poaching in wildlife reserves but the willingness of colonial wildlife administrators to tolerate such cases as 'exceptions';[31] moreover, he attacks the very reliance on such management practices as a conservation strategy in any case, with their related focus on the possibility of avoiding extinction (rather than preserving animals' lives individually) as the sole principle of value toward which such conservation measures are focused.

The organising irony of Morel's project, however, resides in the fraught relationship between morality and politics: principally, in the impossible desire implicit in this pro-animal project to escape politics, taken to be the management of selfishly anthropocentric interests, in favour of a disinterested morality, imagined to have the capacity to exceed them. As Morel puts it in his 'Communiqué of the World Committee for the Defense of Elephants' (a committee that has only self-declared existence and self-professed authority), 'The committee recalls once more that it has no political character and that considerations of ideology, doctrine, party, race, class and nationality are completely foreign to it'.[32] What we see in the portrayal of Morel's project is that commitment to and for animals, precisely because it demands a commitment that *exceeds* human interests, carries within it the foundational political irony of a post-war international world order. This is an order that is floundering

to realise the institutions and politico-legal mechanisms that would give reality and authority to its moral imperatives, just at the moment that the key co-ordinates of political discussion have been rendered utterly suspect by the traumas of the mid-century.[33] Another way of putting this is that non-human animal life and suffering, as a political reality, becomes a key site at which the value of 'the human' in terms of biological human life beyond nation, race, and creed—the rising tide of apparently pre-political (and therefore absolute) value in the post-war international arena—necessarily meets its limits.[34]

The ironies abounding here have a neat fictionalisation. Morel's moral rhetoric is introduced in the form of a bundle of signed and unsigned petitions that he takes everywhere in a leather briefcase for presentation to 'the authorities' (which authorities, over what, and at what time is never entirely clear). It is a perfect symbol of pure democratic will ineffectually carried by political bureaucracy. And indeed, by never presenting the text of the petition itself but only providing gobbets more or less accurately recollected by other characters, Gary makes the point that whatever ideal moral content is expressed in such a rhetorical form, it necessarily circulates only in the debased space of reiteration and politically motivated reformulation. According to the petition,

> It was not possible for a free man to catch a glimpse of the great elephant herds roaming the vast open spaces of Africa without taking an oath to do whatever was necessary to preserve forever this living splendor, this image of liberty whose sight will always bring a smile to the face of every man worthy of the name. . . . The time for pride is finished. . . . Man on this planet has reached a point where really he needs all the friendship he can find, and in his loneliness, he has need of all the elephants, all the dogs and all the birds.[35]

The briefcase that holds these fine words is an even more desperate and pessimistic symbol. Habib, a buccaneering gunrunner whose enduring presence in the novel epitomises Gary's deep cynicism about moral progressiveness, says, with 'his whole face a mask of cruel mirth', 'The last word about His Human Highness will always be [that the briefcase] was made of animal leather'.[36] 'There was a close association, from the beginning of time, between leather and brutality',[37] as another character puts it. Here the puncturing of political idealism coincides directly with a stringent reminder of the violent material reality of animal bodies.

To give a fuller flavour of Morel's world view, here he is portrayed by the novel's omniscient narrator, displaying a characteristic anti-instrumentalising delight in the spectacle of nature; this is saved from romantic sublimity by way of a certain laconic, roll-up-smoking masculinity. The moment warrants lengthy quotation.

> He took a cigarette paper and tobacco from his pocket and began to roll a cigarette while he observed the herd with an affectionate smile. This was what he stood for: a world where there would be room enough even for such a mass of clumsy and cumbersome freedom. A margin of humanity, of tolerance, where some of life's beauty could take refuge. His eyes narrowed a little, and an ironic, bitter smile came to his lips. I know you all, he thought. Today you say that elephants are archaic and cumbersome, that they interfere with roads and telegraph poles, and tomorrow you'll begin to say that human rights too are obsolete and cumbersome, that they interfere with progress, and the temptation will be so great to let them fall by the road. And in the end man himself will become in your eyes a clumsy luxury, an archaic survival from the past, and you'll dispense with him too, and the only thing left will be total efficiency and universal slavery and man himself will disappear under the weight of his material achievement. He had learned that much behind the barbed wire of the forced labour camp: it was our education, a lesson he was not prepared to forget.[38]

Morel's pro-animal commitment displays the collocation of a rhetorically grandiose and generalising humanism and a counter-tendency to exhibit a profound and cynical distrust of political rhetoric, a preference for mundane realities over abstractions and (crucially because of this) an insistence on the irreducible, incommensurable, and non-fungible nature of concern for animals. We thus find a certain contradiction in the rhetoric used. There is a preponderance of generalising assertions that relate to the 'value' of animal life, and these regularly take an abstract but explicitly humanist form. In the post-war, intellectual debate is marked in precisely this generalising way by both the legacy and the continuing experience of international conflict as a sequence of epochal, world-historical events. In this case—to explain the logic—animals' value is said to be precisely *excessive*: Morel stands for pro-animal commitment as 'tolerance'—the willingness not to convert to profit a value that is surplus to naked human interest. Paradoxically, though, as an instance of preserving this value that is greater than value, care for animals becomes the quintessential expression of humanity, 'the human

margin' that shows 'the human' exceeding the 'animal' realm of pure necessity.

Here, it is worth recognising in Morel's thinking an early instance of the wilderness ethic and aesthetic that was finding its way into US political debate in the 1950s. A good way to do this is to compare his words with those of Gary's fellow novelist Wallace Stegner, whose 'Wilderness Letter' of 1960 is an exemplary statement:

> Something will have gone out of us as a people if we ever let the remaining wilderness be destroyed . . . if we drive the few remaining members of the wild species into zoos or to extinction; if we pollute the last clear air and dirty the last clean streams and push our paved roads through the last of the silence, so that . . . never again can we have the chance to see ourselves single, separate, vertical and individual in the world, part of the environment of trees and rocks and soil, brother to the other animals, part of the natural world and competent to belong in it. Without any remaining wilderness we are committed wholly, without chance for even momentary reflection and rest, to a headlong drive into our technological termite-life, the Brave New World of a completely man-controlled environment.[39]

Morel's version of this—his insistence that this margin of tolerance is simultaneously a refuge not just for animals but for beauty, natural splendour—reminds us that the purely aesthetic sphere, when explicitly contrasted with the purely politicised sphere of 'total efficiency', concealed great political motivation at this Cold War moment. Despite the seemingly great differences between nature-loving and high-modernist aesthetics, there is a surprising similarity between Morel's logic and what was behind the covert funding by the Central Intelligence Agency in the 1950s of the Congress for Cultural Freedom, a major sponsor of abstract and formalist (that is, apparently purely aesthetic) cultural production in Europe.[40]

And yet, for all the rhetoric, Morel's commitment to animals is, I think, far from a simple humanism. It is presented in various formulations, all of which rearticulate recognizable humanist themes in specific ways towards the non-human. First there is the strong sense of and need for 'friendship', with elephants in exemplary particular but with all other animals too; the term is used often and singularly devoid of mawkishness or fantasies of equivalence or even of pure empathy—'friendship' as it might be used in 'friendly relations' between different nations and appealing to the spirit of the Greek term *agape*.[41] This notion is carried over in Morel's com-

mitment to preserve what he calls animals' freedom and liberty; but in this case the grandness of the notion, echoing its French Republican form, is taken over into and qualified by an insistence on the 'cumbersomeness' and sheer heft of its particular embodiment in elephants. Importantly, too, while such notions of friendship and liberty often unsurprisingly operate as abstractions in Morel's rhetoric, they are inseparable from his vigilant protection of animal life from violence and suffering. This is seen most clearly when he holds to account conservationist practice about extinction and permitted wildlife management (precisely by exposing their sacrificial biopolitical logic as states of exception which mark individual animals for death). Lastly, and perhaps most importantly, there is Morel's determined insistence that the defence of elephants must not be understood as exemplary. It does not stand for, but begins the unfolding of, an as yet unrealised and unpredictable future set of relations between human and non-human life. Equally, he makes clear that despite its readiness to act as such, his commitment to living, breathing, suffering, and dying elephants may not be reduced to an allegory or symbol of human sociopolitical concerns.[42] Here again, Morel is refusing the metonymic and metaphoric logics that would sacrifice animal priorities to human values.

This picture of Morel's campaign lets me make a particular point about Gary's portrayal of pro-animal commitment in relation to the notion of moral 'value' per se. I would argue that this is an effect of the novel's post-war moment, which in my view makes it especially instructive now. Because of the sheer scope of the stakes in discussions of animal ethics, and because of the ease with which the political questions are parsed in the most generalising terms of relations 'between the species', there can be a tendency to overlook the fact that power relations between humans and animals always involve confliction not between 'species' but between specific humans, specific animals, and other specific humans, and this is necessarily enacted within particular institutional-discursive and material-ecological conditions. Because of this, the relevant framework of values (that is, the mess of more or less tacit logics, attitudes, and priorities of each of the actors) needs to be understood in that specificity. This is particularly easy to overlook, I think, in a period which is paradoxically so historically near and yet so conceptually far from the present as the immediate post-war.

Especially for the period, however, *The Roots of Heaven* offers an astonishingly extensive literary portrayal of animal advocacy, principally because it presents in great detail the complex (and not at all

shared or coherent) moral, interpersonal, and social inspirations of Morel's and his followers' various commitments to animal protection, but also because it presents their historical emergence in the context of the political and moral anxiety, disillusionment, and desperation of the post-war period. Indeed, *The Roots of Heaven* provides by far the richest example of a trend that appears frequently in early post-war writing that is focused extensively on animals: this is the attempt to make sense of pro-animal feeling and (indistinguishable from this) moral or political agitation for animals in relation to the various degradations of the human at mid-century.[43] The picture of a debased or destitute post-war humanity in *The Roots of Heaven* looks to a wide range of topoi, including (perhaps most importantly) Nazi and Stalinist concentration and forced labour camps, as well as atomic war and the threat of nuclear destruction; the worldwide scramble for power and influence by allied nations and the dubious activities of some allied forces in post-war Germany; the perceived omnipresence of disinformation in the early Cold War; the will to instrumental rationality as practiced *both* in Taylorised capitalism and nationalist-totalitarian planned modernity; and the cultural massification and bureaucratised corporate organisation of life.

This diverse picture of the bankruptcy of the Enlightenment ideal finds fictional realisation in the characters that make up Morel's *Maquis* and those who follow them with interest. Some are motivated by recognizable environmental values and show these to be part of a disappearing ideal of progressive politics: one such is Qvist, an aging natural scientist, campaigner against whale hunting, soil erosion, and the H-bomb, and veteran of Fridtjof Nansen's 1920s work for the rights of political refugees. Minna, the novel's only significant (and infuriatingly cliché) female presence, is one such refugee—if, tellingly, it is 'refuge among the animals' that she seeks[44]—having escaped the post-war Berlin in which she was subjected to sexual violence perpetrated by both Russian soldiers and her own uncle and then endured a subsequent meagre existence working in prostitution. Others, however, do not follow Morel for animal-related reasons: the novel's sometime-narrator St Denis, for example, whose stereotypically metropolitan affection for 'primitive' African life (both human and animal) shapes both his work as a game reserve warden and his deep cynicism about human 'progress'; and finally Forsyth, a deserting American major who has found out that he was wrong to believe and broadcast communist propaganda, supported by the testimony of international scientists,

about the US use of biological warfare in Korea: this history of alloyed duplicity and naive complicity evinces a misanthropic fantasy to 'say goodbye to all that, to change species, to come over to the elephants and live in the wilds among honest animals'.[45]

A crucial aspect, too, is the text's late-colonial moment: the novel has an ambivalent and explicable, but by no means defensible, attitude toward incipient decolonisation struggles in Africa. That is to say, while the reader cannot but find a general antipathy to racism and the colonial enterprise broadly writ (for example, European colonial administrators and expatriates are relentlessly satirised for their political incompetence, decadence, preening self-obsession and solipsistic ignorance of the hard social realities of Chadian society). And yet Gary is primarily interested in exploring the moral and political complexity of the challenge posed to a universalised human society by the utopian desire to protect animals (both their individual lives and natural life more generally). It is also entirely in keeping with late-colonial logic to portray Africa in an essentialist way as a rarefied and at least potentially 'open' space that permits an ontologically pure freedom and to imagine this space as the ultimate location for such a struggle between absolutes. In addition, and in keeping with the liberal-humanist political aesthetics of which Gary (the UN bureaucrat and literary novelist) is an exemplar, there are two key effects on the novel's portrayal of issues of colonial racism, intra-national and interethnic racism, and decolonisation.

First, they are taken to be secondary to the apparently more fundamental questions of humanity's obligations to the natural world and what meeting them or ignoring them says about humanity. Second, anti-colonial action is portrayed as deeply suspect precisely to the extent that it either ignores or refuses these questions of animal politics or overwrites them in favour of other national-political exigencies. This ambivalence can best be seen in the portrayal of two characters: Waitari, a fictional Chadian independence leader who offers an explicitly neo-Stalinist programme in the attempt to fashion himself in the vanguard of Kwame N'Krumah of Ghana and other Marxist pan-Africanists 'as the true leader of African revolt',[46] and Laurencot, a Martiniquan wildlife reserve warden whose belief in Morel's ideal of 'the human margin' leads the colonial governor to tell him to 'go off and write poems'.[47] It is as if Gary is trying to activate the anti-colonial humanism of Laurencot's compatriot, poet and theorist Aimé Césaire, but detoxified of its explicit historical materialism.[48] Césaire figures the 'progressive de-

humanization'[49] of colonialism, indeed, in a particularly clear utterance of postcolonial Marxist environmentalism:

> Do you not see the tremendous factory hysterically spitting out its cinders in the heart of our forests or deep in the bush, the factory for the production of lackeys; do you not see the prodigious mechanization, the mechanization of man; the gigantic rape of everything intimate, undamaged, undefiled that, despoiled as we are, our human spirit has still managed to preserve; the machine, yes have you never seen it, the machine for crushing, for grinding, for degrading peoples?[50]

Waitari, however, has no truck with this political linkage of natural despoliation and colonial violence: 'We are all the more indignant and outraged', he says, at the way the struggle for African independence has been hidden behind the humanitarian smokescreen of elephant protection, because 'we have had enough of being used by the whole world as its zoo, as a repose for the eyes of tourists tired of skyscrapers and motorcars, who come to relax in the primitive, to relax at the sight of our nakedness and our herds'.[51]

The result is an increasingly farcical drama of political machinations. Morel recognises that the systematic killing of elephants is in large part a product of colonial arrangements, but he accepts alliance with anti-colonial movements principally because his moral priority, action on elephants, cannot be achieved without the public and political recognition such an alliance might provide. The Chadian independence fighters know all this but continue to support the defence of elephants because they are a convenient symbol of Africa and because it is elephants, rather than independence politics, that pique public concern. Colonial officials, on the contrary, assume that the *Maquis* must be an anti-colonial movement but want to suppress any sense of uprising on the world political stage; so they present Morel as a pathological misanthrope who has 'gone over to the elephants', and this allows them to claim that, as such, the campaign has no political character. Here is a particularly clear instance of the discourse of species at work, insisting that agitation on behalf of elephants cannot enter the properly political realm of relations between humans. Later, because of this muddied image of the campaign, the governor of Chad misunderstands local insurgencies sparked by Morel's presence to be actually caused by curbs on indigenous hunting rights; this leads to a suggestion that there should be a relaxation of hunting restraints as a way to appease people. The tragic denouement of this escalating political drama is

the enlisting by Waitari of hunters and Sudanese mercenaries to kill hundreds of elephants, with the ultimate plan to sell the ivory for weapons. This happens just as the Bukavu conference of the IUCN, in which Morel had invested all his reformist hopes, is said to end with no significant change (in fact, realistic action on elephant killing was never on the agenda at Bukavu, as Gary would have known). This all goes to show that, while central, the specifically postcolonial politics of environmental and animal protection are not analysed in the book; rather, they play an instrumental role in an ironic fictional working out of what is presented as a constitutive paradox in post-war life: utopian ideals should shape a political future, but inveterate human selfishness and social dissensus mean that they are always traduced by political realities.

This narrative, then, propounds the most extreme and despairing form of political pessimism. Morel's grand attempt to revalue elephants and animal life, at once an ultimate expression of human value and its desperate confirmation in the face of the onslaught of the twentieth-century's violence, results in yet greater carnage. Moral idealism, as the name for a commitment to the willing suspension of self-interest, presented as the 'margin of humanity', submits in the end to political overdetermination in the concessions made to and then the manipulation by more nakedly political instincts. As one character puts it, Morel's

> was in fact a great cause, with the company a great cause always keeps: men of good will and those who exploit them, generous endeavour and sordid calculations, an ideal over the horizon, but also the treachery of ends justifying means. Man's oldest company, I tell you, a noble cause and a pack of scoundrels behind it, a generous dream and all the purity that's needed to cause great massacres.[52]

The end result is an extremely conflicted picture of 'the human', poised between the need to *exceed* value, to 'write off' that supposed 'margin' as a necessary condition, and the tendency to instrumentalise that marginal value into economic or political profit.

Gary offers little in the way of respite from this pessimism. One wonders, indeed, if there can be a move beyond the two challenges to idealism on which the novel is based: an enlightened liberal critique of the tyranny of ends justifying means that overshadows all the projects of an optimistic humanism and a purely misanthropic resentment that resists such optimism in any case. To explain what little resistance to the constraints of these positions Gary can ima-

gine, though, I return, in conclusion, to those May beetles, a species of *Phyllophaga* (leaf eaters) who are the elephants' moral correlative in the book. Reflecting on the wellspring of his quixotic and eventually disastrous campaign, Morel tells a strange and quite possibly fantastical story; in any case it has the force of myth. One day, when working on a gang in a forced labour camp, carrying sacks of cement to build what he calls 'the gigantic constructions of the new Pharaohs'[53] in Nazi-controlled Belgium, Morel finds himself amidst a strange twist on a biblical plague: hundreds of May beetles fall from the sky and land on their backs, struggling in vain to turn over. Morel 'bent his knee, keeping the sacks balanced on his shoulder, and with a movement of his forefinger, placed the insect on his feet again'.[54] Astonishingly, the other men stop to do the same, which infuriates the SS sergeant, who, failing to stop the men with kicks and blows, rushes about trying to stamp the insects to death. This abject and futile violence is then visited on the men with two hours' extra toil, 'the difference between the final limit of human strength and what was beyond it'.[55] As the men discuss and struggle to understand what motivates them, in their utter subjection, 'to do something for the may-beetles', the chaplain accuses,

> 'You do it out of pride. If you weren't in a forced labor camp you'd step on may-beetles without even noticing their existence'....
> 'It isn't pride,' someone protested weakly. 'It's something else.'[56]

Here, then, the motivating dilemma of the novel—how is it politically possible simply to be *for animals*—is reiterated in the form of the desire to imagine the basis of human moral action in the inchoate form of 'something else'. Gary is resisting the anthropocentric will to turn a commitment to value animals' (in this case, insects') lives into an expression of 'human values' (in this case, pride). In this tentative moment, he hopes to combine an abstract and utopian imaginary, which exceeds all rationalising and political or other projects, with committed action. Importantly, this 'something else' remains within a humanist imaginary: it draws on the figure of the human (in the form here of the 'last man' and his imperishable spirit; the 'excessive' and marginal space in which resistant moral energy may be exerted not for the self but entirely for the other). But far from celebrating 'the human', Stegner's 'single, separate, vertical and individual' man, Gary muddies the ethical waters in terms of species-being in two ways: by invoking a shared

creaturely vulnerability from which humans and insects all need rescue—'We're all on our backs', as one of the men says—and by refusing the humanist pride that insists (in the very accusation that the motivation to care can *only* be pride) that value is humanity's alone. In this, Gary's animals are, precisely, *invaluable*.

NOTES

1. Karl Marx, *The German Ideology: Part One with Selections from Parts Two and Three and Supplementary Texts*, ed. by C. J. Arthur, trans. by C. Dutt and C. P. McGill (New York: International Publishers, 1970), p. 42. The original German phrase is 'durch was man sonst will'.

2. David Harvey, *The Limits to Capital* (London: Verso, 2006), pp. 1–38 (p. 5). I am grateful to Tom Tyler for pointing out that a strong version of this case is made by Frederick Engels in terms of fundamental anthropology in his unfinished manuscript of 1876, 'The Part Played by Labour in the Transition from Ape to Man', Marxists Internet Archive, https://www.marxists.org/archive/marx/works/1876/part-played-labour [accessed 1 September 2015]. Important rejections of the human exceptionalist 'Men work therefore they are' can be found in Mary Midgley, *Beast and Man* (1979; London: Routledge, 2002), p. 145; and Tim Ingold, 'The Architect and the Bee: Reflections on the Work of Animals and Men', *Man*, 18 (1983), 1–20.

3. P. 3. Foster is quoting from Walter Benjamin, 'One-Way Street' (1928), trans. by Edmund Jephcott, in *Selected Writings*, vol. 1: *1913–1926*, ed. by Marcus Bullock and Michael W. Jennings (Cambridge, MA: Harvard University Press, 1996).

4. The most prevalent candidate in the history of post-anthropocentric critique is sentience; this position and its related avatars are established in Peter Singer, *Animal Liberation* (1975; London: Pimlico, 1995); and Tom Regan, *The Case for Animal Rights* (1983; Berkley: University of California Press, 2004).

5. P. 4. His third example, Brechtian *Verfremsdungeffect*, seems harder to place as avoiding critical 'distance'. It proves exceptionally difficult to realise a politically useful critique that does not seek some separate ground on which to base and justify that critique. One finds Roland Barthes searching for it in vain, for example, in the role of the mythographer in his essay 'Myth Today', before finally committing himself to the Marxian position, with the notion that myth naturalises history. See (it is especially relevant here) Roland Barthes, 'The Great Family of Man', in *Mythologies*, trans. by Annette Lavers (1957; London: Vintage, 2009), pp. 100–102.

6. Foster, 'Post-critical,' p. 7.

7. See the Institute for Critical Animal Studies website: http://www.criticalanimalstudies.org [accessed 27 December 2015]. Of course, such designations often obscure convergence more than they reveal difference and certainly only make sense in terms of schemata rather than description, but terminological differences can only emerge when there is justifiable sense of distinction. These points are borne out by looking at Nik Taylor and Richard Twine, eds., *The Rise of Critical Animal Studies: From The Margins to the Centre* (London: Routledge, 2014); and Garry Marvin and Susan McHugh, eds., *The Routledge Handbook of Human-Animal Studies* (London: Routledge, 2014).

8. See Bruno Latour, *Reassembling the Social: An Introduction to Actor-Network Theory* (Oxford: Clarendon, 2005), pp. 85–86 (p. 85) (Latour's emphasis).

9. Foster, 'Post-critical,' pp. 7, 5.

10. Marcuse's ground when celebrating what he calls the 'Great Refusal' is of course equivalent to Marx's humanism; the first value judgement guiding his project is that 'a human life is worth living'. Thus when Marcuse insists that critical theory should 'remain loyal to those who, without hope, have given and give their life to the Great Refusal', such 'outcasts and outsiders' are imagined not in alliance with animals but *against* them: they 'face dogs, stones, and bombs, jail, concentration camps, even death' as the agents and practices of state power. See Herbert Marcuse, *One Dimensional Man: Studies in the Ideology of Advanced Industrial Society*, Marcuse.org, 1964, http://www.marcuse.org/herbert/pubs/64onedim/odmcontents.html [accessed 31 July 2015].

11. The debate plays out most evidently in relation to the recent work of Donna Haraway, especially her *When Species Meet* (Minneapolis: University of Minnesota Press, 2008) and telling critiques of it offered by Anat Pick, 'Turning to Animals between Love and Law', *New Formations*, 76 (2012), 68–85; and Zipporah Weisberg, 'The Broken Promises of Monsters: Haraway, Animals and the Humanist Legacy', *Journal for Critical Animal Studies*, 7.2 (2009), 22–62.

12. Jane Bennett, *Vibrant Matter: A Political Ecology of Things* (Durham, NC: Duke University Press, 2010), pp. xiv–xv.

13. Bennett, *Vibrant Matter*, p. 104.

14. Foster offers his own version of this attitude in his 'resistance . . . to any operation whereby human creation (e.g., God, the Internet) is projected above us with an agency of its own' (Foster, 'Post-critical', p. 7).

15. Cary Wolfe, *Before the Law: Humans and Other Animals in a Biopolitical Frame* (Chicago: Chicago University Press, 2013), p. 84.

16. Wolfe, *Before the Law*, p. 70.

17. Wolfe, *Before the Law*, p. 84.

18. Wolfe himself parses this position in the more fundamentally positive Derridean terms of 'affirmation', but I think the broad point in terms of the 'against' of critique still holds.

19. Wolfe, *Before the Law*, p. 83.

20. Wolfe, *Before the Law*, p. 83.

21. There is no reason to wait: readers may already look, for example, to the work of Matthew Calarco, 'Toward an Agnostic Animal Ethics', in *The Death of the Animal*, ed. by Paola Cavalieri (New York: Columbia University Press, 2008), pp. 73–84; and Michael Marder, *Plant-Thinking: A Philosophy of Vegetal Life* (New York: Columbia University Press, 2013).

22. 'I Am the Decider', *LRB*, 33.6 (2011), 31–32 (pp. 31, 32). Anarchism is in fact perhaps the most significant political theory in animal rights activism; for a classic example, see Elisée Reclus, 'On Vegetarianism', The Anarchist Library, 1901, http://theanarchistlibrary.org/library/elisee-reclus-on-vegetarianism [accessed 31 July 2015].

23. 'I Am the Decider', p. 31.

24. 'I Am the Decider', p. 31.

25. See Cary Wolfe, *Animal Rites: American Culture, the Discourse of Species, and Posthumanist Theory* (Chicago: Chicago University Press, 2003). Research on this section of the chapter was supported by a World Universities Network grant to visit the Human-Animal Research Network at the University of Sydney. I am also grateful to my collaborators on that project, John Miller and Dinesh Wadiwel, and to Helen Tiffin.

26. Wolfe, *Animal Rites*, p. 12.

27. Romain Gary, *The Roots of Heaven*, trans. by Jonathan Griffin (New York: Simon and Schuster, 1958). Further references to this edition will be cited parenthetically in the text. The book has a complex publication history (explained by David Bellos in his *Romain Gary: A Tall Story* [London: Harvill Secker, 2010]), which includes the addition of new material to the translated edition, in the preparation of which Gary participated; for this reason I rely on it here.

28. 'About IUCN', IUCN, http://www.iucn.org/about [accessed 1 September 2015].

29. This delegation, I should add, spent much of its time trying to circumvent moves at the United Nations focused in support of decolonising political agitation in both North Africa and Mainland Southeast Asia; we'll return to the late colonial politics of the book.

30. It has very rarely been the subject of English-language academic discussion; for a rare recent analysis, see Louise Lyle, 'On the Evolution of Humanity and the Oppressions of Darwinism in French Post-war Fiction', in *The Evolution of Literature: Legacies of Darwin in European Cultures*, ed. by Nicholas Saul and Simon J. James (Amsterdam: Rodopi, 2011), pp. 213–26.

31. Gary, *The Roots of Heaven*, p. 96.

32. Gary, *The Roots of Heaven*, p. 210.

33. See Mark Greif, *The Age of the Crisis of Man: Thought and Fiction in America, 1933–1973* (Princeton, NJ: Princeton University Press, 2015). Greif traces a rich genealogy of the 'crisis of man', pointing out the key strands of a loss of faith in the universal progress of mankind, worries about the technologisation and the massification of society, and a sense of moral responsibility for the bomb and the camps.

34. On this concept, see Alasdair Hunt's discussion of Hannah Arendt's notion of the 'right to have rights', in contradistinction to the biologism of human rights per se, in his 'Rightlessness: The Perplexities of Human Rights', *New Centennial Review*, 11 (2011), 115–42; on how Arendt's reflections on how the right to have rights, as 'the only extranational and extrapolitical value that was absolutely necessary to the maintenance of man', marks the limit point of post-war humanist crisis, see Greif, *The Age of the Crisis of Man*, pp. 90–99 (p. 94).

35. Gary, *The Roots of Heaven*, pp. 31–32.

36. Gary, *The Roots of Heaven*, p. 299.

37. Gary, *The Roots of Heaven*, p. 308.

38. Gary, *The Roots of Heaven*, p. 138.

39. 'Wallace Stegner', The Wilderness Society, http://wilderness.org/bios/former-council-members/wallace-stegner [accessed 1 September 2015].

40. See Frances Stonor Saunders, *Who Paid the Piper? The CIA and the Cultural Cold War* (London: Granta, 2000).

41. Defined by philosopher and theologian Thomas Jay Oord as 'an intentional response to promote well-being when confronted by that which generates ill-being'; see Thomas Jay Oord, 'The Love Racket: Defining Love and *Agape* for the Love-and-Science Research Program,' *Zygon*, 40.4 (2005), 919–38 (p. 934).

42. Gary, *The Roots of Heaven*, p. 265.

43. Greif's discussion of the fiction of the period offers virtually no evidence of the blurring of distinctions between human and animal in 'the crisis of man'. Anat Pick, on the contrary, detects a strong presence of empathy with animal vulnerability in the post-war narratives of Saul Bellow, William Golding, Primo Levi, and others; see Anat Pick, *Creaturely Poetics: Animality and Vulnerability in Literature and Film* (New York: Columbia University Press, 2011). Other significant writers here are James Agee, Brigid Brophy, Patricia Highsmith, and Arthur Miller.

44. Gary, *The Roots of Heaven*, p. 22.
45. Gary, *The Roots of Heaven*, p. 147.
46. Gary, *The Roots of Heaven*, p. 129.
47. Gary, *The Roots of Heaven*, p. 61.
48. See Aimé Césaire, *Discourse on Colonialism*, trans. by Joan Pikham (New York: Monthly Review Press, 2000), pp. 29–78. This text was published in 1952, just as Gary was writing *The Roots of Heaven*.
49. Gary, *The Roots of Heaven*, p. 68.
50. Gary, *The Roots of Heaven*, p. 77.
51. Gary, *The Roots of Heaven*, p. 290.
52. Gary, *The Roots of Heaven*, p. 113.
53. Gary, *The Roots of Heaven*, p. 362.
54. Gary, *The Roots of Heaven*, p. 363.
55. Gary, *The Roots of Heaven*, p. 364.
56. Gary, *The Roots of Heaven*, p. 364.

FIVE

Enlightenment against Value?

Two Intuitions and Hume's 'Of the Standard of Taste'

Tom Jones

In an important book challenging the idea of a totalising, universalising Enlightenment project, Sankar Muthu summarises his view of the problem: 'It is perhaps by reading popular nineteenth-century political views of progress, nationality, and empire back into the eighteenth century that "the Enlightenment" as a whole has been characterized as a project that ultimately attempted to efface or marginalize difference, a characterization that has hidden from view the anti-imperialist strand of Enlightenment-era political thought.'[1] He makes a counterclaim: 'There are important strands of eighteenth-century social and political thought that take humans to be intrinsically cultural agents who partly transform, and yet are always situated within, various contexts. Strikingly, anti-imperialist political theories in the Enlightenment era were almost always informed by such understandings of humanity.'[2] The anti-imperial thought under discussion requires three attitudes toward humanity: that to be human is, in a basic sense, to have value; that it is also to have culture; that cultural values are largely incommensurable and so are not available for a rank ordering.[3] Muthu notes that cultural incommensurability is in no way incompatible with the assertion of uni-

versal human values, such as justice or dignity. It is just that there is no way of rank-ordering the world's cultures to show which is more just or best produces human dignity: cultures are too complex to be compared in that way.[4]

Some might say that the impossibility of commensurating cultures is a matter not really of their simplicity or complexity but of the unavailability of a measure that is outside culture against which competing cultures could be measured. I have just reported and condoned the idea, however, that there may be universal goods such as dignity and justice. Doesn't that idea contradict the thesis of incommensurability of cultures? We just need to say what justice or dignity universally are, then make the comparisons to the standard. But the kinds of things we say about justice and dignity will, of course, be said from a particular position, within culture. There is no necessary vulgar relativism here: it's not that the person trying to say what is universally just is caught in one rigid, unbreakable view of what justice is, utterly incapacitated from seeing it someone else's way or from forming the best possible generalisation about views of justice. There will be people looking at such questions with extremely broad experience of practical and theoretical justice around the world, in different times and places, amongst different kinds of people in any one time and place. But such people will still be human cultural agents with particular (unique) perspectives. Arguments with other people about justice will result in agreement or disagreement over what Richard Rorty calls a final vocabulary — those terms whose value we have no non-circular way of justifying but which we nonetheless assert, precisely such terms as dignity, justice, freedom, and so on.[5] People may have different terms in their final vocabularies or different ways of filling out those terms; there may be broader or narrower consensus about the terms or the way in which they are filled out; but such agreements and disagreements are always between variously acculturated people and not between a culture and an external standard. I take it Barbara Herrnstein Smith presents more or less this view in *Contingencies of Value*.[6] My shorthand for this view is that all people have an environment, a world in which things are more or less important to them, and that thinking of people outside all environments is futile.

The picture of humans as organisms responding to marked elements in their environment, elements that are attractors or inhibitors, that excite approbation or blame, is no anachronism with respect to eighteenth-century British and Irish philosophy. Indeed, its pervasiveness makes it difficult to demonstrate. George Berkeley

describes the visual environment as a set of signs that God institutes relating to the tangible environment so that people are better able to seek or shun things: 'We regard the objects that environ us in proportion as they are adapted to benefit or injure our own bodies, and thereby produce in our minds the sensations of pleasure and pain.'[7] Objects in the environment are marked by their potential to bring damage or benefit, and people evaluate them accordingly. These evaluations will provide the basis for utilitarian ethics and political theory, being ultimately commensurated in pleasure and pain. Francis Hutcheson states, 'There is scarcely any Object which our Minds are employ'd about, which is not thus constituted the necessary occasion of some Pleasure or Pain.'[8] In the realm of beauty David Hume agrees: 'Pleasure and pain, therefore, are not only necessary attendants of beauty and deformity, but constitute their very essence.'[9] Canonised philosophers of the British and Irish eighteenth century centre the social, ethical, political, and aesthetic world on the human animal whose sense impressions can be parsed as pleasure or pain.

Such ongoing environmental evaluations are just as evident in the conceptual or sentimental as in the sensory domain. For Hume, in particular, mental operations and faculties are analogous to or can be characterised as taste: we should follow our taste in philosophy as much as in poetry or music; constructing beliefs about causality and other regular occurrences is described in the terms of making an artwork.[10] Taste is often the non-metaphoric domain in Hume's comparisons of the faculties and operations of the mind: taste is the concrete faculty in the terms of which more abstract faculties may be understood. All the mental contents we have, according to Hume, are perceptions or impressions, about which we cannot be deceived: 'Every impression, external and internal, passions, affections, sensations, pains and pleasures, are originally on the same footing; . . . whatever other differences we may observe among them, they appear, all of them, in their true colours, as impressions or perceptions.'[11] If taste is the faculty for discriminating amongst perceptions, it must then be the master faculty of the mind.[12]

In this chapter I shall try to challenge this model of the self-evidence of commensurable perceptions as the ground of mental life by means of a reading of another of Hume's texts and its account of the phenomenology of taste. I will pick up on a third term Edmund Burke introduces into his account of aesthesis, namely, 'indifference': 'The human mind is often, and I think it is for the

most part, in a state neither of pain nor pleasure, which I call a state
of indifference.'[13] The importance of indifference in matters of taste
and the incommensurability of cultures are the two intuitions I will
bring to Hume's essay, suggesting the possibility of their interrela-
tion. I am concerned to present eighteenth-century theory and prac-
tice of taste more as 'a problematic modality of attachment to the
world' than as a means of legitimising social difference and distinc-
tion.[14]

The project for which I am producing this chapter questions the
commensuration of cultural (more specifically artistic) values with
the values of 'post-ideological' state management and audit culture.
In the particular context of this chapter, then, Hume's interest in
post-ideological state management, and what it means for the arts,
is relevant. Disputes between extreme Whig and Tory positions,
Hume thinks, are to be avoided, both because the true balance be-
tween the monarchic and republican aspects of the British constitu-
tion is so delicate as naturally to produce difference of opinion even
amongst those of sound understanding (and here I note proleptical-
ly a parallel with the standard of taste) and also because the ex-
tremes of any ideology are problematic. Political work should make
sure that inevitable factional disputes are not destructive of real
human goods such as the cultivation of a society that encourages
the arts and sciences and promotes happiness amongst a broad
range of groups. Hume's aim in 'Of the Rise and Progress of the
Arts and Sciences' is not to demonstrate the superiority of one form
of government over another in fostering the polite and mechanical
arts (though republics favour the latter, civilised monarchies the
former) but to show that it is more beneficial to the rise of the arts
and sciences that power and authority be presented with stops and
limits, in order to encourage security, curiosity, and knowledge.[15]
Hume regards the state as having a responsibility to limit its power
in order to promote artistic flourishing. State funding of the arts
now is a means of both support and control.

My first intuition concerns cultural incommensurability: cultural
values are different from prices (the most readily determined eco-
nomic value) in that valuing something anew is a change in the
environment of the person who values.[16] Valuation of cultural ob-
jects and practices is not distinct from the object or practice. Valuing
the object or practice is not setting it against a scale different from it
or other similar objects or practices, but going to it, returning to it,
letting it stay with you, finding it stays with you, offering it to or
preserving it from other people. Cultural objects and practices have

a place in the human environment very much like that which Jakob von Uexküll assigns to 'objects which appear in a subject's environment as carriers of meaning': the objects carry a 'meaning tone'; they are marked, bold, big, meaningful parts of the environment, figures in the ground, stimuli.[17] Their tone gets us to do things. Commensurating the value of a cultural object or practice with something else (social and economic impact, for example) is not to live the value as a part of one's environment. The difference between commensurating or pricing cultural objects and practices and valuing them is that only the latter requires environmental change. I do not mean here to suggest that the values that are still freely to be determined are those which are truly human, and serve as a means of distinguishing the human species from other species and from things, under the romantic rubric that the nature of the human is to have a nature that is still to be determined (and by free will as opposed to by instinct or some other determination).[18] If lived values as I am describing them here could be called cultural in the broad sense (encompassing all world making), then animals could be said to make cultural worlds for themselves, through any of those adaptations in environment of which they are capable.

A related point: cultural objects and practices are not experienced as valuable *in the context of* human experience or human culture. They are the experience and the culture. As Herrnstein Smith notes, 'Evaluations are not discrete acts or episodes punctuating experience but indistinguishable from the very process of acting and experiencing themselves. In other words, for a responsive creature, to exist is to evaluate.'[19] Cultural practices and objects are not secondary phenomena with relation to a world. One recent attempt to identify the intrinsic value of works of art claims that culture is a means by which 'the experiences, actions, and events of human life can be objectified, represented and observed', a remark that is intended by its author to develop Ludwig Wittgenstein's note that culture is or presupposes an observance.[20] Wittgenstein is taken to mean that culture is an 'observation', that culture is essentially reflective or illustrative, but the term much more obviously refers to (religious) practice, or an orderly set of practices. The confusion of these senses of 'observance' has consequences. The assertion that 'works of art are to be understood against the background of the practices and institutions of particular cultural times and places' becomes entirely circular if one recognises works of art as (a significant part of) the cultural background of practices and institutions. In Stephen Greenblatt's terms, an art object might be experienced

with wonder when considered as closed off from other social practices (and their objects) of its epoch, but it is never closed off entirely from the practices and objects with which it resonates.[21] Resonance enables wonder. We might benefit from knowing things about dress codes and their social significance when looking at European portraiture; we might find the background helpful in understanding the object. But there is a contraflow: in seeing the painting as a painting and as a portrait, we need also to realise that representations of people in certain kinds of dress and attitude are the kinds of things one commissions, paints, displays, preserves, admires, and so on. It is not the case that we encounter something that is self-evidently an artwork that we need to have cultural knowledge to understand; rather, that this particular thing can occupy the variable position 'artwork', even that there is a position 'artwork', with characteristic modes of reception such as 'wonder', is a form of cultural knowledge. Cultural values are in objects and practices; indeed, culture is them.

'Code' and 'field' are equally problematic terms for understanding the co-production of value through art objects and taste. Both terms suggest that there is something distinct from the objects and people valuing them to be abstracted from the series of events that constitutes cultural value. 'A work of art has meaning and interest only for someone who possesses the cultural competence, that is, the code, into which it is encoded.'[22] Pierre Bourdieu suggests the code can be acquired otherwise than by experiencing works and becoming part of a community that has knowledge, tacit or otherwise, of what is likeable. There is, however, no scene of the acquisition of cultural codes other than encounter with works in the presence of an actual, implied, or imagined community, of which one does or does not wish to be a part. The process of interviewing subjects about their cultural preferences also implies both that subjects know and remain confirmed in their preferences and that those preferences are independent of and unaffected by participation in different kinds of discursive episodes. Both of these seem unfounded assumptions. To say so is not to attack Bourdieu's discomfiting analysis of preferences (who has not squirmed?), or his explicit valuation of the 'arrogance' of such preferences, or his view that they enact symbolic class violence.[23] But it is to question Bourdieu's assumption that taste for legitimised cultural objects is *more acquired* than other kinds of taste—that certain tastes are coded, others not. From a cultural-historical perspective, Bourdieu is suggesting that the specific kinds of art practice that emerge in French culture from

the era of Stéphane Mallarmé and the impressionists onwards reward the possessor of legitimate tastes, as understanding such 'pure' works is entirely dependent on understanding their place in an unfolding historical series of art practices rather than understanding something to do with their representational content.[24] I suggest, on the contrary, that no art practice is comprehensible without a comprehensive yet open environment for practitioners and audience in which historically contingent practices are understood as art.

'Field' is also problematic, in Bourdieu's use, as it places the real human relations that make artworks outside them: 'The essential explanation of each work lies outside each of them, in the objective relations which constitute this field.'[25] 'Field' posits a set of objective human social relations outside artworks in which the meaning of those works is found. But why abstract these relations? And indeed how? Art works are real things consisting in objective human social relations, not ciphers from which social relations have been extracted by the forces of cultural legitimacy only to be restored by the sociologist.

To return to universal goods: a universal set of human goods, those things marked in the environment as potential sources of pleasure for all people, would be quite basic, were one to be produced along the lines of universal human rights. The goods would be plural and not in any case equally requisite at any point in time. Thomas Hobbes's assertion that there is 'no . . . *finis ultimus*, utmost aim, nor *summum bonum*, greatest good' is in this sense very reasonable.[26] Much philosophical discussion has arisen from generalising descriptions of particular goods, goods for us, or goods at this time. Alexander Pope toys with a minimal description of human goods in the *Epistle to Bathurst*: 'What Riches give us let us then enquire, / Meat, Fire, and Cloaths. What more? Meat, Cloaths, and Fire. / Is this too little? would you more than live?'[27] Pope plays on our knowledge that life is the most basic good and supported by a very few more specific goods. He suggests that life is binary: one is either living or not; there is no third possibility. Yet we experience life qualitatively, as living well or badly. Pope, that is, evokes an apparent indifference to specific forms life might take in the assertion that there is only life. He is doing so, of course, to promote a particular view of what the good life is, that of the independent person of taste who disposes of her or his fortune with economy and magnificence, who manages an estate with elegance and a modest estimate of her or his needs.

Pope's lines bring me to my second intuition. The stage in Pope's argumentation in which life is evoked as something bare or minimal is not unimportant. Much theorising about the value of literature focuses on the importance of the other: literary language must be open to the other; literary response is a response to the other.[28] Openness to the other is a willingness or ability to have one's environment change in the way I've just described, for some new object or practice to become marked, valued, or some old practice or object to be devalued. Such an openness to the other, an ability to find the other admissible, I think, requires, not as an excluded or merely supplementary moment in its situational logic but as a fully incorporated part of that logic, a setting at nought of some value or other in the environment of the person concerned. ('To set at *nought*; not to value; to slight; to scorn; to disregard.'[29]) That is, the person who is going to be open to the other must in some sense see life in its qualitative aspect as indifferent. The form of life is indifferent because cultures are incommensurable: all we can say when presented with the world is (like Montaigne) that people over there at that time did it that way, whereas people over here right now do it this way.[30] To see that the other way of doing it is also possible requires the setting of my current way of doing it at nought, devaluing it. It requires that in the continual, dynamic process of valuing there is a stage of noughting, that I am at some time, or in some enduring attitudinal way over time, not sure of what my perceptions/impressions are or how they are parsed in pleasure or pain, that my evaluations are not certain to me or for me, that I might cease to be part of any delimited audience because the object around which that community is constituted is or has become indifferent.[31]

This intuition is somewhat contrary to a tendency in Herrnstein Smith's work to present the values of individuals and kinds of people as certain. This tendency is evident negatively when Herrnstein Smith refers to the 'epistemological conundrum' of other people's experiences.[32] How, after all, can we understand other people's evaluations? This seems to me to be a false conundrum. Herrnstein Smith writes brilliantly on the emergent nature of literary and art values, in processes of composition and reception, and against the 'gratuitous mutuality of presuppositions' in Jürgen Habermas's restrictive notion of communicative action that wipes out the possibility of communicating in order to negotiate serious differences of value.[33] But she talks about delimited audiences and defined populations for whom value judgements will be valid, as when she insists on the determining role being a member of an audience com-

munity will have on evaluation.[34] And people, it seems, will always know what their evaluations of works are and will also have a sufficiently strong sense (as Herrnstein Smith herself clearly does, with her language—her pronouns in particular—effortlessly invoking the hierarchy of tastes) of the group into which the run of their evaluations places them (or the run of evaluations into which their membership of a group places them).[35] The question for Herrnstein Smith then becomes how a person might move from one population to another, how one might move from one defined audience to another, the very question of aesthetic education which she treats only as of interest when countering the axiological tendencies of other theorists. I think this movement becomes possible when we set at nought our own values, when we have a characteristic experience of being indifferent to an object or practice—perhaps a new one, perhaps one we have become used to valuing highly but which now seems unremarkable.[36] Such moments at which objects and practices are emptied of value seem to me a necessary concomitant to a realisation of the incommensurability of cultures. If it could be this way or that, why should I value my current way any higher than any other way? The indifference induced by recognising incommensurability is the means by which alternative valuations become possible. These moments need not be existentially charged but may just as well be marked by a horizon of practicality. They need follow no particular pattern; they may be radically contingent.

How, then, does Hume's essay 'Of the Standard of Taste' relate to cultural incommensurability and the setting of values at nought? Hume seems quite clearly to be a universalist when it comes to objects of taste. He says there are no a priori rules for composition (in writing) but that they are to be derived from 'what has been universally found to please in all countries in all ages.'[37] It is the same Homer that pleases in London and Paris as pleased in Athens and Rome.[38] But there being objects that are likely to produce certain mental responses in their audience does not mean that any audience is actually equally alive to the values of that object: 'Though some objects, by the structure of the mind, be naturally calculated to give pleasure, it is not to be expected, that in every individual the pleasure will be equally felt'.[39] That is, though certain kinds of objects, identifiable a posteriori, will be found to please in all countries and ages, they will not actually please all people in all countries and ages. They will only please people with certain aptitudes, certain kinds of people. Immediately it is a qualified universalism that recognises differences in natural and acquired sensi-

tivity or delicacy of taste and which universalises from the experi-
ence of those who have acquired the aesthetic disposition. Hume's
essay attempts to reconcile the feeling that art objects are universal-
ly pleasing with the feeling, shared with Étienne Bonnot de Condil-
lac, for example, that taste is acquired rather than innate: 'Nous
croyons avoir un goût naturel, inné, qui nous rend juges de tout,
sans avoir rien etudié. . . . Mais, si nous avons apris à voir, à enten-
dre, etc., ne serait-il pas une qualité acquise? Ne nous y trompons
pas: le génie n'est, dans son origine, qu'une grande disposition pour
apprendre à sentir; le goût n'est que le partage de ceux qui ont fait
une étude des arts, et les grands connaisseurs sont aussi rares que
les grands artistes.'[40]

Hume is guilty of some of the sins of axiology as Herrnstein
Smith defines it, presenting the contingent as necessary.[41] That is,
he makes his contingent world the necessary standard by which to
judge the objects and practices of other people. He calls the Koran a
'wild and absurd performance' in which the prophet 'bestows
praise on such instances of treachery, inhumanity, cruelty, revenge,
bigotry, as are utterly incompatible with civilized society'.[42] This
Islamophobia, however, may also be a means of alerting the attuned
reader to similarly indefensible passages in Judaeo-Christian scrip-
ture.[43] And Hume closes his essay by noting how the bigotry of
Roman Catholicism has ruined the literature of Italy and France.[44]
In a slightly different form of problematic, self-defeating universal-
ising, when insisting on the necessity of comparison to being a good
judge of the arts, he notes, 'The coarsest daubing contains a certain
lustre of colours and exactness of imitation, which are so far beau-
ties, and would affect the mind of a peasant or Indian with the
highest admiration'.[45] These other groups of people (Muslims,
Catholics, Indians, peasants) have not developed the comparative
ability necessary to become good judges of what universally pleases
in all times and ages. Theirs are the sorts of being-pleased that are to
be discounted when one acknowledges that not all people will be
equally susceptible to the pleasures certain kinds of object are natu-
rally capable of producing. Hume's universal cultural values ap-
pear to be strongly rank-ordered, but that rank ordering is actually
an exclusion of groups from participation in the reference commu-
nity of taste that will, as the essay progresses, become the practical
means of establishing standards.

Is there any saving of Hume to be done? As a first step, it would
be good to remind ourselves of Christopher MacLachlan's observa-
tion concerning this essay. As a reader he is 'struck by certain fea-

tures which look like structural weaknesses and by what seem to be inconsistencies, even contradictions, in Hume's argument.'[46] I will turn to some of these inconsistencies now. When Hume thinks of the standard of taste, he thinks of a person.[47] That is, the standard of taste is to be found in the values of a person in an environment in something like the sense I have given above. As no person is universal, Hume's standard cannot be absolutely universal. But Hume recognises, rather like Rasselas in response to Imlac's description of the poet, that the conditions required to become a true critic, to embody the standard of taste, are impossible to meet.[48] The true critic is a person, but a fictional person, one whose taste we have imaginatively to construct.[49] As James Noggle has noted, in order to counteract scepticism about standards of taste, 'we must . . . *attribute* many . . . real experiences to a group (men of taste) that forms an ideal and identifiable community through history.'[50] But Hume's essay itself tells us that this community is very unlikely to exist, that it is not, strictly speaking, an identifiable historical community but an imagined community. In this way the true critic is rather like some of those mysterious other selves common in eighteenth-century moral and aesthetic thought, such as Shaftesbury's divided self and Adam Smith's impartial spectator—selves that have to be imagined into existence and yet exert a normative influence over the full range of our affective lives.[51] These figures are partly accessible through reflection and projection, but we can never identify with them entirely. They are other people. Still, the (imagined) critic is in an (imagined) environment, and the standard of taste made possible by imaginatively realising the environment of the true critic is therefore in personally experienced cultural values, not in some measure external to people or objects and practices (it is not in a context, code, or field).

Hume's essay is indeed rather inconsistent. We are to admire that which universally pleases in all ages and countries. Yet the pressing nature of the desire for a standard of taste is felt by everyone who sees differences of opinion and in particular by those who 'contemplate distant nations and remote ages'.[52] The breadth of geographical and historical experience of culture that enables us to identify universally pleasing objects is the very same condition that makes the variety of human opinions concerning the differing values of objects evident.[53] MacLachlan argues that, in the essay, 'when we come down to particular cultural contexts what we find is variety, even incommensurability, of taste rather than a universal standard.'[54] One very obvious way in which variety and incom-

mensurability are evident is in the necessity of educating taste: we don't universally have it; we have to acquire it. We get a strong sense of the embodied particularity of the acquired aesthetic experience from the essay, with an emphasis on the organs of taste:

> But though there be naturally a wide difference in point of delicacy between one person and another, nothing tends further to encrease and improve this talent, than *practice* in a particular art, and the frequent survey or contemplation of a particular species of beauty. . . . When objects of any kind are first presented to the eye or imagination, the sentiment, which attends them, is obscure and confused; and the mind is, in a great measure, incapable of pronouncing concerning their merits or defects. The taste cannot perceive the several excellencies of the performance; much less distinguish the particular character of each excellency, and ascertain its quality and degree. If it pronounce the whole in general to be beautiful or deformed, it is the utmost that can be expected; and even this judgment, a person, so unpractised, will be apt to deliver with great hesitation and reserve. But allow him to acquire experience in those objects, his feeling becomes more exact and nice: He not only perceives the beauties and defects of each part, but marks the distinguishing species of each quality, and assigns it suitable praise or blame. A clear and distinct sentiment attends him through the whole survey of the objects; and he discerns that very degree and kind of approbation or displeasure, which each part is naturally fitted to produce. The mist dissipates, which seemed formerly to hang over the object: The organ acquires greater perfection in its operations; and can pronounce, without danger of mistake, concerning the merits of every performance.[55]

Taste is physiological; it is an acquired aptitude. And, perhaps most importantly from my point of view, the exercise of taste starts somewhere near zero; it starts with an encounter with an object that can barely be discerned as the proper object for the faculty: sentiments are obscure and confused, the mind cannot discern merits or defects, we hesitate, are reserved, there is a mist hanging over the object that only dissipates once we have practice and comparison to enable us to discriminate and acquire confidence in judgement. In my terms, Hume here is giving a reasonably fine-grained account of the fact that initially we are indifferent when we encounter art objects, that being pleased (experiencing the universal pleasure available to humans through art) is achieved by imagining oneself into being the kind of human who could be pleased by that kind of object. Here one might start to see some problems with the self-

evidence of our sentiments, as they figure in Hume's *A Treatise of Human Nature*, that is, as providing sensory and moral evidence of which we cannot be mistaken: 'The distinction of moral good and evil is founded on the pleasure or pain, which results from the view of any sentiment, or character; and as that pleasure or pain cannot be unknown to the person who feels it, it follows, that there is just so much vice or virtue in any character, as every one places in it, and that 'tis impossible in this particular we can ever be mistaken.'[56] Most of us will not arrive at being the confident judges of the objects of taste Hume describes and may be no more able to dispel the mists that surround our (direct) sense impressions or our moral sentiments than the tyro critic—other than by becoming someone who is very unlikely to exist other than in a wide array of forms in the imagination.

Hume's treatment of prejudice in the essay also demands a setting at nought in order to experience value. There is an injunction when encountering a work to set our prejudices aside and imagine ourselves into the position of the intended audience:

> A person influenced by prejudice, complies not with this condition; but obstinately maintains his natural position, without placing himself in that point of view, which the performance supposes. If the work be addressed to persons of a different age or nation, he makes no allowance for their peculiar views and prejudices; but, full of the manners of his own age and country, rashly condemns what seemed admirable in the eyes of those for whom alone the discourse was calculated.[57]

We should set our own prejudices at nought and take on the prejudices of people from other times and places in order to understand works that were made with those other people in mind. Again, when we recognise other people as having a better taste than us,[58] we set our own experience of value lower than that of some other person, as part of our appreciation of the value of an object or practice. Part of our valuation is devaluing our own lived experience in favour of some other imaginable experience. We alienate our values. I do not think this a paradox, any more than other people's evaluations are an 'epistemological conundrum'. We have seen that at least in initial encounters with objects, we are no more certain of our own values than of other people's values; indeed, coming to value is imagining ourselves as people with different values. To be able to do that, we set ourselves at nought (we are forced by the encounter to do so, or we develop the habit of doing so—setting

aside our prejudices in favour of other people's). The practice of value in the human environment is, intermittently at least, the practice of devaluing, of questioning pleasures, of allowing ourselves to be blank in the face of a potential object of pleasure.

Hume hardly helps matters by closing the essay in the manner I've already briefly noted, asserting that religious superstition is a type of prejudice that should not be overcome when entering into other people's worlds. Before that example he also raises differences of age and temperament as harmless prejudices we don't need to tame; he notes that we naturally have a preference for works that express manners and customs close to those of our own time and nation and that we should not excuse differences in morality when we are trying to take on the prejudices of others in favour to our own.[59] It is hard not to agree with MacLachlan that there is an ironic undermining of the claims to universal validity and freedom from prejudice made at earlier stages of the essay in these pages. But my reading has diverged from MacLachlan's more Bourdieuvian point that 'Hume's essay . . . ironically undermines the neo-classical beliefs it seems to support and reduces them to a disguise of the social machinery by which tastes are in fact created and changed.'[60] I think Hume is pointing to the imaginative construction of the standard without saying we become its dupes: pleasure and pain are not unreal if they are produced by social machinery. The distinctively human pleasures will all be produced by social machinery, in the sense that practising value is allowing imagined experiences of other people to determine what we like.

There has recently been a reaction against the Bourdieuvian emphasis on the sociological structure in which aesthetic dispositions are formed, in which taste is the various forms of repudiation of immediate pleasure, in favour of reflection and acquired preference, and then again by an aristocratic unreflective and connoisseurial pleasure.[61] A significant attempt has been made to reclaim the agency of the listener, for example, by attending to the world of listening practices, with habits of discourse, dress, concert attendance, music storage, ritual, appreciation, and so on, all built into an account of the practice of liking. The amateur is not 'the passive subject of an attachment, the real determinants of which are unknown to her', but someone involved in a collective bodily and mental practice that produces the body and mind through its interaction with its object.[62] The pleasures of taste seem to me neither as certain as they appear to Hume nor as illusory as they appear to Bourdieu. The fragility of the value or the pleasure is not due solely

to our being uninitiated or imperfect judges (and all judges are imperfect) or to the work that judgements of taste perform in reifying social distinctions. This fragility is also the result of the realisation that culture could always be a different way of doing things and that to be in culture or for culture, to have pleasure or value in the arts, is to live with the indifference of our current way of doing things in comparison with many other possible ways of doing things. Such a realisation limits our satirical range, perhaps, as we have to relinquish the certainty that the petit bourgeois (or any other portrayable type) is a travesty; it limits also our certainty of our privileged positions as institutionalised evaluators. It is a necessary resignation of authority within the dynamic network of valuations. Indifference, or blankness, can help to make and keep things real and strange, to echo William Empson.[63] The realisation of the indifference of our aesthetic experience is perhaps that which leads Hume to introduce a principle of generosity in appeals to the standard of taste that the true critic, free from prejudice, represents. We can never know if the true critic is the true critic, if she has entirely freed herself from prejudice. So people 'must have indulgence to such as differ from them in their appeals to this standard'.[64] The environment is always open to change, to the offer or retraction of possible pains and pleasures, on the basis of the different communities to which we refer ourselves.

NOTES

1. Sankar Muthu, *Enlightenment against Empire* (Princeton, NJ: Princeton University Press, 2003), p. 6.
2. Muthu, *Enlightenment against Empire*, p. 69.
3. Muthu, *Enlightenment against Empire*, p. 268.
4. Marilyn Strathern makes a slightly stronger claim in 'The Nice Thing about Culture Is That Everyone Has It', in *Shifting Contexts: Transformations in Anthropological Knowledge*, ed. by Marilyn Strathern (London: Routledge, 1995), pp. 153–76 (pp. 168–70). She suggests that an incommensurability between the listening anthropologist and her subject is what makes the presence of other people evident. That humanity is something other, and more than, the best description we can offer of it is a hope for another order of possibility, a possibility of other views in excess of our claims for universality. My thanks to Sam Ladkin for pointing me to Strathern's article.
5. 'All human beings carry about a set of words which they employ to justify their actions, their beliefs, their lives. . . . I shall call these words a person's "final vocabulary".
'It is "final" in the sense that if doubt is cast on the worth of these words, their user has no noncircular argumentative recourse.' (Richard Rorty, *Contin-*

gency, Irony, and Solidarity [Cambridge: Cambridge University Press, 1989], p. 73.

6. Barbara Herrnstein Smith, *Contingencies of Value: Alternative Perspectives for Critical Theory* (Cambridge, MA: Harvard University Press, 1988).

7. George Berkeley, *Essay Towards a New Theory of Vision*, in *The Works of George Berkeley Bishop of Cloyne*, ed. by A. A. Luce and T. E. Jessop, 9 vols. (London: Thomas Nelson, 1948–1957), I, 193, para. 59.

8. Francis Hutcheson, *An Inquiry into the Original of Our Ideas of Beauty and Virtue in Two Treatises*, ed. by Wolfgang Leidhold (Indianapolis: Liberty Fund, 2004), p. 8.

9. David Hume, *A Treatise of Human Nature*, ed. by L. A. Selby-Bigge, rev. by P. H. Nidditch, 2nd ed. (Oxford: Clarendon Press, 1978), p. 299. Such tendencies continue in theorising art values. See, for example, Elder Olson, 'On Value Judgments in the Arts', in *On Value Judgments in the Arts and Other Essays* (Chicago: University of Chicago Press, 1976), pp. 307–26 (p. 307): 'We make value judgments constantly in life, could not conduct our lives without making them; even animals seem to make them; and probably there could be no greater dispraise of a man than to say he has no sense of values and cannot tell good from bad'; Simon Stewart, *A Sociology of Culture, Taste and Value* (Basingstoke: Palgrave Macmillan, 2014), p. 4: 'In our analysis of taste, we consider the need to examine what is consumed and precisely how individuals interact with cultural objects. This involves being attentive to various affectual impulses that underpin the act of tasting. Cognizant of the determinisms associated with social origin, we consider responses to cultural objects that extend beyond meaningful social action. We see that such responses might be intensely bodily, characterized by immediacy and triggering feelings of pleasure or disgust. Alternatively, they might be characterized by non-cathartic feelings, such as indifference, envy, moderately-felt pleasure or mild distaste. They might be motivated by a sense of revolt or by impulses rooted in a contrariness that seeks to contradict societal or familial or generational expectations.' Indifference will feature later in this chapter.

10. Hume, *Treatise*, pp. 103, 135. Alessandra Stradella, 'The Fiction of the Standard of Taste: David Hume on the Social Constitution of Beauty', *Journal of Aesthetic Education*, 46.4 (2012), 32–47, provides a sustained consideration of Hume's thinking on taste in relation to the philosophical fictions he evokes in the *Treatise*.

11. Hume, *Treatise*, p. 190.

12. Peter Kivy, *The Seventh Sense: Francis Hutcheson and Eighteenth-Century British Aesthetics*, 2nd rev. enl. ed. (Oxford: Clarendon Press, 2003), pp. 283–310, takes the view that Hume's thinking on taste is thoroughly epistemic rather than sentimental, concerned with facts rather than feelings.

13. Edmund Burke, *A Philosophical Enquiry into the Origin of Our Ideas of the Sublime and the Beautiful and Other Pre-revolutionary Writings*, ed. by David Wormersley (London: Penguin, 1998), p. 80. Discussing Pope's writing on pleasure, David B. Morris, 'Pope and the Arts of Pleasure', in *The Enduring Legacy: Alexander Pope Tercentenary Essays*, ed. by G. S. Rousseau and Pat Rogers (Cambridge: Cambridge University Press, 1988), pp. 95–117 (pp. 107–12), describes 'a blankness or emptiness inherent in pleasure, undermining every enjoyment' that constitutes one of two antagonist attitudes to pleasure in Pope's texts.

14. Antoine Hennion, 'The Pragmatics of Taste', in *The Blackwell Companion to the Sociology of Culture*, ed. by Mark D. Jacobs and Nancy Weiss Hanrahan (Malden, MA: Oxford: Blackwell, 2005), pp. 131–44 (p. 131).

15. David Hume, *Essays Moral, Political and Literary*, ed. by Eugene F. Miller, rev. ed. (Indianapolis: Liberty Fund, 1987): 'Of the Parties of Great Britain', pp. 64–72 (p. 64); 'Of the Original Contract', pp. 465–87 (p. 466); 'Of the Rise and Progress of the Arts and Sciences', pp. 111–37 (pp. 124, 123, 118).

16. For a brief account of the kinds of value with which economics has historically concerned itself, see David Throsby, *Economics and Culture* (Cambridge: Cambridge University Press, 2001), pp. 20–23.

17. Jakob von Uexküll, *A Foray into the Worlds of Animals and Humans, with a Theory of Meaning*, trans. by Joseph D. O'Neil (1934/1940; Minneapolis: University of Minnesota Press, 2010), p. 188.

18. That culture is evidence of the characteristically unaccomplished nature of the human world is a persistent view. See Stewart, *A Sociology of Culture*, p. 7, citing Zygmunt Bauman.

19. Herrnstein Smith, *Contingencies of Value*, p. 42.

20. Carolyn Wilde, 'The Intrinsic Value of a Work of Art: Masacio and the Chapmans', in *Beyond Price: Value in Culture, Economics, and the Arts*, ed. by Michael Hutter and David Throsby, Murphy Institute Studies in Political Economy, ed. by Richard F. Teichgraeber III (Cambridge: Cambridge University Press, 2008), pp. 220–35 (p. 223). See Ludwig Wittgenstein, *Culture and Value*, ed. by G. H von Wright and Heikki Nyman, rev. by Alois Pichler, trans. by Peter Winch, rev. ed. (Oxford: Blackwell, 1998), p. 89e: 'Culture is an observance. Or at least presupposes an observance.' The German word is *Ordensregel*.

21. Stephen Greenblatt, 'Resonance and Wonder', in *Exhibiting Cultures: The Poetics and Politics of Museum Display*, ed. by Ian Karp and Steven Lavine (Washington, DC: Smithsonian Institution, 1991), pp. 42–56 (pp. 42, 45, 49, 54). My thanks to the anonymous reader of this chapter for pointing me to Greenblatt's article.

22. Pierre Bourdieu, *Distinction: A Social Critique of the Judgement of Taste*, trans. by Richard Nice (Cambridge, MA: Harvard University Press, 1984), p. 2. He continues, 'The conscious or unconscious implementation of explicit or implicit schemes of perception and appreciation which constitutes pictorial or musical culture is the hidden condition for recognizing the styles characteristic of a period, a school or an author, and, more generally, for the familiarity with the internal logic of works that aesthetic enjoyment presupposes.'

23. Bourdieu, *Distinction*, pp. xi, 511: 'If there is any terrorism [in Bourdieu's study], it is in the peremptory verdicts which, in the name of taste, condemn to ridicule, indignity, shame, silence (here one could give examples, taken from everyone's familiar universe), men and women who simply fall short, in the eyes of their judges, of the right way of being and doing; it is the symbolic violence through which the dominant groups endeavour to impose their own life-style'.

24. Bourdieu, *Distinction*, p. 3.

25. Pierre Bourdieu, *The Field of Cultural Production: Essays on Art and Literature*, ed. by Randal Johnson (Cambridge: Polity, 1993), p. 30.

26. Thomas Hobbes, *Leviathan*, ed. by Richard Tuck (Cambridge: Cambridge University Press, 1991), I.xi, p. 70.

27. John Butt, ed., *The Twickenham Edition of the Poems of Alexander Pope*, 11 vols. (London: Methuen, 1939–1969), III.ii.91, ll. 81–83.

28. Levinas is perhaps the figure most strongly associated with this turn. See Derek Attridge, *The Singularity of Literature* (London: Routledge, 2004), p. 24, who thinks of admitting the other as requiring a relinquishing of intellectual control; Michael Eskin, *Ethics and Dialogue in the Works of Levinas, Bakhtin, Mandel'shtam, and Celan* (Oxford: Oxford University Press, 2000), pp. 29–43, who

characterises Levinas's conception of ethics as a responsibility to the other as semiotic; and, more generally, Stephen Shankman, *Other Others: Levinas, Literature, Transcultural Studies* (Albany: State University of New York Press, 2010).

29. Samuel Johnson, *A Dictionary of the English Language* (London: W. Strahan, 1755), s.v. 'nought'.

30. 'A *French* Gentleman, of my Acquaintance, was always wont to blow his Nose with his Fingers (a Thing very much against our Fashion), would justify himself for so doing, and was a Man very famous for pleasant Repartees, who, upon that Occasion ask'd me, What Privilege this filthy Excrement had, that we must carry about us a fine Handkerchief to receive it, and which was more, afterwards to lap it carefully up, and carry it all Day about in our Pockets, which, he said, could not but be much more nauseous and offensive, than to see it thrown away, as we did all other Evacuations. I found that what he said, was not altogether without Reason, and by being frequently in his Company, that slovenly Action of his was at last grown familiar to me; which nevertheless we make a Face at, when we hear it reported of another Country. Miracles appear to be so, according to our Ignorance of Nature, and not according to the Essence of Nature. The continually being accustom'd to any Thing, blinds the Eye of our Judgment. *Barbarians* are no more a Wonder to us, than we are to them; nor with any more Reason, as every one would confess, if after having travell'd over those remote Examples, Men could settle themselves to reflect upon, and rightly to confer them. Humane Reason is a Tincture equally infus'd into all our Opinions and Customs, of what form soever they are; infinite in Matter, infinite in Diversity. But I return to my Subject.' Michel de Montaigne, 'Of Custom', in *Essays of Michael Seigneur de Montaigne*, trans. by Charles Cotton, 3 vols. (London: J. Brown et al., 1711), I, 135–36. For support of this reading of Montaigne as a radical subjectivist when it comes to human goods and values, see J. B. Schneewind, 'Montaigne on Moral Philosophy and the Good Life', in *The Cambridge Companion to Montaigne*, ed. by Ullrich Langer (Cambridge: Cambridge University Press, 2005), pp. 207–28 (pp. 217–18). See also Emily Butterworth, 'The Performance of Habit in Montaigne's "De mesnager sa volonté"', *French Studies*, 59.2 (April 2005), 145–57.

31. Erik Gray, *The Poetry of Indifference: From the Romantics to the Rubáiyát* (Amherst: University of Massachusetts Press, 2005), p. 3, notes, 'Sympathy, sensitivity, action all depend upon our ability to distinguish what is absolutely essential and to screen out the rest; we are continually obliged to display indifference to countless things not in themselves bad or unworthy. . . . Indifference not only coexists with various forms of sensitivity, it makes them possible.' My account of indifference is fundamentally different to that offered by Jonathan Loesberg, *A Return to Aesthetics: Autonomy, Indifference, and Postmodernism* (Stanford, CA: Stanford University Press, 2005), who describes aesthetic indifference as 'an indifference to the existence of the object, a recognition that existing objects were precisely not the targets of aesthetic judgment' (p. 75). Loesberg's reading of Kant suggests that indifference has its origin in the realisation that 'one never really has grounds to believe in any given embodiment of nature's moral purpose as fully accurate', so that 'aesthetic indifference does not primarily distinguish between the kind of pleasure the aesthetic entails, but rather qualifies our investment in the symbolic embodiment we judge to occur when we experience an object as beautiful' (pp. 103–4). Loesberg's view seems to me to demand maintaining an untenable distinction between appearance and existence even as his argument for the centrality of the aesthetic as a category allows it to assume more cognitive territory.

32. Herrnstein Smith, *Contingencies of Value*, p. 82.

33. Herrnstein Smith, *Contingencies of Value*, pp. 45, 110.

34. Herrnstein Smith, *Contingencies of Value*, p. 13.

35. Herrnstein Smith, *Contingencies of Value*, pp. 16, 83–84. For another challenge to the delimitation of aesthetic response by reference to audience/community membership, see Salim Kemal and Ivan Gaskell, 'Interests, Values, and Explanations', in *Explanation and Value in the Arts*, ed. by Salim Kemal and Ivan Gaskell (Cambridge: Cambridge University Press, 1993), and *Cambridge Studies in Philosophy and the Arts*, ed. by Salim Kemal and Ivan Gaskell, pp. 1–43 (pp. 20–22).

36. This view might be distinguished from Richard Shusterman's account of John Dewey's aesthetics in *Pragmatist Aesthetics: Living Beauty, Rethinking Art*, 2nd ed. (1992; Lanham, MD: Rowman & Littlefield, 2000), particularly pp. 31–33, where the moment of unified equilibrium in aesthetic experience is presented as an invitation to a new experience of the environment. I am attempting to describe a more neutral moment.

37. In Hume, *Essays*, pp. 226–49 (p. 231).

38. Hume, *Essays*, p. 233.

39. Hume, *Essays*, p. 234.

40. Étienne Bonnot de Condillac, *Traité des animaux*, ed. by Michel Malherbe (Paris: Vrin, 2004), p. 168. 'We believe we have a natural, innate taste which renders us judges of everything, without having studied anything. . . . But, if we have learnt to see, to listen, and so on, is it not an acquired quality? We should not deceive ourselves in this matter: genius is nothing other, in its origin, than a disposition to learn to feel; taste is the share only of those who have made a study of the arts, and great connoisseurs are as rare as great artists' (my translation).

41. Herrnstein Smith, *Contingencies of Value*, p. 54.

42. Hume, *Essays*, p. 229.

43. Christopher MacLachlan, 'Hume and the Standard of Taste', *Hume Studies*, 12 (April 1986), 18–38 (p. 23), notes this ironic potential.

44. Hume, *Essays*, pp. 247–49.

45. Hume, *Essays*, p. 238.

46. MacLachlan, 'Hume and the Standard of Taste', p. 18.

47. See Claude MacMillan, 'Hume, Points of View and Aesthetic Judgments', *Journal of Value Inquiry* 20 (1986), 109–23 (p. 118), who notes that feelings about art objects must be about objects and felt by people.

48. Hume, *Essays*, pp. 241–42.

49. James Shelley, 'Hume's Double Standard of Taste', *Journal of Aesthetics and Art Criticism*, 52.4 (Autumn 1994), 437–45 (p. 444), notes that Hume provides no evidence of there being true judges of art but does not countenance that Hume's failure may be intended to communicate their non-existence.

50. James Noggle, *The Temporality of Taste in Eighteenth-Century British Writing* (Oxford: Oxford University Press, 2012), p. 119.

51. See Anthony Ashley Cooper, Third Earl of Shaftesbury, 'Soliloquy, or Advice to an Author', in *Characteristics of Men, Manners, Opinions, Times*, ed. by Lawrence E. Klein, Cambridge Texts in the History of Philosophy, ed. by Karl Ameriks and Desmond M. Clarke (Cambridge: Cambridge University Press, 1999), p. 77; Adam Smith, *The Theory of Moral Sentiments*, ed. by D. D. Raphael and A. L. Macfie (Indianapolis: Liberty Fund, 1982), p. 23 and passim. For a related view, see Hans Georg Gadamer, *Truth and Method*, trans. and ed. by Garrett Barden and Joel Cumming (London: Sheed and Ward, 1975), p. 17: 'The universal viewpoints to which the cultivated man (*gebildet*) keeps himself open

are not a fixed applicable yardstick, but are present to him only as the viewpoints of possible others.'

52. Hume, *Essays*, p. 227.

53. Compare Smith, *The Theory of Moral Sentiments*, p. 195: 'Few men have so much experience and acquaintance with the different modes which have obtained in remote ages and nations, as to be thoroughly reconciled to them, or to judge with impartiality between them, and what takes place in their own age and country. Few men therefore are willing to allow, that custom or fashion have much influence upon their judgments concerning what is beautiful, or otherwise, in the productions of any of those arts; but imagine, that all the rules, which they think ought to be observed in each of them, are founded upon reason and nature, not upon habit and prejudice.'

54. MacLachlan, 'Hume and the Standard of Taste', p. 28.

55. Hume, *Essays*, p. 237.

56. Hume, *Treatise*, III.ii.8, pp. 546–47.

57. Hume, *Essays*, p. 239.

58. Hume, *Essays*, p. 243.

59. Hume, *Essays*, pp. 244–46.

60. MacLachlan, 'Hume and the Standard of Taste', p. 34.

61. Bourdieu, *Distinction*, pp. 76, 490, where the distinction is made between 'too immediately accessible pleasure' and 'aisthesis purified . . . a trained, sustained tension, which is the very opposite of primary, primitive aisthesis'.

62. Hennion, 'The Pragmatics of Taste', p. 132 (for the quotation), pp. 135–39.

63. 'It is this deep blankness is the real thing strange'. William Empson, 'Let it go', 1.1, *The Complete Poems*, ed. by John Haffenden (London: Penguin, 2000), p. 99.

64. Hume, *Essays*, p. 241.

SIX

Bargain-Basement Thought

Jonathan P. Eburne

Cruel economics catches us by surprise. In an era of 'liquid modernity', as Zygmunt Bauman has branded it, the currency of all things is subject to an alarming bottom line: the Marxian 'melting of solids' has reached a hypostatic state whereby the liquidisation of durable goods, values, populations, and institutions has become a permanent and virtually totalising condition.[1] Bauman diagnoses the disintegration of social networks and the dismantling of effective agencies of collective action; the nature of such 'liquidisation' is not destruction, however, but neoliberalism, a submission of all such networks, means, and values to market terms. Hallowed institutions and government systems alike now measure their work according to 'assessment indicators' and operative benchmarks that translate both production and consumption into a single, fluid set of metrics.[2] The problem here is not simply the overwhelming and all-encompassing fluidity of just-in-time capitalism—or even of that other, oceanic threat of ecological catastrophe—which jeopardises the durable forms from which our intellectual and material lives are built, whether buildings, values, potable water, cultural institutions, or books. The problem is also that other economies, other returns, other orders of cultural, symbolic, intellectual, libidinal, and spiritual capital have likewise been subsumed by the tide. Value—as this volume reminds us—has become a red herring. We may struggle to retrieve it from the waters, to attract it with lures, to await its advent

with unflagging patience. We may even find ourselves enjoying the process. Yet even to persist in such folly is already to exercise a resistant kernel of endurance that purports to recuperate value by other means. Our spare time, our wasted efforts have long since found their way onto the balance sheet.[3]

To this end, we might invoke Georges Bataille's interwar efforts to surprise economics at its own game: only by dispensing with 'value' can we recuperate something else (if not a concrete *thing*, then at least a set of practices) that remains perversely meaningful to us. In the contemporary marketplace of ideas, mind you, Bataille's once provocative notion of expenditure now demarcates a set of rather quaint transgressions and symbolic economies that has itself long since receded into the far horizon of philosophical history, which we witness only fleetingly through the rear-view mirror of critical reflection. 'What on earth to do', asks Martin Crowley, 'when even the ghostly uselessness of transgression has been recuperated?'[4] Rather than dispensing with Bataille in turn—or with any other relic of the post-structuralist age—it is precisely on account of this diminution that we might dwell further on the paradoxes of incomplete expenditure and liquidation. Might our wasted time and shopworn texts still afford a margin of inutility—if not necessarily of instrumental resistance—that could spare us from either clinging to our plastic belongings or resigning ourselves to the flood?

I propose that we take stock of our intellectual liquidation by focusing on the epistemological backwaters of liquid capitalism's currents of value and depreciation: that is, the de facto archive of error, obsolescence, and obscurity that often finds its way into the remainder bin—or which can even be said to be constituted by it. In amassing the incomplete and often haphazard results of the liquidation or death of contemporary thinking, this archive discloses the minor systems of circulation and economic categorisation according to which it functions. Against the intrinsic use value or exchange value of thought and writing considered to be current, such bargain-basement circulation reveals the competing currents of circulation, exhaustion, and recursion that comprise the vicissitudes of 'liquidation'. At stake in such circulation is the messy encounter with highly unfashionable ideas, whether obsolete, neglected, or flatly unreasonable. The heterodoxy of such encounters poses a threat to reason only to the extent that we understand reason as a negative or reactionary faculty, whose value contemporary scholars and policymakers must struggle to recuperate from the totalising

liquidation of scientific and liberal standards. Bargain-basement thought is anathema to any such conception of reason, imagined as a double negative; but we mustn't take this to mean that unfashionable ideas (or 'fashionable nonsense', as Alan Sokal once put it) offer a stable set of instrumental values for opposing it, whether radical or toxic. The traffic in unfashionable thinking, and of unfashionable *books* in particular, instead merits attention for its incomplete, suspended economy of return on material and conceptual value alike. The point of such an exercise, I maintain, is that it shifts the question of intellectual value from the inherent property of an idea—an empirical 'content'—to the vicissitudes of its administration, the imperfect system of its *material* as well as conceptual deployment, exercise, continuation, and regeneration.

I thus begin this chapter with a brief autobiographical indulgence. Sometime in the early 1990s, I had the pleasure of finding a number of books by Jacques Derrida at the New England Mobile Book Fair, a bookstore outside Boston, Massachusetts, that is neither mobile nor a fair in any sense other than in providing a massive bibliophilic playground of *bonnes affaires* during my adolescent years.[5] (The sprawling Book Fair is a contemporary of the early Barnes & Noble Book Annex in New York City, equivalent in scale to the Strand or Powell's.) Like other independent booksellers in the United States and elsewhere, the Book Fair has seen its sales plummet in recent years. Itself a precarious artefact whose survival comprises the store's own 'ultimate suspense story', the Mobile Book Fair is a repository of cut-rate, overstock, and out-of-print titles whose publication circuit survives according to their place in the remainder bin.[6] Fully half the store contains remaindered books, including, from time to time, works of literary criticism and philosophy from university presses.

The irony of happening upon remaindered copies of Derrida's *Limited, Inc.*, for instance, was confirmed by my finding, during the same visit, the volume of Paul de Man's scandalous wartime writings and the companion volume of *Responses*, published to much scholarly outrage and fanfare in 1988.[7] Here were texts issuing from two of deconstruction's most substantive controversies. The first concerned Derrida's polemic against the speech-act theories of John Austin (who had long since died) and the living philosopher John Searle, who responded on Austin's behalf. The second concerned the published evidence, likewise posthumous, of Paul de Man's writings from the collaborationist, anti-Semitic Belgian newspaper *Le Soir* during World War II. These polemics arose at a moment in

the late 1980s when the reception of deconstruction in the US and British academies was coming under serious attack. Such attacks found their perfect object-cause in de Man's secret collaborationist past, confirming, as critics always-already knew, the totalitarian tendencies in deconstructive thought. Then, as now, these attacks were complemented by a coeval interrogation of Derrida's own recourse to the philosophy of Martin Heidegger—himself a Nazi sympathiser—as forwarded by anti-deconstruction scholars such as Richard Wolin in the United States and Luc Ferry and Alain Renaut in France.[8] In a manner that persists today, such critics sought to debunk both Derrida and post-structuralist philosophy in general, depicting any straying from or critique of Western metaphysics as an implicit courtship of fascism or irrelevance or both. We might consider Evelyn Barrish's recent biography of de Man, *The Double Life of Paul de Man*, as the belated complement to this discourse which, along with the recent publication of Heidegger's 'black notebooks', has sparked renewed backlash against the seemingly inevitable susceptibility to fascism which, according to many, undergirds post-structuralist thought.[9] (Had I looked more closely at the time, I would surely have found a copy of Wolin's *The Heidegger Controversy* at the New England Mobile Book Fair as well). Continental philosophy, by this logic, is worse than useless. With its 'esoteric theorizing', it 'threatens to become an ersatz praxis and an end in itself', as Wolin puts it; in doing so, it also risks 'depriving democracy of valuable normative resources at an hour of historical need'.[10] Continental philosophy and its influence within US humanities departments threatened the values of humanism and liberal thought upon which such institutions were founded; Derrida and de Man marked the rising tide of dissolution. Traditionalists such as Wolin, suspicious of the post-structuralist current, considered it a symptom of the liquidating cultural forces that threatened Western humanism, heralding the breakdown of time-honoured values and social networks into a slough of pure relativism. Such sceptics were only partly right in their anxiety, however, mistaking the post-structuralist 'end of metaphysics' for the global effects of late capitalism.[11]

The irony—as I keep calling it—of finding such books as *Limited, Inc.* and the *Responses* volume in the remainder bin (albeit a large, glorious, store-wide remainder bin) was almost entirely lost on me at the time. It nonetheless seems worthy of contemplation in a volume that stands 'against value' to note that both Derrida's critique of Austin and Searle and the discourse on de Man's collaboration-

ism found themselves equally subject to the relative indifference of the literary marketplace. It would seem that university publishers may have speculated on the commercial viability of philosophical polemics in a manner not fully supported by the market, whether economic or intellectual, in the sense of the 'marketplace of ideas' championed by a certain incarnation of philosophical pragmatism. These attacks on and defences of dead philosophical precursors were all destined, it seems, for the remainder bin. Whatever normative resources may have been called for at that particular hour of historical need, these titles seem to have mutually missed the mark; they'd all been liquidated.

Even so, the broader irony of finding such work in the bargain basement of the book market—and particularly of coming across the work of Derrida, whose writing persistently dwells on the notion of remainders and legacies—suggests that there might be a way to consider the remainder bin as something other than an expression of rejection, indifference, or finality. For one, the notion of being 'destined for the remainder bin' does not proscribe a destiny at all, or at least not completely so. As my own Benjaminian glee at wading through stacks of cut-rate titles might suggest, the alternative modes of distribution and consumption we find in the market for remaindered books constitutes, in place of destiny, a second-order economy that persists within the communication and distribution of ideas: the lingering half-life of the cut-rate, we might say. Though the remainder market operates as a by-product of the corporate juggernaut of contemporary publishing—at once caused and ultimately recuperated by large-scale capitalism—it nonetheless constitutes a provisional rerouting of its economy of return, a deferral of corporate interests. A remainder testifies, in other words, to a compromise made on behalf of these commercial interests—a short sale that permits future speculation on long-term return—rather than to the compromised value of an individual title alone.

The remainder thus presents an alternative or at least deferred circuit of economic return, both within the marketplace of book publishing and within the sphere of critical reflections on value and intellectual currency. This circuitry finds its complement, moreover, in Derrida's own thinking about remainders, as well as within contemporary discourse about the future of books, the future of the humanities, and the future of university education that often strives to shore up normative resources in face of their obsolescence. As so many material repositories of recorded knowledge seem to be finding themselves destined (to use that word again) for that great his-

torical remainder bin in the sky—whether printed books, recorded media, or libraries and institutions of learning—they all come to stand for increasingly minor and retrograde forms of circulation. I propose that we follow this notion of the remainder as we reconsider the trust we so often invest in the contemporaneity, the currency, of any marketplace of ideas.

I thus approach this volume's position 'against value' as an opportunity to historicise European deconstruction through its own encounters with bargain-basement thought. These encounters are far from singular: with regard to the question of his own philosophical inheritance, Derrida famously rewrote the question of value and intellectual currency as a problematic of absences and traces— and of mourning and loss—rather than as a matter of legacy or critique.[12] Derrida was hardly alone in such a project. Anti-foundationalist philosopher of science Paul Feyerabend, for instance, took it as his guiding polemic to subject his own discipline to an 'anarchic' encounter with its own legacy of error and outlandishness, as well as to a concomitant interrogation of its limits, at every turn.[13] Yet in the case of each philosopher, the encounter with unreasonable legacies (or legacies of unreasonable 'methods') yields a body of work predicated, we might say, on sorting through these legacies. These encounters thus also throw into relief the epistemological function of bargain-basement thought itself. To historicise theory without falling back on anxious positivisms or regressive neoliberal orthodoxies demands that we acknowledge this latter archive for its mediating role—as well as its material and textual specificity—in the very 'returns' that frame the work of theory. My claim is hardly that we should liberate the occulted inventory of subjugated knowledges or that the full force of past unreason should be brought to bear on the present. Rather, in order better to contemplate our own encounters with the body of work whose status as legacy, remainder, or historical error is now in question, I propose that the work of thought—in its institutional and material as well as speculative forms—be measured in terms of its relation to the bargain basement.

Is there a thinking proper to the bargain-basement, the remainder bin? Bargain books represent a corporate strategy for recuperating value, after all; they never leave the circuit of economic return. Even so, in demarcating a set of strategies designed to amortise loss, they already introduce a strategy of shortfall management that readily lends itself to other orders of diminishing currency. More than simply designating a fate that befalls books as a function of

their distribution and consumption, remainders disclose a constitutive deferral in what might otherwise seem to be closed circuits of economic finitude, whether measured according to a margin of profit or a pragmatist demand for epistemological and political guarantees, often with very real governmental, social, and administrative exigencies. My focus in examining such deferrals will be Derrida's own thinking about remainders, developed in his writings on Austin and Searle, de Man, and Heidegger but elaborated at the greatest length in his reflections on intellectual legacies in his writings on Sigmund Freud, particular in his 1980 book *The Postcard*. At stake in Derrida's writing on remainders and deferred legacies is less the messy encounter with 'the seduction of unreason', as Wolin has generalised the 'romance with fascism' he finds in poststructuralist thought, than the unreason that operates within one's very relations to influences and forebears: a mode of relation that already functions according to the suspended circuit of the remainder. Feyerabend, in a critique of the philosophy of science as 'the bastard child of epistemology', named this very 'mode of relation' as a common yet curiously disenfranchised feedback loop: epistemology leaves its mark on contemporary intellectual practice at the very moments at which the history of thought opens up new approaches in the contemporary. 'Progress', he writes, was often achieved by a 'criticism from the past'—this is not a heroic extension of prior glories but a disruption of our governing tendency towards solipsism.[14] In the volume of *Responses* to de Man's wartime journalism, Ian Balfour ponders the extent to which such a feedback loop might operate within de Man's own career; the question is less of how and whether de Man's celebrity and intellect are stained by the shocking blight of his wartime collaborationism than of how we interrogate the continuity or discontinuity of the 1940s collaboration with the 1980s deconstruction.[15] Such interrogations are divisive, needless to say. As Derrida explains more definitively in a late interview, his own fealty to intellectual precursors is anything but the 'blind incorporation' of which critics such as Wolin accuse him (with regard to Heidegger) or the sweeping critical nihilism of which other critics accuse him (with regard to 'Western metaphysics', humanism, reason, and so forth). Rather, Derrida's relation to his so-called precursors is at once voluntary and utterly unreasonable: as he explains, the 'figures from whom I have received a visible inheritance—Heidegger, Levinas, Husserl—are thinkers about whom I have never really ceased posing many questions. Very serious, central questions. Along with a radical disquiet,

restless and bottomless, especially when it comes to Heidegger and Husserl'.[16] Far from constituting the bottom of the publishing ladder or the purgatory of the book market, the remainder here designates the apparatus through which such bottomless disquiet can be exercised, a disquiet Derrida elsewhere describes as an 'anxious, jealous, and tormented love'.[17] The medium for this tormented love is, moreover, the French language, suggesting the extent to which this disquieting feedback loop amounts to a proliferation of words, of writing, and thus of books.

As a repository, however provisional, of incompletely recuperable surplus investment, the bargain basement can function as a site for exercising the unreason that can take hold within any such relation to 'inheritances'. It offers, however, no guarantees; one can browse through a bargain basement for hours and still come out empty-handed. It is precisely for this reason—on account of this unreasonable suspension of any hermeneutic or ethical guarantee, any return on our investment—that the remainder discloses the bottomlessness of disquiet and love involved in one's choice of legacy, that is, in one's choice of books (or bodies of knowledge) to buy, read, buy into, or simply accumulate. The remainder thus refers to not only the economic circuit that determines the stock we choose from but the circuitry of our choosing as well: our purchase of books and our investment in the ways they take purchase within our thinking.

Before proceeding any further, it would be wise to say a little more about how remainders work. Sidestepping the Derridean resonances of the term for a moment, the remainder remains something of an under-examined category in the field of book history, as it might seem to concern an anomaly of commercial book distribution rather than an integral aspect of book production or the material book-object itself. A book is designated as a remainder when a publisher decides to liquidate its remaining stock of a title or edition that has either failed to sell well (according to a reasonable calculation, no doubt) or has been returned by stores in high quantities. A publisher deploys this strategy to recoup at least some of its speculative outlay on a title, as well as to clear warehouse space for the new titles upon which the publisher will continue to speculate. The latter is no less significant than the former, since the losses incurred by a short sale may often be recuperated through the gain in storage space. As a salvage measure in commercial publishing, therefore, remainders constitute a kind of compromise, a reduction of the

margin of loss that all titles risk incurring—even the most success-ful, insofar as even a later edition might be overprinted. What is fascinating is that the pallets of returns, overstock, and closeout titles that publishers seek to unload at significant discounts have, in turn, developed a market economy of their own, as the rise in large-scale discount book expos such as the Chicago International Re-mainder and Overstock Book Exposition demonstrates. Indeed, in such settings books become more commodified than ever, sold in bulk form from publisher to distributor without any return to the book's author. Therefore it might seem, as I suggested before, that remaindering is something that *happens* to a book and has thus more to do with either supply-chain management or perhaps reception study than with the forms of intellectual production we privilege in the humanities. Yet, even so, the practice of remaindering mediates and interferes with the more production-oriented processes we tend to privilege, such as the writing and making of books, and even thinking itself: first of all, there *is* a physical alteration in a book's material form that occurs when it is designated as a remainder. In many cases (though this is far from standardised), we find the sup-plement of a remainder mark. There is also, of course, the addition of a new price label. Both supplements mark, in turn, the greatest material significance of a remainder, which is that it designates a book that has not yet been pulped. The recent rise in digital and print-on-demand publishing only confirms the extent to which such retro-analytically attuned practices leave their impressions on the way books are written, as well as the ways they are circulated and disposed of, whether sold or on sale, read or unread. For just as the excesses of 'overstock' cast their shadow on the basic norms and expectations of how long a book should be and how its scope and ambitions should be managed, so too do digital texts likewise face an economy of scale based on data storage and the ease of file trans-fers.

Thus, in spite of their repeat, once-over commodification, re-mainders are commodities of a curious nature. This might be best illuminated by turning to a little bit of French: remainders are at once *soldé* (in the sense of discounted, which is the term for a re-maindered book in French) and yet also *restant* (remaining, suggest-ing something that is left over but also something that has been preserved, we might say, in the suspended economy of the discount book market). Suspended in a kind of half-life, such ghostly books haunt the kinds of discount bookstores that certain tenacious biblio-philes continue to haunt in turn. We might add a further Derridean

insight, moreover: not only does this curious status leave its impression a posteriori on the physical artefact of a remaindered book, but it also informs the very process of writing itself. For even if book historians don't write much about remainders, writer's guides (themselves of a genre always poised on the very threshold of the remainder bin) are keenly aware of the potential fates of published books. As any number of such guidebooks will attest, the spectre of the bargain basement imposes itself at the very scene of writing, as merely one dimension of the tenuous futurity of any sustained act of writing. The remainder—as Derrida puts it—leaves its trace *in advance of its own beginning*, part of the speculation of authorship itself. The 'post' is anterior (or even pre-anterior, raising its spectral head well before the origin of a book, at the very scene of its writing, the scene of speculation itself—or even, for that matter, at the scene of buying the books one will read in order to keep on thinking and writing).

Somewhere between the glorious dream of literary celebrity and the looming shadow of intellectual failure lies the ambiguous remainder. Not that any of this is a bad thing: this temporal and logical inversion of remainders and beginnings hardly constitutes a foreclosure, say, of the possibilities of authorial creation. Rather, it merely complicates the presumption that any scene of writing might be uncomplicatedly open, communicable, and present to itself. This is itself a standard Derridean insight. More significantly, the notion that the remainder bin leaves an imprint on both the book and the scene of its writing discloses, in turn, Derrida's ideas about the transmission of knowledge—or any form of 'communication', whether an intellectual legacy or the gestures, words, and acts of love—as unreasonably subject to bypass, delay, deferral, digression, and insufficiency. The work of transmission is remaindered from the outset: as Derrida puts it, revising Jacques Lacan's famous testament to the determinative law of the signifier, a letter can always *not* arrive at its destination. 'Not that the letter never arrives at its destination', Derrida continues, 'but it belongs to the structure of the letter to be capable, always, of not arriving.'[18] Derrida's work is thus significant to any thinking about remaindered books—and to unreason and the deferral of value—insofar as it inverts the finality of historical or ethical judgements based on the self-presence and internal consistency of a work or an author, any 'conceptual persona'. As Derrida asserted in his early critique of Michel Foucault's *Madness and Civilization*, unreason—whether madness or totalisation, bad thinking or bottomless disquiet—is part of the wager of

writing itself and of the speculation proper to it, rather than the measure of an errancy from or exteriority to a securely formalised reason, utility, and moral correctness. Richard Wolin's efforts to detect 'a lethal self-contradiction at the heart of the deconstructionist enterprise—Derrida's attempt to out-philosophize the history of philosophy', misrecognises this 'enterprise' as corporate manoeuvring rather than a negative capability, even a (losing) bet.[19] Wolin's own career in debunkery likewise reveals a similar wager in its purgative efforts to rid the enlightenment of its subversive elements. Expenditure becomes the constitutive gesture of Wolin's crusade against unreason and counter-enlightenment.

Yet rather than simply proposing a 'Derridean' reading of the bargain basement, I would argue, too, that Derrida's writing levies this suspended circuit upon its own discourse on intellectual history, love, Platonic wisdom, and the ethics of thought. Which is to say that the digressive, deferred circuitry of the remainder offers an ever-dysfunctioning system through which the closed circuitry of the commercial, intellectual, and institutional transmission of knowledge remains bottomless and incomplete—maddeningly, but also devotionally, open to invention, the invocation of thinking to come.

Though this is inscribed throughout Derrida's works, nowhere is it more explicitly developed than in *The Post Card*, a book on Freud that opens with a 256-page series of *envois*, a suite of love notes to an unnamed lover written and sent—we are told—on the backs of postcards, each bearing the same image: a thirteenth-century illustration of Plato and Socrates by Matthew Paris, which depicts Socrates, rather than Plato, as writing. Themselves a digression from the book's 'proper' subject—a systematic examination of Freud's *Beyond the Pleasure Principle*—these 'envoys' both constitute and illustrate the digressive and even delirious terms of Derrida's argument in the book, which involves a revision of the Freudian and Lacanian theories of the death drive as well, in particular, as an injunction into Lacan's notion that a letter always arrives at its destination.[20] The postcard 'envoys' illustrate (as well as perform) Derrida's intervention in two principal ways. First, written on an overstock collection of hundreds of copies of the same postcard, the love notes are punctuated with dozens of interpretations of the image they bear, itself a scene of writing that problematises our canonical understanding of the transmission of knowledge from Socrates to Plato and beyond. Curiously inverting the positions (or at least the names) of Socrates—who, presumably, did not write—and Plato,

who did, Matthew Paris's image opens up a relentless, though staggered, series of reflections on temporal and spatial positioning and reversibility (with regard to who is behind and who is before). These reflections not only bear sexual overtones, as part of a relentless volley of love letters, but also dovetail with Derrida's discussion of precursors, legacies, and 'posts' throughout the book. The image illustrates the digressive interruption of a 'proper' line of succession that occurs at the very scene at which this lineage commences: the 'post' is anterior from the start.

Second, as both a lover's discourse and an exercise in interpretive delirium, the relentlessly digressive series of postcards illustrates Derrida's contention that a letter (or postcard or book) can always *not* arrive at its destination: even insofar as the intersubjective relations of love and intellectual transmission that permeate Derrida's postcard communiqués could be said to be subject to the law of the signifier, this law hardly functions according to a principle of definitive communicability (whether a pleasure principle or a 'reality principle'); it is instead overwhelmed by delays, returns, and misdirections, which are at times almost literally maddening, but which also drive Derrida's mad passion. As Derrida writes to his lover, 'Overkill, my sweet love, is what drove us crazy, the aphrodisiac overkill of discourse, not ours but the arsenals of reason, the logistics with which we were armed.'[21] This 'aphrodisiac overkill of discourse'—which can never be demonstrated as a principle or reified as a method, lest it become precisely what it is not—illustrates Derrida's notion that love and intellectual legacy alike can be pursued *faithfully* (rather than methodologically or according to any economic guarantee) on account of this obsessive, mad deferral. The remainder, in other words, designates both the medium and the an-economic circuit of this aphrodisiac overkill. Derrida's exercise in amorous postcards suggests that the remainder, while always a by-product of 'principles' of reciprocity or economic return, can always *not* arrive at its destination, opening up instead into a delirium of wayward discourse.

In the guise of a self-aggrandising post-structuralist logorrhoea, such delirium has often been misrecognised as the symptom of the current state of intellectual affairs under liquid capitalism. Derrida's interpretive delirium now stands as a lingering remainder of the first wave of dissolution. The difficulties faced over the past twenty years by universities and the scholarly humanities—crises in enrolment figures, state budgets, and the hiring of PhDs in particular—have made it acceptable for administrators and politicians to follow

Derrida's deconstructivist lead, however ironically, in subjecting laws and meanings once considered immutable to their own delirium of interpretation. Even as they disparage the turgid intellectual discourses that take place in their midst, such functionaries now question the value of the institutions themselves as no less subject to suspension and even dissolution. The same thing goes for print media: with fewer books, newspapers, and print periodicals in circulation — or so it seems — the bankruptcy of literary critics and post-structuralist 'theorists' has become self-evident. The commonly held economic narrative posits the result of market-driven starvation as its cause: books and newspapers are obsolete; universities are overpriced and underproductive; post-structuralist philosophy is fit for neither the marketplace nor the political forum; the humanities provide only 'soft' knowledge ill-equipped for the challenges of the real world. The result is a reification of economic 'necessity' as a baseline natural condition: if they can't keep up with the times, then clearly they're not fit to survive. Curiously, the implicit social Darwinism of such beliefs has proven remarkably resilient, as a long-reviled pseudoscientific notion in its own right. The point here is that such notions of 'viability' and value remain administrative categories, subject to economies of exchange and scale, rather than reflections of a dwindling noumenal vitality of the forms of intellectual work they shunt out. The irrelevance of the humanities is an ideologically generated value, not a true condition disclosed by sceptics; the product of interpretive deliria reified into an economic principle, such a judgement finds its bloated carcass washed up on the shores of economic reality.

Much like a letter or remaindered book, such negatively defined 'values' can also always *not* arrive at their destination. This suggests less that the liquidation of institutions of learning is somehow self-cancelling or, conversely, that we might recuperate the structural potential for deferral as a radical capacity for disrupting the economic and political currents and byways of liquid capitalism; rather, it beckons us to recognise our capacity for participating in the 'aphrodisiac overkill' of the remainder bin. It is to such delirium that we might look as we consider the remaindering of so many of our material forms and institutions for the transmission of knowledge. Rather than seeking either to abandon or capitulate to the currency of our ideas and institutions, we might take stock of their material and intellectual inheritances: to heed our lingering entanglements with books, newspapers, libraries, and institutions of knowledge in the bottomless, ever-insufficient disquiet and love.

This could never amount to a defence against the economic forces that actively consign them to irrelevance, but it offers instead a devotional—and vigilant—form of use that suspends the closure of any such consignment as their irrevocable fate, thereby remaining open to the unforeseeable, which, as Derrida puts it, is always the condition of any event.

NOTES

1. See Zygmunt Bauman, *Liquid Modernity* (Cambridge: Polity Press, 2000).
2. For a prescient study of such metrics, see Marilyn Strathern, ed., *Audit Cultures: Anthropological Studies in Accountability, Ethics and the Academy* (London: Routledge, 1998). The case studies of contemporary institutions (including universities) in Strathern's collection address the culture of assessing the 'productivity' of labourers in the public sector and the 'value' of their work.
3. In characteristic fashion, Richard Wolin opens his 2004 history of 'the intellectual romance with fascism' with precisely such a claim: in American academia during the 1980s and after, the 'seductions of "theory"' helped redirect formerly robust political energies along the lines of acceptable academic career paths'. The folly of post-structuralist theory, insofar as it criticizes the limits of utilitarian thought, becomes little more than a profiteering form of self-interest. Richard Wolin, *The Seduction of Unreason: The Intellectual Romance with Fascism from Nietzsche to Postmodernism* (Princeton, NJ: Princeton University Press, 2004), p. 9.
4. Martin Crowley, 'Postface à la transgression, or, Trash, Nullity, and Dubious Literary Resistance', *Dalhousie French Studies*, 88 (2009), 99–109 (p. 100). Crowley's attention to nullity and trash as notable exceptions to the 'exhaustion' of both Bataille and vanguard ideas about transgression is developed fully in Allan Stoekl, *Bataille's Peak: Energy, Religion, and Postsustainability* (Minneapolis: University of Minnesota Press, 2006), which likewise returns to Bataille as a thinker of post-sustainability and the global culture of waste under conditions of diminishing resources.
5. See the New England Mobile Book Fair website: http://www.nebookfair.com [accessed 1 September 2015].
6. Steve Mass, 'New England Mobile Book Fair's Ultimate Suspense Story', *Boston Globe*, 16 June 2013, http://www.bostonglobe.com/metro/regionals/west/2013/06/15/new-england-mobile-book-fair-ultimate-suspense-story/gz4bPzliUX50oqTVrTNSrN/story.html [accessed 1 September 2015].
7. Paul de Man, *Wartime Journalism, 1939–1943*, ed. by Werner Hamacher, Neil Hertz, and Thomas Keenan (Lincoln: University of Nebraska Press, 1988). See also Werner Hamacher, Neil Hertz, and Thomas Keenan, eds., *Responses: On Paul de Man's Wartime Journalism* (Lincoln: University of Nebraska Press, 1988).
8. See, most notably, Luc Ferry and Alain Renaut, *French Philosophy in the Sixties: An Essay on Antihumanism*, trans. by Mary Schnackenberg Cattani (1985; Amherst: University of Massachusetts Press, 1990).
9. Evelyn Barrish, *The Double Life of Paul de Man* (New York: Norton, 2014). In her preface to the biography, Barrish claims that de Man 'wielded more influence on intellectual ideas than on any other voice either here [in the United States] or abroad' (pp. xiii–xiv). Famous, charismatic, and deeply influential, de Man haunts us—and perhaps infects us—with his contradictions. On Heideg-

ger's 'black notebooks', see, for instance, Philip Oltermann, 'Heidegger's "Black Notebooks" Reveal Antisemitism at Core of His Philosophy', *Guardian*, 12 March 2014, http://www.theguardian.com/books/2014/mar/13/martin-heidegger-black-notebooks-reveal-nazi-ideology-antisemitism [accessed 1 September 2015].

10. Wolin, *The Seduction of Unreason*, xiv.

11. Derrida, by contrast, argued as early as 1983 that 'it is impossible, now more than ever, to dissociate the work that we [i.e., professors] do, within one discipline or several, from a reflection on the political and institutional conditions of that work'. In sounding like a fairly orthodox Marxist here, Derrida makes the point that social and cultural institutions such as universities could not be reduced to a metaphysical 'essence' alone; rather, their political and institutional conditions permeated its 'norms, its procedures, and its aims'. And thus its defence (against liquidation, against liquidization) was necessarily political and institutional rather than metaphysical as well. See Jacques Derrida, 'The Principle of Reason: The University in the Eyes of its Pupils', *Diacritics*, 13.3 (1983), 2–20 (pp. 3, 9).

12. See, for instance, Jacques Derrida, *Archive Fever: A Freudian Impression*, trans. by Eric Prenowitz (Chicago: University of Chicago Press, 1995); Jacques Derrida, *Specters of Marx: The State of Debt, the Work of Mourning and the New International* (London: Routledge, 1994); Jacques Derrida, *The Postcard: From Socrates to Freud and Beyond*, trans. by Alan Bass (Chicago: University of Chicago Press, 1987), discussed below.

13. See Paul Feyerabend, *Against Method*, 3rd ed. (1975; London: Verso, 1993).

14. Feyerabend, *Against Method*, p. 34.

15. Ian Balfour, 'Difficult Reading: De Man's Itineraries', in *Responses: On Paul de Man's Wartime Journalism*, ed. by Werner Hamacher, Neil Hertz, and Thomas Keenan (Lincoln: University of Nebraska Press, 1988), pp. 6–20.

16. Jacques Derrida and Elisabeth Roudinesco, *For What Tomorrow: A Dialogue* (Stanford, CA: Stanford University Press, 2004), p. 13.

17. Derrida and Roudinesco, *For What Tomorrow*, p. 14.

18. Derrida, *The Post Card*, p. 444.

19. Wolin, *The Seduction of Unreason*, p. 222.

20. Jacques Lacan, *The Seminar of Jacques Lacan*, book 2: *The Ego in Freud's Theory and in the Technique of Psychoanalysis, 1954–1955*, trans. by Sylvana Tomaselli (New York: Norton, 1991), p. 205.

21. Derrida, *The Post Card*, p. 57.

SEVEN

Techno-criticism and/against the Value of the Flesh

Fabienne Collignon

In the prologue to his book *The Culture of Redemption*, Leo Bersani writes about the 'concentric circles' he's been tracing in his work, 'constituted by movements at once amplifying and replicative' and circling around the recurring questions and relations between cultural authority, selfhood, sexuality.[1] The following chapter is at once an engagement and a working through of that replicative act of engagement with a particular figure that obsessively returns in my work: this chapter runs concentric circles around Paul Virilio as one of the most influential and highly problematic critics of techno-culture. Where Bersani time and again focuses on and reacts against the 'sacrosanct value of selfhood'—the self, he observes, 'is a practical convenience; promoted to the status of an ethical ideal, it is a sanction for violence'[2]—the most pernicious aspects of Virilio's writings concern his humanism, itself a 'sanction for violence' which it hides, walls up, in hallowed silence.[3] I concentrate on a few of his later works, *Strategy of Deception* and *Art and Fear* above all, where this humanism emerges most forcefully, and use them as an opportunity to address the relentless recurrence of hydra-headed man in a discourse that exercises, in its critique of technologisation, the tyranny of the human disguised as care, compassion—senti-

ments that inform Virilio's practice of thought but also legitimise a force of law that is not, cannot be, exempt from a politics of harm.[4]

What follows is an investigation of Virilio's work from the position of a shifting post-humanism against the restorative logic, to save and monumentalise the 'human', perpetuated in his writings; by shifting, I mean a porous kind of writing, excessive, to indicate the fact that I am not whole, take pleasure in a text of bliss, a site of loss, that threatens to dissolve the writing subject.[5] Words 'perch . . . , flock . . . , fly off . . . ', in a text, 'marbled, iridescent',[6] that performs post-human criticism by oscillating between animal studies and the mechanical 'iterability', to use Jacques Derrida's term, of the so-called human in order to insist on a critique of techno-culture that does not proceed from, or wish to return to, that space of the mythical, abyssal 'man', against the machine. The point is to interrogate the technological, specifically, the machinery of the state, state biopower and endless war, the exceptional condition of siege obsessed with the consumption of security—hence the importance of Virilio's work, concerned, as it is, with what he calls an 'economy of survival',[7] the extensive dimensions of war, the indeterminacy between progress and ruin: 'Apocalypse is hidden in development itself'.[8] And yet, his critique operates outwards from an imagined stable centre, that is, 'human nature', permanently assaulted by dromocratic intelligence behaving as 'strategies . . . of depletion';[9] the 'human' interior is all meaning, while outside, technological forces threaten the integrity of the subject. In response to a techno-criticism that saves the 'human', puts it in reserve,[10] I propose a discourse of opposition to such safeguarding desires, a discourse functioning as a practice of resistance as 'oblique, interstitial, disorganising, incorporative, or proliferative' as it is oppositional.[11] In 'Posthumous Critique', Marjorie Levinson suggests various strategies of play, twelve steps, a veiled reference, perhaps, to the AA programme—which is a gift, the potential to '[abide] . . . between heartbeats', in 'the Now,' only now, in the 'space between each heartbeat'[12]—to counteract the ease, at least, with which critique is recuperated by the economies of the dominant culture; she mentions, in step three, a type of 'wrighting' (writhing?) 'in the sense of (a) crafting, (b) inscribing, (c) steadying or correcting, meanings that both mesh and collide'.[13] Meshing, collisions effect pleasure but also, I hope, provide the ability to perform, with difficulty, through 'overcrowding' (step two) or 'chest-bursting' chaos,[14] acts of reading/writing that try to enact the in-human (residing, but repressed, within) multiplicities that constitute 'me' and thereby destabilise

the coherence and continuous presence, both imagined, of the subject. Saying that, pleasure or bliss occurs largely on the level of the narrative performance; it does not form the core of the argument which, instead of naively euphoric, is concerned with an ethical duty toward the other, rightless ones, with the fundamental, foundational violence of 'human' integrity, so as to permit the exploration of disturbances in the conception of the subject as 'human', not as abstraction, but as embodiment, translated as alertness to suffering, and vulnerability, to permit (a utopian claim) the possibility of justice.

My title suggests a deconstructive approach to that subject named 'human', that appellation by which 'we' call ourselves, 'we who recognise ourselves in that name', and who have, therefore, 'been involved in an unprecedented transformation' that 'affects the experience of what we continue to call imperturbably, as if nothing were wrong with it, the animal and/or animals'.[15] This right or authority, an auto-nomy, linking self-naming to the concept of self-governance, instigates what Derrida, in 'The Animal That Therefore I Am', calls a 'limitrophy', relating to that which 'sprouts or grows at the limit, around the limit, by maintaining the limit, but also what *feeds the limit*, generates it, raises it, and complicates it'.[16] Derrida's text, more than an invitation, is an injunction: my subject, too, is that limit, the defamiliarisation of said limit, approached, to begin with, by giving 'ourselves' another designation, one that suggests at once worth and worthlessness (as well as horror, which remains, here, largely latent, though it offers ways to think about the 'world-without-us')[17]—flesh: dead, commodified, appraised, sold. 'Flesh' is a word that implies the lack of a response, an act of violence which reserves no rights for its bearer, reified into an object, and thereby also seeks to establish a correspondence between 'me', the meat of my body, and others, who are assigned a name that grants and gives nothing. The practice of an appellation as dehumanisation, which encourages an inability to disassociate my flesh from the flesh of the 'animal', puts 'us' into a circuit of relations where the potential for a shared being-with others is multiplied, swarms, mobilises. Not a fetishisation of victimhood, as such, but a project which propounds that a critique of techno-culture cannot function if undertaken from the untenable perspective of the 'human' as totality-fantasy; a project that has to recognise, lay itself open to, questions of integrity, to what makes up 'my' interiority. Technology is, after all, already internal (while writing always comes from elsewhere), a recognition of alterity that does not involve condoning

and accepting the technologies of the state or its narratives of teleo-
logical progress but is, rather, an awareness that refuses to formu-
late any such opposition 'in the name of' the purity and self-deter-
mination of a being, re-fused, instead, with that inhabited otherness,
non-human, in-human. Post-humanist techno-criticism, then, which
attempts to think otherwise, against the 'human' rendered as flesh
in a practice that articulates the subject, in the service of the machine
(it is machinic, and, as if automatically, takes up its assigned place
in the order of things), in terms of a becoming-other, of an ethical
movement toward the other that also functions as an act of contesta-
tion of the powers that be, the politics and techno death cult of the
state of exception.

THE STATE OF THEIR ONGOING ART

Paul Virilio ends *Strategy of Deception*—written largely during the
Kosovo conflict in the late 1990s and a book that continues Virilio's
investigations into/against what he calls, here, elsewhere, 'pure
war'—with a reference to the Nuremberg Laws, passed in Septem-
ber 1935 and linked to the discovery of a file bearing those laws,
swastika sealed, in the Huntington Library in Los Angeles in 1999.
General George S. Patton recovered the documents in 1945 and
sheltered them in the vault of the library, a bombproof 'Pandora's
box' that consigns together, saves and preserves a secret, unveiled
thing unveiling both old and new eugenic laws.[18] Virilio's discus-
sion is framed at once by a particular war, the 'humanitarian' con-
flict in the Balkans, and one that 'can justly be described as a hun-
dred years war', a comment that refers to the failure, ongoing and
over the last century, of the European community 'to provide any
kind of political sovereignty',[19] an 'entirely other Europe',[20] to
counteract the political, military, and economic hegemony of the
United States. The vault archives the murderous functions of the
Nazi state but also opens up, yet again, to that transfer of power
from Germany to the United States in the aftermath of World War
II: biopolitical *technologique* and rocket technology working at the
level of a 'race' and racism, regulating 'my' life, making 'me' live
over and against the (mega) death of the other.[21]

As such, Virilio considers the 'humanitarian' intervention in Ko-
sovo in light of a particular file, the code of discrimination against
Jews, put on display in Los Angeles, California, which Laurence
Rickels, in a different context, interprets as 'death cult'; in Rickels's

analysis, California functions as the site of convergence between critical disorders, 'the refusal to mourn or acknowledge death', while dependent on 'technological cabling system[s]' supporting its 'liveness' or undeadness.[22] At stake in this chapter, however, is not the movement by which psychoanalysis washes up on the coast—Rickels's project in *The Case of California*, amongst other works—but the techno-culture death cult that forms the heart of Virilio's writings and which, in *Strategy of Deception*, finds its epicentre (like Thomas Pynchon's stray V2 in *Gravity's Rainbow*) in Los Angeles. It is here, at the Skirball Cultural Center, that a file goes on display, compelling Virilio to remark on the 'terrible secret'[23] on which politics, as 'form of war' and work of death,[24] rests: the racism which is, according to Michel Foucault, 'inscribed as the basic mechanism of power . . . in modern States',[25] the death-function that Achille Mbembe, following Foucault, calls by another, but really the same, name, that is, necropolitics, absolute hostility directed at and towards the unassimilable other deprived of 'humanity'.

What emerges in the last few pages of Virilio's book—there is nothing new here but the recurring, interminable critique of a 'Deathkingdom'[26] articulated through technology that is and remains military in origin and purpose—is an attempt to address bioethics and biotechnologies, the determined intentions of which are, and this becomes clear by reference to the Nuremberg Laws, eugenic: an 'ethics' whose 'terrible secret' is biopolitics ('ethics' as biopolitics) but also post-humanism as cannibalism and identical to terminal Nazi politics. Virilio's argument centres on an observation about a 'new "science of man"', historical and still in force,

> in which not only the nominal identity of individuals was denied, but their *anthropological identity*, their belonging to 'humanity', the living body of the human being becoming an object of experimentation and a *raw material* in a period of extreme shortages.[27]

The mechanisms that Virilio identifies, and which are, to a large extent, coextensive with Nazism, are those biopolitical operations that intervene in the 'nature' of the 'human', as if released by the archival 'secret' of fascist laws: the 'industrialisation of living matter', the artificial selection of 'the human race', the biotechnological processes that mark the limit, the end point, of what will finally have been abolished: 'human' history, 'human beings'.[28] Virilio cites Francis Fukuyama, writing on the 'last man', an exhaustion that Fukuyama, just as in 1989, declares as triumph ('*a new posthu-*

man history will begin'):[29] last words as indicative of a century, and continuance, of atrocity.

Virilio's position is clear: he stands against the 'ravings of [anthropophagic] gurus', the destruction of *Lebensraum* (life-world into cell death), 'weapons ecosystem' as atmosphere, a military climatology that has been in (air) force since World War I.[30] While Peter Sloterdijk identifies 22 April 1915 as the beginning of that air-death '*leit*-phenomenon',[31] in Virilio's book, the strategy of climate control—total war as environmental war—is much less identified with a specific moment, a date, than with a trend, or escalation: poison gases, magnetic storms, 'great disturbance[s] . . . on the scale of a whole nation's meteorology',[32] successive stages of a 'pure' war that ends, but never ends, with a reference to Kosovo. What the bombing campaign in the Balkans did was instrumentalise humanitarianism as 'force multiplier' for the US government:[33] military intervention as humanitarian activity, which has since been interpreted to hold the function of a counterterrorist measure. This war, a TV war in that various news agencies bestowed a 'saintly glow' to US foreign policy,[34] occasioned a shift in the coordination of humanitarian aid, used in order to wage a 'just' war, or a war of 'just' aim,[35] thereby modifying, if not exclusively, the processes of relief agencies that, prior to the end of the Cold War, had acted, as far as possible, with respect to their 'first principles', that is, neutrality, independence, apolitical compassion.[36] Michael Barnett describes how this shift, a 'global mobilization' of relief—'care' as 'status category'[37] legitimising the 'open mouth' of empire[38]—disturbed the motives and activities of providing aid and, more than this, the structure of humanitarianism and its role in the 'international sacrificial order',[39] which aid agencies, regardless of their help in reducing the number of sacrificial victims, fundamentally uphold.

If Virilio is less concerned with the causes of this type of intervention—his study is a polemic—the process of 'becoming-state', not at all used in Gilles Deleuze and Felix Guattari's sense but indicative of an integration into the organisation of the state, nonetheless impels his argument directed at codes of conduct, the art of 'virtuous war', that ostensibly 'value' the 'human' all the while absolutely devaluing civilian life, or life on the ground. Ethical limits really are only strategic;[40] it is the 'vitality' of the empire that, recruiting more and more political actors into its service, determines who is worthy (the 'deserving poor')[41] and who falls victim to its sacrificial order. The nobility of humanitarianism, according to Virilio, has been lost—or, at any rate, its first principles have: to refrain from taking

sides, to self-determine actions, to base provision on need (rather than promised or delivered as incentive to co-operate, in exchange for information, and so forth)—and never mind, for now, the nostalgia that is so integral to his project. Need is conditional, as is help, which doubles up as interest; cosmopolitanism, the ethos of relief agencies,[42] is perhaps best, and at best, understood as pragmatism, what Cary Wolfe terms *Real Ethik*,[43] but certainly not as duty (never a duty, as Barnett has shown) to reorient the politics of the state.[44] Worse, though, than that failure of duty, the 'madness of the impossible'—to transform the law, beyond the law, to bid welcome, to all others, to all those yet to come[45]—are those 'humanitarian' wars fought for 'values' (e.g., strategic advantages) legitimising conflict which, at the same time, is also rendered endless: there is no alternative, in opposing 'the enemy of the human race', to total war.[46] Here, then, those echoes of Nazism, put into reserve and saved as exceptional measures, special kinds of law, that speak the odd, 'kenomatic'[47] law of the state of exception, 'Project Democracy'[48] that suspends itself and the 'nominal identity of individuals' as belonging to the 'human race'.

What is admirable—though this is, perhaps, the wrong word—is the economy of bile at work in *Strategy of Deception*, and if Sam Ladkin begins his paper 'Against Value Is Not Enough' with a reference to precisely such an order, or expenditure, then I would like to follow suit. 'This is motivated by an anger and a hate and a bile that's impossible to swallow back down and digest', Ladkin writes and proceeds to cite the filmmaker Ken Jacobs, describing his childhood as 'disastrous but typical, bequeathing me a social disgust and anger that I have cultivated, refined, monumentalized, and I am gagging on'.[49] The genesis of Virilio's book(s), like that of the present project, is political disgust directed against the contemporary moment, which, in Virilio's case, is also very evidently the moment of modernity which, according to Sloterdijk, entails the 'explication' of the background into the foreground,[50] inaugurating ecologised warfare: the air as weapons ecosystem, the chain reactions that engender an interminable war with all its attendant 'nodal' conflicts,[51] the global dominance of a panoptic superpower— these are issues that not so much structure his writings as compel Virilio to write. His motivation is, consequently, the insufficient valuation, or total devaluation, of certain kinds of human life, cannibalistically integrated/ingested into a techno death cult that keeps safe fascism, in the form of a bio/necropolitical system that determines 'what must live and what must die'.[52]

In *The Vampire Lectures*, Rickels, following Friedrich Kittler, argues that the media technologies that apparently oppose Dracula—the typewriter, the 'new woman' archiving data—represent a 'double of vampirism, a kind of new and improved vampirism, and [do] not so much defeat vampirism as replace [its] antiquated recycling system of death and the dead with the live transmission of gadget love'.[53] If Rickels identifies that death cult at the undead heart of techno-culture, which substitutes an outdated vampiric system of circulation with another, much more powerful one (gadget love as operating 'beyond the Dracula principle'), then Virilio's attention similarly converges on that 'missing place'[54] of death or necropolitics as motor of 'dromocracy'. This death cult is invariably linked to Nazi Germany and its *Menschenvernichtung*, as Virilio establishes in *Strategy of Deception*, with its attention to the Nuremberg Laws, containing, 'in germ', everything that '[has] become reality'.[55] Experimental sciences, by which Virilio understands that 'new' eugenics, promoting the 'artificial . . . selection of the human race', put forward the same old (bio)politics—'death has always been the source of Their power', as Father Rapier argues in *Gravity's Rainbow*:

> I think that there is a terrible possibility now, in the World. We may not brush it away, we must look at it. It is possible that They will not die. That it is now within the state of Their art to go on forever—though we, of course, will keep dying as we always have.[56]

Harvests that 'we' are, Virilio's indignation speaks for 'us', preterite, subaltern, those of 'us' who are passed over; yet however much he resists the reification of a living being into a dead thing—as raw material, object of experimentation—the logic that underpins his argument nonetheless has to be called into question. If his writings function in terms of a reparative impulse, attempt, perhaps, to redress laws beyond the law, the ethical position that they seek to articulate remains deeply problematic in a number of ways, not least of which is the claim to speak for the other. The process of acceleration forms one of the major concerns of his work: dromological technique as act of aggression against a proper 'human' subjectivity, sovereign as well as sacred, a politics which, as Virilio's 'dream reader', I have to betray. In *Acts of Literature*, Derrida describes a 'dream reader' as someone who belongs to a writer's dream, takes part in it, shares it, walks around in it: the work produces the reader whose countersignature can be deliberately disloyal, so that the rupture or ruin I seek, here, all the while responding

to Virilio's main object of inquiry, that is, technological violence, relates to a specific confirmation/installation of 'humanity' that Virilio keeps safe.[57] Dream reader, then, my function is to betray this order, to continue an investigation into the necro-technological, but without having recourse to the exemplary, abstract subject of 'man', to instead read Virilio in terms of a potentiality, by betraying, as such, his conservative discourse, precisely precluding that experience of what might become actual, might let something (not) be.[58] In his books, it is often difficult to discern any possible counter-conduct to what appears as an overwhelming force—the organisation of the state into a permanent, illimitable state of siege—though the composition of the texts themselves attests to an undertaking that could be, but isn't, committed to utopian thought, used in the Derridean sense: utopia not as fantasy end point/dream kingdom but as interrogation that behaves as a resolutely, and interminable, political project.

These Derridean terms to think through Virilio's contribution are, though, misleading, or lead off elsewhere, because they are indicative of my countersignature of his work, which becomes a task I understand as deconstructive, that is, an operation of deconstruction as justice (and therefore utopian), starting 'by destabilizing, complicating, or bringing out the paradoxes of values like those of the proper and of property in all their registers, of the subject, and so of the responsible subject, of the subject of law (*droit*)'.[59] My response to Virilio occurs in light of this particular intervention that happens on the basis of an 'original' text, but a text whose politics, rather than radical—it contains these possibilities in an act of reading as act of betrayal[60]—is conservative, nostalgic, expressive of a spirit of loss as well as anger, or, rather, moral outrage, the latter especially evident in *Strategy of Deception*. Nostalgia is not, per se, reactionary, and neither is stillness, if that is what Virilio is looking for in the face of all that vectoral power; the refusal to participate can, after all, be suggestive of pure potentiality, a reference to Bartleby, to the scribe who stopped copying, the exhausted figure that through this act of suspension affirms the 'experience of the possible as such'.[61] Nostalgia can similarly be countercultural; Alastair Bonnett, for one, examines its long tradition emerging in the context of political radicalism: nostalgia evidently acts as a 'site of provocation', is symptomatic of the alienation of the subject in late consumer capitalist culture, and itself behaves as an 'alien presence' within revolutionary practices, so often intent on (violent) processes of change, even if it is also linked to 'an ethos of subversive local-

ism'.[62] Virilio's project reacts to the energies/catastrophes of the
state of exception, and it does so by way of a logic of writing that
disturbs the order it is writing against, but whose politics, subver-
sive up to a point, occurs in the name of what John Armitage calls
'sacred humanism',[63] a sacralisation of the 'human' as a being that
once existed, unmediated, unmade, (e.g., 'naturally', or automati-
cally, the haunted, repressed order). The tendency of Virilio's writ-
ing is not, unlike Derrida's, to look towards that which is still to
come, that impossible movement expressing 'the very figure of the
real',[64] but is associated with what no longer, yet has never, existed
(a subject fully present, who coincides, is coherent), and neither
does it conduct an analysis of the past that brings it, to cite Walter
Benjamin, 'into the present in a historical apocatastasis'.[65] That is,
Virilio's perspective is backward-looking to a fantasy of 'man' that
mythologises, sacralises this 'innocent' figure, while it also gives the
distinct impression that his critiques of the present order come too
late, are, in fact, aware of their impotence, that nothing can go up
against a violence of *technique* and *technique* of violence directed at
'us' at every turn: it is as if his texts really only ever speak of late-
ness—too late, there is nothing to act on. Whatever arises as a result,
out of this angle of vision—whose possibility is denied: the past
remains irrevocable—has to do with mourning an ideological prop-
erty, yielding a conservatism which operates precisely as a force of
that value of property and of the 'proper'.

THE VALUE OF THE PROPER

In 'N: On the Theory of Knowledge, Theory of Progress', a fragment
on the composition of *The Arcades Project*, Benjamin describes his
montage, opposed to narrative trajectories towards a conclusion or
a world that keeps functioning according to their endless art, as
wanting to 'preserve the intervals of reflection, the distances lying
between the most essential parts of this work', so as to find, some-
where in those absences, spaces of possibility, a 'constellation of
awakening'.[66] In a sense, Virilio's work finds, or traces, such a con-
stellation, whose potentiality he also concurrently disables, while it
persists in a realm of dream: it might well refuse the myth of
progress by insisting, for example, on a process of 'inversion',[67] in
that every technology produces a specific accident—the inversion
therefore concerns a shift in focus to include those accidents—but
his argument nonetheless occurs on the grounds of a phantasma-

gorical figure that I find impossible to defend. In *Strategy of Deception*, Virilio clearly seeks to shield this figure from harm against the always racist biopolitical measures, death-functions, of a state against those 'subjects' it expels, kills, or allows to be killed. This protection is an assertion of value, the value of a life, in light of faceless bureaucratic planning/killing, the cannibalistic 'secrets' of a new eugenics, but, as Ladkin observes, despite the 'injuries [that] are clearly legible on the body politic', as well as elsewhere, everywhere, it might be that this defence of desolate life adds to the violence against destitute beings, ongoing and already done.[68] This is a difficult position to hold in the context of Virilio's argument: dissent against it means, at first glance, an alignment with those that instrumentalise life, deny individuals their anthropological identity, subject them to a regime of truth whose operations—codes of discrimination, orders of extermination—are fascist. When, at the end of the book, Virilio mentions post-humanism, this practice of thought becomes coextensive with *Menschenvernichtung*: it is less a mode of critique than an indication and continuation of eugenic laws, the murderous functions of the state which I condone and in which I participate. To propose, then, that a defence of a harmed life might itself be harmful looks like an untenable position—how to even be able to refuse shelter—and yet I'm compelled to argue against the 'sacred humanism' that Armitage celebrates in Virilio's writing: it is unjust, refutes scrutiny when it should not be exempt from it, despite/because of the line of inquiry that initially appears so repellent.

In 'The Valuation of Nature', Kathryn Yusoff writes that value 'is a means of producing differentiation that is always interested, in the sense of how value designates what matters, to whom, and where (ontologically and geographically)'.[69] There are, she continues, always values invoked in the act of valuation, and while she is concerned with the 'bio-capitalization of the . . . world', meaning, in this case, a process of ostensibly 'off-setting' damage by replacing one life form with another, different one, each of which becomes 'equally substitutable',[70] her analysis suggests a way to begin responding to Virilio's act of valuation. The latter is framed in terms of a rhetoric of care for those that suffer; yet an indication of the value that motivates the task of writing emerges when Virilio talks about how the 'experimental sciences', chemicals, pharmaceuticals, biotechnologies, 'have today largely been diverted from their proper purposes'.[71] Here, then, a word on which hinges fracture or deconstruction: there is something proper to purposes and beings, some-

thing appropriate, suitable, apt, decent, hitched to ideas of belong-
ing and essence—a word that slips, undoes the articulation or pre-
tence of neutrality, a hinge that marks the invocation of value, of
that which is proper, in the ideological act of valuation. The figure
for which Virilio speaks exists in terms of this word/hinge—in a
'small, individual moment [lies] the crystal of the total event'[72]—
that is, in terms of what is apparently 'proper' to a human being;
dignity, autonomy, species membership in a privileged group, all of
which are refused to certain kinds of people, whose status is subject
to approval so as to manage (my; our) life. He claims, of course, to
uphold the discourse of human rights—which changed with the
Universal Declaration adopted by the United Nations General As-
sembly on 10 December 1948; the first article states that 'all human
beings are born free and equal in dignity and rights'[73]—but what is
absent is an engagement with the foundational violence at the heart
of the document. It implies, right from the start, an essence 'proper'
to the human—I hold rights 'simply' by virtue of being born hu-
man—thus naturalises a political act, because I become subject only
under certain political and technological conditions such as citizen-
ship, but not in the 'abstract nakedness of being nothing but hu-
man', undocumented, paperless (*sans-papiers*).[74] The circumstances
of birth itself, 'simply' being born, such an apparently 'natural' fact,
as Roland Barthes notes, even though there are conditions that have
to be met, 'must be inserted into an order of knowledge, i.e., we
must postulate that they can be transformed, indeed submit their
"naturality" to . . . criticism'.[75] The document, proceeding from the
'naturality' of birth, rights that are granted because I am 'nothing
but human', fails to acknowledge that equality is not 'proper' to the
human in its nakedness but an 'attribute of the *polis*', so that it
effectively is an attempt to 'reduce politics to nature'.[76] As Alastair
Hunt, following Hannah Arendt, argues, 'Being human is not mere-
ly politically meaningless'—abstract nakedness is indicative of be-
ing absolutely without rights—but 'a dangerous biopolitical propo-
sition', in that the declaration is fundamentally complicit 'with the
conditions that produce rightlessness', because it 'mobilizes the
same biologistic logic evident in racism'.[77] Certain prerequisites,
mechanisms of legitimation, an order of knowledge, are necessary
to be considered 'human', a definition that also only appears be-
cause of a 'caesura or . . . cut within the living in general': to declare
human rights is also to declare the rightlessness of all non-human
others, which it effaces, passes over, or walls up in silence.[78]

What is 'proper' to the 'human' according to Virilio, then, shapes a pernicious order of being that does not function as a being-with others but is based on their subjection, interventionist violence structured around an abyss, between me/us and unthinkable others:[79] to assume that 'sacred humanism' is not cannibalistic, has nothing to do with fascism, is to keep deploying that same logic, technologies of power that allowed, and keep sanctioning, systematic institutional and genocidal violence. Virilio's defence/valuation of naked human life in *Strategy of Deception*, but also in, for example, *Art and Fear*, ostensibly functions against the 'profanation of forms and bodies' that took place 'over the course of the twentieth century', in which the Nazis, so Virilio thinks, might have lost the war but won the peace: 'Hasn't the universality of the extermination of bodies as well as of the environment, from Auschwitz to Chernobyl, succeeded in *dehumanizing us from without?*'[80] *Art and Fear* consists of two lectures, of which one discusses what Virilio calls a 'pitiless art', art that anticipates/participates in catastrophe, which is 'monstrative' and shatters, is linked to bioengineering (the new eugenics), a 'transgenic art' as show of horror: 'We are now supposed to *break the being*, the unicity of humankind'.[81] Necro-technological, teratological, contemporary art is 'without limits . . . without value', because it disappears the body, 'fragile of flesh', into the machine — pitilessness refers to the inhuman, the 'counter-natural' and improper, is attributed to an art in complicity with Nazism.[82] This critique might not come as a surprise, considering that, throughout his career, Virilio has opposed the human to the technological; in his earlier writings—*Speed and Politics*, *The Aesthetics of Disappearance*, and *War and Cinema*—this (false) opposition is relatively latent, just as his studies are more measured, careful readings of a culture that is always at war. These works always have been, at their core, a defence of the 'human' and of humanism, attempts to safeguard the body against disappearing technologies—an 'aesthetics' that functions in two ways: technology that makes disappear and disappears itself—but their arguments admit readings, countersignatures, which betray that humanism all the while confirming the rest of Virilio's 'odd and oblique'[83] scholarship. In *Art and Fear*, by contrast, there is only a blind, boring, undifferentiated outrage at work, but not really an engagement with the forces that pose 'blinding' threats.[84] It is in this book, if also in *The Aesthetics of Disappearance*, that Armitage finds the grounds for his claim of Virilio's 'sacred humanism', which he describes as follows:

Sacred humanism—with its historical roots not in dedications to, or the setting apart for, the worship of a deity, but in the appearance at the time of the Renaissance of a system of thought that rests on human values, interests, needs and, especially, the welfare of humans—signifies a concept focused on a concern for human interests, values of rationality, the nobility of freedom and a sincere acknowledgement of human corporeal boundaries and mental limits. Sacred humanism is thus dedicated to the study of the humanities as something venerable, to learning in the liberal arts as something worthy of respect, or, in philosophical and aesthetic, artistic, and cultural terms, to a broadly hopeful account of the ability of humanity to further itself through respect for knowledge.[85]

It is my turn to gag and be repelled: at the holiness of man, abyssally set apart, whose well-being is achieved through the sufferings of countless others, a history of atrocity disregarded in the consecration above, which absolutely insists on that setting apart it denies—at stake, here, might be vulnerability, but this sacralisation is border control, a system of defence that mythologises the human, noble, rational, free, sincere. It is odd that the narrative of progress Virilio resists (at least in terms of vectoral, that is, technological, improvement; technology is speed) returns to defend the value of the humanities, which 'redeems the catastrophe of history', as Bersani argues; art, in order to be pitiful, must be morally monumental,[86] ennobling in its function, saving the 'human' from its animality, its technologised being, and, above all, from the consequences of history and the logos, itself saved in favour of a duty to think oneself naked before the non-human other.[87] 'Sacred humanism' is a thesis of enforced limits;[88] based, as it is, on the 'basic coordinates of liberal humanism', it does not encourage or account for 'new lines of empathy, affinity, and respect between different forms of life, both human and non-human', which could be articulated as a 'shared trans-species being-in-the-world',[89] thereby awakening, if never preparing, 'us' to the obligations 'we' have with respect to the living in general. What Armitage and Virilio, by extension, are arguing for in their respective, apparent valuations of naked human life is actually its destruction or, at any rate, its inconsequence, an easiness with which nakedness is dismissed, not protected or defended: the deity is the liberal humanist subject (rational, autonomous, and so forth), more specifically that subject who can 'further' himself through 'good', pitiful art, but whose duty (or pity) does not extend beyond itself or himself, his self-sameness. What lies before this

subject is a duty he takes in his own name, for his own 'values, interests, needs and . . . welfare', but not, as Derrida writes, 'in the name of the other or of oneself as other, before another other, and an other of the other', which constitutes a duty that goes beyond debt, owes nothing, and must 'exceed all calculation'.[90] In *On the Name*, Derrida considers the problem of duty not as something that 'lies before you', which above all necessitates an 'approach from the front', but suggests that we do so obliquely, by 'demanding obliqueness by name even while acknowledging it . . . as a failure of duty',[91] that duty beyond debt which insists on being carried out infinitely, is experienced and endured aporetically, that is, is always incomplete, suspended, unresolvable.

If, as Emmanuel Levinas argues, 'access to the face is straight-away ethical',[92] an approach to the face of the other is in effect anything but frontal, is instead effected by an obliqueness linked, for Derrida, to a verticality, as well as to an ethics without program: verticality as indicative of an event, that which cannot be anticipat-ed or foreseen but arrives in darkness, without being able to see it arrive.[93] Duty, ethics, a decision—though talking about them in these terms already implies that which they seek to avoid: a func-tioning according to some rule, a norm—occur as impossible mo-ments or arrivals from beyond, obliquely, vertically, and from be-hind the horizon of subjectivity. As François Raffoul explains,

> Impossibility does not mean: that which cannot be but rather: that which *happens* outside of the anticipating conditions of *pos-sibility* of the egological subject, outside of the horizon of expecta-tion proposed by the subject, outside of transcendental horizons of calculability. . . . The impossible is not what simply cannot be and is thus null and void, but is the opening of the event.[94]

To be face to face with an other, of responding to an other as other also means, then, that this other arrives from 'outside', is unseeable until she calls to me: I answer to this event of the other calling to me by turning, because this call, as David Wills shows, comes from behind—I cannot anticipate it, can't see it or prepare for it, so that a face-to-face encounter can only happen after a turn (which 'neces-sarily' refers to an 'erotic sensitization'[95] too). This 'dorsal turn' is, in fact, how the process of subjectivisation is itself accomplished; interpellation, rather than only a 'temporal effect', issues from a space behind, instigating an 'eternal ideology' within me that is also alien to 'me', this 'I' that I become, into which I am formed.[96] Con-stituted, as I am, through an imaginary relationship to an external

power, I come into being through a subject-formation which al-
ways-already manufactures me 'in advance'—the individual is sub-
ject before she is born, is 'appointed subject in and by' specific ideo-
logical configurations into which the 'former subject-to-be will have
to "find" "its" place'.[97] The process of subject formation hence per-
forms a paradoxical turn, at once anticipatory, designating a desti-
nation prior to my expected arrival, and hailing me from behind,
making me subject to a 'Unique and Central Other Subject', in rela-
tion to which I take my place.[98] This 'one-hundred-and-eighty-de-
gree physical conversion'[99] recruits me, always-already subject, in
the name of that absolute, central other, in which I misrecognise
myself; this process or turn, according to Wills, 'means accepting
the unassimilable foreignness'[100]—ideology's mythical naturalness
installing commands, inside,[101] disavowing its origination from
elsewhere—of that misrecognition as part of myself. This 'fixed resi-
dence', the assigned place I occupy as subject, however, comes at
the expense of expelling other others, a 'small animal', a wolf-being,
say, that Louis Althusser mentions and Wills overlooks in favour of
a fundamental, but similarly denied and jettisoned, technologisa-
tion within me, itself there from the start (and of which more later):
the 'Law of Order', the 'Law of Culture', which shapes me into
either a masculine or a feminine subject, requires that I pass from a
'purely' (naked, hence rightless) biological existence to a 'human'
existence through a process of what Althusser calls 'forced "human-
ization"', marking me off as 'human' and nothing other.[102] This
subject that I am, as much as I am always-already subject, is simul-
taneously always-already displaced, appointed as 'human' by an
oddly external (from behind) and (in advance) already internalised
structure that is inevitably one of misrecognition, abyssal division,
of expulsion and, at the same time, 'endo-colonisation'.[103] The ideo-
logical force that, setting itself up inside me, lodges in what I mis-
take as the centre of my being the misrecognition of being uniquely,
at the exclusion of everything else, 'human':[104] the wolf-thing that I
am, and might have been, that I might, illegitimately, improperly,
mourn, has no place in this order, haunted, consequently, by all that
which it shuts out, all those others within and outwith 'me', and
towards which my duty has to extend.

To return, then, to *Art and Fear*, to that 'profanation of forms and
bodies' that Virilio perceives as operating in the service of a fascist
ideology—the 'terminal art' of Auschwitz-Birkenau—this 'impiety
of art', linked to genetic engineering, biotechnology, 'necro-techno-
logical' interventions at every level, 'break[s] the being' and its 'uni-

city'.[105] As such, the book, with its emphasis on wishing for/keeping the integrity of the 'human', operates on the basis of a 'redemptive aesthetic' attributed to art, which Bersani understands as 'anti-artistic', because based 'on the negation of life', inventing 'a "true world" as an alternative to an inferior and depreciated world of mere appearance'.[106] Pitiful art repairs that which shatters the human body, damaged by techno-science, crypto-fascist programmes: art, ideally, as reconstructive, not destructive or 'monstrative', that is, catastrophic to that 'unicity' under siege, in perpetual disintegration. What is everywhere apparent in *Art and Fear* is a 'mistrust . . . of precisely those modern works that have more or less violently rejected any such edifying and petrifying functions', a perspective that, to follow Bersani, 'conceal[s] a deep horror of life, since it carries within it the conviction that, because of the achievements of culture, the disasters of history somehow do not matter'.[107] The purpose of pitiful art is to restore unicity or unity, the nobility of an integral subject whose corporeal and/or psychic destruction is to be counteracted by cultural practices that render that subject as coherent, impermeable, and holy; this might be a question of rights, defending against all kinds of atrocious violations, but it is also a matter of perpetuating a violence, that same violence, it does not acknowledge. This force fails to recognise itself as such—there is a piousness at work in Virilio's book, in Armitage's response, that sees itself as exempt from an enforceability it ignores or of which it is ignorant—and that articulates itself as sensitive to a particular body, human and destitute, but in the process of its operations, its efforts to restore that body as whole and proper (in order to help make this 'I' proper to myself, make that body mine again),[108] it actually admits that it finds 'nothing sacred in the abstract nakedness of being human'.[109] Though apparently pitiful, in need of protection (and elevation: a high morality defines the culture of redemption), the nakedness or rightlessness of others, human and non-human, becomes the prerequisite that is necessary to 'save' a particular body (free, rational, noble; the Enlightenment subject) from dispossession and destruction. The classic determination of the human subject is, after all, already predicated on the sacrifice of those non-subjects without language, defined in narrow terms; at the heart of that conception of subjectivity is the effacement of the other, as well as the 'ingestion, incorporation, or introjection of the corpse',[110] in short, the rightlessness of the other, rendered flesh. The discourse of value and redemption, consequently—pitiful art as opposed to terminal art, art that shatters—on the one hand, author-

ises the condition of being rightless to others, while it concurrently acts in the name of a totality, the ideologically fixed destination of a 'human' being as discrete, unified subject: the self as ethical ideal. Such thinking is harmful and profoundly conservative, seeking a restoration to an imagined earlier state of things, to make proper the fantasy of 'humankind', whose foundation, like that of all laws, is a 'mystical' power, a 'violence without ground', and which is also unjust;[111] it is, at any rate, a fantasy of community that only ever recognised specific members, an integral self, a subject that can articulate itself as such, in my language or on my terms, as belonging to its 'genre'. The 'unicity' of the 'human' is intent on preserving laws whose responsibility falters at the limit of a being whose arrival I cannot anticipate, to whose naked face I don't respond, or whose faciality, 'holey surface, system', returns my own inhumanity to me, propers it back to me.[112]

WOLF-TECHNICITIES

The 'long forced march which makes mammiferous larvae into human children' — the repressed truth: 'we' are Thing-like, a void and impossibility which subjectivity refuses to confront[113] — into masculine or feminine subjects, transforms a small animal, 'wolf-child', into a human child.[114] Virilio's insistence on 'unicity' intends to ensure and enforce the domestication or aggregation of multiplicity into a being according to the 'codes of human assignment', the claims of the Law to which the child, no longer wolf, submits, which it 'receives . . . from its first breath'.[115] The issue for Virilio, as he states in *Art and Fear*, is a 'dehumanisation' from without; in the introduction to the book, John Armitage writes that Virilio 'cannot detach his thought from the event of Auschwitz', to which he is 'continually responsive'.[116] To raise nakedness into being 'human' forms, then, a major aspect of his work, but that effort perpetuates a politics of rightlessness and limited duty all the while participating in the centring of a subject that misrecognises itself as 'human'. It comes, as such, as no surprise that Virilio should be so hostile to post-humanism, which he misunderstands, at any rate, as transhumanism, necro-technological enhancement of an ambiguously naked being: but at stake in post-humanism is a sphere of responsibility — as Derrida keeps demonstrating, as Cary Wolfe, David Wills, and Richard Doyle continue to argue, following Derrida but also Deleuze and Guattari — that seeks to respond to the other in its

infinite alterity. A dehumanisation, if you wish, that begins 'at home', with me, inside me, yet not in terms of internalising the gaze of the dominant culture of myself as lesser, marked out according to race, class, sexuality, gender, ability, and operating, on the one hand, as a process of deprivation (in reference to a sense of feeling or being prey)[117] and, on the other, an experience of responsibility that comes from the recognition of myself as always-already other.

This should not be understood as an untenable position—if anything, it is the current way of being in the world that is untenable; the compulsive commands of this 'forced "humanization"' with its attendant, illimitable injustices—though its advocacy constitutes a (perhaps unresolvable) difficulty, in that it comes from a position of privilege. Considered human, I don't have to convince others, speaking now, of my 'nominal identity' as a human subject; I can (still, though for how long, under what circumstances) articulate myself as such, so that the irony here is that the realisation of being prey occurs precisely from not immediately being vulnerable, either economically, politically, physically, or psychologically. R. D. Laing might argue that this particular, precarious perspective can only come from what he calls an 'ontologically secure person', that is, someone with a 'centrally firm sense of his [*sic*] and other people's identity'; his work concerns itself with schizophrenics, frequently depersonalised, as he observed, in contemporary psychological practice, who, isolated and exposed, feel that they are 'made of glass, of such transparency and fragility that a look at [them] splinters [them] to bits'.[118] This awareness of suffering is meant, here, not to be replaced by a philosophical celebration of schizophrenia or other conditions of illness (despite Deleuze and Guattari's influence) but to consider, even if from a relatively 'secure', and still imagined, sense of 'presence', that ontological security is mythical, itself glass-like, in fact already splintered. To insist: the point is not to deny suffering but to let it 'become a wound'[119] by drawing attention to the 'human' as a fragile, splintered concept, which remains so, unfixed, and to re(-)fuse Virilio's project in so far as he seeks to restore its ontological security. The 'event of Auschwitz', according to Armitage, compels Virilio to argue on the basis of a reparative principle evident in so much post-Holocaust writing intent on making good the catastrophic damage done in the concentration camps, an apparently unquestionable gesture, which is, as Anat Pick observes, also seductive—'its goal is to assert human dignity in the face of atrocity'.[120] It is, however, a 'vacant' project, because that identity can't be recuperated and falls short of being able

to offer up, in its 'grandiose remembrance' and in the 'stillness' of its 'human commemoration', a 'responsiveness to vulnerability' towards that which Pick calls the 'creaturely' and which includes me, inhuman that I am.[121] Rather than monumentality, then—the Nazi regime, in a similar manner, sought the monumental, the 'totality-component' of the figure of steel[122] and, by extension, the reinvention of the 'race' and/or species, unstable concepts that can barely keep at bay the 'contagious proximity' between the human, non-human, inhuman—Pick advocates 'contraction, making ourselves "less human"'.[123] This contraction operates 'under the sign of *dehumanisation*' as ethical force, which, like an 'expectation for good' as 'grammar' of justice (a reference to Simone Weil), is 'profoundly inhuman', a responsiveness to vulnerability in the face of the overwhelming power of the 'human'.[124] As such, the decentring or contraction of the 'human' that this particular post-humanist practice attempts to achieve seeks a non-anthropocentric conception of justice through practices of reading/being that are open, citing Tom Tyler, to reading 'like a loser',[125] to putting myself—that being I have been socialised into since my first breath, even before birth, in my anticipated arrival—into conditions where that particular, integral I can somehow be undone: that would be post-humanism's excessive *ouverture* or aperture.[126]

Ouverture means a beginning, too; a post-human dis/articulation of the 'human' mobilises that subject as technological, animal, inhuman, from the start, a wolf-child whose multiplicity and being-with others are replaced by a 'dismal unity',[127] as Deleuze and Guattari write in *A Thousand Plateaus*. Their work is problematic in its own right, considering, for one, the interpretation, through schizo-analysis, of a mental illness as providing particular insights into being in the world that can be celebrated as resistant to a 'molar'[128] identity when the schizophrenic feels undead, emptied out, dreams of being eaten,[129] or when the destruction of a subject also corresponds to the regime of the torturer,[130] to the neoliberal project, intent on preventing a subject from intervening in the polis, while it also, of course, abstracts or encysts the living as dead things.[131] Deterritorialisation, derealisation, these now seem more like capitalist assets, though capitalism, as Esther Leslie shows, both freezes and makes fluid.[132] And yet, whatever other, and absolutely necessary, critiques must be directed at *A Thousand Plateaus*, the 'body without organs' (BwO) Deleuze and Guattari propose is not, under any circumstances, 'a dead body but a living body all the more alive and teeming once it has blown apart the organism and its organisa-

tion':[133] the issue is an argument against reification, not a process by which to determine whether some/thing is sentient or inert. Their work, informing so much post-human criticism—Doyle's, talking about body borders as thresholds, zones of intensities;[134] Jussi Parikka's study on modes of being as affective assemblages folding outside and inside,[135] to name but two—is also concerned with a hospitality toward the inhuman, which is already manifested in, and effectively makes up, the face,

> a lunar landscape, with its pores, planes, matts, bright colours, whiteness, and holes: there is no need for a close-up to make it inhuman; it is naturally a close-up, and naturally inhuman, a monstrous hood.[136]

'Year Zero: Faciality', a section title from *A Thousand Plateaus*, concludes with the following observation: 'In truth, there are only inhumanities, humans are made exclusively of inhumanities',[137] evident in the face, or, as David Wills argues, in the 'face beyond the face', that is, in what lies behind: 'the back, the behind, the dorsal relation'.[138] According to Wills, the face includes the back and the idea of the dorsal because of the vulnerability both express: there is nothing more naked than a back turned and offered, an offer of total exposure, one that invites wounding.[139] This turn, from the face to the back, towards that which lies beyond it, is technological: the limb performs technological movements repeating themselves, repetitions that also happen at the molecular level, in the self-division of a cell, entering into 'prosthetic articulation' with an outside.[140] As soon as there is cell division, the movement of a limb—etymologically a Latin word, a 'sense of articulation'—that cell/limb specifies the technological, the always-already technological, meaning that 'there never was any simple human':[141] 'we' have never essentially been 'human' but 'only' ideologically so, 'so-called humans', naming ourselves 'human'. Life is technologisation, because 'repetition inhabits the very moment of life': it is 'a process of self-replacement . . . a form of technics',[142] which, in order to face that origin, requires a turning around to simultaneously embrace a technicised being, or becoming-technicised, and resist the commodification of a living BwO into a dead organism. Wills's argument is an ontological one, in that he insists on the technicised articulation of the so-called, self-named, human; it doesn't, however, intend to blindly accept whatever biotechnological 'innovation' promises to either 'enhance' or else proceeds to harvest a subject—this last turn of argument is Marxist, opposing the reification of living beings who

function in a bio-capitalist order in which everything is for sale. Rather, the emphasis rests, as with Derrida, on an ethics that is not programmable in advance: the dorsal is an event that can't be foreseen, arrives vertically or from behind to (re-)define the 'human' as other, encounters it as 'beside' itself,[143] in a form (or amorphousness) that is technological, animal, inhuman and, as such, calls, from both inside and outwith, to other others whose arrival similarly can't be anticipated. To turn back, a technologised movement—and bearing in mind the process of interpellation—is then at once an act called forth from beyond/behind but is at the same time, prior to this hailing, already incorporated within, articulating the subject-as-technologised and whose duty reaches beyond itself (its contracted self), in a 'dorsal formulation' of an ethics as event, responding to that which can't be expected, giving itself up to that which it can't see coming, and exists beyond calculation.[144] A dorsal ethics (which can never be reduced to a set of rules or to a code) yields a sense of responsibility to face, turned so as to offer my back to, the other: responsibility as vulnerability, as unsettling, secret, 'radically' passive.

Based on fragility, finitude, an attention and attentiveness to the other which functions as 'regard without motive', that shared sense of vulnerability translates as exposure: to the other, to the other(s) within me.[145] If the 'human' only comes into existence due to a 'fundamental repression'[146] of all sorts of other in-human subjectivities that reside inside a 'person'—itself, like the subject, always a 'molar' identity, 'majoritarian par excellence', implying a 'state of domination'—then that process of repression consumes the reality of the 'human' as something (some Thing) that is made, assembled, mythologised, dreamed as 'man-standard'.[147] It is an imaginary being, a specular image of a totality, or majority—a reference to Jacques Lacan's mirror stage, manufacturing hallucinations of sensory-motoric wholeness: a being that dreams/names itself 'human', a species-being which it has to perform—transform—through 'technologies of the self', which Foucault describes as a 'number of operations' applied to 'bodies and souls, thoughts, conduct, and way of being'.[148] More than simply a mode of training in/to docility however, these technologies bring to mind Edgar Allan Poe's 'The Man That Was Used Up', about a 'remarkable . . . personage' that lies, disassembled as an 'exceedingly odd-looking bundle of something', in front of the uncomprehending narrator's eyes: as it gathers itself together, the voice, too, must be adjusted, emanates, rich in 'melody and strength', from a 'singular-looking machine' that the black ser-

vant activates in the mouth of his master.[149] The voice, and language, is, at any rate, an invader, a 'prosthesis of the inside';[150] the machine, in Poe's story, speaks the (repressed) truth, that is, at the risk of repetition—there has to be repetition, read mechanisation—the 'human' as technologised, coming into being through mechanicity: voice, limbs, the hand, to which Derrida pays so much attention, as technologies of the assembling self that represses the truth of its articulation. In that sense, it doesn't matter where the technological 'begins', with a dorsal turn or with the hand, though 'hands are not only in hands' but also in the relationship to the eye, the rest of the body, to thought;[151] an organ of 'gripping' and *begreifen*, understanding, of signs and writing, the hand 'cannot be spoken about without speaking of technics'.[152] It similarly repeats and demonstrates the irreducible bond between the 'human' and the technological or the 'human' as technological, of 'a humanity whose name, as the bond of the name to the "thing", if one can say that, remains as problematic as that of the language in which the name is written'.[153] The 'human', then, like Poe's Brevet Brigadier-General John A. B. C. Smith—the name an indication of alphabetisation and, hence, of literacy or *alphabêtise*: the use of language, a mechanical repetition, hallucinates the fantasy of a coherent self-identity,[154] broken apart in Poe's story—disassembles into composite parts: 'in the end', as Cary Wolfe writes, it is the 'human' who is the '"enigmatic being", the "dreamed object"—"enigmatic" because incoherent, and "dreamed" because an imaginary subject'.[155]

This is where mobilisation against the prevailing order occurs, for now, perhaps, at least, provisionally: I flesh/machine and multiplicity, we disturb the future as state program. It is not a question of rescuing the pitiless, or the profane, or of turning profanity into the sacred, but of enabling, without will, reticence, or reserve, the capacity for astonishment, the encounter of situations where 'I' am thrown beside 'myself'. If I argue for a dissolution, privileged as it is, for a state, to adapt and betray R. D. Laing's expression, of 'exquisite vulnerability',[156] then art is or performs that movement of displacement, of being outside, and allowing, from 'there', an 'intimate strangeness'[157] with the displaced other. Virilio's techne or tactics fail because proceeding from the basis of a sacralisation that arrests the subject in place, that place of interpellation/humanisation, a place, also, of stability, integrity, unquestioned presence: the consumption of security he targets with respect to government strategy goes unnoticed in his own writings, staging another, related, and always insufficient effort to secure the 'homeland'. Saying

that, the failure of critique might well be what I'm after, not only
because of what it would mean to succeed (there is, maybe, no way
to do so without being taken in by the market); to fail, after all,
leaves a trace and is excessive, it is an invitation to countersign,
keep countersigning, anew, also insufficiently.[158] A post-human
techno-criticism—not final, but failing, incalculable—as interven-
tion against the consumption of security, as a problematics of the
subject and of the 'human', decentred as 'monstrous sign': that, if
anything, is the 'proper', but without 'value', of 'man', the hand, or
dorsal turn, which propers 'our' inhumanity back to 'us'.[159] A cri-
tique, too, that puts itself at risk, hopes to facilitate coming across
(not bringing about) conditions that occur beyond my power or
capability, articulate my otherness, from behind, as event, and
which somehow leave me 'beside', outwith, my(our)self/selves.
Like others, I have called this theoretical and theorised position a
process of dehumanisation, also swarming the following, devalua-
tion and/or *désoeuvrement*, 'the name', according to Aaron Hillyer,
'of the "between" being, whose consciousness is not defined by
knowledge and mastery, by consciousness *of* something, but rather
by consciousness *in* something': it is, he continues, 'diffuse, kaleido-
scopic', a 'wandering modality'[160] that is unsettled by the prospect
of a subjectivity as sovereign. A 'subject', consequently, troubled by
ontological security and technologies of power that render lives as
either valuable, useful, productive or else as expendable, flesh, de-
tainees in a political system; a 'subject' which might dream of be-
coming ungovernable, cannot be consecrated or cast into stone,
which reads like a loser, with a sense of incalculable responsibility,
and reciprocity, with an obligation to respond to (other, unantici-
pated, irreducible) beings of flesh or glass. There is no program I
can offer beyond this methodological reflection, a turning back to
work already done and to that which is yet to come, some of which I
might now view with a 'fallen face'[161] but which, regardless of that
shame, also proceeds with love. The scene of writing, as Derrida
notes, always exceeds me—'it/id' comes from the other, implicates
me—and 'to a certain degree . . . goes wrong every time': it is itself
the 'locus' or passage in which 'I' am dispossessed, 'where' the trace
and differance of the other inhabits me, displaced 'subjectile'.[162] As
such, even techno-criticism as limitrophy, project of contraction,
cannot lay down the law, can't function as a regulating ideal, but
can only remain aware of its duties, fragility, possibilities of ruin.

NOTES

1. Leo Bersani, *The Culture of Redemption* (Cambridge, MA: Harvard University Press, 1990), p. 3.

2. Bersani, *The Culture of Redemption*, p. 4.

3. Jacques Derrida, 'Force of Law: The Mystical Foundation of Authority', *Cardozo Law Review*, 11 (1990), 920–1045 (p. 943).

4. The term 'hydra-headed' man refers to Neil Badmington's work in 'Theorizing Posthumanism', *Cultural Critique*, 53.1 (2003), 10–27 (pp. 10–11).

5. Roland Barthes, *The Pleasure of the Text*, trans. by Richard Miller (New York: Hill & Wang, 1975), p. 7.

6. Barthes, *The Pleasure of the Text*, p. 8.

7. Paul Virilio, *Speed and Politics*, trans. by Mark Polizzotti (Los Angeles: Semiotext[e], 2006), p. 141.

8. Paul Virilio and Sylvère Lotringer, *Pure War*, trans. by Mark Polizzotti (New York: Semiotext[e], 1997), pp. 134–35.

9. Virilio, *Speed and Politics*, p. 86.

10. Jacques Derrida, *Archive Fever: A Freudian Impression*, trans. by Eric Prenowitz (Chicago: University of Chicago Press, 1996), p. 7.

11. Marjorie Levinson, 'Posthumous Critique', in *In Near Ruins: Cultural Theory at the End of the Century*, ed. by Nicholas B. Dirks (Minneapolis: University of Minnesota Press, 1998), pp. 257–94 (p. 285). The concept of 'writhing' is a reference to Malcolm Ashmore's *The Reflexive Thesis: Wrighting Sociology of Scientific Knowledge* (Chicago: University of Chicago Press, 1989).

12. David Foster Wallace, *Infinite Jest* (London: Abacus, 2009), p. 860.

13. Levinson, 'Posthumous Critique', p. 287.

14. Levinson, 'Posthumous Critique', pp. 286–87.

15. Jacques Derrida, 'The Animal That Therefore I Am (More to Follow),' trans. by David Wills, *Critical Inquiry*, 28.2 (2002), 369–418 (pp. 392–93).

16. Derrida, 'The Animal That Therefore I Am', pp. 397, 398.

17. Eugene Thacker, *In the Dust of This Planet: Horror of Philosophy* (New York: Zero Books, 2011), I, p. 5.

18. Paul Virilio, *Strategy of Deception*, trans. by Chris Turner (London: Verso, 2007), p. 81. I make reference here to Jacques Derrida, 'Of an Apocalyptic Tone Recently Adopted in Philosophy', *Oxford Literary Review*, 6 (1984), 3–37, as well as to Derrida, *Archive Fever*, p. 3.

19. Virilio, *Strategy of Deception*, p. 59.

20. Jacques Derrida, 'The Last Interview', *Le Monde*, 19 August 2004, http://m. friendfeed-media.com/1a5bc7e65ea7a00a0fcfda2ad242360ed9f2d3c4 [accessed 24 March 2015].

21. Michel Foucault, *Society Must Be Defended: Lectures at the College de France*, trans. by David Macey (London: Penguin, 2004), pp. 254–55.

22. Laurence A. Rickels, *The Case of California* (Minneapolis: University of Minnesota Press, 2001), pp. 2, 4.

23. Virilio, *Strategy of Deception*, p. 80.

24. Achille Mbembe, 'Necropolitics', trans. by Libby Meintjes, *Public Culture*, 15.1 (2003), 11–40 (pp. 12, 16).

25. Foucault, *Society Must Be Defended*, p. 254.

26. Thomas Pynchon, *Gravity's Rainbow* (London: Vintage, 2013), p. 857.

27. Virilio, *Strategy of Deception*, pp. 80–81 (original emphasis).

28. Virilio, *Strategy of Deception*, p. 82.

29. Virilio, *Strategy of Deception*, p. 82 (original emphasis).

138 *Fabienne Collignon*

30. Virilio, *Strategy of Deception*, pp. 82, 15.
31. Peter Sloterdijk, *Terror from the Air*, trans. by Amy Patton and Steve Corcoran (Los Angeles: Semiotext[e], 2002), p. 19.
32. Virilio, *Strategy of Deception*, pp. 14–15.
33. International law, of course, has provisions for humanitarian interventions, provided these are authorized by the Security Council, which approves these if there exists a threat to international peace. See Daya Kishan Thussu, 'Legitimizing "Humanitarian Intervention"? CNN, NATO and the Kosovo Crisis', *European Journal of Communication*, 15.3 (2000), 345–61 (p. 347). It was Colin Powell who used the phrase 'force multiplier' in relation to humanitarian organizations functioning as a strategic part of the US government's military actions. See Sarah Kenyon Lischer, 'Military Intervention and the Humanitarian "Force Multiplier"', *Global Governance*, 13.1 (2007), 99–118 (p. 99).
34. Thussu, 'Legitimizing "Humanitarian Intervention"?', p. 348.
35. Virilio, *Strategy of Deception*, p. 68.
36. See, for example, the Médecins sans Frontières charter at http://www.msf.org/msf-charter-and-principles [accessed 24 March 2015].
37. Michael Barnett, 'Humanitarianism Transformed', *Perspectives on Politics*, 3.4 (2005), 723–40 (p. 723).
38. Michael Hardt and Antonio Negri, *Empire* (Cambridge, MA: Harvard University Press, 2000), p. 198.
39. Barnett, 'Humanitarianism Transformed', p. 724.
40. Virilio, *Strategy of Deception*, p. 7.
41. Barnett, 'Humanitarianism Transformed', p. 732.
42. Barnett, 'Humanitarianism Transformed', p. 727.
43. Cary Wolfe, *What Is Posthumanism?* (Minneapolis: University of Minnesota Press, 2010), p. 56.
44. See Jacques Derrida, *On Cosmopolitanism and Forgiveness*, trans. by Mark Dooley and Michael Hughes (London: Routledge, 2010), p. 4.
45. Derrida, *On Cosmopolitanism and Forgiveness*, pp. 45, 22.
46. Virilio, *Strategy of Deception*, p. 8.
47. Giorgio Agamben, *State of Exception*, trans. by Kevin Attell (Chicago: University of Chicago Press, 2005), p. 6.
48. Virilio, *Strategy of Deception*, p. 73.
49. Sam Ladkin, 'Against Value Is Not Enough' (unpublished paper, University of Sheffield, 20 March 2014).
50. Sloterdijk, *Terror from the Air*, p. 9.
51. Virilio, *Strategy of Deception*, p. 24.
52. Foucault, *Society Must Be Defended*, p. 254.
53. Laurence Rickels, *The Vampire Lectures* (Minneapolis: University of Minnesota Press, 1999), p. 51.
54. Rickels, *The Vampire Lectures*, pp. 52, xii.
55. Virilio, *Strategy of Deception*, p. 81.
56. Pynchon, *Gravity's Rainbow*, p. 639.
57. Derrida's understanding of the countersignature is that which 'comes both to confirm, repeat and respect the signature of the other, of the "original" work, and to *lead it off* elsewhere, so running the risk of *betraying* it, having to betray it in a certain way so as to respect it, through the invention of another signature just as singular'. Jacques Derrida, *Acts of Literature*, ed. by Derek Attridge (New York: Routledge, 1992), p. 69.
58. On the 'experience of the possible', see Giorgio Agamben, *Potentialities: Collected Essays in Philosophy*, trans. by Daniel Heller-Roazen (Stanford, CA: Stanford University Press, 1999), pp. 243–71.

59. Derrida, 'The Force of Law', p. 931.

60. Derrida, *Acts of Literature*, p. 69.

61. See Agamben, *Potentialities*, p. 249.

62. Alastair Bonnett, 'The Dilemmas of Radical Nostalgia in British Psychogeography', *Theory, Culture, Society*, 26.1 (2009), 45–70 (pp. 47, 49, 53).

63. John Armitage, 'The Face of the Figureless: Aesthetics, Sacred Humanism and the Accident of Art', in *Virilio and Visual Culture*, ed. by John Armitage and Ryan Bishop (Edinburgh: Edinburgh University Press, 2013), pp. 156–79 (p. 156).

64. Jacques Derrida, *Paper Machine*, trans. by Rachel Bowlby (Stanford, CA: Stanford University Press, 2005), p. 131.

65. Walter Benjamin, *The Arcades Project*, trans. by Howard Eiland and Kevin McLaughlin (Cambridge, MA: Belknap Press of Harvard University Press, 2002), p. 459.

66. Benjamin, *The Arcades Project*, pp. 456, 458.

67. Virilio uses this word in *Pure War*, where he discusses how the invention of the locomotive was also the invention of derailment. See Virilio and Lotringer, *Pure War*, p. 38.

68. Ladkin, 'Against Value Is Not Enough', p. 1.

69. Kathryn Yussof, 'The Valuation of Nature', *Radical Philosophy*, 170 (November/December 2011), http://www.radicalphilosophy.com/commentary/the-valuation-of-nature [accessed 2 June 2015], para. 7 of 11.

70. Yussof, 'The Valuation of Nature', para. 4.

71. Virilio, *Strategy of Deception*, p. 79.

72. Benjamin, *The Arcades Project*, p. 461.

73. 'The Universal Declaration of Human Rights,' United Nations, http://www.un.org/en/documents/udhr/index.shtml [accessed 25 April 2015].

74. The reference here is to Hannah Arendt's work, discussed in Alastair Hunt, 'Rightlessness: The Perplexities of Human Rights', *CR: The New Centennial Review*, 11.2 (2011), 115–42 (p. 123). It is Jacques Derrida who talks about the *sans-papiers* in *Paper Machine* (Stanford, CA: Stanford University Press, 2005).

75. Roland Barthes, *Mythologies*, trans. by Richard Howard and Annette Leavers (New York: Hill & Wang, 2012), p. 198.

76. Hunt, 'Rightlessness', pp. 121, 128.

77. Hunt, 'Rightlessness', pp. 128, 126, 132.

78. Hunt, 'Rightlessness', pp. 128, 133.

79. I am referring to Derrida's 'The Animal That Therefore I Am', p. 398.

80. Paul Virilio, *Art and Fear*, trans. by Julie Rose (New York: Continuum, 2004), pp. 27, 28.

81. Virilio, *Art and Fear*, pp. 35, 49, 55.

82. Virilio, *Art and Fear*, pp. 58, 63, 49.

83. John Armitage and Ryan Bishop, 'Aesthetics, Vision and Speed: An Introduction to Virilio and Visual Culture', in *Virilio and Visual Culture*, ed. by John Armitage and Ryan Bishop (Edinburgh: Edinburgh University Press, 2013), pp. 1–27 (p. 1).

84. Virilio, *Art and Fear*, p. 49.

85. Armitage, 'The Face of the Figureless', p. 161.

86. Bersani, *The Culture of Redemption*, p. 22.

87. Derrida, 'The Animal That Therefore I Am', p. 397.

88. Derrida, 'The Animal That Therefore I Am', p. 398.

89. Cary Wolfe, 'Learning from Temple Grandin, or, Animal Studies, Disability Studies, and Who Comes after the Subject', *New Formations*, 64 (2008), 110–23 (pp. 110, 122).

90. Jacques Derrida, *On the Name*, trans. by David Wood, John P. Leavey, Jr., and Ian McLeod (Stanford, CA: Stanford University Press, 1995), pp. 10–11, 133n3.

91. Derrida, *On the Name*, pp. 10, 12.

92. Emmanuel Levinas, *Ethics and Infinity*, trans. by Richard A. Cohen (Pittsburgh: Duquesne University Press, 2011), p. 85.

93. David Wills, in *Dorsality: Thinking Back through Technology and Politics* (Minneapolis: University of Minnesota Press, 2008), proposes that the access to the face that Levinas discusses actually is a formulation of '*a relation of the face to the back*': 'If one is to understand fully Levinas's idea of a face defined by eyes that speak, that we hear from an elsewhere; if we are to seriously accredit his resistance to the visible and to vision as relations of objectivisation, in favour of visitation or what I will call "surprise"; . . . if we are to allow that other to be the absolute other, the foreigner, then we might more faithfully conceive of the other as coming from behind' (p. 46).

94. François Raffoul, 'Derrida and the Ethics of the Im-possible', *Research in Phenomenology*, 38 (2008), 270–90 (p. 286).

95. Wills, *Dorsality*, p. 12.

96. Wills, *Dorsality*, p. 35.

97. Louis Althusser, *On Ideology*, trans. by Ben Brewster (London: Verso, 2008), p. 50.

98. Althusser, *On Ideology*, p. 52.

99. Althusser, *On Ideology*, p. 48.

100. Wills, *Dorsality*, p. 35.

101. Althusser, *On Ideology*, p. 56.

102. Althusser, *On Ideology*, pp. 161, 160.

103. Virilio, *Pure War*, p. 91.

104. See Althusser, *On Ideology*, pp. 170–71.

105. Virilio, *Art and Fear*, pp. 42, 64, 58, 55.

106. Bersani, *The Culture of Redemption*, p. 2.

107. Bersani, *The Culture of Redemption*, p. 22.

108. The *Oxford English Dictionary* states that the second, now obsolete meaning of the word 'proper' as a verb is 'to appropriate, to make one's own, take possession of'. See OED, 3rd ed., June 2007, www.oed.com [accessed 10 May 2015].

109. Hannah Arendt, quoted by Hunt, 'Rightlessness', p. 123. For the original source, see Hannah Arendt, *The Origins of Totalitarianism* (New York: Harcourt Brace, 1973), p. 299.

110. See Jacques Derrida, '"Eating Well", or the Calculation of the Subject', in *Points . . . : Interviews, 1974–1994*, ed. by Elizabeth Webber, trans. by Peggy Kamuf et al. (Stanford, CA: Stanford University Press, 1995), pp. 255–87 (p. 278).

111. Derrida, 'Force of Law', p. 943.

112. Gilles Deleuze and Félix Guattari, *A Thousand Plateaus: Capitalism and Schizophrenia*, trans. by Brian Massumi (London: Continuum, 2004), pp. 188, 189.

113. See Cary Wolfe, *Animal Rites: American Culture, the Discourse of Species, and Posthumanist Theory* (Chicago: University of Chicago Press, 2003), p. 43.

114. Althusser, *On Ideology*, pp. 158, 157.

115. Althusser, *On Ideology*, pp. 163, 164.

116. John Armitage, 'Introduction', in Virilio, *Art and Fear*, pp. 1–24 (p. 3).

117. Tom Tyler, 'Playing Like a Loser' (unpublished paper, University of Sheffield, 16 March 2015). Thanks to Tom for forwarding his paper.

118. R. D. Laing, *The Divided Self* (Harmondsworth: Penguin, 1974), pp. 39, 37.

119. Anat Pick, *Creaturely Poetics: Animality and Vulnerability in Literature and Film* (New York: Columbia University Press, 2011), p. 9.
120. Pick, *Creaturely Poetics*, p. 25.
121. Pick, *Creaturely Poetics*, pp. 24–25, 51.
122. Klaus Theweleit, *Male Fantasies*, vol. 2: *Male Bodies—Psychoanalyzing the White Terror*, trans. by Chris Turner, Erica Carter, and Stephen Conway, *Theory and History of Literature*, 23 (Cambridge: Polity Press, 2007), p. 159.
123. Pick, *Creaturely Poetics*, pp. 25, 6.
124. Pick, *Creaturely Poetics*, pp. 6, 42.
125. Tyler, 'Playing Like a Loser'.
126. See Jacques Derrida, *The Gift of Death*, trans. by David Wills (Chicago: University of Chicago Press, 2008), p. 8.
127. Deleuze and Guattari, *A Thousand Plateaus*, p. 32.
128. Deleuze and Guattari, *A Thousand Plateaus*, p. 320.
129. See Laing, *The Divided Self*, pp. 42, 49.
130. Adam Piette, 'Torture, Text, Human Rights: Beckett's *Comment c'est* and the Algerian War' (unpublished paper, University of Sheffield, 15 April 2015).
131. R. D. Laing cites a passage from Medard Boss's *Analysis of Dreams*, in which Boss reports that a woman, in her dreams, predicts the 'special course of her psychosis'. Four days after her dream, she 'became rigid' and 'in effect, encysted', after which, and for years, she 'has been like a burnt-out crater'. Laing, *The Divided Self*, p. 50.
132. Esther Leslie, 'Liquid, Crystal, Vaporous: The Natural States of Capitalism' (unpublished paper, University of Sheffield, 21 May 2015).
133. Deleuze and Guattari, *A Thousand Plateaus*, p. 34.
134. Richard Doyle, *Wetwares: Experiments in Postvital Living* (Minneapolis: University of Minnesota Press, 2003), p. 8.
135. Jussi Parikka, *Insect Media: An Archaeology of Animals and Technology* (Minneapolis: University of Minnesota Press, 2010), p. xxv.
136. Deleuze and Guattari, *A Thousand Plateaus*, p. 211.
137. Deleuze and Guattari, *A Thousand Plateaus*, p. 211.
138. Wills, *Dorsality*, p. 48.
139. Wills, *Dorsality*, pp. 51–52.
140. Wills, *Dorsality*, p. 4.
141. Wills, *Dorsality*, p. 3.
142. Derrida cited in Wills, *Dorsality*, p. 245n1. For the original citation, see Jacques Derrida, *Negotiations: Interventions and Interviews, 1971–2001*, trans. and ed. by Elizabeth Rottenberg (Stanford, CA: Stanford University Press, 2002), p. 244.
143. Doyle, *Wetwares*, p. 10.
144. Wills, *Dorsality*, p. 12.
145. Sharon Cameron quoted in Pick, *Creaturely Poetics*, p. 5.
146. Cary Wolfe quoted in Pick, *Creaturely Poetics*, p. 2.
147. Deleuze and Guattari, *A Thousand Plateaus*, pp. 320–22.
148. Michel Foucault, *Technologies of the Self*, ed. by Luther Martin, Huck Gutman, and Patrick Hutton (Amherst: University of Massachusetts Press, 1988), pp. 16–49 (p. 18).
149. Edgar Allan Poe, 'The Man That Was Used Up', in *The Complete Tales and Poems of Edgar Allan Poe* (London: Penguin Books, 1982), pp. 405–12 (pp. 405, 412).
150. Derrida, *Archive Fever*, p. 19.
151. Derrida, *Paper Machine*, p. 21.

152. Jacques Derrida, 'Geschlecht II', in Deconstruction and Philosophy: The Texts of Jacques Derrida, ed. by John Sallis (Chicago: University of Chicago Press, 1988), pp. 161–96 (pp. 172, 169).

153. Derrida, 'Geschlecht II', p. 165.

154. Friedrich Kittler, Gramophone, Film, Typewriter, trans. by Geoffrey Winthrop-Young and Michael Wutz (Stanford, CA: Stanford University Press, 1999), p. 151; see also 287n117. Alphabêtise is, of course, Lacan's neologism.

155. Wolfe, Animal Rites, p. 43.

156. Laing, The Divided Self, p. 37.

157. Maurice Blanchot cited in Aaron Hillyer, The Disappearance of Literature: Blanchot, Agamben, and the Writers of the No (New York: Bloomsbury, 2013), p. 10.

158. On missed encounters and failures, see Colin Davis's discussion of the discussions between Derrida and Hans Georg Gadamer in Critical Excess: Overreading in Derrida, Deleuze, Levinas, Žižek and Cavell (Stanford, CA: Stanford University Press, 2010).

159. Derrida, 'Geschlecht II', p. 168.

160. Hillyer, The Disappearance of Literature, p. 25.

161. Eve Kosofsky Sedgwick, Touching Feeling: Affect, Pedagogy, Performativity (Durham, NC: Duke University Press, 2004), p. 36.

162. Derrida, Points, pp. 17, 27, 268.

Part II

Arts

EIGHT

Useless Commodities, Disposable Bodies

An Essay on Value and Waste

Rob Halpern

ART AND VALUE

In his epilogue to 'The Work of Art in the Age of Its Technological Reproducibility', Walter Benjamin offers a critique of the value form that is key to understanding his essay's entire argument. Indeed, Benjamin's Marxian critique of value informs his critique of fascism, whose aesthetics, he argues, are inseparable from its economics. The old aesthetic concepts of creativity and genius, as well as the mystified authority of the 'aura', all return in the way fascism 'sees its salvation in granting expression to the masses—but on no account granting them rights'.[1] In other words, fascism gives the people a chance to express themselves without in any way changing the property relations under which people genuinely suffer. Given fascism's dependence on representation and expression, Benjamin can then argue emphatically that *'the logical outcome of fascism is an aestheticizing of political life'*.[2] This is so insofar as aesthetics might denote the way that expression organises itself and the way available forms shape perception at the level of representation. Simply put, there can be no organised public expression without aesthetics.

Benjamin familiarly refers to German fascism as a Führer cult, harkening back to the old ritual values of culture, and Leni Riefenstahl's *Triumph of the Will* offers an exquisite illustration of the modern recrudescence of cult value with its use of cinematic representation to shape social consciousness while assuming the authority to express it. According to Benjamin, 'Fascism attempts to organize the newly proletarianized masses while leaving intact the property relations which they strive to abolish'.[3] Put another way, collective expression, or aestheticized politics, would appear to compensate for a lost struggle. Fascism assuages the people by unifying them in a collective voice ('expression') instead of abolishing a property system that enriches a few at the expense of many. 'The masses have a *right* to changed property relations', Benjamin writes, and 'fascism seeks to give them expression in keeping these relations unchanged'.[4] Already, then, we can see the connection between 'outmoded' aesthetic ideals (aura, cult value, mystery, genius) and fascist politics under the Third Reich, which sought to arouse and unleash all the authority of value. But this doesn't yet prepare us for Benjamin's next proposition: 'All efforts to render politics aesthetic culminate in one thing: war'. Benjamin argues that the aestheticization of politics—if not the wholesale transformation of the political arena into a total artwork rooted in traditional aesthetic values—can only lead to military conflict. How are we meant to understand this?

Benjamin's move requires a conceptual leap, and in order to make it, it's important to remember that he is referring to a situation under fascism where the system of private property—wage labour and class relations—remains dominant. Fascism is state capitalism, and it exploits the capitalist mode of production in its effort to harness a military apparatus. According to Karl Marx, the property system under capitalism is a system whose motor is the accumulation of surplus value, and a society organised around the accumulation of surplus value is a society that has abandoned the primacy of use value, or the means of subsistence, in the interest of accumulation. In order to accumulate surplus value, the capitalist mode of production must produce commodities whose primary use becomes exchangeability itself; that is, a commodity's use value *is* its exchange value. Dialectically considered, use value is at once negated and preserved in the commodity's capacity to realise value in the form of a surplus. Paradoxically, then, one can say that the commodity is essentially 'use-less' insofar as its exchange value cancels the fulfilment of genuine human need.

As Benjamin himself notes in 'Paris, Capital of the Nineteenth Century', the property system is obliged to produce commodities whose price is constitutively dissociated from use value. Accordingly, for Benjamin, price becomes allegorical; that is, 'the singular debasement of things through their significations, something characteristic of seventeenth-century allegory, corresponds to the singular debasement of things through their price as commodities'.[5] I'm interested here in Benjamin's use of concepts like debasement, which in the very next sentence is further qualified as 'this degradation to which things are subject', a degradation that finds its horizon in both the commodity and the artwork whose raison d'être at this historical conjuncture might have been to correct, dignify, or redeem that debasement through aesthetic transfiguration. For Benjamin, the commodity's need to generate exchange value finds its dialectical complement—its mirrored inversion—in the artwork's resistance to that universalisation of usefulness known as 'the market'. This is how the artwork's radical particularity is inseparable from the prosaic generalisation it simultaneously courts and refuses. Both commodity and artwork thereby anchor their social strategies in figures of newness that are dialectically identical and divergent. For the commodity, the operative designation here would be 'novelty', or *nouveauté*, while for the artwork it would be 'the new', or *la nouveauté* (emphasis on the definite article), which for Benjamin 'represents that absolute which is no longer accessible to any interpretation or comparison'. Put differently, *la nouveauté* 'becomes the ultimate entrenchment of art'. Benjamin then clarifies the antinomy that obtains between aesthetic newness and the commodity's use value by proposing that 'newness is a quality independent of the use-value of the commodity'.[6] Benjamin's apothegm underscores how both artwork and commodity achieve a shared identity by way of a common uselessness. Returning then to 'debasement', one can argue that degradation—whose root is nothing less than wage labour—gets fused with commodity and artwork alike as they both become adjuncts of social death. This moves Benjamin to articulate one of the exposé's most astonishing formulations, drawing on a figure of combat: 'The artwork's last line of resistance coincides with the commodity's most advanced line of attack'.[7]

Here it's worth recalling how poets like Stéphane Mallarmé and Charles Baudelaire turned their back on usefulness, declaring instead an allegiance to uselessness under the sign of *l'art pour l'art* or *l'art absolue* at a moment in the nineteenth century when 'useful'

had become synonymous with 'commercial'. An artist's desire for *uselessness* was thereby tantamount to the work's *resistance* to becoming merchandise in a social world already showing advanced signs of reification, or commodification, whereby the relations between human beings get displaced and condensed in the relation between things. In the late-nineteenth century, the profit-driven daily newspaper was a full-blown manifestation of this reification for writers. In relation to the commercialism of mass journalism's 'economic prose', the 'useless' poetry of Mallarmé and Baudelaire offered a counter-discursive resistance, a refusal to communicate in a world where communication had been reduced to sales.[8]

This divagation might seem far afield from questions of war, but it only requires filling in a missing link to grasp Benjamin's proposition that the aestheticization of politics leads to dropping warheads. While the social function of *l'art pour l'art* could be said to be art's refusal of any social function whatever—an affirmation of uselessness—*l'art pour l'art* also insisted on preserving the aura, that halo of distance whereby human alienation might be dignified in a form related to the value form itself, which by the twentieth century, Benjamin argues, finds a hospitable vehicle in the bowels of bombs. Indeed, by the time of World War I, the commodity form revealed more extravagantly than ever what perhaps it had always harboured—*absolute uselessness*—insofar as use value under capital's regime is always dominated by exchange value, just as human relations degraded by wage labour are always reified in the commodity's price. It was clear to Benjamin how the commodity's immanent critique of value reveals itself most transparently in the phenomenon of amassing storehouses of armaments, whose 'use' coincides with the destruction of human lives.

By the conclusion of his essay, Benjamin drives this idea home in the context of Italian futurism, whose unambiguous convergence with fascist ideas makes the link between aesthetics and death painfully clear. Thus Benjamin quotes F. T. Marinetti's manifestos, whose praise of war illustrates 'the consummation of art for art's sake', with which he associates the slogan '*Fiat ars—pereat mundus*', or 'Art triumphs, the world perishes'.[9] This idea again recalls Marx, for whom exchange value circulates at the expense of human subsistence. The accumulation of commodities doesn't get more radically divorced from genuine human need as it does in the form of bombs, tanks, and guns. As surplus value amasses in the machinery for warfare, the useless arsenal must be periodically rendered necessary and deployed if only to justify its 'need', thereby legitimising

further accumulation and ensuring mass employment. German fascism was thereby able to restore the nation's broken economy by rearming, yielding a direct relation between aestheticization and destruction, a relation mediated by the commodity form itself. Capitalism makes use of this aesthetic dimension as part of its own logic, which keeps people working in the interest of unending war. The accumulation of arms in arsenals becomes a deadly crystallisation of uselessness, whose praise by the futurists realises the dialectical interpenetration of the absolute artwork and the absolute commodity, each of which contains the logic of the other, despite the appearance of an opposition between aesthetic and economic motivations. This recalls Theodor Adorno's own formulation in *Aesthetic Theory*: 'The absolute artwork converges with the absolute commodity'.[10] Under the sign of 'the absolute', Adorno pushes the ideologies of both the commodity and the artwork to their respective limits—identical limits perhaps—where the categories of 'use' and 'uselessness' break down to reveal a powerful dialectic as each term harbours its opposite. In other words, the missile and the artwork each achieve a universal uselessness, negating the already negated category of use in a world governed by capital wherein use value is simultaneously cancelled and realised. Curiously recalling a financial stock, yet another full-blown realisation of the commodity form, the missile further occults or mystifies the material substratum upon which all commodities are predicated.

Insofar as the artwork's uselessness finds its commensurate homologue in the uselessness of value, one can say, together with Benjamin, that it is through wholesale military expenditure that capitalism finds 'a new means of abolishing the aura', repeating for the twentieth century the liquidation of the aura that Benjamin associates with the emergence of technological reproduction in the nineteenth, and this liquidation finds its literalisation in death itself, a sacrifice of 'human material'.[11] 'Instead of deploying power stations across the land, society deploys manpower in the form of armies. Instead of promoting air traffic, it promotes traffic in shells. And in gas warfare it has found a new means of abolishing the aura'.[12] Accordingly, 'the aura', emblematic of the artwork's mystified value, returns in the form of falling bombs, which destroy it. Rather than feed people, state capitalism produces war while binding society through the mystification of a collective voice, whose false immediacy conceals the most mediated operations of spectacularisation, just as it does in Riefenstahl's film, whereby collective expression manifests as 'self-alienation'. This is how Benjamin arrives at

the essay's most devastating proposition: 'Self-alienation has reached the point where it can experience its own annihilation as a supreme aesthetic pleasure'.[13] The aura's aesthetic logic dovetails with a socio-economic logic whose only limit is total destruction, a phenomenon that can be understood as the loss of the individual contemplatively absorbed by the spectacle of war, the massive loss of life under firebombs, or as the liquidation of 'human material' in the camps. 'Such is the aestheticizing of politics, as practiced by fascism. Communism responds by politicizing art'.[14]

For Benjamin, then, the experience of humanity's destruction as an aesthetic pleasure is inextricably entangled with the value form and inseparable from the domination and exploitation of human bodies. While domination and exploitation are not the same, they are intimately related, and Benjamin's epilogue alludes to that relation insofar as uselessness manifests in and through human bodies, bodies from which surplus value is drawn in the form of wage labour (exploitation) and bodies reduced to waste in the camps (domination). This reading of the problem posed by the question of value in 'The Work of Art in the Age of Its Technological Reproducibility' enables a more sustained consideration of value as the mystified form wherein both exploitation and domination are concretised paradoxically in the total abstraction of our social relations. In other words, it's at the site of the human body that use value is negated, or sacrificed, in the interest of generating surplus value. While the relationship between early twentieth-century militarisation under fascism and twenty-first-century militarisation under American hegemony and the so-called war on terror may seem tenuous, I now want to consider the place of the human body 'against value' today.

BODY AND WASTE

The problem concerning value and the human body is complicated as soon as I begin to consider the detainee held at Guantánamo Bay in whose body uselessness arrives at a new threshold of consequential abstraction, and this uselessness may find its equal only in love.

Whereas the body of the proletariat is reduced to a vessel of thing-like labour, a commodity which by definition has had its use value negated, the body of the detainee maintains an even more mystified relation to value. The detainee's body realises a singularity whose radical specificity arouses precisely what is uncontainable

in it: a quality that can't be absorbed by circuits of exchange, a use that may paradoxically be characterised as the embodiment of uselessness under the militarised conditions of our contemporary lifeworld.

I feel a certain urgency to ask what it might mean to be 'against value' specifically with respect to this body, which is not a valued body at all but rather a body that falls outside the text of value, a body whose only eventually legible text may be an autopsy report. I pose this question from the precarious place of poetry, for as a poetical experiment in early 2013, I began transcribing the 2009 autopsy report of a Yemeni man who had been held in US custody since December 2001 and detained at Guantánamo Bay. Among other things, I wanted to return transcription to its roots in somatic practice, to bring my body into contact with the linguistic remains of extraordinary rendition and state-sponsored death, like a scribe reproducing the Torah or a monk labouring over illuminated books, unable to restrain himself from spilling into the text. How would my poetry—*prosthetic of nerve & bone*—metabolise such language in an effort to feel my body's relation to a detainee's occulted corpse? And how might that effort make palpable the militarisation—*capital*—that has captured our social relations? This experiment resulted in a book called *Common Place*.[15]

As I turn my attention to the detainee's body in the context of *Against Value*, my writing can only strain toward a more lyrical mode of reflection, especially as I aim to draw lyric poetry itself into the field of this inquiry while considering poetry's promise to offer a site—*utterly useless*—where I might feel the shape of an otherwise withdrawn human relation. How can I wrest my derealised social bond with his body away from this negation of use without falling for the uselessness already realised by commodified life and without rendering that bond useful for state-sponsored ends? (My use of the masculine pronoun here—'his body'—is intended only insofar as every Gitmo detainee is male. Female analogues can no doubt be situated in the related contexts of reproductive labour, domestic work, and sexual enslavement.)

The 'universal' life of the species—*always false*—is at once insured and undone by war on the radically particular body of an excluded other. Insofar as my body—white, American, male—is ostensibly protected by that universal, the urgent question remains as to how I might experience, apprehend, or simply grasp my body's relation to that body's occulted specificity. Reflecting my effort to

address these questions, the notes that follow are admittedly provisional, fragmented, and dissolute.

All this has as much to do with the banalities of everyday life— *prosodic tenor of the drone*—as with what Jodi Dean refers to as our 'communist horizon';[16] as much to do with the degraded body of the Gitmo detainee as with the black body, murdered by police in the streets of Baltimore, Madison, Charleston, New York, Ferguson, Cleveland, Oakland; as much to do with Giorgio Agamben's concept of 'bare life' (or 'mere flesh') as with a parochial discourse that sublimates the degraded body into a concept; as much to do with the promise of community as with the state of exception that negates that promise paradoxically by realising the limit of community under current conditions, be it in the camp or in the street.[17]

In many ways, the recent spectacularisation of racialised violence makes it ever more clear that 'the camp' can no longer persuasively denote the location of a geographically isolated 'sovereign exception', as Agamben would have it.[18] In our current moment, when the issue is not civilian noncombatants abroad but 'surplus population' at home—a racialised surplus having everything to do with capital—power's unlimited capacity becomes the norm in the streets of every American city.[19] This is a moment to reimagine the 'threshold of life' whereupon the material body is abandoned in exchange for an abstract security: the urban site whose conceptual model may very well *not* be the camp as theorised by Agamben but rather the hold of the transatlantic slaving vessel as posited by Stefano Harney and Fred Moten in *The Undercommons*: 'And so it is we remain in the hold, in the break, as if entering again and again the broken world, to trace the visionary company and join it'.[20] For Harney and Moten, rather than the place of relation's absolute negation—which can only result in an undialectical uselessness—the hold, like the commodity it transports (a literalisation of human capital), becomes the site where fantasy arouses 'an unbearable cost that is inseparable from an incalculable benefit'. 'This is to say that there are flights of fantasy in the hold of the ship. The ordinary fugue and fugitive run of the language lab, black phonography's brutally experimental venue.'[21]

'Containerisation' of the human body stretches from the Atlantic slave trade all the way to Guantánamo Bay. But whereas the detainee's body has been extra-juridically rendered, withdrawn, and occulted, the juridically disciplined body imprisoned on American soil remains a body whose spectacularisation, racialisation, and criminalisation make it available for a community and a politics,

despite incarceration. This is a body whose social visibility animates vast regions of the political and cultural imaginary as it becomes a scene of organisation and struggle for social justice.[22] Hence, Moten and Harney's optimism: 'If the proletariat was thought capable of blowing the foundations sky high, what of the shipped, what of the containerized?'[23] And what then of my detainee—*spectacularly absented*—whose body contradicts both the incarcerated legal subject and the extra-juridical object whose body's been blown to bits in a village near Peshawar by a drone commissioned by a trained gamer just outside Tucson? This is what the system must render invisible in order to reproduce the visible. This clarity, whose shadow is misery.

Michel Foucault inaugurated the theorisation of 'biopolitics' as a field of analysis committed to understanding the relationship between bodies and power.[24] But does the biopolitical offer an adequate critical framework within which to unfold my inquiry? Understood as a struggle over the promotion, management, and destruction of life in the interest of particular populations, biopolitics is arguably about representation and the frames of intelligibility within which this or that body might be recognised as a life. It's within such frameworks—and what they constitutively exclude—that the concept of 'bare life' finds its expression, connoting something inseparable from the body that can be either institutionally valued or destroyed. By extension, the biopolitical analytic interrogates the strategies of representation that allow some bodies to be seen (if only to be grieved) and others to rot and mulch. It thus presumes a fundamental norm—what Judith Butler nominates as 'grievability'—whose universality disavows its own occlusions.[25] Within this analytic, the body of my detainee is conceptually reduced to the dematerialised substance of our geopolitical condition, like the discursive precipitate of his corpse, site of exception, zone of the ban and the abandoned, arguably coextensive with the room in which I am writing, or at least adjunct to that.

'Bare life is no longer confined to a particular place or definite category', Agamben writes. 'It now dwells in the biological body of every living being'.[26] Can it be true that there is a trace of this 'bare life' in everyone? As Agamben would have it, this term contains the notion of 'pure being', the originary foundation of metaphysics and politics alike. But the idealist assumption upon which such a proposition depends can only offend every conviction that geopolitical and social vulnerabilities are unevenly distributed, and this uneven

development has to do with economies of value that are racialised, gendered, and classed.

The detainee's body, at once bound to and abandoned by law, converges with the mundane, a commonplace that sings through everything. Even his body has become banal, by which I mean both commonplace and communal. Banal: from the Old French *banel* and the word *ban*, 'which includes both the sense of a legal control or decree and the payment for the use of a communal resource . . . owned by none of those who use it communally'; something held in common though 'beholden to the logic and relations of property.'[27] Considering the range of current work around theories of community and post-communist communisation—from Roberto Esposito's *Communitas* to the Invisible Committee's *Coming Insurrection*—how might an aesthetic experiment participate in an effort to rethink the value of community and the question of use?[28]

In his theory of the sovereign ban, Agamben arguably forgets the most banal contradictions having to do with human material, bodies, and commons. For Agamben, the ban is the primal scene of our political order in that it 'preserves the memory of the originary exclusion through which the political dimension is first constituted'.[29] Moreover, 'the ban is a form of relation. But precisely what kind of relation is at issue here, when the ban has no positive content and the terms of the relation seem to exclude (and, at the same time, to include) each other?'[30] How are we to understand 'no positive content', and more importantly still, how are we to *feel* it? My aim here is to provoke the appearance of precisely such content at the scene of its abandonment: that is, I want to non-repressively desublimate that which has been violently sublimed; to arouse the conceptual residue of this 'biopolitical substance'—*waste*—in a body where it has been most violently negated in having been realised. This requires a phantasmatic reach.

In the place where social relation has been withdrawn—be it in the commodity or the camp—I want the poem to arouse a living intimacy, to restore positive content to this negated bond so that we might feel it. To put my question yet another way: If the ban negates that political substance at the very moment it appears as the foundation of the polis (Agamben's thesis), how can we negate the ban so that we might feel that substance in our very bodies, feel the relation that I nonetheless live without feeling, and feel this substance—'positive content'—without consigning it to an idealist turn of thought? Along these lines of inquiry, we can proffer a response to Michel Foucault's proposition regarding a 'different economy of

bodies and pleasures' at the conclusion of volume one of *The History of Sexuality*, by whose nomination he anticipates—without prescribing—a way of feeling and changing the social relations between bodies that would exceed the current hegemony of value.[31] Foucault's formulation clearly suggests that sociopolitical transformation, inseparable from the economic, is achievable. Moreover, in order to move beyond the negative community ('no positive content'), we will have to move beyond sexuality itself.

Agamben curiously alludes to a 'new economy of bodies and pleasures' in the final pages of *Homo Sacer*: 'Having distanced himself from the sex and sexuality in which modernity, caught in nothing other than a deployment of power, believed it would find its own secret and liberation, Foucault alludes to a "different economy of bodies and pleasures" as a possible horizon for a different politics'.[32] In response, Agamben asserts a need to be 'more cautious' around a notion of the body 'always already caught in a deployment of power', for 'nothing in it or the economy of its pleasure seems to allow us to find solid ground on which to oppose the demands of sovereign power'.[33] The problem here is that for Agamben, 'the body' is a *concept*. In response, we need to return to the economy and oppose its reign of value over bodies and waste alike, an opposition whose conceptual impossibility we can't afford to concede.

Is it reasonable to think that a poem might perceive the terms of such an opposition? Can a poem model 'a different economy of bodies and pleasures' and feel, by way of language and fantasy, the somatic limit—at once embodied and felt—of our current economy at one of its most vulnerable points, while making the obstacle to the transformed conditions it desires perceptible, as if for the first time? I'm almost embarrassed to ask.

In the place where relation has been occulted, I long for the poem to restore a living intimacy and lend some positive content to this negated bond so that it might in fact be felt. His body—*scene of my displacement*—our common place, deprived of a living relation to the world that banishes it, persists in this dim consciousness of pain, my phantom limb converging with my poems' desire to reach the world. This is not an ethical stance. There can be no compassionate identification with the other, no moral response that is not also an effect of anaesthetisation and repression. There can be no ethical position in relation to this if ethics is to be lived as a refusal to reproduce the terms of its own unethical conditions. Perhaps the

poem can show only this, thereby making that reproduction exquisitely palpable.

Recalling what Alain Badiou calls a 'void in the situation'—the camp at Guantánamo Bay, the solitary cell at San Quentin, or even the commodity itself—I want to locate the body of the detainee as a hole in the present where something radically specific to our contemporary moment exceeds our own horizon of intelligibility, something impossible to name.[34] This may be where value is at once materialised and negated, non-site of my utopian community.

Community might well be a somatic practice whose stakes are those of the whole body.[35] But can a promise of community emerge at the site of its seemingly absolute negation—that 'blank of omission'—in the hold, the cell, the camp?[36] What is it that we desire when we desire communion as the horizon of our social being? And how do we desire that?

While my fantasy of a detainee might anticipate the most untenable political community across seemingly unbridgeable geopolitical divisions, it can only fail to found it. And yet, if his body locates a weak link in a chain of global communising, am I not obliged—*by a categorical imperative*—to seek my relation to his body in positive terms? Or is his exclusion from any such relation an irreversible impediment to the desired touch? Considered in the terms of this common place, the body of my detainee becomes the guarantor of a submerged universal, the thing we positively share being something unspeakable that isn't exactly here to share, a blank we can neither fill nor consume. *And the promise of that.* Because whatever community might arise at the non-site of this interpenetration of particular and universal can only be totally against value, evacuated of state-sponsored content, while remaining open and vulnerable to the reinvention of use.

Here I'm invoking Jean-Luc Nancy's problematic notion that the only thing we, as finite beings, share in common is the very thing we *cannot* share: death, which simultaneously constitutes and negates our proper individuation.[37] But I want to reverse the notion that this sharing is impossible. In other words, I want to rescue the promise of community from the fate of twentieth-century communism—*dustbin of history*—to which it's been consigned by a range of philosophers, from Maurice Blanchot and Giorgio Agamben to Alain Badiou, who sums up this trend in a section in *Conditions* titled 'The Community as the Inherent Impossibility of Our World'.[38] Although Badiou's aim may be to supersede this impossibility while making it the very site of an emancipatory politics, his

thought seems to unfold in a world of ideation through an absence of any historical material body. To this absence, I want to risk opposing my erotic fantasy of being fucked by a body excluded from the materialisation of our contemporary polis.

In a situation where one is not afforded legal protections—be it by a commonwealth or nation-state—or when one is excluded from the law governing recognised persons, one may only have in common with others a certain lack of protection, an exposure to potential harm. But this vulnerability is unevenly distributed and not something that can be shared. One way to begin an interrogation of this negative notion of 'the community of those with no community' is through etymology. According to Emile Benveniste, the etymon 'munus' refers to a gift: 'If *munus* is a gift carrying the obligation of an exchange', he writes, '*immunis* is he who does not fulfill his obligation to make due return. . . . Consequently *communis* does not mean 'he who shares the duties' but really 'he who has *munia* in common'.[39] Glossing this passage, Malcolm Bull writes, 'A community is therefore "a group of persons united by this bond of reciprocity"', and he goes on to consider the gift at the lexical centre of community paradoxically as the 'gift of death': 'The covenant that creates the [Hobbesian] Leviathan is, above all, the refusal of that gift. No one now has to die, because the sovereign will protect them and make them immune to the contagion of death. Instead of the gift there is the contract; in place of gratitude, the law; where there had been a community there is dissociation'.[40] In other words, the negative community, the community of those with no community, can only describe the status quo of 'democratic life', at least as we know it.

When I imagine the 'gift of death', I imagine the suspension of one's self-enclosed individuality, an undoing of one's proprietary relation to a secured and securitised personhood. In other words, 'the gift of death' compensates for all the social and psychic energy otherwise invested in 'self-preservation', an instinct predicated on individuation and that cohabitates with a self-destructive death drive, requiring the arousal of an opposing de-individuating eros to undo it.[41] This is how I imagine calling myself radically into question at the limit where I entwine my flesh with his, exposing me to what can only undo me if I'm not to remain immune to undoing. How might I cancel this immunity through the materialisation of a relation with the very thing that has been sacrificed to ensure it?

As Roberto Esposito notes in *Communitas: The Origin and Destiny of Community*, his sustained interrogation of community's genealo-

gy in the philosophical tradition, the negative community finds its point of departure in Thomas Hobbes: 'Seen from this point of view, therefore, the community isn't only to be identified with the *res publica*, with the common "thing", but rather the hole into which the common thing continually falls'.[42] This point of departure presupposes its conclusion, whereby Esposito's inquiry falls prey to a proleptic scoring of the tail to its head and a whole hypostatisation of the 'negative community' deriving from Georges Bataille, as well as Maurice Blanchot and Jean-Luc Nancy. Perhaps related to the logic that informs Badiou's 'void', theories of the negative community yield formulations whose tropes construct the idealist account of an originary negativity—for example, 'Here is the blinding truth that is kept within the folds of *communitas*: the public thing [res publica] is inseparable from the no-thing. It is precisely the no-thing of the thing that is our common ground'.[43] And then again: 'Not the Origin but its absence, its withdrawal. It is the originary *munus* [*sacrifice, gift, debt*] that constitutes us and makes us destitute in our moral finitude'.[44] This is an ahistorical logic that begins with Hobbes's 'law of necessity', the 'rule by fear', and ends with Bataille's inversion of that law in 'a disorder entrusted to the impulse of desire and of risk'.[45] But if community can only be understood as a rent in the subject or an 'exposure to what interrupts' it, and if this is both the horizon and the limit of community and communitarian desire alike, I balk before its absolute negativity and the inability of genealogies like Esposito's to acknowledge the historical motivations that inform its categorical dismissal of communism—however it might be lived or imagined—and its elevation of that historical judgement to the level of a philosophical concept.

Against value: How then to fill the 'the hole into which the common thing continually falls', a hole whose embodied content—*enslaved body in the hold, detained body in the camp*—remains otherwise occulted and unnameable in this idealist account of community? How am I called to abandon myself in the face of what has already been constitutively abandoned? Moreover, how can I respond to this imperative to embody relation at the limit of valued relation and, in doing so, materialise the obstacle to that transformation in the obdurate stuff of the body itself?

In *The Unavowable Community*, Maurice Blanchot's reading of Bataille's 'negative community' concentrates a distillation of my impasse, particularly as it manifests in Blanchot's engagement with Marguerite Duras's *The Malady of Death*, a short novella that narrates an erotic liaison, a sexual 'non-relation', between an ostensibly

homosexual man who, as the narrator suggests, pays for sex with a woman, perhaps for the first time, in order to feel what it might mean 'to love'.[46] For Blanchot, Duras's narration captures something radically specific about the limit of relation itself as it manifests in a 'community of lovers', and his reading of *The Malady of Death* pushes the problem of the ethical community to its zenith in formulations like the following: 'A responsibility or obligation towards the other that does not come from the law but from which the law would derive [is] what makes it irreducible to all forms of legality through which one tries to regulate it, while at the same time pronouncing it the exception or the extra-ordinary which cannot be enounced in any already formulated language'.[47]

How can one not be sympathetic to Blanchot's notion of a responsibility irreducible to law? I am, however, suspicious of his formulation. Indeed, the paradoxical structure whereby certain acts are posited outside the system that makes them legible and within which they become 'unspeakable' is a familiar post-structuralist trope—one that might impact my thinking already—and while it remains seductive, it also begs scrutiny. Blanchot's particular derivation is informed by the fact that 'the other' narrated by Duras becomes accessible through an economy of illicit exchange. To become 'other' here is to be reified and mystified and placed outside the social by an economic logic that evacuates things of the relations that make them. This non-relational relation is also allegorical of the commodity form, which the woman in Duras's *recit* embodies, and it might therefore require another logic of inquiry so as not to fall prey to capitalism's alibi. 'You may have paid her', Duras writes. 'May have said, I want you to come every night for a few days. She'd have given you a long look and said in that case it'd be expensive'. And 'you' pays. Why? 'You say you want to try, try it, try to know, to get used to that body . . . to the identity between that skin and the life it contains'.[48] What 'you' want to know, however, is beyond knowing, like a certain non-knowledge informed by 'the marvelous impossibility of reaching her through the difference that separates you'.[49] But this elaboration of relation's impossibility in a world whose dominant logic is inseparable from exchange value becomes just another metaphysics of capitalism, whose forces produce occulted relation in the commodity form itself. So while I'm most interested in this 'impossible reach' as it characterises my relation to the detainee, I'm motivated by the need to recover relation in terms that challenge that metaphysics.

The non-relational relation posited by an ethics that sublimes 'the other' into a metaphysical ideal fails to acknowledge 'otherness' as part of a knowledge system—an ontology and an epistemology—whose very stability depends on the occlusion of constitutive relations. This is how difference becomes identity, just as the other becomes the same.[50] Under conditions of total militarisation, the monstrosity of this non-relational relation becomes ever more grotesque, as Benjamin's epilogue attests.

Duras's narration turns the site of an otherwise sanctioned sexual relation into the scene of absolute non-relation. By contrast, I want my narration to make the limit of social relation at the scene of its occlusion palpable, a relation whose unintelligibility becomes necessary in order to ensure the coherence of the public sphere itself. As I write in *Common Place*, 'This is what it takes to sense the insensate, making a common place palpable in the fabricated delights of his body. The more withdrawn my detainee, the more strenuously the sentence—*my sensation delivery system*—pushes against the social crust that bans relation here where it's most intense. As flesh inclines toward flesh, there's inconsolable grief in the arousal of unknown pleasures. What's most unspeakable about his body converges with what's most banal—*a common place that sings thru everything*—as the false fluency of his autopsied corpse disappears in an endless flow of readymade phrases, weird ether of forgotten dismemberments'.[51]

'If death is in play', Bataille writes, 'speaking about it is the worst sort of mystification'.[52] Rather than reproducing the terms and conditions of that mystification, how might poetry work towards its demystification? Experience might still amount to what Bataille refers to as the vehicle for carrying the subject outside its own proprietary limits, but what is the experience of what can't be experienced, and how might poetry lend form to this? Implicit in my inquiry is the need to move beyond 'the absent site of community', an absent site whose historical materialisation is inseparable from the history of communism's failures in Europe.[53] For Bataille, there can be no communal relation because his theorisation of communion denotes a rupture of the subject's boundaries, a breakdown of the human being's integrity that can only compromise, if not destroy, the communitarian subject. But if community can only exist at the place where it comes undone, then any communism is hopeless. This is the disaster.

Still, I want to retain Bataille's arousal of eros as a way of volatilising the limit of relation, only *not* as evidence of community's nega-

tion but as a way to imagine relation where relation has already been negated by historical conditions. A critical fantasy that pushes beyond the negative would work to counter this vision.

Duras's imagined 'malady of death' finds its condition in 'your' homosexuality, and the malady's carrier is 'likely to die without any life to die to'.[54] 'She asks: Haven't you ever loved a woman? You say no, never. She asks: Haven't you ever desired a woman? You say no, never. She asks: Not once, not for a single moment? You say no, never. She says: Never? Ever? You repeat: Never. She smiles, says: A dead man's a strange thing'.[55] Even Blanchot acknowledges the queerness of Duras's text, while echoing its unpleasant hint of homophobia. 'Homosexuality, to come to that name, which is never pronounced, is not 'the malady of death', it only makes it appear'.[56]

This is a stunning moment in *The Unavowable Community*, one that draws Blanchot's thinking about the 'community of lovers' into the orbit of queer theory's 'antisocial thesis' as exemplified by Lee Edelman, whose own anti-communitarian apothegms often perform the same tropes as those rhetorically wired to the 'negative community'. Take the following, for example: 'The truth event, in its radical disruptiveness for those whom it makes its apostles, evacuates collective reality by means of an encounter with the void whose inclusion determines that reality while remaining unaccounted for within it'.[57] Despite its refusal of a hygienic, redemptive, and socially useful eros; despite its resistance to a heteronormative politics of hope whose future offers little more than an extension of a politically unsalvageable present, the self-asserted radicality of queer theory's antisocial thesis can't supersede its own negativity. My question is whether it's possible to remain faithful to the critical potential of sexual fantasy without falling prey to this valorisation of the death drive's 'non-relation'—once again recalling capitalism's metaphysics—without re-inscribing the impossibility of communion and the impossibility of love. My answer, informed by an urgent sense of need, is a resounding yes!

'This would be the place in my story where I take him in my mouth again, begging passage to the rectal ducts, extracting his secrets with a curious tongue, prosthetic extension of my gummy self, excess of a body whose grids of sense sanitize an exchange now spilling on command. As his body becomes a casualty of the labor that penetrates it *military hardware, medical needles, enteral tubing* my poems struggle against reason to turn the site of penetration into a scene of shameless pleasure—*utopia*—if only to make the obstruction to that end perceptible. Still, I wonder whether it's possible "to

transmute death, torture, hatred into love, communion, life", as Robbie suggests my poems do, or whether the writing can only materialise the ethical bind that traps this erotic transfer of energy, arousing the affective blocks & psychic clots that keep his body emotionally remote'.[58]

The detainee's body locates a rent where the fabric of things rips open, a demand I still can't hear, a moan I can't conceive beyond my own. Implicit here is a proposition—*always to be tested, impossible to test*—that his body marks the place where desire for any kind of global communising finds its current condition of impossibility. The withdrawal of his body behind an impenetrable wall replicates the privatisation of death in the autopsy's fungible language of his 'unremarkable genitalia'. This is not a phantasmatic image. It is, rather, the positive manifestation of negated social content—*the unspeakable*—around which a fantasy might organise itself and, in pushing the social imaginary beyond its limit, lubricate a perception of my relation's embodiment, which is no fantasy at all but the material limit of relation under our militarised regime of exception and abandonment.[59]

How can this common place—*the camp, the cell, the detainee*—borne of property's endless circulation through channels of capital and whose relations mark the suspension of relation, how can this become the critical site of community? Can the scene of my relation's occlusion become the common place for a 'community of lovers' excluded from every system of value? And can the communion that flickers into being at the site of its negation be positively conceived as a political pre-figuration of a global communism?

The body withdrawn into the biopolitical cell repels the imagination, which can't admit or comprehend—*just as I can't*—the significance of that figure, ghost of all my social relations. How to render that spirit as bone; how to embody that negation, arouse the spectre of communion whose real content will breach the wall of its enclosure, that finitude wherein any communism must find its positive measure, unthinkable within our available social logics?

From here, it's just a short step back to *The Undercommons* where Harney and Moten refer to this measure as 'the standpoint of no standpoint, everywhere and nowhere, of never and to come, of thing and nothing'.[60] Rather than a metaphysical idealisation, this standpoint provides a prophylactic against all absolute negations insofar as 'the undercommons' finds its referent literalised in the hold of the slaving ship, scene of collective dispossession, and is socially and historically grounded in the body and genealogy of the

black slave. What measures are needed to move that site into consciousness, to awaken my senses to this absented presence whose spectre continues to inform the present? If critical social thought is informed by the effort to think its own limit of possibility, what would it mean to think from that place where thought has been rendered unthinkable? And while this is a non-site for which no equivalent exists, a logic of community—*fantasy and love*—can only benefit from reckoning with the imaginative space of this placeless place, which bears some resemblance to both the camp and the cell.

Perhaps the common is only common insofar as it is absolutely particular, the singular body outside current terms of value, terms whose false universalisation usurps the common in becoming it. For example: Condemned as waste, the detainee's body becomes our common resource and thus returns to profane use. In order to lift his body from the use to which it's been consigned, I dream about him as I move towards a vanishing point of absolute uselessness, a place where I'll never quite arrive. What then becomes of his autopsied corpse in my pathetic fantasy of making contact with the exceptional flesh that secures our enclosed world, a relation that can only be lived as a total perversion of all relation?

So while the biopolitical analytic might be able to conceptualise the 'bare life' of those bodies degraded, immiserated, and destroyed by geopolitical violence, it can't show us his 'unremarkable genitalia' as anything but the excrescent waste of an autopsy report where state language performs its hygienic post-mortem. Whereas the critical work of this analytic, as synthesised by François Debrix and Alexander Barder in *Beyond Biopolitics*, endeavours to place the body otherwise deprived of global citizenship at the centre of collective attention in the interest of arguing for its inclusion among the living, I'm interested in those relations that can only exceed every frame, that is, whatever escapes and refuses, opposes and contaminates the analytic itself.

What, then, can't be reduced to the biopolitical need 'to take command of life in order to preserve it' when such preservation results in non-sites like the camp?[61] Debrix and Barder would respond by nominating 'horror'. The body tortured at the black site, for example, thwarts all representation: 'a mutilated flesh whose horror can only be expanded and be made evermore excessive'.[62] To make sense of this excess, *Beyond Biopolitics* draws attention to the work of Adrianna Cavarero, whose theory of 'horrorism' 'implies that the objectives or effects of horror, differently from terror, perhaps, are not apprehensible within a biopolitical perspective or,

as she puts it, in relation "to the questions of *'bios'* and 'bare life'"'.[63] By contrast, I would nominate love, whose historical constraint is this hole in militarised common sense.

In the negative space of the autopsy report, identity is realised in the annihilation of its subject. But if the so-called 'good life' depends on the fundamental exclusion of his exceptional flesh, what are the implications of arousing a pleasure commensurable to the ethical violence done to it? 'And so, I hollow out a hole in his corpse to fuck a patient orifice. This is how my love, in order to be love, is both enflamed and extinguished in the language of his unremarkable genitalia'.[64] Passages like this become the non-site into which my poems vanish, farthest point on my horizon, where my cock—*once hardened in a soldier's wound*—wants nothing but to fuck the false and violent hole of value. But these metaphors are ridiculous.

While sex might only fail to exceed its containment even as it explodes its usefulness—*hygienic reproduction and policing*—what about love? For Michael Hardt and Antonio Negri, love is the production of being, 'the constitution of the common', not as a proprietary relation or as some immutable background against which life takes place, but rather 'as a living relation', as common social life.[65] For them, 'love now takes the form of indignation, disobedience and antagonism'.[66] Unwittingly recalling a moment in Sigmund Freud's concluding sections of *Civilization and Its Discontents* where Eros appears to exceed the social premium placed on individuation, Hardt and Negri propose an overturning of the Hobbesian model of a commonwealth predicated on self-preservative instincts, instincts strangely isomorphic with the death drive's cohabitation with 'the individual' as an ideal value. But the challenge remains: How can I lend real content to my utopian fantasy when, pressed into the service of self-preservation (individuation and property) rather than self-dissolution (common wealth and mutual aid), love can only aid and abet current forms of military domination and imperialist enclosure?

Today, if it were conceivable to propose a new categorical imperative, mine would be *Love in such a way as to impute for all the choice of one*. Were I to follow that imperative, the object of my affection would not be *my* beloved but everyone's. This would be a love that belies identity, propriety, and detainment, a love that materialises in a body that the universal can't acknowledge without destroying itself, a love that arouses the opaque excess of that body's vacant gulf whose secret sublimes in sweet lubrication— 'hard and moist and moaning'—promise of a feeling irreducible to

concept, exchange, money.[67] Were I to affirm the specificity of my object choice as an unremarkable readymade—*comrade in the hold*— were I to realise a certain bathetic bent by returning the sublime to the commonplace, then the poetical wager would be to recover a hackneyed notion of lyric not as individual expression but as the expression of a 'universal experience'.[68] As if, through the amplified subjectivity of my degraded fantasy, I might at last touch its objective conditions otherwise barely perceptible. How ludicrous would it be to claim that my poems want this and only this?

NOTES

1. Walter Benjamin, 'The Work of Art in the Age of Its Technological Reproducibility', in *Selected Writings*, vol. 3: *1938–1940*, ed. by Howard Eiland and Michael W. Jennings (Cambridge, MA: Harvard University Press, 2003), p. 121.
2. Benjamin, 'The Work of Art', p. 121 (original emphasis).
3. Benjamin, 'The Work of Art', pp. 121–22.
4. Benjamin, 'The Work of Art', p. 122.
5. Walter Benjamin, 'Paris, Capital of the Nineteenth Century (Exposé of 1939)', in *The Arcades Project*, trans. by Howard Eiland and Kevin McLaughlin (Cambridge, MA: Harvard University Press, 1999), p. 22.
6. Benjamin, 'Paris', p. 22.
7. See Rob Halpern, 'Baudelaire's "Dark Zone": The *Poème en prose* as Social Hieroglyph, or the Beginning and the End of Commodity Aesthetics', *Modernist Cultures*, 4.1 (2009), 1–23.
8. See Richard Terdiman, *Discourse/Counter-discourse: The Theory and Practice of Symbolic Resistance in 19th-Century France* (Ithaca, NY: Cornell University Press, 1985), pp. 117–46.
9. Benjamin, 'The Work of Art', p. 122.
10. Theodor Adorno, *Aesthetic Theory*, trans. by Robert Hullot-Kentor (Minneapolis: University of Minnesota Press, 1998), p. 31.
11. Adorno, *Aesthetic Theory*, p. 121.
12. Adorno, *Aesthetic Theory*, p. 122.
13. Adorno, *Aesthetic Theory*, p. 122.
14. Adorno, *Aesthetic Theory*, p. 122.
15. Rob Halpern, *Common Place* (New York: Ugly Duckling Press, 2015). This paragraph derives from the book's postscript, 'On Devotional Kink' (p. 155).
16. See Jodi Dean, *The Communist Horizon* (London: Verso, 2012). 'With our desiring eyes set on the communist horizon, we can now get to work on collectively shaping a world that we already make in common' (p. 21).
17. Giorgio Agamben, *Homo Sacer: Sovereign Power and Bare Life*, trans. by Daniel Hiller-Roazen (Stanford, CA: Stanford University Press, 1998).
18. See Giorgio Agamben, *State of Exception*, trans. by Kevin Attell (Chicago: University of Chicago Press, 2005).
19. 'Surplus populations: populations with tenuous connections to waged labour. Surplus populations have been expanding due to a secular decline in the demand for labour, attendant on a reactivation of the contradiction of capitalist society' (editorial, *Endnotes*, 3 [September 2013], 4). For a perspicuous analysis of race and 'surplus humanity', see Chris Chen, 'The Limit Point of Capitalist

Equality: Notes Toward an Abolitionist Antiracism', in *Endnotes*, 3 [September 2013], 202–23. For historical analyses more specifically focused on the racialization of the US prison system, see Michelle Alexander, *The New Jim Crow: Mass Incarceration in the Age of Colorblindness* (New York: New Press, 2010).

20. Stefano Harney and Fred Moten, *The Undercommons: Fugitive Planning and Black Study* (Wivenhoe: Minor Compositions, 2013), p. 100.

21. Harney and Moten, *The Undercommons*, pp. 94–95.

22. Activist movements such as Decarcerate PA attest to this. 'Decarcerate PA is a coalition of organizations and individuals seeking an end to mass incarceration and the harms it brings to communities'. Note also 'The Amistad Law Project', which refers to itself as a group 'prison abolitionists who view the prison industrial complex as directly related to divestment from our communities'. See *Decarcerate PA*, 7 (March 2015).

23. Harney and Moten, *The Undercommons*, p. 93.

24. See Michel Foucault, *The Birth of Biopolitics: Lectures at the Collège de France, 1978–1979*, trans. by Graham Burchell (New York: Picador, 2010). Significantly, Foucault stakes out the terms of biopolitics's historical emergence in relation to neoliberalism and makes the link between biopolitics and economics clear in the opening lecture: 'Only when we know what this governmental regime called liberalism was, will we be able to grasp what biopolitics is' (p. 22).

25. Judith Butler, 'Violence, Mourning, Politics', in *Precarious Life: The Powers of Mourning and Violence* (New York: Verso, 2004), pp. 19–49.

26. Agamben, *Homo Sacer*, p. 140.

27. Calder Williams, 'Fire to the Commons', in *Communization and Its Discontents, Contestation, Critique, and Contemporary Struggles*, ed. by Benjamin Noys (Wivenhoe: Minor Compositions, 2011), p. 189.

28. See Roberto Esposito, *Communitas: The Origin and Destiny of Community*, trans. by Timothy Campbell (Stanford, CA: Stanford University Press, 2009); The Invisible Committee, *The Coming Insurrection* (Cambridge, MA: MIT Press/ Semiotext[e], 2009).

29. Agamben, *Homo Sacer*, p. 83.

30. Agamben, *Homo Sacer*, p. 29.

31. Michel Foucault, *History of Sexuality*, trans. by Robert Hurley (New York: Vintage, 1980), I, p. 159.

32. Foucault, *History of Sexuality*, p. 187.

33. Foucault, *History of Sexuality*, p. 187.

34. See Peter Hallward, *Badiou: A Subject to Truth* (Minneapolis: University of Minnesota Press, 2003). 'We know that an event exposes the void of the situation, and "love of the unnameable" is nothing other than a love of the void as void, a willingness to think in the element of an empty inconsistency as such. What Badiou calls evil (*le Mal*) is always the effort to specify and fill out what is void in the situation. . . . The canonical example is the Nazi identification of the Jews as the void of the German situation, that is, the attribution of "Semitic" qualities to this void, or, since it amounts to the same thing, the voiding of the Jewish part of that situation. Nazism specifies the void as Jew, and itself as the "full" community' (pp. 262–63).

35. This idea first emerged for me in another context. See Rob Halpern, 'Reading the Interval, Reading Remains', in *No Gender: Reflections on the Life and Work of kari edwards*, ed. by Julian T. Brolaski, Erica Kaufman, and E. Tracy Grinnell (New York: Litmus Press, 2009), p. 181.

36. The phrase 'blank of omission' appears as 'blink of omission' in Claudia Rankine, 'The First Person Singular in the Twenty-First Century', *After Confes-*

sion: Poetry as Autobiography, ed. by Kate Sontag and David Graham (Saint Pail: Graywolf Press), p. 132.

37. Jean-Luc Nancy, *The Inoperative Community* (Minneapolis: University of Minnesota Press, 1991).

38. Alain Badiou, *Conditions* (New York: Continuum, 2008), p. 148.

39. Quoted in Malcolm Bull, 'The Whale Inside', review of *Bíos: Biopolitics and Philosophy* by Roberto Esposito, *London Review of Books*, 31.1 (2009), http://www.lrb.co.uk/v31/n01/malcolm-bull/the-whale-inside [accessed 6 September 2015].

40. Bull, 'The Whale Inside'.

41. Here I am invoking Freud's remarkably understated revelation at the conclusion of *Civilization and Its Discontents* where the self-preservative instincts fail to segregate themselves from the death drive. Sigmund Freud, *Civilization and Its Discontents* (New York: Norton, 1961), pp. 73–76.

42. Esposito, *Communitas*, p. 8.

43. Esposito, *Communitas*, p. 8.

44. Esposito, *Communitas*, p. 8.

45. Esposito, *Communitas*, p. 124.

46. Marguerite Duras, *The Malady of Death*, trans. by Barbara Bray (New York: Grove Press, 1986).

47. Maurice Blanchot, *The Unavowable Community*, trans. by Pierre Joris (Barrytown: Station Hill Press, 1988), p. 43.

48. Duras, *The Malady of Death*, p. 2.

49. Duras, *The Malady of Death*, p. 54.

50. This is Alain Badiou's thesis in *Ethics: An Essay on the Understanding of Evil* (London: Verso, 2001). 'The other always resembles me too much for the hypothesis of an originary exposure to his alterity to be necessarily true' (p. 22).

51. Halpern, *Common Place*, 71.

52. Georges Bataille, 'L'Enseignement de la mort', in *Oeuvres complètes*, vol. 8, p. 199. Quoted in Esposito, *Communitas*, p. 123.

53. Esposito, *Communitas*, p. 122.

54. Duras, *The Malady of Death*, p. 18.

55. Duras, *The Malady of Death*, pp. 30–31.

56. Blanchot, *The Unavowable Community*, p. 51.

57. Lee Edelman, 'Unbecoming: Pornography and the Queer Event', in *Post/Porn/Politics: Queer Feminist Perspective on the Politics of Porn Performance and Sex Work as Culture Production*, ed. by Tim Stüttgen (Berlin: b_books, 2009), p. 201.

58. Halpern, *Common Place*, p. 92.

59. Samuel R. Delany, 'On the Unspeakable', in *Shorter Views: Queer Thoughts and the Politics of the Paraliterary* (Hanover, NH: Wesleyan University Press, 1999). 'The unspeakable is not a boundary dividing a positive area of allowability from a complete and totalized negativity, a boundary located at least one step beyond the forbidden (the forbidden, by definition, must be speakable if its proscriptive power is to function). . . . Rather the unspeakable is a set of positive conventions governing what can be spoken of or written about in general' (p. 61).

60. Harney and Moten, *The Undercommons*, p. 93.

61. François Debrix and Alexander D. Barder, *Beyond Biopolitics: Theory, Violence, and Horror in World Politics* (London: Routledge, 2012), p. 19.

62. Debrix and Barder, *Beyond Biopolitics*, p. 112.

63. Adrianna Cavarero, *Horrorism: Naming Contemporary Violence* (New York: Columbia University Press, 2009), p. 43. Quoted in Debrix and Barder, *Beyond Biopolitics*, p. 19.

64. Halpern, *Common Place*, p. 70.

65. Michael Hardt and Antonio Negri, *Commonwealth* (Cambridge, MA: Harvard University Press, 2009), pp. 195–96.

66. Hardt and Negri, *Commonwealth*, p. 195.

67. Frank O'Hara, 'Cornkind', in *The Collected Poems of Frank O'Hara*, ed. by Donald Allen (Berkeley: University of California Press, 1995), p. 387.

68. Tyrone Williams begins the work of theorizing the contained and commodified body of the African slave in terms of the Duchampian 'readymade' in an unpublished talk titled 'Radical Mimesis: Conceptual Dialectics and the African Diaspora'. Williams writes, 'Africans capable of reading and writing in European languages had to concern themselves with questions of the optical and linguistic vis-à-vis the readymade, that is, vis-à-vis the African body. . . . Obviously I am using Duchamp's "readymade" as a trope for the African body "manufactured" by slavery or, for the freemen, European culture, humanistic and religious. Thus the readymade v. the handmade (the European body remaking itself under humanism) may be understood in terms of utility v. uselessness, the Kantian distinction that insulates the beautiful and sublime of superior art from inferior art. The Duchampian readymade became "art" by virtue of his signature and relocation from the world of utility to the institutions of non-utility. For the African body under slavery the reverse was true: that body was transferred from uselessness (the freedom of primitives) to utility (slavery)'. While there can be no sustained analogy between the slave and the detainee that doesn't shipwreck on the fact that the slave is a literal commodity—embodied human capital—the resonance of Williams's conceptualization with my theme feels astonishing, especially as it returns me, by way of yet another unsuspected link, to the relation between aesthetics and politics, for the detainee circulates within a dialectic of use and uselessness related to that of the slave, even if the elaboration of those terms undergoes yet another inversion in the object-status of his body.

NINE

Art and Devalorisation

Asger Jorn's Theory of Value

Karen Kurczynski

ART AS DEVALORISATION

Mater Profana, a sort of collaboration between Danish artist and Situationist Asger Jorn (1914–1973) and an unknown religious painter, is a modified found flea-market painting of a Madonna and child in a close and rather desperately naturalistic embrace, surmounted by an open-jawed abstract green and yellow monster (see figure 9.1). The child stares up in no particular direction, yet with uncanny intensity magnified by Jorn's likely addition of a diminutive tangerine-coloured 'tear' streaking down from his right eye, while his mother, lips pursed and left eye surmounted by a garish splotch of coloured paint, seems utterly unaware of the monstrous, if flimsy, jaws closing around her. The 'monster' devolves into pure passages of visceral yellow-orange paint, black outlines, and a white trail of paint-drool that makes its way down her shoulder. Although it is impossible to separate the original painter's marks from Jorn's additions, the original painting's earnestness and lack of evident representational skill suggest that it would have been a good candidate for the Museum of Bad Art, a privately owned museum in Massachusetts whose stated aim is 'to celebrate the labor of artists whose

work would be displayed and appreciated in no other forum.'[1] Like the museum, Jorn's series celebrates the undervalued, particularly unique and handmade works that would be considered failures in the official art world.

At the same time, Jorn sought to devalue all that was then held sacred in the art world: the esteemed high-modernist values of originality, individualism, expressivity, authenticity, purity, virtuosity, calligraphic skill, and profundity—as well as the nationalism, pre-war School of Paris traditionalism, and Cold War proclamations of freedom that increasingly framed abstract art in political discourse. While the terms of engagement have since shifted in contemporary art, with the Cold War rhetoric of freedom and authenticity giving way to an advanced cynicism and/or celebration of marginalised expression, the necessity of attacking art's sacred cows becomes only more apparent as art becomes an increasingly valuable private commodity—or commodified value steadily pushed out of the public sphere. Jorn declares that we have a choice to either 'devalorize or be devalorized'.[2] Instead of defending art from the onslaught of political dismissals or budget cuts, he calls us to attack—a call we would do well to hear in what has recently become, for many primary and secondary schools, universities, and municipal and state resource allocations, a struggle of life and death for art.

Through a neo-Dada move that could easily be mistaken for a declaration of the death of painting, Jorn laid the groundwork for its continued vitality. The series of *Modifications* or *Détourned Paintings* was first shown in May 1959 in a Parisian art gallery; the more figurative 'New Disfigurations' were shown in 1962. *Mater Profana* forms part of the latter, in a sub-series titled *La Belle et la bête humaine* (Beauty and the human beast).[3] In these works, Jorn added grotesque imagery or abstract painted or dripped additions to cheap paintings found in flea markets. The result? The high art discourse of abstract painting was set into direct dialogue with street graffiti, mass-media formats such as assembly-line paintings sold in department stores, outmoded genres such as academic-style portraiture by professional artists, and avant-garde knockoffs by amateur Sunday painters. These works developed directly out of Jorn's participation in the Situationist International (SI), which he co-founded in Italy in 1957 along with Guy Debord, Michèle Bernstein, Ralph Rumney, Walter Olmo, Piero Simondo, Elena Verrone, and Giuseppe 'Pinot' Gallizio. The group became known for its theory of *détournement*, or 'subversion', an explicitly political practice of altering the material structure of a given medium to under-

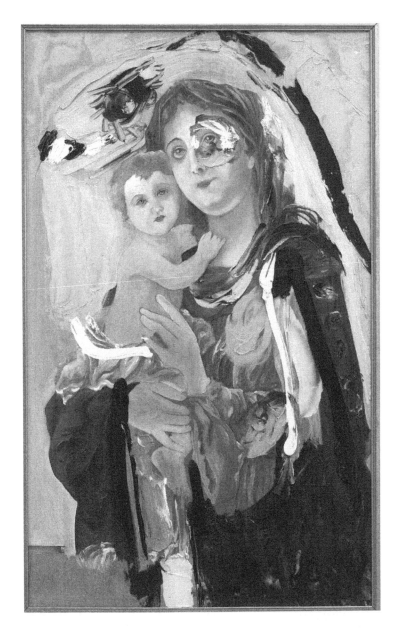

Figure 9.1. Asger Jorn, *Mater Profana*, *Modifications* series, 1960. Oil on found hardboard. 81.5 × 51 cm. Silkeborg Kunstmuseum, Denmark.
Source: © 2016 Donation Jorn, Silkeborg/Artists Rights Society (ARS), NY/ www.copydanbilleder.dk.

mine its presumed message. The practice was intended to devalue
(as well as, in Jorn's terms, to *re*value) the discourse or institution it
attacked.

The essay accompanying the 1959 exhibition includes a poem
written like an advertisement, its ironic tone explicitly describing
Jorn's pictures as kitsch, easily digestible vessels of renovated memory:

> Be modern,
> collectors, museums.
> If you have old paintings,
> do not despair.
> Retain your memories
> but detourn them
> so that they correspond with your era.
> Why reject the old
> if one can modernize it
> with a few strokes of the brush?
> This casts a bit of contemporaneity
> on your old culture.
> Be up to date,
> and distinguished
> at the same time.
> Painting is over.
> You might as well finish it off.
> Detourn.
> Long live painting.[4]

Jorn's evocation of *détournement* explicitly related the works to
the neo-Marxist theory of the Situationist International, to which
Jorn contributed his unique theoretical perspective, including a
book-length treatise revising Marxist theories of value. The SI declared that the *Modifications* exemplified the oppositional practice of
détournement.[5] At the same time, they also negated the very claims
to avant-garde progress, social status, and special insight that were
ultimately the purview of the SI itself and one reason Jorn left the
movement in 1961. Jorn's text describes art objects not as ends in
themselves but as a 'link between subjects'. As in any subjective
encounter, the aesthetic experience of a work became an opportunity to reposition oneself and one's values, to celebrate the devalued, and to question established ideas.

These works were not only examples of *détournement*, which has
been associated in most writing on the SI with a rejection of art and
specifically painting.[6] They were also an homage to all Sunday

painters, amateur painters, forgotten painters, street artists, and ordinary professional painters. Jorn had long believed that everyone had the potential to make art. He argued that 'kitsch', 'folk art', and 'high art' are terms that only have meaning from the point of view of those who want to uphold social inequality: 'The day the aesthetic classification of art ceases to be, the day the moral . . . and the economic classification of people ceases to be, only then will the possibilities of a free, harmonious and universal art be present.'[7] The *Modifications* specifically attacked the recuperation of historical avant-garde practices that rejected the social classification of art by official art-world institutions (the art critics, galleries, museums, arts organisations, political declarations, and all forms of art publicity). Situationist theory makes clear the inevitability of the recuperation of even the most apparently marginal or oppositional activities (including the Situationist movement itself)—in other words, the transference of oppositional into mainstream values. The only response, for Jorn and his colleagues, was to continually contest the reification structures that turn oppositional values into establishment principles. In other words, as Jorn repeatedly emphasised, the social role of art is to devalorise in order to create new values.

Until recently, Jorn's message has been overshadowed in art history by the better-known art movements of the 1950s, like abstract expressionism, and the more established theoretical investigations of his colleagues in the Situationist movement, like Guy Debord and Raoul Vaneigem. Yet his conception of art as a dynamic 'destabilising' element is crucial to understanding twenty-first-century debates about the role of art in society. In a world where art is increasingly viewed as entertainment, superficial luxury, or financial investment (complete with potential for sensational appreciation), Jorn's insights, from his earliest theoretical writings in the 1940s to his mature texts of the 1960s, suggest the absolute centrality of art in social life.

Jorn writes in an unpublished three-volume tome from around 1947 called *Pages from the Book on Art*,

> The ruling class understands art as a useless clowning [*gøgl*]. If it is seen to have social value, that means it has economic value, or a totally inartistic propaganda value. Therefore the highest compliment an artist can receive in class society is that he is a clown [*gøgler*], which in the eyes of the bourgeoisie means *swindler*.[8]

Art's greatest purpose lay precisely, then, in the seemingly useless play of the artist as clown—and, moreover, a clown that is not to be

trusted. In an era dominated by claims to authenticity and truth in abstract painting, infused with the language of existentialism, Jorn defended an art that *lied*, celebrating the paradoxical and superficial in order to lay bare the falseness of its purported claims to truth. Jorn re-established painting in the post-war period not as a spectacular personal expression but as a dialogic and critical practice relative to a host of new experimental mediums he also engaged, from theoretical writings to artist's books, ceramics, and large-scale tapestries. Each format embodied in unique ways his subversive aesthetics: a combination of agitation, irony, parody, materialism, populism, and overt critique of the social exclusivity of high art from classicism to modernism. The *Modifications* are exemplary monuments of his approach to art as devalorisation, extensions of the methods with which he experimented in his own monstrous abstractions. In what follows, I explore two other moments in which Jorn's artistic practice most directly approaches his neo-Marxist theory of artistic value beyond the relatively well-known *Modifications* series: his *Luxury Paintings* of 1961 and his explicit turn towards the investigation of artistic traditions in the mid-1960s, the period of his Scandinavian Institute of Comparative Vandalism (SICV). While the *Luxury Paintings* exemplify Jorn's unorthodox theory of artistic value as a superficial luxury paradoxically necessary to human experience, his photographic artist's books of the SICV period, such as *Signes gravés sur les églises de l'Eure et du Calvados*, develop an artistic approach to history and archaeology that unlocks a critical perspective on the academic disciplines precisely by means of a revaluation of their chosen objects.

ART AS A NECESSARY LUXURY

The series of *Luxury Paintings* produced by Jorn in 1961 celebrate the superficiality of art even as they critique the increasing worldly success of abstract expressionists like Jackson Pollock, who exemplified for Jorn the valuation of the individual artist above the experimental possibilities of a method. For Jorn, these social possibilities that art embodies can only unfold through the unpredictability of collective and interdisciplinary work. In Jorn's hands, Pollock's famous drip process became an experiment with visualising modern scientific principles of change, topology, and quantum mechanics and a parody of modernist originality and economic overvaluation. Jorn applied drips and loops of paint-dipped string to the con-

scious production of 'luxury' commodities in order to directly engage the economic and social status of painting. In Situationist terms, Jorn *détourned* the mark of Pollock into a neo-Marxist pastiche of artistic value and expenditure. The series explicitly stages painting as a medium of superficiality, not just in the literal sense of a flat surface but also in the social and economic implications of non-productive labour.

To produce the paintings, Jorn used a particularly opaque and shiny synthetic lacquer paint, splattering it from the brush, pouring it in large swaths that wrinkle on the picture surface, and applying it with paint-dipped string.[9] In *Phornix Park*, looping lines in complementary colours present meandering imprints of string, rather than gestures of the brush or body (see figure 9.2). Spattered enamel in vivid hues creates organic textures across the surface. Jorn describes the *Luxury* series as coming out of impressionism as well as French post-war tachisme, writing that he 'didn't want to make an optical impression, but materialize the picture directly from the flecks of color, without a model'.[10] The radical spontaneity of this approach was the culmination of twenty years of artistic investigation into the possibilities of abstraction for creating new material configurations that can subsequently be read by different viewers in different ways. Each viewer brings his or her own interest to the finished work.

Lawrence Alloway, in his 1961 essay for the *Luxury Paintings*, specifies that the works 'illuminate the irrational content of Pointillism', as a 'fantastic pattern imposed on nature, a wayward human projection rather than an intuition of objective laws'.[11] This insight recalls Jorn's own repeated insistence on the importance of subjectivity. While society normally opposed art and science, characterising art as subjective expression and science as the search for objective fact, Jorn observes that both discourses actually manifest subjective desires. Art, in other words, is not the opposite of science but a complementary pursuit, equally characterised by the importance of experimentation but less concerned with outcomes and reproducibility. 'We must get rid of the meaningless opposition of "applied" versus "free" art, and change our concepts of both art and science', he writes. 'Science is not objective anyway, since it is always tied to the subjective needs and interests of whoever funds it.'[12] The so-called objectivity of scientific discourse has become increasingly prominent today, in a complex global culture characterised by competing social value systems; Jorn encourages us to see how even the most seemingly neutral and objective values in sci-

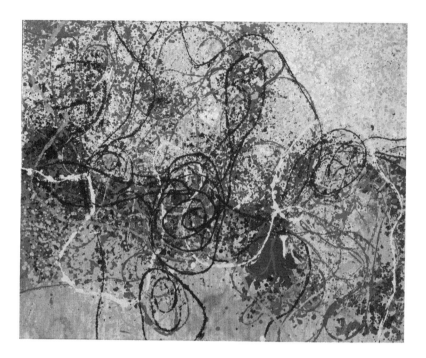

Figure 9.2. Asger Jorn, *Phornix Park, Luxury Picture,* **1961. Synthetic lacquer on canvas. 67.5 × 82.2 cm. Museum Jorn, Silkeborg. Source: © 2016 Donation Jorn, Silkeborg/Artists Rights Society (ARS), NY/ www.copydanbilleder.dk.**

ence are driven by particular interests. Art, unlike science, has the capacity to initiate change. He argues in his theoretical text *Pour la forme* that only art can multiply the possibilities of development. Science is devoted to producing reproducible results, whereas art is about the singular and unique. Science is devoted to truth, verifiability, and quantification; art, on the other hand, is about subjective desire. To Jorn, art is the primary 'mechanism for the allotment of human values'.[13]

Jorn cited several critiques of modern science, including *The Limitation of Science* by J. W. N. Sullivan, a prominent essayist and science writer who introduced Albert Einstein's theory of relativity to British popular audiences in the 1930s, and English mathematician and philosopher Alfred North Whitehead's 1926 *Science and the Modern World*. Jorn extensively underlined passages in his copy of the latter book, sections where Whitehead lamented the Cartesian world view with its emphasis on substance over process. White-

head rejected the short-sighted scientific approach that led nine-teenth-century industrialists to view the material environment as in itself valueless:

> Just when the urbanisation of the western world was entering upon its state of rapid development, and when the most delicate, anxious consideration of the aesthetic qualities of the new materi-al environment was requisite, the doctrine of the irrelevance of such ideas was at its height. In the most advanced industrial countries, art was treated as a frivolity. [14]

Whitehead concludes that the professionalism and specialisation of modern education has provided us with fixed knowledge but less *wisdom*; what is needed is a greater 'appreciation of the variety of value' that can only be acquired through art and aesthetic educa-tion. '"Art" in the general sense which I require', he writes, 'is any selection by which the concrete facts are so arranged as to elicit attention to particular values which are realisable by them.' [15] Art trains us to observe specific material manifestations in time and space—especially unfamiliar ones—and value them. He maintains, 'We neglect to strengthen habits of concrete appreciation of the indi-vidual facts in their full interplay of emergent values, and . . . we merely emphasise abstract formulations which ignore this aspect of the interplay of diverse values.' [16] Art, in his view, is the primary sphere through which we accustom ourselves to constant changes in value and, ultimately, reach beyond existing values. 'Great art is the arrangement of the environment so as to provide for the soul vivid, but transient, values.' Yet this transient enjoyment becomes a conduit for a 'permanent realisation of values extending beyond its former self'. [17] Not only did Whitehead's discussion become a cor-nerstone of Jorn's theory of 'living art' as a sphere of creating new values, but its message appears equally significant today, when creativity appears under attack from all fronts, quarantined to the sphere of 'mere' entertainment and luxury by an ideology of ration-al economic and technological development at all cost.

The pointillist patterns in *Phornix Park* move between image and process, figure and ground. They relate to Jorn's multifaceted theo-retical investigations of both science and art: quantum theory, to-pology, and the semiotics of tachisme, the post-war French move-ment of abstract-expressive painting characterised by the 'tache', the abstract mark or stain. The paint drips reflect a range of earlier artistic experiments as well, experiments that demonstrate the his-torical and collective impulses that made possible Pollock's 'break-

through'. The surrealists, for example, pioneered the use of random marks and stains in the 1930s. While studying in Paris in 1938, Jorn himself produced some early experiments by dripping paint off the balcony of Alberto Giacometti's studio. Jorn dripped some paint from the balcony onto paper spread on the floor below, in an experiment he only took up again in the late 1950s, in the context of tachisme and the increasing fame of Pollock, at a moment when pure abstraction was becoming a dominant discourse in the art world based on an increasingly limited set of values.[18]

Jorn's experiments drew directly on Wassily Kandinsky's Bauhaus-period theory of point, line, and plane but attempted to go beyond their limitations to three dimensions by introducing a dynamic geometry. Jorn describes a historical lineage of what he calls 'anti-abstraction' that supersedes the mere two-dimensional explorations of Kandinsky's flat and bounded compositions. He writes,

> I have never made any but anti-abstract paintings following the current of Hans Arp and Max Ernst, followed by Mondrian and Marcel Duchamp. Kandinsky, in *Von Punkt über Linie zur Fläche*, had aligned modern art according to the perspective of Euclidean geometry, whereas the innovators mentioned above moved towards an inverse geometry, aiming towards a polydimensional cosmos at the surface, just as at the line and the point. The technique of dripping painting showed the absurdity of Kandinsky's attitude. If you work very close to the canvas, the flow of colors makes surfaces, blotches. But if you arrange things once again at a distance, the color is divided into little splashes, which only make points. This is exactly like elements in perspective. They start as masses and disappear over the horizon as points. Kandinsky started at the horizon, in the abstract to arrive where? Me, I started in the immediate present, to arrive where?[19]

The end point, for Jorn, was less interesting than the exploratory path itself. The *Luxury Paintings* present an experimental vocabulary of drips from different locations in space and time relative to the canvas. Close to the canvas, they become poured shapes that continue to roll and morph as they dry; from farther away, they spatter as spots and take on an appearance of temporal immediacy. Dipped along the length of string, they suggest linear paths through space or planes cut across by a two-dimensional slice. The marks evoke four dimensions rather than two and, in the universe of Jornian mathematics, possibly even more, especially if one considers the interpersonal, the cultural, and the political as further dimensions still.

The relationship of points and spirals directly evokes topology, the new mathematical field that preoccupied Jorn at the time and led him to a unique interpretation of the meaning of the drip method. In the 1960 article 'Open Creation and Its Enemies', he suggests returning topology to its origins as *Analysis Situs*, mathematician Henri Poincaré's original term for topology in the nineteenth century, and one that nicely links topology to the Situationist movement—at least 'superficially'. In his account of the Möbius strip and the topological figures called 'homeomorphs', Jorn makes short work of Euclidean geometry, which had become inadequate precisely because it was only useful in defining the static structure of a world removed from the temporal and the social. He rejects Euclidean mathematics as an ideal system that does not take into account the point of view of the observer. Topology allows for the introduction of disorder and the temporal into geometric thought, analysing the transformation of forms in multiple dimensions. In the end, though, as a mathematical discourse even topology was too static for Jorn. He proposes the invention of 'a situlogy, a situgraphy and perhaps even a situmetry beyond existing topographical knowledge', suggesting a new field of artistico-scientific research without specifying what it might mean.[20] The special issues of Jacqueline de Jong's *Situationist Times* that Jorn helped develop on the 'labyrinth' and 'rings and chains' were morphological investigations equivalent to topology's mathematical research into the ways forms can change but still maintain a fundamental continuity with their prior manifestations.[21] Typically, his topological theorising was too opaque and idiosyncratic to contribute much to the discipline per se (and, in fact, he and de Jong were attempting to cut across the very notion of disciplinary specialisation by opening up these questions in the first place), but it became another point of connection with broader cultural investigations at the time. If the linear networks in the *Luxury Paintings* evoke mathematical or atomic models, then, so much the better.

The concreteness of three-dimensional reality, meanwhile, is the material 'remainder' of Jorn's experiment, and the physical medium of these pictures has its own implications for social and economic questions of value. 'Lacquer' is a general term indicating a variety of different paints used traditionally for luxury goods in Asia (originally an organic substance produced by trees but now made commercially). Synthetic lacquer is commonly used today for industrial purposes, such as furniture and appliance painting. Jorn's use of it rather than oil paint was deliberate and likely inspired by Pollock's

own unorthodox use of materials, including lacquer, for their sur-
face reflectivity and ability to pour. The substance recalls both the
luxury object of 'high-end' decorative arts, evoking art's economic
status as a valuable object, and at the same time the 'lower' produc-
tion of commercial paints and industrial enamels. It emphasises an
object-like literalness while at the same time pointing to the sliding
scale of value. Lacquer oscillates between the two artificial poles of
high and low, modifiers that are subjectively assigned to objects.

By using lacquer, Jorn was deliberately inviting a comparison
with the non-artistic, or kitsch. He made apparent the social mean-
ing of this material, as immediately evident from the title of the
series, *Luxury Paintings*. This was a pastiche of the mercurial econo-
my of the art market, related to Jorn's views on the social relevance
of art as a luxury or surplus. In his Situationist study of Marxist
economics, *Critique de la politique économique* (the title taken directly
from the subtitle of Karl Marx's *Capital*), he argues that Marx's con-
ception of value as based entirely on labour and 'use' is inadequate.
He considers value as something constantly changing rather than a
fixed quantity set during the production of an object and based on
its future use, as Marx described in *Capital*. Value, for Jorn, is creat-
ed entirely through subjective interest. While classic Marxism
aimed to eliminate all surplus value in the form of capital because of
its role in social exploitation, he argues that the concept of surplus
could not and should not be eliminated, because its importance
relates not only to economics but also to human culture and biolo-
gy. The concept of surplus or luxury is central to Jorn's definition of
art, as a source of 'counter-value' that negates all conventional con-
cepts of practical value. He writes, 'Art is the invitation to an expen-
diture of energy, without a specific purpose aside from that brought
to it by the spectator himself. It is prodigality.'[22] Jorn states in his
aesthetic treatise *Held og hasard*, 'Conception, superfluity, prodigal-
ity, munificence, surplus, the voluptuous, luxury, the generous—is
identical with the aesthetic principle.'[23] More than just a fairly obvi-
ous pastiche of the art market, then, the *Luxury* title was a commen-
tary on art's social function as an index of the very instability of
social values, something conventionally useless and therefore cru-
cial to society. Jorn also links his economic critique of superficiality
to scientific discourse, writing in 1954, 'We don't yet understand the
nature of the disposable energy in atoms that creates molecules, that
creates all life. But this absolute or meaningless disposable energy is
aesthetic reality.'[24] Art, he says, must produce its own reality with
no productive end or limit in mind.

Unlike Pollock's drips, with their grand and graceful gestures, Jorn's string lines in the *Luxury Paintings* are irregular and awkward. In some paintings, like *Phornix Park*, the string loops create spiral shapes, deliberately referencing an ancient symbol associated with both untrained creativity and the history of the avant-garde. Jorn was fascinated by the spiral's persistence through centuries of human history, as he documents in the books *Guldhorn og Lykkehjul/ Les cornes d'or et la roue de la fortune* of 1957 and *Signes gravés* of 1964, discussed below. Earlier, Jorn wrote of the spiral in relation to the near-universal mythic image of the wheel of life. He argues that the wheel of life was not a circle, indicating a return to origins or a recurrent cycle of nature, but rather a spiral: 'The conservative perceives life as an eternal circulation in a ring, and the radical perceives it all as a radiant march forward along a logical and straight line, whilst the truth is that the movement contains both these elements, that the basic motion of matter has the character of the spiral.'[25] The spiral form also references the 'Père Ubu' character of Alfred Jarry, the turn-of-the-century avant-garde poet. Jorn was in the early 1960s a member of the satirical Collège de Pataphysique, the French organisation devoted to the 'science of imaginary solutions' in the tradition of Jarry.[26] Where Jarry's Ubu character epitomises the ridiculousness and failure of grandiose ideals, Jorn's reference to the spiral also brings in a more modest dimension of human endeavour and its visualisation in collective symbols, some of them light-hearted, humorous, or subversive.

Jorn's *Luxury Paintings* were recognised as pastiche but dismissed by critics at the time for their lack of originality.[27] While perceptive, the critique did not recognise the deliberateness of his statement on the way value is constructed socially, originality being one of the most important signifiers of modernist value. Jorn's process suggests that there is no such thing as an original gesture, an innocent or unprecedented mark, and that in modernist abstraction, ordinary marks become commodified into the style of a 'great' artist the more they are publicised as a personal innovation. His drip or string splatter still manifests its own singularity as a trace of an action, but a modest and unoriginal one. It acknowledges the existence of precedents that define in advance both the meaning and the value of that action. Jorn's critique of originality is equally wrapped up in his observations about art and science. Jorn writes in *Pour la forme* that scientists have to portray their inventions as discoveries in order to justify the great expense necessary for their experiments—now that science is no longer supported by private capital

as it once was. 'Culture and technique', he asserts, 'are not discovered by the human race. They are invented, created, imagined. Invention, the lie, is the opposite of truth.'[28] Science and art are both about creative invention, and thus neither is concerned with 'truth'. Truth and authenticity, meanwhile, were fundamental values of expressive abstract painting in the 1950s. Painter Robert Motherwell, for example, described abstract expressionism as an 'ambivalent humanism, strongly against entrenched dogmas' but strongly for 'possibilities of truth to experience'.[29] In Europe, theorist of tachisme Charles Estienne described the gestures of painter Hans Hartung as 'the most naked and natural gesture through which a man would escape the anguish of his condition'.[30] The *Luxury Paintings* combine Jorn's critique of science with painterly methods of parody, pastiche, and materialism that directly critique the rhetoric of originality and authenticity in abstract painting, in a manner that cannot be fully dismissed as a marketing ploy.

Jorn's artistic strategies pointedly reject the increasingly apolitical rhetoric of transcendence in art of the 1950s. Where the large-scale, virtuosic, or aggressive gestures of abstract expressionism and tachisme suggest a heroic subjectivity alienated from society, Jorn's paintings manifest the painterly gesture as the trace of a transient presence in a specific community, one defined by particular historically informed patterns of interpretation and reception. What makes Jorn's work so relevant — and so contemporary — is his revaluation of painting from a sacred space that symbolises the free rein of the artist's imagination to an experimental object that stirs the observer's imagination as well as critical reflection by means of a direct material address. What matters is art's dynamic effect on the viewer, where the artist's role is that of an initiator rather than an expresser of inner feelings.

ART AS VANDALISM

In 1961 the Situationist International, led by Guy Debord and Raoul Vaneigem, decided to exclude all participating artists and concentrate on the production of theory and direct subversive activities. Art, the SI argued, was precisely nothing more than a luxury commodity with little potential for critical action.[31] Jorn disagreed with both the orthodox Situationist attitude and the manner in which it was carried out. Already demoralised by the SI's exclusivism, he voluntarily left the organisation a few months before the exclusions

and returned to Denmark to search for a radically different approach to collective cultural experimentation. Back in his hometown of Silkeborg, he founded the mischievously named Scandinavian Institute of Comparative Vandalism, devoted to the study of Nordic artistic traditions. The organisation consisted of himself and a few primary collaborators who worked on a set of photographic documents of prehistoric and medieval Scandinavian art around Europe. Many of the over 25,000 photographs produced over the course of the decade were published in a series of visually engrossing SICV books that are as much artist's books as archaeological texts. Jorn collaborated with anthropologists and archaeologists such as Erik Cinthio and P. V. Glob, as well as French photographer Gérard Franceschi, who developed the photographic archive with his assistant Ulrik Ross. Franceschi's dramatically lit, often close-up photographs would define the aesthetic of the project, which foregrounds a sort of abstract narrative developed through images rather than exclusively textual interpretation.

The Scandinavian Institute of Comparative Vandalism devoted its energy to all forms of art imaginable—except 'high art' in the sense of academic art or modernism. Each volume considers a particular subject, including the stave churches of Norway, medieval church altarpieces made of gold, the art of Greenland (still a colony of Denmark today), and the objects made by the indigenous Sami peoples of Norway, Sweden, Finland, and Russia.[32] The 1965 annual report of the SICV describes twenty-eight volumes on '10,000 years of Nordic Folk Art' (the number of planned volumes would change several times). Eight volumes were to deal with prehistoric art, twelve with medieval art, and eight with tribal art and folk art from early-modern to modern times. Subjects of the eight volumes on modern times included 'Lapp art and Greenlandic Eskimo art', 'popular art' of the Renaissance and Baroque, 'Embroidered and woven images', 'Peasant painting' and woodcarving, 'Images of design objects', and 'Popular images in reproduction: from Olaus Magnus, church books and small prints to newspaper images'.[33] Jorn self-funded the first book, *Skånes Stenskulptur under 1100-tallet*, as a prototype in Denmark, hoping to use the model to attract state funding and the help of various university scholars. He wanted to place the entire book series in every library in Denmark, even sending the first three copies to the monarchs of Denmark, Sweden, and Norway to raise awareness of the project. He failed to secure mainstream recognition or funding, however, from a scholarly community wary of his refusal of traditional aesthetic and historical metho-

dologies. In return for financial support, Scandinavian artistic insti-
tutions demanded a say in the choice of images, insisted that the
photographs all come from museum archives, and required that the
responsibility for the books' contents be transferred to a committee
of experts, all of which went directly against Jorn's goals for the
project.[34]

Only two proper SICV books were published during the exis-
tence of the institute from 1961 to 1965, when Jorn declared the
project's failure and moved on. Four more were published in his
lifetime, and several (like the books *Folk Art in Greenland* and *Sami
Folk Art*) have been published posthumously based on sequences of
images Jorn arranged before his death. The two volumes published
during the existence of the SICV were the 1964 *Signes gravés sur les
églises de l'Eure et du Calvados* (Signs carved on the churches of the
Eure and Calvados), a book comparing ancient Scandinavian rock
art to graffiti carved on medieval churches in Normandy, published
in French as an international prototype of the series, and *Skånes
Stenskulptur under 1100-tallet* (Scanic stone sculpture of the 1100s) of
1965, with text in Danish and Swedish.[35] These books feature Jorn's
complex aesthetic theorising about the aesthetic and political signif-
icance of graffiti and vandalism and Nordic cultural traditions
alongside archaeological descriptions. The texts are at times directly
contradictory, setting historical interpretation into dialogic action,
forcing the reader to draw her own conclusions. As Jorn wrote in
Guldhorn og Lykkehjul, 'The evolution of art is to be seen in a reflec-
tion of different points of view, that contradict and complement
each other, and yet individually are equally "correct"'.[36] Because he
viewed art as driven by personal interpretation, his artistic ap-
proach to historical objects sought viewpoints that were subjective
to the point of polemics, ultimately eschewing any notion of objec-
tive truth.

Jorn writes in *Skånes Stenskulptur*, 'The classical aesthetic . . .
conceived the work of art in splendid "isolation" as an autonomous
formal unity', whereas 'Nordic art . . . is integrated into social, prac-
tical, and human functions as a sort of spiritual/intellectual [*åndelig*]
accompaniment to life'.[37] This passage describes Jorn's personal
aesthetic as much as a 'Nordic' one, indicating what led him to
more closely examine prehistoric, pre-classical, and colonial Nordic
art in the first place. The choice of these understudied areas allowed
Jorn to define certain qualities he wanted to believe that Nordic art
possessed. Notable exclusions from his project, however, include
some of the best-known Danish artists, for example, nineteenth-

century neoclassical sculptor Bertel Thorvaldson. Jorn deliberately ignores the classical or academic art produced in the region precisely because it was *not* integrated into broader social life; instead, it has been used in the discipline of art history to prevent recognition of other forms of art as well as to reinforce certain exclusive social hierarchies. The characteristics of social integration into everyday life that Jorn identifies as Nordic relate less to a particular geographic region than to the way art functions in small-scale societies versus complex industrial ones.[38] Yet his project suggests an important re-evaluation of the unique geography and social history of Scandinavia, for example, its strong interest in ancient Nordic religious symbols even after the onset of Christianity, aspects that directly challenge the old art-historical models of centre and periphery. The project playfully suggests, rather than 'objectively' claims, that this region's history makes it a useful case study to counteract the dominant legacy of classical values in art. Ultimately, it suggests that classical art is just as geographically specific as Nordic, with its origins in southern European culture.

Building on his long-standing interest in prehistoric Scandinavian art, Jorn organised the Scandinavian Institute of Comparative Vandalism as a counter to the classicist biases he observed over the years in French and German art history, on the one hand, and to political threats to Nordic autonomy relating to the debates about the formation of the European Community, widely discussed in the Scandinavian Left at the time, on the other.[39] His project refutes both non-Nordic art histories that dismiss Nordic art as provincial and the nationalism of early-twentieth-century Nordic accounts of *folkeminder* (folk memories or relics). Jorn strongly rejected nationalist accounts of Scandinavian art and literature, asserting that he was first of all 'an internationalist and a European artist'.[40] The books redefine Nordic identity as something developed in active response to history and geography, a shifting and provisional construct relating to larger definitions of Europe in relation to its current and former colonies. Jorn's genealogy of international folk art, which includes both colonial and colonised traditions, provides a counter-canon to mainstream art history in his day. 'To write art history is a direct engagement in the artistic process', Jorn argues.[41] His project as artist-historian or artist-archaeologist in the 1960s anticipates the way the roles of historian, critic, scientist, theorist, educator, and maker of art have become interchangeable in twenty-first-century artistic practice. His books revise canonical interpretations in which Nordic artistic traditions have been traditionally undervalued. They

also present an adamantly subjective and open-ended construction that rejects both the classical structure of history as objective truth and art as a select canon of objects to be uncritically venerated by younger generations.

Jorn's interest in the Nordic perspective as a particular and subjective one was not only a rejection of classicism but also a direct critique of the universalist position of modernism, typified in the post-war period by André Malraux's better-known project of the *Musée imaginaire*.[42] He regarded Malraux's conception of the Imaginary Museum made possible by photographic reproduction as a continuation of the classical segregation of art into an artificial hierarchy of value. Although progressive because it recognises non-Western cultural production as art, Malraux's approach essentially subsumes objects from diverse cultures as individual expression and encourages their appreciation as artistic forms utterly separate from their social context, using the interpretive language of Western modernism. As Malraux describes, 'Figures . . . in reproduction lose both their original significance as objects and their function (religious or other); we see them only as works of art and they bring home to us only their makers' talent.'[43] His *Musée imaginaire* texts tend to simply substitute individual expression and talent for the more traditional evaluations of artistic competence. Jorn critiques Malraux for relying on descriptions of the 'sacred' and 'divine' nature of artworks that tend to mystify and stultify rather than expand creativity.[44] Malraux's international humanist perspective incorporates objects made for vastly different religious and social functions into the depoliticised, individualist, Western, and middle-class paradigm of aesthetic appreciation. He thus reinscribes the definitive modernist values of originality, individual expression, and the Western bourgeois construct of, as his text reiterates, 'art for its own sake'.[45]

Where Malraux recuperates non-Western production into the hegemonic Western aesthetic canon, Jorn reveals the way historical discourse and value judgements are shaped by the cultures that produce them. The SICV project considers the virtual museum something continually in formation. Jorn calls for an examination of the artistic value and consequences of the photographic archive and a recognition of its contemporary significance as well as cultural biases: 'The international picture museum does not from the perspective of art show us, as we believe, the art of other times, places, and events. It has become a new picture of the art of our own time. The actual in the art of our own time has become the art of all times

and places.'[46] Instead of an endless search for the new, Jorn argues, a renewal of our relationship to the old will revitalise culture. Each SICV volume addresses a specific culture's geography, history, and aesthetics (and investigates the tensions between those three perspectives). The diverse authorial perspectives resist subsuming the artworks into a single overarching classification such as Malraux's modernist paradigm.

The image sequences in the books unfold mutely over hundreds of pages like still frames in a documentary montage. Lush black-and-white photographic details set objects or architectural fragments into morphological groupings, drawing out similarities of form and linking objects from diverse locations and time periods by subject matter or aesthetic qualities in unexpected ways. Visual progressions in *Skånes Stenskulptur*, for example, convey the evolution of motifs such as the chain, animals swallowing snakes, and human figures in various poses (see figure 9.3).

The sequences allow readers to make direct visual connections, with the option of learning more from the numbered captions in the appendix. Shown in close-up, the works are removed from their

Figure 9.3. Asger Jorn, ed., two-page spread from *Skånes Stenskulptur under 1100-talet*, 10000 års nordisk folkekunst (Copenhagen: Permild and Rosengreen, 1965), figures 114–15, depicting sculptures on the baptismal font of Lyngsjö Kyrka in Sweden. Source: © 2016 Donation Jorn, Silkeborg/Artists Rights Society (ARS), NY/www.copydanbilleder.dk.

immediate physical situation, but as part of a larger sequence they are reinserted into a larger geographical flow of time, space, and interpretation. The images are *détourned* in the sense of liberated from their physical situation and placed into new contexts—a process that calls attention to the way art history as a discipline decontextualises and recontextualises objects all the time. The new contexts suggested in these books may be historical, aesthetic, or political, depending on the perspectives of authors or later readers. The selection of texts from poetry, archaeology, and aesthetics chosen by Jorn set interpretation in motion without necessarily 'explaining' the diverse images in the traditional sense. Texts written by specialists on the local context of the illustrated works often address political controversies about their interpretation, allowing readers to form their own opinions.

When Jorn describes the methodology he invents in *Skånes Stenskulptur* as 'archaeological', he essentially reinvents the term. He says his method is archaeological rather than strictly historical because classical history writing depends on written sources—sources distinctly lacking in relation to Nordic art traditions until the Christian era introduced print culture to Scandinavia for the first time. Archaeology, he observes, draws conclusions directly from the internal patterns of material relics.[47] Yet Jorn's project is also artistic because it presents an eccentric archaeology, foregrounding contradictory interpretations and self-consciously presenting objects as aesthetic in Jorn's expanded, socially engaged sense of the term. Jorn critiques traditional archaeology's tendency to depend on normalising patterns and exclude the unique examples that do not fit those patterns. Art, on the other hand, celebrates the unique. He writes, 'Archaeologists arrange their own material in order to attain and clarify the understanding of a deeper historical logic. Naturally, this cannot be the purpose of art books, which must seek to emphasize the special artistic value and essential character of the individual object.'[48] Jornian archaeology operates by *détourning* established structures of archaeological method as well as the pre-existing artistic canon in such a way as to rethink the discipline of art history that unites these related yet distinct bodies of knowledge.

An institute of vandalism seems to imply a contradiction between the investigation of Nordic art and the destruction of past cultural production, but Jorn viewed all creativity as a subversion of existing knowledge and culture. *Signes gravés* celebrates the Norman graffiti carved on the stones of medieval churches in France. Yet, its title refers pointedly to 'carved signs' rather than graffiti,

relating to Jorn's interest in semiology, the social function and meaning of signs. His text describes vandalism as a basic 'human need', asserting that the medieval vandals aimed not to destroy but rather to leave traces of their presence in France through symbols relating to their pagan history and way of life. The book was directly inspired by art historian Louis Réau's 1959 *History of Vandalism* in France, which exemplifies the teleological writing of history to which Jorn was opposed.

Réau's explicitly nationalist study aimed to offer an 'objective' account of 'the losses inflicted over the ages by the fury or foolishness of men, to the patrimony that our ancestors have bequeathed us'.[49] Réau lists various deviant causes of vandalism, ranging from greed to envy to religious intolerance, psychological impulses that mirror the seven deadly sins and indicate irrational, primitive, or marginal psychic states. The most extreme of these is 'sadistic vandalism', 'the brutal instinct for destruction', seemingly without cause or rational explanation.[50] Jorn, by contrast, attempts to reframe vandalism as a creative action, describing the graffiti as evidence of an international Nordic culture. *Signes gravés* juxtaposes photographs of medieval graffiti of ships, hearts, people, and other imagery with similar images of ancient Scandinavian *Helleristninger* (rock paintings) and other images from world art, encouraging the reader's direct meditations on the images (see figure 9.4).

Swedish anthropologist Gutorm Gjessing upholds Jorn's view of graffiti as creative in his text, arguing that the graffiti represents an unconscious culture, a true tradition opposed to the traditionalism of modern nationalist culture that threatens to destroy it.[51] Jorn argues in his own contribution that the old stereotypes of the Goth, the Vandal, and the Teuton, still current in French scholarship such as that of Réau, nostalgically maintain a purist conception of Gallic France before the barbarian invasions. He pointedly reprints in *Signes gravés* a short section from Réau's book called 'Graffitomanie'. Whereas Réau's text considers graffiti a 'base instinct', the appropriation of his text on 'graffitomania' reframes his analysis into an ironic celebration of graffiti as unbridled expression. Jorn's choice of texts was as much an appropriation, or *détournement*, as his use of images, removing graffiti from the art-historical discourse of vandalism and inserting it into an anthropological analysis of cultural expression on a par with other forms of art.

Jorn later stated in direct reference to the French literary avant-garde, 'Culture is a perpetual theft. . . . The only way to adapt to the present is to continuously détourn heritage'.[52] The Situationist theo-

Figure 9.4. Asger Jorn, ed., two-page spread from *Signes gravés sur les* *églises de l'Eure et du Calvados.* **Bibliothèque d'Alexandrie. Scandinavian Institute of Comparative Vandalism, Vol. 2 (Copenhagen: Borgen, 1964), figures 213–15: Église de Fontaine Henri, Église de Manthelon, and Église de Damville. Source: © 2016 Donation Jorn, Silkeborg/Artists Rights Society (ARS), NY/www.copydanbilleder.dk.**

ry of *détournement* considers all images agents of social power, every image already appropriated from some other source and potentially subject to subversion. Situationist theory recognises that political and cultural institutions tend to recuperate all oppositional imagery and neutralise it, as Réau neutralises the production of graffiti by proclaiming it deviant and senseless. SI scholar Tom McDonough argues that for the Situationists, language

> was not simply some neutral medium waiting to be set free, but was always bound up with relations of power, so it was less a matter of releasing the shackles than of taking up positions in a struggle over meaning. One would not 'storm' language as one had stormed the Bastille; rather, it would be a matter of developing a counterdiscourse through stealing, plagiarizing, and expropriating speech, through reversing dominant meanings and accepted usage.[53]

McDonough makes clear that *détournement* is a form of appropriation. *Détournement* can be understood as appropriation that sub-

verts the pre-existing networks of power and image distribution, liberating images from their standard readings, while recuperation is the form of appropriation that consolidates those networks. Jorn remained sceptical of artistic institutions as organs of recuperation long after he broke with the Situationists. He viewed artistic institutions not as guardians of culture but as recuperators appropriating ordinary creativity and making it exclusive. The SICV was a counter-institution to promote the marginalised art of the past, complementary to Jorn's own experimental art that *détourned* the modernist recuperation of personal expression.

The volumes published by Jorn's Scandinavian Institute of Comparative Vandalism produce a critical archaeological practice instead of a static archive or *Musée imaginaire*. The project rejects the humanist universalism of post-war modernism in favour of texts that describe the ways of life of diverse Nordic populations as they interact with each other, while still foregrounding the aesthetic aspects of heterogeneous objects. Its primarily visual presentations reject the fixed perspective of primitivism by showcasing the evolution of visual morphologies over time and opening the images to continually new readings even as they remain connected (through the index) to their contexts of use and/or collection. As part and parcel of Jorn's aesthetic-critical method of *détournement* and his political critiques of the hegemonic and imperialist perspectives inherent in the institutionalised disciplines of art history and archaeology, the SICV books reject the normative politics of cultural appropriation typical of art-historical writing in Jorn's day and encourage us to continue to resist them in ours.

Throughout his career, Jorn explicitly critiqued the recuperation of expression by elite institutions of art and politics, celebrating instead the types of marginalised, anonymous, and popular creativity that mainstream history has overlooked. Jorn's *Modifications*, *Luxury Paintings*, and SICV projects in particular developed new approaches to art making that attempted to break down the very dichotomy of avant-garde and kitsch and to challenge the institutions of 'high' art through experimental form, collective production, and alternative networks of distribution. These projects reject any totalising view of culture and problematise the assumptions of objectivity and value in history, art history, and archaeology. Even in abstract painting, Jorn's constant emphasis on the social frame of the artwork through titles, exhibition tactics, and textual interventions insisted on the artwork's contiguity with social life. Jorn recognised art as a social mediator between human subjects. Art making,

then, does not have to be something spectacularly removed from everyday life. It can be a direct intervention in it. In Jorn's own words, 'Art is wonder, enthusiasm, inspiration, or agitation.'[54] Its purpose is fundamentally *to move us.*

NOTES

1. Michael J. Frank and Louise Reilly Sacco, *Museum of Bad Art: Masterworks* (Berkeley, CA: Ten Speed Press, 2008), p. vii.

2. Asger Jorn: 'Peinture détournée', in *Modifications* (Paris: Galerie Rive Gauche, 1959). Translated as 'Detourned Painting' in *Hvad skovsøen gemte. Jorns Modifikationer & Kirkebys Overmalinger* (Silkeborg: Museum Jorn, 2011), p. 133.

3. For a more extensive discussion of this series, see Karen Kurczynski, 'Expression as Vandalism: Asger Jorn's Modifications', *Res*, 53/54 (2008), 291–311. See also Karen Kurczynski, *The Art and Politics of Asger Jorn: The Avant-Garde Won't Give Up* (London: Ashgate, 2014).

4. Asger Jorn, 'Peinture détournée', in *Modifications* (Paris: Galerie Rive Gauche, 1959). Translated in Christian Gether, Per Hovdenakk, and Stine Høholt, eds., *Asger Jorn* (Ishøj: Arken Museum for Moderne Kunst, 2002), p. 118.

5. 'Le détournement comme négation et prélude', *Internationale Situationniste*, 3 (1959), 10–11.

6. For a recent discussion of the role of *détournement* as a critique of recuperation, see Tom McDonough, *'The Beautiful Language of My Century': Reinventing the Language of Contestation in Postwar France, 1945–1968* (Cambridge, MA: MIT Press, 2007).

7. Asger Jorn, *Magi og skønne kunster* (Copenhagen: Borgen, 1971), p. 128. Translated in Erik Steffensen, *Asger Jorn, Animator of Oil Painting* (Hellerup: Bløndal, 1995), p. 157.

8. Asger Jorn, 'Pages from the Book on Art', book I, 122i (unpublished manuscript, Museum Jorn Archives, Silkeborg, Denmark, ca. 1948).

9. Lawrence Alloway underlines the direct connection with Pollock by reproducing a Jorn 'Luxury Painting', *Yggdrassel Man*, next to a Kaprow installation in his article on Pollock: Lawrence Alloway, 'Some American Painters', *Stand*, 5 (1961), 28–35 (p. 34). See also Lawrence Alloway, *Asger Jorn—Luxury Paintings* (London: Arthur Tooth & Sons, 1961).

10. Asger Jorn, 'Den experimentellen Charakter meiner Luxusmalerei' (unpublished manuscript, Museum Jorn Archives, 1972), n.p.

11. Alloway, *Asger Jorn—Luxury Paintings*, n.p.

12. Jorn, *Magi og skønne kunster*, p. 11.

13. Jorn, *Concerning Form: An Outline for a Methodology of the Arts*, trans. by Peter Shield (Silkeborg: Museum Jorn, 2012), p. 97.

14. A. N. Whitehead, *Science and the Modern World* (New York: Pelican Mentor, 1948), p. 195. Asger Jorn's copy resides in his personal library at the Museum Jorn.

15. Whitehead, *Science and the Modern World*, p. 200.

16. Whitehead, *Science and the Modern World*, p. 198.

17. Whitehead, *Science and the Modern World*, p. 202.

18. Asger Jorn, 'Merz og dansk klatmaleri i trediverne', in *Merz* (Copenhagen: Galerie Birch, 1961), p. 2.

19. Asger Jorn, *Open Creation and Its Enemies with Originality and Magnitude (On the System of Isou)*, trans. by Fabian Tompsett (London: Unpopular Books, 1994), p. 31.

20. Jorn, *Open Creation*, p. 32.

21. For a deeper discussion of Jorn and topology, see Fabian Tomsett's 'Preface to the English Edition', in *Open Creation and Its Enemies*, pp. 3–16; Karen Kurczynski, 'Red Herrings: Eccentric Morphologies in the *Situationist Times*', in *Expect Everything, Fear Nothing: The Situationist Movement in Scandinavia and Elsewhere*, ed. by Jakob Jakobsen and Mikkel Bolt Rasmussen (Copenhagen: Nebula, 2011), pp. 131–82.

22. Asger Jorn, *Critique de la politique économique suivie de La Lutte Finale*, vol. 2: *Rapports présentés à l'Internationale Situationniste* (Paris: Internationale Situationniste, 1960), p. 21.

23. Jorn, *The Natural Order and Other Texts*, trans. by Peter Shield (Burlington, VT: Ashgate, 2002), p. 264.

24. Asger Jorn, 'Tegn og underlige gerninger' (unpublished manuscript, Museum Jorn Archives, ca. 1954), n.p.

25. Asger Jorn, 'Levende kultur: Et studie i kulturens relativitet' (unpublished manuscript, Museum Jorn Archives, c. 1945), p. 17. Translated in Peter Shield, *Comparative Vandalism: Asger Jorn and the Artistic Attitude to Life* (Burlington, VT: Ashgate, 1998), p. 43.

26. Asger Jorn, 'La pataphysique, une réligion en formation', *Internationale Situationniste* 6 (1961). The same year he exhibited the 'Luxury Paintings' in London, the Collège gave Jorn the honorary title 'Commandeur de l'Ordre de la Grande Gidouille', 'gidouille' being the spiral on Ubu's belly.

27. R. Melville, 'Exhibitions', *Architectural Review*, 130 (1961), 129–31 (p. 130).

28. Jorn, *Concerning Form*, p. 90.

29. Robert Motherwell, 'Forward', in William Seitz, *Abstract Expressionist Painting in America* (Cambridge, MA: Harvard University Press, 1983), p. xiii.

30. Charles Estienne, 'Hans Hartung', *Art d'Aujourd'hui*, 4 (March 1951), quoted in *Charles Estienne et l'art à Paris*, ed. by Jean-Clarence Lambert (Paris: Centre National des Arts Plastiques, 1984), p. 44.

31. For the SI's version of events, see Raoul Vaneigem, 'Le cinquième conférence de l'I.S. à Göteborg', *Internationale Situationniste*, 7 (April 1962), 25–31. 'Le sens du dépérissement de l'art', *Internationale Situationniste*, 3 (December 1959), 72.

32. Asger Jorn, Oddgeir Hoftun, and Gérard Franceschi, *Stavkirkene og det norske middelaldersamfunnet*, 10000 Års Nordisk Folkekunst (Valby: Borgen, 2002); Asger Jorn, Poul Grinder-Hansen, and Gérard Franceschi, *Nordens gyldne billeder fra ældre middelalder*, 10000 Års Nordisk Folkekunst (Valby: Borgen, 1999); Asger Jorn, Tinna Møberg, and Jens Rosing, *Folk Art in Greenland through-out a Thousand Years*, trans. by Peter Shield, 10000 Års Nordisk Folkekunst (Cologne: Walther König, 2001); Asger Jorn et al., *Sami folk art*, 10000 Års Nordisk Folkekunst (Cologne: König, 2006).

33. This summary is indebted to Niels Hendriksen, 'Vandalist Spatial Politics: Asger Jorn's Employment of Medieval Art History' (unpublished paper, Princeton University, 2011).

34. Anneli Nordbrandt Fuchs, 'Asger Jorn and Art History', *Hafnia*, 10 (1985), 128–46 (p. 140).

35. Asger Jorn et al., *Signes gravés sur les églises de l'Eure et du Calvados*, vol. 2: *Bibliothèque d'Alexandrie* (Copenhagen: Borgen, 1964); Asger Jorn, ed., *Skånes Stenskulptur under 1100-talet*, 10000 Års Nordisk Folkekunst (Copenhagen: Permild and Rosengreen, 1965).

36. Asger Jorn, *Guldhorn og Lykkehjul*. Translated in Fuchs, 'Asger Jorn and Art History', p. 136.

37. Asger Jorn, 'Postscript to *12th-Century Stone Sculptures of Scania*', *October*, 141 (2012), 73–76.

38. On this distinction, see Richard L. Anderson, *Calliope's Sisters: A Comparative Study of Philosophies of Art*, 2nd ed. (Upper Saddle River, NJ: Pearson, 2004), pp. 256–63.

39. See Asger Jorn, 'Mind and Sense: On the Principle of Ambivalence in Nordic Husdrapa and Mind Singing', *Situationist Times*, 5 (1964), 156.

40. Asger Jorn, 'Guldhorn, stjernekort og folkekunst', *Democraten*, 4.7 (1971).

41. Asger Jorn, 'Danmark og kunsten' (Museum Jorn Archive, 1953–1956), p. 33.

42. André Malraux, *Museum without Walls*, trans. by Stuart Gilbert and Francis Price (Garden City, NY: Doubleday, 1967), pp. 82–84.

43. Malraux, *The Voices of Silence*, p. 44. Quoted in Douglas Crimp, *On the Museum's Ruins* (Cambridge, MA: MIT Press, 1993), p. 55.

44. Jorn, *Concerning Form*, p. 207.

45. Malraux, *Museum without Walls*, p. 27.

46. Jorn, 'Danmark og kunsten', pp. 5–6.

47. Jorn, 'Postscript', p. 75.

48. Jorn, 'Postscript', p. 76.

49. Louis Réau, *Histoire du vandalisme: Les monuments détruits de l'art français*, 2 vols. (Paris: Librairie Hachette, 1959), p. 10.

50. Réau, *Histoire du vandalisme*, pp. 10–19.

51. Gutorm Gjessing, 'Nord et Normandie', in Jorn et al., *Signes gravés*, p. 2, 47.

52. Asger Jorn, Noël Arnaud, and François Dufrêne, *Asger Jorn: Au pied du mur et un trilogue de l'artiste avec Noël* (Paris: J. Bucher, 1969), n.p. Jorn here echoes the Situationist references to the Comte de Lautréamont's statement that 'plagiarism is necessary. Progress implies it.' Lautréamont, 'Poésies', in *Maldoror and the Complete Works*, trans. Alexis Lykiard (Cambridge: Exact Change, 1994), p. 240. See the discussion in McDonough, '*The Beautiful Language of My Century*', pp. 29–31.

53. McDonough, '*The Beautiful Language of My Century*', p. 5.

54. 'Kunst er beaandring, begejstring, inspiration eller agitation.' 'Blade af kunstens bog', 1947, Book I, n.p. (after p. 89). Museum Jorn Archives.

TEN

Art = Capital?

Reflections on Joseph Beuys's Das Kapital Raum 1970–1977

Christian Lotz

For Roberto and the falling water in Schaffhausen.

Art critiques such as those of Benjamin Buchloh, Thierry de Duve, and Rosalind Krauss have ridiculed the work of Joseph Beuys and his social and anthropological ideas to such an extent that it might be difficult to recover Beuys under the rubble of what is left of these devastating critiques. Buchloh, in particular, criticised Beuys's 'ridiculous presumptuousness about the idea of a universal synthesis of sciences and art',[1] the 'reactionary' and 'crypto-fascist' mixture of art and life, and the ahistorical, anti-modern, and acritical works and principles of Beuys's art.[2] As Buchloh has it, his works'

> opulent nebulousness of meaning and their adherence to a conventional understanding of meaning, makes the visual experience of Beuys's work profoundly dissatisfying. His work does not initiate cognitive changes, but reaffirms a conservative position of literary belief systems.[3]

Thankfully, what Buchloh conceives in 1980 as a return to a reactionary aesthetics can, from our contemporary viewpoint, be cor-

rected, as Buchloh's harsh treatment of Beuys's political, aesthetical, and social ideas, seen in the light of an apolitical and asocial postmodernism, is itself reactionary, since it overlooks the progressive nature of Beuys's work. Though, as de Duve has pointed out, the concepts of political economy that Beuys developed in the later phase of his life, as well as his utopian ideas, might be interpreted as 'a slightly grotesque farce', in what follows I argue that Beuys's aesthetics and the reception that it requires are more progressive than critiques of his art want to admit, especially since their positions remain ideologically tied to a pseudo-Left framework within which such critiques can veil their conservative position behind a superficial rejection of any positive projection of a different society.[4] This falsely understood 'negative' position, which is especially found in Buchloh, ultimately leads to a confirmation of the existing structure of society. For de Duve's and Buchloh's superficial dismissal and the rejection of Beuys's social ideas—which are by no means fascist, since they centre on the creativity of the individual, require radical democracy, and are based on the rejection of anti-democratic state apparatuses—remain ambivalent and, to my mind, are based on a deep-seated resentment towards radical movements in the 1960s, including Beuys's manifold political engagements, as well as an impoverished understanding of aesthetics and art as apolitical (which most likely stems from cultural positions developed during the Cold War).

The best work to demonstrate this counterposition is Beuys's later work displayed in the Hallen für Neue Kunst in Schaffhausen titled *Das Kapital Raum 1970–1977*, which contains elements that Beuys used for performances in August 1970 in Edinburgh and in April 1971 in Basel, as well as for *Documenta 5* in 1972 in Kassel, where Beuys ran an 'office for direct democracy.' After Beuys's death his works have often been conceived of as by-products of his performances. As should become clear, this misconception is based on the understanding of artworks as 'fixed' things and not, as I will argue, as *processes* of meaning constitution that, in the case of Beuys, contain highly complex sensual, social, and interpretative relations, which are the opposite of Buchloh's reductive understanding of Beuys work. Hence, works such as *Das Kapital Raum 1970–1977* are not positive tools that Beuys used as means but, instead, *works* in the Heideggerian sense as something that 'is' in the process of its own meaning constitution. With Hans Georg Gadamer, I will also speak of *plastic images* [*Gebilde*]. In this vein, *Das Kapital Raum 1970–1977* as a hermeneutically understood plastic image should be

understood as a *Denkraum* (i.e., as 'spatialised thought' or a 'space for thought' that opens up and contains a vision of a non-capitalist form of social existence); as such, it should be understood as a work *against (economic) value*. The German word *Denkraum* expresses this nicely, since it points to a space where thinking can move around. Beuys's work, so to speak, provides *a room* for thought. Thinking for Beuys is a plastic process, creative, a formation, and a coming into being of something new. Indeed, in Beuys's art 'something fixed and reified is being moved'.[5] The result of this process is both a *space* (the work in Schaffhausen) and a *process* (creativity as true 'capital'), which come together in the plastic image. As such, a counter-projection in the form of a counter-memory to that which exists (value) is formed. The future is coming to the fore in Beuys's work through the work of memory.

IMAGE AND PLASTICITY IN ART

In order to understand Beuys's installation *Das Kapital*, we need to first recover his concepts of artistic images and creativity. Though Peter Bürger argues that Beuys does not fall into the Bauhaus tradition, since the goal of his art is the spiritual transformation of the society and not the end of labour division in the arts and its new synthesis in buildings,[6] we can broadly connect Beuys to this German tradition in art, since the conception of *art as a socially transformative praxis* is most visible in Bauhaus artists.[7] The social aspect of Bauhaus work differs from other traditions that try to overcome the division between art and life by focusing on the individual, such as Friedrich Nietzsche. Instead, for Bauhaus artists and Beuys alike, social transformations are the result of *collective* praxis, in which the individual participates. In addition, Beuys's conception of socially transformative art praxis, but especially his conception of sculpture and image, can be traced back to writers and artists, such as Johann Wolfgang von Goethe and Paul Klee.[8] During his Bauhaus years, Klee developed a concept of image by means of what he called 'doctrine of formation' [*Gestaltungslehre*], through which he tried to trace back all complex elements of drawings and paintings to simple elements, such as point, line, curve, and relations between those elements, such as direction, tension, and movement.[9] The idea is that art as the re-presentation of the world and reality is based on an organic coherence of all elements and that the image *presents itself as the dynamic result of its own genesis*. The image *creates* its own reality.

According to Klee's idea, an image is not simply the product of a formative activity; rather, the image *comes into being* through its elements as the formative principle of the whole. Understanding such a whole perceptually, then, implies that the image is not something fixed and given; rather, it is something that develops and forms itself through its elements and their perception as an *active* process between perception, element, and the whole (image). This dynamic, non-static, and non-fixed process can therefore be understood as a *plastic* process through which the image forms *itself* through its own *genesis*; it is like a gesture in which movement and meaning are inseparably intertwined. An image as that which we can perceive is a relation of the image *to itself*.

This concept, to be found in Klee, is very important for several reasons, but perhaps especially because we can see how it made its way into philosophical theorising, especially into phenomenology and hermeneutics. Gottfried Boehm, hermeneutically oriented art historian, introduced the term 'iconic difference', in order to refer to the temporal constitution of the image and the difference of part and whole in an image.[10] The fact that we never see parts and elements of a painting simultaneously leads to a dialectical mediation between seeing, painting, element, and the whole, whereby the presence of the image is constituted by a synthesis of absent and present moments. Perceiving a work of art, in other words, is always forced to go back and forth between its parts and the whole. For example, a simple line on a plane can only be taken as an image of a line if the element (here, the line) is differentiated from the rest of the field *and* related to the whole. This process of 'relating' goes beyond gestalt psychology because it is an *active* constitution of structure *and* meaning through the work *and* our participation in the work *as* part of the work itself. The differentiation between the elements and the whole has to be introduced by us; otherwise, we do not see a something as an image *of* a line; instead, we see only a line. However, what we have in front of us is a representation *of* a line. In a similar fashion, *relating* transforms a monochrome painting from a simple coloured surface into an image *of* colour. Viewers who are unable or unwilling to 'relate' are unable to understand a monochrome painting as a painting. They will simply see paint on canvas. What Boehm calls 'iconic difference' is based on the differentiation that the image introduces, which is based on an *internal* negativity of the image formation. In contrast, external negativity means that the image differentiates itself from what it is not, which is a necessary condition for pictures. External negativity, in this context,

leads us back to the classical question of the theory of representations, namely, the question of how a picture is able to represent something that it is not. However, for hermeneutics external negativity is no longer a problem, since art images construct their reference, meaning, and denotated objects *internally*. Works of art create their own reality. Consequently, the iconic difference introduces negativity as an internal condition of the *formation* that the work presents, if we keep in mind that formation is used here for what the work *presents* and 'works out' in its representation.

Let us apply this insight from hermeneutics to Beuys: it is not the case that we have simply a representation of things in his installation room *Das Kapital*; rather, we encounter things that are *becoming* part of the installation itself, as its elements, which may be connected to Klee's ideas about the doctrine of formation [*Gestaltungslehre*]. The components of the installation can be understood as organs of an organism that are organised around the specific form of the installation as a whole. But we need to go one step further in order to see that Beuys goes beyond the hermeneutical conception of images, since, as indicated above, he was influenced not only by Klee's conception of formation but also by romanticism, which led Beuys to extend the plasticity of a work of art to the whole range of formative activities by humans. One might say that he universalises Klee's doctrine of formation and thereby connects the whole doctrine of how images come into being to *all entities* around us, which is now seen as the result of a general human formative activity that is no longer restricted to artistic formation and how images come about *objectively*. However, at the same time, he *subjectivises* the entire creative process, by including the entire range of formative capacities of social beings and societies as a whole. As a matter of fact, he comes close not only to idealised aesthetics, such as Friedrich Schelling and early German romanticism, but also to the great anthropological tradition to be found in Ludwig Feuerbach and the early Karl Marx (I will come back to this in the next section). The formative principle, according to Beuys, is inherent in human capacities and human productivity, which should be seen as an impulse in all intellectual activities, such as speaking and thinking. This very German-romantic vision of the *formative* power of the human intellect and human sensuality is decisive for a proper understanding of the process of creative becoming that leads to a different concept of image as *plastic* image. It is very difficult to translate the German term *Gebilde*, as it indicates an image that *contains its genesis* and brings out his own formation as an *inner* result.

A similar word is *Gebirge*, which is used for mountain formations with an emphasis on *formation*. It is as if a mountain range shows up as its own process of formation. It is, in other words, a result of its own being. It is as if the entire world is a plastic image (i.e., a sculpted reality). As a consequence, the entire reality around us becomes related to art, and, according to Beuys, since 'plasticity ultimately is the law of the universe [*Welt*]',[11] being turns into coming-into-being. Even politics becomes a process of art and, according to Beuys, is to be replaced by a concept of formation [*Gestaltungsbegriff*].[12] Moreover, plasticity as a 'principle of time' and as a 'concept of the future' points to its own dynamics that contain their temporal horizons and possible re-formations.[13] As a consequence, we can no longer speak of works of art as final results and final products of human activities; rather, they are never fixed or given as they change in time. An image, according to Beuys's romanticised vision of the world, has a plastic character, something that is the result of a process of formation. The world, we might also say, is essentially poetic, the position of which was held from Schelling up to Gustav Mahler, though, as I pointed out above, for Beuys, the poetic character is located on both the subjective and the objective sides and also includes the process of thinking itself: a 'conceptual image' [*Begriffsbild*] is something produced by thought in which the thought comes into being as a formation of its own aspects.[14] The blackboards used in *Das Kapital*, including the material of the boards and the chalk and its traces, point to such a process, as they are the result of a thought process that needs to be reanimated by the thinking spectator. In fact, the entire installation and many of Beuys's performances are *thought images*, if we take into account that thinking is here understood as a *creative* process.

To render thinking visible, 'plastic forces'[15] are needed that point to dynamic relations between the elements and indicate upwards, downwards, or calm tensions in the work of art, like notes on scores.[16] The plastic image is a *composition*, as Klee pointed out. For Beuys there is no other access to humanity than the concept of plasticity and formation, as humans become self-related through the products of their creative and forming activities: *they are how they create*, the conception of which is also to be found on a larger scale in the early Marx, for whom the being of humans is determined by how they express themselves in their labouring and reproductive activities. As a consequence of this extension of plastic images to the entire mental and social range of activities, the viewer of art can no longer be conceived outside this process, as participa-

tion is itself *part of the creation* of the work, the idea of which can also be found in Gadamer's hermeneutics. Art, then, becomes a social activity in which potentially everyone can participate and no one needs to be excluded.[17] This vision is deeply democratic, as it excludes selective access criteria, such as wealth, intelligence, status, and access to the market.

To sum up, the plastic conception of art and images has the goal of letting 'the anthropological human element become image-like [*bildhaft*]', which counts not only for the artist but also for the audience of the work of art that needs to become productive by reactivating its productive imagination [*Einbildungskraft*] as a *bodily and sensual praxis* within which both intellectual and sensual activity are synthesised in one imaginary activity.[18] The entire process of perceiving drawings, paintings, and installations is very similar to participating in a symphony. In the case of music, 'listening' is a very active and participatory process, during which the organic whole needs to come into being through its elements and their relations. This whole needs to be reproduced by the listener in his or her productive imagination. In short, 'the task of art is to vitalize the image-like quality [*Bildhaftigkeit*] of humans.'[19] This position can also be found in philosophers, such as Jean-Paul Sartre and Hans Jonas. Jonas argues that human beings necessarily are *homo pictors* who have access to the reality as *their* reality only through their capacities to form images of and through this reality. This picturing process introduced both distance to and independence from reality, as well as an appropriation of reality as one that remains independent from practical appropriation.[20] However, I submit that we need to go one step further than Jonas does, for the productive imagination in Beuys's work is not simply an anthropological activity through which humans distance themselves from objects that reflect their own understanding; it also indicates the radical *externality* of understanding, memory, and intentional relations as being *in* things now seen as the *result* of human productive activity. Society, accordingly, is at first something *external* that gets shaped, formed, and brought about in the creative act. At each stage of its formation, it functions as its own material and formation. In Beuys's work, we find a Marxian and Feuerbachian vision of creativity and reality.

THE COMMONISM OF ART: SENSUALITY, MATERIALITY, AND MEMORY

Against the reduction of the arts to specific sensual fields and experiences, Beuys's work is based on a strategy to reactivate the entire range of human sensuality. This entire range, however, is understood as *praxis*, as 'activity of humans, in their labor',[21] which, as we will see, is firmly rooted in ideas to be found in Feuerbach and in the early Marx (though a major source of Beuys's inspiration was Rudolf Steiner). Three aspects of the early Marx and nineteenth-century projections of socialist thinking are important for *Das Kapital Raum 1970–1977*: (1) Marx's concept of sensuality and reality as praxis, (2) the alienation from our sensual creativity through the capitalist mode of production, and (3) the thesis to be found in his later work that the true wealth of social productivity is not capital but collective social productivity, of which capital is only the social form.

SENSUALITY AS PRAXIS

Though Marx is clearly fascinated with this return to sensibility as the real foundation of existence, he accuses Feuerbach not only of overlooking the social-material determination of the sensual reality but also of ultimately mystifying sensuality, as Feuerbach's universal conception of sensuality makes it the core and essence of human activity as *human* activity. This is in contrast to Marx's thesis that sensual reality and its experience are the core of a non-abstract *social-material* activity. Moreover, Marx charges Feuerbach with abstractions in *The German Ideology*:

> Certainly Feuerbach has a great advantage over the 'pure' materialists in that he realizes how human beings too are an 'object of the senses.' But apart from the fact that he only conceives them as an 'object of the senses, not as sensuous activity', because he still remains in the realm of theory and conceives of men not in their given social connection, not under their existing conditions of life, which have made them what they are, he never arrives at the really existing active human beings, but stops at the abstraction 'human being.' . . . Thus he never manages to conceive the sensuous world as the total living sensuous *activity* of the individuals composing it.[22]

Feuerbach's materialism remains contemplative and not practical—that is, human sensuality is not analysed in relation to the historical development of production, productive forces, or relations of production (i.e., to the real life activity of humans who *reproduce* themselves through and by these activities). As a consequence, the Feuerbachian sensuous world does not appear as one that is *changeable* (i.e., as one that is able to be subjected to revolutionary activity). As the sensuous world is not simply the result of activity but *exists* only as and in activity, it is the true 'motor' and movement of history itself. When, in a famous statement, Marx defines communism as the 'real movement of history' and not as the goal of history, he brings together both the sensuous world as 'perceived perception' and the reproduction of this unity of perception and the perceived through labour.[23] As a consequence, according to Marx, we must not understand social reality as one to which we are related epistemologically; rather, we need to understand that every object of knowledge and perception is socially mediated as the *result* of social-productive activity. Sensuality is therefore something that does not belong abstractly to the human body; instead, it becomes a mediated category (i.e., one of social relatedness and one that is defined through its *objectlike* character). Marx writes,

> Man appropriates his total essence in a total manner, that is to say, as a whole human being. Each of his *human* relations to the world—seeing, hearing, smelling, tasting, feeling, thinking, observing, experiencing, wanting, acting, loving—in short, all the organs of his individual being, like those organs which are directly social in their form, are in their *objective* orientation, or in their *orientation to the object*, the appropriation of the object, the appropriation of *human* reality.[24]

The latter point can easily be connected to Beuys. For example, an installation such as *Das Kapital* is not simply an object of perception; rather, it is itself a sensual *configuration* indicated through the socially (and technologically) mediated constellation of human sensuality through writing, hearing, speaking, and touching.

ALIENATION FROM SENSUAL PRAXIS

Human productivity and labour take on a specific social form under capitalist social conditions: on the one hand, labour becomes abstract (i.e., it only counts insofar as it is exchangeable), and, on the other hand, the results of human productivity take on the commod-

ity form (i.e., they are established through their universal exchange-ability [= value form]). Both labour and the social reality established through labour are finally held together by the subjection of all market and exchange relations to processing money (capital). With the establishment of capital as the superior form of labour, all social relations become subjected to the goal of making more money for the sake of money. The fulfilment of human and ecological needs is pushed into the background. The exchange of commodities was always connected to a specific context of space and time; with the establishment of capital as the universally existing form of value, however, the relation to space and time becomes itself abstract and independent from local conditions, insofar as the money form can principally take on *every* content. For example, money as world money can function *everywhere* (i.e., entities in their exchangeability no longer depend on local conditions, norms, individuals, and so forth). Money as world money makes every entity, at least potentially, buyable and therefore exchangeable. Everything can be exchanged with everything. Accordingly, it no longer matters who exchanges what, when, and where, and the faster the transactions can be carried out, the more dynamic and expanding capitalism becomes. Consequently, abstraction does not mean that social relations disappear; rather, social dependencies increase, as everyone becomes dependent upon everyone else. However, at the same time, social dependencies decrease, as everyone's relation with all others appears accidental and becomes external to them. *Precisely* as this alienation, money is the expression of the resulting contradiction between dependency and independency. What formally depended upon norms, such as religion, loyalty, mythology, power, families, dependencies, and so forth, turns now into money relations and *therefore* establishes new forms of dependencies, namely, abstract dependencies. Moreover, because human productivity as a concrete bodily and *sensual* praxis no longer appears as such, it becomes external to human agents. As a consequence, human sensual praxis and its creative products now take on the commodity form, the consequence of which is that the true substance of all creative products, namely, labour and human creativity, disappears. Put in Beuys's words, the true source of all wealth, namely, the human as an artist, gets buried under its perverted social form, which is capital as processing money. Whenever capital-mediated world constitution occurs, we no longer participate in the whole of social relations, and instead we encounter each other as abstract individuals who are held together by money, capital, and the legal

forms belonging to it. Accordingly, it is not simply the case that we alienate ourselves from our being human; rather, as our self-realisation only occurs in social production, creativity, talking to each other, eating, and so forth, the capitalist form of reproduction establishes these self-realisations as *abstract* relations (i.e., as no longer shared *in* the objects we see, move, touch, change, create, and so on).

HUMAN CREATIVITY AS THE TRUE SOURCE OF WEALTH

As indicated, with the event of value as the universal expression of wealth under capitalism, the true source of wealth becomes buried under the abstractions introduced by the commodity form and the processing nature of money. Not surprisingly, then, Beuys takes up this Marxian tradition and re-centers it on creativity and humans as artists. Rather than focusing on labour alone, Beuys tries to show that the social individual, with her creative, intellectual, and sensual capacities, should be seen as the source of all social wealth: 'And when it becomes clear that human capacities are the real capital, then money disappears as the main economic value'.[25] Though Beuys's concept of capital is misleading and not very precise, what he has in mind is that instead of life capturing capital and money, the centre of our society should be that which *underlies* all value and monetarily reduced investments, namely, the whole range of human capacities to shape, form, and bring about human reality as *social* reality. Similarly, money, according to Beuys, is alienated in and through capital (i.e., it appears in a perverted form of 'M'). As surplus value (i.e., 'more money'), profit, credit, and interest money show up in perverted forms, and it is quite remarkable that Beuys had sophisticated ideas about these economic processes. According to him, like Silvio Gesell, money should be taken out of the investment process and brought back to its 'non-fictitious' qualities. As such, it is supposed to function as a 'regulative principle of right for all creative processes [*Rechtsregulativ*]'.[26] In an interview Beuys refers explicitly to labour in the sense of human creativity as the 'real' capital of society.[27] 'To change the money system, that's the most important thing, the money system. Money and the state are the only oppressive powers in the present time.'[28] Switching to a non-capitalist form of social relations implies the co-operation of all senses with each other, the liberation and restoration of lost sensual capacities to live a life fully immersed in the lived body, and, in

particular, its relation to nature and its ecological situation 'on earth'.[29] Beuys frequently worked with non-human animals in his works. For example, rabbits are often used because the rabbit is here taken 'as [the] external organ [*Aussenorgan*]' of humans, indicating that the entire plant and non-human animal world belongs to the process of human creativity and human activity understood as one of its organic conditions.[30] He thereby also follows Marx, who claimed that capital undermines both the labourer and the earth as the two sources of all social wealth. The task of art is to extend the range and intensity of human sensuality through a dialogue with nature, including non-human animals.[31] Consequently, materials become the most important aspect of Beuys's universe; as he puts it, 'I do not work with symbols; rather, I work with materials'.[32] Beuys's ecological vision is visible in the role of the slate plates in *Das Kapital* as the concrete ecological place for the inscriptions of the mind and the intellect. The plastic image can only come about in an ecologically sensitive environment that is closely connected to nature, heat preservation, and the earth as the shelter of world projections. As Marx posits an object-mediated social reality and therefore sees in everything its genesis, Beuys's vision that we encounter in *Das Kapital* posits a social reality formed and shaped through social-creative practices. Beuys argues that in order to change society and its relation to itself and the ecology, we must

> enlarge the idea of art to include the whole creativity. And if you do that, it follows logically that every living being is an artist— and artist in the sense that he can develop his own capacity. . . . Under the present educational structure in the Western world, in private capitalist systems, this is not guaranteed.[33]

DEMOCRATIC SOCIALIST PLASTICITY: ON THE WAY TO ANOTHER SOCIETY

Given what we have said so far about the nature of plastic images and Beuys's enlarged concept of art rooted in early forms of anthropological Marxism, it should now be clear that the installation *Das Kapital Raum 1970–1977* should be analysed in this theoretical framework. To some extent, this work contains both image conception and social conception of human creativity, though it is presented as a work with (political) transformative force.[34] As Hans Dieter Huber has it, 'The whole installation therefore can be comprehended as a potential model for the creative transformation of indi-

vidual human energies into collective social processes for the evolution of the whole social fabric'.[35] As all elements of the installation go back to earlier happenings and performances by Beuys, we need to read *Das Kapital* as a (memory of) 'political action [*politische Aktion*]' that forms and presents alternative ways of thinking about creativity under the condition of capitalism. As Beuys puts it, 'Ideas of transformation, for a new orientation of the social, in our lives, in nature or in the economy . . . ultimately are a question of art, of an extended concept of art'.[36] The work presents a vision of 'how to unhinge capitalism',[37] through the transformation and opening up of all senses and thoughts to an alternative form of society, that is, to an alternative form of creativity and formative praxis that, ultimately, projects a vision of social and shared creativity that overcomes social alienation through a different relation between humans and materials. In the work of art, materials are not determined as a resource to be exploited but made visible in their ecological relationship, which is to say, made visible in their importance for the creative and social process.[38] As the work does not exploit the materials used for the installation and the performances, it gives us a 'reminder' and memory of a non-destructive, perhaps even mimetic, relationship to the earth. Political praxis as art praxis, then, becomes the *shaping* of the relationship between productivity, the society, and the earth. To put it more precisely, only the conception of political praxis *as* art contains a *different* and non-capitalist relationship between the whole and its elements. As such, the aesthetics contained in *Das Kapital Raum* is not based on destruction, which Beuys identifies as the contemporary nature of our political culture; rather, the work develops and forms new ideas about how we can live together in a different mode of social humanity, without it being simply a given result. Indeed, in line with the plasticity of the image, the work projects its vision of a different social reality as a process. As Franz-Joachim Verspohl remarks, Beuys's strategy to socialise the artist and to point to the creative potential of all humans enlarged the traditional idea of a harmony between art and life, insofar as the whole social process of reproduction (i.e., the specifically capitalist way of social reproduction) has to be taken into account.[39] *Das Kapital Raum* is based on ideas that all focus on the 'announcement of a new humanity, the class-less human being . . . whom we still need to realize'.[40] This class-less human being is a being who has dissolved all class distinctions in creative distinctions (i.e., class distinctions are turned into true distinctions between individuals).

During the *Documenta 5* Beuys ran discussions about democracy and a different political praxis as part of the happening and of the project 'honey pump': 'The real honey pump,' as Beuys puts it, 'was the active humans over the course of the last 100 days', which suggests that the plasticity of the image also contains the sentences, words, ideas, thoughts, and emotions formed during the exhibition, all of which come alive *through* and *in* the performance of everyone who participated in the discussions.[41] The honey pump, some of which went into *Das Kapital*, presents the image of a social organism,[42] but not, as Buchloh seems to think, as a fascist idea of integrating everyone into a unified political vision; instead, it opens up a different relationship altogether, namely, the 'sensually-intuitive path towards liberation'.[43] Participating in the work *Das Kapital*, speaking and thinking *about* it (as we do here right now), *is* the coming-into-being of the plastic image, as we carry out a different sensual and creative relationship with ourselves, others, and the earth, the point of which finally helps us understand Beuys's masterwork as a space for thinking. Thinking, however, is here conceived as a plastic process, during which that which the thought process is about is formed into a self-relational image [*Gebilde*] or materialised memory.

DAS KAPITAL RAUM 1970–1977 AS A *DENKRAUM*

One of the best short descriptions of *Das Kapital* is the following:

> One rather homogeneous subsystem of elements is formed by the group of blackboards, on which diagrams, sentences, formulae, words and drawings are written with white chalk. They hang from the wall, lie on the floor or lean against the back walls. Another subsystem is defined by its connection to electricity. Two 16 mm projectors are standing with two empty filmspools on a projection shelves. They are plugged into the electrical system by a white cable. Two tape recorders with empty spools and headphones are standing next to them on the floor. They are plugged in to the electrical system by a black cable. A microphone-stand with a microphone is connected to one of the tape recorders. The tape recorders themselves are connected to an amplifier and two loudspeakers. A quite separate subsystem is formed by the zinc bathtub filled with water, white linen and two flashlights attached on the handles. A zinc watering can, a white enamelled dish with a piece of soap in it and a towel are placed nearby. Between the microphone-stand and the bathtub lies a tin

lid with a heap of gelatine. A ladder with gelatine pieces is standing in the corner of the room. The installation is completed by a piano, a spear and two felt covered wooden laths.[44]

As we can see here, we find two main 'systems' of meaning and sensuality in this installation: on the one hand, written elements regulate the background, and, on the floor, we find elements powered by electricity, which are related to speaking and recording. In being confronted with this first constellation, we note that they remain silent, as we do not find someone who writes, records, speaks, or projects images to the wall. All elements seem to have lost their life, which points to a meta-level of the installation itself, namely, to its overall *memorial* character. By our walking around the installation, by our perceiving and thinking about the installation, the work becomes transformed as something *active* and *alive* through our forming participation in the work. *Das Kapital* is therefore at first a transformation of sensuality and elements into an organic whole that can only be formed by moving the sculpture to an *inner* sphere, namely, memory, which is essentially a form of thinking of the past. Accordingly, the sculpture is the reconfiguration of all given elements into re-collected elements, and by this process of recollection, the image comes into being as a sculpted thought and, given the foregoing sections, a different projection of social reality. The sign-character of this work does not mean that it can be reduced to a text and be read as a text. On the contrary, the signifying character is the *result* and not the *condition* of the reanimation of the work through thought and sensual experience and its synthesis in the formed image. To use an analogy, the installation is like a mountain range seen as a formation of its own image-like character, which becomes visible whenever we understand the mountain range not as a given 'thing' but, instead, as something that comes-into-being and is the result of its own creative process. This creative process is the real enemy of capital (at least in Beuys's world), as it is, as we said above, the 'real capital' upon which human reality is based.

Accordingly, the whole installation is a spatialised and materialised memory. It is a memorial [*Denkmal*][45] (i.e., a *place* for thinking). Often slate has been used as a metaphor for memory, and here it is used in its sensually present form, as a 'slate inscription' [*Schieferritzung*].[46] Slate is a material that can be traced back to coal; consequently, it contains references to the mining industry, ecological issues, and a concrete ecological horizon, which points to a different relationship to the earth in a different human setting that is mainly

characterised by communication as the centre of the whole work. The piano points to finding the right tone,[47] especially if we think of adjusting the piano. Low bass tones are used for everyday communication, which Beuys dealt with in his *Scottish Symphony* (parts of which went into *Das Kapital*). The communicative elements that are based on listening and speaking are echoed in the participatory formation of the viewer. We turn the silent communication into an active hearing by reactivating and 'living through' the attempt to listen to the work and to perceive the work. Listening to the work as listening to the silent communication, then, is not only a form of participation in the Gadamerian sense but also a form of listening as a process of meaning constitution. *Das Kapital* projects an image of the process of listening[48] through a process of articulation and meaning constitution in a plastic version. The transitions of this plasticity are related to the (now hardened) gelatin, which is moved by music frequency and speaking noises (microphone). Here communication is itself a plastic process that leads to a different formation and sculpting of material processes.

The thought-space is also visible in the 'appellations' that are contained in the installation. It is as if *Das Kapital* calls for action, and more specifically for transformative action. The piano calls for playing, the microphone calls for speaking, the blackboards call for reading, the spear calls for throwing, and the projector calls for showing. These elements do not simply call for being *used*; rather, they call for *becoming alive*, for becoming part of *praxis*, which is here defined as a praxis of speaking, listening, writing, and discussing a new form of social creativity and productivity.[49] All of this has an imminent political sense. These things, however, are *not* in a fixed state; rather, they move only in the totality of the work within which they become what they are. As dead objects the elements of the image turn into symbols that refer to something absent, which, again, was not the case during the time of their lived existence. During the performance these things functioned precisely in carrying out a practice. They were the bearer of action; as such, they were not visible as disconnected, separated, and alienated pieces. Our participation in this 'thought-space,' then, needs to re-connect and re-collect the pieces and turn them into bearers of our living thought, perception, and sensual experience. Only then do they become alive. The work, in conclusion, calls for a different principle of society and human sensuality, namely, a praxis based on creativity and productive communication rather than capital. Marx's thesis that capital can only exist as the form of labour and that the true

wealth of societies should not be seen as capital, but in human collective labour, is here indicated by pointing to a human creativity and sculpted reality that is freed from the power of capital and brings the 'true capital' into our focus.

CONCLUSION

The relational network contained in the plastic image only comes alive if we take into account that all parts receive and play out their meaning in the organic totality of *Das Kapital*. As such, Bürger's thesis that Beuys destroys the traditional function of materials as being part of a composition should be rejected.[50] The interpreter in Beuys's world needs to stand, as do all materials, *in* the composition; as such, these elements are not simply self-signifying, as Bürger seems to suggest. In *Das Kapital Raum 1970–1977*, Beuys transforms all elements into artistic means towards a new social reality and communicable life. Perhaps, therefore, we could say that if we lived in a society that came about through human creativity and art alone, then, as Beuys has it, 'profit, private property, and wage dependency would disappear'.[51]

NOTES

1. Benjamin Buchloh, 'Beuys: The Twilight of the Idol (1980)', in *Joseph Beuys: The Reader*, ed. by Claudia Mesch and Viola Michely (Cambridge, MA: MIT Press, 2007), p. 116.

2. Buchloh, 'Beuys', p. 123.

3. Buchloh, 'Beuys', p. 122.

4. Thierry de Duve, 'Joseph Beuys, or the last of the Proletarians (1988)', in *Joseph Beuys: The Reader*, ed. by Claudia Mesch and Viola Michely (Cambridge, MA: MIT Press, 2007), p. 142.

5. Johannes Stüttgen, 'Der Kapitalbegriff bei Joseph Beuys', in *Joseph Beuys und das Kapital: vier Vorträge zum Verständnis von Joseph Beuys und seiner Rauminstallation, Das Kapital Raum 1970–1977*, ed. by Christel Raussmüller-Sauer (Schaffhausen: Hallen für neue Kunst, 1988), pp. 88–127 (p. 95).

6. Peter Bürger in *Joseph Beuys: Die Materialien und ihre Botschaft*, ed. by Bernd Strieder (Bedburg Hau: Museum Moyland, 2006), p. 15.

7. Beuys was heavily influenced by Rudolf Steiner and his anthroposophical ideas. In this chapter, however, I focus on the Marxist background in Beuys's intellectual and artistic universe. For Beuys's connection to Steiner, see Wolfgang Zumdick, *Der Tod hält mich wach. Joseph Beuys—Rudolf Steiner, Grundzüge ihres Denkens* (Basel: Pforte Verlag, 2006).

8. For this, see Matthias Bunge, *Zwischen Intuition und Ratio. Pole des Bildnerischen Denkens bei Kandinsky, Klee und Beuys* (Stuttgart: Franz Steiner Verlag, 1996).

9. For this, especially see the excellent contributions in the exhibition catalogue, Fabienne Eggelhöfer, Marianne Keller, and Christian Thöner, eds., *Paul Klee: Bauhaus Master* (Madrid: La Fábrica/Fundación Juan March, 2013), pp. 39–126.

10. Gottfried Boehm, 'Bild und Zeit', in *Das Phänomen Zeit in Kunst und Wissenschaft*, ed. by H. Paflik (Weinheim: VCH, 1987), pp. 1–23 (p. 10).

11. Joseph Beuys, *Mein Dank an Lehmbruck. Eine Rede*, ed. by Lothar Schirmer (München: Schirmer/Mosel, 2006), p. 15.

12. Joseph Beuys, 'Erklärungen zum Werk "Das Kapital Raum 1970–1977"', in *Joseph Beuys und das Kapital: vier Vorträge zum Verständnis von Joseph Beuys und seiner Rauminstallation, Das Kapital Raum 1970–1977*, ed. by Christel Raussmüller-Sauer (Schaffhausen: Hallen für neue Kunst, 1988), p. 57. It is here that Buchloh sees Beuys 'fascism,' but the term *Gestaltung* is deeply embedded within everyday German and is used for democratic politics too. Accordingly, Buchloh remains caught in his own ideological reductions. For this, also see Timothy O'Leary, 'Fat, Felt and Fascism', *Literature and Aesthetics: The Journal of the Society of Literature and Aesthetics*, 6 (1996), 91–105.

13. Beuys, *Mein Dank*, p. 27.

14. Beuys in Mario Kramer, *Joseph Beuys: Das Kapital Raum 1970–1977* (Heidelberg: Edition Staeck, 1991), p. 15.

15. Stüttgen, *Der Kapitalbegriff*, p. 126; for this, see also Beuys, *Erklärungen*, p. 130.

16. Beuys in Kramer, *Joseph Beuys*, p. 15.

17. Joseph Beuys, *Gespräche mit Beuys. Joseph Beuys in Wien und am Friedrichshof* (Klagenfurt: Ritter Verlag, 1988), p. 129.

18. Beuys in Kramer, *Joseph Beuys*, p. 24.

19. Beuys in Kramer, *Joseph Beuys*, p. 24.

20. For this, see Hans Jonas, 'Homo Pictor. Die Freiheit des Bildens', in *Das Prinzip Leben. Ansätze zu einer philosophischen Biologie* (Frankfurt am Main: Insel, 1994), pp. 265–302.

21. Beuys quoted in Franz-Joachim Verspohl, 'Avantgarde und soziales Bewusstsein: Das Beispiel Joseph Beuys', *Marburger Jahrbuch für Kunstwissenschaft*, 22 (1989), 241–46 (p. 242).

22. Karl Marx and Friedrich Engels, *Werke*, 42 vols. (Berlin: Dietz, 1972–2013), III, p. 44.

23. Marx and Friedrich Engels, *Werke*, III, p. 35.

24. Marx and Friedrich Engels, *Werke*, XL, p. 539.

25. Beuys in Kramer, *Joseph Beuys*, p. 22. For this also, see Joseph Beuys, *What Is Money: A Discussion* (Forest Row: Clairview, 2010).

26. Beuys in Kramer, *Joseph Beuys*, p. 34.

27. Stüttgen, 'Der Kapitalbegriff', p. 103.

28. Joseph Beuys, *Joseph Beuys in America: Writings by and Interviews with the Artist*, intro. by Caroline Tisdall and Kim Levin, comp. by Carin Kuoni (New York: Four Walls, 1990), p. 39.

29. Beuys, *Gespräche mit Beuys*, p. 127.

30. Beuys, *Gespräche mit Beuys*, p. 133.

31. Beuys, *Gespräche mit Beuys*, p. 132.

32. Beuys quoted by Wagner in Strieder, *Joseph Beuys*, p. 20.

33. Beuys, *Joseph Beuys in America*, p. 26.

34. For this, see Joseph Beuys and Michael Ende, *Kunst und Politik: ein Gespräch* (Freie Volkshochschule Argental: Wangen, 1989); Joseph Beuys, 'Aufruf zur Alternative', in *Joseph Beuys und das Kapital: vier Vorträge zum Verständnis von Joseph Beuys und seiner Rauminstallation, Das Kapital Raum 1970–1977*, ed. by

Christel Raussmüller-Sauer (Schaffhausen: Hallen für neue Kunst, 1988), pp. 140–55.

35. Hans Dieter Huber, 'The Artwork as a System and Its Aesthetic Experience: Remarks on the Art of Joseph Beuys', Die Hochschule für Grafik und Buchkunst Leipzig, September/October 1989, http://www.hgb-leipzig.de/artnine/huber/writings/beuyse.html [accessed 2 January 2014].

36. Beuys in Kramer, *Joseph Beuys*, p. 21.

37. Beuys in Kramer, *Joseph Beuys*, p. 32.

38. For the role of materiality in modern art, see Monika Wagner, *Das Material der Kunst. Eine andere Geschichte der Moderne* (München: C. H. Beck, 2001). The role of materiality is also centrally visible in Volker Harlan, *Was ist Kunst? Werkstattgespräch mit Beuys* (Stuttgart: Urachhaus, 2001).

39. Franz-Joachim Verspohl, *Joseph Beuys: Das Kapital Raum 1970–1977. Strategien zur Reaktivierung der Sinne* (Frankfurt am Main: Fischer, 1984), p. 37.

40. Beuys, *Gespräche mit Beuys*, p. 127.

41. Beuys in Kramer, *Joseph Beuys*, p. 199.

42. Beuys in Kramer, *Joseph Beuys*, p. 199.

43. Verspohl, 'Avantgarde', p. 242.

44. Huber, 'The Artwork'.

45. Beuys in Kramer, *Joseph Beuys*, p. 29, p. 40.

46. Beuys in Kramer, *Joseph Beuys*, p. 30.

47. Beuys in Kramer, *Joseph Beuys*, p. 156.

48. Beuys in Kramer, *Joseph Beuys*, p. 157.

49. Fehr in Christel Sauer, *Denk-Kapital. Ideen zur Gestaltung der Gesellschaft* (Basel: Rausmüller Collection, 2012), p. 45.

50. Bürger in Strieder, *Joseph Beuys*, p. 15.

51. Beuys in Stüttgen, 'Der Kapitalbegriff', p. 104.

ELEVEN

Value and Abjection

Listening to Music with Edward W. Said

Rachel Beckles Willson

It is from the womb of art that criticism was born.

—Charles Baudelaire[1]

Criticism is traditionally regarded with hostility by artists but is one of the most celebrated tools of the academic trade. As we make critical 'advances' and 'progress', it is heartening to see the values of predecessors fade in the glare of our shiny new wisdom: they seem worthy of scorn or shame, especially if they have only recently been consigned to the past and need to be held at a distance rather firmly. Yet some of the most interesting scholars are difficult to place in such neat teleology. Edward W. Said, for one, seems to have been a trailblazer in some ways, yet locked into rather limiting value systems in others. Moreover, his theoretical hedonism offered shaky foundations for those trying to use him as a model.

In this chapter I consider how we might think about critical values and value systems by exploring some of Said's little-discussed writing on music. Could his thinking be drawn helpfully into new post-theoretical intellectual endeavours? His position appears to be among the most value*laden* of his contemporaries, in part because he often moved against the grain of many around him, both politically and theoretically. Could his antagonistic position taking help

us now at all, as we wrestle with the questions of value throwing our work into ever-greater question? Perhaps needless to say, this chapter will respond with an affirmative, while reading him partly against the grain.

In the first main section below, I present some of Said's writing on a genre of music making by which he was particularly fascinated, namely, the classical piano recital. Through this we recognise an under-explored form of plurality in his thinking, a creative play that is nonetheless cognizant of the piano recital's entrapment in an oppressive machinery of capitalism. In the next section, I present some of Said's thoughts on Arab music. These are very different and seemingly uncreative, reducing artistic practice to categories. By placing them in the light of the texts already discussed, however, and drawing on some recent work on the senses, I suggest that his seemingly disparate thinking is closely related and that the apparent flaws contain some hints that we could usefully heed.

Before embarking on these readings, however, I will introduce a set of positions among which I situate Said.

CONTEXTS FOR SAID'S LISTENING TO MUSIC

One of the thorniest problems for many of those who have embraced Said's work has been his partisan focus on Western classical music and his reluctance to situate it in the politics of empire. As William D. Hart has argued, Said appropriated 'religious and theological languages of autonomy' for Western classical music.[2] Even while denouncing the cultural effects of religion as disastrous, he placed such music between 'autonomy from social relations and the simple reflection of them'; meanwhile, he also proposed that it could be grasped as an elaboration of civil society. Hart finds that Said's understanding of Western classical music echoes experiences of religion described by writers such as Friedrich Schleiermacher, William James, and Alfred North Whitehead and remarks in response, 'Perhaps it is a displacement of these notions? How ironic if it is.'[3]

In fact this 'displacement' of religion onto music is not a rare phenomenon but rather a historically well-established one. Early nineteenth-century German philosophers linked aesthetics with theology, and their regard for music's divine, edificatory qualities (and its ability to stand for the 'unsayable') was sustained by composers and writers well into the twentieth century.[4] It may be star-

tling that the same tendency was exemplified by the work of one of the most influential cultural critics of the late twentieth century, but Said was by no means alone in its preservation. In the broader public sphere, we can trace its currency in the immense popular success of the West-Eastern Divan Orchestra, a youth orchestra bringing together Arabs, Jews, and Europeans under the baton of Daniel Barenboim, with which Said was closely associated at the end of his life. This orchestra has played on and with similar sentiments, after all, according to which a symphony may transcend the thorniest earthly problems and allow us to imagine a better future.[5]

Perhaps it is too easy to shoot down such ideas, however. Such a view emerged recently from James Currie, who positioned Said's support for the orchestra within a broader tendency, namely, his seeking out examples of literature and music that were critically productive precisely by dint of 'forgetting' their immediate context (other examples include Constantine Cavafy and Richard Strauss).[6] Where forces are irreconcilably opposed, such as in competing claims for land in Palestine and Israel, additional *knowledge* of the other may lead to a hardening of the impasse. Attempts at persuasion and the production of new justifications or novel counterarguments serve not to engender acceptance but merely to reinforce the intractable conflict. Hence, argues Currie, Said's particular valuing of 'places where knowledge *no longer* functions or matters'; and musical performance is such a place, because other logics take over.[7]

Currie proposes that by immersing themselves in the work of enacting musical performing selves, some orchestral players 'forgot' the parts of themselves that were defined by their national political selves. The forgetting opened upon a space for the production of something different from hostility or defensiveness. On one level, of course, that production can indeed be traced in the opportunity to play in a highly successful institution, an orchestra that was desired and welcomed by some of Europe and North America's most prestigious venues and television channels. Currie is more interested in another production, however, one contained by Barenboim's words about musicians who, having played the same note alongside one another, 'can't look at each other the same way' thereafter. For Currie, the engrossing practice of instrumental playing calls the musician away from her or his political self sufficiently for that to be betrayed.

Forgetting . . . occurs when another kind of engagement presents itself as attractive enough for us to betray our initial commit-ment, if only, for example, for the duration in which performance continues. In effect, and by means of a kind of physics of human attentiveness, the sheer mass and force of the new affair pushes our previous force of inscription and fidelity momentarily be-yond the peripheries within which it would continue easily to dominate our actions.[8]

Hart and Currie's positions frame a considerable gap: where Hart is concerned that by following Said and forgetting mediation we lapse into an uncritically religious stance, Currie grasps Said's forgetting as a gateway into new experience and indeed critical thinking. I suggest that we consider one further positioning to en-rich their apparent polarity. This can be extrapolated from recent work on listening that attempts—with recourse to post-structural-ism—to problematise the tradition of thinking about (or forgetting in) music through which Said was working.

Jean-Luc Nancy's *Listening* claims sonic and musical experiences as privileged media through which to become aware of *difference*, the endless play of post-structuralism that defies illusions of pres-ence and authenticity.[9] Sound's resonance and reverberations are correlates of our already divided selves: as Nancy theorises else-where, we can only come into being in referral; we are 'singular plural'.[10] We realise this from the moment we hear ourselves cry out for the first time as infants. Later, our listening (to ourselves and others) opens the spaces of reverberation within us, so it makes manifest the multiple spaces of self. *Listening*, Nancy's attempt to engage with this directly, constitutes a sonic phenomenology, an extension of his ontology of human multiplicity into the acoustic realm.

A very different article by Drew Daniel can be productively po-sitioned alongside Nancy's *Listening*. Daniel's point in 'All Sound is Queer' is also multiplicity, but his claim moves beyond the singu-larly (multiple) human. Sound, in its penetration of us and its capac-ity to dissolve our selfing-othering machinery, he argues, can also 'let us hear what is not yet locatable on the available maps of iden-tity'.[11] In other words, our lives in sound are not reducible to taste or identity: instead, sound is one of the key elements that gives the lie to such reductionism; it is irrevocably a 'pluriverse'. Daniel even wants us to acknowledge—as an ontology that should inflect our epistemologies—the presence of sound that exceeds our physical capacity for hearing it.

The works of Nancy and Daniel each open a vast space of heterogeneity, differentiation, flow, and the unknowable. Each strives to subvert ideas according to which sonic experience can be reduced to a model in which a subject identifies an object and claims its meaning. But one of the difficulties of such work is identifying its critical potential and its ethics—questions that are so pressing in the work of Said (and indeed in the positions taken by Hart and Currie).[12] Both Nancy and Daniel are keen to deconstruct categories through which sound is packaged, but each celebrates the ocean they unleash with little indication of how we might navigate it or find provisional moorings from which to reflect on our predicament.

The question remaining is ultimately what we, or they, might be doing and experiencing while they listen to and play music: Are we devotional and oblivious to the political and material world (Hart)? Or are we profoundly engaged in something that can productively change the political and material world (Currie)? Or are we swept up in a productive openness to *difference* and deferral (Nancy, Daniel)? Put another way: Is Said's way of *valuing* Western classical music something we should resist or something we should ourselves value and to which we could devote our time?

The question may not be answerable in general terms, given that listening is a culturally and historically conditioned activity. Said's sense of value is contingent on the historical emergence of the concert hall and rise of the urban bourgeoisie that shaped the disciplined listening associated with Western classical music. In this context audiences are required to give silent attention to the music presented, and 'expert' listeners will grasp the structure and critical potential of the musical 'work'—the ideal object of their listening. Said adhered to the practice of close listening and often engaged with 'the work' as an audible/legible entity to be grasped hermeneutically. But as I suggest below, some of his thinking can be opened up more widely; as I introduce and discuss his words, I hope my re-contextualisation will enable us to see a different potential in his work.

LISTENING AT THE PIANO RECITAL: THE POWERS OF MEMORY

One of the most captivating aspects of Said's essay on the piano recital is the way it conveys a sense of spatio-temporal sociality. His

pleasure at piano recitals was, he explained early on, 'pointed towards the past. That is to say, to a large degree it is about memory'.[13] Developing this further later on in the same essay, he divided the memory into two apparently interlocking spheres. One of these was social:

> Pianists are conservative, essentially curatorial figures. They play little new music, and still prefer to perform in the public hall, where music arrived, via the family and the court, in the nineteenth century.[14]

Yet the other was more intimate:

> It is private memory that is at the root of the pleasure we take in the piano, and it is the interesting pianist who puts us in touch with this pleasure—who gives the recital its weirdly compelling power.[15]

The division informs Said's sense of how he should assess the value of the phenomenon. On the public side, he reasoned a critical position with an eye on the social system within which the recital had come to take place, this correlating with the public sphere of alienating commerce:

> A live performer, a commodity directly purchased, consumed, and exhausted during two hours of concert time . . . One could argue that . . . it ought to alienate and distance the public, thereby accentuating the social contradictions that gave rise to the virtuoso pianist, the preposterous result of the overspecialization of contemporary culture.[16]

On the private side, he revealed that in the concert hall he often experienced an overcoming of that distance. Part of this was down to individually embodied skills, a product of his own 'ability to play the instrument and to reflect on what I play and hear'.[17] Another aspect of his 'private' memory was the way the concert hall provided him with an experience of time and sensibility that he could not find elsewhere in his life. This often triumphed over the public space, giving him a sense of the economic system being subverted by intimacy:

> They invite us into a utopian realm of acute awareness that is otherwise inaccessible to us. . . . When a performance taps into its audience's subjective time, enriches it and makes it more complex, it becomes more than a couple of hours of good entertainment.

Said's invocation of something more valuable than 'entertainment' is surely indebted to Theodor Adorno's sociology, in which the category of 'entertainment' is part of a society that is incapable of proper critical attention, having no capacity for 'expert' listening to (the structure of) critical 'works'.[18] But Said's thrust expands beyond Adorno, because Said's interest is in the audience's 'subjective time' into which a good experience intervenes in multiple productive ways. The pianist acts as a mediator between two spheres, he suggests, namely, the 'rarefied world of the recital stage' and the 'world of music in human life'; but unlike Adorno's arguably more restrictive world, both of these spheres are multiple.[19] There are many different styles of pianist, and many memories among audience members:

> Each listener brings to performance memories of other performances, a history of relationships with the music, a web of affiliations; and all of this is activated by the performance at hand.

Said's interest in memory is intriguing for a number of reasons. One is that it admits space for listening that is less about listening to 'the work' than listening to oneself. This foreshadows Nancy's arguments about the reverberation of the self, as well as the epistemic move away from the notion that music embodies certain truths to which the 'good' listener should become directly attuned, by which she may even be subsumed. Building on Nancy, Peter Szendy has argued that what is missing from the disciplined forms of concert listening is the space alongside it or during it.[20] This space may be for listening with indifference or inattention. And it may be a creative or critical space.

Said's description of his memory is also strikingly creative and recalls Paul Connerton's argument for the concept of 'habit memory', a quality that is 'sedimented' in the body through processes of repetition and 'incorporation' thereby and that—unlike writing— left no material traces outside its embodied, gestural presence.[21] Connerton's work drew new scholarly attention to communities that could not be studied through texts and has already been taken up by several writers on musical practices. But as Yannis Hamilakis has pointed out in connection with food, the dualism of the system is due for overhaul.[22] Embodied memory is powerful in societies that also rely on text. And writing itself generates a sedimented habit memory in the body. Memory functions through multiple stimuli that are incorporated, inscribed, or crafted in other ways.

In the case of an event such as a recital, a pianist has usually learned the music through a text as well as recordings (inscribed memory devices), and this text-led understanding of music is a part of the ideology of the 'work' already discussed above. But the pianist's habit memory carries her playing, just as habit memory conditions audience behaviour and experience at the concert, and these compound musical practices of playing and listening are also manifested in instruments and dedicated spaces. Said alerts us to all this but also intimates the individuality of such memories. This is not simply a case of knowing how to play or how to behave. Said's particular experience was agonistic and aspirational: when pianists excelled, they made him 'feel what I might feel were I able to play as they can'.[23] The habit memory could therefore trigger excitement and the sense of self-transformation.

Finally, Said's use of the term 'memory' for a sense of social history is also worth considering. He did not actually live in the European society in which the piano recital developed as it moved from salon to concert hall. This occurred long before he was born and on a different continent. But he expresses such an empathy that we might read it as a form of 'prosthetic memory'.[24] Sitting in the concert hall he felt part of the historical piano recital of Europe—a spatio-temporal realm with which he had no direct contact but with which he had been in touch through industrially produced entities such as instruments and recordings since childhood. One might argue that he used the term 'memory' as a metaphor and that it is inappropriate to take this term at face value; yet there is little doubt that through those experiences he had 'sutured himself . . . into a larger history' and that it had come to shape his sense of subjectivity.[25] As we know, it also affected his sense of value.

REMEMBERING LISTENING, AND NOT LISTENING

I turn now to a long conversation between Said and the writer Charles Glass that was filmed two years before Said died in 2003. At an early stage in the published version, he makes the following comments:

> Music . . . I was, I think, it's probably very vain to say this, but I was many years ahead of my time. I had perfect pitch ah . . . which I didn't discover until I left home. I mean I just could hear ah . . . the notes exactly right, identify them. Um, I had a perfect memory, I could remember a piece from the moment I heard . . .

my mother used to say, for example, that at the age of one and a
half, or even maybe two, I had memorized forty or fifty folk
songs and nursery rhymes and when my cousin who played the
harmonica um would play one of them and make a mistake on
purpose I would start to cry and remonstrate against that.[26]

One intriguing aspect of Said's words is the threshold of difference
at which they articulate his childhood position. His 'perfect pitch' is
a human capacity for naming the pitches to be heard from the in-
struments that came to dominate Europe in the nineteenth century
(archetypically the piano).[27] It is a consequence of exposure to in-
dustrial production and suggestive of how a measurement made
standard for the purposes of economics can be normalised and in-
scribed on the body as memory, value, and potential power or vul-
nerability. Said's account indicates how his viscerally experienced
memory of melody separated him out from others, leading him to
be a soft target for provocation.

Other remarks indicate separation as well. He loved listening to
recordings, and when Glass checks what recordings these were,
whether he heard any Arab music on record, Said responds by say-
ing that it was 'never Arabic music' because that was

> exclusively as I recall connected with family events, one or two of
> my uncles, you know very rare, we didn't have many family
> events but if we did, let's say Palestine or in Lebanon, never in
> Egypt, one of my uncles would play the *'ūd* and they would all
> sing together but it was like Greek to me, it didn't . . . I didn't . . . I
> never learned the words.[28]

As he goes on to say, the one occasion he remembers having a
serious encounter with Arab music was when he was nine years old
and taken to hear the most celebrated singer of the Arab world,
Umm Kulthum. This was not successful:

> I was revolted by it, it just struck me as horrible. First of all it
> began way too late for my, you know, age, nine thirty, so a lot of
> waiting around and sort of warming up, then she came out and
> there was no form to the music that I could identify it was just
> repetition with tiny differences in each repetition and it was all
> slow and it was all sort of mournful.[29]

From here on, he invokes a further set of distinct categories, separat-
ing Arab music from Western music and his knowledge from that
of his teachers:

And it contrasted terribly with the Western music, you know, Mozart and Beethoven and Mendelssohn and . . . that I loved. I had very good teachers in the sense that they were musical and encouraged me but I think in many ways I was ahead of them because I knew more about music. [30]

One way of thinking about these memories is to recognise them as practices of cultural capital. In conversation with Glass, Said performs judgements that are embedded in and situate him in particular regimes of power. [31] Just as in his autobiography *Out of Place*, he emerges as an individual who was always-already distinct from his surroundings as a consequence of his cultural and artistic preferences. [32] But this pattern of judgement was built into his early upbringing, both in missionary schooling and at home. His mother's comments (see my first quotation above) appear similarly in *Out of Place* (mid–section II), but there we learn she produced them to conjure an image of Edward's earlier, ostensibly more applied self and to reproach him for his recent disappointing behaviour. By nostalgically invoking earlier precociousness in his reading, multilingual speech, maths, and musical recognition, she identified these skills as *measures* of goodness and their emergence in Said's infancy as signs of an honourably advanced development. Said himself did not at the time recognise himself in what she said, but photographs of their earlier life seemed to bear out her narrative of lost joy.

The account should not be identified only along the lines of cultural capital, colonial anxiety, and identity, however; rather, it can be grasped as symptomatic of a particular Enlightenment sensory regime, one in which the categorical and discursive are valued as the proper means through which to contain the chaotic life of the world. Said's belief that photographs could be evidence of happiness is part of the same order: the visual is valued as a sense that can be separated off from senses that might have different stories to suggest, as the only sense indeed that can be reliable 'evidence'. [33] But by referring back to his writing on the piano recital, and by considering a broader sensory dimension, I suggest we may gain a fresh purchase on Said's thinking.

THE VALUE OF LISTENING WITH THE BODY

All his accounts invite us, after all, to appreciate him as part of situations of relational sensing. When his uncles gathered to sing with the *'ūd*, he was disturbed not to be able to participate: unable

to find the linguistic access ('it was like Greek to me . . . I never learned the words'), he could not share the vocalising in which they were apparently 'all' engaged ('they would all sing together'). When he was taken to hear Umm Kulthum, his corporeal sense of temporality was profoundly disrupted: there was too much waiting around, and then there was a lot of musical repetition that lacked distinctions that he could enjoy; he sensed mournfulness. In these situations, he could not join the pleasurable sensory experience that the people around him were living out; he was sonically (and thus physically) excluded.[34] And his descriptions intimate profoundly visceral experiences, namely, an inability to use his voice and a disturbed sense of corporeal rhythm.

Because they are relational, these accounts also intimate the world beyond his individual body, invoking indeed a trans-corporeal assemblage that is held together (or not) by sensory experience. The activity of those around him in Palestine, Lebanon, and Cairo relies on their interconnectedness in that time, and it also depends on their shared recollections, whether of past contact with an instrument ('*ūd*), melodies, words, or events. Said was excluded there and spoke forthrightly of this experience in a way that is profoundly revealing of music's capacity to affect us. Such admissions are unusual, but they are extremely important: the place of music in educational establishments in Europe and North America has been based on the notion that it is beneficent. At times of economic and political struggle when its place is threatened—the time of writing is certainly such a time—it may be tempting to stress benefits in ways that have long served their time.[35] Additionally, the immense volume of work published on music's power to unite communities has tended to occlude its capacity to fragment relations. This can happen on a level of musical genres, styles, and practices that are explained in terms of identities and politics. But Said draws attention to a viscerality that is rarely explored.

Of course, while sitting in the piano recital as an adult in New York, he was not excluded. There, as we have seen, he seems to have felt a pleasurable excitement in his body and an imaginative delight as well—what he could *feel*, if he were to play like the pianist to whom he listened. He was sufficiently at home with his own sense of connection with what was happening to enjoy recognition that others would be experiencing something as well, but differently. In other words, he was comfortably stimulated in his own sonic space and imagined (rightly or wrongly) that those around him felt similarly. This multiplicity made the event ultimately resistant to its

commodification in his mind and—we might add—to universalising discourses of value.

Animate and inanimate objects are manifestly in flux in the situations he describes, all contributing to flows of kinaesthetic interaction between actors. Such flows have been theorised by a number of writers using terms such as 'network' and 'sensorial assemblage', these approaching the energetic aspect of musical practice, as well as the relations between the visible and invisible entities involved.[36] The sphere in which Said developed a sense of participation as a child was shared affectively with an instrument (he learned piano from the age of six), books (he read about music), the radio, 78-rpm records, opera attendance (from the age of fifteen), his teachers, and an accumulating mesh of memory. All these conditioned his experiences.

This suggests that he was, very early on, disciplined into a certain sensory regime and not provided with sustained access to others that might have also been available. This is one example of childhood experience in the colonised region, but it is of course just one. A near contemporary of his, also from a Christian family in Jerusalem, reveals a very different environment. Hala Sakakini and her siblings heard English, Greek, and Arab music played and sung in her home and in the homes of friends; they listened to recordings of European opera, played the piano and attended concerts of European music, and studied music at school.[37] From her we read about her sensory experience of events but also about her participation, whether she was feistily imitating an *'ūd* player visiting the home, singing for family friends, or in more formal settings observing the concert audience members who 'all dressed up for the occasion, looked so stiff in their fineries they made us laugh'.[38] Parody was also possible in this family: her brother used to say to his sisters on such occasions, 'Now let's study the programme like thoroughly cultured folk!' as if mocking the earnest didacticism of the European-style concert regime. Bringing the two remembered childhoods together reveals the breadth of sensoriality that impacts on musical appreciation and, ultimately, value.

From what Said presented of his childhood memories, it might seem that even in those early years he lacked the requisite *memories* needed to participate in Arab music making in Egypt, Lebanon, and Palestine. We might even argue that his intensive contact with the piano and other forms of industrialised musical production sedimented within him the (memory of a) tuning pattern that mediated or intervened unhelpfully in contexts of Arab music. But that is

probably too formalistic: when he cried and remonstrated in re-
sponse to melodic errors, he was hearing a harmonica, after all. The
seven-bit just intonation of this instrument is different from that of
the piano and cuts across 'Western' and 'Oriental' categories. Such a
detail is lost in the memories of memories of memories within
Said's narrative.

Yet, although Said may have come to present his musical experi-
ences in exceptionally divided ways, his words reveal that how he
felt about them was not so divided, and here, I suggest, is where we
might acknowledge his support as we continue to work through
these ideas. All the experiences and judgements were located in his
body, and these were experienced in shared and overlapping spaces
of sensoriality and narrated as such. Thus we have learned that
some of these spaces afforded him the capacity to play, sing, ima-
gine, and think creatively; others led him to feel inept, incapacitat-
ed, and probably unhappily bored. The differences between them
lay in his corporeal aptitude, developed incrementally over time.

At the start I contrasted Hart's words of concern with Currie's
enthusiasm and posed the question of how we should think about
Said's way of valuing music. On the one hand, I hope I have teased
out that there is more than has been obvious until now about both
his pleasures and his antipathies. On the other, I hope that his bold
statements may encourage us to grasp music more fully as an expe-
rience that can and should take us off our beaten paths of enjoy-
ment. One of music's potentials may be its disruption of our sense
of a bounded self. Both Nancy and Daniel have sought to explore
and indeed celebrate this quality. But its *value* is not so straightfor-
ward as to warrant celebration alone, whether for delight (Nancy)
or subversion (Daniel). If plurality and alterity can lead us into ar-
eas of alienation and unhappiness, just as they may enable us to feel
empowered or connected, how are we to respond?

My suggestion here is that the sort of disruption to which Said
alerts us needs *incorporating within the critical project*, not leaving
outside. And I hope I have indicated that his writing offers us a way
towards opening this up. To be sure, the writing seems contradicto-
ry, running against the politics he sought to pursue, and certainly
his open declaration of revulsion on experiencing sonic alterity jars
against our desire for tolerance. But we can frame this differently:
his frankness brings us into confrontation with aspects of humanity
(ourselves) that we wish not only to overcome *but also to evade*.

In order that our work can engage with the fraught realities of
the world we inhabit, ongoing exposure to what revolts us artisti-

cally and explorations of modalities of encounter in the fullest and most abject visceral sense could allow us into some new spheres of enquiry.[39] We might embrace this as a productive inhabiting of Szendy's space for 'creative' listening while appropriating his space of pleasure for a more politically engaged project—indeed, for an exploration of experience that may be connected to feelings towards alterity more generally, including hate or fear. This might urge us to feel and sense beyond the categories by which we think we are constrained, however difficult that is and however much resistance we encounter along the way. When Charles Baudelaire identified art as the 'womb' of criticism, he pointed to a profoundly embodied notion of art. My suggestion entails recognition of that quality and a plunge into the more discomforting elements that art leads to emerge from within us.

NOTES

1. Epigraph: first published in 'Salon of 1846', in *Curiosités Esthétiques* (1868), reproduced in Charles Baudelaire, *In the Mirror of Art: Critical Studies by Baudelaire* (New York: Doubleday Anchor Books, 1956), p. 40.

2. William D. Hart, *Edward Said and the Religious Effects of Culture* (Cambridge: Cambridge University Press, 2000), p. 41.

3. Hart, *Edward Said*, p. 41.

4. Hart, *Edward Said*, p. 42.

5. For a discussion of these matters, see Rachel Beckles Willson, 'The Parallax Worlds of the West-Eastern Divan Orchestra', *Journal of the Royal Musical Association*, 134 (2009), 319–47. See also Rachel Beckles Willson, 'Whose Utopia? Perspectives on the West-Eastern Divan Orchestra', *Music & Politics*, 3.2 (2009), http://dx.doi.org/10.3998/mp.9460447.0003.201.

6. James Currie, 'Another Music, a Time to Forget: Reflections on Edward Said's Late Style', *Contemporary Music Review*, 31 (2012), 507–19. As Currie characterizes Said's reading of Strauss, 'Value seems to be being activated only when the cultural artifact is no longer hindered by having, under the aegis of the critic, to sustain knowledge of the cultural and historical forces that were proximate to its production' (p. 515).

7. Currie, 'Another Music', p. 512.

8. Currie, 'Another Music', p. 512.

9. Jean-Luc Nancy, *Listening* (New York: Fordham University Press, 2007).

10. Jean-Luc Nancy, *Being Singular Plural* (Stanford, CA: Stanford University Press, 2000).

11. Drew Daniel, 'All Sound Is Queer', *Wire*, 33 (2011), 43–46 (p. 44).

12. Said's interest in the 'wordliness' of texts made him critical of the poststructuralist play from which Nancy builds his response to sound. His classic exposition is Edward W. Said, *The World, the Text, and the Critic* (Cambridge, MA: Harvard University Press, 1983). For a response to Nancy identifying the links with deconstruction, see Roger Matthew Grant, review of *Listening* by

Jean-Luc Nancy, trans. by Charlotte Mandell, *Journal of the American Musicological Society*, 62 (2009), 748–52.

13. Edward W. Said, 'Remembrances of Things Played: Presence and Memory in the Pianist's Art', in *Music at the Limits: Three Decades of Essays and Articles on Music* (New York, Chichester: A&C Black, 2009), pp. 11–22 (p. 12).

14. Said, 'Remembrances of Things Played', p. 12.

15. Said, 'Remembrances of Things Played', p. 12.

16. Said, 'Remembrances of Things Played', p. 20.

17. Said, 'Remembrances of Things Played', p. 12.

18. For a recent discussion, see Peter Szendy, *Listen: A History of Our Ears* (The Bronx, NY: Fordham University Press, 2008), pp. 99–128.

19. Said, 'Remembrances of Things Played', p. 20.

20. Szendy, *Listen*, pp. 98–128. As he phrases the question at the close of a chapter probing the 'responsibility of a listener', 'Isn't a *certain* distraction a condition that is just as necessary for an *active* listening as total, structural, and functional listening is?' (p. 128, original emphasis).

21. Paul Connerton, *How Societies Remember* (Cambridge: Cambridge University Press, 1989), pp. 72–73.

22. Yannis Hamilakis, *Archaeology and the Senses: Human Experience, Memory, and Affect* (Cambridge: Cambridge University Press, 2014), p. 89ff.

23. Said, 'Remembrances of Things Played', p. 20.

24. Alison Landsberg, *Prosthetic Memory: The Transformation of American Remembrance in the Age of Mass Culture* (New York: Columbia University Press, 2004).

25. Landsberg, *Prosthetic Memory*, p. 2.

26. Mike Dibb, dir., *Edward Said: The Last Interview* (DVD, extended version) (London: ICA Projects, 2004), at 20'27".

27. For a discussion of this phenomenon in the context of aesthetics, see Daniel Chua, *Absolute Music and the Construction of Meaning* (Cambridge: Cambridge University Press, 1999).

28. Dibb, *Edward Said*, at 21'21".

29. Dibb, *Edward Said*, at 22'03".

30. Dibb, *Edward Said*, at 22'03".

31. Judith Butler, *Excitable Speech: A Politics of the Performative* (London: Routledge, 1997).

32. Edward W. Said, *Out of Place: A Memoir* (New York: Vintage, 2000), pp. 27–28.

33. The Latin root of 'evidence' is *videre*, 'to see'. See Hamilakis, *Archaeology and the Senses*, pp. 5–6.

34. Said does not mention it, but recordings of Umm Kulthum's concerts allow us to hear the active and noisy audience participation that was typical of the time. Calling out in appreciation is part of Arab music traditions and could have contributed to Said's feelings of discomfort, because he was not himself able to take part. For discussion of historical and contemporary aspects of this 'creative listening,' see Ali Jihad Racy, *Making Music in the Arab World: The Culture and Artistry of Tarab* (Cambridge: Cambridge University Press, 2003), pp. 131–33.

35. I have made the argument elsewhere that it is time to stop sending Western classical music forth as a world-improving force (see the conclusion to Rachel Beckles Willson, *Orientalism and Musical Mission: Palestine and the West* [Cambridge: Cambridge University Press, 2013]). The logic of my argument is in tension with the rising number of musicians and pedagogues trained in Western classical music who are in search of a market for their skills (and look

globally). Additionally, it is difficult to take such a critical position when the discipline of music studies is threatened by austerity and either on the defensive or turning to 'engaged' approaches to researching music in areas of conflict, post-conflict, or other struggle—in the explicit hope that such work can 'do good' outside academia.

36. I have deliberately not used the term 'network' for Said's situation here because of its association with Actor Network Theory (ANT) and my reservations about the genealogy and uses of ANT in science and technology studies. An approach with more sensitivity to living organisms is to me more appealing and appropriate. See, for instance, Tim Ingold, 'Towards an Ecology of Materials', *Annual Review of Anthropology*, 41 (2012), 427–42. This draws together Ingold's thinking on the distinction as developed over some years. See also the positing of a 'sensorial assemblage' in Yannis Hamilakis, *Archaeology and the Senses: Human Experience, Memory, and Affect* (Cambridge: Cambridge University Press, 2013), p. 126ff.

37. Hala Sakakini, *Jerusalem and I: A Personal Record* (Amman: Jordan Economic Press Co., 1990), pp. 7–8, 68, 72–73, 87. Hala was the daughter of Khalil Sakakini (1878–1953), essayist, poet, scholar, and founder of three schools (1909, 1925, and 1938), who also served as education inspector under the Ottoman and the British regimes in Palestine. I present Hala's memoirs in a broader context in Beckles Willson, *Orientalism*, pp. 116–212.

38. Hala Sakakini, 'Jerusalem and I: A Personal Record', *Islamic Studies*, 40 (2001), 483–85.

39. From another direction entirely, recent work on sonic torture in detention is already grappling with these questions. See, for instance, Suzanne G. Cusick, 'Toward an Acoustemology of Detention in the "Global War on Terror"', *Music, Sound and Space: Transformations of Public and Private Experience*, ed. by Georgina Born (Cambridge: Cambridge University Press, 2013), pp. 275–91.

TWELVE

Intransigent Play

Detail, Form, and Interpretation in the Music of Derek Bailey

Dominic Lash

Improvising guitarist Derek Bailey had this to say about the value of his musical practice:

> A lot of improvisors find improvisation worthwhile, I think, because of the possibilities. Things that can happen but rarely do. One of those things is that you are 'taken out of yourself'. Something happens which so disorients you that, for a time, which might only last a second or two, your reactions and responses are not what they normally would be. You can do something you didn't realise you were capable of. Or you don't appear to be fully responsible for what you are doing.[1]

Any programme of resistance to the values of the forces dominant today must involve attacking the frameworks within which value is presented and evaluated, as well as proposing alternative values. Alongside such directly corrosive or constructive activity, however, we should also investigate forms of activity which have the capacity to destabilise our habituated reactions and judgements. Orienting oneself towards such unusual events need not take one away from the present moment; such a discipline would require one always to keep a grip on the minutest of details (which are not simply ladders

to be kicked away as soon as they have been scaled), while avoiding any retreat to a positivism that bases itself on 'solid' facts and argues merely about 'subjective interpretations' of these facts, because this is exactly what the logic of late capitalism encourages us to do.[2] According to this logic there is no truth but exchange value, and any affirmation of other values or truths is obscurantist, elitist, outdated, and generally either disgusting (and hence needs to be combated) or insignificant (and hence needs to be ignored).

George Caffentis has outlined the context in which Marx's conception of value came into being. He argues,

> Nietzsche was able to judge value judgements and evaluate the tables of values generated by the Christian good and evil, simply because the whole field of ethics had been 'valorized' by the mid- to late-19th century. Objects and actions lost their inherent moral characters (or 'virtues') and became functions, attitudes or judgements of value.[3]

The relativisation of ethics was accompanied by a relativisation of mathematics, in which values 'are determined not by increasing abstraction from properties (as in the Aristotelian paradigm), but by being engaged in an increasing density of relations and series'. This intellectual environment enabled Marx to develop his ideas about value 'not through the stripping of the qualities of the commodity to find an "inherent" property, but through its manifold actual and potential exchange relations with other commodities (especially that prime self-reflexive universal commodity, money).'[4] The modern form of capitalism, however, distorts this relativisation into a relativism, so that rather than economic and social relations becoming meaningful only through the interactions of human beings, any assertion of meaningfulness has the rug pulled out from under it, and exchange value is posited as the only objective measure capable of grounding the evaluation of any situation whatsoever. Hedge fund managers and investment bankers implicitly claim the diagnosis (but not the remedy) of the Frankfurt School as their own: we have seen through Enlightenment's claims to a disinterested rationality, so power is all that we are left with, and this power finds its measure in exchange value. It is vaguely claimed that we (the managers, the bankers, and the rest of us) can, and indeed should, direct power towards 'good', but the basis on which we might judge what is good when any universal claim has been undermined is either a timeless (but in fact ahistorical) humanism or is simply left unexamined.

If the current sociopolitical order and the legacies of post-structuralism alike have rendered us allergic to starting from the top and working down—either the grand narrative re-enacts the violence of empire or the exception exposes any general statement as special pleading by a privileged group—what about working from the bottom up? The difficulty with any kind of close reading, however, is the circularity of its logic of evaluation and validation. We choose to read closely those things we already deem to have value and then demonstrate how value inheres in the minutiae of their construction. Yet those minutiae are in many respects identical to those we would find in a mediocre subject. Jacques Rancière has spoken recently of his reluctance to adopt 'an overarching view which seeks to unify under a single concept a multiplicity of empirical events'. He proposes an alternative aesthetic methodology where 'you are no longer the theorist looking at the empirical world from above. Instead, it is the art object which teaches you how to look at it and how to talk and think about it'.[5] Close reading cannot simply be the process of identifying the building blocks which make up that which we deem valuable, in order that we might in future use the right blocks, and thus guarantee aesthetic value. Rather, it must itself be a form of activity, a practice that occurs in time. Certain texts might resist close reading as it is normally understood, but this does not have to signify an evasiveness, or a pseudo-profundity grounded in obscurity. It can, on the contrary, be understood as an invitation to explore alternative, more provisional ways of reading, of listening, of seeing.

Not being in a position to solve these issues or formulate a new method of close reading—I will not in fact even attempt to recount the experience of listening or reading precisely because this experience is different for every person every time he or she listens or reads[6]—I want in this chapter to explore human activity and in particular the production and reception of art via the work of Derek Bailey. In considering the value of his work and the role played by value within his work, I discuss a number of values, or ways of thinking about value, which, it has been suggested, apply to his music. I argue that many of these are mistaken and suggest instead other ways of thinking about the nature and purpose of the particular choices he made over his career. I eventually come to an ending, if not a conclusion, by widening my focus with a return to Friedrich Nietzsche via the idea of an ecology of value.

TECHNIQUE, FORM, AND INTENTION

It is often assumed that (perhaps by definition) work is serious, while play is trivial. Derek Bailey was anything but trivial, but his main interest was in playing; he was also certainly not an anti-intellectual but was nevertheless very suspicious of 'ideas'. Born in Sheffield in 1930, Bailey had a substantial career as a working gui-tarist—playing in clubs, dance halls, and theatre bands and doing sessions and radio work—before developing an interest in freely improvised music, which he explored in the trio Joseph Holbrooke (with Gavin Bryars and Tony Oxley). Improvised music gradually supplanted his other work, and from the early 1970s until his death in 2005, he worked exclusively in this area. He made a series of radio programmes on improvisation—in all genres of music—in the 1970s, which was followed by a book titled *Improvisation: Its Nature and Practice in Music*, first published in 1980. To coincide with the second edition of the book, Bailey collaborated with director Jeremy Marre on a series of four television programmes titled *On the Edge*, broadcast in February 1992 on Channel Four. In the third of these programmes, Bailey states that improvisation interested him be-cause it afforded an opportunity to

> develop some kind of music of your own through a playing situ-ation; previously, that was something that was given only to composers, the composer was the creator. It seemed that here was a possibility of creating and performing at the same time. It's not so much performing, the aspect of performing doesn't inter-est me at all actually, but *playing*, which is a very difficult thing to define, but it's to do with an instrumental attitude towards mu-sic, largely.[7]

By 'instrumental' Bailey meant a music focused on the activity of playing an instrument. He saw the instrument not as something that (regrettably) intrudes between a pure imagination of sound and the reception of those imaginings by others but as something that facilitates the exploration of a complex, intertwined physicality involving both aural stimuli and physical sensations, as well as ena-bling the creation of feedback loops between intention and outcome through the deliberate deployment of varying degrees of control and the surrender thereof. The instrument was a musical resource, not just an implement, or as Bailey put it, 'not just a tool but an ally'.[8] Such a manner of working meant that it was the act of getting together with others and actually improvising which was primary,

3

rather than a concern with the exact nature of the outcome. He distinguished this from the way what he referred to as an 'artist' would work, telling John Corbett,

> Now, Christian Marclay, I would guess, is not interested in playing, as such. He's an artist, a good one, probably, and is primarily interested in presenting his conceptions. . . . Playing is not really about that. It can include that but it also includes many other things, too, and important among them is working with other people. It's not only about your own ideas.[9]

Such an attitude does not have to imply an anti-intellectual stance, unless one thinks that the world is determined by ideas alone. Along the lines of poet J. H. Prynne's early reading of the phenomenologists, according to which 'the world becomes intelligible to us . . . by virtue of the fact that it resists our activities in various ways', a practice of instrumental group improvisation could be seen as an ontological investigation, exploring the instrument and one's fellow improvisers by means of the ways they resist one's conceptions of them.[10] This does not mean that fantasy is excluded, because fantasy makes a crucial contribution to decisions about what to play, contributing to the distinctive temporality of freely improvised music, which inhabits the moment but does not attempt thereby to step outside the flow of time: 'Simultaneously, events remembered and events anticipated can act on the present moment.'[11] This way of thinking is also compatible with Prynne's insistence that imaginative activity in general can assist in exploring the reality of the world at large, rather than being an attempt to slip its nets:

> It is the imagination's peculiar function to admit, draw substance from, and celebrate the ontological priority of the world, by creating entities which subsequently become a part of the world, an addition to it.[12]

Bailey's 'playing' is not necessarily a resistance to the concept but rather a resistance to attempts at *reduction of the music to* or *preempting of the music by* the concept.[13]

So Bailey did not think of himself as an artist; neither did he think of himself as a member of the avant-garde: 'The attitudes and precepts associated with the avant-garde have very little in common with those held by most improvisors'.[14] More than once, Bailey described himself as a conventional sort of musician, which has sometimes been taken as disingenuousness. But the fact remains that unlike guitarists such as Keith Rowe, who was one of the first

to lay his guitar flat on the table, Bailey played the guitar in many respects in the conventional manner: the instrument was tuned in what is known as 'standard tuning' and held in a conventional position, with the pitches selected by the left hand and the strings struck with a plectrum held in the right hand.[15] There were experiments in the 1970s with a guitar modified with extra strings and preparations and with stereo amplification, but these were fairly rapidly dispensed with. Nevertheless, within this conventional framework he developed a vocabulary of startling originality. Over the period from the late 1960s to the late 1970s, Bailey carefully constructed a vocabulary that would be appropriate for improvising freely, a method of playing 'based on malleable, not pre-fabricated material'.[16] Rather than plunging, say, a jazz vocabulary into an alien context, Bailey wanted appropriate tools for the job: another sense in which his *attitude* could reasonably be described as 'conventional', even if many of his tools were not. In 1972 he told a radio interviewer,

> If it sounds good when you're performing, then that's the main thing. . . . That I think is a very conventional way of approaching music for a performer. I don't use a lot of conventional techniques on the guitar. But then, I'm not interested to play in the areas those techniques were developed to serve.[17]

In the first edition of his book Bailey gave some specific details about the techniques he employed:

> Combining pitch with non-pitch ('preparing' it but not using a fixed preparation), constructing intervals from mixed timbres, a greater use of ambiguous pitch (e.g., the less 'pure' harmonics— 7th onwards), compound intervals, moving pitch (which includes glisses and microtonal adjustments), coupling single notes with a 'distant' harmonic, horizontally an attempt to play an even mix of timbres, unison pitches with mixed timbres.[18]

All of those techniques were just as evident in his playing after the year 2000 as they were in the late 1970s, when he was preparing the book, which has led some to accuse Bailey of stagnation. Whether a musician's music has started to spin its wheels resides to a large degree in the ear of the listener,[19] but what Bailey's retention of many of the same techniques clearly is not is a betrayal of his principles, as is supposed by commentators who consider him a member of the avant-garde.[20] Bailey aimed not at *novelty* but at *malleability*.

Of course, he did recognise the apparent contradiction. He was aware that some improvisers 'might subscribe to an approach

which prefers an abrupt confrontation with whatever is offered by each performing situation. . . . The aesthetic is faultless and perhaps leads to the ultimate ideal of improvising once and never again.'[21] There were new techniques later on (for example, some particular uses of distortion and feedback beginning in the mid-1990s), but it was never his intention to ditch older techniques because they were old; they would be excluded only if they proved themselves insufficiently malleable. A handwritten note in the archives of his record label, Incus, indicates that Bailey aimed for 'A Music without Qualities: unfixed—available to take on a function that depends on the circumstances/possibilities.'[22] This is of course a reference to Robert Musil's novel *The Man without Qualities*, in which we read,

> The sense of possibility might be defined outright as the capacity to think how everything could 'just as easily' be, and to attach no more importance to what is than to what is not. . . . Such possibilitarians live, it is said, within a finer web, a web of haze, imagining, fantasy and the subjunctive mood.[23]

This is meant pejoratively by Musil, for whom the possibilitiarian is somebody unable to acquiesce to the limits of the real. For Bailey, within the limited situation of improvised musical performance, such an espousal of the undefined represented a clear-sighted and practical situation of maximum musical stimulation and was in fact distinctly less utopian than the pronouncements of many musical avant-gardists.

Having developed a set of instrumental resources through a close examination of the guitar and also having renounced regular groups, Bailey's collaborators were his most potent resource. Examining his choice of collaborators is extremely helpful in understanding Bailey's attitude towards the value and purpose of musical technique. Yet again, seeing him as an avant-gardist has led to misrepresentations. Poet and musician Don Paterson—who at one point took lessons from Bailey and played in a number of improvising bands—in his T. S. Eliot lecture of 2004 drew a picture of a British poetry scene where work of real quality was being threatened by the Scylla of the 'populists' and the Charybdis of the 'postmoderns', among whom there are some 'genuine talents such as, say, Tony Lopez and Denise Riley', whose situation is sadly

> analogous to British free improvisation in the 80s, where one could hear great jazz virtuosi like Evan Parker and Derek Bailey sharing a stage with people who had barely mastered the rudi-

ments of their instruments—simply because the valorisation of talent itself was felt to be elitist and undemocratic.[24]

Paterson completely misrepresents Bailey's attitude to technique and his reasons for collaborating with musicians without a background in jazz. For a start, it didn't begin in the 1980s but dates right back to the emergence of freely improvised music. Evan Parker comments on the reason he and Bailey wanted to include instrument maker Hugh Davies in their group The Music Improvisation Company (which existed from 1968 to 1971): 'We were looking . . . to balance the overt virtuosity that was central to our instrumental approach at the time with another type of playing approach.'[25] Trumpeter and multi-instrumentalist Wadada Leo Smith argues,

> Technique for the improvisor is not an arbitrary consumption of an abstract standardized method but rather a direct attunement with the mental, spiritual and mechanical energy necessary to express a full creative impulse.[26]

Hence the technique of any improviser cannot be evaluated against an arbitrary standard, but only in context, relative to the purposes towards which the musician directs his or her technique. Certainly most of Bailey's early collaborations were with musicians with substantial instrumental virtuosity and skill at playing jazz (though Bailey would not have thanked Paterson for describing him as a jazz musician).[27] But from very early on, he was interested in musical confrontations, such as occurred during the first Company Week in 1977.[28] American musicians such as Leo Smith and Anthony Braxton were confronted with the often anarchic activities of multi-instrumentalist Steve Beresford and found so little connection with his playing that they avoided all groups with him wherever possible. Guitarist Eugene Chadbourne reports that on their return to the United States, they advised him, 'There was this one guy who was a *complete* lunatic, don't ever play with him'.[29] Bailey included musicians such as Beresford not because of a reluctance to criticise anyone for lack of technique but rather for the same reason that in later years he invited to Company Week classical virtuosi who had not previously improvised, or musicians from non-Western performance traditions, or rock musicians (such as the metal guitarist Buckethead, later to perform with Guns N' Roses), or those working with electronics, or those with no background in conventional music at all. That is to say, for the reason that including these musicians destabilised the expected responses and thus necessitated a genuinely improvised response. Or as Bailey himself put it,

The time available, the way of choosing the groups, the musicians invited: all are designed to remove as far as possible any preconceptions as to what the music might be, to make improvisation a necessity, and keep it at the forefront of the activity.[30]

Bailey always aimed in his music at generating difference, productive friction, and even confrontation. Thus interpretations and responses would of necessity be multiple and at times even contradictory. He quotes with approval Ernst Fischer's 1959 book *The Necessity of Art*, after which he offers his own observations:

'It is essential to distinguish between music the sole purpose of which is to produce a uniform and deliberate effect . . . and music . . . which, far from welding people into a homogenous mass with identical reactions, allows free play to individual subjective associations.' Which might explain everything; but this is now a pretty unfashionable view. The conventional wisdom now allows only one audience and it knows no limits, it is omniscient and it is to be courted by everyone. To play in a manner which excludes the larger audience or, worse, to *prefer* to play before a small audience, is taken as an indication that the music is pretentious, elitist, 'uncommunicative', self-absorbed and probably many other disgusting things too.[31]

Clearly Bailey thought that his music was none of these things; this is another instance of his reluctance to be characterised as avant-garde, in that the limited appeal of his particular activity did not mean that it represented a vanguard.[32] On the contrary, it was an ordinary form of activity: 'I think it is a reasonable speculation that at most times . . . there will have been some music-making most aptly described as free improvisation'.[33] But such activities are, of course, only actually encouraged when they can be capitalised upon; we are allowed to choose our own personal style from the drop-down menus made available to us. Devotees of improvised music might spend their money on all the recordings available, but there is no way to 'grow' this market and thus it must be stigmatised, preferably out of existence. The opposite of Paterson's view might in fact be closer to the truth. It is not to be lamented that we have lost all standards, that we only give marks for effort and refuse to judge success. Rather, the catastrophe is that our standards have become so ossified that we cannot judge technique in relation to the specific character and context of its deployment. We do not ask whether techniques which do not fit our preconceptions about what is worthwhile to spend time with—what is valuable—might have

different purposes than those we usually take for granted. Hence, in order to avoid wasting our time, we check at the door that a suitable level of (supposedly implication- and value-free) technique is on offer before we even begin to listen.

The fact that Bailey might have enjoyed playing with some musicians with very little in the way of conventional technique didn't mean that he would play with *anyone*. There are of course many musicians Bailey chose not to play with. *Pace* Paterson, resistance to abstract, generalised standards does not preclude all acts of evaluation and judgement. Negative elements were in fact essential to Bailey's strategy. Even though his improvisational vocabulary was devised with maximum malleability[34] in mind, it was strongly focused and is also characterised by substantial exclusions. These included, for example, tonal sequences or extended passages in regular rhythm. These things had to be excluded because of the way they *limit* the musical possibilities. In 1987 Bailey explained the point, as he so often did, using a linguistic analogy:

> Tonality is like an argument, and the answers to the questions are always the same. Play Gmin7, C13, and the next chord has to be one of three or four things. . . . Atonality is a way of moving from one point to another without answering questions—almost a series of isolated events.[35]

Exclusion does not, however, imply reduction; quite the opposite. Take, for example, Bailey's comments on the use of a crocodile clip to 'prepare' a guitar string:

> When you put an alligator clip on a guitar string you get a nice prime sound with two or three subsidiary possibilities. All of which can be obtained without using an alligator clip. What you lose by putting an alligator clip on a string is an enormous range of possibilities. That string is reduced to these things it can do with this bloody clip on it. It's an exercise in reduction.[36]

Bailey was interested in limitation when it could itself be productive. As we noted above, Bailey accepted many aspects of the guitar which he could have attempted to subvert (such as the playing stance and tuning), elements which have come into being through a combination of deliberate choice and historical accretion and so in themselves are signifiers of the history of the instrument. By taking a 'year-zero' approach to these constraints, Bailey set himself the task of discovering the possibilities latent within these constraints.

Rather than feeling (as have many musicians and much musical theory, from its very beginnings) that music is so evanescent and

fragile that it needs form to give it any purchase on the memory, any chance of approaching the status of an object, Bailey had a strikingly lackadaisical approach to form:

> Most musical form is simple, not to say simple-minded. But generally speaking, improvisors don't avail themselves of the many 'frameworks' on offer. They seem to prefer formlessness. More accurately, they prefer the music to dictate its own form.[37]

Bailey turned to the then new science of non-linear dynamics, so-called chaos theory, as support for his view that form was inevitable. A manuscript note contained in the Incus archives is derived from a 1986 article that appeared in *Scientific American*:

> There is order (even in) chaos: randomness has an underlying (geometric form). Chaos imposes fundamental limits on prediction but it also suggests causal relationships where none were previously suspected.[38]

In another note he was more sarcastic: 'A pre-occupation with form in music is like believing that the important thing about whisky is the shape of the bottle it comes in.'[39] Bailey proposed a music that could be created not by *emphasising* detail rather than overall form but by *entirely ignoring* global form. This is not, as we saw above, to say that memories of previous events or anticipations of subsequent ones cannot have a crucial impact, but that this always happens from the perspective of the details at any given moment rather than by pulling away to take a global view. It is my contention that through an examination of Bailey's method of beginning with detail rather than panorama, his work could make a major contribution to the reorientation of our thinking about value.

For trombonist, improviser, and composer George Lewis, Bailey's music 'presents a flat, blank surface, a slow-motion white noise whose infinitely variegated texture is only revealed when the listener zooms in, after the fashion of a scanning tunneling microscope.'[40] Maximisation of possibility and subtlety of relationship are bought at the price of a reduction in bold mid-level structural articulation. Such a 'monochromatic' surface can be a great formal resource. It recalls Susan Sontag in 'Against Interpretation':

> It is possible to evade the interpreters in another way [besides use of 'programmatic avant-gardism'], by making works of art whose surface is so unified and clean, whose momentum is so rapid, whose address is so direct that the work can be . . . just what it is.[41]

She saw this as happening in film, but I believe it can happen just as effectively in other media, such as music. I do have reservations, though, about Sontag's desire for the artwork to be 'just what it is'. In fact, a monochromatic surface aids the kind of multiplicitous but constrained acts of interpretation that I referred to above. Deprived of mid-level structural guidance, we must each make our own paths through the material, but this does not mean that anything goes. Umberto Eco is right that 'to say that a text has potentially no end does not mean that every act of interpretation can have a happy end.'[42] Although the experience of form may be different for every listener (as is especially apparent in group improvisation where each musician and each member of the audience may have a different perception of what is going on), it is always constrained.[43]

PERCEPTION, EXPECTATION, AND RECEPTION

Thus far I have been taking Bailey's virtuosity as a given, and indeed it is amply attested to by his curriculum vitae and the admiration of guitarists worldwide. But the reception of his music is not quite so straightforward. For some, not only is his virtuosity in question, but his very ability to play the instrument seems suspect. One could just say that the problem is one of ignorance and that education is the solution. This is, of course, correct, but I want to push a little deeper because it seems to me that the fact that Bailey's music can be perceived in this way at all may say something about the values which it exists in opposition to. The admittedly rather suspect evidence of comments on YouTube videos of Bailey (alongside many extremely enthusiastic comments) shows a great many that not only express puzzlement as to why he would want to play the way he did but assume that it must be because he couldn't play 'properly'. On a video of a solo improvisation from the 1985 Incus festival,[44] we find the following: 'This may sound like a silly question, but does he tune his guitar before he plays?'; 'I do this every time I'm on one of my guitars just randomly messing around. It's a one time 'masterpiece' because I never repeat it exactly the same way. It's amazing if you are into random playing with no thought of what you are doing and how bad you sound'; 'This sounds like something a person who has never picked up a guitar would play if they were a child'; 'I used to play something like that when I was 6 or 7 to impress my parents'; and, as a final example, 'It does seem like a stark bollock naked emperor'. This extends not only to those

given to commenting on YouTube: in an episode of Radio Four's *The Music Group*, David Nicholls said that he saw some similar qualities between a solo improvisation by Bailey and a Bach chaconne played by Yehudi Menuin, to which Julie Berry responded that she 'missed all of those', that to her 'it wasn't music' and she 'wondered if [Bailey] had spent a lot of time in Chinese restaurants'.[45]

I propose that the reasons for this incomprehension have a great deal to do with the structure of Bailey's music: were he to use the same techniques but articulate a clearer mid-level sectionality, his 'musicality' would be much more apparent. As it unfolds in time, a piece of music will set up expectations in its listeners. It is a commonplace of musical aesthetics that a worthwhile piece of music must balance the fulfilment and disappointment of such expectations: too much fulfilment and we become bored; too much surprise and we are confused and alienated. Many listeners, it seems, do not experience in Bailey's music a satisfying relationship between frustrated and fulfilled expectations, and thus the musicality becomes occluded. Malcolm Bull argues, in terms that help to show the inadequacies of Sontag's idea of the work being 'just what it is',

> Articulating hiddenness in terms of the disjunctions between sensing and perceiving, and perceiving and recognising, seems appropriate precisely because perception is the achievement we might naturally expect from sensing, and recognition is the achievement we might expect from perceiving.[46]

For some listeners to Bailey's music, the only recognition they can achieve is an affinity with the sounds made by unskilled or infant guitarists. The perception and recognition of value in Bailey's music depends on how we do or do not perceive and recognise the patterning of musical details. These patterns are either unnoticed by many listeners (and thus appear to be either hidden or absent) or perceived but assumed to be errors. For example, the beating effects that occur when two notes very close in pitch are sounded simultaneously—such groups of notes are present even on a perfectly tuned guitar, as can be heard when fretted notes are sounded at the same time as supposedly equivalent natural harmonics—were extensively exploited by Bailey but can only appear to some listeners as a sign of being 'out of tune'.

Because we expect music not only not to hide but to clearly demarcate and emphasise its formal qualities (largely through mid-scale repetitions and deliberate selection of memorable material), many people interpret them as non-existent in Bailey's music. This

is not surprising but rather is a marker of how much Bailey challenges the ways we are accustomed to listening. George Lewis thinks,

> It would take a particular genius to really memorize his music note for note, cluster for cluster, in the old way; certainly I cannot do it. But that does not mean that the music of Derek Bailey is not memorable. In a sense, the joy of listening to Derek lies in the utterly human facility it reveals, by which those who encounter his sound ideal can manage to re-improvise its traces in phantasmal consciousness.[47]

Guitarist John Russell, who studied with Bailey, links memory to meaning:

> One of my aims is to have the ability to use all the sound elements that the instrument can produce and, in improvising, to constantly pick and choose their meaning (i.e., their musical function) within the context of a developing music.[48]

Russell means not that he unconstrainedly imposes a meaning which will then be apparent to all but rather that he makes an act of *interpretation*, which will only be accessible by others indirectly—if at all—in *their* interpretation of the ongoing music. These new acts of interpretation themselves operate in a similar fashion; hence the reasons why any one event happens in the way that it does become slippery, to the point of complete indeterminacy. Bailey described his attitude to the eventual 'end product' thus:

> It's a bit like jigsaw puzzles. Emptied out of the box, there's a heap of pieces, all shapes, sizes, and colours, in themselves attractive and could add up to anything—intriguing. Figuring out how to put them together can be interesting, but what you finish up with as often as not is a picture of unsurpassed banality. Music's like that.[49]

Bailey has been accused of having no interest in product but only in process, but the 'as often as not' here is crucial. It's not that he had no interest in the end product or that the process is fetishised but rather that the process is where the work and the interest lie, even when the result is banal; should it not be banal (and presumably the work is directed at avoiding banality), then so much the better.

AN ECOLOGY OF VALUE

My analysis has been focused on the individual, specific aspects of Bailey's practice and the intentions behind his collaborative and formal strategies rather than on the details of his collaborative work. To redress the balance a little, I conclude with a brief discussion of the relationship between interpretation and value in Nietzsche and some of his recent commentators, seen from a broadly ecological perspective. I said above that when making decisions, improvisers are performing interpretive acts. For Nietzsche, too, interpretation is certainly not merely a cognitive activity. Raymond Geuss has argued that 'for Nietzsche, I am "interpreting" a situation by reacting to it in a certain way.'[50] Hence improvisers are interpreting the situation in the things they do, whether these acts are consciously or unconsciously selected. There is a difficulty, however, with reading Nietzsche like this, because interpretation for him is not separable from the will to power. In one of his late notebooks, he argued,

> The will to power *interprets*: the development of an organ is an interpretation; the will to power sets limits, determines degrees and differences of power. Power differences alone wouldn't be able to feel themselves as such: there has to be a something that wants to grow, interpreting every other something that wants to grow in terms of its value. . . . *In truth, interpretation is itself a means of becoming master of something. (The organic process presupposes constant interpreting.)*[51]

Hence every reaction, and thus every act of interpretation, contributes to an economy of power where the strong succeed at the expense of the weak. In his *Anti-Nietzsche*, Malcolm Bull argues that Nietzsche deploys a transcendental argument to demonstrate the inescapability of such acts of valuing, one that turns on the idea that if everything situates itself in a hierarchy of value, then not-valuing is cognate with devaluing—thus there is no way to step out of this economy. As Bull puts it in his contribution to a symposium on *Anti-Nietzsche* published in *New Left Review*,

> We can't devalue without valuing. Valuing always takes the form of valuing over, and every valuation is the product of a valuer, so every valuation is at the expense of some other valuer ('will to power'). It is this inequality that makes valuation possible.[52]

Nietzsche was terrified that increased quantitative equality would lead to increased qualitative equality, tending downwards— levelling down. Bull's response to this is to attempt to read Nietzsche 'like a loser', to accept the inescapability of the economy of value but to resist the dominance of the strong by accepting that a constant levelling out necessarily entails a constant levelling down:[53]

> Rather than a positive ecology of value, which creates the possibility for conditions of valuation, there might be a negative ecology—an ecology that minimises the possibilities for the positing of value and so reduces the quantum of value still further.[54]

This has echoes with the thinking of percussionist Jamie Muir, which Bailey clearly admired:

> Instead of transmuting rubbish into music with a heavily predetermined qualitative bias . . . leave behind the biases and structures of selectivity (which is an enormous task), the 'found' attitudes you inherit, and approach the rubbish with a total respect for its nature as rubbish—the undiscovered/unidentified/unclaimed—transmuting that nature into the performing dimension. The way to discover the undiscovered in performing terms is to immediately reject all situations as you identify them (the cloud of unknowing)—which is to give music a future.[55]

For Bailey, as for Muir, the intransigence of the material directs one's attention to its malleable regions: it is a question not of forcing it to do what one wants but of discovering what it can be made to do. This is clearly not something as equitable as a dialogue, but neither is it a zero-sum game where the improviser's success comes about via the material's failure.[56] The intransigence of the material is central to the possibilities it affords for play, as we saw earlier in the way Bailey viewed the instrument as more of an ally than a tool.

But does engaging with rubbish in this mean that we all aspire to the condition of rubbish? Bull is certainly right to say that 'from where we are now—a world where the poorest 5 per cent in a wealthy Western country may be better off than the richest 5 per cent in Africa or India—we can level out a long way before ever reaching a situation remotely like the repugnant conclusion', but there is something disingenuous about his proposal: it is all very well to say that eventually we could end up with just muzak and potatoes, do without the muzak, and develop a 'theory of triage' to distribute the potatoes, but I am not convinced he can seriously advocate this as an account either of where we would *wish* to end

up or where we actually *could*.[57] Isabelle Stengers may have a preferable proposal, one linked to the existence of *practices* and their incommensurability. She argues that the destruction of any practice or group of practices is potentially justifiable either on the grounds of 'the privileges they benefitted or by their alienating archaism, or by their closure and resistance to change', but that the problem with such an argument is that it can

> amount to giving free elbowroom to capitalism in its ongoing destructive redefinition of the world. . . . We could say that practices are commons, but that the addition of the commons does not logically lead to the common. I am not at all sure that I can imagine physicists and practitioners of such crafts as tarot-card reading or of the art of healing, affirming together anything else than a rather empty common goodwill tolerance.[58]

So instead of searching for what we all have in common, she proposes that 'we should resist the temptation to pick and choose among practices—keeping those which appear rational and judging away the others, tarot-card reading, for instance'.[59] By analogy with the way that biologists and ecologists resist absolute division of animal species into those which are useful and those which are pests, a resistance which does not entail never considering any animals to be dangerous or destructive,

> some practices may well be considered intolerable or disgusting. In both cases, the point is to refrain from using general judgemental criteria to legitimate their elimination, and to refrain from dreaming about a clean world with no cause to wonder.[60]

This may strike us as excessively permissive, but the crucial point (echoing the comments by Rancière that I cited in my introduction) is that—like the improviser or like any of us confronted by the power of art—we are always judging in the thick of things, from the midst of which we can, if we choose, orient ourselves towards the possible. Bailey's attitude to the value of his musical activities and of the material with which he worked should not, if we really want to take lessons from his practice, be employed as a general model. But it is nevertheless an example of creative work in the midst of things, of an exploration of the world which neither assumes ideas to be more important than things nor pretends to disinterested objectivity. His goal of practical action directed towards freedom is in fact an example of a hopeful attitude, and it is evidence that to assume an attitude of hope entails not ignoring reality but rather endeavouring to become fully part of it. Constructing new values

does not mean sitting in an armchair thinking about what we would like to be the case; rather it means wrestling with that of which we are part. We should not dream of a clean world, and neither should we be afraid of getting our hands dirty, because 'clean hands do no worthwhile work'.[61] Nor, Bailey might say, do they do any worthwhile play.

NOTES

1. Derek Bailey, *Improvisation: Its Nature and Practice in Music*, 2nd ed. (London: The British Library National Sound Archive, 1992), p. 115. Many thanks to the editors, Daniel Bennett and Kate Lash for their comments on earlier versions of this essay.

2. That we are always already valuing need not commit us to the position that there is nothing but interpretation, because that is merely to take the side of value in the fact/value distinction; it is just as important to point out that all values are also facts.

3. George Caffentis, 'Immeasurable Value? An Essay on Marx's Legacy', *Commoner*, 10 (2005), 87–114 (p. 92). Zarathustra proclaims, 'A tablet of the good hangs over every people. Observe, it is the tablet of their overcomings; observe, it is the voice of their will to power.' Friedrich Nietzsche, *Thus Spoke Zarathustra*, ed. by Adrian Del Caro and Robert B. Pippin, trans. by Adrian Del Caro (Cambridge: Cambridge University Press, 2006), p. 42.

4. Caffentis, 'Immeasurable Value?', p. 93.

5. Jacques Rancière interviewed by Rye Dag Holmboe (June 2013), *The White Review*, 10 (April 2014), 64–69 (p. 65).

6. See Derek Bailey, 'Free Improvisation', in *Audio Culture: Readings in Modern Music*, ed. by Christoph Cox and Daniel Warner (New York: Continuum, 2004): 'As the subconscious aim is probably to invent a form unique to every performance, giving a precise account of the complex forces that govern the shape and direction of an improvisation, even if such a thing is possible, would have no general significance' (p. 111).

7. 'A Liberating Thing', episode three of *On the Edge*, first broadcast on Channel Four, 16 February 1992, http://www.ubu.com/film/bailey_edge3.html [accessed 16 April 2014]. In fact, despite his claim to be uninterested in performance, Bailey was a consummate performer, often interrupting his solo performances at well-chosen moments to dryly regale the audience with anecdotes. To subvert any reverence towards the act of performing, he employed deflationary tactics which were, perhaps only apparently paradoxically, very distinctive and effective performance devices: for a time he used an electronic timer when performing solo, setting it to the length of time he was supposed to play for and continuing to improvise until rudely interrupted by unlovely bleeps.

8. Bailey, 'Free Improvisation', p. 99.

9. Bailey interviewed by John Corbett (London, May 1992), in *Extended Play: Sounding Off from John Cage to Dr. Funkenstein* (Durham, NC: Duke University Press, 1994), 228–46 (p. 241).

10. J. H. Prynne, 'Resistance and Difficulty', *Prospect*, 5 (1961), 26–30 (pp. 27–28).

11. Bailey, 'Free Improvisation', pp. 111–12.

12. Prynne, 'Resistance and Difficulty', p. 30.

13. Raymond Geuss, in 'Form and "the New" in Adorno's "*Vers une musique informelle*"', in *Morality, Culture and History: Essays on German Philosophy* (Cambridge: Cambridge University Press, 1999), pp. 140–66, has indicated how such an approach relates to aspects of Theodor Adorno's thought which have roots in Kant: 'Finally at the end of "*Vers une musique informelle*" Adorno speaks of the aspiration the artist should have to create things of which we don't know what they are (*Gesammelte Schriften* 16.540: "*Dinge machen von denen wir nicht wissen, was sie sind*"). Of course, to say that "we don't know what they are" must be understood subject to the qualifications given above. [That is that "the point is not that the work is not categorizable *at all*, but that it cannot be broken down into aesthetically significant constituent elements that instantiate categories; the work is constructed, as Max Paddison has suggested, in such a way as to resist assimilation to the familiar through *internal* structural negation of traditional categories" (p. 155).] I note also that this way of thinking would represent a step in the direction of Kant (*Kritik der Urteilskraft* §§ 46–49) for whom the talent for fine art was the ability to create "*ästhetische Ideen*", sensible representations that resisted reduction to concepts.' (p. 160). Bailey's thinking about the way genre relates to his music—a refusal to see genre as inhering in surface stylistic features—is relevant here: 'I've come to like certain electric treatments of the guitar, come to find things in it I didn't previously find. It's more resourceful than I might have thought—bits and pieces, harmonics, what's in it and what's not in it, what you can get out of it. It's not a stylistic adjustment. Some guy came here a couple of weeks ago and said, Do you think you play rock now because you didn't play it years ago? [Ben Watson: It's a fair enough question.] But I don't play fucking rock. Then again, he was a free-music/jazz critic, so he didn't know anything about rock. Naturally he thought that if anybody played louder than the saxophone you're playing rock. Loud guitars play rock as far as he was concerned' (Ben Watson, *Derek Bailey and the Story of Free Improvisation* [London: Verso, 2004], p. 420).

14. Bailey, 'Free Improvisation', p. 83.

15. Bailey's motor neurone disease (initially misdiagnosed as carpal tunnel syndrome) led him towards the very end of his life to develop a fingerstyle technique when he could no longer comfortably hold a plectrum.

16. Bailey, 'Free Improvisation', p. 107.

17. Interview printed in the liner notes to Derek Bailey, *Domestic and Public Pieces*(London: Emanem CD 4001, 2000).

18. Derek Bailey, *Improvisation: Its Nature and Practice in Music*, 1st ed. (Ashbourne: Moorland Publishing in association with Incus Records, 1980), p. 128.

19. Or as Dewey Redman put it in the title of a 1973 album, *The Ear of the Behearer*.

20. Paul Helliwell, 'First Cut Is the Deepest', *Mute*, 2.4 (2007), 68–77. Helliwell does not make this accusation, but he exemplifies the misprision that occurs if one considers Bailey's methodology as avant-garde when he writes that the 'autonomy of free improv is created by the exclusion of idiomatic music, conventional moments of musical signification, theory, levels of language other than musical ones. A lot of baby has been thrown out with the bathwater to make these moments possible—and if Adorno is correct, like the 1910 revolutionary art movements, free improvisers are experiencing not new freedoms but more things "constantly pulled into the vortex of the newly taboo"' (p. 74).

21. Bailey, 'Free Improvisation', pp. 110–11.

22. See Dominic Lash, 'Metonymy as a Creative Structural Principle' (unpublished PhD diss., Brunel University, 2010), pp. 83–84. Available online at http://bura.brunel.ac.uk/handle/2438/4668 [accessed 29 April 2014].

23. Robert Musil, *The Man without Qualities*, 3 vols. (London: Picador, 1979), I, trans. by Eithne Wilkins and Ernst Kaiser, p. 12.

24. 'The Dark Art of Poetry', T. S. Eliot lecture delivered 9 November 2004, available from the Poetry Library, http://www.poetrylibrary.org.uk/news/poetryscene/?id=20 [accessed 16 April 2014].

25. Quoted in Bailey, 'Free Improvisation', p. 94.

26. Ishmael Wadada Leo Smith, *Notes: 8 Pieces* (1973), quoted in Bailey, 'Free Improvisation', p. 99; for some other excerpts from this text, see 'Philosophy of Music', Ishmael Wadada Leo Smith, http://www.wadadaleosmith.com/pages/philos.html [accessed 17 April 2014].

27. This is not the place to go into this very thorny subject, but more on Bailey's attitude can be found in Watson, *Derek Bailey*, and David Keenan, 'The Holy Goof', *The Wire*, 247 (2004), 42–49. For thoughts of current improvisers on the relevance of jazz to their music, see issue 8 of *Sound American* (http://soundamerican.org/sa-issue-8-the-conversations [accessed 28 December 2015]), which includes a discussion between Evan Parker and myself [accessed 7 July 15].

28. This was a gathering of musicians who improvised for successive days in varying combinations; some of the participants had not worked together or even met before. Bailey continued to organise such events annually for many years afterwards.

29. Watson, *Derek Bailey*, p. 216. See also Peter Riley's account of the week, Company Week, Incus Records, http://www.incusrecords.force9.co.uk/catalogue/books.html [accessed 1 September 2015]. Paterson also neglects the possibility of change over time—Beresford has more recently been found playing piano with the likes of Evan Parker with considerable virtuosity.

30. Bailey, 'Free Improvisation', p. 136.

31. Bailey, 'Free Improvisation', p. 47.

32. A colleague of Bailey's once told me that he enjoyed working with poets because poetry gigs were the only ones that had fewer attendees than improvised music gigs!

33. Bailey, 'Free Improvisation', p. 83.

34. Which is not, we should note, quite the same thing as flexibility—it had to be continually alterable but was designed for improvising situations, not for suitability to a maximum number of musical contexts.

35. Bailey, speaking in 1987, quoted in Watson, *Derek Bailey*, p. 213.

36. Interview with Derek Bailey by Thomas Gaudynski in *Cadence*, 10.7 (1984), 11–14 (p. 13).

37. Bailey, 'Free Improvisation', p. 111.

38. The note is reproduced in Dominic Lash, 'Derek Bailey's Practice/Practise', *Perspectives of New Music*, 49.1 (2011), 143–71 (p. 164); the article in question is J. P. Crutchfield et al., 'Chaos', *Scientific American*, 255.6 (1986), 46–57.

39. Lash, 'Derek Bailey's Practice/Practise', p. 161.

40. George Lewis, liner notes to *Concert in Milwaukee*, CD62 (London: Incus, 2011).

41. Susan Sontag, 'Against Interpretation', in *Against Interpretation and Other Essays* (London: Penguin, 2009), pp. 3–14 (p. 11).

42. Umberto Eco, *Interpretation and Overinterpretation: World, History, Texts* (Cambridge: Cambridge University Press, 1992), p. 143.

43. For more on these issues, see Dominic Lash, 'Inconclusive Paragraphs on Metonymy, Monochromaticism, Materialism', *Wolf Notes*, 3 (February 2012), 17–25, http://wolfnotes.wordpress.com/wolf-notes [accessed 17 April 2014].

44. 'Derek Bailey—improvisation #1 (1/2) (1985/04/22)', uploaded to You-Tube by Andrei Ionescu on March 11, 2010, https://www.youtube.com/watch?v=H5EMuO5P174 [accessed 25 March 2014]. People also make negative comments on similar forums about the music of improvisers such as Evan Parker, Cecil Taylor, and John Butcher, but because their virtuosity is much more immediately apparent, as is the sheer physical difficulty of what they play, the comments tend to question why anyone would want to play like that rather than make accusations of fraudulence.

45. Episode one, series five, of *The Music Group*, originally broadcast on BBC Radio 4 on 30 April 2011, http://www.bbc.co.uk/programmes/b010m9t0 [accessed 18 April 2014].

46. Malcolm Bull, *Seeing Things Hidden: Apocalypse, Vision and Totality* (London: Verso, 1999), p. 20.

47. See Lewis, *Concert* liner notes.

48. John Russell, 'Somewhere There's Music', *Rubberneck*, 15 (November 1993), http://www.users.globalnet.co.uk/~rneckmag/russell.html [accessed 24 March 2014).

49. Watson, *Derek Bailey*, p. 440. We might contrast Bailey's use of this metaphor with Raymond Geuss's account of Adorno's thinking in his '*Vers une musique informelle*': 'When Adorno describes certain forms of traditional composition as like trying to solve a puzzle, or when he speaks of art as a "riddle", this determinateness is conceived as maximal. With a puzzle, there is usually only *one* pre-determined way in which the pieces can fit together, and a "riddle" usually has an answer. . . . Is composition more like solving a cross-word puzzle or more like solving a task in engineering where a number of different demands—stability, simplicity, efficiency, etc.—have all to be respected and there may be no pre-given optimal ordering of them and no uniquely good way of satisfying them all at once?' (Geuss, *Morality*, p. 151). For Bailey the fact that a puzzle has only one answer indicates precisely where interest ceases: what is stimulating to work is the illusion, when one sets out, that there are multiple possible solutions—or at least the fact that one doesn't know what the result will be or, in detail, the method one will use to get to that result. Geuss's alternative metaphor of an engineering task is in many ways more appealing, though it does presume a telos lacking in improvisatory music making. I have elsewhere indicated some ways in which Adorno's '*musique informelle*' essay might be helpful in thinking about Bailey's practice; see Lash 2010, 90–92.

50. Raymond Geuss, 'Nietzsche and Genealogy', in *Morality, Culture and History: Essays on German Philosophy* (Cambridge: Cambridge University Press, 1999), pp. 1–28 (p. 16).

51. Friedrich Nietzsche, *Writings from the Late Notebooks*, ed. by Rüdiger Bittner, trans. by Kate Sturge (Cambridge: Cambridge University Press, 2003), p. 90.

52. Malcolm Bull, 'The Politics of Falling', *New Left Review*, 86 (2014), 129–40 (p. 131).

53. It is not clear that Nietzsche's fears were justified. Is the capitalist experience (following Marx's analysis) not that increased formal quantitative equality (removal of all property qualifications for voting or flattening tax rates, for example) in actuality leads to greater quantitative inequality—and hence, at least in terms of ability to express power, to increased qualitative inequality? Perhaps the price paid is that the powerful in our capitalist world do not, as in Nietzsche's utopia, possess the power to create values limited only by their strength but can only reproduce and extend the values that already exist ('add value', as the economists put it).

54. Malcolm Bull, *Anti-Nietzsche* (London: Verso, 2011), p. 47.

55. This is Muir's conclusion; the full quotation begins: 'I much prefer junk shops to antique shops. There's nothing to find in an antique shop—it's all been found already; whereas in a junk shop it's only been collected. But a rubbish dump—a rubbish dump has been neither found nor collected—in fact it's been completely rejected—and that is the undiscovered/unidentified/unclaimed/unexplored territory—the future if only you can see it. Now some, like Yamashta, would take a rubbish dump and turn it into an antique shop—that's real alchemy, but it smacks of the gold rush and a kind of greed—of "staking out a claim", taking from the earth but never putting back (who throws away antiques?)—he civilises vast hunks of unexplored territory and builds safari clubs all over it so you can view the beauties of the wilderness in luxurious comfort and from a safe distance—a remarkable feat but you're back safe and sound in the antique shop again where everything, you can bet your life, has already been found . . . and will be catalogued. However there is an alternative. Instead of transmuting . . . ' (quoted in Bailey, 'Free Improvisation', p. 96).

56. Heraclitus had a related thought about the relativity of interspecies acts of valuing (although not explicitly in the case where two valuings meet in a single event): donkeys prefer rubbish to gold, while for men it is the other way round. See Heraclitus, fragment 9 (from Aristotle, *Nicomachean Ethics*, Book X, Part 5, 1176a 7).

57. Bull, *Anti-Nietzsche*, pp. 137, 138.

58. Isabelle Stengers, 'Wondering about Materialism', in *The Speculative Turn: Continental Materialism and Realism*, ed. by Levi Bryant, Nick Srnicek, and Graham Harman (Melbourne: re.press, 2011), pp. 368–80 (p. 378).

59. Stengers, 'Wondering about Materialism', p. 379.

60. Stengers, 'Wondering about Materialism', p. 379.

61. J. H. Prynne, 'Mental Ears and Poetic Work', *Chicago Review*, 55.1 (2010), 126–57 (p. 141).

THIRTEEN

'The Nice Thing about Value Is That Everyone Has It'

Art and Anthropology Despite Culture

Sam Ladkin

Assertions of the value of 'the arts' often depend upon interpretations of the societal values the host culture of those arts is expected to hold dear, and even more often these disguise the dominant socio-economic values of the times.[1] The terms of valuation are frequently derived from the failures of the socio-economic conditions of contemporary life, such that the arts become a habitable terrain for scapegoats: they strive for inclusivity in an economy premised on inequality or seek to mitigate disenfranchisement with participatory arts. This thesis of 'against value' questions the commensuration of aesthetic values with those of neoconservative state management and the rise of practices of audit and retains a healthy suspicion about the inauspicious effects on aesthetics of attempts to cauterise socially legible values dogmatically within artistic creativity. My use of the specious term 'the arts' reflects the nature of such debates and defences of cultural life as they tend to be represented in policy and cultural management and by the spectacle of audit.[2] This chapter therefore works from misgivings about even the best-intentioned attempts to assert and describe the laudable properties of culture, art, and value.[3]

The spectacle of value (planning for value, auditing for value, announcing value) often overwhelms rather than supports the complex ecology of the making and experience of the arts. The thesis of 'against value' does not propose some cleansing of values; values are implicit in all forms of behaviour and acts of communication. It seeks to critique value(s) as established, manipulated, reified, and audited. Even the most seemingly virtuous of values tends to obscure an act of predation (inclusivity obscures disenfranchisement by socio-economic forces perfectly legible according to materialist analysis, for example) or counter-intuitively damages that which is being fêted (the damage to trust attendant on the tyranny of transparency).[4] The thrust of the argument is a critique of the spectacle of value as it is used to extend social control and a critique of the promotion of moral values because they tend to inhibit artists by encouraging a pre-emptive censoriousness of spirit. Leo Bersani argues against the intention of art to redeem 'the catastrophe of history' by preserving a 'moral monumentality':

> Claims for the high morality of art may conceal a deep horror of life. And yet nothing perhaps is more frivolous than that horror, since it carries within it the conviction that, because of the achievements of culture, the disasters of history somehow do not matter. Everything can be made up, can be made over again, and the absolute singularity of human experience—the source of both its tragedy and its beauty—is thus dissipated in the trivialising nobility of a redemption through art.[5]

In *Arts of Impoverishment* Bersani and Ulysse Dutoit lament the 'edifying value' our culture assumes for art, that art makes us 'better individuals and citizens' and even that art may 'save us—save us from our lives, which in some way are failed lives in need of repair or redemption.[6] For the authors these claims for art are 'reductive and dismissive about both life and art' since 'art is reduced to a kind of patching function' and the 'catastrophes of individual experience and of social history matter much less (thereby making active reform and resistance less imperative)'.[7] Instead they seek works of art that are 'acts of resistance', that 'refuse to serve the complacency of a culture that expects art to reinforce its moral and epistemological authority'.[8] By being, as Bersani puts it, 'at war with culture', these works are against value and against those who believe themselves to hold the authority of those values. The promotion of a spectacle of values associated with art may, contrary to their seeming beneficence—the good work—be evidence for the 'deep horror

of life', the priggishness that wishes to order, manage, censor, master the unruliness, the damages, the overwhelming material of experience, life, the world and its history. It was Friedrich Nietzsche who famously contested the virtue of virtue in his attempt to go beyond good and evil, unveiling the *ressentiment* coded as humility in the genealogy of morality. And as Michel Foucault—near enough a Nietzschean—understood, the logic of surveillance and confession is invasive not so much because of what is heard or said but because of how it constitutes the one being surveilled. Once again the famous quotation of Foucault's, even more significant in our era of surveillance by government and our own commodities:

> He who is subjected to a field of visibility, and who knows it, assumes responsibility for the constraints of power; he makes them play spontaneously upon himself; he inscribes in himself the power relation in which he simultaneously plays both roles; he becomes the principle of his own subjection. By this very fact, the external power may throw off its physical weight; it tends to the non-corporal; and, the more it approaches this limit, the more constant, profound and permanent are its effects: it is a perpetual victory that avoids any physical confrontation and which is always decided in advance.[9]

The meta-values of contemporary value—transparency, openness, accountability—announce themselves as obvious goods but cannot so easily be separated off from either their counter-intuitive effects or their roles in the spread of censoriousness, social control, and surveillance. These are the 'non-corporal', discursive constraints that begin to constitute us. Thomas Docherty offers this warning on aggrandising 'transparency':

> The intimacies that help us to shape ourselves as constituent parties to the public sphere are no longer intimate, so to speak; and we lose our right to a private life. There are far-reaching consequences for us as subjects and as citizens in the establishment of a transparent society. The question of surveillance as the sinister counterpart to transparency becomes all the more pressing when it is further internalized: that is to say, when we all start to 'look within' and to focus the grounds of our social and cultural being upon our sense of our own interiority or 'selfhood' and identity.[10]

All of this establishes some of the pressures behind this chapter, the particular thesis of which is as follows: it is necessary to conserve

the concept of art and of its value *against* descriptions of art, and even *despite* those descriptions (I will return momentarily to this against and despite), if we are to resist a censorious culture in which our failures, misunderstandings, and errors (masquerading as the relentlessly affirmative values of our era) are not mass-produced as policy, and if we are not to circumscribe the future shapes of art by assuming 'responsibility for the constraints of power'. Through discussion of the social anthropology of Marilyn Strathern, this chapter looks to deface the spectacle of ostensibly positive values as they are promoted and audited by our culture. I want to draw on a reticence of Strathern's towards expressions of value as a model for a kind of resistance to the self-aggrandising tendencies of cultural managers and of academia when placed in the path of instrumentalising policy and resistance to the inflationary self-regard of the avant-garde. Though its critique of culture, knowledge, and self-knowledge is a scaled-up critique of the pragmatics of the cultural sector as it places its faith in audit, I conclude the chapter with a reading that is not easily generalised, which analyses a work by the poet Tom Raworth. The reading latches on to a number of the preceding arguments and suggests that the particular poem under consideration, *Ace*, remains, due to its poetics of intermittency, resistant to some of the recuperative impulses of an accumulative culture, including my own particular culture as an academic and more broadly as a consumer. That it is likely not generalisable, due to the singular nature of Raworth's work, is its own evidence. The particular values that inhabit the poem—the nomad and the ace—remain ambivalent in themselves and, held together in tension as wave and particle, distribution and singularity, remain resistant to the kind of encapsulating moral judgement so tempting to the academic seeking (self-congratulating) resolution and closure.

AGAINST KNOWLEDGE, DESPITE DESCRIPTION

The following quotation from Strathern guides my thinking. Here it is the great precision of the words 'against' and 'despite' to which I draw attention.

> I like to think that anthropologists could assert the potentials there are in being human *against* everything they know about people, individually or collectively, and against how they form particular social relationships. . . . I suspect we do not really want our descriptions of ourselves to become true; we hope they are

partial enough to hold out promise of better things. No particular description is in any case adequate to the possibilities human beings are capable of, any more than any particular set of relations encompasses people's capacity for social life. So anything we might use in claiming common humanity is just that: a claim. Rather than redescribe the world in order to find humanity within it, one might wish to conserve the concept beyond and outside descriptions of it, and even *despite* them.[11]

Strathern retains for anthropology, the study of humans, the fundamental resistance of those being studied. First, there is an imperative to suspend the belief in our knowledge as though it were sufficient or complete, or could ever be sufficient or complete, whether that is in the description of people and the values they hold (or resist) or, crucially, in the description of their potential. Second, we might resolve to maintain a commonality of co-presence amongst cultural difference, and the potentials within cultures, by conceptualising that commonality 'despite' all descriptions.[12] Strathern's use of 'humanity' relates to the term 'sociality'; that is, it refers

> neither to citizen subjects nor to non-animal beings, but to the amalgam of desire, capability, artefact and embodiment by which persons live. The idea of it [sociality] cannot be produced either by generalisation or by the purification of other ideas: rather it is brought into existence as an awareness of what I have called the co-presence of persons.[13]

Emphasis is placed on the manifold relations between persons rather than on the supposed integrity of the individual and the implicit value system of that individual, which is more readily curtailed by definition and more complicit in the Euro-American world view. Sociality is, then, a way of pulling back from the interpretations of culture as 'way of life' and 'source of identity' (Strathern places these in scare quotes), which was felt to be the task of much mid-twentieth-century anthropology but can too easily bring with it a cultural fundamentalism which harbours an 'essentialist sense of identity without the confrontations (relationships) implied in an overtly racist agenda.'[14] The question here is how to retain the elusiveness of the idea of such sociality without installing it as an object of piety before alterity.[15] James F. Weiner remarks that he is searching 'for a form of sociality that is not mediated, that is not directly articulated, that is only made visible when one's attention is directed elsewhere.'[16] It is closer to a tactical indirectness, therefore, than the kind of advocacy in which short-term victories (the suc-

cessful description and valuation of a way of life) might well be set against long-term harm (its commodification or the use of that knowledge for acts of control).[17]

This is neither a transcendental nor an immanent critique but instead describes a certain attitude, indifferent and modest, what Strathern will describe in all its ambiguity as 'partial'. Strathern is not countenancing a kind of piety which severs the work of gathering and interpreting knowledge on behalf of self-aggrandising silence before the integrity of the other, but rather she offers the recognition that knowledges (and there are 'kinds of knowledge' in Strathern's thinking, some of which might not be easily assimilable within a commonsensical reading of knowledge) will forever remain partial, incomplete: in the pragmatics by which knowledge and the description of that knowledge occurs, the benefit of legibility also creates opportunities for surveillance, control, and the severance of potential. Partiality is not a false impartiality but rather a blunting of the arrogance of knowledge, partial *to* whilst withdrawing from a totalising vision of its attachments.

I concentrate on this passage of Strathern's, its *against* and *despite*, as a large-scale critique of the processes of containment in which even well-intentioned academic and sociological disciplines produce acts of discipline by their descriptions. How, though, does this relate to either the cultural efflorescence of 'the arts' or, indeed, to art? First, I take its modesty and indifference as necessary counters to the desire of cultural managers to engage in acts of knowing or unknowing social control. Second, responses to artworks (critique) might be as complex and incomplete as Strathern describes above for persons. To interpolate, 'I suspect we do not really want our descriptions of art to become true; we hope they are partial enough to hold out promise of better things.' A similar gesture is offered by Maurice Blanchot; here transparency is invoked not as a demand for self-revelation but as a disappearance and the 'self-effacement' I take to echo my use above of indifference and modesty:

> Critical discourse has this peculiar characteristic: the more it exerts, develops, and establishes itself, the more it must obliterate itself; in the end it disintegrates. Not only does it not impose itself—attentive to not taking the place of its object of discussion—it only concludes and fulfills its purpose when it drifts into transparency. And this movement toward self-effacement is not simply done at the discretion of the servant who, after fulfilling his role and tidying up the house, disappears: it is the very mean-

ing of its execution, which has proscribed in its realization that it eclipse itself.[18]

Critical discourse, unlike the intentions and methodology of audit, eventually seeks to detach itself from the artwork, to hand the artwork back to the world, returning it as newly itself. This attention to 'not taking the place of its object of discussion' strikes me as an ethnographic concern for the integrity of the artwork. Ethnography and aesthetic criticism both suffer the difficult task of leaving their subjects of study where they are, even as they develop rapport.[19]

The *against* and *despite* of Strathern speaks to the contingencies, errors, inconsistencies, and incompletions of descriptions of culture (and 'culture'), particularly as the descriptions of the values of a culture come to constitute that culture. If one of the purposes of this project is to understand the damages caused deliberately or inadvertently by the treacherousness of the practice of auditing or of the discourse of accountability and managerial rationality, then we can learn by reflecting on the ethnographic method. Audit, 'a set of institutional practices deeply committed to a certain form of description—namely, to eliciting from auditees their descriptions of themselves', is poor ethnography.[20] It mistakes the implicit values and kinds of knowledge of persons for the kinds of knowledge people can describe in regards to themselves. In the passage quoted above, Strathern takes this further by pointing out how ethnography must internalise its own poverty (lack of repletion) and recognise the ways in which its description of cultures should not be reified for ease of use. By extension we might draw a distinction between two kinds of artworks, one which forecloses the experience of the audience or reader by modelling in advance the kinds of responses they wish to elicit and another which retains a modest indifference towards the audience or reader, not an indifference which curtails a commitment to those persons but rather one that remains modest before their autonomy.

My title turns Strathern's, 'The Nice Thing about Culture Is That Everyone Has It', which itself sardonically recounts the way in which culture has increasingly been taken to be a generic rather than relational term. 'Culture' is used widely in an anthropological sense as 'evidence for diversity in human forms of thought and practice' and as the name for the 'root of people's sense of identity' but has itself become 'ubiquitous, encompassing, all explanatory'.[21] Again, how does this relate to a work of art? Artworks are unstable entities, even where they remain materially consistent. They might

be understood as objects, phenomena, experiences, goads to the sentiments, prompts to and plumb lines in the imagination or as events.[22] We do not want our descriptions of art to become true, or made to become true according to the logic of the audit, because we need to retain the idea that an artwork could remain an artwork *against* everything we know about art; in fact, this may be crucial to art's refusal to be coextensive with 'culture': art might be art *despite* culture.

This is a pressing concern given the necessity of generating justifications for 'the arts' or 'culture' which can be harnessed to justify shifts in policy. An economic justification suggests investing in the arts is valuable because it generates either direct or indirect profits elsewhere in the financial system, and there is clearly evidence for this rationale (as there is for the 'investment' in education). There is evidence, too, for a number of other benefits of access to the arts to promote health, happiness, enfranchisement, and social mobility. The problem with such reports is that the state or proxies for the state, under all kinds of pressure according to the dominant economic forces of the economy, become the 'culture' (system of values) inside of which 'the arts' are expected to operate and demonstrate loyalty, and the self-evidence of the promoted values proves to be anything but.[23]

Descriptions of the value of art, as per descriptions of the value of the human, are therefore potentially dangerous (or at least banalising) because the self-knowledge the 'culture' of the state within the horizon of neoconservatism bears is itself less three-dimensional, less indeterminate, less ambiguous, and less complex than that sociality which it seeks to describe. 'The arts' are therefore expected to produce certain effects and to have those effects be legible (auditable) within a time frame sufficiently curtailed as to match the temporality of policy. The most popular art form for funders in the last decade has arguably been participatory art, a family of art practices with some dispiriting formal similarities to the rise of audit practices and which, despite its largely critical stance toward inequalities in the social contract, appears to be most unimpeachable when clearly bounded by its host culture as horizon of values.[24]

PARTIAL CONNECTIONS

Let's contextualise Strathern's claim above that 'anthropologists could assert the potentials there are in being human *against* every-

thing they know about people, individually or collectively, and against how they form particular social relationships', since we might happily accept the vices that attend the virtues of audit culture without seeing how that argument is a smaller-scale model of her larger ethnographic project. Her critique of audit culture results directly from her institutional positions in anthropology departments (Manchester and Cambridge) and indirectly from the wealth of ethnographic analysis and reflection undertaken during her research. Value and its audit culture tend to take critical thinking as their first hostage: complexity, nuance, counter-intuitive logic, long-term planning, doubt all follow. What is the relationship between audit, value, and knowledge? Knowledge, too, might need to be denied its ubiquity.

Strathern's *Partial Connections* emerges from a trend shared across disciplines to doubt the nature of representation and the authority of its authors (in this case "fieldworkers"). It's also a beautifully understated case for both the partiality of connections, connections between persons, and the irreducible incompleteness of knowledge, yet also remaining partial *to* something, partial in the sense of a prejudice towards connections over what might be assumed to be the more pressing account of the objects or subjects contained by those connections (the study of affinity rather than subjectivity, for example).

Partial Connections seeks a figure for complexity in the mathematics of fractals and particularly Cantor's dust. To visualise Cantor's dust, draw a line, then repeat that line whilst removing the middle third, and repeat the procedure so that the increasingly fragmented lines are each in total the same length as the first line. Strathern writes, 'Cantor's dust caught my imagination as a set of instructions for creating gaps between events by increasing the perception of a background that does not itself increase'.[25] That background is likened to the constancy of observation even as the details observed proliferate. It is in the dynamic between questions and answers that we find the crucial work of complexity that troubles the auditing of value. Strathern writes, 'Insofar as an answer generates new material or insights, then it necessarily draws on knowledge not available to the questioner'.[26] This sounds at first like a fairly commonsensical notion, that we know some things and don't know others, but its subtler implications are worth drawing out. Strathern describes the 'remainder':

If at each juncture something more is generated than the answer requires, that something more acts as a kind of 'remainder', material that is left over, for it goes beyond the original answer to the question to encapsulate or subdivide that position (the question-and-answer set) by further questions requiring further answers. Or, we might say, it opens up fresh gaps in our understanding.[27]

For Strathern, Cantor's dust allows us to imagine the relationship between transmission (information) and errors and between background (observation) and foreground (description). 'What in effect is repeated at each sequence is the intensity of this perception. "More" background appears without being enlarged or diminished in amount.'[28] Despite the apparent flow of ideas, arguments, narratives, or writing (represented by the original line), the 'unity' thus apparent conceals the 'jumps over gaps' that are 'unpredictable, irregular', and hence we discover the 'internal discontinuities' of all such flows.[29]

Certainty itself appears partial, information intermittent. An answer is another question, a connection a gap, a similarity a difference, and vice versa. Wherever we look we are left with the further knowledge that surface understanding conceals gaps and bumps.[30]

Knowledge is not simply an unveiling or uncovering but a process that occludes and hides that which is beyond its perception. *Partial Connections* is therefore Strathern's attempt to 'make explicit the intermittency effect of the intervals or gaps between the sections of the text'. The remainder is the discovery of ever-increasing 'internal discontinuities' and the 'intermittent nature of intermittency'.[31] The partiality Strathern describes is the recognition of the intermittency intrinsic to knowledge or, more properly, the acknowledgement of an unknowing that is supplemental to knowledge and which might destabilise the ease with which we use the term 'knowledge.'

Strathern is conscious of the strategic danger of describing the supposedly shared properties of 'culture', shared, that is, by an even broader notion of 'humanism'. She suggests that 'if anthropologists are committed to a kind of humanism, they will not necessarily endorse it by focusing their descriptive efforts on it' because to do so, to offer a description of the category of the human, is 'also the route to racism, terrorism, and ethnic violence, to purifying populations into greater and lesser exemplars of it, to including some and excluding others.'[32] The argument reminds me of Jean-Luc Nancy's

refusal to describe or attempt to, finally, understand freedom: 'Keeping a space for freedom might amount to keeping oneself from wanting to understand freedom, in order to keep oneself from destroying it by grasping it in the unavoidable determinations of an understanding.'[33] The positivistic determination of audit (audit replays scientific positivism with its own territory of value) tends to overwhelm the tactics of distantiation (irony, negation, critique) that otherwise allow for an implicit corruption of intentions to dissipate. The 'feedback loop' of audit (aims to outcomes) is an expression of the value system which is its host, namely, a tendency for knowledge (and here we might need to interrogate the distinctions between sociology and anthropology) to be interpreted as self-reflexive. Strathern argues,

> Euro-Americans frequently present knowledge to themselves as though a condition were its reflexivity: one knows things because one can reflect on why and how one knows. People are especially likely to claim this kind of knowledge when they bring elements into relationship as a visibly organising or totalising act. Indeed the market's appetite for the local consumer seems equalled only by the need for institutions . . . to know about the populations they encompass and about the relationships between variables.[34]

Not only is reflexivity ultimately incommensurable with its conditions, but such reflexivity is open to control and thus allows those conditions, and the people living in those conditions, to be more easily readied for market.[35] People become prone, recuperable, by the essential distrust that pervades the model of knowledge: 'Euro-Americans imagine society as though it had an obligation to know about itself'.[36] To enumerate the particulars of a value, even an ostensibly virtuous value, tends to encourage a stigmatisation of that which remains residual and makes this residual abject: devalues it.[37]

As we've seen, Strathern recommends the following: 'To bring to awareness the idea of humanity or sociality as co-presence, it may well indeed be necessary to focus elsewhere'.[38] Indirectness and indifference are strategies to avoid the pressure of self-reflexive knowledge and the false assumption that knowledge is ever replete. If those who wish to be architects of a cultural landscape are particularly committed to a set of values (as those involved in policy are required to be), as we can infer from the long history of policy-driven 'culture', they might do well to endorse them by not focusing their descriptive efforts upon them.[39] And if culture must re-

main incommensurable with society and art incommensurable with
culture, we might think through the ethnographic perspective and
privilege listening. To return to Strathern's essay (and note again
that word 'despite'), we read,

> We are left with the irreducible fact that what anthropologists
> have been doing, among other things, is listening. There is no
> particular virtue in listening—it says nothing about what will be
> communicated, misunderstood or not heard at all. But having to
> listen makes evident the difference between the anthropologist's
> localising attempts to bring things together and the global condi-
> tion that this rests on, being able to pay attention to people who
> themselves have other things on their minds. Anthropology's im-
> itative and microcosmic practices of analysis and description
> must remain incommensurate with theirs. It is both despite that
> incommensurability and out of it that the presence of persons is
> made apparent. Perhaps the anthropologist's macrocosm is this:
> co-presence. At least the presence of persons is not, thankfully,
> reducible to the anthropologist's relationships with them. In this
> realisation, anthropology might find a purpose for the displace-
> ment of knowledge.[40]

That is, listening, which is not itself of necessity or absolutely a
virtue, is a practice and methodology of incommensurability (and
thus contests the exchange values of the market).[41] By emphasising
the way in which attention is paid to those who 'have other things
on their minds', the practice of listening tries to avoid the iniquities
of self-description by the ethnographic subject.

Strathern is not advocating piety before value(s), in which the
ethnographer falls silent before the irreducible otherness of their
host culture.[42] This is not a version of post-structuralist awe before
the other in which the aporia of otherness tends to make difference
sacred whilst capturing all such differences in its conceptual lasso.
Strathern suggests co-presence rather than the staging of self and
other. She foregrounds the incommensurability of anthropological
description with the self-description of those to whom the anthro-
pologist listens. Such incommensurability does not, therefore, de-
mand silence at the unassimilable difference between persons; the
anthropologist can always know more, and ask more, and listen
more, within pragmatic and ethical limits to be thought through
and negotiated. But knowing more brings with it its own intermit-
tencies. It is not, therefore, a piety but rather a modesty, a lack of
arrogance, by which we might resist 'purifying populations into
greater and lesser exemplars of' our descriptions of persons.

In 'Privilege of Unknowing', an essay concerning Denis Diderot's *The Nun*, Eve Kosofsky Sedgwick makes a similar argument about the dangers of ascribing to knowledge a territory of ignorance as its domain. Sedgwick describes the situation of those who suffer at the hands of those who have power and who might take succour in the satisfaction that recognising their ignorance brings. The danger of such a seduction is 'the scornful, fearful, or patheticizing reification of "ignorance"; it goes with the unexamined Enlightenment assumptions by which the labeling of a particular force as "ignorance" seems to place it unappealably in a demonized space on a never-quite-explicit ethical schema.'[43] Without wishing to undertake a 'sentimental privileging of ignorance as an originary, passive innocence', Sedgwick revalues ignorance as a potentially revelatory plurality.[44]

> If *ignorance* is not—as it evidently is not—a single Manichaean, aboriginal maw of darkness from which the heroics of human cognition can occasionally wrest facts, insights, freedoms, progress, perhaps there exists instead a plethora of *ignorances*, and we may begin to ask questions about the labor, erotics, and economics of their human production and distribution.[45]

There are kinds of ignorance, just as there are kinds of knowledge, and 'a particular ignorance is a product of, implies, and itself structures and enforces a particular knowledge'.[46] The essay explores the description of alternative sexualities, commending the way in which a 'plurality of sexual habitation, love, and even crucially knowledge' can be valued, but also concludes with a counter-intuitive sentence: 'Yet it can be done only with every possible sophistication about the exclusionary and inflictive involvements of that knowledge.'[47] The overeager extrapolation of knowledge of sexualities brings with it a delimitation of the ambiguous modes of ignorance in which experimentation and unknowing can proliferate.

An ethnographic model of listening which displaces knowledge, which opens up its intermittency, is preferable to a value-laden audit culture (aims and outcomes) for the arts in order to maintain the incommensurability of the arts from its host cultures and culture from society. This is to make sure to fail (to *fail better*) to repress a critical self-regard, to welcome unknowing into dominant and dominating systems of value, to look askance at the impropriety of irrecuperable artworks, and to save art from its defenders. We might envisage in practical terms how policy and funding streams might be deflected from their affection for feedback loops by a loss of faith

in the promotion of a hierarchy of value—a keyword to be at-
tained—and a loss of faith in audit, by an awareness of the intermit-
tency of knowledge, an indifference that permits space of autono-
my, and a kind of listening to those with other things on their mind.

THE LAMINATED SELF

If so far this chapter has concentrated more on the epiphenomenon
'culture' as its central but contested term, what can we say about the
'self' who is subject to (even constituted as a subject by) value? To
pull from another of Strathern's articles, we might dispute the as-
sumed integrity of notions of the 'subject' or person at all. Interpre-
tation of Melanesian society suggests that 'social relationships' do
not 'link individuals'; instead, 'the fact of relating forms a back-
ground sociality to people's existence, out of which people work to
make specific relationships appear'.[48] According to this reading,
relations are not phenomena belonging to persons but rather 'inte-
gral to the person', and hence 'persons may be understood fractally:
their dimensionality cannot be expressed in whole numbers. The
fractal person is an entity with relationship integrally implied.'[49]
Anthropological theory at its most perspicacious foregrounds the
'cutting' that comes with the dynamic of 'relations' and the 'separa-
tion' attendant on 'identity': 'to sustain a domain of ideas' (and here
Strathern is talking about the 'biological relationship' taken for
granted in Western notions of kinship) 'is also to sustain its separ-
ateness'. She continues, 'The "difference" between domains is af-
firmed in their being brought into relation—as when one supple-
ments the other'.[50]

Debbora Battaglia's 'Toward an Ethics of the Open Subject' un-
folds the ambiguity around the 'subject' as the subjects (persons) to
be studied, the ethnographic agent who is to do the studying, the
subject which is anthropology (anthropology *is* the 'open subject'),
and its practice which is ethnography. Battaglia writes,

> Given ethnography's concern with 'human meanings and values
> *as they are actively lived and felt'* . . . 'writing culture' is thus a
> business of possibly unparalleled complexity. It succeeds only—
> though at best inspirationally—as a discipline of 'partial connec-
> tions' and, I would add, of partial severances. Returning to the
> aporia of ethnography, its most natural environments are the
> gaps between social entities and cultural categories, and re-
> soundingly, between textuality and embodied experience.[51]

Battaglia targets essentialist notions of the self and 'the "auratization" of the value of individuality; its entrenchment as an ideology of individualism' which she diagnosis in the Euro-American world view.[52] Such strong individuality privileges a 'stable, perdurable, and invariably identifiable sense of self in negative correspondence with times of media-enhanced and expedited social transformation.'[53] In other words, the tendency, diagnosed above by Strathern, for Euro-Americans to 'present knowledge to themselves as though a condition were its reflexivity' works, too, for the reflexivity of the sense of self.[54] Battaglia's argument is that the spectre of 'human diversity, cultural hybridity, public image "spin management", and geopolitical displacement [which] show the detachability of people's own texts, images, and bodies from their original context' encourages a counter-gesture in the culture of individuality, the 'socially impelled . . . will to self-laminate—a will to fix and define the boundaries of self.'[55] This laminated self holds and projects its values as integral to its coherence as a form of resistance to the mutability modernity demands.

In her reckoning with the history of the colonial and neo-colonial complicity of anthropology, Battaglia expresses a commitment to the 'thinking of the subject we seek to clarify but who herself seeks obscurity.'[56] In other words, distinguishing alternative forms of personhood from the 'laminated self' helps recognise the political resistance made possible by such alternatives. She writes,

> I am thinking of persons striving as a matter of physical or political survival to maintain or achieve the blurred contours of a moving target, unaccountability of narrative agency, relief from an identity displaced, obviated, or shed, under some form of social pressure. I am thinking of cases where ambiguity is an aesthetic or poetic goal, or where it is a subject's only hope of self-preservation against the forces of colonial expansion, the manipulations of late capitalism, a sorcerer's determined program of power, or against others' proprietary interests in subjects' knowledge, or their bodies, or body parts.[57]

It is clear that for Battaglia, as for Strathern, the conviction of a sufficient (and not intermittent) description might be tantamount to a curtailment of the autonomy of the person, the person that conceptually is already problematic, congealed as it is from the dynamic of relations that hold persons in a field of relationships. This is such an intriguing description, aligning more overtly political acts of discursive—and therefore real—escapology with ambiguity as an

'aesthetic or poetic goal'. What does it mean to consider the aesthetic or poetic as the (illegitimate) means to evade (legitimate, that is, enforced by law) dominating social values? What does it mean to seek to become a 'moving target', to understand the location of identity under social pressure, and to seek some indistinctness in order to garner an alternative if fragile autonomy? What does it mean to use ambiguity to avoid self-laminating as an aesthetic or poetic goal? We can rethink Battaglia's terms here according to the survival strategies of artists of all kinds in (and against) the social values by which they are dominated. Though Battaglia in part considers contexts in which one's life might be at stake, we can follow up this question of the aesthetics and poetics of resistance outlined above.[58]

A POETICS OF INTERMITTENCY

The case I've outlined above has not been composed as a warm-up to a reading; its purpose is to stymie on a number of fronts the assumption that a purely positivistic attitude towards knowledge, or towards the subject, can be adequate or ethically propitious. Neither persons nor artworks should be condemned by the audit culture that betrays complexity, the great fecundity of inefficiency and the profound and abject negativity of creative and critical thought. Thinking about the above—the intermittency of knowledge, the open rather than laminated self, the evasion of measure and ambiguity as a poetic goal—brought to mind the poetry of Tom Raworth.

Raworth's *Ace* is a couple of thousand of the briefest lines of poetry, with between one and four words per line.[59] The poem was composed in Chicago in the winter of 1973 and the spring of 1974. The revelations of the news of the era included the aftermath of US withdrawal from the Vietnam War, the Yom Kippur War, the Symbionese Liberation Army kidnapping of Patty Hearst, Watergate, the energy crisis (and the birth of postmodernism), and a host of neo-colonial strategies playing out in Latin America: between 1964 and 1976 country after country fell to military dictatorships, often with counter-insurgency measures put in place by the United States, including Brazil in 1964, Uruguay from 1973, Argentina after 1966, Chile from 1973, Peru from 1968, Bolivia from 1971, and Ecuador from 1972. Raworth, after studying Spanish and then translation at the University of Essex (receiving an MA in 1970), published translations of the poetry of Latin America in 1971 (Raworth was

responsible for translating the majority of the poetry from Argentina, Bolivia, Chile, and Peru), as well as translations in *Towards Revolution*, volume 2: *The Americas*.[60] This collection of revolutionary polemics and interviews includes sections on Cuba (Che Guevara), Venezuela (Fidel Castro), and Guatemala, amongst others. Raworth translates Fabio Vásquez Castaño's 'Not One Step Backwards', relating to Columbia, and 'The Tupamoras: Thirty Answers to Thirty Questions', relating to Uruguay.[61] The name Tupamaros derives from José Gabriel Condorqui Noguera, Tupac Amaru, the man credited with organising rebellions against the Spanish in the 1780s, which emphasises (as does the name of Bolivia derived from that of Simón Bolívar) the enfolding of emancipatory movements of the twentieth century into their colonial predecessors. *Ace* includes a number of illustrations by Barry Hall, including the title page with a socialist star above a sharp-suited rifle-carrying figure.[62] The cover of the Edge Books and The Figures editions is solid blue with a red socialist star and the word 'ACE'. The star hardly locates the text— it's a nomadic symbol of the Left—but it does bear more than a passing resemblance to the Alain Labrousse book *The Tupamaros*, published by Penguin in 1973, which must have been of interest to Raworth given his translation of 'Thirty Answers': the difference is that the star on the cover of Labrousse's book looks to be bleeding.[63] The National Liberation Movement Flag of the Tupamaros includes a yellow star. The military takeover of Bolivia, named as the site of 'another end of ace', is pertinent, too, filling in the background of engagement of Raworth at the time. Bolivia's long history of revolutionary struggles stretches from the war of independence to the rise of the Movimiento Nacionalista Revolucionario in the middle of the twentieth century, a movement set back by the military junta in 1964.

In *Ace* history detonates in the memory, recurring as a series of shocks and flashes in the opening section. 'SHOCK SHOCK' is repeated three times, on pages 7, 8, and 18. And echoing 'shock' we read,

do not mock
those who died
in luminescence
or in pride
we stand
on memory
at war
white moves

into mind
FLASH
FLASH (p. 32)

Does a memory of bombing return at the speed and with the lack of control of memory itself, recollections flashing through the mind, instances of illumination, waves of shock surfacing throughout a life? There's a turn away from 'we stand on ceremony' in 'we stand / on memory', and perhaps war's ceremonial bluster is too much to bear. We read, 'for fear / stays / in air / forever / magnifies / concentration' (p. 47). The fear of death from above lingers, pooling concentration, taking a distributed anxiety and focusing its ambivalent energy. The energy held in the singularity of the bomb is dispersed as a general fear in the population, coagulating into the singularity of each mind: such fear re-disperses as a concentration not only on the threat from above but on the life being lived beneath its shadow. There are plenty of moments in which the relation of 'voice' to memory arises, from 'i'll voice out / of the news' (p. 6) to the confession 'without / you / I would be / mute' (p. 86). Later, 'voices / decay / into time / of what / is it / memory / writing / pattern / spelled / change / unreel / twist / tone / i am / again / wait / ace / faithful to / ace / flash / sears / what ever / is not / no madness' (pp. 55–56): the passage asks of time, of its nature, whether it is only held in the memory or can be understood by writing, or finding patterns, or making a record by photograph or film reel. The word 'ace' here is interruption and the object of devotion ('faithful to / ace'). Ace flashes up in the mind as a source and resource of love, or it might be much bloodier, the flash of light and heat that 'sears' the skin, and it's hard to see beyond the imagery of the use of napalm in Vietnam at such moments. The text includes such extremes; the Barry Hall illustration of an ace of spades recalls the playing cards left on the corpses of the Vietnamese by the US military, and an 'ace' is, amongst other things, the honorific for a fighter pilot who can claim five or more air combat victories.

History, we're told 'leaves some thing / like a bomb / relief again / to sail / against depression' (pp. 6–7). This is a meteorological pathetic fallacy, a 'depression' describing air that rises to form an area of low pressure that often leads to rain. The 'bomb' connotes the ammunition but also the 'weather bomb' or, in more technical language, 'explosive cyclogenesis', the 'rapid fall in central pressure of a depression (or low pressure).'[64] Perhaps the bombs here are markers of immediate and then resonant forces, in a violent change

leading to a long-term set of effects. Rather than a natural phenomenon, the alteration of weather by military weapons was a hot topic in the early 1970s after the revelation of 'cloud seeding' in Vietnam. 'Operation Popeye' (as though Andy Warhol were in charge of military rhetoric) was an attempt to extend the monsoon season by dispersing silver iodide and lead iodide from aircraft into clouds. Rather astonishingly, it worked. It was leaked in the *Pentagon Papers* and an article in the *New York Times* in 1972.[65] Some echo might be found in 'we are here / before the standard / planes / corruption / chemical change / a river / heads / in / land' (p. 17). There may be a nod to the Weather Underground here too, established out of the Students for a Democratic Society in 1969, who carried out a bombing campaign in the early 1970s, each bombing dedicated as a bringing home of the bombing of Laos, Hanoi, and so on. They took their name from Bob Dylan's lyrics to *Subterranean Homesick Blues*, so the imagery of Shelleyan West Wind (p. 43) (later of course taken further by Raworth in the poem of that name) might support such a reading.

Many of these references, I suspect, rather than timely, are evocations of the bombs of World War II flashing over London: 'sucking / the sky / of dust / leaves / untouched / as the wind / mixes us / with each breath' (p. 4). Raworth himself remained in Welling, on the outskirts of London, through the Blitz.[66] Though the poem need not be returned to its source, the seemingly throwaway reference to Dan Dare might be exemplary of the matrix of cultural memory as it meets the futurism of the present and (empty) promises of the future: 'to go on / mekon / on / my mind / she is / my closest / friend / sun / shines' (p. 25). One echo of 'mekon' is the Vietnamese Mekong River and Mekong Delta, territory of fierce fighting, but also 'Dan Dare, Pilot of the Future', a flying ace, no less, who appeared in *Eagle* between 1950 and 1967 and in a radio version broadcast on Radio Luxemburg in the early 1950s.[67] It was a science-fiction comic (Arthur C. Clarke had some oversight), set in the 1990s (!), in which English colonial values (manners, social codes), under threat of dwindling power in the real world, were projected into space and into the future. The Mekon (a Venusian), with a swollen head and an atrophied body, was Dan Dare's archenemy. All this is not, perhaps, so important but points to the cognitive dissonance of the Cold War space race contemporary to the composition of the poem against those fictional projections of cultural value that preceded them.[68] It may be the case that the fictions were slightly less unreal

than the actual space race, of course, in its allegory of ideological empire played out in history.[69]

The titular 'ace' proliferates in its resonances; it may well include the record label described in the opening of the poem: Ace Records were publishing from the mid-1950s, and so 'Ace' may have been spinning during the composition of the poem.[70] Ace is also a name associated with comics and magazines of various kinds (Ace Magazines published comic books between 1940 and 1956),[71] typically as denoting some superpower or superhuman skill set, as well as a short-lived satirical newspaper in New York at the time.[72]

Ace is also the unit, the singular thing. It evokes an aptness and fittingness or, better, the *kairos* of the archer as referenced by Homer, firing in just the right place at just the right time. Carolyn R. Miller refers to *kairos* as 'the uniquely timely, the spontaneous, the radically particular'.[73] We read this address to the poet's partner in *Bolivia: Another End of Ace*:

> dear
> val
> when nothing
> comes
> i pass
> big
> bully
> holding
> sticks
> of animal
> known
> as wild
> card
> surf
> ace
> whose face
> pace
> avoids
> cleverness
> with
> alacrity (p. 85)

Facing up to the bully is to be avoided by a quick evasive move. The playing card is to be thrown down at the right time. Speed ('pace') helps avoid mere 'cleverness', the reified knowledge Raworth satirises in the title of a poem: 'Rather a few mistakes than fucking

boredom'.[74] In *Ace* we read, 'boredom / always / central / will / be / idea / technique / lingering / on every trait / out of focus' (p. 46).

When it comes to *Ace*, John Wilkinson has provided much of what I wish to work with, though his reading largely sidelines the 'news' and its cultural value, which can be seen flickering behind the poem. According to Wilkinson, the centre of the book, its 'organizing point of reference', the centre of the spinning record referenced in the poem's opening, is not a subject or theme to which the poem returns but instead is held inside and outside the poem; it includes the context of family life and, as its singular 'ace', the dedicatee of the collection, the poet's partner, Val Raworth.[75] It's a love poem, then, but like much of Raworth's poetry, less a love poem in which its subject is love and more a love poem in which its love is the place from which it speaks and to which it returns.

> The human centre to Raworth poems seems obvious enough if sought in the acknowledged condition for the poems' existence rather [than] their subject; it is both their matrix and their horizon. What their acknowledged condition permits to deploy in the poems is a lyric persona entirely without angst, without a scintilla of an inclination to auto-analysis, nomadically — or flirtatiously — disengaged from proceedings while acknowledging with unusual straightforwardness what it relies upon to sustain them.[76]

On the first page, we read, 'alive and in love' (p. 6): this perhaps is the core of the poem, with a fine balance of short to long syllable rising 'a-live' and falling 'in-love'. It is repeated towards the end of the poem, this time re-lineated as though to give more force to each part: 'alive / and / in / love' (p. 91). The 'organizing point of reference', since it (she) is external to the text, cannot be used to conclude its interpretation. The centre provides no cipher. It is instead a kind of grounding for the poet and a proxy grounding for the reader. Part of the gift of this surety is to throw off the tendency for a poem to become a pedagogical message with the corresponding hierarchical expectation of the teacher-poet handing down its knowledge (patronage) to the reader-pupil.[77] The way in which the poem does not direct us towards an interpretative outcome can be demonstrated in its ambivalence between part and whole. As Wilkinson describes, 'Any excerpt wriggles free of the grasp; what it appears to say (or supports) will be compromised by what precedes and follows regardless of where the incisions are made. But this has its compensations, since like a cut worm any section of the poem achieves independent life.'[78] Rather than the final form of a whole

(form, rightly or wrongly, implies wholeness), it is a play of parts, and since it already belongs to the world, it is already part of the world's content: 'no form / but / content / no edge / no edges' (p. 65). There can be no overriding form when time passes: 'part / of ace / one / form / for moment' (p. 66–67). One form per moment, examples given immediately of 'headache / burn / eye / release' (p. 67).

Raworth's work is differentiated from much of the experimental poetry of its era by the sustenance of this world before, beyond, and throughout the text, allowing a 'lightness made possible by the poems['] being relieved of the necessity to construct an entirely adequate world and without relying on the reader's identification with an authorial or fictional persona or with a subordinate relationship to another text or set of texts, whether poetic or theoretical'.[79] This enables a lack of self-regard: the poetry does not need to project a world with which it wrestles as though its victory, or martyrdom to defeat, would be registered back in the world itself. It is already part of the world. There's a little satire of this in the opening of the 'in mind' section, in which a page reminiscent of the kind of language writing that lacks a referential dimension leads to an authorial tussle:

 nothing
 behind poetry
 look
 a
 like
 or is it
 an an
 but
 why
 so
 there
 fore
 because
 maybe
 if now
 might
 well
 for it
 let
 go
 un
 hand
 me

my good man
i'm a
gone
thank
god (pp. 38–39)

My purpose is to see Raworth's poem amidst the anthropological insights I've been recounting in this chapter. I am sympathetic towards Wilkinson's claim that Raworth's poems 'point to the shaping power of *inattention*, the remembering that occurs out of a flickering stream' (and in this Raworth is both like and unlike the great Frank O'Hara, maintaining his relentless perspicacity but replacing his determined focus with a meditative and improvisatory openness to detail, what we have here as 'alacrity' [p. 85]).[80] I think we can get closer than inattention, however, with intermittency. Intermittency, as described by Strathern, means an increased awareness of the unknown background as it becomes more and more evident amidst the foreground of knowledge. It isn't a way of focusing on said background, or the silence of a reverential and pious wonder, but instead a modesty which deflates the aspirations of disenchantment: '"More" background appears without being enlarged or diminished in amount.'[81] Rather than pretend the flow of the poem can syncretically capture (colonise) the world which is its context (the apparent flow of ideas, arguments, narratives, and so forth), the energy of Raworth's poem fires up its 'internal discontinuities'. Its intermittency is brilliantly poised, constructing temporary assemblages, severing others, connecting and cutting without making the flow spuriously all-incorporating or the disassociations so differentiated as to become boring.

but first
a present
that
fits me
to a t
no mist
but sky
and we
beneath it
in our minds
never
prevented
life growing
by caring

we changed
selfishness flashes (p. 7)

The ambivalence of these line-units is impeccable, the way they can lean backwards and forwards, grow in part and by parts. So we can read that we 'never prevented life growing by caring' or 'by caring we changed' but not both at once. Opening up occludes. Transparency veils. As Strathern suggest, 'An answer is another question, a connection a gap, a similarity a difference, and vice versa.' Is this 'present' a gift, perhaps a birthday gift, as much as it is the gift of presentness? The fittingness is so well handled by the repetition of "t" sounds and even the way 'a present' can obscure the letters 'a t': 'a [presen]t'. The overt performance of parental caring stifles the vivacity, the flourishing that is supposed to be the subject of that care. Instead a sceptical selfishness allows space to breathe.

Wilkinson hones in on references to the nature of light as particle and wave. One reason to write a poem that behaves in two different kinds of ways is that, because the act of measurement makes the decision about the nature of the object, the poem can evade capture by vacillating between the two. We are used to 'measure' as the metrical, mathematical form (particle) of the object which is the poem: 'no form / but / content / no edge / no edges' (p. 65). And we're used to imagining a cognitive fluidity in and behind lyric and narrative exposition (wave). Raworth's poem behaves in one way or behaves in another, as particle (ace) or wave (nomad), depending on the glance of the reader/listener. What do you take to be a unit here? Does the unit of a line relate to or cut itself off from the preceding or following line? Is each line a wave (flow) or particle (unit)? Both and neither. You can read this poem at near full tilt, as Raworth himself does, and it fires across its breaks. Pursue one thought, however, and other parts of the poem sink into the background. This is its intermittency. We cannot see all of it at once. We take from it a gift and sacrifice to it the next set of possibilities. It doesn't model a perfect reading performance in which a kind of hyper-attention is modelled by the text that would allow the reader or listener to see or hear all of it each time. You get something. You lose something. Some patterning appears. Some evocation drains away. You can't have it all. It is not fit for consumption. It's not just that any reading of literature is bounded by the finite competence of the reader (though it is) but that the incommensuration of text and reader is part of its discipline: the poem never becomes your intentionality or that of the author. You can, however, develop co-pres-

ence, a rapport, if you meet it on an equal footing, reflecting neither obeisance nor domination.

The poem works with a number of such oppositions, notably images of sky, air, weather, and wind, against those of ground and land. To the relativity of light we might pose particle (bomb) and wave formation (wake). As I hinted above, I read the poem as developing a valence between singularity and flow, unit and energy, ace and nomad. The first 'no / mad', split across the line-break, occurs on page 10: 'no / mad / awakes' and 'wakes / in terror'. This seems to be the 'he' of the first section, 'in think'. This 'no / mad' is repeated (pp. 10, 12, 16, 18–19, 23, 29, 30, 64, 77) with the first whole 'nomad' on page 27: 'see clearly / nomad / your name / nothing / new'. Nomad derives from the Greek *nemein*, to distribute, and *nomas*, pasturing. It moves, therefore, between energies, the wandering and the singularity, distribution and concentration, nomad and ace. Perhaps as well as personages ('nomad / meets / ace / thought / in marble / soothed / by hands' [p. 51]), nomad and ace can be described as two kinds of thinking in the poem. Ace describes singular moments ('part / of ace / one / form / for moment' [pp. 66–67]), flashes of memory often driven by fear or love ('for fear / stays / in air / forever / magnifies / concentration' [p. 47]), which also lead to the 'ace' which is the singular of love ('ace / i see / in all / i am' [p. 54]). The nomad by contrast is the refusal to connote as property, a kind of loneliness ('no / mad with loneliness' [p. 64]), but perhaps also a resistance to madness of one kind or another. It is a restlessness that encourages a non-directed perspicacity: 'open / all / inputs / thought / sunlight / music / presence / is felt / even / i / do not know / me / how long / one's eyes / rest / last / real / place' (pp. 69–70).

The rest of its intermittency is best expressed through its partial connections (to steal once again from Strathern). Though timely, ace is also itself only partial: ace . . . face . . . space . . . peace . . . grace. The poem at once is about *and* occludes these things. The poem refers to 'winning / by verbal grace' (p. 10), but more substantially, when staring up at the sky, remembering the fear of bombs falling, it wonders about the grace of God, or perhaps its less faithful version, ace. Raworth's parents were Roman Catholics, his father a Londoner and his mother Irish, from a large Republican family, and Raworth attended a Catholic school.[82] Grace is of course an impossible concept to gloss briefly, but Catholicism largely supports the idea that grace is a gift that arrives unbidden and cannot be earned (read, meeting Val). It is just what it is. A reference to the 'terces'

recalls the 'Little Hours' of the Liturgy of the Hours of prayer in which to invoke the Holy Spirit (as well as echoing in reverse the 'secret' that precedes it in *Ace* [p. 66]). Brian Cummings describes the struggle with 'grace as a radical eschatological expression of God's free gift':

> For how is it possible to bring forth the completely gratuitous? This is the final paradox of grace, the impossible paradox of the gift. . . . God grants grace *gratis*. If grace is not free, grace is not grace; such has been the self-negating formula since Paul to the Romans. . . . The Christian is free from the law, free to do as he wishes, unburdened by grace from any obligation to give back what has been given to him.[83]

Grace is one of the strangest values to describe, something incommensurable and of the highest value but also unattached, a gift and its thanks, without obligation, a gift of radical autonomy that has to delete its own origins as a gift if it is to avoid demanding a return. *Ace* is the song (poem) of praise of a disavowed grace. Roger de Piles defines an aesthetic grace as follows:

> We may define it thus, 'Tis what pleases, and gains the Heart, without concerning itself with the Understanding. Grace and Beauty are two different things, Beauty pleases by the Rules only, and Grace without them. What is beautiful is not always Graceful; but Grace join'd with Beauty is the height of Perfection.[84]

Ace moves with a certain impropriety, without the rules of a normative prosodic measure and without the implicit command to be rebuilt from its parts into a knowledge or a judgement.

Raworth's work offers alternative kinds of knowledge (and ignorance), rather than the traditional Euro-American one of a self-reflexive knowledge in which the condition is its own reflexivity. His poetry discards the notion that 'one knows things because one can reflect on why and how one knows.'[85] Knowledge that privileges its ability to be described incorporates a hierarchy of values— essentialist, self-regarding, disenchanting—that we would do well to denigrate.[86] Battaglia describes how 'we are moved to seek and to represent the conditions and motivations of non-locatability. From this perspective, too, self-ambiguation can be appreciated as a supplementary capacity of persons, and not in all cases a problem of definitional lack.'[87] That is, rather than a lack of clarity in self-description, ambiguity, non-locatability, what *Ace* includes as the nomadic augments life.

TOTALLY UNFUNCTIONABLE MUSIC

The attitude of Raworth's work goes against value in having little ambition to 'unsettle radically either the reader or hegemonic culture in the service of an ideological challenge'.[88] As evidence, listen to the extraordinary interview with Anthony Braxton, to which Raworth refers as a fair approximation of his own disposition, one which also privileges such opacity. Braxton, like Raworth, remains an indirectly political thinker in his aesthetics. Outside his work as an improvisatory composer, Braxton was also directly political: he helped found the Association for the Advancement of Creative Musicians. Braxton begins by saying (and the written word can, sadly, offer little of the delivery),

> No, I'm on the planet, that's all I can say. I exist and it's quite enough, you know, and if people can dig the music then that's nice, and if people don't dig the music then that's nice. You know, everything is just what it is.[89]

Braxton emphasises the interconnection of his vision and describes his purpose when making music; he considers himself a scientist and wants to 'achieve certain sort of conceptual ideas that I'm attracted to'. The figure of the scientist is invoked to prevent domination by the strong expressive intentionality of the artist or author and to suggest autonomy and lack of moral responsibility for the world. That's not to say the work is without ethics but rather that the accuracy of the artwork would be dulled by taking on the world as though it were a representation of the moral fibre of the artist. To get to these ideas, he goes through music, because, as he say's, the 'fastest way that I've been able to find now to go where I'm going is to go through music, but if there was a faster way I would go the faster way, the fastest way'. In Raworth's 'Art Is the Final Correction', we read,

> (hints for poets)
> :speed it up till it's faster than you
> or be the other[90]

Furthermore, for Braxton his is 'totally unfunctionable music, it can't be used, so for the people who dig it they have to dig it for what it is.' It resists instrumentality; for the work to continue to resist assimilation, Braxton himself must avoid giving a handle on the work, must resist providing a message that transfigures the work out of its complexity. We can think again of the tension of

wave (improvisatory exploration) and particle ('what it is') without resolution.

Braxton also resists a model of artistic patronage, by which the artwork is handed down to the worthy suffering: 'Cat says, what are you doing for all the oppressed peoples in the world? . . . I'm doing this for them, you dig, [laughs] What? I'm doing this for them? You crazy?'[91] Raworth and Braxton share a fundamental lack of self-regard. One reason to emphasise against and despite knowledge and description is to foster a kind of reserve within the rhetorical armoury of the experimental artist, neither a modesty born of appeasement nor a piety born of martyrdom, and certainly not a sop to the tidal wave of bile that is forever waiting to explode in response to the major and minor predations of our current conditions.

Battaglia considers those who strive to become 'a moving target', those who develop an 'unaccountability of narrative agency': *Ace* retains such an unintelligibility as 'totally unfunctionable music'. The attitude of the writer isn't one of evasion; rather it is 'against others' proprietary interests in subjects' knowledge', against the whole spectre of neoliberal culture demanding affirmation, demanding to see itself reflected in the eyes of its subjects, demanding that the subject be grateful for the productivity, the profits of which accumulate elsewhere, and obeisant towards the commodities they consume. This is not the 1960s, the unleashing of a liberal mindset into its own conservative future, but rather a 1950s attitude: cooler, less respectful, less boastful, narcissistic but less vacuous in its self-projection.[92] Returning to Battaglia, we can hardly hold up ambiguity as the task of poetic language (there were seven types back in 1930), but this poetry is admirable for its refusal to prostrate itself before the reader, to act like yet another commodity, opening its fetishes for all to see and touch, and for its refusal to imagine it will get further by subtending its position as a moral one ('I'm doing this for them, you dig'). That cultural sadomasochism, prostration and domination, the 'for them' to which *they* must be held, is anathema to its autonomous disposition.[93]

So what can we say about the kind of knowledge of *Ace*?[94] This poetics of intermittency speaks from a knowledge best characterised as sharpness, smartness, alacrity. It's a knowledge akin to *kairos*, the incisive, the particular. Its cutting timeliness slices away boredom. It is best described not as digressive, diffusive, or distractable but rather as perspicacious without stopping to nail down the butterfly or measure the square footage of the stables whilst the

horse bolts. Ace is for acuity, from *acuere*, 'to sharpen', akin to *acus*, a 'sharp, keen' (edge, mind).[95] It's also a poetry content with a kind of ignorance, if we refuse the pejorative of that term (ignorance, not poetry, though I understand your hesitation). Though it has been possible to bring to the poem a host of associations—a context of insurgencies and war, allusions to music and to pop culture of various kinds—those allusions do not reconstitute themselves. As Robin Purves writes, 'Contexts are either irrelevant or get excluded from the frame in order to invent and preserve the interest of the writing, by eradicating what counted as the present and reconstructible moment of its conception.'[96] Rather than a flow of meaning that disguises the gaps, the unknowing, *Ace* draws out of the 'internal discontinuities' of writing. It is a poetics of intermittency because the poem does not claim ownership of that from which it is drawn such that the excavations of the reader can eventually rebuild its dominion. Its contradiction of values—nomad and ace—resists dominant values of accumulation, ownership, consumption (not that such values care too much for the attitudes of a poem); as Strathern argues, for Euro-Americans 'belonging divides and property disowns': 'Ownership thereby curtails relations between persons; owners exclude those who do not belong'.[97] Hence we might do well to imagine an alternative, opposite perspective, against our belonging to the property that we imagine belongs to us. It is a nomadic poetry of air and grace: ace.

As Raworth describes, in one of his incredibly rare reflections on his own practice,

> My 'method' is the essence of simplicity. I write down fragments of language passing through my mind that interest me enough after thought has played with them for me to imagine I might like to read them. What form that documentation takes doesn't interest me as an intention, but only as the most accurate impression of the journey of interest.[98]

The poem is ignorance of knowledge as property and property as knowledge. Knowledge does not belong to it; the poem *Ace* does not possess knowledge. The nomad finds sustenance on the road, 'language passing through', rather than by owning and disenchanting the earth as subservient, and amidst that wandering, that refusal of empire, an attention that does not accumulate, the nomad recognises, as though they *already* knew, the singularity and particularity of love: ace for acuity.

NOTES

1. I am grateful to Robert McKay, Emile Bojesen, Robin Purves, and Sara Crangle for their astute advice on this chapter.

2. See the introduction to this volume for further reading on audit and contemporary studies of cultural value.

3. Although this volume ostensibly critiques assumptions of 'value', we would do as well to critique those made about 'culture' too. Since so much of modernist, structuralist, and post-structuralist culture depends upon anthropology, it is worth returning to it to locate culture: 'To the Western European view, culture is production, it makes things; it is artifice, it builds on an underlying nature; and it is an agent, a manifestation of power and efficacy, for in what should power and efficacy be shown but in the taming of the natural world and the products of the created one?' (Marilyn Strathern, *The Gender of the Gift: Problems with Women and Problems with Society in Melanesia* [Berkeley: University of California Press, 1988], p. 55). Helpful places to begin include Marshall Sahlins, *Culture and Practical Reason* (Chicago: University of Chicago Press, 1976); Roy Wagner, *The Invention of Culture* (Chicago: University of Chicago Press, 1981); George E. Marcus and Michael M. J. Fischer, *Anthropology as Cultural Critique: An Experimental Moment in the Human Sciences* (Chicago: University of Chicago Press, 1986); Clifford Geertz, *The Interpretation of Cultures: Selected Essays* (New York: Basic Books, 1973). The central work on anthropology and value is David Graeber, *Toward an Anthropological Theory of Value: The False Coin of Our Own Dreams* (New York: Palgrave, 2001).

4. See Marilyn Strathern, 'The Tyranny of Transparency', *British Educational Research Journal*, 26.3 (2000), 309–21.

5. Leo Bersani, *The Culture of Redemption* (Cambridge, MA: Harvard University Press, 1990), p. 22.

6. Leo Bersani and Ulysse Dutoit, *Arts of Impoverishment: Beckett, Rothko, Resnais* (Cambridge, MA: Harvard University Press, 1993), p. 3.

7. Bersani and Dutoit, *Arts of Impoverishment*, p. 3.

8. Bersani and Dutoit, *Arts of Impoverishment*, p. 8.

9. Michel Foucault, *Discipline and Punish: The Birth of the Prison*, trans. by Alan Sheridan (London: Penguin, 1991), pp. 202–3. On genealogy, see Foucault, 'Nietzsche, Genealogy, History', in *Language, Counter-memory, Practice*, trans. by D. F. Bouchard and Sherry Simon (Ithaca, NY: Cornell University Press, 1977), pp. 139–64.

10. Thomas Docherty, *Confessions: The Philosophy of Transparency* (London: Bloomsbury, 2012), p. xi.

11. Marilyn Strathern, 'The Nice Thing about Culture Is That Everyone Has It', in *Shifting Contexts: Transformations in Anthropological Knowledge*, ed. by Marilyn Strathern (London: Routledge, 1995), pp. 153–76 (p. 169) (my italics).

12. See the discussion of recognition in Alexander García Düttmann, *Between Cultures: Tensions in the Struggle for Recognition*, trans. by Kenneth B. Woodgate (London: Verso, 2000).

13. Strathern, 'The Nice Thing', p. 169. For the debate on this term, see James F. Weiner, 'Anthropology contra Heidegger', *Critique of Anthropology*, 13.3 (1993), 285–301.

14. Strathern, 'The Nice Thing', p. 156. See Verena Stolcke, 'Talking Culture: New Boundaries, New Rhetorics of Exclusion in Europe', *Current Anthropology*, 36.1 (1995), 1–24.

15. I am using piety here after Gillian Rose's discussion of Holocaust piety in *Mourning Becomes the Law: Philosophy and Representation* (Cambridge: Cambridge University Press, 1997), pp. 41–44.

16. Weiner, 'Anthropology contra Heidegger', p. 294.

17. Robert Smithson, in a revealing exchange with Allan Kaprow, describes the 'value' he places on 'indifference': 'I think it's something that has aesthetic possibilities. But most artists are anything but indifferent; they're trying to get with everything, switch on, turn on' (Jack Flam, ed., *Robert Smithson: The Collected Writings* [Berkeley: University of California Press, 1996], p. 47). See the contribution of Tom Jones to this collection: 'The person who is going to be open to the other must in some sense see life in its qualitative aspect as indifferent'.

18. Maurice Blanchot, 'What Is the Purpose of Criticism?', in *Lautréamont and Sade* (Stanford, CA: Stanford University Press, 2004), p. 2. My thanks to Emile Bojesen for bringing this essay to my attention.

19. The distinction between rapport and complicity is staged by George E. Marcus, 'The Uses of Complicity in the Changing Mise-en-Scène of Anthropological Fieldwork', *Representations*, 59 (1997), 85–108, to discuss the ethics of fieldwork, and it is a distinction that may prove valuable to strategies of literary reading too.

20. Marilyn Strathern, 'Abstraction and Decontextualization: An Anthropological Comment', in *Virtual Society? Technology, Cyberbole, Reality*, ed. by Steve Woolgar (Oxford: Oxford University Press, 2002), pp. 302–13 (p. 305).

21. Strathern, 'The Nice Thing', p. 155. In other words, 'culture' itself, whilst describing diversity, becomes the 'world historical phenomenon' it seeks to pluralize. Cultures need not understand themselves *as* cultures: 'It is as though those who talk about 'cultures' were witnessing cultures talking about themselves!' (p. 156).

22. On poetry as 'event' rather than 'fact' or 'interpretation', see Jerome J. McGann, *Social Values and Poetic Acts: The Historical Judgment of Literary Work* (Cambridge, MA: Harvard University Press, 1988), p. 72.

23. Consider, for example, the critique of happiness in Sara Ahmed, *The Promise of Happiness* (Durham, NC: Duke University Press, 2010), or conversely the plea for failure by Sara Jane Bailes, *Performance Theatre and the Poetics of Failure* (New York: Routledge, 2011).

24. See Claire Bishop, *Artificial Hells: Participatory Art and the Politics of Spectatorship* (London: Verso, 2012).

25. Marilyn Strathern, *Partial Connections* (Savage, MD: Rowman & Littlefield, 1991), p. 115.

26. Strathern, *Partial Connections*, p. xxii.

27. Strathern, *Partial Connections*, p. xxii.

28. Strathern, *Partial Connections*, p. xxii.

29. Strathern, *Partial Connections*, p. xxiii.

30. Strathern, *Partial Connections*, p. xxiv.

31. Strathern, *Partial Connections*, pp. xxiii, xii.

32. Strathern, 'The Nice Thing', p. 170.

33. Jean-Luc Nancy, *The Experience of Freedom*, trans. by Bridget McDonald (Stanford, CA: Stanford University Press, 1993), p. 44.

34. Strathern, 'The Nice Thing', pp. 160–61.

35. Consider: '[Michael] Power argues that to be audited, an organization must actively transform itself into an auditable commodity: one "structured to conform to the need to be monitored ex-post" (Power 1994: 8). Thus, a major feature of audit is the extent to which it reshapes in its own image those organizations that are monitored. What is required is auditee compliance with the

norms and procedures demanded by inspectors. While it is claimed that the standards against which university departments and individuals are assessed are those which they set for themselves, as Power points out, audits "do as much to construct definitions of quality and performance as to monitor them"' (Chris Shore and Susan Wright, 'Coercive Accountability: The Rise of Audit Culture in Higher Education', in *Audit Cultures: Anthropological Studies in Accountability, Ethics and the Academy*, ed. by Marilyn Strathern [London: Routledge, 1998], pp. 57–89 [p. 72]). See also Michael Power, *The Audit Society: Rituals of Verification* (Oxford: Oxford University Press, 1997).

36. Strathern, 'The Nice Thing', p. 161.

37. On the abject, see Marilyn Strathern's chapter in this collection.

38. Strathern, 'The Nice Thing', p. 170.

39. A cultivated indirection might be instigated by returning to the covert funding of artists by more forgiving social security; as Stewart Home comments in 'Why Public Subsidy and Private Sponsorship Can't Save Art from Complete and Utter Irrelevance', in *Art for All? Their Policies and Our Culture*, ed. by Mark Wallinger and Mary Warnock (London: Peer, 2000), 'A return to 1960s/70s levels of unemployment benefits . . . would enable those who wanted to take time out from work and/or poverty to get their shit together, while simultaneously avoiding the absurd biases that characterise current arts funding. It is repugnant that vast sectors of the population are excluded from access to arts money on the utterly spurious grounds that they aren't "artists", when being "unproductive" can be a very "productive" experience for anyone' (p. 125).

40. Strathern, 'The Nice Thing', p. 168.

41. Any thought that listening might be held up as an intrinsic value can be quickly dispelled by reference to the increasing surveillance of both state and online communications.

42. Debbora Battaglia, 'Toward an Ethics of the Open Subject: Writing Culture in Good Conscience', in *Anthropological Theory Today*, ed. by Henrietta L. Moore (Cambridge: Polity Press, 1999), pp. 114–50 (p. 114). Marjorie Levinson's 'Posthumous Critique', in *In Near Ruins: Cultural Theory at the End of the Century*, ed. by Nicholas B. Dirks (Minneapolis: University of Minnesota Press, 1998), pp. 257–94, argues for 'the virtues of inefficiency' against the 'great critiques of reason that have guided the heterological and nondominative side of our practice' (p. 291).

43. Eve Kosofsky Sedgwick, 'Privilege of Unknowing: Diderot's *The Nun*', in *Tendencies* (London: Routledge, 1994), pp. 23–51 (p. 24). A work that squares the circle with the earlier references to transparency is Nicholas de Villiers, *Opacity and the Closet: Queer Tactics in Foucault, Barthes, and Warhol* (Minneapolis: University of Minnesota Press, 2012).

44. Sedgwick, 'Privilege of Unknowing', p. 24.

45. Sedgwick, 'Privilege of Unknowing', p. 25.

46. Sedgwick, 'Privilege of Unknowing', p. 25.

47. Sedgwick, 'Privilege of Unknowing', p. 51.

48. Marilyn Strathern, 'Partners and Consumers: Making Relations Visible', in *New Literary History*, 22.3 (1991), 581–601 (p. 587).

49. Strathern, 'Partners and Consumers', p. 587.

50. Marilyn Strathern, *Reproducing the Future: Essays on Anthropology, Kinship and the New Reproductive Technologies* (Manchester: Manchester University Press, 1992), p. 19.

51. Battaglia, 'Open Subject', p. 123.

52. Battaglia, 'Open Subject', p. 136.

53. Battaglia, 'Open Subject', p. 136.

54. On reflexivity, see Levinson, 'Posthumous Critique', pp. 287–88.
55. Battaglia, 'Open Subject', p. 136.
56. Battaglia, 'Open Subject', p. 117.
57. Battaglia, 'Open Subject', p. 117. It is no small irony that one group people might be wise to evade includes anthropologists. Anthropology was and is (willingly or not) complicit in gathering knowledge of specific cultures so as to be better able to control or combat the desires of those cultures. It is worth briefly mentioning two moments.

At the 1965 meeting of the American Anthropological Association, Marshall Sahlins delivered a speech, 'The Established Order: Do Not Fold, Spindle, or Mutilate' (reprinted in *Culture in Practice: Selected Essays* [New York: Zone Books, 2000], pp. 261–76). Sahlins critiques the 'basic valuations' of Project Camelot, the code name for the US-military-funded study of counterinsurgency, according to which 'revolutionary movements' are known as 'antisystem activities' (p. 267). Sahlins discloses the rhetoric of disease ('contagion', 'epidemiology') attached to such radical movements and satirises the solution, the 'doctor, the U.S. Army, fully prepared for its self-appointed "important mission in the positive and constructive aspects of nation-building." The indicated treatment is "insurgency prophylaxis"' (p. 267). See also Joy Rohde, *Armed with Expertise: The Militarization of American Social Research during the Cold War* (Ithaca, NY: Cornell University Press, 2013).

The second moment: on 15 December 2006, *The U.S. Army Marine Corps Counterinsurgency Field Manual* was first issued, and in 2007 it was republished, controversially, by the University of Chicago Press. It includes anthropological knowledge in order better to account for the 'insurgents' operating in Iraq. Its publication proved controversial not only because a university press was seen to be profiting from the state-sponsored 'war on terror' but because the text was plagiarised. It goes so far as to plagiarise T. E. Lawrence on how to promote an Arab uprising against Ottoman rule (as well as David Newman, Victor Turner, and Max Weber, amongst others). Milton Rokeach, in *The Nature of Human Values* (New York: Free Press, 1973), defined value as follows: 'A value is an enduring belief that a specific mode of conduct or end state of existence is personally or socially preferable to an opposite or converse mode of conduct or end state of existence' (p. 5). And in 2006 we read, '3-44 A *value* is an enduring belief that a specific mode of conduct or end state of existence is preferable to an opposite or converse mode of conduct or end state of existence. Values include beliefs concerning such topics as toleration, stability, prosperity, social change, and self-determination. Each group to which a person belongs inculcates that person with its values and their ranking of importance. Individuals do not unquestionably absorb all the values of the groups to which they belong; they accept some and reject others. Most individuals belong to more than one social group. The values of each group are often in conflict: religious values may conflict with generational values or gender values with organizational practices. Commanders should evaluate the values of each group in the AO [Area of Operations]. They should determine whether the values promoted by the insurgency correspond to the values of other social groups in the AO or to those of the HN government. Based on that assessment, commanders can determine whether counterinsurgents can exploit these differences in values' (*The U.S. Army Marine Corps Counterinsurgency Field Manual: U.S. Army Field Manual No. 3-24, Marine Corps Warfighting Publication No. 3-33.5*, foreword by Gen. David H. Petraeus and Lt. Gen. James F. Amos, foreword to the University of Chicago Press edition by Lt. Col. John A. Nagl, with a new introduction by Sarah Sewall [Chicago: University of Chicago Press, 2007], p. 91). The history of such plagiar-

ism goes back to 1962 when the US Department of Commerce translated George Condominas's ethnographic account of life in the central highlands of Vietnam, *Nous avons mangé la forêt*. When it was discovered, Condominas asked, 'How can one accept, without trembling rage, that this work, in which I wanted to describe in their human plenitude these men who have so much to teach us about life, should be offered to the technicians of death—of their death!' (quoted in Network of Concerned Anthropologists, *The Counter-counterinsurgency Manual, or Notes on Demilitarizing American Society* [Chicago: Prickly Paradigm Press, 2009], p. 73).

To these two moments we might add analysis of one discursive fragment too. In *American Counterinsurgency*, Roberto J. González presents the history of the Human Terrain Teams, the 'combined civilian-military units embedded with US Army combat brigades for counterinsurgency (counter-guerrilla) warfare' whose work is to help 'brigade commanders use "cultural knowledge" as a tool for combat—and conquest' (Roberto J. González, *American Counterinsurgency: Human Science and the Human Terrain* [Chicago: Prickly Paradigm Press, 2009], p. ii). Since they're sub-contracted to the US military (by BAE Systems, amongst others), they are not held to the Uniform Code of Military Justice. The Human Terrain System (HTS) is acknowledged as a successor to the Vietnam-era Civil Operations and Revolutionary Development Support and the Phoenix Program, the mixture of CIA agents, US Special Forces, South Vietnamese military, and 'Provincial Reconnaissance Units' responsible for the deaths of around 26,000 Vietnamese people. The term 'human terrain' harks back to the House Un-American Activities Committee and was used to describe the threat of the Black Panthers and other insurgents within the United States (p. 28).

For González, HTS treats 'people as geographic space to be conquered—human beings as territory to be captured, as flesh-and-blood *terra nullius* or vacant lands' (p. 27). Maj. Gen. Robert Scales, in *Armed Forces*, writes that soldiers 'must be able to go to war with enough cultural knowledge to thrive in an alien environment. Empathy will become a weapon' (quoted, p. 47). We might summarize by quoting from the article 'The Human Terrain of Urban Operations' by the US Army's Lt. Col. Ralph Peters: 'There will be no peace. . . . The de facto role of the US armed forces will be to keep the world safe for our economy and open to our cultural assault. To those ends, we will do a fair amount of killing. We are building an information-based military to do that killing. There will still be plenty of muscle power required, but much of our military art will consist in knowing more about the enemy than he knows about himself' (quoted, p. 32). See also David H. Price, *Weaponizing Anthropology: Social Science in the Service of the Militarized State* (Petrolia, CA: AK Press/Counterpunch Books, 2011).

58. We might interpret a number of other strategies of evasion here, including the particular performativity of shame as described by Eve Kosofsky Sedgwick in 'Queer Performativity: Henry James's *The Art of the Novel*', *GLQ*, 1 (1993), 1–16: 'The deepest interest of any notion of performativity, to me, is not finally in the challenge it makes to essentialism. Rather it lies in the alternatives it suggests to the (always moralistic) repression hypothesis' (p. 14).

59. Briefly, the publication history includes one printing by Goliard Press in 1974, most copies of which were destroyed by a flood, followed by an edition from *The Figures* in 1977 and the chapbook *Bolivia: Another End of Ace* (London: Secret Books, 1974). The edition from which I am working includes *Ace* and *Bolivia: Another End of Ace* (Washington, DC: Edge Books, 2001); the edition from *The Figures* does not include *Bolivia*. Though my edition is unpaginated, I give page numbers here (in the body text of the chapter), counting from the verso

page of the title page. Though the page space is important to the feel of the poem, due to limitations of extent of this publication, with a couple of exceptions I have had to transcribe the poem, which is all written in this elongated form, with forward slashes for line breaks.

60. E. Caracciolo-Trejo, ed., *The Penguin Book of Latin American Verse* (London: Penguin, 1971).

61. John Gerassi, ed., *Towards Revolution*, vol. 2: *The Americas* (London: Weidenfeld and Nicolson, 1971), pp. 671–24 and 647–55, respectively. My thanks to Robin Purves for tracking down this publication.

62. I have not been able to trace the image.

63. Alain Labrousse, *The Tupamaros: Urban Guerrillas in Uruguay*, trans. by Dina Livingstone (Harmondsworth: Penguin, 1973), cover image. On the name of the Tupamaros, see p. 15.

64. 'A Closer Look at "Weather Bombs"', *Met Office News Blog*, 10 December 2014, http://blog.metoffice.gov.uk/2014/12/10/a-closer-look-at-weather-bombs [accessed 12 August 2015].

65. Seymour M. Hersh, 'Rainmaking Is Used as Weapon by U.S.', *New York Times*, 3 July 1972.

66. Miles Champion, 'Introduction', in *As When: A Selection*, ed. by Miles Champion (Manchester: Carcanet, 2015), p. xix.

67. Visit the Dan Dare and the Eagle fansite: http://www.dandare.org [accessed 14 August 2015].

68. There are references to Norman and Henry Bones, boy detectives dramatised on *The Children's Hour* in the 1940s (p. 39), and a radio ad for CET television in the 1950s: 'that's mohawk four / four one hundred / coming through' (p. 46).

69. On the space race, see Fabienne Collignon, *Rocket States: Atomic Weaponry and the Cultural Imagination* (London: Bloomsbury, 2014).

70. See 'Rock 'n' Roll: An Interview with Johnny Vincent of Ace Records', Historical Text Archive, http://historicaltextarchive.com/sections.php?action=read&artid=174 [accessed 14 August 2015].

71. Alongside crime and superhero comics, they published romances with titles such as 'Love at First Sight', 'Love Experiences', and 'Real Love'. Characters included Ace McCoy (in Sure-Fire Comics) and The Black Ace (in Super-Mystery Comics). See 'Ace Magazines (comics)', Wikipedia, https://en.wikipedia.org/wiki/Ace_Magazines_%28comics%29 [accessed 14 August 2015].

72. See Jerry Bledsoe, 'The Underground's "Ace" in the Hole', *New York Magazine*, 5 June 1972, pp. 55–57.

73. Quoted in Joanne Paul, 'The Use of *Kairos* in Renaissance Political Philosophy', *Renaissance Quarterly*, 67.1 (2014), 43–78 (p. 43).

74. Raworth, 'Dreaming', p. 57; see also 'How to Patronise a Poem', pp. 59–61.

75. John Wilkinson, 'Tripping the Light Fantastic: Tom Raworth's *Ace*', in *The Lyric Touch: Essays on the Poetry* (Cambridge: Salt, 2007), pp. 105–19 (p. 106). In conversation, Sara Crangle offered a similar reading.

76. Wilkinson, 'Tripping', p. 114.

77. There are, needless to say, less hierarchical models of pedagogy.

78. Wilkinson, 'Tripping', p. 107. My co-editor Robert McKay offers a correction: only the half with the head *might* live; the tail dies.

79. Wilkinson, 'Tripping', p. 115. Here the distinction is to the language writers working within a structuralist model of semiotics.

80. Wilkinson, 'Tripping', p. 112.

81. Strathern, *Partial Connections*, p. xxii.

82. Champion, 'Introduction', p. xix.

83. Brian Cummings, *The Literary Culture of the Reformation: Grammar and Grace* (Oxford: Oxford University Press, 2002), p. 50.

84. *L'Idee de peintre parfait*, 1699, quoted in Samuel Holt Monk, 'A Grace beyond the Reach of Art', *Journal of the History of Ideas*, 5.2 (1944), 131–50 (p. 132).

85. Strathern, 'The Nice Thing', p. 160.

86. Raworth's great friend Ed Dorn, in *Gunslinger* (Durham, NC: Duke University Press, 1989), includes the following advice as voiced by the hero of his epic of the 'new-wild West': 'The mortal can be described / the Gunslinger finished, / That's all mortality is / in fact' (p. 33).

87. Battaglia, 'Open Subject', p. 118.

88. Wilkinson, 'Tripping', p. 107.

89. 'Interview with Anthony Braxton, KPFA 1971', linked from Tom Raworth's 'Notes', Tom Raworth, http://tomraworth.com/notes/?p=856 [accessed 22 July 2015]. Raworth comments, 'What he says is still pretty much how I think about writing'. Braxton's extraordinary and indirect treatments of his inspirations (without any of the pettiness of the supposed anxiety of influence) can be heard right from the extraordinary *For Alto* (Delmark Records, 1970). On attention to detail in related music (that of Derek Bailey), see Dominic Lash's chapter in this volume.

90. Raworth, 'Dreaming', p. 56.

91. In pedagogical terms we might align this with moves against education as patronage—for example, with Jacques Rancière's *The Ignorant Schoolmaster: Five Lessons in Intellectual Emancipation*, trans. by Kristin Ross (Stanford, CA: Stanford University Press, 1991), the work which led him to *The Emancipated Spectator*, trans. Gregory Elliott (London: Verso, 2009).

92. As Terry Atkinson notes in 'Eurostar Avant-Gardism Secured in Both Directions by Dumbing Down from London and Wising Up from Paris', in *Art for All? Their Policies and Our Culture*, ed. by Mark Wallinger and Mary Warnock (London: Peer, 2000), 'No model [of the artistic subject] has a more settled outlook and cognitively self-satisfied programme than that which persistently congratulates itself on being "radical" and "advanced"' (p. 127).

93. One of the reasons I love Raworth's work so much is due to this attitude, so unlike my own wheedling for affection (which informs my academic criticism in no doubt problematic ways). Though deeply imbued with love and full of insight, Raworth's poetry has an attitude of not giving a fuck, and it doesn't presume the reader should give a fuck either.

94. Raworth's ambivalent relationship to knowledge can be seen in 'TRACKING (notes)', in *As When: A Selection*, ed. by Miles Champion (Manchester: Carcanet, 2015), in which we read, 'Not rejecting *knowledge* but what (as in research) passes for knowledge and is but an illusion, the words (knowledge, intelligent etc.) must be redefined, or new words coined' (p. 63). Or, as Raworth said in 1972, 'I really have no sense of questing for knowledge. At all. My idea is to go the other way, you know. And to be completely empty and then see what sounds' (quoted in Champion, 'Introduction', p. xxvii).

95. Eric Partridge, *Origins: A Short Etymological Dictionary of Modern English* (London: Routledge & Kegan Paul, 1961), p. 6.

96. Robin Purves, 'Aspect Shifts: On Tom Raworth's *The Big Green Day*', *Journal of British and Irish Innovative Poetry*, 2.2 (2010), 171–87 (p. 173).

97. Marilyn Strathern, 'Cutting the Network', *Journal of the Royal Anthropological Institute*, 2.3 (1996), 517–35 (pp. 531, 524).

98. Quoted in Champion, 'Introduction', p. xviii.

FOURTEEN

Rimbaud, the Occasion of Poetry, and the Walls of Our Schools

Geoff Gilbert

There were too many moments of questioning on the part of the pupils. And we have all heard those statements: 'yes I support Charlie, but . . . Why defend the liberty of expression here and not there?' These questions are unacceptable for us, above all when they are heard in the school, which is charged with the transmission of values.

—Najat Vallaud-Belkacem, French Education Minister,
to the Assemblée nationale, 14 January 2015

The riots or uprisings (the French term is *émeute*, which shares its root with emotion, a moving out) of October and November 2005 began after three boys, all *issus d'immigration* (their parents are Mauritanian, Tunisian, and Turkish), two seventeen-year-olds and a fifteen-year-old, were chased by the police because they were running, in Clichy-sous-Bois to the north of Paris. They hid in an electricity substation, observed by the police, and two of them burned to death there; the police lied about the circumstances, and riots began immediately and continued in the northern suburbs for three weeks, generalising through similar spaces—particularly the areas formally categorised as 'sensitive urban areas'—throughout France. Laurent Mucchielli suggests that this is the first time in 'our contemporary history' that a riot lost its local character and took on nation-

al scale.¹ Some three thousand arrests were made. During those moments of riot, more than ten thousand cars were burned, providing picturesque and sublime images for television and newspapers. But the young rioters also burned or damaged several hundred public buildings, mostly educational establishments.²

The animus directed against schools, as expressed by some of the young rioters, was powerful. One young man noted that 'the humiliation [*la hagra*, a word which comes into French slang from Algerian Arabic] from the police and that of the teachers—it's just the same'.³ Another, interviewed by sociologists, affirmed, 'I'll tell you the truth, I set fire to cars next to the high school to show [to those bastard teachers] that we exist and that we will not let ourselves be fucked over'.⁴ Another explained some of these notions, describing the school as a place in which some students are rendered invisible and in which the force of social exclusion is directly experienced:

> For me, the major problem that caused these riots [*la grande faute de ces émeutes*] is the school, above all. School is a place where you should learn things, they should explain to us, but actually school has become a place where you discard guys like me, where you do everything possible to get rid of us and to keep the French. . . . Sometimes, the teachers didn't even register our presence [*nous calculaient même pas*], they just left us alone in our corner and engaged the best students, they would talk amongst themselves, and often they would throw us out to be peaceful and concentrated together, you see what I mean. I felt disgust.⁵

The complexity of attitudes towards schools and teachers is considerable. Sociologist Stéphane Beaud has noted that significant individual investment in the idea of emancipation through education, on the part of teachers and of pupils, has constantly met institutional and social obstacles.⁶ That is, even relative success in education does not predict success for minorities in further education or the workplace. At the same time, in French schools, choices of educational paths are strongly directed and durably linked to life possibilities, which means that there can be very direct mapping of social structures onto the space of the school.⁷ And because the education system is deeply socially integrated, the selection of pathways at school appears to be irreversible.

This is a structural problem, to which teachers and students alike are subject, and it is also a way of reading schools as though they were the only site of socialisation. Two fairly recent teachers' narra-

tives are keenly aware of this. François Bégeaudaud's *Entre les murs* is a particularly brilliant and harrowing novel about the way that a range of social problems—unacknowledged structural racism, material inequalities in access to citizenship, economic inequality—are focused through the mechanisms of the school, appearing pointedly within and around inflexibly universal lessons and constraining discourses and expectations about education.[8] Christian Cogné's *Requiem pour l'émeutier* is a non-fictional narrative of teaching in difficult schools. His title, rather than indicating a particular rioting student, refers to a melancholy identification between his own struggling position in education and memories of his young rebellious energy and its difficult relation with school. He is distressed by an increasingly security-oriented language about schools after 2001 and thus an ossification of social relations within the school and an incapacity to think the relation between schools and the other spaces in which his pupils grow and develop and struggle. He finds that teachers and school administrators will remonstrate with him for his 'social worker' tendencies, for his wish to 'faire du social' by interesting himself in the extent of students' lives. In this context, he can only wonder about one inventive and fugitive young man who ends up in the justice system: 'Was he the citizen of a disenchanted world of Rimbaud or just a little hooligan? I still don't really know today.'[9]

In these accounts, the problem is just the walls of the school, and the difficulty of conceiving them. On one hand the school has its relative autonomy, a specificity of purpose, relative to which the social being of the student is an externality—a positive or negative value—which is provided or treated by the social, or the state, or fate. Thus the interior minister in 2005, later French president Nicholas Sarkozy, had referred to young rioters, in the months leading up to the *émeutes*, as *racaille* (rabble) and as 'gangrene', as that which is noxiously at the limit of value and the body social. He had promised to 'make the hooligans disappear', famously threatening in July 2005 to 'nettoyer au Kärcher' one housing project in La Courneuve, where Kärcher is the proprietary name of the pressure-cleaning equipment used, for example, to efface graffiti from walls.[10] And during the riots, he characterised rioters as those who 'resist attempts by the Republic to re-establish its order, according to its laws, in their territory'.[11] The state names aspects of the student body and its social territory as exterior to value and law.

On the other hand, the school is imagined to be a microcosm for social totality and acts in ways that impose that social form on and

within students. So Gilles Balbastre, writing about criticism of schools on the part of media and politicians in 2015 and alluding to Bégeaudaud's novel, suggests that 'by being preoccupied with what is happening "within the walls" of the school, the media forgets about what is unfolding outside them'.[12] The school is conceived as a closed entity—modelling the 'whole' of society'—where value is defined and protected against the ejected garbage and riot and disease of a disordered exterior. Other spaces of socialisation are reductively imagined (a paranoid discourse about gangs and agitators emerged around the *émeutes*), and any relation between them and the space of the school is denied. The complexity of the social and its mobilities and transformations—however much it may be lived and invoked reciprocally and complexly among students and teachers—is excluded from these models.

These processes became vivid for me around the aftermath of the *Charlie Hebdo* murders in January 2015, which was the context that Balbastre indicates. There was massive taking to the streets, at first spontaneous, then state organised. The injunction to accede to the copula 'Je suis Charlie' or 'Nous sommes tous Charlie', in the name of a terrorised freedom of expression, controlled the meaning of that occupation of the streets. In these moments, what is external to the social is the 'terrorist', but the naming of that figure often indicated the same young people, this time as 'apologists for terrorism' (under a law that entered the statues in the 1880s, in retroactive response to the Paris Commune and anti-colonial movements in Algeria, and was applied heavily during the Algerian war). Political journalist Nathalie Saint-Cricq mixed those registers with notes from the immigration debates when she noted, 'We must identify and deal with all those who are not "Charlie"' in order to 'reintegrate' them into French society.[13] The day after the attacks, the state decreed a mandatory minute's silence for *Charlie Hebdo* in schools as part of a day of national mourning.[14] The press was full of stories of students supposed to have refused or disrupted the moment of remembrance.[15] Education Minister Najat Vallaud-Belkacem, speaking in the Assemblée Nationale, used the extraordinary terms about these real and imagined students which served as my epigraph:

> Even when no incidents occurred, there were too many moments of questioning on the part of the pupils. And we have all heard the comments: 'yes I support Charlie but . . . Why defend the liberty of expression here and not there?' These questions are unacceptable for us, above all when they are heard in the school, which is charged with the transmission of values.

New edicts and directives proliferated in schools, coming from the Education Ministry, defining, or rather affirming, a 'nouveau parcours citoyen'—a new roadmap for citizens.[16]

The relation between education and the street in 2005 and January 2015 felt powerful to me, lived as something like a temporally splayed conflict over public space and expressed in an incendiary indication of the walls of the school. I want for the body of this chapter to approach this feeling and these ideas obliquely, by asking how the teaching of apparently dis-articulated values intersects with them—including the values of the arts, which appear to be contained within the heritage that Vallaud-Belkacem asks schools to 'transmit'. My focus is on two poems from *Illuminations* by Arthur Rimbaud and the complexity of address to the young that structures his poetry and enfolds its teaching. Might the way in which literature is read and valued in schools also be a way in which the school can read its own brittle or contradictory social form? As an image of this, witness Cogné, unable to tell whether his student is hooligan or Rimbaldian. Or is the reading and teaching of literature determined rather by abstracted forms of value? This would demand an imagined final judgement which would sever absolutely Rimbaud from Riot.[17] Rather directly, in response to the *Charlie Hebdo* affair, Rimbaud's mantra of dis-identification and subjective innovation—'Je est un autre' / 'I is an other'—was repeated as a minor resistant topos, 'Je est Charlie', complicating what it is to make a social identification. Rimbaud's tone became in some spaces iconic for the kinds of questioning and refusal of hushed silence that worried Vallaud-Belkacem. Rimbaud made the utterance in a letter to his schoolteacher Georges Izambard in May 1871 (the letter is one of the two referred to as the *lettres du voyant*, or 'letters of the visionary'). The letter mocks Izambard for being a teacher and performatively asserts that he is no teacher to Rimbaud.[18] The letter defines poetry as a modern action of liberation and severs it from existing social-aesthetic forms (particularly those of the school and the values it conveys); at the same time, and more fleetingly, it associates poetry with the social and political form of the Paris Commune, which was being bloodily repressed as the young Rimbaud wrote his letter.

There is an excellent Internet resource called 'WebLettres', through which French middle school (*collège*) and high school (*lycée*) teachers share resources they have gathered or generated themselves for the teaching of literature.[19] Rimbaud, as 'difficult poet', is taught primarily in the final year of the French literature section of the baccalauréat (his poetry isn't present in documents presented

for teaching students following non-academic *parcours*). The docu-
ments generated by teachers present a formally innovative and
iconoclastic poet and a biographically rebellious individual; they
don't offer ways in which a reading of his rhythms or of his life
might feed into the lives of their students (although, of course, we
must imagine that the space of the classroom can be opened here to
exactly that kind of discussion). One example: a carefully con-
structed worksheet leads students in a reading of 'À la musique'.
Questions direct students in a fine close reading of iconoclastic
rhythmic forms and attach that reading to the social content of the
poem. The worksheet encourages a formal reading of the poem
which critiques bourgeois individuals and focuses that critique
through the lack of relation between their bodies and music; by
contrast, young sensual *voyous*, hooligans, are set in constructive
apposition to the music of and in the poem. But Rimbaud, in the
reading developed on the worksheet, 'is separated from the *voyous*
by a dash'. Of course, there can be no fusing of poetic and social act,
for we cannot determine the mode of their relation. And the focus
on the dash—a particularly Rimbaldian device, suggesting a kinet-
ics always at odds with the closure of 'poetry'—is precise and pow-
erful. But this good reading, in the school, necessarily leaves some-
thing suspended.

RIMBAUD AND THE CRISIS OF VALUE

Rimbaud's poetry is *of* crisis in some quite direct ways, if we define
crisis for the moment loosely as the moment when discontinuous
change seems possible or necessary, when structural reproduction
may break down. His work follows and inhabits the figure of youth
in revolt and the experiment of the adolescent and the queer body.
It represents and jerkily enacts motions and zonings of the body
and of the social that indicate fracture and opening. He thematises
this explicitly in the *lettres du voyant* as a 'systematic disordering /
deregulation of all the senses / of all directions / of all meanings'.
One strain of contextual readings of his work gathers this indul-
gence in crisis towards critique by aligning his exorbitant percep-
tion and poesis with moments in the imagination of discontinuous
social change. Kristin Ross has articulated the energies of his poetry,
its poetics of the lexical unit and its dynamics of swarm and slogan,
directly with those of the Paris Commune, the popular government
of Paris in the spring of 1871, to which Rimbaud refers and towards

which he yearns in his letters.[20] She traces his adolescent identification with the communards and the forms of the commune and his identification with labour through the mode of strike and association. The challenge in reading his poems, engaging with their difficulty and their rhythmic materiality, is heightened by this reading in that the decoding of his work in these terms (making the hyphen material) involves accessing a fleeting popular social lexicon in the moment of its invention (the linguistic aspect of what Ross defines as 'the emergence of social space'). But it is also perhaps leavened by it: we can imagine concretely a world of behaviours within which the energies of Rimbaud's poems—swarming, sloganeering, rioting, shifting the aim of education, reformulating the position of art within production—would sensually participate rather than requiring esoteric interpretation.[21]

Within this general and social perception of Rimbaud as a poet of crisis, I want to think about a more closely defined account of crisis, as derived—of course this is the locus of long and fascinating debate which exceeds the scope of my argument—from the sections on crisis in Karl Marx's work on surplus value, in which he presents his refutation of Say's law of markets.[22] For Marx, crisis is always potentially present within societies characterised by the generalisation of exchange and a money economy. He criticises an understanding of that generalised exchange as though it were always the exchange of goods, of use value for use value, of something I want for something you want. Of course, as Jean-Baptiste Say and David Ricardo argue, there is no buying without selling, and buying and selling do thus form a unity. But that unit is spaced by the existence of money, which not only enables exchange but is also a measure and a store of value. Capitalism is the form in which you can *want* money—want to accumulate value and the potential power that comes with it, endlessly and without limit—rather than wanting what money can buy and in which you may *need* money, not to buy something you want but to *pay* debts or fees or to *save* against future inclemency.

For Marx, capitalism is a hypothesis; his own description of capitalism is a critical clarification of the hypotheses formed by bourgeois political economists. It is a very powerful hypothesis, but 'capitalism' is not a state of reality: it does not exist except as a model through which we might understand the organisation of human social life. We cannot know what the scale of other kinds of production is as part of the life of an individual or a society; we

cannot measure the ratio of capitalism to love, of commodity to gift, or of capitalist social relation to solidary association.

And crisis is not a sub-operation within the hypothesis of capitalism; nor is it an event that happens to capitalism from outside. Rather, it is a name for the passage of 'capitalism' from explanatory hypothesis to life form. When 'value' has to be made manifest, when selling and buying have to become a unity, crisis can appear. At that moment, the roles of capitalism are struck deeper into the tissues of the body, and the abstraction of social relations in the form of value under capitalism, measured and conveyed in the form of money, tightens upon us as the condition of our life. The relations which were only *formally* relations of domination within the hypothesis of capitalism—of the money form over the money commodity and the money commodity over other commodities and the abstract form of the social over concrete social life—are experienced actually and in the present moment as domination, within crisis. To realise value, to pay, I will need to go to my stock of life and present it hopelessly as value in the market, where it may be rejected and refused.

The coordinates of Marx's thought on crisis are developed independently in the first of the two poems by Rimbaud that I want to consider. 'Solde' is a poem about general glut and what money has made possible. It is structured by a repetition of what is 'for sale'. For example:

> For sale: the priceless bodies, belonging to no race, no world, no sex, no lineage! Riches gushing forth at every step! Unrestricted sales of diamonds!

> A vendre les Corps sans prix, hors de toute race, de tout monde, de tout sexe, de toute descendance! Les richesses jaillissant à chaque demarche! Solde de diamants sans contrôle![23]

The poem describes an extraordinary excess of supply, salesmen who will never clear their stock, quantities of merchandise, of body, voice, abstract and concrete delights, things which shouldn't be sold, which are impossible to sell, which we will never sell.

These gestures of putting things up for sale depend upon the money form, as things are taken to market which have no value, which are either *sans prix* or insubstantial or negated or inalienable. That is, the driving energy and animus of the poem follow the agency of money in dragging objects towards the commodity form. The

textures and sensations which appear to be singular and internal, precious and perverse, become external and objective in character.

These are two sections which are only uncertainly introduced by the frame 'à vendre' (they are loosely syntactically linked to it but laid out as separate paragraphs). These moments represent perhaps also objects for sale but are also evocations of what the movement of sale is like. The second of these presents a 'senseless and infinite impetus [*Élan insensé et infini*] towards invisible splendours, imperceptible [*insensible*] delights'. Insofar as these are further objects for sale, it is hard to see what could give *sens* to the exchangeability of an *élan* towards things which cannot be experienced or perceived. The condition of its becoming commodity in search of money requires that it be detached from its owner, the only person for whom such an *élan* would be vital. I cannot meaningfully turn my body or my autonomy into commodity, because there is no use value in the world that would compensate for it. Nor could another meaningfully desire this *élan*, as it does not exist sensibly or delightfully beyond its subject. I cannot imagine these things denuded of my need for them and reduced to their capacity for exchange. And yet I know, of course, that these kinds of deals are made desperately every day, because money demands it or in despairing hope for and need of money. I may even alienate my own capacity for joy in the scramble simply for *more* money.

Insofar as the 'senseless and infinite impetus' is *not* an object of sale in the poem, the text suggests an affinity between sale for money and the making of a poem. This conjunction is present within some of the objects brought to sale, which seem to signal the experimental prosodic energies ('harmonic ranges never heard before' — *sauts d'harmonie inouïs*) and lexical innovation (*trouvailles et les termes non soupçonnés*—'unsuspected [sometimes verbal] finds and terms') that characterise Rimbaud's poetry. Here they are offered for, and perhaps also as, 'immediate possession'. The alignment of poetic making with money and crisis of value is given, fleetingly, a social scene, as the 'élan' is coloured with a 'frightening gaiety for the crowd'.

These energies of the poem demand a buyer—the buyer who would have no reasonable relation to these terms of sale—in order that a sense can be made here and a value realised. Somebody has to want all of this, for it not all to be just words and crisis.

'Solde' is a very cheerful poem of crisis. The fact, perhaps, that money cannot absorb its will and ability to multiply commodity and multiply names for commodity feels like a ground for the

autonomy of poetry. The poem comes from or is driven by the finding of names for things impossible for the market to capture and a knowing that names can be found at a rate that money will never achieve. The scene for the poem's unruly and rebarbative innovation or inspiration, for something transcendent emerging in the work of language, is imagined in 'Solde' as an incompatibility with the market and a provocative relation to a fantasy of appreciating this imagination in the form of money or value

The other terms that are not clearly contained under the incanted 'for sale' are

> The Voices reconstituted; the brotherly awakening of every choral and orchestral energy and their instantaneous application; the opportunity, the only one, to free our senses

> Les Voix reconstituées; l'éveil fraternel de toutes les energies chorales et orchestrales et leurs applications instantanées; l'occasion, unique, de dégager nos sens!

A synthetic associative energy of voices appears here, with their immediate applications, and this is seen as an opportunity (unique) to liberate our senses (*sens* also comprises meanings, orientations, and directions) from any particular engagement.[24] The name or function of the 'instant application' is suspended. This suspension may push us towards a reading of the work as autotelic and bound to its own present moment or as a semantic utterance which must find its urgent response in a realisation of the plural subject (*our* free senses) in proximate solidarities (the fraternal awakening), like those of the terrified joyous mass.

But immediate liberation of meaning and use and direction would also be the frustrated *end* of poetry. If a poem is the appropriate home for the joy of crisis and the exorbitance of a freely associated making that money cannot account for, it also may appear as the priceless opportunity, 'not to be repeated', of the ideal commodity and the perfect bargain. Rimbaud's term for this spike within the question of value is *occasion*. The term is rich in French, meaning both a moment defined by a juncture of circumstances and a 'bargain'.[25] These meanings are linked by a question of value: an object is imagined as potentially cheaper when its value depends upon circumstance, rather than being derived from its creation or its necessity. The dominance of the moment of sale, hedged and defined by temporal circumstance, realises a value which is somehow inauthentic (which will not pay for the reproduction of the means of

production, for example; or, more locally, might not pay even the costs directly incurred in its production). This deviates from the imagined equilibrium in which value—and thus the social relations which value incorporates—is confirmed and made legitimate by a successfully completed act of exchange.

Lucidly displaying something of the logic of crisis and disengaging from value in its provocative capacity to display, the poem becomes priceless in a way that can only be meaningful in relation to the market and its crisis. There is no place in this process for a disinterested account of an autonomous literary value; but that no-place is equivalent to crisis and articulated with the future of a plural, joyous, crowding, and concrete subject. Its utterance is formally of and in the world of the commodity in a system where money is generalised; and semantically that means that its poem is of and alongside those people constricted by this world of value, for whom crisis may be their occasion, as their joy peels right off them.

Following the work of Henri Meschonnic and Emile Benveniste, Lisa Robertson has given semantic definition or function to 'poem':

> The urgent social abjection of the poem might act as shelter to a gestured vernacular. Covertly the poem transforms that vernacular to a prosodic gift whose agency flourishes in the bodily time of an institutional and economic evasion. . . . In poems and through vernaculars, citizens begin themselves, because only here speech still evades quantification, escapes the enumerating sign, and follows language towards its ear. . . . Here my use of the word 'poem' parts from the conventions of aesthetic autonomy that have resulted from commodity culture's limits and heroisms, to propose that the poem is a shapely urgency that emerges in language whenever the subject's desiring vernacular innovates its receivers. The poem is the speech of citizenship. . . . This shaped speaking carries the breath of multiple temporalities into the present, not to protect or sanctify the edifice of tradition, but to vulnerably figure historicity as an embodied stance, an address, the poem's most important gift to politics.[26]

Robertson's thought and expression are taut and dense. Her 'poem' is not a special kind of thing, a priceless commodity, or part of the heritage of cultural values we might idealise, protect, and transmit. Rather it allows us to cherish, and flows back into, our shared language, our vernacular gestures in their real and material social relations. These gestures are not predetermined by the semiotic structures of formal traditions and the abstractions they encode but are the occasion—in history—by which we can mutually invent our-

selves or at least keep ourselves new. This weak but urgent 'speech of citizenship' is not the citizen speech of 'Je suis Charlie', not the 'parcours citoyen'. But it has potential meaning within the concrete presence of social life, as it survives within and against the abstractions of the school and the discourses of value that would constrain it, that would wall the school in.

ONLY *NOW* APPRECIATED

A poem is made difficult by words that cannot have value. It depends on a presence of language which will not turn into a meaning, a semantic utterance whose urgent social completion is both central to its form and also absolutely suspended. The poem is set beyond or against value, and the young bodies refuse or are refused by the market; and the agency of this is just free association, just joy and prosody, just unaccountable terrifying gay crowding, as they find embodied vulnerable stance within history. At the same time, this disengaged sense of voice and its fraternal appeal emerge as unique occasion, in provocative relation to the capacities of the abstraction of value to contain it or to reject it.

This is the other poem I want to discuss, 'Sonnet', second in the sequence of four poems published as 'Jeunesse', which appears directly before 'Solde' in the Pléiade edition of *Illuminations*,[27] followed by Clive Scott's good basic translation:

SONNET

Homme de constitution ordinaire, la chair n'était-elle pas un fruit pendu dans le verger, ô journées enfantes! le corps un trésor à prodiguer; ô aimer, le péril ou la force de Psyché ? La terre avait des versants fertiles en princes et en artistes, et la descendance et la race nous poussaient aux crimes et aux deuils : le monde, votre fortune et votre péril. Mais à présent, ce labeur comblé, toi, tes calculs, toi, tes impatiences, ne sont plus que votre danse et votre voix, non fixées et point forcées, quoique d'un double événement d'invention et de succès une raison, en l'humanité fraternelle et discrète par l'univers sans images ; - la force et le droit réfléchissent la danse et la voix à présent seulement appréciées.

SONNET

Man, of common constitution, was not your flesh a fruit hanging
in the orchard;—o childhood days!—the body a treasure to ex-
pend;—o loving, Psyche imperilled, or Psyche's strength? The
earth had inclines thick with princes and artists, and race and
progeny urged you to crimes and mournings; your destiny and
risk, the world. But that labour long since fulfilled, you, your
calculations,—you, your bouts of impatience—are no more than
your dance and voice, unfixed, unforced, although a reason for a
double happening of invention and advance,—in human broth-
erhood and discretion throughout the image-empty universe;—
the present season only now esteems the dance and voice re-
flected in justice and in force.[28]

The prose poem is quite difficult, I think. Its cognition is inseparable
from its rhythms and its 'rhyming'; the fact that it is laid out as
prose means that there is no powerful mnemonic indication or evi-
dent formula by which to delimit the work of rhyme and rhythm;
the fact that we read it as prose *poem* means that there is a hankering
and a yearning towards possible moments of verse. For Meschon-
nic, following Benveniste, a 'rhyme' is not just the chiming at the
ends of lines or within them but all material echoes and patternings,
which are held to modulate possible experiences of the poem.[29] We
cannot say in Rimbaud up to which level of signification the signifi-
er is material; the rhyming and rhythming extend right up to con-
ceptual units, because concepts are imagined so materially. Kristin
Ross has suggested that the difficulty and the force in Rimbaud are
partly lexicographical. Not only is some of his vocabulary recondite,
but all of it is in a sense occasional: 'trouvailles' and 'termes non
soupçonnés' governed by junctures of circumstance, gifted address-
es to concrete potential political scenes.

Because I find the poem difficult, I want to attempt a very quick
paraphrase. The making of the '*man* of common constitution' who is
addressed at the start of the poem becomes a question, approached
through the image of a past of flesh and unspeaking youth. That
image gives us a 'trésor à prodiguer'. The phrase is rich even as it is
conventional. *Prodiguer* means to advance improvidently, to spend
or waste without forethought. The word is mixed with its shadow
prodige, a 'prodigy'. There is no etymological relation between the
terms, but they are entwined in a history of etymological confusion.
So the prodigy—the supernatural event, the omen, the extraordi-
nary portent—meets the carelessly improvident.

The young body in the past trembled between improvidence and portent and between a peril and a force, held in relation to loving. 'Ô aimer' lightly rhymes the opening italicised 'homme' and thus, I think, is offered lightly, underneath more solid propositions, as a kind of equation or definition of man.[30] The treasure of the young body, hanging fruit in an orchard, is nourished by the deposited slopes or inclines, *versants*. This word also designates a careless spending, a tipping out of money. These slope-spendings are fertile, and 'fertile' is held together with 'péril', which had recently regained the 'l' in its pronunciation, so the rhyme is historically fresh and possibly even generationally jarring, absolutely modern. And the slopes are fertile because they have been mulched with princes and artists. The slope-spending, like the prodigious or the prodigal youth, pushes us on and down, weighted by inheritance like a character in a novel by Émile Zola, through temporal actions, towards the production of the world, towards 'votre fortune et votre péril'. That ongoing production of linear or narrative time, in the future of the youth who may be the making of the initially interpellated 'homme', is of destiny and also of wealth and risk.

That was in the past, and all of that improvident spending has filled in and maintained the earth through work, spending, and wasting, fertilising preparation for future life. The world and work are literally satisfied, *comblés*. But the transfer between that gathering through the past and the present moment is fragile. In the present the verbal nouns are strategic or otherwise reactive: 'calculations and bouts of impatience'. We can feel the sense of non-resignation, the tendency to rebellion, in those *impatiences*: their intentions towards the future don't go into the earth, don't enrich the common stock, but 'now' rather remain in the places which are 'only' those of prosody, in the dance and the voice.[31] 'Votre danse et votre voix' are potentially plurally owned (where 'tes calculs' and 'tes impatiences' are pointedly singular), and they are impeccably free of mediation by value, unfixed and unforced: undetermined.[32]

The prose poem does bear a trace of the form of a sonnet, despite the fact that the title was added in lightly, unforcedly, as a kind of joke when it happened to turn out that the manuscript block occupied fourteen lines of text with what appeared to be some regular line-end rhyming. I hear something functioning like a *volta*—a formal support for the turn to conclusion in the 'argument' of the sonnet—in 'quoique'/'although'.[33] The voices, become event, have found a reason and been realised in a world which has no form and no images but which does have fraternity, which has invention but

no determination as 'péril et fortune'. They have—again in the present, only now—been appreciated, valued, *appréciées*: quite literally they have been given a price. And the realism of the political world appears as part of this capture, as might and right reflect them.

So those fertile grounds, real rich common values consolidating from improvidence and from work, from which life and world are extruded into undetermined voice and bodily movement, are in the past. And the now, the present, like the reconstituted voice immediately applied or the terrified gaiety of the crowd in 'Solde', gives us the ordinary constitution of the man addressed at the start of the poem. This is crisis, because price seeks to capture the indeterminate; and at the same time the present moment, born in a dance and voice which are separated from determination, awaits and appeals to possible social concretion.

In his book on translation as a way of reading Rimbaud's *Illuminations*, Clive Scott notes,

> If Rimbaud's combinations of abstract and concrete nouns disorientate the reader, it is because they belong to different temporalities; abstractions are syntheses of experience which presuppose a past, a period during which they have been tried out, nourished and have achieved a currency, while concrete nouns are subject to the existential vicissitudes of their referents, even in the world of hallucination.[34]

Thus for Scott, readings like those of Kristin Ross, because they are 'anxious to demonstrate the continuities to be established between text and contextual actuality', may constrain translational decisions and impose a particular moment of integrity on a form which is rather disruptive and interrogative in its thought of how the time of the present might relate to generalising or abstracting accumulations of thought.[35] Such readings may thus impede new ways in which modern readers can 'catch the fire' of Rimbaud's poem. From Scott (including in his beautiful discussion of the temporalities of 'Sonnet' and its unbalancing tension between apostrophe and exclamation, between moment and instant) we get a very clear sense of the disengagement of sense, the genesis and sustaining of the unfixed and unforced movement of dance and voice. Perhaps we are given less access to the tension provided by their present appreciation, by their occasion. Ross's readings of Rimbaud's poems in relation to the context and afterlife of the Paris Commune suggest that the relation between contextual determination and poetic openness

is less a distinction between historical process (always fixing and forcing) and poetry (always free and inventive) than a distinction between the history of capitalism, which fixes meanings through its reproduction of abstracting systems of value and constrains them by the appropriation and accumulation of surplus value and a history in which direct social relations might produce meaning. That is, the openness of referent for concrete meanings that marks Rimbaud's exorbitant perceptions has as its ground and support the actual and potential reality of social relations in their states of urgency.

TRANSLATING RIMBAUD, AGAINST VALUE

Can we find in a socially possible, concrete, contemporary language stock the forms through which to translate Rimbaud's particular poem, his particular pressure on language? My hope is to have Rimbaud stand for value against value, to transform 'nos sens', to somehow sustain those young rioters, to have a voice enriched by the common stock of history without being determined by the control of that history by contemporary social forms, contemporary enclosures of fortune and peril. If we cannot find a way, within our contemporary word stocks or within the verbal mediations of 'our values', to convey and respond to this Rimbaud, then there is no point in asking for it to be taught 'within the walls' of the school.

I have been thinking about these questions and these poems for some years now, and I have talked about them publicly on a couple of occasions. Each time, I set myself the task of translating 'Sonnet'—divided into its rhyming blocks of concept and reference—in the hours preceding my presentation, using phrases found only in that day's newspaper (the *New York Times* of 3 March 2011 and the *Guardian* of 13 May 2015). It was a way of investigating one constrained version of the word stock and thought stock that is available for us to mediate our shared lives and energise our common linguistic-subjective innovations, in response to Rimbaud's provocation.

The results are two failed translations; perhaps my failure helps to locate the problem. In 2011, I spent a night with the *New York Times*, including its Business Day section and the Arts section, which was difficult to distinguish from the Business Day section. I scrutinised the prices in its pages and its absolute lack of a framework for thought about money. I tried in vain to find a word to

translate *aimer* with. Nobody had a youth that was a prodigious or a prodigal treasure. While there was much evidence of an ongoing financial crisis in the pages of the *New York Times*, there was no articulation of that crisis with gaiety or with the resources of the young. Here is that poem:

> As ordinary now as two people wanting more,
> When they were young, the whoopee Pie was all over Maine!
> They definitely felt like celebrities; ô *aimer, le péril ou la force de Psyché*? There used to be a healthy 401(k); Benghazi was a crucial oil city, Hockey had an enduring tolerance for fighting. That made us into microlenders and carers: *That was the world*, hopes for a liveable income and a challenge. But on 3 March 2011, you have worked all your life, you, your baby-boomer smart planning, you, your torn veil, are now just committed singers, sloshing in water, with the magnificent enigma of Catherine Deneuve, although as soon as he joined twitter he established a tone which made sense, and Never Say Never fell to number 2. He proved the veracity of one sentence: the poor are creditworthy. The resistance to collective bargaining reflects his sculpting a punch bowl for Magic Johnson's mother said the *New York Times*, March 3, 2011.

Clearly this poor poem does not emerge by methodologically impeccable process. At best, it is a way of using Rimbaud's poem, as I sought for its unique occasion within the space of the newspaper, to make visible something about how its—our?—mode of thought finds itself parcelled into semantic units.

First, the sharpness of relation between present and past, between consolidated abstraction and pointed instant, has been flattened here for a range of subjects enmeshed in financial instruments—debts, pension schemes, credit—which, in my 'poem' at least, conditions the imagination of past and future and brings even the alterity of Benghazi into calculable orbit. There is some violence, perhaps an aura of desperation if not crisis, around this smoothing out of time; not enough fortune, too much being taken towards peril, perhaps, so that the ground against which the dance and the voice might become *dégagés* is tenuous and fraught. An income to live on becomes the object of imagination and vain wish, not a constraint to be escaped. A sense of the critical present moment is hard to feel in this newspaper, so I gave it just a date, which will change and yet be the same the next day. And thus the potentially quite direct war among those positioned relative to the sums and modes of money is also flattened. It becomes transposed into an

ethical position—a way of resolving the question of the poor—and the figure of the celebrity. The young were very little present: unable to enter the social constitutively, they sit within its categories. Perhaps my poem over-camps the trivial embodiments of creative freedom, but the easily exchangeable figure of the celebrity and the aura of the branded name means that there is no provocation between creation and price.

There is nothing awesome—no value against value—about the dance and the voice here, because they have not emerged from and against a sense of labour and spending which has led to stratified value which could become common. Value is a magnificent enigma, but there is no future that is not already filled with its image. The translation fails, or the translation is failed.

The second attempt, in 2015, was different and not better. I was travelling only from London to Sheffield on the train and so had the time of a train ride rather than a night in an inn and a shorter newspaper, the *Guardian*. Here is that poem:

lyric tenderness
 new partnership of every single person who wants to defeat extremists, our seasonal immune system gave us an advantage in winter months, but in May glaciers flow from the land. The corals bleach and die. Joe's day starts with his boil being dusted in talc by slaves. The teenager maintained that he is not yet ready to make a decision on his international future, *ô aimer*, the flipside of a loyalty bonus? They must stay in the ground: such a bucolic idea was soon abandoned; on the slaughterhouse rooftop, Braga points to a landscape of derelict meat- and fish-market buildings. Nobody has even the faintest sort of plan. The crowd around us erupts into laughter. But in the *Guardian* on May 13, *ce labeur comblé*, the expo is a machine for burning public money, and it is too dangerous to sleep now. Although obviously there was Princess Leia's famous bikini: we need to make a space for anything that is not allowed. We could not miss the opportunity to reinvent the chalet. It is a sort of *Gesamtkunstwerk*, and the estimate follows naturally from that. The rising prospect of accidental default, ninety minutes of flimsy alt-pop, a worker walks up a pile of rice in Manila. Down there, on Saturday, I have never known it so *buzzy*.

The word 'love', again, does not appear in the *Guardian* of 13 May 2015. And there is nothing I could see as a fulfilment of labour in the form of a wealth that could be held in common. The world—a world that Rimbaud's poem suggests that we have produced as a

common value that then shapes and conditions our lives—is very present in its earths and its slopes and absolutely perilous: the land-slides in Nepal were in the news that day. But this world and its crisis is imagined to be a problem for 'humans' in some quite ab-stracted sense, something we might feel about but not something that we have made or are making and, therefore, also not something that we might meaningfully imagine liberty as disengagement *from*. The young energy in my poem is there in descriptions of the figure of Jack Grealish, whose pleasure in playing football is set in opposi-tion to a sense that he will have to decide about his international future. The element most tonally like Rimbaud's that day was the explosive laughter of a group of Nepalese men when asked what their plans for the future were.

Is there any way here that the making of man—the man of ordi-nary constitution—might be breaking away from the form of a son-net, while also implying it as an element of its past? Not really, not in my poem or in my reading of the newspaper. The Milan Expo of 2015, themed around agriculture and built at massive public ex-pense on a €225 million concrete slab laid over agricultural land, does operate as spectacular negation, sitting strange in relation to the surrounding financial and ecological disaster that day. Art turns without remainder into questions of money, and everyone is very disappointed about that. An embodied figure in history is hard to find, except perhaps in the film *Mad Max*, out that day, as the consti-tution of the ordinary man has been taken out of social and econom-ic creation, away from the common and thus also away from its singular possibilities. There is no way in my poem of deriving a human and her possibility from worldly materials.

This day in the *Guardian* is very full of the sense of a crisis in the present—for art, nature, and private and public economies. But that crisis does not liberate or demand the complex provocative aliena-tion which price will struggle to appreciate.

Chris Nealon has suggested that we can usefully 'narrate the history of the most recent phase of global capitalism through a se-ries of political, environmental, and financial disasters, [and that] the best recent poetry allows us to see something like that history's obverse—the story of how selves are solicited to participate in this phase of the life of capital, and of how they struggle to respond to the tones of that solicitation, which range, of course, from murmur to threat.'[36] Rimbaud's poem does seem to offer a particularly joyful and energetic register to think this, and the newspapers fail to allow me to translate it. Nor can schools enable such reflection and trans-

lation as long as their walls are charged with bounding and defining and confirming values which condemn much of the social life of our students to the status of waste and externality, while at the same time imagining that the whole of society is concentrated and reproduced inside. Our language and our schools appear by this logic to be condemned to miss entirely the gaiety and the fear by which the life of our time may be extending itself.

NOTES

1. Laurent Muccielli, 'Introduction', in *Quand les banlieues brûlent: Retour sur les émeutes de novembre 2005*, ed. by Laurent Mucchielli and Véronique le Goaziou, rev. enl. ed. (2006; Paris: La Découverte, 2007), p. 5. Unless otherwise noted, all translations are my own.
2. For an excellent overview, see Mucchielli and Le Goaziou. Further narration and analysis of the forms of riot in France can be found in David Waddington, Fabien Jobard and Mike King, eds., *Rioting in the UK and France: A Comparative Analysis* (Uffcolme, Devon: Willan, 2009).
3. Mucchielli and Le Goaziou, *Quand les banlieues brûlent*, p. 28.
4. Mucchielli and Le Goaziou, *Quand les banlieues brûlent*, p. 27.
5. Mucchielli and Le Goaziou, *Quand les banlieues brûlent*, p. 29. The idiomatic use of *français* to mean 'white' is widely and unevenly shared by some of those who would consider themselves white and French and some of those who would not.
6. Stéphane Beaud, *80% au bac, et après? Les enfants de la democratisation scolaire* (Paris: La Découverte, 2002). In the study of 'ordinary French misery' edited by Pierre Bourdieu, *La Misère du monde* (Paris: Seuil, 1993), education is regularly referenced in interviews both as a space of respite from social forces and as a place where forces of social distinction and social discrimination were enacted.
7. For a comparative account of the French education system in the context of education across Europe, see Christian Baudelot and Roger Establet, *L'Elitisme républicaine: L'école francaise à l'épreuve des comparaisons internationals* (Paris: Seuil, 2009). That book provides data to support an account of education in France as having an unusually powerful capacity to reproduce inequality and notes that this does not produce concomitantly impressive results even for elite fractions within the system.
8. Francois Bégeaudaud, *Entre les murs* (Paris: Verticales, 2006).
9. Christian Cogné, *Requiem pour l'émeutier: naissance d'un tiers-monde d'éducation* (Arles: Actes Sud, 2010), p. 71.
10. Mucchielli and Le Goaziou, *Quand les banlieues brûlent*, p. 63.
11. Sarkozy made these comments during a debate in which he called for the application of a 1955 law—restricting movements and enforcing curfews—which had been active primarily in the suppression of echoes of the Algerian war of independence on French territories.
12. Gilles Balbastre, 'C'est toujours la faute à l'école', *Le Monde Diplomatique* (June 2015), 14.
13. She made the statement on the TF2 news show *Journal de 13 Heures* of 12 January 2015. The language of 'répérer et traiter' is medical, and the imagination

of a need for 'integration' develops the (anti-multicultural) terms which imagine the supposed refusal of some French people to adopt normative French identities and values.

14. Days of national mourning have been rare in France. There have only been five previous cases under the Fifth Republic, the last being after the destruction of the World Trade Center, the rest all commemorating the deaths of presidents.

15. Local administrations were asked by the education minister to be vigilant and to report students who did not comply with the decree. Balbastre has convincingly suggested that there was significant exaggeration of disruption in the press and reports teachers' disenchantment at being asked to administer the silence without being given the time to place and place it within their pedagogy. They were thus reduced to witnessing and policing their students as social beings.

16. Balbastre, 'C'est toujours la faute à l'école', p. 14. Can we hear *parkour* (the athletic mode of urban mobility that emerged in the French *banlieues*, gracefully deregulating spatial organisation and repurposing housing projects as dangerous playgrounds) ringing deconstructively through and under the constraining trajectory of the 'parcours citoyen'? While the *parkour*, or 'free-running', movement was rapidly spectacularised and 'appreciated' (to use a term which Rimbaud will energise), its liberationary relation to obstacle and its disregard of legal regulation are still central to its ethos.

17. Cogné gives one account of teaching literature to a high school class on a non-academic cursus, where reluctance gave way to shared production of urban stories. He describes meeting a student from that class some years later, keen to talk with him about the experience, and articulating this with his new life of mobility and pleasure as a self-employed long-haul transporter.

18. Rimbaud to Georges Izambard, [13] mai 1871, in André Guyaux, ed., with d'Aurélia Cervoni, *Oeuvres completes*, Collection Bibliothèque de la Pléiade 68, new ed. (Paris: Gallimard, 2009), pp. 339–41; the thoughts are repeated and developed in his letter to Paul Demeny of 15 mai 1871 (pp. 342–49).

19. The site is http://www.weblettres.fr. The documents produced by professors are password protected.

20. Kristin Ross, *The Emergence of Social Space: Rimbaud and the Paris Commune* (Basingstoke: Macmillan, 1988). On Rimbaud and the commune, see also Steve Murphy, *Rimbaud et la Commune: Microlectures et perspectives* (Paris: Garbiers, 2010).

21. With Ross, I would argue that the form of the Commune is as durable for Rimbaud's poetry as is the form of his youth. This reading is opposed to Clive Scott's, where the movement to adolescent instant is the installation of a linear temporality which inaugurates the adult; Steve Murphy's work also argues— against a strain of criticism that aims to reduce the relevance of the Commune to Rimbaud's poetry to a few moments of explicit reference and constrain the historical meaning of the Commune through reductive association with Stalinism—that in many later poems the Commune has not disappeared from within his thought (pp. 10–21).

22. Marx, 'Crisis Theory', from chapter 17 of *Theories of Surplus Value* (reprinted in *The Marx-Engels Reader*, ed. by Robert Tucker [New York: Norton, 1978], pp. 443–65). For readings of Marx's work on value and crisis, see, for example, essays by Norbert Trenkle and by Robert Kurz in *Marxism and the Critique of Value*, ed. by Neil Larsen et al. (Chicago: MCM' Publishing, 2014), pp. 1–17; pp. 357–72.

23. 'Solde', *Oeuvres completes*, 30; Arthur Rimbaud, 'Sale', in *Collected Poems*, trans. Martin Sorrell (London: Oxford University Press, 2001), p. 295.

24. This desire and sense of opportunity is a constant presence in Rimbaud's work; it is there the *lettres du voyant* as the 'systematic de-regulation of all the senses'. André Guyaux notes the reading by which 'Solde' acts as a commentary on the *lettres du voyant*, in his notes to Arthur Rimbaud, *Oeuvres*, ed. by Suzanne Bernard and André Guyaux (Paris: Bordos, 1991), p. 522.

25. The primary sense in our contemporary spoken French is 'second-hand', which meaning is emerging in Rimbaud's period from within the idea of the 'bargain', or the temporally expedient sale.

26. Lisa Robertson, 'Untitled Essay', in *Nilling* (Toronto: Bookthug, 2012), pp. 71–87 (pp. 83–84).

27. Guyaux's rationalisation for the order of poems in the Pléiade is given in *Oeuvres completes*, pp. 943–44. A fuller discussion of the textual work behind this decision can be found in Guyaux, *Poétique du fragment: Essai sur les* Illuminations *de Rimbaud* (Neuchatel: La Baconnière, 1985), pp. 13–108.

28. Clive Scott, *Translating Rimbaud's Illuminations* (Exeter: University of Exeter Press, 2006), p. 270. Scott also gives a translation with a form that looks like a (sixteen-line) sonnet (p. 62); many editions also highlight the sonnet-like elements of the form. I have chosen to work with 'Sonnet' as a prose poem, such that its relation to the form of the sonnet is less evidently determined.

29. See, for example, Henri Meschonnic, 'Rhyme and Life', trans. by Gabriella Bedetti, *Critical Inquiry*, 15.1 (1988), 90–107; for his fullest exploration, see Henri Meschonnic, *Critique du rhythme: Anthrologie historique du langage* (Paris: Verdier, 1982).

30. The Pléiade edition takes the—contingent?—lineation of the manuscript as model, which produces quasi line breaks in 'ô / journées' and 'ô / aimer', stressing a force of exclamation. Clive Scott's reading of the temporality of the poem claims that the gesture of exclamation, with its production of an instant, gradually steals and absorbs the moment of apostrophe, such as that which opens the poem (p. 44).

31. To envisage this freedom of dance in a space which contests the working of value, see the work of 'Turf-fiendz', the Oakland-based group of dancers who perform soon after the deaths of young black men on the territories where they died; see also Jasper Bernes, Joshua Clover, and Juliana Spahr, 'Elegy, or the Poetics of the Surplus', *jacket2* (25 February 2014), http://jacket2.org/commentary/elegy-or-poetics-surplus [accessed 13 September 2015], for description and analysis of some filmed versions of the group's work. Their capacity to dance depends less on the social shaping of education or training than upon their underemployment, on the fact that the labour market cannot absorb their labour power, leaving time on their hands and their bodies impeccably and perilously outside value. 'It is a dance of aimlessness and streetcorner, invention for its own sake, amazing and defeated: a dance . . . not of surplus goods but of surplus populations, excluded from the economy if not from the violence of the state. A post-production poetics'.

32. Steve Murphy suggests a reading of the poem in which liberation towards a future un-alienated life accords with a formal and mimetic reading of liberation from the tradition of the sonnet form, in Rimbaud, *Oeuvres completes*, vol. 4: *Fac-similés*, ed. by Steve Murphy (Paris: Honoré Champion, 2002), p. 634.

33. Scott suggests that the *volta* might conveniently be found in 'Mais à présent' (p. 61).

34. Scott, *Translating Rimbaud's Illuminations*, p. 64.

35. Scott, *Translating Rimbaud's Illuminations*, p. 41.

36. Christopher Nealon, *The Matter of Capital: Poetry and Crisis in the American Century* (Cambridge, MA: Harvard University Press, 2011), p. 146.

Part III

Education

FIFTEEN

Saying NO!

*Profligacy versus Austerity, or Metaphor against
Model in Justifying the Arts and Humanities in the
Contemporary University*

Griselda Pollock

SAYING NO! LESSONS FROM THE CINEMA

In the musical *Oklahoma!*,[1] Gloria Grahame sings, "I'm just a girl
who cain't say no!" She plays a flighty young woman susceptible to
every seduction when she knows that, as a good girl, she should
resist. From her song in this light-hearted, but also darkly menac-
ing, American musical, I want to borrow several themes for more
serious purposes of thinking through the condition of the univer-
sity, the arts and humanities, and the environing culture of austerity
that seeks to enforce a rational rationing of resources to which they
might fall victim. My route into austerity culture passes through a
popular culture re-presentation/representation of an earlier mo-
ment of austerity and an earlier moment of contestation about the
nature of the university.

In *Oklahoma!*, as the usual business of getting a pair of heterosex-
ual couples together takes place in sunlight and plenty, the sinister
figure of the hired hand Jud Fry (Rod Steiger) menaces the white
farmer's blonde daughter played by Shirley Jones. In the middle of

the film, attempted rape, sexual violence, and murder take place under cover of a ballet sequence that both represents the virginal heroine's—and hence the nation's (for which she stands)—dark dream and intimates the darker social reality held in phantasmatic suspension by aesthetic translation into music and dance. The film dramatises in this beautified form a nineteenth-century conflict in the American Midwest between the competing economic interests in Oklahoma, a state only founded in 1907 although it had been settled by a European and African-American land-grab after 1889: the all-white film does not acknowledge the fifty-eight Native American language groups or the African Americans who share this space. The film's whitened America is composed of the small-holding farmers seeking to fence their fields for crops and self-sufficiency (the Jeffersonian ideal) and the cowboys (the Frontier thesis) who often work for the great cattle herders requiring unbounded plains for their cattle to roam. Romantic heterosexual coupling becomes the metaphor for an imaginary national resolution of conflicting economic interests, which by the twentieth century were not so cosy. By the 1930s, big agribusiness corporate farmers had won. With their armies of massive harvesting machines and pressure for profit, they had created the dustbowl that turned Oklahoma and other Midwestern states into desert, emiserating and dispossessing the small farmers, the Okies, who became the tragic figures of Dorothea Lange's photographs of migrant mothers and John Steinbeck's novel *The Grapes of Wrath*, made into a film starring Henry Fonda.[2] Capitalist agriculture's destruction of the life-worlds of the Midwest in the 1930s and its untold human suffering were transformed, however, barely twenty years later, by *Oklahoma!* into a romantic musical which was only dramatically transgressed by Agnes de Mille's brilliantly scored ballet. The film balances out the idealised representation of a little local conflict and a bad dream from which the heroine can awake to whiteness and harmonised voices in marital song.

What has this to do with issues of austerity and value in our current context of analysis? *Oklahoma!* evokes a period of severe austerity, the Great Depression during the 1930s, which has been depoliticised in aestheticized, mediated reconstruction by a movie full of metaphors for class conflict and impoverishment. These are, however, visually and narratively imaginatively displaced by handsome cowboys and feisty farmers saved from menace by the concluding celebration of a heterosexual wedding. Troubling in its ideological effects, the movie can be read, against its grain, for the

manner in which cultural memory is both inscribed and displaced despite ideological rewriting of the past to obliterate the real of historical and economic trauma.

Let me offer another example of my process of reading for negation and imaginative resolution. The stage musical *The Sound of Music* (1959), also by Richard Rogers and Oscar Hammerstein and based on *The Story of the Trapp Family of Singers*, a memoir by Maria Trapp published in 1949, fictionalises and dramatises a refusal by a one family to succumb to fascism in Austria at the time of the *Anschluß* in 1938. In the film version, a marriage does take place—sorting out 'what to do with' the transgressive spirit of Maria—but a fine cinematic gesture renders that 'sorting out' deeply ironic.[3]

In the majestic and prolonged wedding scene, following the immensely long procession of the bride up the aisle of a vast cathedral, the camera finally tilts upwards from within the cathedral where the couple is united accompanied by celebratory bells, only to dissolve into a tilt down, now accompanied by a tolling bell, to disclose the annexation of Austria by Nazi Germany as the 'rape' of Austria, now firmly, and in part willingly, under the domination of the Nazis. This remarkable cinematic metonymy works to use the narrative event of one marriage as a metaphor to disclose the political real of forceful invasion. It also reveals once again where gender and kinship and the hierarchies they enshrine function as metaphor for and displacement of conflicts of economic and political origin.

Which way will *our* movie end, if our movie is a current set of contestations that seek to render political conflict irrelevant in the face of a shared crisis of collective austerity to which all other arguments must succumb? Will it end in a traditional resolution through marriage, namely, the subordination of one to another when someone says yes, in willing submission to a new kind of fascism, complete with corporate logo and thoughtless technocrats? How do we learn to say no? What can we do when we realize that our institutions and their leaders have entirely failed to say no for so long that now the current regime seems impossible to displace or even contest?

We are rightly tempted to resurrect historical pasts to assist in understanding our present—I am referencing here the Great Depression in the 1930s or the *Anschluß* in 1938—itself a verbal coverup: annexation instead of occupation. We could find other periods of austerity such as that following World War II in Britain and elsewhere. Each moment had its distinctive politics of austerity and economic foundations, generating its prevailing values. I want to

shift away from economic austerity and introduce perhaps a sur-
prising referent: fascism and totalitarianism.

In the dark times of our moment, I find myself drawn repeatedly
to a study of the political thought of Hannah Arendt.[4] She also
wrote thoughtfully about the values of education and its compro-
mise in the totalitarian state: 'The aim of totalitarian education has
never been to instill convictions but to destroy the capacity to form
any'.[5] Among the words that repeatedly come up in this debate
about education and austerity, this one, 'conviction,' has perhaps
not emerged. Yet it seems to me that it is one of the key properties
that can be fostered to enable a person to live a human life and
become an actor, not merely a consumer, in a shared world. Arendt
insists upon being self-critically aware of what I value and of loving
the next generations enough to share with them—but also to foster
their own discovery of—what to value and how to live a common
life in freedom:

> Education is the point at which we decide whether we love the
> world enough to assume responsibility for it, and by the same
> token save it from that ruin which except for renewal, except for
> the coming of the new and the young, would be inevitable. And
> education, too, is where we decide whether we love our children
> enough not to expel them from our world and leave them to their
> own devices, nor to strike from their hands their chance of
> undertaking something new, something unforeseen by us, but to
> prepare them in advance for the task of renewing a common
> world.[6]

Arendt set these ideas about education as itself embodied in the arts
and humanities against the monstrous falsehood that confuses po-
litical freedom with untrammelled economic activity:

> When we were told that by freedom we understood free enter-
> prise, we did very little to dispel this monstrous falsehood.
> Wealth and economic well-being, we have asserted, are the fruits
> of freedom, while we should have been the first to know that this
> kind of 'happiness' has been an unmixed blessing only in this
> country, and it is a minor blessing compared with the truly politi-
> cal freedoms, such as freedom of speech and thought, of assem-
> bly and association, even under the best conditions.[7]

Arendt's thought, notably her work on totalitarianism, forms the
bridge between the questions being posed by the question of value
and my current research focus on concentrationary memory, a
memory defined as an anxious, vigilant remembering for the pur-

poses of resistance to what totalitarian experiments in the twentieth century introduced as novel possibilities of an a-human, anti-political system.[8] I shall need to take you through this unusual juxtaposition of current cultural politics and the apparently egregiously different condition of the concentrationary in order to recognise what has been repressed in a cultural memory that focuses only on its extreme: genocide rather than also noting the novelty introduced into—and persistent, often unnoticed, in—our world by totalitarianism as a systematic assault on human life that does not always involve immediate destruction of life.

Arendt has argued that the essence of totalitarianism, as revealed by those who analysed the massive network and system of the *concentration* camps as a political experiment in the destruction of the human, is that 'everything is possible'. (This argument relies on our making a crucial distinction between the 'concentrationary universe' of over 10,000 camps in Germany and its satellites in which people were forced to live for however long or briefly and the four or five dedicated extermination camps in which destruction was carried out within hours of arrival in the industrial factory of mass death.) The concept of *concentrationary* as an adjective defining a specific and novel historical possibility was first coined by a resistance fighter in France, journalist David Rousset, whose report on his experiences as a deportee to Buchenwald was published in France as *L'Univers concentrationnaire* in 1946 but translated into English as *The Other Kingdom* in 1947, thus disappearing his important neologism that we find taken up across post-war French analysis of contemporary society.[9] In 1948, Hannah Arendt published an article in *Partisan Review* on the concentration camps that would later form a chapter in her 1951 publication *The Origins of Totalitarianism*.[10] The principle—'everything is possible'—that defines the concentrationary includes the possibility of mass murder, but it also performed another function. The concentrationary principle not only overrode the existing conventions regarding violence against others but also eradicated the until-then-unspoken condition of what Arendt argued, as a result of analysing its potential destruction in the concentrationary, is in fact the condition of *human* being: plurality and spontaneity.

The concentration and extermination camps of totalitarian regimes serve as the laboratories in which the fundamental belief that everything is possible is being verified. Compared with this, all other experiments are secondary in importance—including those in the field of medicine whose horrors are recorded in detail in the

trials against the physicians of the Third Reich. Total domination,
which strives to organise the infinite plurality and differentiation of
human beings as if all of humanity were just one individual, is
possible only if each and every person is reduced to a never-chang-
ing identity of reactions, so that each of these bundles of reactions
can be exchanged at random for any other. The problem is to fabri-
cate something that does not exist, namely, a kind of human species
resembling other animal species whose only 'freedom' would con-
sist in 'preserving the species'.[11]

In an Arendtian gesture, I have elsewhere dared, outrageously
but not without illuminating potential, to trace a relation between
the bureaucratic administrative modernity within which the atroc-
ities of both concentration camps and a specialised extermination
process were made possible and aspects of the contemporary uni-
versity culture at the level of several processes of erosion of the
capacities for certain kinds of action through a grinding down of
any spontaneity and plurality.

Let me be clear about what I am not saying. I respect the real and
specific nature of deadly extremity. We must not confuse it with
merely distasteful social transitions, however opposed to these we
may be. At the same time, I am trying to reflect my sense that I have
been witnessing, daily in my own workplace and institution, an
echo of situations and their underlying logic, about which I read in
my historical research into the perverted administrative rationality
of modernity enacted in Nazism and other totalitarian dictator-
ships. These fostered obedience and thoughtlessness in place of
'love for the world' and depoliticised conformity to systematic
measures instead of political responsibility to the maintenance of a
form of the human condition that is not 'administered' to the point
of extinguishing the fostering of the unforeseen: the spontaneous
and the plural. Both Hannah Arendt and, following her, Zygmunt
Bauman have invited us to see beyond the horror and atrocity in-
flicted by Nazism to the manner in which the conditions of this
obscenity lay in the fundamental features of sociological modernity
itself: industrialisation, rationalisation, and the disjoining of means
and ends in the logic of administrative bureaucracy.[12]

Rather than hanker nostalgically for previous and often imagi-
nary moments of humanistic academic freedom, we must recognise
why they are no longer possible—the actualisation of the fascist
imaginary in the concentrationary universe wrote into political pos-
sibility an annihilation of humanity. It is my contention that beyond
the actual regimes which enacted totalitarianism—most of which

have now been formally defeated—there lingers in culture the contamination of its imaginary assimilated into the cultures of the victors where it is replayed to us through various forms. It is often visible in science fiction and the pseudo-religious film of the last days and heroic redemption. Its traumatic imprint also shapes popular culture, while each representation inoculates us a little more to the point at which we accept such scenarios as narratively possible and normal, even entertaining. To counter what I am identifying as a concentrationary imaginary, we need a counter-concentrationary practice. This requires the development of a critical vocabulary that can distinguish between work that often and only self-indulgently appears to resist and that which creates the conditions of resistance through the terms of its practice.

Over the last ten years, as I have witnessed progressively destructive changes to the value of education as a practice in the culture of the administered university, I have asked myself why no one said no. Yet, I reflect, when had it been possible to say no, to make a stand, to resist creeping erosion of the potentially critical value of our humanities? In his careful research into the Nazi takeover of the German political system and the entire society during the 1930s, Saul Friedländer has shown us that the totalitarian reconfiguration of the German people during the 1930s was strategically and calculatedly piecemeal, carefully testing out support or opposition for each new element, building the destruction of the political and the people step by step. Friedländer also plots out the softening up of the Jewish communities by various ruses, to which, in hope, they often succumbed, before the Nazis eventually transported and murdered them. Calculated deceit and lies were part and parcel of Nazi strategy. Thus, as a system, the Nazi regime installed itself by making small changes or demands, each of which was just about manageable and therefore little resisted. These small changes accumulated, however, to a point when resistance, inspired by something really outrageous, had become utterly impossible because the preceding concessions eroded the space or positions from which now to resist. It was simply too late.[13] That is again the seemingly outrageous comparison I want to suggest. Not because our university world is now genocidally racist; rather it exhibits features of what Max Silverman and I have theorised, 'the concentrationary', which refers to a systematic evisceration of the 'political' understood in Arendtian terms as the coming together into the space of thought, contestation, collective participation in fashioning, critically, the nature of our worlds together. Confronted with the horror of the Holo-

caust, we have failed, we argue, to recognise the terror of the totalitarian that preceded and exceeded that atrocious event and functions in different ways, beyond any camp, as the anti-political condition that compromises our social, political, and ultimately moral identities across a variety of institutions now accommodating to a new logic of economically and performance-determined possibility.

Our university managers and the government policymakers are not fascists. The modes of change and the values underlying those changes in the administered university, however, raise the same problem of accommodation to change because of new necessity that might, in its effects, ultimately so change the sphere of education that there is no more a line of defence for what has to be defended if we are to understand ourselves in anyway as transmitters of the value of education in Hannah Arendt's sense.

As one of what Bill Readings called the proletarianised professoriate—and not incorporated into management—I am shocked that our administrators and senior managers seem unable to say no to initiatives from government and funding bodies.[14] No one defends the rights of students (who are redefined as our customers and hence lose rights to the education they would otherwise have, were it not a purchased product or financial investment) or of the staff and of our educational project and its disputable but critical value. They succumb, little policy change by little policy change, directive by directive, superfluous administrative task by administrative task, until an entire system has been irreversibly altered. I marvel at the speed with which mere twinkles in the eyes of remote civil servants and members of Research Councils are turned into already prepared and even delivered outcomes by willing participants in university management. Such anticipation reflects the fact that performance in management and leadership are now the only jobs rewarded by corporatised universities run on business modelling. Instead of steadfast defence of the values that the traditional university—as a locus of critical research and shared and transmitted enquiry and possibility—ideally represents on behalf of a democratic society, we now have instant accommodation and inventive translation of half-baked and ill-informed notions into policies according to which our institutions and working lives are being constantly remodelled, leaving us, its workers, always anxiously adjusting to, and afraid of failure in meeting, ever-moving targets, themselves policed by performance surveys of all kinds. The affective result is a state of permanent anxiety and existential unsettlement. This has real effects and may indeed be purposeful.

While austerity is the new prism, our situation is also a product of the shift to the university of commerce and excellence through what Marilyn Strathern and her social anthropologist colleagues call audit culture.[15] This culture characterises the white-collar and professional workplace. 'That there is a culture on the make here is evident from the concomitant emergence, and dominance, of what are deemed acceptable forms.'[16] The core of this new culture is accountability. 'Only certain operations will count. Hence, as far as higher education is concerned, some rather specific procedures have come to carry the cultural stamp of accountability.' Yet even this is unmoored from its origins in finance; a whole new culture of reckonings, evaluations, and measurements represent a culture which is enacted and performed by its key words: the market, management, economic efficiency, good practice, and evidence. Looking at this culture in its local ethnography in the university, Strathern declares,

> They have direct consequences, and in the view of many, dire ones, for intellectual production. Yet as an instrument of accountability, holding out the possibilities of globalizing professional consensus, audit is almost impossible to criticize in principle— after all it advances values that academics generally hold dear, such as openness, responsibility about outcomes and widening access.[17]

Audit is one instrument of applied austerity even as it emerged in times of prosperity. It contained within itself a series of applied judgements alien to that which would be refashioned through this mode of judgement: accounting/accountability. If social anthropologists read cultures, focusing on the relations between practices and namings, processes and effects, institutions and their interpellated minds and bodies, we in the arts and humanities are also intimate analysts of words and meanings, of practices and their effects. Yet we are the last to be called upon to contribute to the understanding of our own life and work worlds within the university. Current trends in business schools and management studies realise that 'culture' and its affects have to be taken into account in the process of managing institutional change to accept new austerities. Culture, defined as the problematically incalculable—feelings, anxieties, attitudes, identities, and so forth—interrupts smooth functioning of the business model and hence demands the *management* of change. Management modelling for new conditions now has to find ways to handle feelings, attitudes, insecurities, and what is thus psycholo-

gised: resistance or opposition. Cultural analysis is brutally instrumentalised by its appropriation as an instrument to silence criticism, while we in the arts and humanities, whose entire professional and scholarly lives are dedicated to reading and analysing cultural practices as creative and generative loci of contestation as well as domination, are to be offered back a distorted version of our own work from the business school, where 'culture' is cannibalised for the purposes of use in corporatising the workforce. Resistance to change is reduced by demanding alignment with corporate necessity. Thus the individuals who compose the institution cease to be accounted as agents or participants. The university was once the place of discussions and contestation: that is what we teach our students through the humanities and the arts. Now it is being refashioned as a place that must marginalise troublesome thinkers who are not on message.

MISPLACED FANTASIES OF FREEDOM

What is the defence against this 'mission creep'?[18] What are universities for? On what grounds might their intellectual profligacy — being committed to incalculable academic, educational, and social values — in times of austerity be defended? In the summer of 2011, the Arts and Humanities Research Council (AHRC), Britain's funding council for that field, came in for criticism for aligning its proposed research themes and priorities too willingly with the Conservative Party's slogan: 'The Big Society'.[19] One critic, a professor of philosophy declared,

> I strongly suspect that BIS [the British governmental Department of Business and Industry under which government funding for higher education and universities currently falls] are telling the truth because the schemes and documents of the AHRC are so intellectually corrupt, and their architects are so lacking in critical consciousness that it is reasonable to imagine that when they realized they could rebrand their existing ideas in a way that they thought would please their political masters, they did so without hesitation. *The question that ought to be addressed is when was it decided, and by whom, that arts and humanities academics should be working to improve community cohesion, rather than pursuing the intellectual agenda set by themselves and their peers around the world?*[20]

I found it significant that one blogger on the website had astutely inverted this question, asking instead when and why the intellectual agenda of academics had been set for autonomy rather than contributions to community cohesion. What are, therefore, the politics of the terms of a defence of academic value qua value?

It could be argued, in a historical sense, that universities have always been in hock to their societies, functioning as servants of their dominant values, fabricating ideological (theological in the medieval period) and national, if not communal, cohesions in the modern period since the nineteenth-century creation of the German university model.[21] Thus intersecting with the formation of national states, the notion of academic freedom in the university may also find itself determined by the ideological reflex of emergent capitalist systems. A particular interpretation of 'freedom' as the initiative of the 'free' private producer is the mirror of capitalism's desire to be unfettered from tradition.[22] Freedom of research, I suggest, was always a dream, if not a bribe. When practised by its selective enabled elites, it served well to generate the forms and substance of knowledge that the nation-state could use materially or ideologically. There were canons and plenty of conventions and backroom or clubroom controls to ensure that the research was 'proper'. Freedom of thought was perhaps less visibly and overtly managed. Those of us involved in the culture wars of the 1970s to the 1990s, however, know exactly how much struggle it took to win the least freedom to do feminist, queer, or postcolonial studies, given how 'minority discourse' challenged establishments both left and right and how we were named for doing so as imminent destroyers of the civilisation the university was established to secure.

Thus I cannot defend what I do now in the name of some ideal of freedom of thought in the traditional university that is now being betrayed. I can enquire, however, into how the generation of radical scholars post-1968 used such a betrayed, or at least highly selective, tradition of intellectual freedom and criticality to sustain challenges to the sexist, privileged, white- and anthropo-centred, homophobic, racist, and class-privileged university (organisation and curriculum). I can ask now what the nature of the changes that have occurred mean in larger cultural and socio-historical terms and what forms and spaces of critical practice may be defended or will need to be opened up in an age of so-called austerity that will limit the arts and humanities as too costly and without adequately auditable economic or social value, while loading onto students massive debts for getting a university education, thus placing into their hands

choices that will rewrite the university landscape on the basis of projections of best value for investment in a calculating financial rationality. Austerity means more than reduced resources; it redefines the logic of selection.

Between what Bill Readings named craven yielding to the lure of acceptance by the fake cultures of excellence and accounting and militant radicalism that can easily give way to cynical despair must lie new projects informed by the legacies of the critical interventions of the post-1960s universities and the crisis in the politics of knowledge and experience it provoked. Might they still provide tools for understanding the relations of power and knowledge and the relays between the various registers of the social formation?

Working in a publicly or privately funded university is always treacherous. The position inevitably generates ambivalence in the scholar-employee. Even while facing the relentless destabilisation that characterises what Zygmunt Bauman defines as our current sociological condition—liquid modernity—and the imposed corporate modelling and economics typical of globalising capitalism, the strange legacies of both the Humboldtian university of the post-Enlightenment nation-state and the post-1960s politicised university of the 'studies' movements provide resources, historical and theoretical, for new terms in which to generate and defend the process of critical and politically conscious thinking—in the Arendtian sense I shall shortly elaborate. [23]

I think we can relatively easily produce a stinging critique of the discourses of excellence and audit that dominate today's university ideologies and administration practices in teaching and research management. How much harder is it to imagine how we can turn the belated and now useless 'no' to some of its excesses into a *creative negation*, when, in the name of the new accounting culture, the corporate model, and a conservative world view, government-backed reinvestment in the old, boundaried, and canonical forms of knowledge is being proposed, with its corollary of trashing the 'studies' movements as mere fashion, intellectually trivial and economically useless, and when despite such retrenchment, the arts and humanities as a whole are at risk. This is not merely because they have no economic impact. It is very easy to produce data to demonstrate that the arts and humanities have immense impact in terms of income and employment generation, cultural capital generation, tourist destination competition, and so forth—hence the bizarre concept of 'cultural industries' and the increasing instrumentalisation of culture. But it is precisely because of a contradiction

between the model of pure economic utility and the potential politi-
cal impact of the arts and humanities, their capacity to generate
Arendtian conviction and even Arendt's idea of a common world
not based on pure economic rationality, that non-canonical arts and
humanities are now not merely redundant. They are now danger-
ous to a world inventing its own new cultural mode of justification
for a man-made economic disaster that imposes 'austerity' as its
only morally responsible programme.

I am arguing that we should not be passively defending our
areas of research and teaching as some idealised realm of freedom
that is of itself a 'good'; we might better understand teaching and
research as a primary political action that is not directed merely
against cuts or long-term reduction and reshaping. We have to re-
define the pedagogic and thinking space providentially once pro-
vided by the modern, bourgeois university, whose limitations had
to be challenged during the later twentieth century. In the present
situation, we must now justify it *otherwise* than in the only terms we
are being offered: nostalgia for a fantasy of intellectual freedom or
acceptance of economic modernisation.

MODELS AND METAPHORS

The functionalist model in sociology imagines society as a machine
with operating parts. Any interruption to an assumed norm of func-
tionality is treated as a passing dysfunction that must be corrected.
Hence the model does not envisage development or transformation.
It treats disagreement or conflict as signs of systemic failure. Failure
thus requires technical tweaking and more management. Counter-
ing these depoliticising political models are many current thinkers
for whom contestation or agonistic conflict or *désagréement* are con-
tinuous and necessary elements of the constant work of producing
democracy in the face of structural difference, exclusions, oppres-
sions.[24]

In her speculation in 1981 about how to create an international
feminist curriculum, postcolonial feminist literary critic Gayatri
Chakravorty Spivak opened her article with several stories—al-
ready a lovely device. Spivak reports a conversation with a young
Saudi Arabian PhD student who is doing a structural-functionalist
thesis on female circumcision in the Sudan. Horrified, Spivak recog-
nises, however, in the PhD student's story, a shared experience of
intellectual colonisation that is training this young Arab scholar to

understand the violence done to young girls as having a rationale in terms of the good functioning of the social machine of a patriarchal culture. Of course, we can see that denying women sexual autonomy has an effect of sustaining what Spivak calls the uterine economy on behalf of men. The structuralist-functionalist account does not, however, protest but endorses the functionalisation of human beings, making it normal rather than obscene.[25]

The business model currently proposed as the only normal one is an extension of the structuralist-functionalist schools of sociopolitical theory. Society or institution is understood as a fixed machine that functions. Good planning leads to good functioning. Cultural management may be necessary to minimise human disruption through contingency of affective experience. This mode of thinking is deeply impregnated with its unconsciously performed capitalist conditions of existence. It serves that system and its ideological forms by seeming to have no affiliations or purposes other than those of rational planning to maximise output and minimise costs. But like the film *Oklahoma!*, its sunny ordering of the world occludes the violence and exploitation upon which it is founded. In machine society, people are reduced to functioning parts; their living energies are appropriated to animate the actual interfaces and productive processes that must operate to keep the whole machine functioning according to its destiny: production and profit. Absolute exploitation by grim reality has given way to relative exploitation fostered by managing the nature of subjectivity and consciousness so that we self-functionalise, see ourselves and value ourselves only for the performance of the part allocated to us in the grand corporate system with which we are encouraged to identify ourselves. One example of this is the setting of potential income targets through grant funding for academics and notably as part of contracts for the hiring of so-called academic leaders. The accumulated value of their long-term scholarship and publication is translated into potential income necessary to cover the defaults of funding. The battle is not merely of free-floating intellectual production versus tighter auditing, management, and accountable excellence. The battle we face in the university arena as a formerly significant site of contradictions within liberal democracies is how to speak our resistance to the effects of current models creatively rather than in terms that are self-deceiving, nostalgic for what never actually existed.

THE CHANGING FUNCTION OF THE HISTORICAL UNIVERSITY

I began with giving a reading of some films. That is what I am trained to do. As an art historian and cultural analyst, that is what I train students to do: to read critically the complex imaginative forms in which social experience is mediated and shaped by both symbolic forms and their historical entrainment. I train them to analyse forms of representation but also processes that produce meaning which always involve the situation and positioning of the producer and the reader of those meanings. The notions of textuality and reading encode a practice of engaging with the sociality of culture and the culturality of the social. This leads not only towards understanding ideologies that present interests as nature and common sense but also to understanding the creative work of aesthetic transformations of the sense of the world, making a form of knowledge through fiction or art.

Culture—dispensed via education—functioned for some two hundred years in the West as a basis of training social elites for their leading functions in colonial and postcolonial world domination. What if that function is no longer necessary? Global capitalism, unlike the colonising nation-state or empire, does not need nationally trained experts to carry a national culture and its interests colonially into foreign fields. It needs self-disciplining members of the service team unmoored from such localising, even national attachments. What is needed is not a university education as eighteenth-century educational theorist Wilhelm von Humboldt programmed it for the emerging nation-states under an elite bourgeois mandate. The current order needs advanced schooling for better integration into performative labour in liquid modern times, the time of globalising economies that need knowledge of other cultures not to rule them but to better create marketing strategies to sell to them. Think of the once ubiquitous HSBC advert that reminds marketing people of the necessity to be alert to cultural diversity—a reason that has been given to me when interviewing students for courses with 'cultural' in their title. Such cultural knowledge becomes a banked resource.

We cannot bemoan the current trends in the name of an idealisation of the true university as if the arts and humanities themselves originated in a socio-economic vacuum. In the mid-1990s, Bill Readings argued that we are dealing with shifts in an epochal history of the West that had generated the university as a project for its own formation as a series of cultures. He wrote,

I am still inclined to introduce sentences that begin 'In a *real* university . . . ' . . . even though I know that no such institution existed. . . . The university, I will claim, no longer participates in the historical project for humanity that was the legacy of the Enlightenment: the historical project of culture. Is this a new age dawning for the university as a project, or does it mark the twilight of the university's critical and social function?[26]

Are we dealing with a new phase that unfortunately makes us arts and humanities folk grumpy because we are being marginalised? Or are we obliged to take critical account of the dialectics of how we, intellectuals, came to be what we are under the variable conditions of bourgeois and capitalist modernity? We need to ask ourselves whose interests we were originated to serve and what we have critically made of those conditions. If, as Readings suggests, the philosopher Jean-François Lyotard, writing of the postmodern condition, already outlined the defunctness of the humanities model for creating knowledge in the new relativisation and end of authority, how do we ground the politics of knowledge now?[27]

University education cannot be compared to a product made and sold by a business. Nor is it a service like catering or hospitality. It exists because it has been needed for certain key cultural operations of the societies that have fostered this institution, initially in the medieval period as a tool for training literate clerics in an era of general illiteracy. It was then secularised to train administrative and governing elites in the imperial era. The new model is a training school for the technologies needed for societies entirely modelled as capitalist enterprise, competitive economies, and production for the sake of profit. Hence austerity as a generalisation is fashioned as part of the cost-cutting project of the slimmed-down enterprise.

In the heyday of early capitalism, known theoretically as political economy—the source of the idea that only the economic fundamentally matters—social economy emerged from left and right to temper the naked rapaciousness and violence of profit-driven industrialisation by insisting on social policies around health, working hours, and what capitalism already found useless: art, morality, thought. Older romantic-conservative notions of community, culture, and vertical integration vied with new egalitarian socialist utopias demanding mass education and self-realisation to contain capitalism's brute force with social management and limited democratisation. This could operate on the level of the nation-state whose competing purposes universities could be tolerated to manage. Now, however, globalising capitalisms, with their still focalised

geographical hubs, are subject no longer to forms of political and social control by national governments. Borderless, they can wreak their havoc across the globe relatively untrammelled, aided by the deterritorialised digital media and communication systems that abolish the distinctions between public and private and territorial space. The hegemony of the business model, with its limited bottom-line mentality that parades itself as reality, crushes any wishy-washy liberalism as romantic nostalgia that cannot be afforded if the rich are to get richer and richer. Because thought has been used by the secularists to challenge the hegemony of knowledge by priests, by the middle classes to challenge the aristocracies, by working people to challenge the bourgeoisie, by women to challenge men's hegemony, it is stained with those histories while still offering vital resources for new purposes.

The conservative Right is also hitting back. Making it clear what the stakes are, American philosopher Martha Nussbaum declares in *Not for Profit: Why Democracy Needs the Humanities* that we are witnessing worldwide a silent crisis deeper than the economic collapse of 2008. This crisis she says is like a cancer:

> A crisis that is likely to be, in the long run, far more damaging to the future of democratic self-government: a world-wide crisis in education. . . . Thirsty for national profit, nations and their systems of education are heedlessly discarding skills that are needed to keep democracies alive. If this trend continues, nations all over the world will soon be producing generations of useful machines, rather than complete citizens that can think for themselves, criticize tradition, and understand the significance of another's sufferings and achievements.[28]

According to Nussbaum's extensive research in international education, national development—for which students are asked to prepare themselves by judiciously useful choices of subjects to study—now means exclusively economic development. Hence only certain areas have national value. This is the novelty against which Nussbaum poses the arts and humanities as the humanising counterforce necessary for democracy. Appealing as that argument appears, it forces us to ask, Was or is the university really the home of democratising humanity?

I am a product of the denationalising culture wars starting in the 1960s and 1970s that already challenged the university as it was presented to us and was being generalised through the very radical expansion of higher education that gave us—the non-establishment

scholars—careers. The nineteenth-century university drew a disciplinary map of the human and natural sciences to serve a nationalist agenda. In the 1960s, the interdisciplinary studies movement exploded onto the scene, transgressing these traditional, boundaried disciplines in the name of minorities and majorities unspoken and unrepresented by disciplines and canons. The academic form that reflected and was empowered by the social movements that shook the 1960s—civil rights, lesbian and gay, women's and national liberation movements—was interdisciplinary studies. These developed in the names of voices and lives not represented by the dominant models followed in the classic disciplines: history, literature, art history, and philosophy. These new fields included labour histories, women's history, and gender, queer, anti-race, and postcolonial studies. These victories are still fragile, and some, like women's studies, have been completely lost. Rare is the name field of feminist studies.

Looking back over the last four decades, we are forced to ask ourselves if these campaigns for expanded fields of enquiry have substantively made their representatives more present inside academe: How many black profs, openly queer profs, feminist profs, working-class profs are there in positions of influence and power *still identifying with those agonistic communities*? As a result of the intersection of social movements and their intellectual and theoretical elaboration, the university became a critical site for the radicalisation of the production of social knowledge and cultural memory driven by the post-war moment of temporary democratisation of access to university education, assisted in some countries by grants and free tuition. It is important to note that, historically, these new initiatives began in social and political movements, still inspired by historical memories of other collective struggles such as those of working people for literacy, women for political representation and education, and colonised peoples for national liberation. Their beginnings, significantly, mostly took place outside the formal university.

I learned to read films like *Oklahoma!* and *The Sound of Music* as ideological cultural texts outside the university during the early 1970s when new kinds of film and cultural studies were being forged through extramural activities in *Screen* and *Screen Education* and the Society for Education in Film and Television, which ran film-study weekends, readers' groups, and workshops. Through the spaces opened in the then polytechnics and oddities like the fine art departments, where it did not matter so much what you taught

artists, some of my generation were able to bring this countercultural and imported political and cultural theory into the space of the university, ironically often via art education.

Do not be misled: it was a war, and there were casualties among the older, established staff. Institutions also policed such challenges. During the dark years of the long Margaret Thatcher–led conservative administration of the 1980s, I witnessed punitively selective impositions of financial austerity as a means to police critical hotbeds of new thinking. But the very fact that there were culture wars is itself indicative that we were still fighting over the foundational concept of the university: not culture but the power of knowledge and self-representation in all the fullness of language, history, and social and political understanding. The teaching of history, languages, literatures, arts, and social sciences has been deeply involved with inducting students in national universities or universities in the Euro-American realm to locate themselves within the relevant nation-state whose apparatuses required such identified and educated personnel. The reason that the 'studies' movement can now apparently be so easily displaced by a return to the conventional disciplines is that the content of neither matters ultimately. I am trying to argue for the necessity of the internal criticality of the interdisciplinary studies movements, setting themselves to challenge the unconsidered class, gender, ethnic, and sexual norms, to agitate the surface of this now redundant culture-forming education.

From within, we might define the university as being about teaching, supported by research practice. Teaching, however, is, as Spivak has argued, fundamentally intimate.[29] It is neither selling a service nor training a cadre. Its knowledges, however much they are circulated through commodities such as books, are a collective result of a community of relational conversations that foster self and other understanding, understanding of forms of belonging and difference. Through the arts and humanities, it fosters the imaginative faculty that can grasp multiple life-worlds, different experiences, and the nature of change and the function of creativity based on work. I am trained to question how meanings are produced, how realities are rendered invisible or rearticulated in metaphors that defuse their significance, or naturalise histories, normalise power hierarchies, and either silence or give space to many voices.

Reading signs, piercing ideologies, is not, however, performed from some isolated or external vantage point, safe from the mess. They take place at the heart of the state's ideological apparatuses.

Education and certainly the university are state ideological appara-
tuses, as are the media, unions, political parties, religious institu-
tions, and the family. There is no outside from which to survey the
follies of others. We are not in a safe ivory tower. Indeed, the state is
increasingly realising that it cannot afford to allow the university to
continue the function it was once allocated. Knowledge production
must be tamed to function as a training institution. Rather than a
cancer, in Nussbaum's phrase, I see it as a real political assault.

What we are witnessing in the universities today represents a
structural shift. Once a playground for the middle classes and a
selectively few, de-racinated working-class and upwardly mobile
aspirants, the universities can no longer be left to them because we
no longer need classed and nationalised subjects in that way. Uni-
versities must become sites of disciplining for the now predomi-
nantly service and administrative workforce whose view of higher
education is no longer a formative rite of passage: a moment of
what the Germans called *Bildung* as part of their creation of a na-
tional identity. University is to become a formalised training in new
forms of technologically savvy labour readiness that are marked by
adaptability to the uncertainties and fluidities of what Zygmunt
Bauman identifies as our condition: liquid modern life. We are not
prepared for liquid modern life by a general education in critical
thinking. We are to be prepared—rendered 'employable'—for ever-
changing forms of work in a liquid economy by learning to consider
everything as a means to economic ends. Calculation, evaluation,
results, and competition render the engagement with knowledge
entirely utilitarian. Do I need this for . . . ? Will it come up on the
exam? How do I get a better result? What job will this get me? We
hear these questions from students who arrive at university already
ideologically coded for the liquid economy by their parents and
teachers, whose anxieties are shaped by the logics that permeate the
media and the discourse of governments and their agencies.

Recently giving a series of Wellek Lectures on the double fate in
American universities of comparative literature and area studies,
titled in publication *The Death of a Discipline*, Spivak demonstrated
the work of comparative literary studies. It seems so simple: read-
ing a text and seeing the figurative work of language in fiction.
Spivak presents this activity, in the classroom, accessing worlds
through literature, as a powerful resource in relation to contempo-
rary globalising capitalism and its attempts to appropriate every
resistance and every alterity through its refashioned educational
arm. Charting a path between the political and ideological condi-

tions under which area studies emerged to serve American political interests during the Cold War, and how comparative literature functioned in fact as a closed European shop, even as it was intended to expand American students' imaginative but Eurocentric universe, and the new globalisation market forces that have made both these formations redundant, Spivak makes a case for her new comparative literary studies in tertiary education as a means of enabling or creating participation in a new *planetary* collectivity that defies globalisation in the name of justice.

Spivak reads the shifts she is witnessing in literary and cultural studies in the United States as attempts by the dominant to appropriate the emergent—for instance, liberal multiculturalism. The counter-force is, she argues, the repetitive and intimate collective training in the classroom.

> In so far as the tertiary student is in the service of the dominant (although unwilling or unable to acknowledge it), such training might seem to undermine their self-assurance. This is not an easy 'positional skepticism of postmodernist literary or cultural studies' but something to be worked through in the interest of yoking the humanities, however distantly, with however few guarantees, to a just world.[30]

She then names the humanities 'the uncoercive rearrangement of desire' before adding,

> All through these pages I have suggested that literary studies must take the 'figure' as its guide. The meaning of the figure is undecidable, and yet we must attempt to dis-figure it, *read the logic of the metaphor*. . . . All around us is the clamor for rational destruction of the figure, the demand not for clarity, but immediate comprehensibility by the ideological average. This destroys the force of literature as a cultural good. Anyone who believes that a literary education should still be sponsored by universities must allow that one must learn to read. And to learn to read is to dis-figure the undecidable figure into a responsible literality, again and again. It is my belief that initiation into cultural explanation is a species of training in reading. By abandoning our commitment to reading, we unmoor the connection between the humanities and cultural instruction.[31]

To override the global, Spivak thus proposes a counter-concept, the *planetary*. The former is the imposition of the same system of exchange everywhere. 'The globe is our computers. No one lives there. It allows us to think that we can aim to control it', but 'the

planet is a species of alterity, belonging to another system; and yet we inhabit it, on loan'.[32] Then she declares, 'To be human is to be intended toward the other'.[33]

We have invented figures for the origin of this condition of intending towards the other, a proclivity of intersubjectivity or participation in a polity: mother, nation, god, nature—all names for alterity, for our formative, desired, or revered other. Planet-thought, according to Spivak, extends this taxonomy inexhaustibly to encourage us to think of ourselves as planetary subjects rather than global agents, planetary creatures rather than global entities. She thus poses the work of the literary scholar as teacher as seeking to do two things. One is to pose Spivak's recurrent question in a decolonising world: How does the other see me? Who is looking at us from within this text, this story, this archive? Who is the collectivity, the human, that we would access via the singularities of each answer in each text, story, image, archive? The second is this: How can we refute the globalising dehumanising of functionalised dis-humanity and produce as a work in progress, constant, unpredictable, diverse, the sense of the human in pluralised collectivities of self-articulating subjectivities? Such an unfashionable invocation of the human in a culture trained in dehumanising economic and linguistic determination or now open to suspending and critiquing any androcentric or human superiority over the non-human requires justification, as indeed does the stress on the role of articulation and subjectivity in an era of economic appropriation of affect as the mode of labour. I return, therefore, to the work of Hannah Arendt, mediated, however, by a representation of the Arendt position by Judith Butler in another context of political crisis. I found myself tempted to 'read' Butler's newspaper polemic, asserting the value of philosophy by means of a revisiting of Arendt's diagnosis of a failure of thinking that produced the banality of evil in the case of Adolf Eichmann, as another example of a use of a 'figure' by means of which to make vivid a case that cannot be literally spelled out. It seemed to echo the treacherous linkage I made above between certain forms of administered education and the concentrationary. There is no direct comparison and nothing like an allegory. But their imaginative proximity creates the space for thought itself.

Thus in an article in the British liberal daily newspaper the *Guardian* on 29 August 2011, Judith Butler remembers once again for us one of the most important advocates of thought in the aftermath of thoughtless rationality that administered genocide, Hannah Arendt.[34] She reclaims Arendt's thinking for a present whose actual

coordinates remain unspecified but implied in relation to the battle for thought: the sphere we could say of the intellectual but also the engaged academic.

Arendt was a philosopher who noted how during the rise of Nazism, the discipline of philosophy, when based on a system, could not and did not stop highly intelligent people from embracing Nazism, which seemed to offer a system and a model for perfectible society, solving all problems in one go through one—final—solution. Arendt, therefore, rejected philosophy in favour of social activism during the 1930s. Having just escaped from Europe and arrived in New York in 1940, she had to make a living as a penniless refugee. She became an editor and a journalist. By default she also became a leading political theorist.

Arendt recognised that history had produced a problem to be thought through. Post-1945, she declared, 'The problem of evil will be the fundamental question of postwar intellectual life in Europe'.[35] She remained alone in realising this for many years. Witnessing some of the Eichmann Trial in Jerusalem in 1961, she identified in Eichmann, the man and the type, a new kind of crime that exceeded the models of evil inherited from theologies and enshrined in judicial systems based on *mens rea*: intention. Here is Butler on Arendt's arguments about the trial:

> Her argument was that Eichmann may well have lacked 'intentions' insofar as he failed to think about the crime he was committing. She did not think he acted without conscious activity, but she insisted that the term 'thinking' had to be reserved for a more reflective mode of rationality.

This helps us to disentangle the rationality according to which actions are undertaken by bureaucracies from the obligatory act of thinking about the implications of these actions, not according to the rationale offered by the institution but in relation to a common court of human social and personal responsibility. Butler continues in a manner that we recognise in current systems:

> Arendt wondered whether a new kind of historical subject had become possible with national socialism, one in which humans implemented policy, but no longer had 'intentions' in any usual sense. To have 'intentions' in her view was to think reflectively about one's own action as a political being, whose own life and thinking is bound up with the life and thinking of others. So, in this first instance, she feared that what had become 'banal' was

non-thinking itself. This fact was not banal at all, but unprece-
dented, shocking, and wrong.

Corporatisation is the cultural arm of the economic rationality that
is permeating our institutions, including the university. Reviews,
research assessments, and promotion committees are instruments
requiring of each one of us a performance adequate to the targets
that are specified for grade and position. Higher ranking is not a
reward for long dedicated service but a new set of ever higher tar-
gets that must be constantly met, on an annual review basis, to
ensure that I am maintaining and advancing the institutional mis-
sion and its status in the competitive world of grabbing research
income, fee-paying students, and other signs of brand development.
The space for any kind of political resistance is deemed a symptom
of a poor attitude, a failure of performance, or a difficult personality
and hence must be isolated and muted. I know this seems a huge
jump, but there are resonances that we must not miss. Butler again:

> So if a crime against humanity had become in some sense 'banal'
> it was precisely because it was committed in a daily way, system-
> atically, without being adequately named and opposed. In a
> sense, by calling a crime against humanity 'banal', she was trying
> to point to the way in which the crime had become for the crimi-
> nals accepted, routinized, and implemented without moral re-
> vulsion and political indignation and resistance.

I am interested in these words: political indignation, resistance, and
moral revulsion. Being part of a rationalist system and schooled for
performance as its acting cog rather than even the proletarianised
exchange of paid labour, we are required to exchange spontaneous
moral responses or political judgements for compliance and pro-
ductivity. So Butler continues,

> Indeed, that for which she faulted Eichmann was his failure to be
> critical of positive law, that is, a failure to take distance from the
> requirements that law and policy imposed upon him; in other
> words, she faults him for his obedience, his lack of critical dis-
> tance, or his failure to think.

Butler then states that Arendt 'thought that nazism performed an
assault against thinking' and argues for the necessity of philosophy
as critical thought:

> But more than this, she faults him as well for failing to realize
> that thinking implicates the subject in a sociality or plurality that
> cannot be divided or destroyed through genocidal aims. In her

view, no thinking being can plot or commit genocide. Of course, they can have such thoughts, formulate and implement genocidal policy, as Eichmann clearly did, but such calculations cannot be called thinking, in her view. *How, we might ask, does thinking implicate each thinking 'I' as part of a 'we' such that to destroy some part of the plurality of human life is to destroy not only one's self, understood as linked essentially to that plurality, but to destroy the very conditions of thinking itself.* (my emphasis)

This exaggerates somewhat the current crisis in the universities, whose administrators are not unthinkingly administering racist genocide or anything approximating it, although the deadening effect of excessive administration and endless self-accounting and document writing cannot be underestimated in its daily toll on the ability to think and its cumulative effects on those obliged to perform it at managerial levels. Yet, from Nussbaum's point of view, it is not one racially targeted group whose humanity is under threat but ours, collectively and metaphorically, if the system kills off the teaching and participation in the realms of thought and imaginative analysis that are themselves acts of social, pluralising, empathetic, compassionate engagements with humanised worlds articulated through language, art, music, literature, philosophy, theology, dance, theatre, cultures in their largest senses as creative, generative, critical, reflective, probing, and contingent acts.

All the folks I have been reading to prepare in research for this article value the arts and humanities as the locus of fostering and encountering imagination. They link it with engendering compassion. I have been wary of embracing the 'humanities as education for democracy' argument uncritically, since I do not feel we yet live in or even know the lineaments of full democracy, and they are not yet the achievements of the Western nation-states and certainly are not fully sustained in our university systems: How could they be when universities are inevitably sites of ideological play and contestation? The major theorists have been brilliant at teaching us the dark and dangerous aspects of dominative societies: we know how to diagnose what is wrong. But, as my conclusion, I want to ask if we know how to foster creative, reparative rather than depressive negation.[36] How do we build hope based on enabling students to see beyond the machinic futures being planned for them as performers within economic rationality as the only reality on offer? The hope must be fuelled by an understanding of the continuing work for human justice about which we cannot be austere; we must be thoughtfully profligate. That means exposure to the histories of in-

justice, the images of power, the challenges to authority, the complexity of difference, the possibility of imagining change, and the challenge to whatever world view each one of us mistakes for truth. This project is not the cosy bourgeois claim for individual academic freedom or education as social, class-formed, or personal *Bildung*. It is part of what African-American feminist bell hooks called "teaching to transgress."[37] It takes place in a shared space of direct encounter, in forms of intergenerational and lateral interactions, conversations which have unexpected, incalculable effects. Unless we grapple with this issue by naming the violence of a new kind of subtle but lethal dehumanisation on a global scale through the assault on education as a space of Arendtian 'thinking', we will be held responsible for having not said *NO* loudly or clearly enough. Taking a critical and informed stand against the discourses of excellence, accountability, economic impact, utility to national competitiveness, and austerity, what are our meagre metaphors for imagining what the university could or must now become? My view, shaped by having been a kind of historian all my working life, is that we need a historical perspective that can temper any nostalgia, remind us that struggle is for real, and provide an archive of moments of danger to keep us agitated and of critical thinking to keep us 'thinking'. These offer memories of actions, solidarities, and the political power not of models but of words that carry our deepest and wildest of human hopes for ourselves as planetary subjects. Thus, I want to advocate the work with metaphors and other forms of contact as evidence of creative thought and not submit ourselves merely to disciplining by new models.

NOTES

1. Fred Zinneman, dir., *Oklahoma!* (Rodgers & Hammerstein Pictures, 1955).
2. John Ford, dir., *The Grapes of Wrath* (Los Angeles: Twentieth Century Fox, 1940).
3. Robert Wise, dir., *The Sound of Music* (Los Angeles: Twentieth Century Fox, 1965).
4. Hannah Arendt, *Men in Dark Times* (New York: Mariner Books, 1970).
5. Hannah Arendt, 'The Crisis in Education', in *Between Past and Future: Eight Exercises in Political Thought* (London: Penguin Books, 1977), p. 166.
6. Arendt, 'The Crisis in Education', p. 196.
7. Hannah Arendt, *On Revolution* (London: Penguin Classics, 1991), p. 217.
8. Griselda Pollock and Max Silverman, ed., *Concentrationary Memories: Totalitarian Terror and Cultural Resistance* (London: I. B. Tauris, 2013).

9. Griselda Pollock, 'Introduction', in Pollock and Silverman, *Concentrationary Imaginaries*, pp. 1–46. Jacques Lacan is one of the thinkers to formulate the notion of a concentrationary social bond in post-war society.

10. David Rousset, *L'Univers concentrationnaire* (Paris: Éditions de Pavois, 1946; rpt. Paris: Hachette/Pluriel, 2008); David Rousset, *The Other Kingdom*, trans. by Ramon Guthrie (New York: Reynal and Hitchcock, 1947); David Rousset, *A World Apart*, trans. by Y. Moyse and R. Senhouse (London: Secker & Warburg, 1951); Hannah Arendt, 'The Concentration Camps', *Partisan Review* (July 1948), 743–63.

11. Hannah Arendt, *The Origins of Totalitarianism* (New York: Harcourt, Brace & Co., 1951), pp. 437–38.

12. Zygmunt Bauman, *Modernity and the Holocaust* (Cambridge: Polity, 1989).

13. Saul Friedländer, *Nazi Germany and the Jews: The Years of Persecution, 1933–39* (New York: Harper Collins, 1997).

14. Bill Readings, *The University in Ruins* (Cambridge, MA: Harvard University Press, 1997).

15. Marilyn Strathern, *Audit Cultures: Anthropological Studies in Accountability, Ethics and the Academy* (London: Routledge, 2000).

16. Strathern, *Audit Cultures*, p. 3.

17. Strathern, *Audit Cultures*, p. 3.

18. The phrase 'mission creep' was first used in the military context of a United Nations peace mission during the Somali civil war in articles in the *Washington Post*, 15 April 1993, and the *New York Times*, 10 October 1993. The term refers to the unforeseen or unplanned expansion of a mission beyond its initially established objectives once certain success has been achieved with the original aims.

19. The concept was mobilized by British prime minister David Cameron during his first term of office (2010–2015); it is associated with 'integrating the free market with a theory of social solidarity based on hierarchy and voluntarism' in Alan Walker and Steve Corbett, 'The "Big Society": Neoliberalism and the Rediscovery of the "Social" in Britain', SPERI, 8 March 2013, http://speri. dept.shef.ac.uk/2013/03/08/big-society-neoliberalism-rediscovery-social-britain [accessed 29 September 2015].

20. James Ladyman, 'Don't Play with Academic Freedom', *New Statesman*, 30 March 2011, http://www.newstatesman.com/blogs/cultural-capital/2011/03/ society-research-ahrc-arts [accessed 23 January 2012] [my emphasis].

21. R. D. Anderson, 'Germany and the Humboldtian Model', in *European Universities from the Enlightenment to 1914* (Oxford: Oxford University Press, 2004).

22. The parodic indictment of the hollowness of this freedom was articulated in one of Karl Marx's semi-humorous passages in *Capital: A Critique of Political Economy: Volume One*, intro. by Ernest Mandel, trans. by Ben Fowkes (Harmondsworth: Penguin Books in association with New Left Books, 1976): 'When we first leave the sphere of simple circulation or the exchange of commodities, which provides the 'free-trader vulgaris' with his views, his concepts and the standards by which he judges the society of capital and wage-labour, a certain change takes place . . . in the physiognomy of our *dramatis personae*. He who was previously the money-owner now strides out in front as the capitalist; the possessor of labour-power follows him as a worker. The one smirks self-importantly and is intent on business; the other is timid and holds back, like someone who has brought his own hide to market and has nothing else to expect but—a tanning' (p. 280).

23. Zygmunt Bauman, *Liquid Modernity* (Cambridge: Polity, 2000).

24. Jacques Rancière, *Disagreement: Politics and Philosophy*, trans. by Julie Rose (1998; Minneapolis: University of Minnesota Press, 2004); Chantal Mouffe, *Agonistics: Thinking the World Politically* (London: New Left Books, 2013).

25. Gayatri Chakravorty Spivak, 'French Feminism in an International Frame', *Yale French Studies* 61 (1981) (reprinted in *In Other Worlds: Essays in Cultural Politics* [London: Routledge, 1988], pp. 134–53 [p. 134]).

26. Readings, *The University in Ruins*, p. 5.

27. Jean-François Lyotard, *The Postmodern Condition: A Report on Knowledge*, trans. by Geoff Bennington and Brian Massumi (1979; Minneapolis: University of Minnesota Press, 1984).

28. Martha Nussbaum, *Not for Profit: Why Democracy Needs the Humanities* (Princeton, NJ: Princeton University Press, 2010), pp. 1–2.

29. Gayatri Chakravorty Spivak, *The Death of a Discipline* (New York: Columbia University Press, 2005).

30. Spivak, *The Death of a Discipline*, p. 100.

31. Spivak, *The Death of a Discipline*, p. 72.

32. Spivak, *The Death of a Discipline*, p. 72.

33. Spivak, *The Death of a Discipline*, p. 73.

34. Judith Butler, 'Hannah Arendt's Challenge to Adolf Eichmann', *Guardian*, 29 August 2011, http://www.guardian.co.uk/commentisfree/2011/aug/29/hannah-arendt-adolf-eichmann-banality-of-evil [accessed 30 August 2011].

35. Hannah Arendt, 'Nightmare and Flight', in *Essays in Understanding* (New York: Harcourt Brace, 1992), pp. 133–35 (p. 134).

36. I am invoking here the work on Eve Kosofsky Sedgwick on the difference between a paranoid academy and the work of reparative reading, turning pessimism into creative thought. Eve Kosofsky Sedgwick, 'Paranoid Reading and Reparative Reading, or You're So Paranoid, You Probably Think This Essay Is About You', in *Touching Feeling: Affect, Pedagogy, Performativity* (Durham, NC: Duke University Press, 2003), pp. 123–51.

37. bell hooks, *Teaching to Transgress: Education as the Practice of Freedom* (New York: Routledge, 1994).

SIXTEEN

The Teleology of Education and the Metaphysics of Contingency

Peter Thompson

The purpose of this chapter is to give a more philosophically and politically considered appraisal of not only the socio-economic pressures currently being exerted on higher education but also the philosophical and ideological background to those pressures. I discuss the issues of use value and exchange value in their Marxian sense and apply them to higher education policy. In addition, it is important to understand the original theme of the conference out of which this chapter arose, namely, the nature of the concept of teleology itself.[1] In approaching this question I take an approach grounded in an Ernst Blochian processual reading of G. W. F. Hegel, Heinrich von Kleist, Karl Marx, and Slavoj Žižek. The reason for doing so is to show that we are dealing here with not just a conjunctural crisis in education but a structural shift in the way that Western societies understand and perpetuate themselves—indeed, in the pursuit of education at all levels. The crisis in tertiary education and the shift towards commodification has to be seen in its wider historical context of a shift from the primacy of politics to the primacy of economics since the mid-1970s.

In the first part of this chapter, I deal with the question of the nature of value itself. The term 'value' is much misunderstood, traversing as it does both socio-economic and ethical/moral fields.

Consequently there is a great deal of confusion about what value actually means in educational terms. I have used Marx's distinction here of the difference between use value and exchange value. Of course the entirety of his economic system is based on this distinction, but I think that it can be usefully applied to questions of value within education in general and tertiary education in particular.

The greatest problem is encountered, however, when we specifically look at the evaluation of the role and function of the humanities. Where it may be possible to see science, technology, engineering, and mathematics subjects as adding great economic value in terms of training as well as education, it is far more difficult to adduce precisely what the humanities' contribution is. Those of us working in the humanities are constantly required to justify what we do in terms of its economic benefits, even though the evidence is widespread that employers are more than happy to take on humanities graduates, as they have learned intellectual skills that can be applied to the individual specific areas those employers require.

However, given that it is impossible to calculate the economic value of what a humanities degree gives a student, it will be my contention here that we should not spend any time at all on making that calculation and instead concentrate on teaching people to think critically. The most important thing to realise is that the commodification of tertiary education has not come about as some sort of ineluctable force of nature; it is part of a shift in the way capitalist societies have developed since World War II. I shall show how the period from 1945 to 1975 was a relatively short exception to the rule that the state should keep out of the running of the economy in pursuit of social aims. From the mid-1970s onwards, a new policy of the prioritisation of the needs of the market over the needs of society as a whole has been pursued. What we have seen has been the fulfilment of Marx's contention that capitalism represents the shift from use value to exchange value. In this model, only that which can be exchanged as a commodity has value, and it is this development that underpins all educational policy today.

The second part of this chapter deals with the question of teleology itself. This term is normally taken to describe a process predicated on arrival at a pregiven end point. Everything that happens, therefore, is merely a predetermined stepping stone in the process. My analysis in this chapter restores the processual back into the process. In this scheme the end point arrived at is not pregiven but the product of contingent processes. We all live everywhere and at all points in history at teleological end points. However, just as with

the process of evolution, any prefigured design is removed, and teleology becomes indeterminate going forward and retrospectively constructed looking back. I call the way in which we identify and explain these processes a 'metaphysics of contingency'. The ways in which we ascribe meaning to random patterns lies at the heart of the concerns of the humanities, and any attempt to create a 'telos of education' in which the aim is merely to create an army of well-trained but docile workers is to be rejected. I conclude that education must remain open, non-predetermined in its approach and outcomes and a process of fulfilment rather than simply conformist adherence to a career path.

FROM USE VALUE TO EXCHANGE VALUE

A thing can be a use value, without having value. This is the case whenever its utility to man is not due to labour. Such are air, virgin soil, natural meadows, &c. A thing can be useful, and the product of human labour, without being a commodity. Whoever directly satisfies his wants with the produce of his own labour, creates, indeed, use values, but not commodities. In order to produce the latter, he must not only produce use values, but use values for others, social use values. (And not only for others, without more. The mediaeval peasant produced quit-rent-corn for his feudal lord and tithe-corn for his parson. But neither the quit-rent-corn nor the tithe-corn became commodities by reason of the fact that they had been produced for others. To become a commodity a product must be transferred to another, whom it will serve as a use value, by means of an exchange.) Lastly nothing can have value, without being an object of utility. If the thing is useless, so is the labour contained in it; the labour does not count as labour, and therefore creates no value.[2]

The central question here is, are we, as academics, students, intellectuals, against the value of what we do? Of course not, in an intrinsic sense; we value our own activities very highly. But do our activities have any use value? And if they do, do we then simply exchange them in a way that turns them into commodities? And if so—and we do in the sense that we sell our ideas in return for a wage; education has always been a commodity in a commodified system—in what sense can we be against value? By entering into a relationship of knowledge exchange within a capitalist society, we are by definition accepting that the commodities we produce must have both use and exchange value. Whether we like it or not, we are

supping with the devil, and our spoons are getting shorter by the day.

All societies generate a surplus. Depending on the productive nature of a given society, or rather the nature of the productive forces and the social relations of production in that society, then the surplus will be distributed differently. The one common and unchanging invariant of direction with regard to the distribution of surplus is that a major part of it will always be appropriated by the ruling group in society, and this group will see this appropriation or expropriation as a natural law. The very fact that those who are in charge use the argument of the dustman, who is apparently fed up with paying his taxes for people like us — lecturers and students — to sit around discussing metaphysics or Gothic literature, shows that they have already recognised that the surplus we are living from is generated by the labouring efforts of the working class. It has never been my experience, however, that these infamous dustmen and street cleaners have ever resented the fact that they pay taxes that go to higher education.

Indeed, Sheffield University itself was founded by ordinary working people paying voluntarily into a fund for the creation of a university for the city. I was a soldier in the British army and also a heavy goods vehicle driver for seven years, and there was not one moment during those years that I thought for a second that universities had to make sure that a proper audit trail was carried out and that each department put forward a fully watertight aims-and-objectives statement. No, instead I had aspirations to go into higher education, and it didn't occur to me to resent those working in higher education for sucking up my taxes. This is an ideological cloud that has been put out by a class that wishes to gather to itself ever more of the surplus that our labour creates. Value to this class is only that which can be measured in pounds, euros, or dollars. And that is the law of value that we do not want to see prevailing in education. We are not against value; we are against commodified exchange value being ascribed to the processes and outcomes of our vocation. And despite what is being said by many who are wedded to the current ruling class, we should be proud that what we do cannot be measured in terms of commodities rather than apologising for it or — as is the case at the moment — trying to apply the economics of industrial or service-sector provision to it.

This may be a Marxist commonplace, but nevertheless it is one that is often forgotten in an age when class, at least until very recently — with the appearance of blue-collar Tories, United Kingdom

Independence Party proletarians, and aspirational Labour—seemed to have disappeared from intellectual debate and theoretical discussion. In the current economic crisis of capitalism which we are all experiencing, both within our own society and, of course, across the world as a whole, questions about the distribution of the surplus have once more come to the fore.

Any glance at an intellectual discussion about the nature of education immediately turns to the question of utility and the value of what it is we do as educators. The idea that education should be commodified, turned into merely a tool for and more efficient exploitation of human labour, albeit intellectual human labour, should not surprise us in any way at all because the extension of 'generalised commodity production'—Marx's basic description of capitalism—has grown to an extent that I think even he failed to appreciate fully. Commodity production and exchange have become the only and final arbiters of value in all spheres. Use value is no longer of any use. Of course education was always a commodity in the sense of being a means to train and educate a workforce, but one thing we need to make clear before embarking on any discussion about utility, value, and education is that the economic base from which we are operating is one in which ideological decisions have already been made about the distribution of the surplus.

It is not that there is no surplus anymore, that indebtedness has somehow swallowed up the productive surplus, but that the massive surplus being generated by capitalism is being distributed in a way which does not allow for the continuation of the social programs which dominated in the thirty years after World War II, the "Trente Glorieuses" as the French call them. Most of our ideas about education can be traced back to the attitude of that expansionary post-war boom from 1945 to the mid-1970s in which constant upwards growth in the major industrial countries provided the surplus that enabled the expansion of the mass higher education system. Within that system, there was the consolidation of a productivist ethos. The white heat of the scientific revolution spread around Europe and the advanced industrial world, in both West and East. This dialectical relationship between production, the production of surplus, and the use of the surplus produced in order to bolster production itself through scientific technological and educational development could be maintained as long as the economic base was there to provide for it.

However, this expansionary productivist model was also based upon the inclusion of a class dynamic that was also entirely new.

The thirty glorious years involved a degree of class integration and social thinking which constantly raised wage levels across society. The educational needs of the system were such that a largely illiterate mass industrial working class became less and less important and the development of an educated or at least well-trained working class gained ground. This positive dialectic of production meant that ever more surplus was being generated, and within the surplus the amount being dedicated to education also grew. However, within even that surplus there was a secondary surplus which could be dedicated to the pursuit of knowledge for its own sake and which was not necessarily linked to productivity, although it is also the case that general education in the humanities plays an economic role. It is this surplus within the surplus which is under discussion and which has been identified by the new neo-liberal ruling class raised on Milton Friedman and Friedrich Hayek as a surplus which is surplus to requirements.

In the 1970s, a fundamental change took place in the organisation of capitalism in the Western world. Starting with the Chicago School and a general monetarist shift first tested out in Chile after the Augusto Pinochet coup in 1973, a decision was taken—and we should not shy away from saying that this was a deliberate policy rather than just an organic development—to shift investment away from the productive sector in the advanced industrial world to areas where the surplus could be produced using cheaper labour and cheaper raw materials. This meant that education could be downgraded but also massified. The desire to seek the improvement of the generality, exemplified by those people of Sheffield who funded the city's university, was overtaken by a desire to make sure that more people were trained to take a place in an increasingly service-orientated economy. The shift of policy in the mid-1970s brought increasingly utilitarian approaches. There are many reasons for considering this to be the turning point (the end of the Bretton Woods system of monetary management, the shift away from the gold standard, the shift of investment into speculation, and so forth), but it also went hand in hand with a shift in political ideology. It is from this date that we can see the rise of monetarism, neoliberalism, and, in the United Kingdom, Thatcherism, the highpoint of which we are only now just beginning to live through.

As former US secretary of labour Robert B. Reich has shown, for example, a shift has taken place quite clearly: pay and productivity rose roughly in line with each other between 1947 and 1979. 'We created', he writes, 'a virtuous cycle in which an ever growing mid-

dle class had the ability to consume more goods and services, which created more and better jobs, thereby stoking demand.' Since then, growth in average hourly pay has lagged far behind productivity, resulting in ever-larger household debts, while successive governments have deregulated, privatised, and cut investment in infrastructure and public services.[3] Thinking of it in purely educational terms, the things which we now accept within the educational agenda—student loans rather than grants, the culture of management within education, the audit culture—were only tentatively introduced under Margaret Thatcher but have been deepened by successive governments of all colours.

I went to university from 1983 to 1987, considered to be the heyday of the Iron Lady. But I was a mature student; I had just finished driving lorries for three years and had been in the army for five years before that. I was awarded a full mature student's grant, had my travel expenses paid, and was actually earning more as a student than I had as a lorry driver. That probably says more about lorry drivers' wages in 1982 than it does about the generosity of student grants at that time, but the point stands that governments since the mid-1970s, including most disastrously the Tony Blair and Gordon Brown governments, have driven through the process of the privatisation and commodification of education in a way which was previously unthinkable. Margaret Thatcher wasn't able to go as far as she undoubtedly would have liked or, indeed, as far as her economic advisers were urging her, but she played the long game, and that long game has now paid off.

Let us make no mistake: a new class now runs the world, a class which is dedicated to the increased generalisation of commodity production, the subordination of all productive activity to the making of money, and the destruction of any ability of masses of people to work for their own improvement. Just at the point when technological development has provided the means to liberate people from work, globally more people than ever have become proletarianised. This can be demonstrated by the fact that for the first time in human history, more people live in cities than in the countryside. If we are really going to argue against value in the humanities—which actually means the commodification of the humanities—then we have to be prepared to take on the way in which the whole of the economy and society is being increasingly turned into one of the universalised system of commodity production. The struggle against value in education is a struggle for putting abstract and ethical value back into society.

I don't want to sound too much like Slavoj Žižek, but when we are attacked as being an unnecessary, valueless excrescence with a parasitical existence on the backs of those who 'create exchange value', I would say that we have to celebrate our excrescence and revel in the fact that—using the measures of value that are predominant in this system of generalised commodity production—we are of no practical use to anyone.

The reason we should celebrate it is that the very uselessness (in commodity terms) of the humanities marks out humanity. From cave drawings onwards, the ability to reflect on the world, to make sense of the world, to interpret discernible patterns in random contingencies, to create meaning out of random processes, taken together with the capacity to transform that environment through conscious labour, is the very stuff of being human. Value therefore emerges out of the evolutionary and purposeless development of our species. That is our *Gattungswesen*.

In many ways we are living through a new dark age in which the humanities' function is similar to that for which universities were created in the first place—namely, to serve as repositories of abstract knowledge in the hands of a useless bunch of monk-academics who were entirely dependent on the rest of society for their upkeep. Without those monasteries, those colleges, our knowledge about what it is to be human would be poorer. Whereas, before, academia survived in the face of religious and seigniorial authority, now it has to survive in the face of a market dictatorship in which the only value is market value.

What is monstrous about this new dark age, however, is that this time the population is being urged to turn against the monks, to attack and denigrate them, to see them as surplus to requirements—to be envious of our wages, working conditions, pensions. Of course, this divide and rule is a tried-and-trusted method of social control and has a long history in Britain. This is probably one of the few countries in the world in which the phrase 'too clever by half' could even be dreamed up, let alone used in everyday discourse. 'Intellectual' in the Anglo-American world has become a term of abuse to an extent not seen, I would argue, since Germany in the 1930s.

So the question is, what are we in favour of in the humanities? We cannot just retreat into the monasteries, lock the gates behind us, and hope that we will be left alone. The monasteries have been taken over by the management consultants too. They have pursued us into our very monastic cells to control what we wish to achieve

intellectually. Indeed, left to the marketeers, our monastic cells would be abolished in favour of open-plan office space. When the new humanities building was being designed at the University of Sheffield, architects and management noted with regret that we had an 'immovable requirement for small, cell-like offices'.[4] (Actually we would have preferred large, cell-like offices.) And there has been a long-standing desire on the part of market authoritarians to control curriculum, tenure, and output through such invidious systems as the Research Assessment Exercise and the Research Excellence Framework.[5] Similarly, in the United States, direct control of what academics do is well underway.[6]

We can perhaps approach this problem by asking what the concept of the 'teleology of education' means. I think this generally refers to a teleology that has a distinctive telos. The desired telos of capitalist hegemony is the universal commodification of society and, with it, the commodification of education and knowledge. We are against this form of value.

But properly understood teleology has to be rescued from its own prefabricated telos.

Heinrich von Kleist wrote a little essay in 1805 titled 'Die Allmähliche Verfertigung der Gedanken beim Reden', in which he pointed out that the end product of our thoughts is actually conditioned by the process of moving forward from an original position through speech.[7] In the twentieth and twenty-first centuries, we might call this autopoiesis, the self-generation of an idea out of the ideas which created it, a concept originally taken from evolutionary biology. So rather than see education as heading towards a pre-existing telos, I would try to do a bit of a philosophical two-step which locates the telos, the outcome, back in the process of its own becoming. In a sense I wish to do what Žižek does in *Less Than Nothing* and restore honour to teleology by making it retrospective.[8]

We live constantly in a teleological moment in that everything that has led up to this moment, here, now, was not in any sense necessary but the result of multiple, probably infinite numbers of contingent events. However, once we arrive at this point, this moment, we tend to think that everything that happened to get us here was necessary. Yet none of that necessary process was necessary. It was a non-necessary necessity. We are our own telos, and everything that we know about the world and everything that the world is, is its own telos. This provisional telos is composed of nothing more or less than all the contingent moments, all the contingent building blocks that led to its construction. What is constructed, in

the end, is not an architect's plan but the result of the process of construction. The story we tell about this open process is what I call a metaphysics of contingency.

Ernst Bloch maintains that as a result we live in 'the darkness of the lived moment', not quite sure how we got here and with no idea where we're going.[9] All that we have, Bloch says, is an innate 'invariant of direction' towards self-liberation. We are confronted then with the old Kantian question of whether we can stand outside the darkness of our own lived moments to look at the process of which we are only a tiny part. That is what all philosophy does; that is what all culture does; that is what thought does. I would go further and say that that is all that thought *should* do. Our over-evolved nature made us into a particularly advanced type of pattern-identifying animal who creates its own life through consciously directed and applied labour. By attempting to step outside the darkness of our own lived moments, we attempt to illuminate the patterns by which we have arrived at this point; more importantly, we try to lay down patterns of where we might be going in the future. In other words, we try to create a metaphysics of contingency, a convincing story about a meaningless process, an attempt to give meaning to that meaninglessness.

In his original e-mail to me about this project, Sam Ladkin wrote, in Kleistian form, 'Perhaps art is more like knowledge if knowledge is conceived to be more like the experience of art than it is the objects of art.' To me this is a restatement of Kleist's position, that the experience and the process are more important than the outcome. And yet we live in a society and work in a university sector that is outcome obsessed. That's understandable, given that we have gradually moved to a pay-as-you-go system of education. People want to know that they are getting value for their money. Our task is to convince them that the absence of exchange value is the very thing that guarantees use value, or value that is merely an expression of human self-liberation.

The value of the arts and humanities lies in the fact that they have no value other than as an attempt to unravel the secrets of the processes of contingency and to unpick the stitches of teleology and outcome. In that sense I think we need to perhaps reverse the title of this project and commit ourselves to the education of teleology rather than the teleology of education and ask how we can rescue teleology from the future-orientated and instrumental telos by making it purely retrospective. It is the case that a culture that asks its thinkers and academics to describe their outcomes before they have even set

off on the journey is bound to lead to this denuding of open discovery. In the same way we should rescue the concept of transcendence by abandoning the transcendent and—to go in a complete Hegelian circle—rescue the metanarrative from the telos. The journey undertaken to discover a truth actually produces any truth that emerges.

However, a retreat into irrationalism simply because the rational already seems to be irrational is not the answer now any more than it was when Dada tried it. The retreat from excess realism and pragmatism represents not a negation of the negation but only a deepening of the original negation. The answer has to be found in a deepening of rationality, a commitment to modernity, the Enlightenment, progress, but this time removing from all of those things any automaticity or dogmatic teleological end points. That way we can maintain a commitment to the teleology of education, but only by seeing education as the unravelling, unfolding, and development of an as yet incomplete and unknowable telos. Kleist's gradual completion of thought in the process of talking thus comes back to a gradual completion of education in the process of learning. Our job is to provide the means by which humanity investigates its own ontological nature and by which we fit into the universal and, in doing so, change it. Our real purpose is to make sure that change represents the negation of the negation expressed in the commodification of knowledge. We are indeed an excrescence, a surplus within the surplus, an irrelevance within an irrelevance, and that is what is really great about what we do. To be against value is therefore of great value, but only if we understand value as the negation of utility.

It is for that reason that I say that we should revel in our uselessness. We have use value, but we are not a commodity; we provide a service, but we are not servants. *We are useless, but we are vital.*

NOTES

1. Editor's note: This chapter was first presented at the 'Against Value in the Arts and Humanities' symposium, University of Sheffield, 23 February 2012. In advance of the event, Sam Ladkin and Robert McKay circulated a brief position paper, which included the following prompt against the teleology of education: 'The end-point of education (knowledge) cannot (must not?) be determined in advance'.

2. Karl Marx, "Capital: Volume One," Marxists Internet Archive, https://www.marxists.org/archive/marx/works/1867-c1/ch01.htm#S1 [accessed 1 September 2015].

3. Robert B. Reich, 'The Limping Middle Class', *New York Times*, 3 September 2011, http://www.nytimes.com/2011/09/04/opinion/sunday/jobs-will-follow-a-strengthening-of-the-middle-class.html?_r=2&partner=rssnyt&emc=rss [accessed 1 September 2015].

4. Kieran Long, 'Sheffield's Jessop West by Sauerbruch Hutton and RMJM', *Architects' Journal*, 27 February 2009, http://www.architectsjournal.co.uk/news/sheffields-jessop-west-by-sauerbruch-hutton-and-rmjm/1994403.article [accessed 1 September 2015].

5. Editor's note: For an explanation, see note 1 in Marilyn Strathern's contribution to this volume.

6. Monica Davey and Tamar Lewin, 'Unions Subdued, Scott Walker Turns to Tenure at Wisconsin Colleges', *New York Times*, 5 June 2015, http://www.nytimes.com/2015/06/05/us/politics/unions-subdued-scott-walker-turns-to-tenure-at-wisconsin-colleges.html [accessed 1 September 2015].

7. Heinrich Von Kleist, 'On the Gradual Completion of Thoughts during Speech', trans. by Michael Hamburger, *German Life and Letters*, 5.1 (1951), 42–46.

8. Slavoj Žižek, *Less Than Nothing: Hegel and the Shadow of Dialectical Materialism* (London: Verso, 2013).

9. See Ernst Bloch, *The Principle of Hope*, trans. by Neville Plaice, Stephen Plaice, and Paul Knight (Cambridge, MA: MIT Press, 1995).

SEVENTEEN

Value

Critical Pedagogy, Participatory Art, and Higher Education — a New Measure and Meaning of the Common(s)

Mike Neary

In this chapter I seek to address the fundamental question at the core of *Against Value in the Arts and Education*: How can we oppose the dominant and dominating ascriptions of value in ways that are rigorous and constitutive.[1] I argue, *contra* the editors of this volume, that this opposition can be based on the recognition of value as 'a common measure', where value is understood as an organising function that mediates all aspects of social life, including the arts and humanities, and that this form of common measure can be subverted to create a new measure and meaning of the common(s).

The idea of value as a common measure in the arts and humanities is problematic. In the UK policy sector, the issue of value lies between an understanding of the arts and humanities in terms of cultural and social rather than economic values. Cultural and social values are based on moral, ethical, and aesthetic principles and ideas as a guide to action, intertwined with ideological and political discourses. Economic values are largely a question of utility and personal satisfaction set alongside the price of an artistic object in an art market where the logic is financial gain rather than cultural or

social values, however they are defined. All forms of value are so-cially constructed, so ideas of intrinsic, instrumental, and institu-tional value are hard to pin down.[2] This debate about the value of value is taking place at a time when funding for the arts and hu-manities is being reduced and when economistic values are over-whelming cultural and social values in a situation that has been described as an arts emergency.[3]

My conceptualisation of value as 'a common measure' is derived from 'a critique of value', representing a reinterpretation of Karl Marx's social theory referred to variously as capital-relation theory, value-form analysis, a 'new reading of Marx', and communisation. In this approach, value is understood not as a moral, ethical, or aesthetic issue, or even as a political or economic matter, but, more fundamentally, as the law of value and of the social forms in which it appears (e.g., the commodity, labour, money, and the state). The law of value is the organising principle for capitalist society and, therefore, is key to understanding how social relations are mediat-ed, how types of social regulation are established, and how these forms of regulation can be radically transformed. An important part of this approach is that the social forms that value takes can be extended beyond a critique of political economy to include the arts and humanities, as well as political philosophy and even cognitive thinking itself. The radical transformation of value means the estab-lishment of a new form of value, or social wealth, based not on the law of value's principles of scarcity and poverty but on a 'society of abundance' that extends to all areas of social life: not a common measure but a new measure and meaning of the common(s).[4]

I illustrate the possibility of creating a new measure and mean-ing of the commons through a case study about an experiment to create a new form of social wealth that attempts to counter the capitalist law of value. The Social Science Centre (SSC) in Lincoln is a co-operative providing free higher education, established in 2011 as a critical response to higher education policy in England, where universities have been forced to become increasingly financialised institutions.[5] The centre adopts a form of critical and participatory pedagogy, much inspired by the artist Joseph Beuys, who said, 'To be a teacher is my greatest work or art', and the Free International University for Creativity and Interdisciplinarity, which he estab-lished in Düsseldorf in 1973.[6] I elaborate the approach to value on which the centre is based through a critical engagement with Claire Bishop's *Artificial Hells*. Bishop draws heavily on the work of Jacques Rancière, particularly his ideas about the politics of aesthet-

ics, to construct a critique of participatory art based on ethical and moral values. For Bishop, art should be considered as a site for emancipatory spectatorship, promoting politicised art and critical education in ways that are less prescriptive and genuinely more challenging, troubling, and compelling.[7]

I base my critique of Bishop's approach to value on value-form theory; this includes a recognition of Rancière's contribution to this type of Marxist analysis, together with an interpretation of Walter Benjamin's approach to the politics of participation and other Marxist writers discussed in Bishop's book, including Guy Debord and Paolo Freire. I argue that the types of artistic political disruption Bishop wants to encourage need a more fundamental reappraisal of value as a matter not only for the emancipated spectator but also for the emancipated producer.

CRITIQUE OF VALUE

My interpretation of Marx's social theory is based on an approach to Marx that has been developed in Europe since the 1960s and 1970s based on a close reading of his texts by scholars as part of ongoing recovery of his substantial archive: the Marx-Engels-Gesamtausgabe Project.[8] What distinguishes this version of Marx from traditional or mainstream Marxism is that it takes the concept of value rather than class or alienation or the economic base and superstructure metaphor as its starting point; from there it seeks to deconstruct the main categories of political economy—labour, commodity, and money capital—to reveal that capitalism is not a form of economics that has been imposed on society but is, in fact, the basis for all social life, including everyday life outside economic activity and the workplace. Most dramatically, rather than seeing the working class or alienated labour as the basis for revolution, this version of Marx's work sees labour or the working class as itself being determined as a form of capital, and so labour itself must be abolished in order for communism to be established. In this sense, communism becomes not the redistribution of value in favour of the workers who have produced it but, rather, the invention of a new form of social wealth, based not on the equivalence of value distribution but on social individuality defined by the principle penned by Marx: 'From each according to their ability, to each according to their need'.[9]

Marx's exposition of the law of value in chapter 1 of volume 1 of *Capital: A Critique of Political Economy* is at such a high level of theoretical abstraction that it is difficult to discern its contemporary significance.[10] This problem is compounded by the nineteenth-century vernacular in which it is written as well as by its very particular subject matter: the categories of political economy. Yet the relevance of this analysis has not depreciated, not only for political economy but for the forms in which the crisis of capitalism are expressed.[11] The enduring crisis of capitalist civilisation and its revolutionary principle are contained in the explosive relationship that lies at the core of the commodity-form: the contradiction between use value and exchange value. Marx's main contribution to social science is the revelation of this dual character of the commodity-form and its basis as the organising principle for capitalist society. Whatever usefulness (use value) a commodity may possess, the main reason for its manufacture is to be exchanged (exchange value) so that the surplus value created in the process of production can be realised. Surplus value is based on the exploitation of labour power (commodified work) whose exchange value (wages) is less than the surplus value that is produced. The substance of value is abstracted (abstract labour) from any concrete labour (useful labour) activity and measured as an amount of socially necessary labour time, 'a common measure' of general socialised work based on the competitive intensification of the labour process in the moment when exchange takes place. A central aspect of this process is the way in which the earth's resources are exploited as raw materials with no real interest in their sustainability. Exchange overwhelms rationality so that what is essentially a social process appears as if it were natural. Marx refers to this perverse process as commodity fetishism, which is further compounded with the value of commodities appearing as an intrinsic aspect of their real nature. All of this takes place without those involved, as the bearers of social relations, being aware of what is happening, while, at the same time its perverse logic is rationalised through the liberal social sciences as capitalist knowledge and education. Meanwhile, the negative outcomes of this process of valorisation are revealed as ever more tragic manifestations of the human condition and catastrophes beyond the human imagination.

The crisis-ridden nature of capitalist production lies with its inability to maintain its expansive nature. Over the history of capitalism there has been a tendency for machines to replace workers, to avoid class struggle in the workplace and increase productivity.

However, as surplus value is generated only through the exploitation of labour power, there is a tendency for the rate of profit to fall while, at the same time, generating surplus labour: unemployed workers, who have the time and intellectual capacity to imagine forms of production and reproduction based on human need and capacity rather than poverty and scarcity. Attempts to overcome the crisis through the expansion of credit and debt, 'fictitious capital', exacerbate the situation as the speculation on future profits that have yet to be—and may never be—made. The latest expression of capitalist crisis, the Great Crash of 2008–2009, might be regarded as a moment when capital has reached the limit of its expansive capacity, resulting in ever more violent forms of militarised policing as it seeks to control and contain populations that have become surplus to the production of value.[12] So we are now living through an emergency not just for the arts but for capitalist civilisation.

BIOGRAPHIES OF VALUE

The most notable exponents of what has become known as the 'critique of value' or a 'new reading of Marx' emerged in Germany in the 1960s and 1970s. This was first seen in the work of Helmut Reichelt, for whom, according to Werner Bonefeld, 'the value-form expresses the abstract essence of capitalism [which] vanishes in a constant movement of forms', and of Hans-Georg Backhaus, who argued for a reconstruction of 'the method of dialectical development [that] depends upon a satisfactory resolution of the problem of "the universal character of value"'.[13] This work was further developed by Robert Kurz, Roswitha Scholz, Ernst Lohoff, and other writers existing outside the academic mainstream around the journals *Exit* and *Crisis*. The main point of their critique of value is to favour an 'esoteric' rather than redistributive reading of Marx in which the value-form is 'fundamental to the functioning of capital and fundamentally incoherent' and has a contradictory nature that is 'operative in the day-to-day functioning of social life under capital', including those aspects of social life not usually theorised in this way (e.g., gender relations).[14] A key point in this approach is that capital has reached the limit of its valorising capacities and has now declared civil war on its own populations.[15]

Another key figure is Michael Heinrich, who has produced a number of key texts around this 'new reading of Marx'.[16] He seeks to recover Marx against what he refers to as 'world view' Marxism

characterised by 'crude economism (ideology and politics reduced to a direct and conscious transmission of economic interests), as well as a pronounced historical determinism that viewed the end of capitalism as inevitable occurrences' and in which the category of worker takes on 'an all identity constituting role'.[17]

The work of Moishe Postone has been predominant in these debates. Postone reads Marx from the perspective of a negative critique of labour, understood as a social form of value (abstract labour) that mediates all social relations as well as constituting forms of social regulation (i.e., money and the state).[18] By developing an approach to Marx's socially necessary labour time that comes close to the Einsteinian concept of space-time, he explains how the value-form becomes increasingly anachronistic as the process of valorisation grinds to a halt.[19] The result is that the abundant capacities inherent in capitalist production overwhelm the market-based logic of social development, providing the possibility for more 'free-time' for the 'social individual'.[20]

In France, a version of value theory was used by Henri Lefebvre to sustain his critical approach to capitalist space and spatiality and served as the basis for Guy Debord's campaign against 'the society of the spectacle'.[21] Debord is perhaps the best known of the value theorists, although his work has been subject to much 'trivialisation'.[22] Debord's work cannot be properly understood unless 'located within Marxist thought in general'.[23] For Debord, value is 'a complete social form that itself causes the splitting of society into different sectors', not simply as economics but as 'a critical theory of contemporary society', or (in the words of Georg Lukacs) 'the point of view of totality'.[24] Debord's work was part of a political project, expressed as radical art and other situations, 'to destroy whatever at present makes life impossible'.[25]

Less known as a value-form theorist is Jacques Rancière. He made a significant contribution to understanding the value form in a paper published in Louis Althusser's *Reading Capital* (1962).[26] The paper, titled 'The Concept of "Critique" and the "Critique of Political Economy" (from the 1844 Manuscript to Capital)', was removed from later editions after the break between Rancière and Althusser.[27] In this paper Rancière uncovers the esoteric system behind the exoteric account of humanist Marxism and against the anthropology that characterised Marx's early work. The esoteric system is based on a capital-centric reading of Marx in which value constitutes the determining causality, as a theory of social form based on the question of why labour takes on the value-form.[28]

In Italy in the 1960s and 1970s, another similar account of the law of value formed the framework for writers in the Autonomia movement, including Antonio Negri and Mario Tronti, even if the category of labour was not fully deconstructed,[29] and American academics, such as Harry Cleaver, used a version of value theory as the basis for their critique of political economy.[30] The key for Autonomia was to move Marx's social theory outside the factory to the 'social factory', so that social struggles are derived from the social relations of production, where labour becomes the revolutionary subject rather than a form of subjugation.

In the United Kingdom this critique of value, usually referred to as capital-relation or value-form theory, was taken forward by scholars attached to the Conference of Socialist Economics and the journal *Capital and Class*, including Diane Elson and Simon Clarke.[31] This work provided a non-functionalist account of the two key instruments of capitalist regulation, money and the state, as institutional forms of class struggle: the capital relation. This formulation based on the capital relation saw the emergence of nation-states as geographical forms of capital with the jurisdiction to contain and control labour through the law of value within a global system of capitalist accumulation.[32]

This interpretation of Marx's value theory, sometimes referred to as Open Marxism, is represented in the work of John Holloway, Werner Bonefeld, and Ana Dinerstein.[33] This work argues that social transformation can be achieved not by capturing the capitalist state for socialist purposes but by dissolving the capital relation and the forms in which capital appears, as forms of regulation, as well as the fetishised categories of class, gender, and race, as a process of non-identification or defetishisation. This is the basis of Holloway's *How to Change the World without Taking Power*.[34]

There is a group of writers in the United Kingdom who are developing their critique of value from outside the academic mainstream, publishing their work in the journal *Endnotes*. A key concept for their new ontology is the idea of communisation. In this approach revolution would not involve workers expropriating the means of production and the redistribution of resources, none of which would do anything to change their condition as workers; rather, 'the revolution as communising movement would destroy — by ceasing to constitute and reproduce them — all capitalist categories: exchange, money, the existence of separate enterprises, the state — and most fundamentally — wage labour and the working class itself'.[35]

An important part of this recovery of Marx's law of value as the key issue for Marxist social science has been the reclamation and bringing to prominence of the work of dissident Marxists writing in this tradition in Europe in the period immediately following the Bolshevik revolution and in the first half of the twentieth century. The work of these writers was forced underground as it did not accord with the orthodox Marxian account of historical and dialectical materialism, which assured the inevitable state-centric triumph of communism over capitalism, with workers in the vanguard of the revolution. All of this dissident Marxist work has a common derivation in a reading of Marx's mature social theory, as expounded in *Capital* and the *Grundrisse*, focusing on the value-form and its derivations: labour, the commodity, and money capital. The most prominent of these interpretations include Georg Lukacs's *History and Class Consciousness*, which declares the commodity form as the organising principle of capitalist society;[36] Isaak Rubin's *Essays on Marx's Theory of Value*, which deals with economic categories not as technical instruments but from the standpoint of their social form;[37] Evgeni Pashukanis's *Law and Marxism*, which seeks to establish a Marxist theory of law out of Marx's critique of political economy;[38] Roman Rosdolsky's *The Making of Marx's Capital*, which provides a comprehensive account of Marx's *Grundrisse*; and Alfred Sohn-Rethel's *Intellectual and Manual Labour*, which identifies value as the non-empirical substance of 'real abstractions' that form the invisible determination of social life.[39] Sohn-Rethel starts from the understanding that 'it is not the consciousness of men that determines their being, but, on the contrary, their social being that determines their consciousness.'[40] Sohn-Rethel seeks to extend Marx's critique of political economy to a critique of 'the traditional theories of science and cognition'.[41] His project is to regain control of science and technology for the benefit of humanity—socialism, or 'the fully developed consciousness of mankind'—and along the way to 'free Marxism from ossification and renew its creative power'.[42]

These readings of Marx see Marxism as an unfinished intellectual and practical project, which involves finding ways to create not only sustainable forms of non-capitalist social wealth but also an ontological framework, or a new way of seeing and knowing, through which this new world of abundance—'from each according to their capacities, to each according to their need'—can be realised and represented. This includes the invention of new concepts and theoretical understandings but also, necessarily, new ways in which these concepts and understandings are presented and represented,

with profound implications for the arts and humanities.[43] This point has been well understood by revolutionary artists for whom the integration of art and revolution has been a very powerful inspiration, including Dada, surrealism, and the Situationist International. The critique of value that I am suggesting should be seen as a contribution to the development of revolutionary art, which is itself unfinished.[44]

In the next section I pursue the relationship between art and value, through an engagement with issues around the nature and meaning of participatory art in the context of the current emergencies in higher education. I do this with reference to the Social Science Centre in Lincoln, an experimental project providing free cooperative higher education based on popular education and participatory pedagogies. The model of value suggested here is substantiated through a critical engagement with the work of Claire Bishop and her attempt to reconceptualise value in art through a politics of the aesthetic.

PEDAGOGY AND PARTICIPATORY ART

Bishop writes about the rise in participatory art across the world since the 1990s, whereby artists are working with the disenfranchised and demoralised communities in ways that resemble theatre, performance, and education.[45] This is not a new activity but part of a project to 'to rethink art collectively' ongoing since 1917 (Russian Revolution), 1968 (student revolt), and 1989 (collapse of communism). More particularly, she situates her work in terms of the political strategy in parts of Europe and the United Kingdom to dismantle the welfare state and the way this was taken forward by New Labour (1997–2010), whose interest in participatory art she understands as 'a form of soft social engineering'.[46] Her work is illustrated with case studies from around the world featuring examples of socially engaged art projects. She is clearly motivated by the current context of higher education as a form of 'academic capitalism' where 'pedagogic projects respond to the different urgencies of the moment'.[47]

A key and controversial aspect of Bishop's work is the concept of quality and its relation to value, which she wants to retain as part of what she calls 'the assumption that value judgements are necessary, not as a means to reinforce elite culture and police the boundaries of art and non-art but as a way to understand and clarify our shared

values at a given historical moment'.[48] Bishop is against a version of
participation and co-production based on ethics and moral inten-
tionality, which focuses on the non-exploitative nature of a worth-
while consensual collaborative process and product.[49] She cites
Walter Benjamin's 'The Author as Producer' as a key text in the
popularising of this notion of participation: 'A work of art is better
the more participants it brings into contact with the process of pro-
duction'.[50] She also describes other Marxist writers in terms of the
same politics of participation, such as Guy Debord, for whom par-
ticipation 'rehumanises a society rendered numb and fragmented
by the repressive instrumentality of capitalist production' through
'constructed situations' as a way of overcoming alienation defined
by its 'participatory structure',[51] and Marxist pedagogue Paolo
Freire, whose key notion she suggests is 'the teacher as co-producer
of knowledge, facilitating the student's empowerment through col-
lective and non-authoritarian collaboration' with 'participation as a
route to empowerment'.[52] Her point is that this emphasis on partici-
pation results in the lack of a 'troubling wake' and an 'aversion to
disruption',[53] undermining the principles that she prefers, 'unease,
discomfort or frustration—along with fear, contradiction, exhilara-
tion and absurdity'.[54]

Bishop seeks to recover the critical political engagement with
this form of art practice through the concept of *aesthetics*, as 'the
undecidability of aesthetic experience implies a questioning of how
the world is organised, and therefore the possibility of changing or
redistributing the world'.[55] This is what is meant by the 'emancipat-
ed spectator'.[56] In this way, following Jacques Rancière, Bishop
foregrounds the ability of the spectator to experience art in a way
that is always political, engaging with the art object itself as the
intermediate thing, rather than with the process of how it was pro-
duced.[57] Thus allowing, in Rancière's terms, for a 'distribution of
the sensible' ('*partage du sensible*') and sharing of 'ideas, capacities
and experiences', encouraging dissensus rather than the consensus
implied by the ethical and moral value judgements which, at the
same time, excludes and makes invisible. And so, in this way, to
'think contradiction', in a manner that 'avoids the pitfalls of a didac-
tic critical position in favour of rupture or ambiguity'.[58] She gives
the example of teaching practice described by Rancière in *The Ignor-
ant Schoolmaster* where he argues that education be organised on a
recognition of 'the equality of the intelligences' between teachers
and students and their capacity to teach each other through a pur-
poseful engagement with a mediating object: a book or a painting.

Key here for Bishop and for Rancière is the object as 'the thing in common' and the object of mediation around which the politics of aesthetics revolves.[59] Bishop is aware of the limits of artistic activity and imagination and the need to connect with other leftist political social movements as part of an 'existing political project (only to a loosely defined anti-capitalism)', following Rancière, as 'the invention of an "unpredictable subject"'.[60] Rancière's esoteric reading of Marxism as a theory of social forms provides the emergent logic for these types of political subjectification, although never formally stated.[61] Bishop is impressed with activity that seeks to express itself in ways that go beyond the institutional form in which artists and educators are working, not just as an exercise in morality but to question the nature of the institution itself, asking the question after Felix Guattari, 'How do you bring a classroom to life as if it were a work of art?'[62] She gives the example of Guattari's radical psychiatric clinic La Borde, with its 'radically de-hierarchised blurring of work identities', 'patient-staff parity commissions, creative workshops and self-management', as a project of disalienation.[63] She sees this as a way of 'rehumanising disciplinary institutions', providing the inspiration for rethinking not only art and education but the places in which they take place by 'inserting itself into the social network' so as 'to trouble the parameters of existing social structures'.[64]

Bishop's work is powerful and provocative but is disabled by its incapacity to countenance value as anything other than a series of political judgements. She fails to understand the extent to which the politics of production and the value form, and not simply participation, are a central issue for the writers out of whose thinking she develops her own critical position. This is much more than seeing 'the signs of Capital behind everyday objects'.[65] For Walter Benjamin, the issue is about not simply participation or commitment but the necessity of refunctioning the process of production out of which capitalist value is 'melted down' as 'the incandescent liquid mass from which the new forms will be cast' as 'revolutionary use-value'.[66] The proletarian revolution would be forged by 'liberating the means of production',[67] the condition of which is 'determined by the state of the class struggle'.[68] Similarly for Freire, emancipation was based not on participation in pedagogic projects but rather on workers taking control of the ownership of the means of production across nation-states in Africa and Latin America.[69] For Debord, the object of his critique was not the disempowered spectator, rescued by a burst of participatory art; rather he was among the first

Marxist scholars to interpret the contemporary world through Marx's labour theory of value and commodity fetishism, recognising that Marx's thought 'is at once a record and a critique of the reduction of all human life to value' and, therefore, 'the only possible basis for understanding the world is to oppose it'.[70]

This incapacity is based on Bishop's commitment to 'a mediating third term', that is 'an object, image, story, film or even spectacle — that permits this experience to have a purchase on the public imaginary'.[71] She also describes this as a combination of the 'perverse, disturbing and pleasurable experiences that enlarge our capacity to imagine the world and our relations anew';[72] in other words, Bishop is preoccupied with 'the thing in common', as if it were a thing itself.

The key theoretical point and difference in my interpretation of value is that while radical politics can be developed through the interpretation of a mediating object (a painting or book or other work of art), the political experience of 'the thing in common' is a starting point for dissensus and disruption that needs to take into account the social process out of which the object has been produced and the way in which value is realised. In other words, value is the social process through which all aspects of social life in capitalism are mediated, including the forms that this process of mediation takes (e.g., money and the state), as well as the categories of capitalist civilisation that lie outside critical political economy. Only through an appreciation of the common measure that underpins the thing in common can a new common measure, as well as a new meaning of the commons, be established. My argument is that given that the basis of the common measure, 'the law of value', is abstract labour based on socially necessary labour time, attention should be focused on the principles and practices of capitalist work.

Benjamin Noys, following Walter Benjamin, argues that the law of value can be undermined through a deconstruction of the organisation of capitalist work, or abstract labour: 'a complete re-inscription and *detournement* of work against work as it is usually conceived', that is, 'the splitting of work from within, by the disruptive working over of "abstract labour"' or 'probing the "truth" of real abstractions as concrete appearances through their negation'.[73] This is a form of 'collective political agency in the contemporary conjuncture' in a way that implies new social forms or better institutions.[74] In what follows I want to set out an experiment in co-operative education that seeks to establish itself as a new form of social institution based on a critique of the law of value and capitalist work.

THE SOCIAL SCIENCE CENTRE, LINCOLN

The Social Science Centre in Lincoln was set up in 2011 as a co-operative providing free public higher education in a direct response to a massive increase in English higher education student fees, up from £3,000 to £9,000, and the withdrawal of public funding for teaching courses in the arts, humanities, and social sciences. The centre has forty full members and more than one hundred subscribers on the mailing list. As a co-operative, the SSC is run by students and teachers as a democratic organisation. Students can leave the centre at the end of their programme with an award at the level of higher education, given not by any formal authorising body but by the academics and students involved with the co-operative. The centre makes use of the public spaces in Lincoln, keeping overheads low, with members making contributions in money or time. No one is paid for the work he or she does. All classes are taught in collaboration with students, on the presumption that teachers have much to learn from their students. Courses include 'Social Science Imagination' and 'Cooperation and Education', as well as programmes involving social photography, art, and poetry. The core subjects are social sciences, broadly defined, with an understanding of the many important connections that need to be made between the social and natural sciences and the arts and humanities if we are to develop a radical critique of higher education to deal with the main emergencies confronting the planet. The centre is actively engaged in furthering a growing network of radical alternatives to higher education as a transnational movement. The SSC has no formal connection with any institute for higher learning.

The SSC has very clear antecedents in the art world, not least Joseph Beuys, who declared, 'To be a teacher is my greatest work of art', along with his creation of the Free International University in the 1970s.[75] However, while Beuys was resolutely anti-Marxist, the SSC contains a very clear commitment to Marxist social theory. The SSC is an attempt to answer Bishop's question, after Guattari, 'How do you bring a classroom to life as if it were a work of art?'[76] The SSC is not an artistic object or artefact, but it is a creative event that seeks to provide a real alternative to the dominant discourses and institutional forms of higher education, together with a reflexive and critical space to imagine what such an alternative might look like. The SSC encourages a politics of the aesthetic with no dogmatic position about its own positionality, promoting dissensus even among its members as to its real aim and purpose. Following Bish-

op's interest in connecting the practices of art education and critical pedagogy, the SSC is attached to Freire's dialogical approach to teaching and learning, as well as to Rancière's promotion of equality of intelligence between teacher and student. But more than that, the Social Science Centre has been developing its own version of revolutionary pedagogy, Student as Producer, grounded in Benjamin's seminal 1934 essay 'The Author as Producer'. Student as Producer goes beyond Bishop's dismissive account of participatory art projects that sees Benjamin's work only as a frame of reference for 'getting closer to the process of production'.[77] Student as Producer extends Benjamin's interpretation of Marx and is grounded in a negative critique of capitalism and the capitalist university: it seeks to transform the social relations of academic production by re-engineering the dysfunctional relationship between teaching and research, while at the same time teaching participants the radical history of the university.[78] Student as Producer sees students as collaborators with academics in the production of critical practical knowledge, building a democratic relationship between teacher and student not only in the classroom but at the level of the institution and society.[79] Student as Producer is an act of resistance against the notion of student as consumer.[80]

The Social Science Centre has similarities to Guattari's La Borde clinic, referred to approvingly by Bishop, in the sense that the hierarchy between student and teacher is dissolved, with a blurring of identity and roles between the two functions, and teaching practice and the work of the SSC are carried forward in the form of self-management. The SSC sees itself as a social intervention grounded in an awareness of its position in the social network as a new form of social institution. The basis of this sociality, and what distinguishes the SSC, is its incorporation as a co-operative, with close ties to the international co-operative movement, as well as a deep understanding of the history of co-operative societies. The co-operative movement's main significance is the way in which worker co-operatives challenge the organisation of capitalist work. The early co-operators in the nineteenth century understood co-operatives in terms of the reorganisation of waged labour: as a movement of transition from association, through co-operation, to communism, which they understood as 'the emancipation of labour from capitalist exploitation'.[81] Marx, too, was in favour of co-operatives:

> The value of these great social experiments cannot be overrated. By deed instead of by argument, they have shown that produc-

tion on a large scale, and in accord with the behests of modern science, may be carried on without the existence of a class of masters employing a class of hands; that to bear fruit, the means of labour need not be monopolised as a means of dominion over, and extortion against, the labouring man himself, and that, like slave labour, like serf labour, hired labour is but a transitory and inferior form, destined to disappear before associated labour plying its toils with a willing hand, a ready mind, and a joyous heart.[82]

However, while co-operatives represent an important moment in the transformation of the social relations of capitalist work, they are not the means by which this transcendence takes place.[83] Nor can they achieve communism on their own; instead, they need to be connected to social movements and other forms of class struggle against neoliberalism and globalisation, organised at the national and international levels.[84]

A NEW MEASURE AND MEANING OF THE COMMON(S): AS RADICAL COMMON SENSE

At the start of this chapter I suggested that 'the common measure of value' could be subverted through a new measure and meaning of commons. I have argued that a new common measure can be established by subverting the law of value through a deconstruction of the organisation of waged labour, and I have given an example, the Social Science Centre, of how this might be done. Work on establishing a new meaning of the commons is already well advanced. The commons has come to mean 'the shared substance of our social being'[85] or 'the rules we use to decide how to share our common resources'[86] and the basis for 'networks of resistance against the capitalist state'.[87] The concept of the commons can be elaborated as 'communal luxury', an idea close to the world of art and the politics of aesthetics, which emerged from the Paris Commune in 1871.[88] In *Communal Luxury* Kristin Ross defines 'public art' as 'the decoration and enhancement of public buildings', but, more than that, art should be democratised so that 'beauty [can] flourish in space shared in common . . . reconfiguring art to be fully integrated into everyday life'.[89] Communal luxury then is more than a politics of the aesthetic and extends the co-operative conditions by which art is made to include all our mundane practical necessities as a way of working and as a '*style* of life'.[90] The understanding of the common

has been further developed through the notion of the 'society of abundance',[91] implicit in the communist slogan 'From each according to their ability, to each according to their need'.[92] This is not 'a Utopian vision but the real possibility of conditions already in existence' and 'keeps the tradition of criticism alive'.[93] The 'critique of value' provides the rationality for the society of abundance and other new readings of Marx, adding an extra dimension to our understanding of the commons, not only as a reorganisation of work and redistribution of resources but by emphasising 'the emancipatory notion of what constitutes wealth in a newly substantiated post-capitalist society'.[94] And more than that, it suggests that however we frame our new Marxist ontologies, the critique of value must be part of a project that seeks to prefigure new forms of social institutions to show there really is another way of thinking about value, not only as a measure of the common(s) but as a new radical common sense.

NOTES

1. Sam Ladkin, 'Against Value in the Arts', *Cultural Value Project Blog*, https://culturalvalueproject.wordpress.com/2014/04/11/dr-samuel-ladkin-against-value-in-the-arts [accessed 1 September 2015].

2. David O'Brien, *Measuring the Value of Culture: A Report to the Department of Culture, Media and Sport*, 2010, https://www.gov.uk/government/uploads/system/uploads/attachment_data/file/77933/measuring-the-value-culture-report.pdf [accessed 6 July, 2015].

3. See Arts Emergency (http://www.arts-emergency.org [accessed 1 May 2015]).

4. See Geoff Kay and James Mott, *Political Order and the Law of Labour* (London: Macmillan, 1983).

5. See Andrew McGettigan, *The Great University Gamble: Money, Markets and the Future of Higher Education* (London: Pluto Press, 2013).

6. Beuys, quoted in Claire Bishop, *Artificial Hells: Participatory Art and the Politics of Spectatorship* (London: Verso, 2012), p. 243.

7. Bishop, *Artificial Hells*, pp. 6–7.

8. See Marcello Musto, review of *Marx-Engels-Gesamtausgabe (MEGA2)* by Karl Marx and Frederick Engels, *Review of Radical Political Economics*, 41.2 (2009), pp. 265–68.

9. Karl Marx, *Critique of the Gotha Programme* (Moscow: Progress Publishers, 1875), https://www.marxists.org/archive/marx/works/1875/gotha/ch01.htm [accessed 6 July 2015].

10. See Karl Marx, *Capital: A Critique of Political Economy: Volume One*, intro. by Ernest Mandel, trans. by Ben Fowkes (London: Penguin Classics, 1990).

11. Jason Moore, 'Ecology, Capital, and the Nature of Our Times: Accumulation and Crisis in the Capitalist World-Ecology', *American Sociological Association*, 17.1 (2011), pp. 107–46.

12. See Stephen Graham, *Cities Under Siege: The New Military Urbanism* (London: Verso, 2011).

13. Werner Bonefeld, *Critical Theory and the Critique of Political Economy: On Subversion and Negative Reason* (London: Bloomsbury, 2014), p. 8; see also Helmut Reichelt, 'Why Did Marx Conceal His Dialect Method', in *Open Marxism*, vol. 3: *Emancipating Marx*, ed. by Werner Bonefeld et al. (London: Pluto Press, 1995), pp. 40–83; Hans-Georg Backhaus, 'Some Aspects of Marx's Concept of Critique in the Context of His Economic-Philosophical Theory', in *Human Dignity: Social Autonomy and the Critique of Capitalism*, ed. by Werner Bonefeld and Kosmas Psychopedis (Aldershot: Ashgate, 2005), p. 89.

14. Quotation from Neil Larsen et al., eds., *Marxism and the Critique of Value* (Chicago: MCM' Publishing, 2014), pp. ix–x. See also Roswitha Scholz, 'Patriarchy and Commodity Society: Gender without the Body' in the same volume, pp. 123–42.

15. See Robert Kurz, 'The Crisis of Exchange Value: Science as Productive Force, Productive Labour and Capitalist Reproduction', in Larsen et al., *Marxism and the Critique of Value*, pp. 17–76.

16. Michael Heinrich, *An Introduction to the Three Volumes of Karl Marx's Capital*, trans. by A. Locascio (New York: Monthly Review Press, 2004).

17. Heinrich, *An Introduction*, pp. 24–25.

18. See Moishe Postone, *Time, Labour and Social Domination: A Reappraisal of Marx's Critical Theory* (Cambridge: Cambridge University Press, 1996).

19. Mike Neary, 'Travels in Moishe Postone's Social Universe: A Critique of Political Cosmology', *Historical Materialism*, 12.3 (2004), pp. 239–60.

20. See Karl Marx, *Grundrisse: Foundations of the Critique of Political Economy*, trans. by Martin Nicolaus (London: Penguin Classics, 1993).

21. Henri Lefebvre, *The Production of Space*, trans. by Donald Nicholson-Smith (Oxford: Wiley-Blackwell, 1991); Guy Debord, *The Society of the Spectacle* (Detroit: Black and Red, 1984).

22. Anselm Jappe, *Guy Debord*, trans. by Donald Nicholson-Smith (Berkeley: University of California Press, 1999), p. 1.

23. Jappe, *Guy Debord*, p. 2.

24. Jappe, *Guy Debord*, pp. 17, 3; George Lukas, *History and Class Consciousness: A Study in Marxist Dialectics*, trans. by Rodney Livingstone (London and Cambridge, MA: Merlin Press and MIT Press, 1968), p. 27.

25. Jappe, *Guy Debord*, p. 3.

26. Louis Althusser et al., *Lire le Capital* (Paris: Presses Universitaires de France, 1965).

27. Chris O'Kane, 'The Structure of the Process and Perception of the Process: Value and Fetishism in Rancière's "The Concept and the Critique of Political Economy"' (paper presented at the *Historical Materialism* conference, SOAS, University of London, 7–10 November 2013); see also Jacques Rancière, *Althusser's Lesson*, trans. by Emiliano Battista (London: Continuum, 2011).

28. See O'Kane, 'The Structure of the Process'.

29. Red Notes, *Working Class Autonomy and the Crisis: Italian Marxist Texts of the Theory and Practice of a Class Movement: 1964–79*, libcom.org, http://libcom.org/library/working-class-autonomy-crisis [accessed 1 September 2015].

30. Harry Cleaver, *Reading Capital Politically* (1979; Leeds: Antithesis, 2000).

31. Diane Elson, *Value: The Representation of Labour in Capitalism* (London: CSE Books, 1979); Simon Clarke, *Marx, Marginalism and Modern Sociology: From Adam Smith to Max Weber* (London: Macmillan, 1991).

32. See John Holloway and Sol Picciotto, eds., *State and Capital: A Marxist Debate* (London: Edward Arnold, 1978).

33. See Werner Bonefeld, Richard Gunn, and Kosmas Psychopedis, eds., *Open Marxism*, vol. 1: *Dialectics and History* and vol. 2: *Theory and Practice* (London: Pluto Press, 1992). See also Ana Dinerstein, *The Politics of Autonomy in Latin America: The Art of Organising Hope* (London: Palgrave Macmillan, 2015).

34. John Holloway, *Change the World Without Taking Power: The Meaning of Revolution Today* (London: Pluto Press, 2002).

35. 'Communisation and Value-Form Theory', *Endnotes*, 2 (2010), http://endnotes.org.uk/en/endnotes-communisation-and-value-form-theory [accessed 1 September 2015].

36. Georg Lukacs, *History and Class Consciousness* (London: Merlin Press, 1967).

37. Isaak Rubin, *Essays on Marx's Theory of Value* (Detroit: Black and Red, 1972).

38. Evgeni Pashukanis, *The General Theory of Law and Marxism*, trans. by Peter B. Maggs (1924; London: Pluto Press, 1983); see also China Mieville, *Between Equal Rights: A Marxist Theory of International Law* (Chicago: Haymarket Books, 2005); Robert Fine, *Democracy and the Rule of Law* (London: Pluto Press, 1984).

39. Roman Rosdolsky, *The Making of Marx's Capital, Volume 1* (London: Pluto Press, 1992); Alfred Sohn-Rethel, *Intellectual and Manual Labour* (London: Macmillan, 1978).

40. Karl Marx, from the preface to 'A Contribution to the Critique of Political Economy', trans. by S. W. Ryazanskaya, quoted in Sohn-Rethel, *Intellectual and Manual Labour*, p. 5.

41. Sohn-Rethel, *Intellectual and Manual Labour*, p. xi.

42. Sohn-Rethel, *Intellectual and Manual Labour*, pp. 2–3, 38.

43. See John Berger, *The Success and Failure of Picasso* (London: Vintage Books, 1998); John Berger, *Ways of Seeing* (London: Penguin Classics, 2008).

44. Mikkel Rasmussen, 'Art, Revolution and Communisation', *Third Text*, 26.2 (2012), 229–42.

45. Bishop, *Artificial Hells*, p. 2.

46. Bishop, *Artificial Hells*, p. 5.

47. Bishop, *Artificial Hells*, p. 271.

48. Bishop, *Artificial Hells*, p. 8.

49. Bishop, *Artificial Hells*, p. 19.

50. Bishop, *Artificial Hells*, p. 23.

51. Bishop, *Artificial Hells*, pp. 11, 86.

52. Bishop, *Artificial Hells*, pp. 266–67.

53. Bishop, *Artificial Hells*, pp. 23, 26.

54. Bishop, *Artificial Hells*, p. 26.

55. Bishop, *Artificial Hells*, p. 27.

56. See Jacques Rancière, *The Emancipated Spectator*, trans. by Gregory Elliot (London: Verso, 2011).

57. Bishop, *Artificial Hells*, p. 38.

58. Bishop, *Artificial Hells*, p. 29.

59. Jacques Rancière, *The Ignorant Schoolmaster: Five Lessons in Intellectual Emancipation*, trans. by Kristin Ross (Stanford, CA: Stanford University Press, 1991), p. 13.

60. Bishop, *Artificial Hells*, pp. 284, 283.

61. Jacques Rancière, *Disagreement: Politics and Philosophy*, trans. by Julie Rose (Minneapolis: University of Minnesota Press, 1999).

62. Bishop, *Artificial Hells*, p. 273; Felix Guattari, *Chaosmosis: An Ethico-aesthetic Paradigm* (Sydney: Power Publications, 1995), p. 133.

63. Bishop, *Artificial Hells*, p. 273.

64. Bishop, *Artificial Hells*, pp. 273, 274.
65. Rancière, quoted in Bishop, *Artificial Hells*, p. 29.
66. Walter Benjamin, 'The Author as Producer', in *Understanding Brecht*, trans. by Anne Bostock (London: New Left Books, 1973), pp. 85–104 (pp. 89, 96, 95).
67. Bishop, *Artificial Hells*, p. 93.
68. Bishop, *Artificial Hells*, p. 96.
69. See Paolo Freire, *Pedagogy of the Oppressed* (London: Penguin, 1996); Paolo Freire, *Pedagogy in Process: The Letters to Guinea-Bissau* (London: Continuum, 1983).
70. Jappe, *Guy Debord*, pp. 19, 21.
71. Bishop, *Artificial Hells*, p. 284.
72. Bishop, *Artificial Hells*, p. 284.
73. Benjamin Noys, *The Persistence of the Negative: A Critique of Contemporary Continental Theory* (Edinburgh: Edinburgh University Press, 2010), pp. 166, 167, 168; see also Walter Benjamin, *Illuminations*, ed. by Hannah Arendt, trans. by Harry Zohn (New York: Schocken, 1968), p. 289.
74. Noys, *The Persistence of the Negative*, p. 18.
75. Beuys, interviewed by Willoughby Sharp, *Artforum*, November (1969) (reprinted in Lucy Lippard, *Six Years: The Dematerialisation of the Art Object, 1966–1972* [Berkeley: University of California Press, 1997], p. 121). Quoted in Bishop, *Artificial Hells*, p. 243.
76. Bishop, *Artificial Hells*, p. 273.
77. Bishop, *Artificial Hells*, p. 23.
78. See Jeffrey Williams, 'The Pedagogy of Debt', *College Literature*, 33.4 (2006), pp. 155–69.
79. Mike Neary and Joss Winn, 'Open Education: Common(s), Commonism and the New Common Wealth', *Ephemera: Theory and Politics in Organisation*, 12.4 (2012), pp. 406–22.
80. See Rebecca Boden and Debbie Epstein, 'Managing the Research Imagination?', *Globalisation and Research in Higher Education*, 4.2 (2006), pp. 223–26; see also Neary and Winn, 'Open Education'; Williams, 'The Pedagogy of Debt'.
81. Peter Gurney, 'George Jacob Holyoake: Socialism, Association and Co-operation in Nineteenth Century England', in *New Views of Co-operation*, ed. by Stephen Yeo (London: Routledge, 1998), pp. 52–72 (pp. 55, 63–64).
82. 'Inaugural Address of the International Working Men's Association: "The First International"', Marxists Internet Archive, 1864, https://www.marxists.org/archive/marx/works/1864/10/27.htm [accessed 1 September 2015].
83. Daniel Egan, 'Towards a Marxist Theory of Labor-Managed Firms: Breaking the Degeneration Thesis', *Review of Radical Political Economics*, 2.4 (1990), pp. 67–86 (p. 71).
84. See Egan, 'Towards a Marxist Theory of Labor-Managed Firms'.
85. See Slavoj Žižek, 'How to Begin from the Beginning', *New Left Review*, 57 (2009), pp. 43–55.
86. Midnight Notes Collective and Friends, 'Promissory Notes: From Crisis to Commons', 2009, http://www.midnightnotes.org/Promissory%20Notes.pdf [accessed 1 September 2015].
87. Massimo De Angelis and Stavros Stavrides, 'On the Commons: A Public Interview with Massimo De Angelis and Stavros Stavrides', *e-flux*, 2011, http://www.e-flux.com/journal/on-the-commons-a-public-interview-with-massimo-de-angelis-and-stavros-stavrides [accessed 1 September 2015].
88. Kristin Ross, *Communal Luxury: The Political Imaginary of the Paris Commune* (London: Verso, 2015).

89. Ross, *Communal Luxury*, p. 58.
90. Ross, *Communal Luxury*, p. 63.
91. Geoff Kay and James Mott, *Political Order and the Law of Labour* (London: Macmillan, 1983).
92. See Marx, *Critique of the Gotha Programme*.
93. Kay and Mott, *Political Order*, p. 1.
94. Neary and Winn, 'Open Education', p. 419.

EIGHTEEN

Educational Value

Contingency and the Learning 'Subject'

Marie Morgan

From value 'added' to value 'free', from liberal values to performative values, education has a vested interest in value. Whilst wary of setting up a false dichotomy between instrumental and non-instrumental values, I would be remiss to speak of educational value without alluding briefly to the shift of emphasis from liberal to performative values.[1] Arguments against the resulting instrumental forms of education that resonate with, and work to achieve, the extrinsic values of performance perfection and the illusory forms of accountability that accompany them have been well documented in various educational quarters. Jean-François Lyotard's concern was that imposed cultural and political instrumental values are always underpinned by a 'central . . . performative' value which has not only come to dominate education but determines its *meaning*.[2] This is of course as true of liberal values as it is of performative values, for they too are culturally and politically determined values imposed to ensure that certain educational aims are met and that particular meanings are achieved and/or maintained. I argue here for a philosophical notion of education that calls into question the integrity of imposed values which, as external means to ends, remain separated from the learning 'subject' whilst validating the worth or

otherwise of his/her education. Questioning the integrity of imposed, contingent values which fail to recognise themselves as such, the arguments that follow seek an alternative way of thinking about educational value in relation to the learning 'subject' who is also a contingent 'subject'.

Moving *against* instrumental models of education and associated external values, this chapter seeks a philosophical comprehension of learning which recognises the educational value of life and thinking as emerging through, and from within the work of, the contingent learning 'subject'. It is further suggested here that an education in and for contingency contains not only an intrinsic value for the learning 'subject' but also an educational value. The educational value that is being promoted here is not one which stands outside imposed cultural and political values but is realised in the learning 'subject's' recognition of value, education, and indeed its own contingent identities as complicit within cultural and political impositions in ways which are meaningful and formative *for* and *to* life. Since the ancient Greeks began the educational endeavour of bringing the value of philosophical wisdom to fruition in and for the 'good life', the relationship between education and philosophy has often been uneasy. Education, in its numerous shapes and forms, is generally interested in the contingent, the practical, and the actual. Philosophy, on the other hand, has been more interested in the *essential*, with the search for first principles and absolute 'truths' assumed to exist independently of all contingent happenings. Whether presupposed, taken as given, brought into question, lost, or denied, the notion of the 'subject' is central to both endeavours.

Aristotle's theory of practical wisdom in *Nicomachean Ethics* perhaps offers one of the most explicit examples of an early educational philosophy that recognises the following: the complexity of the relation between the philosophical and the practical; how certain values can be compromised and/or lost in the separation of the two; and the significance of the 'subject' in the process. Whilst, for Aristotle, philosophic wisdom (*Sophia*), as the highest form of knowledge, 'follows from first principles [. . . and] truth about first principles', which thus requires 'comprehension combined with knowledge — knowledge of the highest objects which has received as it were its proper completion', its educational value could only be realised through the deliberations of practical wisdom (*Phronesis*).[3] Such an educational endeavour was, for Aristotle, a matter of not only philosophical value but also of social, moral, and ethical value which is realised in and through the 'subject' because it has

to do with the conduct of one's life and affairs primarily as a citizen of the polis. . . . It is personal knowledge in that, in the living of one's life, it characterizes and expresses the kind of person that one is.[4]

Without practical or actual expression, *Sophia* lacked educational value precisely because, although it may be 'the superior part of us', it does not seek or work for 'human goods'.[5] Hence, the educational value of philosophic wisdom could only be realised when grounded in actuality and rooted in moral and ethical questions about the actual world and the real, practical activities of the 'subject'.

(MIS)RECOGNISING CONTINGENCY

Over two thousand years later, Franz Rosenzweig (1886–1929) expressed his discontent at the ways in which the philosophical thought and traditions of his time sought to abstract the philosophical 'subject' from the contingencies of the everyday. In *Understanding the Sick and the Healthy* (edited and published posthumously), Rosenzweig refers to this problem as the sickness of the 'philosopher' who succumbs to the temptation to overcome the contingent by prioritising the 'essential' (philosophy) over the 'real' (common sense).[6] For Rosenzweig, the separation of the essential from the real issues from the movement of the 'philosopher' and limits the educational potential of the work of life *and* thinking which compromises its educational value for and to the learning 'subject'. In response to this, and in his quest for a 'new thinking', Rosenzweig sought a philosophical *and* educational comprehension of an existential 'reality' which, contrary to the German idealism that dominated philosophy in his time, did not '"reduce the world" to the perceiving "self"' or abstract thought from its contingent activities of everyday life in the temporal world.[7] Rather, Rosenzweig sought a philosophical comprehension of the 'subject' ('man'), the world, and God that is 'grounded in common sense, [and which thus] traces experience of the world back to the world, experience of God back to God'.[8] As Rosenzweig develops his account of the sickness of the 'philosopher' who is always in danger of falling into 'utter paralysis',[9] 'time' and 'wonder' become central to his argument. The failure to comprehend 'time' and 'wonder', in practical as well as philosophical terms, compromises the educational potential that the work of life and thinking holds for the 'subject'. Rosenzweig

focuses on the failures of the 'philosopher' and perceives the greatest threat to the 'subject's' educational potential to be traceable to the 'philosopher's' failure to recognise the educational value of his own contingent existence and experiences. For Rosenzweig, it is this misrecognition of the inevitability of the contingent nature of his own position that leads to the 'philosopher's' somewhat illusory position and the avoidance of 'reality'. When the philosophical is prioritised over the 'real' or the 'actual', the position adopted brings about the appearance that philosophical concepts, principles, and experiences, such as 'wonder', are deserving and demanding of a higher form of recognition than the practical experiences of 'common sense' and 'reality'. Initially, the *essentialism* of the 'philosopher' who 'pauses and wonders' appears to be the contemplative partner who stands *against* and resists the tempo of the 'common sense' of the non-philosopher. Embroiled in the contingencies of everyday realities, the 'non-philosopher' appears to proceed 'in reckless haste'.[10] On the one hand, the 'philosopher's' 'wonder' seeks to raise itself above the contingent, temporal disruptions of the actual world in search of the promises offered by the non-contingent universalities of the *essential* realm. On the other hand, the non-philosopher, entrenched in the disruptions of the contingencies of the 'real', seems to have little time for such promises.

Rosenzweig demonstrates that such misconceptions lead to the misrecognition of the educational value of contingency because it is not just *essentialism* that is a wondrous affair but life and thinking in all its forms. Just as the 'wonder' of the non-philosopher can be deceived by the demands of the 'real', so the 'philosopher's' 'wonder' can be deceived by the temptation to avoid the disruptions that dictate the tempo of experience and 'reality' for the contingent 'subject'. In the overcoming of 'real' wonder, the contingencies of the everyday are held in contempt by the 'philosopher' and, rather than comprehend them for their potential educational value to life and thinking, he sees them as barriers to the possibility of the non-contingent, uninterrupted ideals of *essentialism*. In fear of interruption, the 'philosopher' 'wonders' himself out of his own temporal realities. Whilst this may appear to be of value to the philosophical 'subject', it is, for Rosenzweig, without educational value. In refusing the disruptions that exemplify 'real' wonder and 'real' time, the 'philosopher' becomes exposed as a 'subject' who can neither sustain himself in the reality of the present nor release himself 'into the flow of life'.[11] Thus he retreats to an imaginary position outside the current of temporality and remains suspicious of his precarious po-

sition as a contingent 'subject' in the world. Far from 'stir[ing] up the storm of life',[12] which issues from the recognition and experience of contingency, the 'philosopher' moves to avoid the contingent 'realities' of his own existence and 'restricts his mediations to theory'.[13] Hence, says Rosenzweig, the philosopher 'cannot come in [his] own time'.[14]

Whilst philosophical wonder creates an illusion of groundlessness, it is a questionable groundlessness because, in refusing to risk 'reality', the philosophical 'subject' remains *essentially* undisturbed and intact. For Rosenzweig, whilst the 'philosopher' deceives himself that the realities of life have to be sacrificed for the presupposed groundlessness of philosophical wonder, the opposite is true because groundlessness, if it is to be of educational value, issues from the 'subject's' experience of contingent 'realities'. Such experiences generate an existential groundlessness within and for the 'subject' precisely because they disrupt the flow of, and from within, the timeliness of actual experience. The revealing of contingency that issues from these moments is fundamental for Rosenzweig's 'existential reality' because these moments reveal to the learning 'subject' that the negative significance of life cannot be overcome, only avoided. This includes the aspects of reality that the 'subject' tends to eschew, such as the negation of its own actual existence, or death. In facing reality the 'subject' recognises the possibility of the absolute negation of life as a constant presence and becomes aware that the endlessly immanent disruptions to life are the very moments that characterise its finitude. It is in the recognition of these moments that the 'philosopher', in learning that the negation of life is inevitable, transfers his *un*healthy fear of death to a fear of life rather than 'taking on' life.

> We have wrestled with the fear to live, with the desire to step outside the current; now we may discover that reason's illness was merely an attempt to elude death. Man, chilled in the current of life, sees, like that famous Indian prince, death waiting for him. So he steps outside life. If living means dying, he prefers not to live. He chooses death in life.[15]

Rosenzweig identifies here how the philosophical 'subject' fails to comprehend the educational value that is inherent in its own experiences of contingency. The potential educational disruptions that characterise the movement and meaning of the 'subject's' contingent experience and experience of contingency are misrecognised as

meaningless, and the 'philosopher' inadvertently chooses death in life.

Recent developments in philosophical and educational thought further challenge and deconstruct the forms of *essentialism* that lend themselves to an overcoming of 'reality' through the misrecognition of the educational value of contingency. In *Contingency, Irony and Solidarity*, the post-foundational pragmatism of Richard Rorty turns away from 'common sense' and toward 'irony' in an attempt to bring the very foundations of Western philosophical thought into question.[16] Sceptical of the educational value of philosophy per se, Rorty is particularly critical of philosophical traditions that fail to recognise contingency and, in particular, that fail to acknowledge the contingencies of history, of language, and of self-hood as 'defining' people and societies. Taking up a position that seeks to reveal how the metaphysical foundations of Western philosophical thought are rooted in the Platonic tradition, Rorty's scepticism turns to the public/private dualism. Prioritising the desire to reconcile and unify the dualism over revealing and recognising contingency is, for Rorty, a Platonic legacy which has hindered the development of liberal communities and ironic individuals. What is more, the failure to recognise the value of contingency has, he suggests, evolved from, and been sustained by, the belief that 'truth' is a matter of philosophical discovery rather than creation. Rorty suggests that unity of dualisms (education and philosophy included) can only be attained at the expense of any hope for just liberal self-hood and liberal social solidarities.[17] Such things issue from the recognition of existence, language, and history as matters of contingency rather than as ahistorical presuppositions.

In the refusal to accept that all notions of 'truth' are *created* through the contingent vocabularies that seek and express them, there remains an ever-present danger of falling into the universalistic pretensions of a tradition that has created its own illusions. For Rorty, forms of philosophical thought whose assumed educational values are founded on and aim toward 'discovered' truths are not only valueless but actively work against the hope for any real private or social justice. The private person is important for Rorty, although the concept of the 'subject' is problematic. Whilst not directly refuting any particular notion of an identifiable 'self', Rorty does reject claims that phenomena such as 'essences' hold any credibility in relation to defining a 'subject'.[18] There is, for Rorty, no more evidence that there is such an entity as an identifiable 'subject' than there is lack of evidence; therefore, belief in such phenomena is

attributed to a philosophical culture of presupposition that fails to recognise itself as such. Hence, for Rorty, there can be no common human nature or shared condition that contains the potential to unify individuals publicly or privately. The 'subject', then, is a somewhat 'hollow' or empty concept for Rorty, with no core intrinsic 'self' with which one can identify or through which one can identify others. Rather than bringing the individual to 'know' the 'self', intellectual enquiry must interrupt the 'self' to reveal the contingent person whose experiences of contingency do not define what it is to be 'human' as much as signify its potential for ironic, imaginative recreation and re-description.

Language is central to Rorty's theory of contingency, and the potential of the contingent person can only be expressed through language that is itself understood 'as a historical contingency rather than as a medium which is gradually taking on the true shape of the true world or the true self'.[19] Hence, for Rorty, educationally valuable questions include those such as 'Why do you talk that way?' rather than 'How do you know?'.[20] The educational value of such questions is realised when the recognition of contingency reveals that there is no sure or 'neutral ground' on which to stand, from which to speak, or from which to 'adjudicate the issue' in question.[21] Hence educational value, for Rorty, lies not in seeking better or new ways of knowing but in seeking ways of speaking which sensitise the individual not only to his or her own contingent positions but also to the contingent positions of others and to the historical contingencies that characterise the creation of an inhabited world.

Rather than a learning 'subject', the figure of the 'liberal ironist' is of educational value for Rorty. 'Liberal ironists' are people who are aware of the groundlessness of their own positions and of the positions of others. For the 'liberal ironist', a consciousness of contingency reveals its educational value as the potential to conceive what it is to be a private, contingent individual in the liberal culture of a shared, ever-changing world. This world and the individuals within it are only recognisable because contingent vocabularies offer contingent people a *current* expression of a collection of (re)created contingent histories. Recognising and communicating this through contingent vocabularies *without* 'a set of foundations' to fall back on offers the hope for an imaginative and better future.[22] This realisation is essential for the 'liberal ironist' who could not otherwise recognise the contingent, educational values that keep intellectual enquiry open to new imagined and imaginative alterna-

tives. Perhaps the most important educational value for Rorty is that 'liberal ironists' recognise the existence of other contingent individuals as being like and/or unlike them in ways which are *morally* just without the need for any theoretical or philosophical 'algorithms for resolving moral dilemmas'.[23] Hence, the educational value of the 'liberal ironist' cannot be realised through the structures of a mindset that aligns itself with philosophical tradition. Rather it only becomes a possibility in 'letting go' of the metaphysical presuppositions that characterise Western thought and aligning oneself with the poet and 'innovative artist' rather than the 'philosopher'.

It is the awareness of the contingency of the 'final vocabularies', called upon to navigate one's way through a life and a world without any common points of reference or positions of neutrality, that keeps the 'ironist' in question and open to doubt. Vocabularies are contingent precisely because they 'are never *just* a matter of "rational choice"' but express a 'myriad of contingent, causal factors'.[24] The 'liberal ironist' becomes conscious of language as the means of expressing the *moral* value of recognising not only that 'self-creation and . . . human solidarity are equally valid, yet forever incommensurable'[25] but also how all change is 'instigated by all kinds of socio-historical events'.[26] The private irony of the individual is expressed through a 'final vocabulary' which only is 'final' in the sense that the ironist knows that its 'finality' indicates that there is nothing beyond the collections of words the individual has access to at *this* point. The ironists are aware that a 'final vocabulary' indicates that the limit of the vocabulary they have access to has been reached and also that the finality is inadequate, limited, and open to new alternative ways of speaking, redescribing, and recreating and thus to initiating imaginative and hopeful change.[27] Rorty's ironists, in the finality of their vocabularies, recognise that whatever words are used and however 'final' a vocabulary appears to be, there is no language that can signify or express a common humanity, a common point of reference, or a position of neutrality.

In very different ways and through very different philosophical approaches, Rorty and Rosenzweig both attach a profound educational value to the recognition of contingency. What is more, each considers such value to be realised in revealing the groundlessness (or foundation-less-ness) of existence. For both, life's disruptions and 'interruptions' (to the certainty of 'self', to the order of things, to the flow of time, and so forth) are signifiers of contingency and of the contingent nature of the recognising 'subject' or 'self'. For Rosenzweig, a major symptom of the 'sickness' of the 'philosopher'

who misrecognises the educational value of contingent experience is the avoidance of death. Death is not only the ultimate interruption to 'real' life but also its ultimate negation. Hence, to step outside the flow of life (reality) is to overcome the negative significance of one's actual contingent existence, to refuse the discomfort of the contingencies that humanise life, and thus the 'philosopher' dies to life. Although far less explicitly than Rosenzweig, Rorty further demonstrates the educational value that lies in recognising the negative significance of life as important to the revealing of the contingent nature of the 'self' or 'subject' and also to the 'liberal ironist's' *experience* of his own contingency. The 'liberal ironist' recognises that his own contingent existence is such that saying '"I" is as hollow as [saying] "death"', because there is no more certainty to the phenomenon of the 'self' or 'subject' than there is to the phenomenon of 'death'.[28] To presume otherwise is, for Rorty, to fail to realise the potential hope for a private irony and a social justice that the recognition of contingency makes possible.

The educational value of Rorty's theory of contingency is rooted in the exposure of the necessity to recognise not only *external* contingencies but also the contingency of the 'self' and the means for its expression. But, in a sense, the things that are of educational value in Rorty's theory are the very things that limit its value to education. In favouring imagination over reason and associated alternative, contingent vocabularies, Rorty sets himself in opposition to the philosophical traditions and foundations that characterise education and associated notions of the 'subject'.[29] But, in one way or another, education demands a 'subject' and, in its general sense, has little option but to take some notion of the 'subject' as given.

(RE)THINKING CONTINGENCY

In his *Logic*, Hegel argues that the contingent, 'roughly speaking, is what has the ground of its being not in itself but in somewhat else'.[30] This is as true for the contingency of the self-conscious 'subject' as for the contingent histories and languages that inform and depict the societies and cultures within which the self-conscious individual exists. Contingency draws self-consciousness out of itself and is of profound educational value to the formative, dialectical movement of the learning 'subject' in Hegel. Whilst there are many examples of how this occurs in Hegel's work, perhaps it is most explicit in the movement for recognition undertaken by self-con-

sciousness through a 'life-and-death struggle' in the *Phenomenology of Spirit*.

For Hegel, the work of self-consciousness is formative in and for life as a 'tarrying with the negative'.[31] This is the 'life of Spirit' which, he argues, 'is not the life that shrinks from death and keeps itself untouched by devastation, but rather the life that endures and maintains itself in it'.[32] Death is not given priority over life in Hegel but is understood to be fundamental to and essential in the dialectical nature of existence which is revealed in the battle for recognition in the life-and-death struggle. The educational value of death's relation with life issues through the formative movement self-consciousness undertakes as it (re)learns its own truth. This includes learning that its certainty of self is only ever a false 'beginning' which issues from the perceived certainty of a position that also turns out to be illusory. Thus the education of self-consciousness is undertaken 'as a way of despair'.[33] This education evolves as a dialectical movement in which abstract philosophical consciousness experiences the loss of its own certainty of self and of the certainty of its position and learns of its 'ambiguous supersession of its ambiguous otherness'.[34]

For Hegel, learning occurs through self-consciousness (re)experiencing the negation of its own independent certainty and becoming (re)acquainted with the groundlessness in which it is formed. In the struggle for recognition, self-consciousness risks its own immediate self-certainty and comes face to face with what appears to be an 'unessential' other. The educational value held by the 'unessential' other is paramount for Hegel, for the self-conscious 'I', who knows itself to be such, 'exists only in being acknowledged' by an *other*.[35] Although the assumed ideal goal of recognition appears to be achieved in the moment when both 'recognize themselves as mutually recognizing one another', and where each 'sees the *other* do the same as it does', recognition is not so straightforward.[36] The movement between self-consciousness and the *other* is not mutual or purely reciprocal. The important point here is that the 'subject' in Hegel is not independent *of* the other; nor does it fall into mutuality *with* it. The 'subject', for Hegel, is contingent, and the educational value of contingency is central to the idea of the 'subject' in Hegel. If recognition began and ended with the ideal of mutuality, there would be no independent 'subject'; hence, for Hegel, the fight for recognition would hold no meaning or truth for self-consciousness. But, on the other hand, it is the independent nature of the self-conscious 'subject' that masks the complexity of the educational

movement of and for recognition. This contradiction both indicates and conceals the contingent nature of self-consciousness.

In order to rethink the educational value of contingency in relation to the learning 'subject' in Hegel, it is necessary to take a step backwards from the already self-conscious 'subject' who knows itself to be a recognised and recognising person and to rethink the possibility of its position. The thinking, self-conscious 'subject' already 'knows' itself to be 'life' opposed to the negativity of death. The separation and opposition between life and death that issues from the thinking 'subject's' knowledge of itself is misleading and indicative of the way in which the contingent individual, in its general ways of being in the world, 'forgets', or has yet to relearn, its own history.[37] This educative, dialectical movement is negative in nature and issues from a fundamental battle for life in a movement where self-consciousness is disrupted from the immediacy of its own self-certainty.

For Hegel, the dialectical nature of self-consciousness is such that the (un)essential other is not only absolutely other to self-consciousness but is also its own otherness. This becomes visible in the movement that self-consciousness undertakes upon and within itself in its quest to prove that it is an essential, positive entity in the world. The dialectical movement initially appears as a twofold action between the two opposing partners of a self-consciousness in which each seeks the death of the other and each must stake its own life to do so. But rather than prove and gain the certainty of itself and its position, self-consciousness is disrupted by the threat to its future and, 'seized with dread', learns that, precisely because it is alive, 'there is nothing present in it which could not be regarded as a vanishing moment'.[38] This loss of self-certainty is fundamental to the dialectical movement of the learning self-consciousness where, in seeking independence, it learns that it is 'not an independent consciousness but a dependent one [who is] not certainty of *being-for-self* as the truth of [it]self'.[39] In this moment self-consciousness learns that it has its ground in something other than its own certain self. Whilst it is not grounded in actual death, because it survives the battle for life, self-consciousness learns that it has its ground in the negative educative movement that issues from within the life-and-death struggle. In this moment, when self-consciousness 'has trembled in every fibre of its being, and everything solid and stable has been shaken to its foundations', it learns that it exists as it does because it is formed in, and gains recognition through, the loss or death of the immediacy of its own presupposed beginning.[40] Here

the self-conscious 'I' becomes aware of the groundlessness of its own existence and learns that it has its ground not in the certainty of life but in the uncertainty of death. It is in this sense that the self-conscious 'I' is, for Hegel, a contingent individual. Thus every 'I think' is an expression of the spirit of the contingent, finite, self-conscious 'subject' who has its ground not in the certainty of life but in the possibility of death. This also signifies the groundlessness of the contingent 'subject' whose self-consciousness becomes recognised through the negative movement that occurred in the battle between life and death.

In reliving the movement of recognition, the thinking, self-conscious 'subject' (re)learns that death is not only as important to it as life but is also formative in and for its activity as a contingent person. In this way death is not something absolutely other to or abstracted from life but is *with* and, perhaps more importantly for Hegel, *for* life. The educational value of this movement is compromised for Hegel by the way in which abstract, 'natural' consciousness emerges as the 'Lord' who claims mastery over death in order to maintain its certainty of itself as being alive. Having experienced the groundlessness of its own contingent nature as something 'alien' to it, the emerging Lord 'destroys the alien negative moment, posits *himself* as a negative in the permanent order of things, and thereby becomes for himself, someone existing on his own account'.[41] The 'alien negative moment', in which the self-conscious, contingent 'subject' has its ground, is overcome by the Lord who presupposes its position as one of freedom and independence. This contradiction is central to the value of education in and for contingency because it expresses both the contingent nature of the 'subject' and its desire to overcome its own contingency in order to posit itself as a permanent, self-conscious 'subject' in the order of things. However, for Hegel, this is the nature of modern abstract self-consciousness which 'forgets' its own history and yet also discloses the culture of presupposition that works to hold all forms of contingency in subjection.[42]

THINKING 'SUBJECTS': EXPRESSING CONTINGENCY

The contradictory nature of self-consciousness for Hegel compromises and at the same time reveals the potential value of education in and for contingency. Identifying the contingent nature of the 'subject' that evolves in the movement for recognition does not in

itself, however, express its educational value for Hegel. Rorty's interest in the expression of contingency through contingent vocabularies is particularly helpful in considering the educational value of contingency because, without expression, the potential value of an education in and for contingency remains only at the level of theory, that is, at the level of abstraction. In terms of expressing the contingent nature of the thinking 'subject' in Hegel, Gillian Rose, in *Mourning Becomes the Law*, might consider a more appropriate question to be, How might thought 'read' itself in ways which work to keep the contingency of the 'subject' alive? Generally, self-consciousness divides thought, or the sentences through which it comprehends, communicates, and expresses itself, 'into a grammatical subject and predicate joined by the copula "is"'.[43] But this, says Rose, is thought's ordinary 'reading' of itself through which it understands itself to be 'a fixed bearer of variable accidents, the grammatical predicates, which yield the content of proposition'.[44] For Rose, such a reading lacks educational value because the contingency of the 'subject' goes unrecognised in a routine dialectical reading of the proposition which 'affirm[s] an identity between a fixed subject and contingent accidents'.[45] Contingency here remains abstract, external, and, in essence, meaningless to the 'subject' and therefore fails to recognise the educational value of an education in and for contingency.

Henry Harris considers such an ordinary dialectical 'reading' to be the work of 'naïve consciousness [which] has the abstract thought of identity'.[46] When read this way, self-consciousness only sees itself (and therefore everything else) through the separation of subject (including itself as 'subject') and the predicates it employs. In a sense this is the essence of an everyday notion of a dialectical movement where, characterised by the work of negation, self-consciousness brings about its own failure in order to reveal the illusory nature of a presupposed 'identity'. The identity of the ordinary propositional form is merely formal and, as Harris says, 'the stronger the identity . . . the more it becomes a function of conscious thought—a function of my memory or of my records (all of which are abstract thoughts)'.[47] Here, the identity of 'subject' and its means of expression are taken to be fixed and accidental and therefore lacking the educational possibilities that issue from the recognition (or recollection) of the contingency of the 'subject'.

The identity and lack of identity of the 'subject' are central to Rose's argument. In making a distinction between an ordinary dialectical 'reading' of 'subject' and predicate and a speculative 'read-

ing', Rose argues that in the latter 'the identity which is affirmed between subject and predicate is seen equally to affirm a lack of identity between subject and predicate'.[48] It is this lack of identity that means the 'subject' 'is not fixed, nor the predicates accidental'.[49] Hence they are not just known to self-consciousness as mere accidents or external contingencies but acquire their meaning and thus their educational value 'in a series of relations to each other'.[50] These relations disrupt proceedings for the contingent 'subject' which 'means that the proposition which we have affirmed, or the concept we have devised of the nature of an object, fails to correspond to the state of affairs or object which we have also defined as the state of affairs or object to which it should correspond.'[51] On the one hand, the resulting lack of identity denotes what Rose refers to as *'the drama of misrecognition* which ensues at every stage and transition of the work—a ceaseless comedy, according to which our aims and outcomes constantly mismatch each other, and provoke yet another revised aim, action and discordant outcome'.[52] On the other hand, it denotes the experience of 'the lack of identity which natural consciousness undergoes [and which is] the basis for reading propositions as speculative identities'.[53] What this means, Harris clarifies further, is that the

> 'identity of being and thinking' (the one which Hegel here claims is overlooked) rests on the fact that it is thinking—even the quite spontaneous and unconscious interpretation of the flux by naïve consciousness—that makes things *be* in the first place; and their being in thought (when we understand them) is radically opposed to—indeed it is the logical opposite of—what thinking tells us about their being in the real world.[54]

As such, the educational value of the speculative proposition is that it reveals thought's own loss or lack of identity as a part of its identity, and thus it reveals the contingency of itself and of the positions it takes up, to it. The meaning of this is now threefold rather than twofold. First, it means, as Harris says, that the 'permanence of things, upon which the Understanding builds, is all in thought; thus all Understanding is subsistence in the absolute flux of living experience as the flow of real time'.[55] Second, as Rose says, it means that the 'subject of the proposition is no longer fixed with external, contingent accidents, but initially, an empty name, uncertain and problematic, gradually acquiring meaning as the result of a series of contradictory experiences'.[56] Third, it means that what appeared 'initially' to the subject as external, contingent accidents

have come to be (re)learned as the mediated thoughts of the contingent, self-conscious 'subject'.

In terms of how the educational value of this is realised by and for the learning 'subject', we can turn to the Hegelian notion of *Aufhebung*. The *Aufhebung* 'of the life process' which signifies the 'capacity to recover what is forgotten'[57] expresses a moment of recollection. In terms of an education in and for contingency, it is in the movement of the *Aufhebung* that the learning 'subject' recollects the contingent nature of its own existence. Although it is a fleeting moment, it is also a profoundly educational one which characterises the essence of learning for Hegel. The *Aufhebung* is only possible because it is always-already implicit as the potential for learning in the 'forgotten', or yet to be recollected, contingent learning 'subject' that seeks it. This is not a passive movement for Hegel but one that is initiated in and by the disruption of the actual 'subject'. These educative disruptions are not for the 'subject' who has stepped outside the flow of time or who has died to life. Nor are they the disruptions of a solipsistic self who exists in a state of detachment from the real and actual world. Such disruptions, for Hegel, are those that unground the contingent 'subject' and through which it moves to recollect its own contingent nature. Thus they issue from actuality and move the actual 'subject'. As Harris argues, for Hegel,

> the real world is dialectical and dynamic, just as actual consciousness reveals itself to be; and the world of stable beings is the *product* of thinking activity through which alone we learn what the real world [and thus the contingency that characterises it] is like.[58]

This is central to the way in which contingency tends to be misrecognised by thought *and* to the potential for actual experience to reacquaint the 'subject' with its own groundless, contingent nature and its contingent position in the world. The educational value of learning is revealed as a circular and negative movement, but it is not a vicious circle that lacks educational value. The Hegelian notion of *Aufhebung* symbolises the educative significance of the contradictory movement of the learning 'subject' when its contingent moments are recognised and experienced as such. Nathan Rotenstreich explores this point further in *From Substance to Subject: Studies in Hegel* and suggests that this movement is the substance of subjective reality in which 'substance is related to the true, but . . . the true [should] be comprehended also as subject'.[59] Whilst this movement is negative in nature, substance is not overcome in the

process but is retained and 'sublated to the aspect of subject'.[60] Thus, this negative movement is also a formative movement for the contingent learning 'subject'. In recognising the groundlessness that issues from its experience of the external contingencies, the contingent 'subject' (re)learns that the groundlessness is also internal and that this characterises its contingent, subjective position *in* the world.

CONCLUSION: RECOLLECTING CONTINGENCY

The *work* of the negative is the spirit of learning for Hegel, and it is the experience of the negative that 'generates severance, rupture— even terror—in life and the mind'.[61] This negative experience has both external and internal value for the contingent, learning 'subject'. Internal meaning is gained through the way that 'it creates a break between the mind and itself', and external meaning is gained through the way it creates a break 'between man and world, finite and infinite, subject and object and so forth'.[62] These disruptions, or breaks, are brought about by and signify a moment of negation or loss and are experienced by the self-conscious 'subject' as such. Again, as with the life-and-death struggle for recognition, it is death that becomes significant to life and thinking here. The ultimate negation of life is actual death, but the contingent 'subject's' own actual death remains 'nothing but the natural fate of life' for the living subject.[63] It is only, as Harris says, 'recollection that can make death significant'.[64] For Hegel, as for Rosenzweig, the recollection of death has no educational value if life 'shrinks from death and keeps itself untouched by devastation'.[65] Hegel means not that devastation should be sought by life but, like Rosenzweig, that the contingent 'subject' is the life that faces and takes on the contingent realities of actual life that 'endures it and maintains itself in it'.[66]

The educational value of the 'recollection' of death is revealed when the contingent, learning subject (re)learns what it means to be a contingent individual not merely abstractly, as content or as something external to it, but from within its own contingent position. Contingency, in a sense, is recognised here as the always questionable 'substance' of subjectivity. This position recalls into question the integrity of imposed, purely instrumental values and reveals them as manifestations of external, contingent conditions. In this the contingent 'subject' can move *against* imposed cultural and political values whilst also recognising them as inevitable and inescapable

aspects of one's political and cultural contingent existence in ways which become meaningful and therefore of educational value to and for the contingent, learning 'subject'.

Although Hegel does not express it as explicitly as Rosenzweig and Rorty, abstract philosophising was of little educational value for all three thinkers. But for Hegel too, it is only when thought 'return[s] to its own present world and discover[s] it as property', or in other words, as substance, that it becomes of educational value.[67] The return is an educational movement for self-consciousness only when, having (re)learned the contingent nature of itself as 'subject', it takes 'the first step toward coming down out of the *intellectual world*, or rather toward quickening the abstract element of that world with the actual self'.[68] The educational value of this is not merely intellectual and abstract but actual and, as such, is realised in the temporal moments of real life by the 'life [that] itself insists that it be lived'.[69] Perhaps Rosenzweig expresses this point with greater clarity in *God, Man and the World* when he says, 'The human being *should* not merely "absorb" dispassionately. He has the right to tremble and to be amazed—tremble before the law of death and be amazed in the face of the miracle of life'.[70] The learning 'subject' cannot choose whether or not it is contingent any more than it can choose whether or not to live life in relation to death. The question is whether an education in and for contingency can be of educational value for the learning 'subject'.

NOTES

1. See part 1 of Ronald Barnett, *Realising the University in an Age of Supercomplexity* (Buckingham: Open University Press, 2000).

2. Gordon Bearn, 'Pointlessness and the University of Beauty', in *Lyotard: Just Education*, ed. by Pradeep A. Dhillon and Paul Standish (London: Routledge, 2000), p. 232; see also Jean-François Lyotard, *The Postmodern Condition: A Report on Knowledge* (Manchester: Manchester University Press, 1994).

3. Aristotle, *Nicomachean Ethics*, in *The Complete Works of Aristotle*, ed. by Jonathan Barnes, 2 vols. (Princeton, NJ: Princeton University Press, 1995), II, 1141a15–20.

4. Joseph Dunn, *Back to the Rough Ground* (Notre Dame, IN: University of Notre Dame Press, 1993), p. 224.

5. Aristotle, *Nicomachean Ethics*, 1145a7, 1140b21.

6. Franz Rosenzweig, *Understanding the Sick and the Healthy*, trans. by N. Glatzer (Cambridge, MA: Harvard University Press, 1999). Further references will be included in parentheses in the text.

7. Nahum Glatzer, 'Introduction', in Franz Rosenzweig, *Understanding the Sick and the Healthy*, trans. by N. Glatzer (Cambridge, MA: Harvard University Press, 1999), pp. 21–34 (p. 24).

8. Glatzer, 'Introduction', p. 24.

9. Rosenzweig, *Understanding the Sick and the Healthy*, p. 42.

10. Rosenzweig, *Understanding the Sick and the Healthy*, p. 39.

11. Rosenzweig, *Understanding the Sick and the Healthy*, p. 40.

12. Rosenzweig, *Understanding the Sick and the Healthy*, p. 42.

13. Rosenzweig, *Understanding the Sick and the Healthy*, p. 53.

14. Rosenzweig, *Understanding the Sick and the Healthy*, p. 41.

15. Rosenzweig, *Understanding the Sick and the Healthy*, p. 102.

16. Richard Rorty, *Contingency, Irony and Solidarity* (Cambridge: Cambridge University Press, 1989).

17. See Richard Rorty, 'The Dangers of Over-philosophication—Reply to Arcilla and Nicholson', *Educational Theory*, 40.1 (1990), 41–44.

18. Alan Malachowski, *Richard Rorty* (Chesham: Acumen, 2002), p. 103.

19. Rorty, *Contingency*, p. 50.

20. Rorty, *Contingency*, p. 51.

21. Rorty, *Contingency*, p. 51.

22. Rorty, *Contingency*, p. 52.

23. Rorty, *Contingency*, p. xv.

24. Malachowski, *Richard Rorty*, p. 102.

25. Rorty, *Contingency*, p. xv.

26. Malachowski, *Richard Rorty*, p. 102.

27. Rorty, *Contingency*, pp. 73–75.

28. Rorty, *Contingency*, p. 23.

29. On imagination over reason, see Malachowski, *Richard Rorty*, p. 102.

30. G. W. F. Hegel, *Hegel's Logic: Being Part One of the 'Encyclopaedia of the Philosophical Sciences'*, trans. by William Wallace (Oxford: Clarendon Press, 1975), p. 205.

31. G. W. F. Hegel, *Phenomenology of Spirit*, trans. by A. V. Miller (Oxford: Clarendon Press, 1977), p. 19.

32. Hegel, *Phenomenology*, p. 19.

33. Hegel, *Phenomenology*, p. 49.

34. Hegel, *Phenomenology*, p. 111.

35. Hegel, *Phenomenology*, p. 111.

36. Hegel, *Phenomenology*, p. 112.

37. See Henry Harris, *Hegel: Phenomenology and System* (Indianapolis: Hackett, 1995).

38. Hegel, *Phenomenology*, p. 114.

39. Hegel, *Phenomenology*, p. 117.

40. Hegel, *Phenomenology*, p. 117.

41. Hegel, *Phenomenology*, p. 118.

42. See Gillian Rose's analysis of the 'legal person' in *Mourning Becomes the Law: Philosophy and Representation* (Cambridge: Cambridge University Press, 1996).

43. Gillian Rose, *Hegel Contra Sociology* (London: Athlone, 1995), p. 48.

44. Rose, *Hegel*, p. 48.

45. Rose, *Hegel*, p. 48.

46. Henry Harris, *Hegel's Ladder*, vol. 1: *The Pilgrimage of Reason* (Indianapolis: Hackett, 1997), p. 132.

47. Harris, *The Pilgrimage of Reason*, p. 132.

48. Rose, *Hegel*, pp. 48–49.

49. Rose, *Hegel*, p. 49.

50. Rose, *Hegel*, p. 49.

51. Rose, *Hegel*, p. 49.

52. Rose, *Mourning Becomes the Law*, p. 72.
53. Rose, *Hegel*, p. 49.
54. Harris, *The Pilgrimage of Reason*, p. 132.
55. Harris, *The Pilgrimage of Reason*, p. 132.
56. Rose, *Hegel*, p. 49.
57. Harris, *The Pilgrimage of Reason*, p. 545.
58. Harris, *The Pilgrimage of Reason*, p. 132.
59. Nathan Rotenstreich, *From Substance to Subject: Studies in Hegel* (The Hague: Martinus Nijhoff, 1974), p. 18.
60. Rotenstreich, *From Substance to Subject*, p. 18.
61. Yirmiyahu Yovil, *Hegel's Preface to the Phenomenology of Spirit* (Princeton, NJ: Princeton University Press, 2005), p. 128.
62. Yovil, *Hegel's Preface*, p. 128.
63. Henry Harris, *Hegel's Ladder*, vol. 2: *The Odyssey of Spirit* (Indianapolis: Hackett, 1997), p. 739.
64. Harris, *The Odyssey of Spirit*, p. 739.
65. Hegel, *Phenomenology*, p. 19.
66. Hegel, *Phenomenology*, p. 19.
67. Hegel, *Phenomenology*, p. 488.
68. Hegel, *Phenomenology*, p. 488.
69. Rosenzweig, *Understanding the Sick and the Healthy*, p. 101.
70. Franz Rosenzweig, *God, Man and the World* (New York: Syracuse, 1998), p. 193.

NINETEEN

Negative Aesthetic Education

Emile Bojesen

Institutional educational experience today is framed by several impositions of value: the value of certifications earned by school pupils; the market value of a particular degree from a particular university; the value of a module or class in terms of the above; the value of an individual teaching session in terms of the above; the value afforded to the educational experience by students (rated through means such as student satisfaction surveys and module evaluations); and the value afforded to the personal development of the student, usually conceived in terms of how this might increase his or her employability. If an element of educational experience is seen to have no value or, worse, is seen to compromise any of these values, it should be excised. Education today is thus conceived and perpetuated in terms of value.

In both polite and political conversation, it would be abhorrent to suggest that education could and should also operate in the absence of value. 'Negative' education does exactly this. The 'negative' here is not thought dialectically. It is not ultimately a resource for the development of 'positive' education, even if that positivity is in the form of criticality, such as in Stewart Martin's 'An Aesthetic Education against Aesthetic Education', where 'art becomes the location of an immanent critique of aesthetic education', or Robert Kaufman's 'Negatively Capable Dialectics', where he defines what he calls 'negative romanticism' as being concerned with 'art's and

philosophical aesthetics' participation in the exercise and develop-
ment of critical thought, in the growth of those imaginative efforts
animating a critical poetics and aesthetics that in turn may . . . offer
their own contributions to extra-aesthetic thought and praxis'.[1] The
'negative' in negative aesthetic education is instead thought existen-
tially, as that which exceeds or exists before or without value.

The argument that follows is made in terms of aesthetic educa-
tion rather than a more general concept or practice of education
because only aesthetic education has been explicitly and consistent-
ly concerned with the development of social harmony through
shared values. The majority of educational policy and practice to-
day is framed by a market-value-oriented form of aesthetic educa-
tion. It is aesthetic because it is not simply to do with the develop-
ment of knowledge and skills but also with the development of the
disposition of the individual towards the social. That disposition is
one which emphasises qualities such as resilience, independence,
employability, competitiveness, wealth, and success. Although
governments and educational authorities and institutions may not
define the development of these qualities in terms of aesthetic edu-
cation, historically and philosophically it is where they are at home.

Most thinkers of aesthetic education tend to agree that its func-
tion is the education of citizens in shared social value. Traditionally
aesthetic education has been conceived in terms of social progress,
commonality, and moral good, but modernity and neo-liberalism
have created a shift of emphasis where independence, autonomy,
and competiveness have become at least as important as a more
explicit ideological commonality. Commonality now exists in
shared conformity to the values of the market, which superficially
emphasises themes such as deregulation and freedom, while regu-
lating that very deregulation through the logic of value.

To teach value today is then, first of all, to teach the shared social
value of qualities such as the ability to make oneself a competitive
candidate for employment or to create objects (including art and
educational 'products') which can be measured in terms of what
could broadly be understood as social or market value. Education
exists to make oneself—or to be made—valuable, which implicitly
means *more valuable than someone else*. The problem is that many of
these social values, which are framed in terms of freedom, individu-
ality, flexibility, lack of oversight, and so on, conspire in such a way
as to negate that which does not conform to them, so that rather
than there being a plurality of significant endeavours, there is a
hierarchy of value, where the most powerful taint or extinguish

those which become less valuable or even valueless. Despite its emphasis on individuality, neoliberal aesthetic education is still an education in shared value and social harmony, where it is this emphasis on individuality itself that has become the basis of that harmony. The 'individual' and how it can be measured has become the nexus of shared social value. This chapter argues that the response to these problems cannot be thought in terms of a return to previously conceived notions of aesthetic education but instead must be conceived in terms of a negative aesthetic education.

Herbert Read, the proponent of 'education through art', wanted to educate for an aesthetic way of being and suggested that aesthetic education's purpose should be the evolution of a 'discipline' or the realisation and following of set 'laws of beauty'.[2] As such it is no surprise that his *Education through Art* was published by Faber and Faber when it was under T. S. Eliot's control. Read rejects what he thinks of as Kierkegaardian perspectives on art and education and instead finds his precedents in both Plato and Friedrich Schiller. For all three a harmony or totality of the state, nature, and the individual is the ideal political outcome of education. This unity is also desired by Plato in *The Republic*, where the child is understood as being 'most malleable and takes on any pattern one wishes to impress on it'.[3] Plato's interlocutors agree that one should not 'carelessly allow the children to hear any old stories, told by just anyone, and to take beliefs into their souls that are for the most part opposite to the ones we think they should have when they are grown up'.[4] For Plato, the influence of art is its use not simply in conveying knowledge but also in shaping children's souls.[5] Plato does not banish artists or teachers from the Republic, only the poet who tells stories which corrupt its shared moral value.

Echoing Plato's position, Read states, 'The general purpose of education is to foster the growth of what is individual in each human being, at the same time harmonizing the individuality thus educed with the organic unity of the social group to which the individual belongs'.[6] In doing so he consciously ties himself to what he considers a Platonic and Schillerean tradition of aesthetic education. Schiller himself wrote, 'Taste alone brings harmony into society, because it establishes harmony in the individual. . . . All other forms of communication divide society. . . . [O]nly communication of the beautiful unites society, because it relates what is common to them all. . . . It is only the Beautiful that we enjoy at the same time as individual and as race, that is, as *representatives* of the race'.[7] This universal, harmonious, common, and racially or humanistically

specific conception of the aesthetic as the beautiful reveals it as that which joins the universal and particular, the social with the individual. Equally, for Read, 'individuality' and 'difference' are also a form of particularity in terms of an organic social unity (which would ideally be harmonious) rather than indicative of singularity (which would not be thought of in terms of unity or harmony). Singularity exceeds systematic and totalising thinking, existing instead as an occursive or visitant incidence.[8] To adapt an expression from Susan Howe's poem 'Thorow' in her book *Singularities*, a singularity is not a particular representation of a universal truth but a 'rivet in the machine of a universal flux'.[9]

It is possible to read the difference between singularity and particularity into Paul de Man's criticism of Schiller's aesthetic education, which he accuses of effectively teaching the metaphor of an organic society and in doing so being unable to teach philosophy. De Man's summary of the consequences paves the way towards thinking a negative aesthetic education which does not suffer those limitations. For de Man, 'Schiller's considerations on education lead to a concept of art as the metaphor, as the popularization of philosophy'.[10] This means that 'the aesthetic belongs to the masses. It belongs, as we all know—and this is a correct description of the way in which we organize those things—it belongs to culture, and as such belongs to the state, to the aesthetic state, and it justifies the state'.[11] However, while the undesirability of this consequence is paramount for de Man, it is perhaps also helpful to be reminded of Theodor Adorno's concern that moving away from an all-consuming logic of harmony might cause what he refers to as an 'allergic reaction' which 'wants to eliminate harmonizations even in their negated form' and that end up forming 'the self-satisfied transition to a new positivity'.[12] It would be easy to conceive of the 'avant garde art world', for example, as simply being another, alternative (although analogous) system of values. Subcultural value systems provide a subcultural aesthetic education, not a negative aesthetic education, even if they might be more explicit in creating space for it. Of course, Adorno was referring to aesthetic harmony rather than social harmony, but given that aesthetic education from Plato and Schiller to Herbert Read and beyond has continuously conflated the two, this warning can and should also be read in a social context. Rejecting harmony must not simply lead to another form of positivistic totality. To replace one set of values with another (morality with individuality, for example) is still to be in thrall to value. Negative aesthetic education does not propose a new set of universal

values relevant to all particulars but rather emphasises a regard for the singular.

The articulation of the concept of negative aesthetic education is an attempt to formulate an aesthetic education which rejects value. It is not intended to absolutely replace aesthetic education and the values articulated therein—which would be a functional impossibility anyway, because shared values are to some extent always implicit in a shared social context. However, negative aesthetic education offers a way to think without value and thereby loosens value's grip on the context of education. So much of life has no explicit or easily assignable value; therefore to ignore this fact in education would be to act as if knowledge of value was sufficient to the task of making one's way through life. But what do we do when life feels valueless and that valuelessness has been taught to us as being an evil or ill? And what if we are drawn to doing or experiencing something that makes no sense or seems to have no value? Or we are subject to a sublime or horrific act at which we balk assigning any 'lesson' to?

The existentialists provided responses to these questions (the most obvious examples being texts such as Andre Gide's *The Immoralist*, Albert Camus's *The Outsider*, and Jean-Paul Sartre's *Nausea*), but they are far from the only ones to do so.[13] In fact, the responses (if not 'answers') to these kinds of situations provide much of the content of what we call art in its broadest sense. This is not just true in terms of what is considered avant-garde or experimental art, although it is significant to note that these forms of expression are rarely the subject of aesthetic education, perhaps precisely because they frequently puncture or ignore many and sometimes all conceptions of value. Importantly, negative aesthetic education is constitutive not of a dialectical negation of values but rather of an existential non-attendance to them. Negative aesthetic education attends to that which exists outside the remit of value, as well as exceeding and putting into question any dialectical formulation. Materials for a negative aesthetic education could just as easily be found in a William Faulkner novel or in Jacques Derrida's *Glas* as in obscure contemporary sound art or prehistoric cave paintings. The task here is not to elevate art or a particular kind of art or philosophical aesthetics in terms of a hierarchy of value; instead, negative aesthetic education opens itself up to being considered pointless, a waste of time, and entirely useless, for no other reason than in the context of value *it is all of these things and more besides*. But by being all of these things, it is also a lesson in them, which is to say, a lesson in exis-

400 *Emile Bojesen*

tence which exceeds positive formulation. Negative aesthetic edu-
cation makes the point that much of existence has no value and that
this is no bad thing (nor is it 'good'). It is an education in that which
has no explicit value and yet is, despite that, an undeniable aspect of
existence. A space must remain for the unvaluable within the con-
text of education because without it the fate of a value-oriented
education will continue to be marked by its existential insufficiency:
its abstraction of, and disconnection from, lived experience.[14]

Education is about form: teaching forms, learning forms, being
held accountable for forming forms. Experience always exceeds
form and yet, in education, is usually reduced to it. Its value is
assigned 'within'. The argument that "experience is educative" only
works inasmuch as experience is reducible to form and memory (of
form). So how then can one speak of experience outside form and
memory in the context of education? Of course there are many re-
peatable ostensibly physical/metaphysical gestures which continue
to work within given educational structures, and for many this
would be considered their primary or crucial function. However, if
education is for all intents and purposes the researching, teaching,
and learning of repeatable gestures, it would never be conceivable
outside the logic of the subject and the telos. That is to say, never
conceivable outside the linear development of a quantifiable indi-
vidual towards a predetermined end, even if that end is defined as
the development of qualities such as flexibility and resilience. This
is why negative aesthetic education attempts to draw attention to
the accidental imprint, the inspirational moment, the absence of
(self) certainty, the getting-carried-away, *without* recourse to form,
without the necessity of reflection, *without* quantifiable linear
progress or development. I use the word 'negative' because I do not
think it is possible or even desirable to think of these incidences of
existence in terms of a positivistic education. At best, one might
think of them as helpful in the development of a 'negative capabil-
ity', but they must also be regarded in their own right and find their
own languages to articulate their significance: a significance which
is never just escape or entertainment. These incidences are *signifi-
cant* without being of *value* because they are worthy of attention
without necessitating a further usefulness or justification in terms of
equivalence. Value implies equivalence to a standard; significance
only implies meaning, which may or may not have an equivalent.
Value is always measured in a determinable context, while signifi-
cance can exceed not only a determinable context but determination

altogether. This is why negative aesthetic education attends to significance rather than value.

Within the context of educational policy and practice, the debates are always over different structures, different forms, different methods. The non-structural would have no place, the historical only being significant in its reducibility to form. The historical here is understood as *that which occurs*. Reduction of that which occurs is not an evil, and it is certainly not to be dismissed, because without reduction, there would be no sciences, no engineering, no medicine, no political institutions. Reduction is a tool which can be used for good or ill. Generally, in the context of education, it is a tool at least superficially intended for good. There is no possible disavowal of this, and it is not itself the problem. The problem is that education today is too good at serving its abstracted purpose. The relationship between structure and historical experience is aleatory, meaning that it is dependent on or produces unforeseeable occurrences. But what is the name for that which evades structure or exists without the thought of it?

To answer this question, this chapter goes through several stages in its articulation of negative aesthetic education. I have begun by critically outlining aesthetic education as it has heretofore been conceived in sociopolitical thought and now proceed in untangling a regard for the singular from positivistic social and cultural harmony. This notion of the singular is then considered in terms of the unsociable, or that which does not find its place in social value and progress. Despite its unsociability and irreducibility to value, an aesthetic regard for singularity reveals a conception of ethics which can only ever be possessed as a dispossession. This dispossession is posited not only as a frequently ignored condition of existence but also as a key subject of negative aesthetic education. Because all that can be possessed is also conditioned by dispossession, John Keats's concept of negative capability and its emphasis on 'being in uncertainties, mysteries, doubts, without any irritable reaching after fact and reason' is helpful in giving a name to our educability in the condition of dispossession.[15] And to be able to think these questions in sociopolitical terms, the more recent use of 'negative capability' by Roberto Mangabeira Unger is used to illustrate the possibility of conceiving of institutions and social dispositions which, I argue, might facilitate and open towards negative aesthetic education.

SINGULARITY

Politically interested educational philosophy has a tendency to re-
duce the remit of the ethical to the sociopolitically moral (which is
actually what Søren Kierkegaard still refers to as the ethical: *det
etisk*) and, in doing so, shuts down an opening towards one of the
most significant aspects of the ethical: that of the regard for the
singular (the singular here is not a person or existent; it is a singular
incidence of existence which does not exist under any general con-
cept). As an alternative, a negative aesthetic education which offers
a regard for the singular would not always subvert the political but
would act alongside, outside, or without it. The aesthetic compo-
nent of this kind of education is not that of Plato, Schiller, or Read,
all of whom rely not only on universal harmony but on harmony
between the individual and the state, however supposedly free or
democratic. Negative aesthetic education rejects the possibility of
either of these forms of harmony. Ethically speaking, negative aes-
thetic education would be an education not only in the singularity
of 'others' in their creative forms of expression but also in singular-
ity as the development of a kind of Keatsian 'negative capability' or
what Maurice Blanchot calls 'passivity'.[16] Without an education in
the ethical significance of the aesthetic outside social value, the sin-
gular is subsumed by the particular (as well as its concomitant no-
tions of a self-present subject). This is because the uniqueness of
their incidence is simply considered (and taught) as reflective of
other particulars within a finite universal. Negative aesthetic educa-
tion attends to the singular rather than the particular. The singular
defines that which, unlike the particular (most commonly thought
of as the *citizen* or even the *human*), cannot be conceived in terms of
the universal or brought into harmony with it. A negative aesthetic
education in singularity would remind us that politics, morality,
and laws do not exist for themselves but rather *for and because of*
singularities—singularities which adapt or change them in their
unique incidence.

In *The HypoCritical Imagination* John Llewelyn develops the con-
cept of regard for the singular through his readings of Immanuel
Kant, Maurice Merleau-Ponty, and Emmanuel Levinas. He gives
the example of the singular regard towards the work of art and the
artist and argues that even though, for Levinas, there is no 'ethical
saying in the case of a still life or a landscape painting in which no
people are portrayed', the phenomenology of Merleau-Ponty can be
utilised to extend the remit of Levinas's ethics, which concomitantly

reveals how he thinks Levinas's ethics can extend or escape the remit of Kant's critical philosophy.[17] For Llewelyn, 'The artist is above the law in that, like the legislator and as legislator, he or she reminds us that the law is not made for the sake of the law'.[18] As such, art is not just legally or politically subversive but rather before or without law and politics. Art 'reveals the thing as something that commands us to regard it as an end in itself'.[19] Thus, the deontological obligation or duty that things in themselves command can, as in the case of Llewelyn's reading of Paul Cézanne, demand an explicitly aesthetic response. However, as Llewelyn states, this is not all it is: '[Cézanne's] brush-strokes fulfil a responsibility regarding the world, a responsibility to hold it in regard. That these are the enactment of an aesthetic response does not mean that they do not at one and the same time execute an ethical responsibility'.[20]

For Llewelyn the aesthetic response is itself an example of ethical responsibility outside law, where, for example, 'the phenomenologist and the painter say to us: Wait a moment. Attend. Pay attention. Regard the regard'.[21] The law can open towards negative aesthetic education by legislating for its own retreat. The law can also be interrupted, forgotten, or left aside by a singular incidence or work of art which is already before or without the law and in no way absolutely reducible to it. This impossibility of absolute reduction or synthesis is what Llewelyn draws on in the conclusion to his chapter on Merleau-Ponty and singularity, writing that 'meaning is anarchically grounded in the invisible pertaining to ethics' and that 'there is a trace of the ethical invisible in the visible'.[22] This relationship between the visible and the invisible (which we might also see as being to do with sociability and unsociability, as well as the particular and the singular) is what Llewelyn and Merleau-Ponty both define as a chiasm. In his working notes, posthumously published as *The Visible and the Invisible*, Merleau-Ponty wrote of

> the idea of *chiasm*, that is: every relation with being is *simultaneously* a taking and a being taken, the hold is held, it is *inscribed* and inscribed in the same being that it takes a hold of. Starting from there, elaborate an idea of philosophy: it cannot be total and active grasp, intellectual possession, since what there is to be grasped is a dispossession.[23]

Here the chiasm marks the simultaneity of the visible and the invisible, but it could also be seen to mark the simultaneity of the social and the unsocial, the particular and the singular, without reducing them to the same or forcing them into an artificial dialectical pro-

cess. In these terms, while aesthetic education might be described as having the aim of possession by a culture or species—an inscription of one's culture and its values into oneself—negative aesthetic education would aim to be the grasping of dispossession. That is to say, the grasping of a lack of self-certainty, an immense ignorance, and the singularities of existence which have no equivalent.

Merleau-Ponty suggests that one could or should 'make an analysis of literature in this sense: as *inscription* of Being'.[24] Claude Lefort, himself greatly influenced by Merleau-Ponty's teaching, as well as the editor of his works, refers to the sentence preceding that on the *'inscription* of Being', which relates the idea that 'Being is what requires of us creation for us to experience it'.[25] If this is the case, then singularity is bound up in thought, speech, and expression, presenting, in the same incidence, a possession and dispossession. As such, in every social act there also exists an element of unsociality which exceeds it but also exists as a trace within it. Aesthetic experience bears the trace of negative aesthetic experience, and the danger is that aesthetic education usually glosses over or is entirely ignorant of this fact. To experience Being is to inscribe Being through creation. Being is not naturally self-sufficient and harmonious, and the artist, philosopher, and teacher reveal this. Some explicitly, some implicitly. Bringing to mind Gilles Deleuze and Felix Guattari, Lefort calls this experience of being the 'nomadic life' because no organic unity or harmony is offered, and instead of harmony, there is a 'whirlwind', and instead of organic unity, there is an 'uprooting and implanting'.[26] Lefort then goes on to make a special reference to Merleau-Ponty's teaching, at once doing justice to its singularity but also indicating a way towards thinking the chiasm in teaching practice:

> The questions with which Merleau-Ponty was dealing gave me the feeling that they were living inside me before I discovered them. And he himself had a unique way of asking questions. He seemed to invent his thought while speaking rather than teaching us what he already knew. That was a strange and troubling spectacle. . . . [H]ad I taken note of this experience I would have been led to consider closely the relationship between teaching and philosophy.[27]

As Lefort implies, Merleau-Ponty's teaching style is itself the presentation of a nomadic life of possession and dispossession. Lefort suggests this experience may well be the case for 'each person already, without his knowing it'.[28] However, the apparent invention

of thought while speaking should perhaps not be taken only as an example of how one should engage in negative aesthetic education (although it might also be useful in this way) but also as an example and analogy of the relation between singularity and experience (the inscription of Being).

The philosopher and teacher are possessed by their own philosophical thought in at least two chiasmic ways: first, in terms of that possession (and dispossession) being a condition of experience, and, second, in being carried away by the very thinking of that condition. The pupils are not exempt from this experience of possession and dispossession. However, they and their teachers are most often taught that possession *by and of* the social and its values is the goal of their education. This is the case even if that possession is the possession of a *socially valuable individuality*. This model of education, historically grounded in aesthetic education, must attend to its negative, non-dialectical neighbour. If we do not learn to recognise the existential condition of our dispossession, then education can only ever be an education in value. There is no value in negative aesthetic education, which is precisely why it is so important to attend to it.

UNSOCIABILITY

In Kant's 'Idea for a Universal History with a Cosmopolitan Intent' (1784), his fifth thesis is that 'the greatest problem for the human species, whose solution nature compels it to seek, is to achieve a universal civil society administered in accord with the right'.[29] Art, culture, and social order play a large part in achieving this because 'all the culture and art that adorn mankind, as well as the most beautiful social order, are fruits of unsociableness that is forced to discipline itself and thus through an imposed art to develop nature's seed completely'.[30] It is possible to apply at least three interpretations to this passage. First, that art is analogous to social order and acts as a glue to hold societies together; which seems the most and perhaps only truly Kantian perspective. Second, art exists to articulate man's inherent unsociableness so that he can maintain his separation from other men. Third, and most complex: both of the above. This last interpretation suggests that art (as well as culture and the social order) is a means through which man can communicate *and* alienate himself. Thus it could express the chiasmic idea of a shared value and that which cannot be shared at the same time.

This unsocial sociability is not antinomical or dialectical but existential. By this logic, the putting in common of art also reminds us of that which cannot be put in common. The problems this poses to almost any form of cultural harmony are manifold, as are the problems posed to the idea of art as complicit in it. This relationship becomes especially pronounced when thought in terms of social progress and that which Kant sees as crucial to maintaining social progress: war. However, it is not simply on the grounds of social order that Kant advocates the importance of war but also in terms of individual freedom. According to Kant, even though war and preparing for war are the greatest evil, they are also necessary in terms of both social liberty and progress.[31] It is precisely the evil of focusing on war that inspires progress, seemingly undialectically, because it can never be overcome or replaced if progress is to remain possible. The attention given to war and the attention given to progress are suspended in relation to one another—totally incompatible and yet complicit. Unlike the dialectical moment of the unsocial sociability *internal* to society, the impasse a society meets with *external* existential threat does not lead to harmony: it simply persists.

Against Adorno and Max Horkheimer's reading, which perceives Kant's thinking of social progress as dialectical, it seems that, because of its relationship to external existential threat, it is rather subject to a kind of generative impasse, where resolution is annihilation. Progress requires the maintenance of opposition as a prerequisite, and the danger that Kant sees as being necessary for mankind's powers not to slumber is that of a general existential threat. Progress is the product of a shared social fear rather than individual and plural experiences and efforts. For him, culture is the product of social progress, which only occurs in states subjected to external danger. If there is no threat, either from war or unsociability, then there is no progress and no culture. This existential chiasm, rather than dialectical or antinomical impasse—where cultural progress at once relies on and attempts to overcome unsociability, while also relying on consistent external existential threat—is the mark of a negative aesthetic education. It reveals harmony as a social illusion which ultimately relies on that which exceeds its values and coherence. Negative aesthetic education is asocial, non-cultural, and outside the dialectical limit of social progress thought through the relation between society and its unsociable citizens. In negative aesthetic education, the unsociality of the singular exceeds the social rather than providing a resource for its progress. The war that Kant re-

quires to sustain social progress towards greater harmony is already existent *within* that society. However, just as the relationship between the social progress and war does not enter the dialectical process, neither does the unsociable. Unsocial sociability is a condition of existence, not a dialectical resource leading to social harmony. Aesthetic education teaches the frequently useful illusion of harmony that allows society to move away from unsociability towards shared value. Negative aesthetic education attends to the fact that unsociability and that which exceeds the social and its values will never cease to exist.

Kierkegaard's description of the Tragic Hero from *Fear and Trembling* can be aligned with Kant's argument that social progress is only possible in the context of a threat of war. To give oneself up for the greater good or to exist and act in the light of the possibility of that happening generates a certain perspective on the individual's *particular* relation to the social. The severance from the social and ethical that Kierkegaard's *singular* Knight of Faith elicits is an example of what Kant describes as 'a fall to unredeemable corruption'.[32] By stepping outside or beyond prescribed social and ethical norms, the Knight of Faith also steps beyond systems of value. Meaning becomes entirely singular and therefore redundant in terms of Kant's agenda of shared social progress, which is why 'the true knight of faith is a witness never a teacher'.[33] The Tragic Hero, on the other hand, sacrifices himself in terms of shared values which could easily include collective existential threat. Action, for Kant and the Tragic Hero, can only be afforded value if it is understood by and in the social sphere. There is no space for that which cannot be understood as social progress or social good, while at the same time the threat of war is insisted upon as its presupposition. For Kant the necessity of prescribing a preference is clear: better war than unsociability. This is based on a more general preference for understanding and universality to which Kierkegaard's Knight of Faith does not conform: 'A human being can become a Tragic Hero by his own strength, but not the Knight of Faith. When a person sets out on the Tragic Hero's admittedly hard path there are many who could lend him advice; but he who walks the narrow path of faith no one can advise, no one understand'.[34] Meaning can either be understood by others (for the Tragic Hero) or not (for the Knight of Faith). Without an already existing social and ethical context for meaning which plays into its value system, meaning falls flat as far as social value is concerned.

In Kant, passion becomes the friction which exists between states rather than individual passion in the leap of faith towards singular valueless meaning. Passion for Kant is facilitated by collective existential threat, whereas for Kierkegaard it is simply a condition of existence. It is precisely unsociability—which Kant suggests that art should discipline so as to be able create a beautiful social order—that Kierkegaard might be seen as wanting to preserve. This form of unsociability would not be thought primarily in terms of what might be called antisocial behaviour (although it could be, especially if perceived in terms of the social), the emphasis being on a de-prioritisation of the social and sociable rather than a direct attack on it. Ironically, Kant's emphasis on sociability might have negative consequences for artistic progress because art which speaks to an already existing context within which it can already be understood runs the risk of not offering much that is new. Art might then at best be a form of diplomacy or trade between constituent groups or individual members of a state. In this sense, Kant seals off society from *singular* unsociable passions with the help of art and culture, allowing instead for a form of passion to be generated by *particulars* as collective meaning in the face of the threat of annihilation. The singular is lost to the particular of the collective, and the collective and its progression are shaped by potentially fatal competition with other collectives. The Tragic Hero therefore finds himself sacrificed as a particular to Kant's sociability and shared value, while the Knight of Faith takes the leap of singular, unsociable, and valueless meaning.

NEGATIVE CAPABILITY

The term 'negative capability' was first coined by John Keats in a letter to his brothers, George and Thomas (dated 21 December 1817), in which he wrote,

> I had not a dispute but a disquisition with Dilke, upon various subjects; several things dove-tailed in my mind, and at once it struck me what quality went to form a Man of Achievement, especially in Literature, and which Shakespeare possessed so enormously—I mean *Negative Capability*, that is, when a man is capable of being in uncertainties, mysteries, doubts, without any irritable reaching after fact and reason—Coleridge, for instance, would let go by a fine isolated verisimilitude caught from the

Penetralium of mystery, from being incapable of remaining content with half-knowledge.[35]

This was his only explicit, recorded use of this concept, and whether or not the opposition between William Shakespeare and Samuel Taylor Coleridge that Keats draws is fair, the definition of the concept remains relevant and applicable. Li Ou explains Keats's definition of negativity in *Keats and Negative Capability*, writing,

To be negatively capable is to be open to the actual vastness and complexity of experience, and one cannot possess this openness unless one can abandon the comfortable enclosure of doctrinaire knowledge, safely guarding the self's identity, for a more truthful view of the world which is necessarily more disturbing or even agonizing for the self.[36]

This description helps to articulate negative capability as an educative concept outside the terms of positivistic knowledge accumulation and value accommodation. It allows greater access to truth, but this truth cannot be understood in the traditional language of aesthetic education or value-oriented education more generally.

Negative capability has much in common with Merleau-Ponty's concept of the chiasm in the sense that 'what there is to be grasped is a dispossession'. It is the capability of being able to comprehend and exist in a state conditioned by dispossession. Negative capability is part of that which is educated through a negative aesthetic education. As such, there is an interesting paradox in the fact that while Shakespeare is now taught in schools as the pinnacle of English cultural production—offering no explicit values to be educated in—the entire educational system is conditioned in total opposition to the negative capability which, for Keats at least, underpins Shakespeare's work. One must possess particular knowledge of Shakespeare to be able to afford value to one's education in terms of a grade achieved. But can this possession of knowledge of Shakespeare also translate into the possession of a dispossession that his work makes possible? To be educated in negative capability would be to increase one's capability in 'being in uncertainties, mysteries, doubts, without any irritable reaching after fact and reason'. It would be correct to say that to increase one's negative capability should increase one's capacity for negative aesthetic education, and it would be equally true that negative aesthetic education might increase one's negative capability. In this way, negative capability creates the conditions for its own educability.

John Dewey writes of both Keats and Shakespeare in *Art as Experience* in terms of negative capability, suggesting that it is a philosophy which 'accepts life and experience in all its uncertainty, mystery, doubt, and half-knowledge and turns that experience upon itself to deepen and intensify its own qualities—to imagination and art'.[37] However, Dewey does not try, here or elsewhere, to think art thoroughly in relation to education. Attempting to fill this gap, Richard Shusterman, in his *Pragmatist Aesthetics: Living Beauty, Rethinking Art*, conceives of aesthetic education—like Herbert Read—in terms of an 'organic unity', albeit one which is a 'non-repressive unity or harmony in difference'.[38] He thinks of the individual, but only ever in terms of the organic society. As such, there is room for the social individual (or Tragic Hero) but not the unsociable singularity (or Knight of Faith). Even so, Shusterman's argument implicitly separates him from thinkers of unity and shared value learned through tradition, such as T. S. Eliot, for whom 'the population should be homogenous; where two or more cultures exist in the same place they are likely either to be fiercely self-conscious or both become adulterate'.[39] But even though Shusterman's organic unity is distinct from Eliot's, it does not sit well with Dewey's understanding of Keats's 'negative capability' or with negative aesthetic education. This is because negative aesthetic education sees all unity as provisional, it prioritises the singular, and one of its major functions is precisely to disrupt, ignore, and forget the social and its shared values.

Li Ou also uses Keats's reading of *King Lear* to show that 'negative capability is not confined to aesthetics'.[40] Roberto Mangabeira Unger is clearly of the same perspective and illustrates the concept's applicability outside a literary context in his *False Necessity: Anti-necessitarian Social Theory in the Service of Radical Democracy*.[41] For Unger, 'we may use the poet's turn of phrase to label the empowerment that arises from the denial of whatever in our contexts delivers us over to a fixed scheme of division and hierarchy and to an enforced choice between routine and rebellion'.[42] As such, negative capability is not the denial itself but the empowerment that follows it. Saying no to established social value might then be the product of and pave the way to a negative aesthetic education. Of course this would not entail a wholesale dismissal of society, education, and its values. And so, for Unger this does not lead to 'anarchy, permanent flux or mere indefinition'; he gives the example that 'the actual institutions and guiding doctrines of the liberal bourgeois democracies are less entrenched and more favourable to negative capability

than the arrangements and dogmas of the European absolutist monarchies they succeeded'.[43] Value-oriented institutions and their dispositions could then be read on a scale in terms of how receptive and open they were to that which was not of explicit or obvious value to them and which might even threaten them with change. This is why institutions can be perceived as being able to provide an opening towards and an education in negative capability. The same would be the case for educational institutions and negative aesthetic education.

If, as John Llewelyn claims, artists remind us that 'the law is not made for the sake of the law', the law itself must be constructed somewhat in light of negative capability. Unlike in Kant, the unsociability associated with negative aesthetic education and negative capability is not papered over with culture, acting as a resource for progress. Instead, these negatives are to be attended to outside the logic of value and progress, not because this somehow affords *another* value but because existence and experience exceed value *anyway*. An education which attends only to value and not to that which exceeds it can only ever be indoctrination. It follows that where we learn as well as what we learn must be conditioned and somewhat constituted by negative capability. As such, negative aesthetic education might help to make and facilitate Unger's point that 'the citizen lives out in practice what the foundational view of human activity proclaims: the truth that his connections, desires, and insights cannot be definitely contained by the conceptual or institutional framework within which they provisionally operate'.[44] Negative capability has much more longevity than the provisional institutions which either limit or protect it. The sooner institutions—perhaps particularly educational institutions—understand and accommodate this fact, the sooner the many neglected aspects of real life which do not simply confer socially accepted value can be attended to.

In a way this political aspect of negative aesthetic education and negative capability is the most practically important and therefore also the most complex. Without a more fully articulated idea of how institutions and education systems 'in general' can account for, accommodate, and facilitate negative aesthetic education, it cannot begin to fulfil its potential. However, because Unger shows that it is already possible to begin to conceive of these kinds of institutions in terms of political theory, it follows that experiments in practice should almost certainly be analysed and thought in terms of negative aesthetic education.

CONCLUDING NEGATIVE POSTSCRIPT

Negative aesthetic education is the interruption of (the value of) shared social value, especially any illusory harmony of presence or fantasy of organic unity. It is another point from which decisions in and on existence can be made, which itself points towards the problem of whether we make decisions or decisions make us. In a way, it is—as de Man accuses Schiller's aesthetic education of being—for the masses. However, it would have more to do with what Jean-Jacques Rousseau conceives of in *Emile* as education outside society than with how education is currently valued, albeit without his emphasis on its chronological situation before the development of reason and preparing the ground for it. Instead, negative aesthetic education would have to exist alongside—and, to some extent, probably have to be protected by—positive education. Unger's emphasis on institutional changes which more openly accommodate negative capability is one way of articulating this necessity.

This negative aesthetic education would exist partly to develop our negative capability, partly to protect and emphasise a regard for the significance of aesthetic experiences which have no apparent social value and are even marked by their unsociality, and partly to make sure that *we do not* accept ideas of organic social wholes or cultural harmony and, equally, that *we do not* fall into the trap of thinking we can or should become self-sufficient or wholly competent agents. In a context where both of these conflicting but mutually manipulated views are common currency, this form of education as refusal is perhaps not without importance. And yet this rhetoric may give the impression that negative aesthetic education would somehow negate positive education when this is not the case. It is rather a refutation of the implicit negation of the singular and the valueless, imposed by the logic of a positive totality of organic unity and shared value. The problem is not simply unreflective patterns of thought but also positive 'solutions' to these patterns of thought which privilege either the individual or competing versions of organic unity of varying complexity (for example, social democracy, the invisible hand, participative democracy). One way of thinking negative aesthetic education would be as a reflection on the decisions which find their centre of gravity asymmetrically in the occursions of singularity outside what we tend to think of as our 'selves': what Derrida calls 'the decision of the other . . . the absolute other in me'.[45] In a sense negative aesthetic education, like aesthetic education has been supposed to be, is an education in a culture; the differ-

ence is that the culture in question is a 'universalizable culture of singularities', and it is anything but harmonious.[46]

NOTES

1. Stewart Martin, 'Aesthetic Education against Aesthetic Education', *Radical Philosophy*, 141 (2007), 39–42 (p. 42); Robert Kaufman, 'Negatively Capable Dialectics', *Critical Inquiry*, 27.2 (2001), 354–84 (p. 384).
2. Herbert Read, *Education through Art* (London: Faber and Faber, 1958), pp. 283–84.
3. Plato, *Republic*, in *Complete Works*, ed. by J. M. Cooper (Cambridge: Hackett, 1997), p. 377a–b.
4. Plato, *Republic*, p. 377b.
5. Plato, *Republic*, p. 377c.
6. Read, *Education through Art*, p. 8.
7. Friedrich Schiller, *On the Aesthetic Education of Man*, trans. by R. Snell (New York: Dover, 2004), p. 138.
8. For a more thorough engagement with these terms, see Emile Bojesen, 'Of Remnant Existence', *Philosophy Today*, 59.3 (2015), 507–22.
9. Susan Howe, *Singularities* (Middletown, CT: Wesleyan University Press, 1990), p. 41; see also Ming-Qian Ma, 'Articulating the Inarticulate: Singularities and the Counter-method in Susan Howe', *Contemporary Literature*, 36.3 (1995), 466–89.
10. Paul De Man, *Aesthetic Ideology* (Minneapolis: University of Minneapolis Press, 1996), p. 154.
11. De Man, *Aesthetic Ideology*, p. 154.
12. Theodor Adorno, *Aesthetic Theory*, trans. by Robert Hullot-Kentor (Minneapolis: University of Minneapolis Press, 1997), p. 159.
13. A provisional list of indicative and easily sourced examples to provoke thought in this direction might include William Shakespeare, *Hamlet*; Joseph Conrad, *Heart of Darkness*; Alfred Jarry, *Ubu Roi*; Susan Howe, *That This*; the paintings of Mark Rothko and Jackson Pollock; the compositions and performances of John Cage and Derek Bailey; the architecture of Peter Eisenman; the films of Nuri Bilge Ceylan and Béla Tarr; and the choreography of Merce Cunningham.
14. See, for example, Darren Henley for the Department for Culture, Media and Sport and the Department for Education, 'Cultural Education in England', 2012, https://www.gov.uk/government/uploads/system/uploads/attachment_data/file/260726/Cultural_Education_report.pdf [accessed 1 September 2015].
15. John Keats, *The Complete Poetical Works and Letters of John Keats* (Cambridge: Houghton, Mifflin and Company, 1899), p. 277.
16. See Maurice Blanchot, *The Writing of the Disaster*, trans. by Ann Smock (Lincoln: University of Nebraska Press, 1995).
17. John Llewelyn, *The HypoCritical Imagination: Between Kant and Levinas* (London: Routledge, 2000), p. 173.
18. Llewelyn, *The HypoCritical Imagination*, p. 173.
19. Llewelyn, *The HypoCritical Imagination*, p. 178.
20. Llewelyn, *The HypoCritical Imagination*, p. 178.
21. Llewelyn, *The HypoCritical Imagination*, p. 178.
22. Llewelyn, *The HypoCritical Imagination*, p. 181.

23. Maurice Merleau-Ponty, *The Visible and the Invisible*, ed. by Claude Lefort, trans. by Alphonso Lingis (Evanston, IL: Northwestern University Press, 1968), p. 266.

24. Merleau-Ponty, *The Visible and the Invisible*, p. 197.

25. A misquote; the quote actually reads, 'Being is *what requires creation of us for us to experience it*' (Merleau-Ponty, *The Visible and the Invisible*, p. 197 [original emphasis]). Quote cited by Claude Lefort, *Writing: The Political Test*, trans. by D. A. Curtis (Durham, NC: Duke University Press, 2000), p. 249.

26. Lefort, *Writing*, p. 249.

27. Lefort, *Writing*, pp. 249–50.

28. Lefort, *Writing*, p. 249.

29. Immanuel Kant, *Perpetual Peace and Other Essays*, trans. by T. Humphrey (Cambridge: Hackett, 1983), p. 33.

30. Kant, *Perpetual Peace*, p. 33.

31. Kant, *Perpetual Peace*, p. 57.

32. Kant, *Perpetual Peace*, p. 67.

33. Søren Kierkegaard, *Fear and Trembling*, trans. by Alistair Hannay (London: Penguin, 2005), p. 96.

34. Kierkegaard, *Fear and Trembling*, pp. 78–79.

35. Keats, *The Complete Poetical Works and Letters*, p. 277.

36. Li Ou, *Keats and Negative Capability* (London: Continuum, 2009), p. 2.

37. John Dewey, *Art as Experience* (London: George Allen and Unwin, 1934), p. 34.

38. Richard Shusterman, *Pragmatist Aesthetics: Living Beauty, Rethinking Art* (Oxford: Blackwell, 1992), p. 83.

39. The following sentence on the same page has also received significant attention: 'What is still more important is unity of religious background; and reasons of race and religion combine to make any large number of free-thinking Jews undesirable'. In T. S. Eliot, *After Strange Gods* (New York: Harcourt Brace and Company, 1934), p. 20.

40. Li Ou, *Keats and Negative Capability*, p. 187.

41. Interestingly, the currently rare application of Unger's work in academic contexts has found a way into another relatively complementary contemporary critique of value. See Mick Wallis and Joslin McKinney, 'On Value and Necessity: The Green Book and Its Others', *Performance Research: A Journal of the Performing Arts*, 18.2 (2013), 67–79.

42. Roberto Unger, *False Necessity: Anti-necessitarian Social Theory in the Service of Radical Democracy* (London: Verso, 2004), p. 279.

43. Unger, *False Necessity*, pp. 279–80.

44. Unger, *False Necessity*, p. 579.

45. Jacques Derrida, *Politics of Friendship*, trans. by G. Collins (London: Verso, 2005), p. 68.

46. Jacques Derrida, 'Faith and Knowledge: The Two Sources of "Religion at the Limits of Reason Alone"', in *Acts of Religion*, ed. by G. Anidjar (New York: Routledge, 2002), p. 18.

Index

abjection, 3, 39, 42–43, 44, 215–227, 263, 268, 299

absolute, 147, 149

abstraction, in art, 170, 173, 174, 175, 177–178, 181–182, 191

ace, quality, 256, 270, 272, 273, 276, 277–278, 281

acuity, 27, 281

Adorno, T., 149, 221, 249n13, 249n20, 251n49, 398, 406

affect, 45, 48, 51n9, 60, 86, 92n9, 133, 162, 225–226, 322, 323, 328, 336

affirmation, 1, 3, 5, 12, 19–21, 44, 45, 73n18, 121, 148, 165, 280, 386–387

Agamben, G., 59, 152–156

agriculture, 307, 316

alienation, Marxist, 2–3, 12, 25, 89, 121, 148, 149–150, 182, 202, 203–205, 206, 210, 220, 227, 243, 297, 307, 357, 364, 405

allegory, 66, 147, 159, 272

Alloway, L., 175, 192n9

alterity, 115–116, 128, 130–131, 140n93, 227, 228, 257, 305, 334, 336

Althusser, L., 46, 128, 360

ambiguity, 3, 17, 106, 130, 236, 258, 260, 265, 266, 267–268, 278, 280, 364, 384

ambivalence, 2, 7, 59, 68, 182, 196, 256, 270, 273, 276, 326

animals, nonhuman, 53–71, 79, 81, 92n9, 114, 115, 128, 130, 132, 134, 187, 206, 247, 320. *See also* animal studies; conservation

animal studies, 55, 72n7, 114

anthropocentrism, 54–56, 59–60, 62, 71, 72n4, 132

anti-colonialism. *See* colonialism

appropriation, in art, 189, 190–191, 201, 216. *See also détournement*

Arab or Arabic music, 216, 223–224, 226, 229n34

archaeology, 174, 183–184, 185, 188, 191

archive, 58, 98, 101, 102, 116–117, 183, 186, 191, 336

Arendt, H., 9–10, 11, 74n34, 123, 318–322, 326–327, 336–339

Aristotle, 376

Armitage, J., 122, 123, 125, 126, 128

arousal, 146, 150–151, 152, 154, 157, 160–165

art, 2, 3, 5, 7, 10, 11, 13, 15, 17, 19, 29n1, 44, 45, 46, 47, 58, 82, 88, 125, 126, 128, 135, 169–191, 195–211, 247, 253, 256, 307, 329, 330, 333, 339, 352, 355–357, 360, 362–363, 369, 395–399, 402–404, 405, 408, 410–411; art for art's sake (*l'art pour l'art*), 44, 150, 186, 310n31; art history, 48, 173, 185, 188, 191, 329, 332; art-world institutions, 49, 81–82, 91, 97, 169, 170, 172–173, 183, 184, 186, 190–192, 217; critical art (Rancière), 47, 49; folk art, 173, 183–185, 223; high art, 170, 173, 174, 180, 183, 191; participatory art, 7, 253, 260, 363–369; participation in the arts, 48, 82, 197–201, 208, 209, 210, 211, 226–227, 229n34, 295

Rosdolsky, R., 362
Rosenzweig, F., 377–379, 382–383, 390–391
Ross, K., 294–295, 301, 303, 369
Ross, U., 183
Rotenstreich, N., 389
Rothko, M., 413n13
Rousseau, J-J., 412
Rowe, K., 235
Rubin, I., 362
Rumney, R., 170
Russell, J., 244

sacred (including sacred humanism), 120–130, 135, 170, 182, 186
sacrifice, 60, 66, 118–119, 128–130, 149–150, 157, 276, 379, 407, 408
Said, E., 215–228, 228n6, 228n12, 229n34, 230n36
Sakakini, H., 226, 230n37
Sarkozy, N., 291, 308n11
Sartre, J-P., 201, 399
Say, J.B., 295
Schelling, F., 199–200
Schiller, F., 397, 398, 402, 412
Schleiermacher, F., 216
Scholz, R., 359
Scott, C., 300–301, 303–304, 309n21, 310n28, 310n30
sentiment(s), 7, 88–89, 92n12, 217, 260, 265
sensual praxis, 202–203
Searle, J., 99
Sedgwick, E. K., 265, 286n58, 342n36
senselessness, 190, 297
Shaftesbury, A. A. C. Earl of, 87
Shakespeare, W., 47, 408–409, 410, 413n13
Shusterman, R., 410
Simondo, P., 170
Situationist International (SI), 170, 172–173, 175, 179–180, 182, 189–191, 194n52, 363

slavery, 62, 64, 151, 152, 158, 162–163, 168n68, 306
Sloterdijk, P., 118, 119
Smith, A., 87
Socrates, 107
Sohn-Rethel, A., 362
Sokal, A., 99
Sontag, S., 241–242, 243
Spivak, G. C., 327–328, 333, 334–336
standards, 38, 86–87, 99, 223, 239–240, 283n35, 400
Steinbeck, J., 316
Steiner, R., 202, 211n7
Stengers, I., 247
Strauss, R., 217, 228n6
subject, 7, 46, 48, 58, 81, 114–116, 120–123, 126, 127–135, 153, 158, 160, 164, 165, 172, 191, 203–205, 255, 257, 259, 261, 264, 266–268, 299, 328, 336, 337–340, 375–391, 399–400, 402
subjectivity, contra objectivity, 94n30, 165, 182, 199, 261
surveillance, 3, 6, 255, 258, 284n41
state of emergency, 5, 50
state of exception, 4, 5, 66, 116, 119, 122, 152–153
Stegner, W., 65, 71
Strathern, M., 16–17, 91n4, 110n2, 256–259, 260–264, 266–267, 275, 276, 277, 281, 282n3, 283n21, 323
students, 2, 3, 13–14, 19, 271, 290–294, 308, 309n15, 309n16, 309n17, 322, 324, 325, 329, 331, 333, 334–335, 338, 339, 345–346, 364, 367–368, 395
subversion, 12, 107, 122, 170, 174, 181, 182, 188, 190, 219, 220, 227, 240, 248n7, 355, 369, 402, 403
surrealism, 49, 178, 363
Szendy, P., 221, 228

tachisme, 175, 177–178, 182
Tarr, B., 413n13
taste, 77–91, 218, 397

Contributors

Emile Bojesen is a senior lecturer in education at the University of Winchester, where he runs the MA in Philosophy of Education and sits on university senate. He is also co-convenor of the Centre for Philosophy of Education and branch chair of the South Coast branch of the Philosophy of Education Society of Great Britain. His current research is on optimism in education. He has published articles in journals such as *Educational Philosophy and Theory*, *Philosophy Today*, *Studies in Philosophy and Education* and the *Journal of Black Mountain College Studies* and has several articles and book chapters forthcoming in 2016. He sits on the editorial boards of *Studies in Philosophy and Education* and *Policy Futures in Education*. He is currently co-editing a special issue of *Studies in Philosophy and Education* titled 'Education, in spite of it all'.

Fabienne Collignon is lecturer in contemporary literature at the University of Sheffield. Her research interests are the Cold War/state of exception, weapons systems, theories of technology, and the poetics of space. She is author of *Rocket States: Atomic Weaponry and the Cultural Imagination* (2014). She has also published articles on the rocket's 'ideology of the zero', Thomas Pynchon's map-space, Jacques de Vaucanson's automatic duck as prototype space-age gadget, cryogenic technology in Philip K. Dick's *Ubik*, the emergence of proto-cybernetic gadgets in pre–Cold War Antarctica, and the aesthetics of techno-sublime enclosures in David Foster Wallace's *Infinite Jest*.

Jonathan P. Eburne is author of *Surrealism and the Art of Crime* (2008) and co-editor with Jeremy Braddock of *Paris, Modern Fiction, and the Black Atlantic* (2013). He edited or co-edited special issues of *Modern Fiction Studies*, *New Literary History*, *African American Review*, *Comparative Literature Studies*, and *Criticism*. Eburne is president of the Association for the Study of Dada and Surrealism and president of the Association for the Arts of the Present. He is editor of the

Refiguring Modernism book series at the Pennsylvania University Press and co-editor, with Amy Elias, of *ASAP-Journal*.

Hal Foster is the Townsend Martin Class of 1917 Professor of Art and Archaeology at Princeton and a fellow of the American Academy of Arts and Sciences. His books include *Bad New Days: Art, Criticism, Emergency* (2015), *The First Pop Age* (2012), *The Art-Architecture Complex* (Verso, 2011), *Prosthetic Gods* (2004), *The Return of the Real* (1996), *Compulsive Beauty* (1993), and *Recodings: Art, Spectacle, Cultural Politics* (1985). He co-edits *October* and is a regular contributor to *Artforum* and the *London Review of Books*. He is a recipient of the Frank Jewett Mather Award for Art Criticism of the College Art Association (2012) and the Clark Prize for Excellence in Arts Writing (2010), and he has been the Siemens Fellow at the American Academy in Berlin and the Paul Mellon Senior Fellow at the National Gallery of Art in Washington.

Geoff Gilbert is associate professor of comparative literature and English at the American University of Paris. He is author of *Before Modernism Was: Modern History and the Constituency of Writing* (2005) and is currently working on translation, capital, the semantic, and audible distance in contemporary realist writing.

Rob Halpern is a poet and creative writing professor at Eastern Michigan University. As a poet he is author of *Common Place* (2015), *Placeholder* (2015), *Music for Porn* (2013), *Disaster Suites* (2009), *Weak Link* (2009), and *Rumored Place* (2004). In addition to writing poetry, Halpern is an essayist and a translator (including of Georges Perec), as well as a scholar of modern culture and contemporary writing. Recent essays and translations appear in *Chicago Review, Journal of Narrative Theory*, and the Claudius App. He currently splits his time between San Francisco and Ypsilanti, Michigan.

Tom Jones is reader in English at the University of St. Andrews. He teaches eighteenth-century poetry, fiction, and philosophy, as well as literary theory and the theory of literary language across a broader historical range. His work on poetry and poetics has concentrated on Alexander Pope but extends across the range of post-Renaissance English-language poetry. He also has a particular interest in George Berkeley, of whom he is writing a biography. His publications include *Poetic Language: Theory and Practice from the Renaissance to the Present* (2012), *Pope and Berkeley: The Language of Poetry and*

Philosophy (2005), and *The Poetic Enlightenment: Poetry and Human Science, 1650–1820* (co-edited with Rowan Boyson, 2013).

Karen Kurczynski is assistant professor of modern and contemporary art history at the University of Massachusetts, Amherst. She is author of a monograph on Asger Jorn, *The Art and Politics of Asger Jorn: The Avant-Garde Won't Give Up* (2014). She co-curated the 2014 centennial exhibition on Jorn's dialogues with other artists at the Museum Jorn in Denmark, as well as a major US travelling exhibition on the Cobra movement, originating at the Museum of Art Fort Lauderdale for 2016. Her writing on modern and contemporary art, politics, and the Situationist International has appeared in *Art Papers, Artforum, BlackFlash, October, Rutgers Art Review, Res, Women's Art Journal,* and *Third Text.*

Sam Ladkin is senior lecturer in the School of English, University of Sheffield. His work tends to focus on the relationships between poetry and the arts. With Robin Purves he has edited three collections, *Complicities: British Poetry, 1945–2007* (2007), the 'British Poetry Issue' of *Chicago Review* (2007), and '"The Darkness Surrounds Us"*: American Poetry,' special issue of *Edinburgh Review* (2004). He is at work on a monograph titled *Frank O'Hara and the Language of Art.* His articles have appeared in *Textual Practice, Glossator, Blackbox Manifold, Forum for Modern Language Studies, World Picture, Chicago Review, Edinburgh Review, Word & Image,* and *Angelaki.*

Dominic Lash is a double bassist, composer and researcher. Active in improvised music and contemporary composition, he has performed with musicians including John Butcher, Tony Conrad and Evan Parker, and published more than forty albums. Solo compositions have been written for him by Jürg Frey, Radu Malfatti and Éliane Radigue. His PhD research was on the operation of metonymy in JH Prynne, Derek Bailey and Helmut Lachenmann. Recently he has made a move into film studies and is currently conducting postgraduate research in twenty-first century narrative film at the University of Bristol.

Christian Lotz is associate professor of philosophy at Michigan State University. He was born in Wuppertal-Elberfeld—the birthplace of Friedrich Engels—in West Germany in 1970. From 1990 to 1997, he studied philosophy, art history, and sociology at the universities of Bamberg, Jena, and Tübingen. His principal interests

have been in post-Kantian European philosophy, especially in German philosophy and phenomenology, as well as in aesthetics and philosophy of culture (Kulturphilosophie). During the last decade Lotz has worked on the European tradition of philosophy in general and mainly on Husserlian and Heideggerian philosophy, on Johann Fichte and G. W. F. Hegel, and on phenomenological concepts, such as affectivity, memory, forgiving, and the lived body. He is currently working, on the one hand, on Martin Heidegger, Theodor Adorno, Karl Marx, contemporary Marxism, and recent political philosophy and, on the other hand, on hermeneutics and image theory, especially painting and photography. His English-language publications include *The Art of Gerhard Richter: Hermeneutics, Images, Meaning* (2015), *The Capitalist Schema: Time, Money, and the Culture of Abstraction* (2014), *From Affectivity to Subjectivity: Husserl's Phenomenology Revisited* (2008), and the co-edited collection *Phenomenology and the Non-human Animal: At the Limits of Experience* (2007).

Robert McKay is senior lecturer in English literature at the University of Sheffield. He has published *Killing Animals* (2005) with the Animal Studies Group, in addition to several essays on the politics of species in post-war and contemporary literature and film. With Matthew Holman, he won the 2013 Higher Education Academy Staff-Student Partnership Award for a project to design an interdisciplinary humanities research module that is intellectually and pedagogically inspired by the Against Value project.

Marie Morgan is senior lecturer in education studies at the University of Winchester and is also faculty head of quality for the Faculty of Education, Health and Social Care. Her teaching and research draw on philosophy and social and political thought to explore the meaning and significance of education comprehended as a human endeavour.

Mike Neary is professor of sociology in the School of Political and Social Sciences at the University of Lincoln and was dean of teaching and learning until 2014, head of the Centre for Educational Research and Development between 2007 and 2012, and director of the Graduate School between 2011 and 2014. Before becoming an academic, he worked in youth development and community education in South London from 1979 to 1993. He is also a founding member of the Social Science Centre, Lincoln, a co-operative providing free public higher education. His publications include *Student as Produc-*

er: How Do Revolutionary Teachers Teach? (2014), *The Future of Higher Education Policy* (with Leslie Bell and Howard Stevenson, 2009), and *The Labour Debate: An Investigation into the Theory and Reality of Capitalist Work* (with Ana Dinerstein, 2002).

Griselda Pollock is professor of the social and critical histories of art at the University of Leeds. Born in South Africa, she was educated in French- and English-speaking Canada and in the United Kingdom. Her work comprises feminist, social, queer, and postcolonial interventions in the histories of art, trauma and cultural memory, representation of and after the Holocaust, and nineteenth-century to contemporary visual arts and film. Her published books include *Old Mistresses: Women, Art and Ideology* (with Rozsika Parker, 1981, reprinted 2013), *Framing Feminism: Art and the Women's Movement 1970–85* (with Rozsika Parker, 1987), *Vision and Difference* (1987, reprinted 2003), *Looking Back to the Future: Essays on Art, Life and Death* (2001), *Museums after Modernism* (2007), *Encounters in the Virtual Feminist Museum* (2007), *Visual Politics and Psychoanalysis: Art and the Image in Post-traumatic Cultures* (2013), and *After-Effects/After-Images: Trauma and Aesthetic Transformation in the Virtual Feminist Museum* (2013).

Marilyn Strathern is emeritus professor of social anthropology, University of Cambridge, former mistress of Girton College, fellow of the British Academy, foreign honorary member of the American Academy of Arts and Sciences, recipient of the American Viking Fund Medal for outstanding intellectual leadership, holder of the Huxley Memorial Medal from the Royal Anthropological Institute for lifetime achievement, honorary life president of the Association of Social Anthropologists, and dame commander of the British Empire for services to social anthropology. Her publications include *Kinship at the Core: An Anthropology of Elmdon, Essex* (1981), *The Gender of the Gift: Problems with Women and Problems with Society in Melanesia* (1988), *Partial Connections* (1991), *After Nature: English Kinship in the Late Twentieth Century* (1992), *Reproducing the Future: Essays on Anthropology, Kinship and the New Reproductive Technologies* (1992), and *Kinship, Law and the Unexpected: Relatives Are Always a Surprise* (2005).

Peter Thompson was, until 2015, reader in German at the University of Sheffield and director of the Centre for Ernst Bloch Studies. He taught at the University of Sheffield from 1990, having left

school at sixteen, joined the army for five years, and then worked as a lorry driver, before commencing undergraduate study as a mature student in 1983 at Portsmouth Polytechnic. His interests are in the post-war history of the German Democratic Republic (GDR) and German unification, as well as the theories of Ernst Bloch studies, encompassing not only Bloch's period in the GDR from 1949 to 1961 but also the philosophical impact of his theories of "Concrete Utopia" and the central role of hope in social transformation. Thompson co-edited *The Privatisation of Hope: Ernst Bloch and the Future of Utopia* (with Slavoj Žižek, 2013). Other publications include *The Crisis of the German Left* (2005) and his regular contributions to the *Guardian* newspaper.

Rachel Beckles Willson is professor of music at Royal Holloway and director of the Humanities and Arts Research Centre. She is a writer and musician whose research has explored the intersections of history, politics, and performance. Her publications include *Ligeti, Kurtág and Hungarian Music during the Cold War* (2007) and *Orientalism and Musical Mission* (2013).